PICTURING TIME

P I C T U R

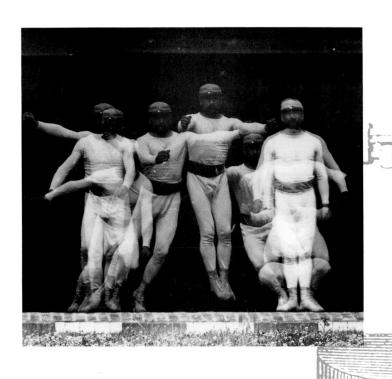

The University of Chicago Press Chicago and London

Marta Braun

I N G T I M E

*The Work of
Etienne-Jules Marey
(1830–1904)*

Marta Braun is professor in the Department of Film and Photography at
Ryerson Polytechnical Institute, Toronto.

MM

Publication of this book has been aided by a grant from the Millard Meiss
Publication Fund of the College Art Association.

The University of Chicago Press, Chicago 60637
The University of Chicago Press, Ltd., London
© 1992 by The University of Chicago
All rights reserved. Published 1992
Printed in the United States of America
01 00 99 98 97 96 95 94 93 92 5 4 3 2 1
ISBN: 0-226-07173-1

Library of Congress Cataloging-in-Publication Data
Braun, Marta.
 Picturing time : the work of Etienne-Jules Marey (1830–1904) /
Marta Braun.
 p. cm.
 Includes bibliographical references and index.
 1. Chronophotography. 2. Art and photography. 3. Human
locomotion. 4. Animal locomotion. 5. Human mechanics.
6. Animal Mechanics. 7. Marey, Etienne-Jules, 1830–1904. II. Title.
TR 840.B73 1992
770'.92—dc20
 [B] 92-9371
 CIP

♾ The paper used in this publication meets the minimum requirements of the
American National Standard for Information Sciences—Permanence of Paper
for Printed Library Materials, ANSI Z39.48-1984.

To Ida and Sydney,
who opened the first doors

How do you know but ev'ry Bird that cuts the airy way
Is an immense world of delight, clos'd by your senses five?

William Blake, *The Marriage of Heaven and Hell*

Contents

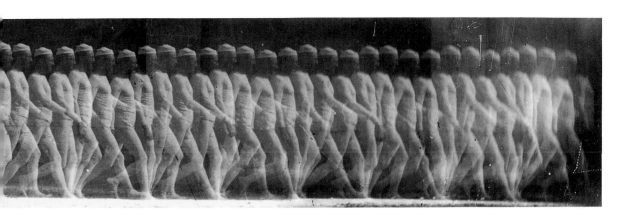

Acknowledgments

I began research for this book more than ten years ago with two mentors, first Hollis Frampton in Buffalo and then Dr. Alfred Fessard in Paris. Sadly, neither is here to be thanked as he deserves.

From the beginning I have enjoyed the support, first in collaboration and then in friendship, of an international community of scholars. I am particularly grateful to Christine Delangle, archivist of the Collège de France, and Noëlle Giret, chief curator of the Museum of the Cinémathèque Française, for their energetic and ongoing involvement with the work of Marey and with this project.

Marey is still a living presence in Beaune, thanks to the efforts of Henri Savonnet and his "Amis de Marey." The former curator of the Musée Marey there, René André, who unfortunately did not live to see the present work, gave me all the help I asked. His successor, Marie-Pierre Romand, and the present curator, Marion Leuba, who share his dedication to Marey, continued his generosity to me. Marey's family, M. et Mme Etienne Noël-Bouton of Chagny-sur-Saône, have throughout these years afforded me every kindness.

For assistance in understanding critical aspects of the many disciplines to which Marey contributed, I am indebted to a number of people. Dr. Ralph Sonnenschein allowed me to draw upon his encyclopedic knowledge of physiology. He also read the chapter on the graphic method and kindly corrected its errors. Drs. Zuzana Sramek, Vincent DeMarco, and Eva Friede gave me invaluable help with material about medicine and its history. The late Léo Sauvage, as well as Virgilio Tosi, guided me through the labyrinth of cinematic invention. Charles Musser and Ray Phillips answered many queries about Edison's early work. Marion Shipley of the Kingston Heritage Centre, Kingston-on-Thames, David Wooters of Eastman House, Rochester, and Blake Fitzpatrick provided additional material on Muybridge, and Mike Mandel and Jane Morley helped with Gilbreth.

Over the years many people have read parts of the manuscript and have offered comments, criticism, and counsel. They include all my family of inveterate readers and writers: my parents, Frank and Tina Braun, and my four sisters, Kathryn Hughes, Elisabeth Braun, Anita Agar, whose persuasive insistence on clarity is mirrored throughout this book, and Emily Braun, whose work in twentieth-century Italian art benefited me immensely. Mark Roskill, Christopher Phillips, Maria Morris Hambourg, Brian Henderson, Gian Paolo Lozej, Karen Mullhallen, and Gail and Barry Lord deserve special thanks for their discerning critical suggestions and advice. Penny Arthur and Hélène Boizeau Waverman refined my French translations, Robin Roger, Ben Lifson, David Kilgour, and Alice Bennett deftly edited succeeding versions of this manuscript. For help with research and visual material I want to thank Mary-jo Stevenson, Robarts Library, University of Toronto; Eleanor McGill, Blacker-Wood Library of Biology, McGill University; Antonella Vigliani Bragaglia, Centro Studi Bragaglia; Pierre Braquemond and Catherine Ficat, Cinémathèque Française; Sylvain Pelly, Société Française de Photographie; Catherine Mathon, Ecole des Beaux Arts; Jacqueline Sonolet, Musée de l'Histoire de la Médecine; Frédérique Desvergnes and Jeaninne Bruno, Musée National des Techniques; Emma Hedderwick, Science Museum,

London; Jim Purcell, Centre National de la Cinématographie; Kate Lewin, Annaliisa Luik, and Ezio Molinari.

Last, there is that small supportive circle that every writer needs. Allard Tobin and Brian Shaw made a home for me in London. Sydney and Ida Leach and Joe Plaskett created a haven for writing and thinking in Paris. The discriminating judgment of Marx Wartofsky and Giuseppe Scavizzi has been a constant source of inspiration from the time I began.

I wrote this book with the help of two mentors, Joel Synder and Eric Wright. Their unstinting generosity has sustained me throughout this work, and it would be impossible to express all the ways I have been enriched by their wisdom, counsel, and innumerable acts of kindness.

Finally, without my husband Edward Epstein, it would never have been possible.

Research for this book was supported from 1981 to 1983 by grants from the Social Sciences and Humanities Research Council of Canada.

Introduction

I began this study of Etienne-Jules Marey in fall 1979. I was working with the filmmaker Hollis Frampton on nineteenth-century motion photography and its relation to painting, and Marey was central to the project. At the time, Marey's name was coupled in my mind with that of Eadweard James Muybridge; both were pioneers in the photography of movement, and the work of both photographers had considerable effect on nineteenth- and twentieth-century painting. Muybridge was certainly the better known. His flamboyant and eccentric character (he is always introduced with the story that he murdered his wife's lover) and his photographs of California's early pioneering history had made him a vivid and quasi-legendary figure in the history of photography. Marey, by contrast, was shrouded in mystery. Apart from the scientific books and articles he had written, very little was known about him. His private life remained secret; all his personal letters and papers had been destroyed after his death. By all existing accounts, his public life was lacking in drama and excitement. In 1979 no biography of the man existed; no book had been devoted to his work. Although he made significant contributions to the fields of cardiology, physiological instrumentation, aviation, cinematography, and the science of labor as well as to photography, the few articles written about him or the exhibition catalogs devoted to his work concentrated on only one of these. Even this plethora of disciplines was puzzling. Was it possible that one man could have been instrumental in so many spheres and yet remain unknown to all but a few scholars, themselves so specialized that they seemed almost unaware of his work outside their own disciplines?

A relatively minor puzzle drew me into the larger mysteries that seemed to surround Marey's life and work. In his writings before 1898, Marey often refers to the Station Physiologique in the Bois de Boulogne; in 1898 another name, the Institut Marey, appears in its place; and thereafter he uses the two names interchangeably. Were they indeed two places? Or was the Station Physiologique renamed and did its old name persist in common usage? About the end of December 1979 I asked a friend in Paris to telephone the Collège de France, which had annexed Marey's establishment in the Bois, for clarification.

Because she did not get much information by phone, and is persistent, my friend drove to the Bois de Boulogne, on the outskirts of Paris, on a bitterly cold January day, to see if she could clear up this mystery. There she learned that "Station Physiologique" was used interchangeably both for this area of the park and for a building in it, and that there was another building in the park called the Institut Marey. But this discovery, useful enough in itself, was all but forgotten because of what else she learned that day. By the first of what were to be many of the coincidences scholars usually only dream of, my friend arrived at the site at the same time as a crew of wreckers who, making way for the expansion of the Roland Garros tennis stadium, were demolishing a large old building that turned out to be the Institut Marey itself. A workman told her that that very morning, as they began their work, they had discovered four large wooden cases carefully hidden under the roof. Two of the cases had been opened by the foreman, who found boxes of glass-plate negatives and papers. All four cases

had been sent to the office of Professor Alfred Fessard in the Collège de France.

Fessard, a neurophysiologist world famous for his pioneering work in electroencephalography, had been the last director of the Institut Marey and in that position had, since 1974, overseen its slow dismantling. He had been responsible for disposing of the contents of the Institut and the Station, sending them to various archives. The Musée Marey in Beaune, Marey's birthplace, got the lion's share, including Marey's scientific instruments, his still and cinema cameras, and five of the ten albums of photographs made during his lifetime to comply with the conditions of a subsidy the city had awarded him in 1882. The other five albums were in Paris: one remained in the Collège de France, and Fessard had sent one to the Bibiliothèque Nationale; the last three were still in the Hôtel de Ville. Apart from 112 negatives also at Beaune, the photographs in these albums constituted everything that was known about Marey's photographic experiments.

I became obsessed by the contents of those wooden cases. If the glass plates were Marey's negatives, which had disappeared sometime after his death in 1904, their reemergence meant that the work of one of the most important experimenters in the history of photography had been rediscovered, perhaps intact.

I arranged to meet Professor Fessard in Paris the following June. As I entered his office at the Collège I saw in the glass-fronted bookcases stacks and stacks of small blue boxes labeled "Lumière"— the name of the most famous French photographic suppliers of the nineteenth century. Fessard, a tall, distinguished man in his late seventies, opened one of the boxes and gingerly pulled out its contents: about twelve of Marey's glass-plate negatives of human locomotion. The other 150 boxes were similarly packed. Fessard turned to a large cup-

board behind his desk, then brought out and opened two large wooden cases containing the documents found with the negatives: the manuscripts of Marey's books and the bills for running the Station from its founding in 1882 until Marey's death in 1904. In the six months that Fessard had possessed this treasure, virtually Marey's lifework, he had cared for it lovingly, even though he knew that because of a stroke he had suffered a year earlier he had neither the strength nor the time to study the material as he would have liked. Seeing my fascination, he asked if I was interested in working on the material. I said yes; he invited me to use his office. He himself could not come often, he explained, but he would be happy to help in any way he could, and we would meet periodically. This extraordinary generosity, this expression of confidence in a younger student outside his field, whom he had known for only a few hours, was typical of Fessard as I came to know him.

At the end of June he arranged a meeting with Etienne Noël-Bouton, Marey's grandson, who was in Paris to attend an exposition on Marey's cardiovascular research that was the highlight of the European cardiology congress. That meeting marked the beginning of my unraveling the mystery surrounding Marey's private life. Over the next two years Fessard introduced me to many other people who would shed light on Marey. He also patiently guided me through what were then the totally unfamiliar waters of the history of science and medicine. His recollections of the history of physiology, in which he had played such a large part, were invaluable; he could instantly clear up obscure areas that would have taken me much longer to solve on my own. This kind and unstinting help ended with Fessard's death in February 1982, a great loss to countless students, colleagues, and friends.

There were about thirteen hundred negatives and some three hundred positives and diapositives

in Fessard's bookcases; my first task was to identify, sort, and catalog them, and it seemed overwhelming. Marey was not a photographer in the traditional sense but a physiologist who had used the camera to study the mechanics of locomotion; therefore his negatives presented enormous difficulties to one not trained in physiology, for they were the raw data of his experiments in movement and not objects in the art historian's sense of the word. Some of the subjects were impossible to identify without additional information; the photographic techniques he used varied; the negatives were of different sizes, some numbered, some not; only a few included descriptions handwritten onto the emulsion—others gave no clues at all. Just the task of devising working categories for these negatives seemed impossibly difficult.

Luckily a number of people and events made that task easier, in particular Christine Delangle, archivist of the Collège de France, who, after the material was transferred to the archives, spent most of summer 1981 with me constructing the catalog.

Since no exact chronology of Marey's photographic experiments existed, the most difficult part of the work was assembling the material to accurately establish one. I assigned dates to the negatives according to a number of determinants, including size differences that could unambiguously be attributed to datable changes in Marey's apparatus and technique. Marey's own illustrated reports—he published over two hundred works, including nine full-length books—provided valuable clues, and the albums of photographs in Beaune and Paris were key documents: they were dated by Marey, and the prints they contained were made from the series of numbered negatives in the cache found under the roof of the Institut Marey. Also in Beaune were two of Marey's greatest admirers, René André, curator of the Beaune Museum, and Henri Savonnet, professor of philosophy at the local lycée and founder of

the "Amis de Marey." Both were excited about the discoveries in Paris and provided inestimable help.

As the finishing touches were being put on the catalog, the work was crowned by a coincidence that for a while let us speak of the project in poetic terms. Marey's ashes were brought to the archives and kept in a cupboard there while the monument to him that had stood in front of the Institut Marey since 1914 was moved temporarily to make way for the continuing expansion of the tennis stadium. At the end of the summer, Mlle Delangle and I accompanied the urn back to the stadium grounds, where it was again sealed up in the monument. Five others stood with us during the small ceremony outside the walls of the Garros stadium. A showplace of supreme athletic skill, we thought, was an appropriate site for the monument of a man who had photographed fencers, pole vaulters, runners, and other athletes with the object of visualizing the principles of their virtuosic movement.

The summer of 1982, a few months after Fessard's death, yielded the solution to another mystery. In his search for the perfect instrument for recording movement, Marey had invented a motion picture camera, and in 1963 four hundred of his films had been cataloged by Lucien Bull, Marey's last assistant and Fessard's first. Yet when I began my research, the whereabouts of only a few of these films were known; none had been found under the roof of the Institut. The missing films turned up, again by chance, when I was engrossed in an unrelated search, this time for Marey's letters.

All French histories of cinema written before the 1970s mention a group of more than three hundred letters that Marey wrote to his assistant Georges Demeny; the letters were said to be in the possession of the Cinémathèque Française, but I could not find them there at first, partly because in 1982 the Cinémathèque was in flux. It had been almost single-handedly created in 1935 by Henri

Langlois, a passionate film lover who had been obsessively dedicated to collecting and preserving films and cinema memorabilia when both were largely held in contempt or ignored.[1] Langlois hoarded everything he could find but cataloged his treasures idiosyncratically. When he died in 1977, the Cinémathèque was left in disarray.

But on one visit there to ask after the letters, the luck that had graced so much of my project was with me. The chief technician of the Cinémathèque, Pierre Braquemond, himself a Marey enthusiast, happened to be in the room; overhearing my request, he suggested that I be shown a box in the reserve that contained, in his words, "some Marey things." Twenty minutes later a nondescript cardboard box was brought in. I expected to discover memorabilia, but to my astonishment I found layers of tightly wound bobbins of film, many of them beginning to disintegrate into a fine powder. Braquemond then led me to another cache of 132 more glass-plate negatives that turned out to belong to the series in the Collège. How long they had lain hidden in the depths of the Cinémathèque, or indeed how they got there, no one could say.

In 1984 Noëlle Giret, the Cinémathèque's new curator, found the Marey letters as she tracked down, opened, organized, cataloged, and found space for the great amount of material collected by Langlois and began the process of preservation. The letters had been in one of the many suburban storage depots where Langlois had stockpiled his collection. They were the last piece in the puzzle; with them, and the films and negatives, it was now possible to reconstruct Marey's photographic and cinematographic career.

To this day our knowledge of Marey has remained limited, partly because the study of his photography grows out of critical assumptions that view his techniques and methods as a small part of a larger teleological history of photographic invention or that stress the artistic value of his imagery. Either approach detaches his work from its original purposes and separates Marey from his historically precise intellectual context—nineteenth-century positivism and scientific thought generally. As I worked with the negatives and documents, I became progressively persuaded that this idea of Marey was incomplete.

One of the most striking discoveries that emerged during my study was the enormous difference between Marey's photographic study of locomotion and the one Eadweard Muybridge carried out in Philadelphia at roughly the same time. Our belief that Muybridge was a disinterested observer using a camera to objectively record the mechanics of locomotion is based on a faulty reading of his work. Muybridge was an artist whose roots in the pictorial traditions of his day conditioned the way he used his camera. That his work has long been seen as scientific testifies in equal measures to the power of our response to the "scientific"-looking clues in his photographs and to our beliefs about the sequential structure that governs his depictions of locomotion. Misled by the apparently scientific apparatus shown in the pictures—the grid against which Muybridge posed his figures and the chalked-off area in which they move—which in fact give us no way to measure anything real, we have misread his photographs. They are in fact not scientific depictions of movement, but fictions.

Conversely, while the photographs Marey made are beautiful, an aesthetic response to them that ignores their reason for being falsifies the production, the evolution, and the meaning of his imagery. Indeed whereas Muybridge's photographs have little to do with science, Marey's photographs are all but incomprehensible without a knowledge of his scientific aims in making them and of his achievements in physiology generally, both before and after his

photographic experiments. A specific scientific question led to his becoming a photographer in the first place; his general scientific work set the terms for all his photography. The photographs he produced are raw scientific data. Marey's cameras are together only one kind of the variety of scientific instruments he created or refined in order to study motion throughout his long scientific dedication to this subject. Therefore, to understand both how he arrived at making pictures and the kind of pictures he made, it seemed essential to explain what kind of scientist he was.

Like Leonardo da Vinci before him, Marey desired above all to make the world visible; only thus, he believed, could it be measured, and only through measurement could it be truly known. Marey's world was the world of motion in all its forms; its conquest was his greatest achievement.

He began in the late 1850s with graph-making instruments that intercepted movements invisible to the eye, such as the rhythm of the pulse, and traced them onto the surface of a smoke-blackened cylinder. With these instruments he was able to monitor movements that were hidden within the body, like the beat of the heart, or that happened in units of time so large or small as to be beyond reach of the senses, like the gaits of a horse or the flight of a bird, and to translate them into a form of writing that made them fully intelligible for the first time. The sinuous curves made by his instruments gave physical expression to the time in which the movement occurred and allowed Marey to show the relation of time and space, which is the true form of any movement. Through the intermediary of these machines the present moment was no longer a singular and ephemeral instant; it was made into a continuous and permanently recorded event.

With his earliest graphing machines he worked primarily on movements inside the body, and these investigations resulted in a number of important

"firsts." He was able to give effective proof for the first time of the way the elasticity of the arteries affected the circulation of the blood; and together with his equally gifted colleague Auguste Chauveau, he was the first to produce an accurate graphic tracing of the sequence of the heart's movements. He went on to develop instruments that could measure most physiological functions, such as respiration, circulation, and muscle function, and that could demonstrate the difference between their normal and pathological states.

Marey thought of the body as an animate machine whose motion was subject to the laws of theoretical mechanics—laws that govern any assemblage of matter in motion. His aim was to discover these laws in physiology. That is why graphing machines—instruments that had already proved extremely useful in physics and mechanics—seemed eminently suitable to his task. When the relations among the parts of the animate machine were highly complex and numerous, however, Marey found that his instruments could not provide all the information he needed to make a proper analysis. Such was the case with the study of locomotion proper, which he began about 1870.

In essence Marey wanted to arrive at a visual description of the common types of human motion—the walk, the run, the jump, and so on—and the forces at work in their execution; specifically, he wanted these descriptions to depict the relationships in time and space of the various body parts. But this required a less abstract visual representation than his graphic method could produce. To know what is involved in the walk, for example, Marey needed a depiction of the movement of the leg as one foot goes up and the other goes down, and of the oscillations of the lower part of the leg as it moves against the upper; of the relation of the up-and-down movement of the leg to the shifts in the body's center of gravity; and of the connection of this

movement to the movements of the arms and the head. Finally, he wanted to know the amount of muscular force needed to move the body through space. This is only a sketch of the kind and number of relations Marey wanted to record, but it gives an idea of the complexity of the subject. To understand how ambitious his aim was, however, and how daunting the task, we need to keep in mind one other thing. Marey wanted to picture all these factors simultaneously, in a single and legible representation. In other words, he wanted to depict in a single image all the relationships occurring both between one body part and each of the others and between one body part and the body as a whole at each of several instants of a specific movement executed during a discrete unit of time and in a specifically defined and constant space. In 1870 there was no machine that could do this.

The camera, of course, could describe the body and all its parts at once, but no camera could provide a description over time. It could freeze a single image of a moving body if the figure were at a distance (if it were closer, the image of the moving body would be blurred), but photographic optics and chemistry prohibited the recording of ongoing movement, at least until 1878. In that year the Anglo-American photographer Eadweard Muybridge published a series of photographs he had taken of moving horses. Muybridge's work, which aimed to show the horse as a dark silhouette against a white ground and thus could take advantage of much faster shutter speeds, was a stimulus for Marey (as was a new product, a much more sensitive negative material, that was put on the market that same year). But whereas Muybridge had used multiple cameras to capture the shape of the horse's body at isolated phases of its motion, Marey wanted to give a visible expression to the continuity of movement over equidistant and known intervals, as his graphing machines had done, and to do so

within a single image. Only this, he believed, would give him quantifiable results—photographs from which measurements could be taken. But though a graph gives a visual expression to the relation between the entities being graphed, it does not give a picture of its object as a photograph does. Marey wanted both. He wanted to combine the photograph's power to mirror objects in space with the graph's power to produce a visible expression for the passage of time. So to approximate the accuracy of the graphic method with a camera, Marey had to use the camera in a manner entirely different from anything done up to this time.

By 1882 Marey had succeeded in making the camera into a scientific instrument that rivaled his graphing instruments in its power to clearly express change over time. With a single camera that he both devised and constructed to make multiple images on a single plate and from a single point of view, he photographed movement in a way that did more than just stop time. He captured ongoing phases of movement and spread them over the photographic plate in an undulating pattern of overlapping segments. Almost without precedent in the history of representation (only Leonardo da Vinci had attempted to depict motion in the same form of overlapping contours), Marey's photographs gave visible extension to the present, virtually representing the passage of time.

Once he had refined his photographic method, Marey was able to give the first incontrovertible descriptions of how we actually move and, similarly, of how the animals with whom we share this planet propel themselves over the earth and through the water and the air. Marey's last investigations into movement were done with a cinema camera, an instrument he invented (seven years before the advent of commercial motion pictures) to overcome the limitations of his photographic method. By the end of his life, his study of motion had led him to make

visible the most ephemeral movements of all, those of water and air.

Marey's data and his methods were adopted by pioneers in many fields, sometimes with significant results. His studies of the flight of birds were important to the foundation of aviation in Europe and in America, especially to the Wright brothers. His descriptions of human locomotion were used as the scientific foundation of a physical training program for both soldiers and athletes, and in France they were absorbed in the nationalistic desire (a result of the French defeat by the Prussians in 1870) to increase the endurance and fortitude of the average citizen. His graphic, chronophotographic, and cinematographic techniques were adopted and developed by European physiologists and psychologists to create a science of human labor that revolutionized the concept and execution of work. In the science of industrial management, his method of decomposition and his subject, human motion, were used in America to control the productivity and efficiency of the labor force. And finally, the cinema camera he invented was a key element in the foundation of the motion picture industry.

Marey's influence was also quickly felt in the field of art. During his lifetime, academic painters and sculptors looked to his images (and Muybridge's) as an authority for the representation of humans and animals in motion. Less than ten years after he died, his images were either directly reproduced or strongly echoed in the works of many avant-garde painters. We can trace Marey's influence, for example, in Marcel Duchamp's painting *Nude Descending a Staircase* (1912), in which the artist attempts to illustrate the interaction of time and space on a canvas; in František Kupka's *Planes by Colors* (1910–11), in which Kupka tries to demonstrate the experience of motion; and to the Italian futurist painters, who borrowed Marey's imagery to epitomize the dynamic sensation of felt time.

Both Marey's investigations and the unprecedented qualities of his imagery were seen to be the expression of a general preoccupation, among artists and intellectuals in Europe and North America, with the subjective impression of time. As Marey was spatializing time with his camera so that he could analyze motion, the experience of time itself was undergoing a profound transformation in the Western world, perhaps the most profound transformation since the fourteenth century, when the proliferation of clocks and watches suddenly made visible two dimensions of time that earlier had been unobservable: uniformity and universality. Once these dimensions were visible, their authority—hitherto only suspected—was itself made not only visible but absolute. And with the scientific discoveries of the nineteenth century it was revealed to have almost infinite magnitude—and became overwhelming. But paradoxically, while the authority of uniform and universal time in the public world became increasingly imposing, in the private world of individual consciousness it fostered a heightened awareness of subjective time: a sense that, for the individual, time proceeds at an irregular pace beyond the reckoning of any standard system of measurement, that it is both heterogeneous and varied from one person to another. At the core of this subjective or psychological experience of time—founded in the technological innovations of the late nineteenth century, such as the telephone, telegraph, and phonograph—was the moment called "now," an expanded present full of multiple events perceived simultaneously. In the culture of the early twentieth century (called the "culture of time" by the contemporary scholar Stephen Kern) no unifying concept could rival the coherence and the popularity of the concept of simultaneity. The heart of psychoanalysis, the stream-of-consciousness novel, cubism, futurism, simultaneous poetry, and so forth, is to be found in that exploration of the

thickened present—"a continuous flux, a succession of states each of which announces that which follows and contains that which precedes it," as Henri Bergson described it.

The culture of time transformed everything, including our perception of the photographic work of Marey; its force severed his photographs from their scientific roots and made them into artifacts of subjective time. The photographs of movement Marey made have generally been perceived as one of the most vivid forms in which the cultural experience of the thickened present was visually articulated in the late nineteenth century, and certainly they were among the most influential. Rather than the unique frozen instant separating the past from the future—the traditional photographic method of operating on time and the traditional mode of thinking about the present—Marey's pictures seemed to exemplify the new experience of time as a succession of overlapping forms melded together and flowing into each other, perceived simultaneously.

That so many dissimilar artists and intellectuals adopted Marey's techniques and images can most easily be understood when his pictures and methods are examined as part of the culture of time and in relation to this culture's impact on the early part of the twentieth century, as can the variety of uses later investigators made of his findings and imagery. Such a reading, however, clouds any real understanding of Marey and limits our evaluation of his achievements.

Marey was first and last a research scientist, engaged in pure scientific research into the nature of motion. His graphic, chronophotographic, and cinematographic instruments were to him only instruments with which to observe and record movement in such a way that it could be measured and then quantified so that its principles might be known. The subject of his pictures, broadly speaking, was nature; their content, knowledge. He considered them data; the audience he imagined and addressed was made up of scientists like himself and of those artists who aligned themselves with the scientific quest for truth. And while it is true that Marey's photographs are beautiful and meaningful in the way that art objects are meaningful, their beauty and meaning have little to do with what later artists and intellectuals found in them and took from them.

If Marey's work is set apart from his beliefs and aspirations, it becomes difficult to recognize the differences between it and the work of others with which it is usually coupled (for example, that of Eadweard Muybridge) or held as a precedent (futurism, the development of the cinema, and the work of Frank Gilbreth). Indeed, the different goals of the scientist and the artist as well as the unique roles of art, science, and industry in the late nineteenth century are lost if these differences are not both recognized and honored. Marey is lost too, reduced to a "photographer" pure and simple—a "precursor" in areas he consciously avoided. And the meaning of his work, and therefore its beauty, is lost as well.

PICTURING TIME

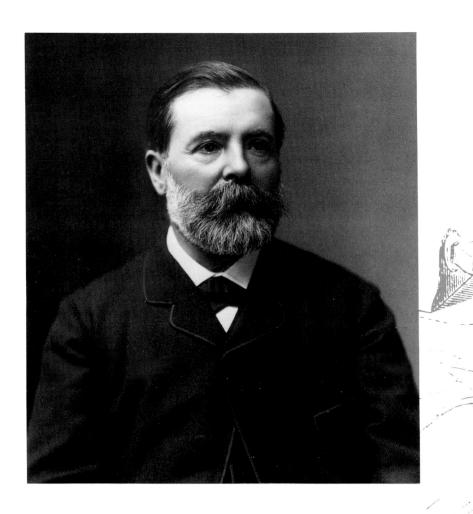

Etienne-Jules Marey, in a portrait
taken in 1878, the year he was
elected to the Académie des
Sciences. Collège de France.

Part One

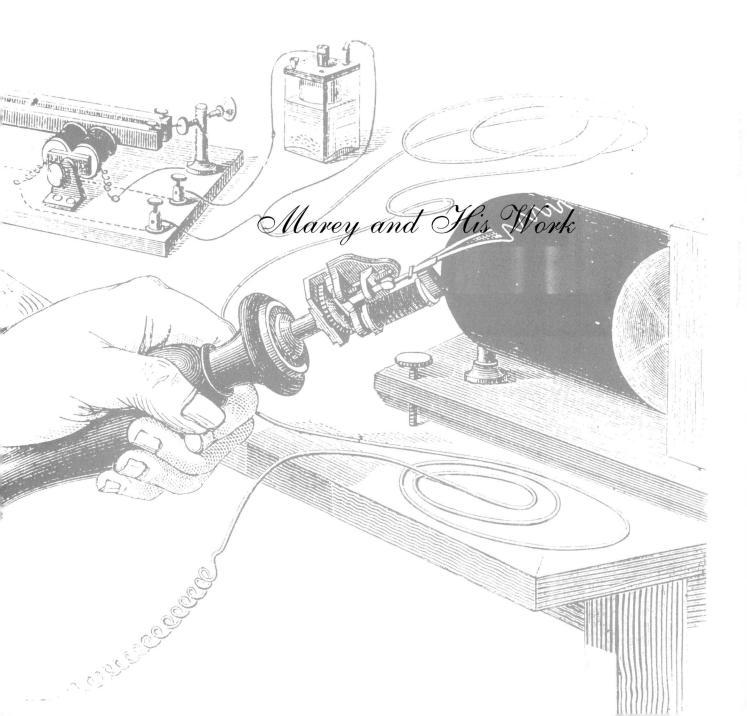

Marey and His Work

Etienne-Jules Marey was born on 5 March 1830 in Beaune, the great wine-producing town of Burgundy. He was the only child of Marie-Joséphine Bernard—the intelligent and devout daughter of the local schoolmaster—and Claude Marey, a wine steward for the still-famous vintners Père Bouchard et Fils. Marie-Joséphine wanted her son to be a priest; Claude wanted him to be a docter who would practice at Beaune's Hôtel-Dieu. The young Etienne-Jules, however, showed neither extraordinary piety nor unusual interest in medicine; his passion was for machines. He was a mechanical genius, one of those tinkerers with "brains in his fingertips." Even as a child he was making elaborate working machines, intricate puzzles, miniature mechanical animals, and other mechanical playthings from household odds and ends and treasures collected on his rambles across the Burgundian hills.

He began his formal education in 1838 at the Collège Monge, the local private boys' school named for Gaspard Monge, Napoleon's most famous engineer and a cofounder of the Ecole Polytechnique in Paris. At school Marey used his magical mechanical gifts to make toys for his friends out of almost nothing; he was much sought after by his schoolmates. A daydreamer, he was called absentminded; his teachers said he defied authority. But he was an excellent student in everything but mathematics and won many school prizes—including the Latin prize—year after year. In 1848 Marey left the Col-

lège to become a *lycéen* at Dijon, where he received his baccalaureate with highest honors.

When it came time to decide on a career, he had only one desire—to prepare for the entrance examinations to the Ecole Polytechnique. His father's wishes prevailed, however, and in 1849 Marey entered the faculty of medicine in Paris; his parents made the journey to the capital with him and took up residence there for the duration of his medical studies.

When Marey entered medical school, doctors in France had achieved a near monopoly on all matters pertaining to health. They enjoyed a social and economic status quite different from a hundred years earlier, when they had to compete with charlatans and folk healers for patients and fees.

After the 1789 revolution the practice of medicine (theory) and that of surgery (manual operations) were merged; both the education and the professional activities of doctors came under state jurisdiction.[1] The enhanced social and economic status doctors enjoyed was reflected in the rapid increase in applications to medical faculties after 1800. Consequently the competition was stiff, the number of degrees was limited, and the path to a practice was arduous. Marey did excellently in his two years of coursework (1849–51), in his three years as an extern (1851–54), in the highly competitive state examination, and in the internship that it qualified him for (1854–58 at the Cochin Hospital) and that in turn qualified him for hospital service. Marey was a brilliant student, deft of hand and mind, who delighted his professors and astonished his peers with the originality of his approach to clinical research. In the 1850s the state of medicine offered wide scope for his mechanical gifts and engineering skills. He gravitated toward the fields of cardiology and blood circulation, where his command of purely mechanical principles such as hydraulics and hydrodynamics could be immediately applied and dramatically demonstrated.

He began to publish in 1857—while still an intern—with a paper on the circulation of the blood. A paper on vascular contractility (1858), gave science its first evidence of the influence of vascular elasticity on blood circulation. In his thesis year he studied the dicrotic pulse (the second "blip" of the pulse wave) and wove the data from this research and from his earlier papers into a thesis titled "Circulation du sang à l'état sain et dans les maladies" (The circulation of blood in normal and pathological states), which he successfully presented and defended on 4 March 1859, the day before his twenty-ninth birthday. He then passed the state competition for the practice of medicine but had the good luck—at least as far as his future was concerned—to fail the *agrégation*, the exam that qualified successful candidates to hold teaching positions in the faculties of medicine. In 1861, therefore, he took the only route toward a medical career left

open to him and set up a modest practice in Paris. This failed within the year. And so, after having done his best to meet his father's expectations, he set himself up as a *physiologiste en chambre,* giving private tutorials to medical students, and turned resolutely toward pure research and the career that would ultimately bring him to photography, cinematography, and the highest of official honors.

Marey's chosen area of physiological investigation was movement, which he defined as the most important characteristic of life. His contribution to this study and to physiology in general lay in what was then an embryonic field: the invention and development of instruments for making permanent graphic representations of movement of and within the body. And with the instruments he invented Marey not only analytically decomposed movement and created a powerful new language of time and motion, but founded a graphic method that became the origin of all the graphing machines—cardiographs, encephalographs, oscilloscopes, and so forth—on which medicine and physiology utterly depend.

When Marey began his career as a pure research scientist, physiology itself was a new science. There were hardly any official posts in France for physiologists, and the instruments to do physiological research as such—to say nothing of the research Marey had in mind—did not exist. Like his contemporary Claude Bernard, probably the most famous physiologist of the nineteenth century, Marey had to set up his own laboratory and then fabricate his tools from scratch. There was no other way of doing pure science. The first graphing instrument he devised, developed in 1859 while still a student, was a pulse writer or sphygmograph. Instantly and widely adopted by medical practitioners, the sphygmograph earned Marey enough royalties to furnish the kind of laboratory he needed, installed first in the rue Cuvier and then, in 1864, at 14 rue de l'Ancienne

Comédie, in a house that had once belonged to Molière. Marey had the fifth floor, a large sunlit attic that had originally served as a theater for Molière and more recently had been the studio of the painter Horace Vernet. Marey subdivided it into chambers and compartments of various sizes; the photographer Nadar, who visited it in 1864, likened it to a beehive at whose center Marey worked, surrounded by a "beautiful, irreproachable order . . . among machines and scientific instruments of every kind, classics or ones thought up yesterday—new tools for a new science."[2]

In addition to Marey's office, his living quarters, and his mother's apartment,[3] the attic held a lecture room and a series of small drumlike rooms under the eaves—the "cells of the hive" for the young scientists, "their bright faces illuminated with the noble curious passion." Their glances and activity converged, Nadar says, "towards a center . . . the impeccable conductor of this silent orchestra, the beloved master"—who was, at the time of Nadar's visit, still almost as young as his assistants and students.

One room was devoted exclusively to creating, developing, and experimenting with new machines and scientific instruments, and another was given over to the subjects his machines would study. It was crammed, Nadar tells us, with

cages, aquariums, and beings to live in them: pigeons, buzzards, fish, saurians, ophidians, batrachians.[4] The pigeons coo, the buzzards don't breathe a word. . . . A frog who . . . has escaped from a jar absentmindedly jumps in front of you to escape the caress of your shoe. Full of gravity, a tortoise proceeds . . . with an obstinate continuity over different obstacles from one corner to another. He is tireless in his task, as if in quest of some problem under the force of an idée fixe. . . . Under the ladders of a trellis, the yellow-collared grass snakes enervatingly distend their muscles, enjoying the tepid temperature, and

in the neighboring compartment the wide little bright eye of a gray lizard lies in wait—just in case—for the passage of some imprudent ephemera, visible almost to him alone. Everywhere, in every corner, life. (Nadar, p. 4)

This arrangement never changed, no matter where Marey lived.

Marey's lectures and publications on the circulatory system and the diagnosis of cardiovascular disease did not go unnoticed for long. Acclaim for his thesis brought his name to the attention of other scientists, and he soon found himself part of an ever expanding circle of brilliant men with the same ideals. Recognition by the French scientific establishment came steadily, albeit slowly. In 1867 he was named the *suppléant* or assistant of Pierre Flourens (1794–1867) at the Collège de France, who outfitted a laboratory for him. A year after Flourens died Marey was elected to his chair and named professor of "Natural History of Organized Bodies." Other honors followed: election to the Académie de Médecine in 1872 and to the Académie des Sciences in 1878, where he replaced Claude Bernard. In 1882 the municipal council of Paris created the Station Physiologique in the Bois de Boulogne for his work. He was elected President of the Société de Navigation Aérienne in 1884, of the Société Française de Photographie in 1893, of the Académie des Sciences in 1895, and of the Académie de Médecine in 1900. In 1896 he was made a commander of the Legion of Honor. In 1901 the Institut Marey—an international institution created to standardize physiological instruments—was built on the grounds of the Station Physiologique.

In 1870 Marey had enough money to purchase a large house, Villa Maria, in Posilipo, just outside Naples, where he set up a laboratory and began to spend the winters each year. In 1880 he moved one last time to a spacious house on the boulevard Delessert in Paris's wealthy sixteenth arrondissement.

Marey's private life is almost a blank. He had two illegitimate children: a daughter, Francesca, born to a Mme Vilbort, wife of the director of the Paris *Globe,* and a son born to a cook in Marey's employment. But this man, unorthodox in his research, ambitious for his ideas, public in his profession, retained in respect to himself a more than conventional discretion and insisted that all personal papers in his possession at the time of his death be destroyed. Francesca carried out his wishes. But from the few facts concerning his private life that have come down to us, this much is plain: Marey paradoxically defied the sexual mores of his time yet respected the social ones to the letter. In 1883, for example, he brought Francesca, who was born in Naples in 1871, to Paris and installed her in the boulevard Delessert as his niece: a masquerade, perhaps, to the outside world, but if the scientific profession knew that Marey was an only child, then a discreet formality to his friends and colleagues. M. Vilbort seems to have acquiesced in this state of affairs; Marey's Italian villa and his Paris house were both purchased with the help of Vilbort, and he was co-owner. In Paris Marey and Mme Vilbort apparently lived largely separate lives, being together only in Italy. The only picture we have of their intimacy lies in a few of the letters from Marey to his younger colleague and close friend Arsène d'Arsonval (1851–1940).[5] In these Marey is deeply concerned and tender, engaged yet detached, but nonetheless selfless.

Mme Vilbort was sickly and emotionally unstable; to d'Arsonval he confessed that her frequent nervous crises and many physical ailments—which he described vividly—drove him to despair. Yet in his accounts of his response to these he was to Mme Vilbort herself a calm and patient nurse—a compartmentalization of his affective life that parallels that of his laboratory and residences. But it was Francesca who seems to have held the center of her

father's affections; she stayed by his side even after her marriage to Noël Bouton, an artist and scholar whose treatises on heraldic painting Marey admired. After Mme Vilbort's death in 1893 she was Marey most trusted confidante, and he died in her arms on 15 May 1904.[6]

We can take some measure of Marey's intellectual, professional, and public personalities from the reminiscences of his friends, from his letters to them, and from his published writings. From these he emerges not only as a mechanical prodigy of great erudition but as a man of great sensitivity—a talented pianist and an accomplished artist whose sculptures of birds in flight testify both to the skills of his eye and hand and to his sensibility. He was a good-natured and high-spirited colleague; his amiability and joviality were, however, tempered by the exacting nature of a true perfectionist who made equally rigorous demands on himself and on his students and colleagues. He had, he once said, "a lot of patience, but . . . of short duration."

Marey never suffered fools gladly; his contempt for dishonest thinking and slipshod methods was notorious. Students and colleagues alike discovered that errors were met with cutting sarcasm. To the rest of the world he showed a captivating sense of humor, a trenchant wit, and an engaging conversational manner touched with an "amiable skepticism and an agreeable scoffing."[7] And for those whose intellectual curiosity and passion equaled his own he was—as colleague, as teacher, as trusted friend, as patient confidant—the kindest of men. This unusual generosity extended toward the past. In his lectures and his writings, Marey scrupulously enumerated the contributions of his predecessors. Each of his books began with a review and assessment of every study that had preceded his own. At the outset of his career, perhaps, this was to lend the weight of authority to his own unorthodox work, but he never lost this ingrained habit of generosity

even as his methods became celebrated. At the same time, he never hesitated to question even the most sacrosanct authority, as in his attacks on Claude Bernard's use of vivisection. But such criticism was free from the disfiguring snobbery common to his profession at this time, and he would listen attentively to the discoveries and hypotheses of rank beginners, for he never forgot his own earlier exclusion from the scientific establishment. Marey's affability was no doubt part of the reason for the general respect he commanded in the many worlds to which he contributed: physiology, medicine, photography, cinematography, aviation, and physical education. His death was universally mourned, and laudatory obituaries were written in popular and specialized medical and scientific journals all over the world.

Ten years after his death his longtime friend Dr. Charles Richet said that Marey had given the world "the truth itself, translated into simple images and in that way described with a complete and incomparable precision," and the president of the Third Republic, Raymond Poincaré, gave, in his reminiscence of Marey lecturing shortly before his death, this revealing portrait of a man who relegated to the background of his talk not only his personality but his own contributions to the subject at hand:

I still remember the enchantment of the listeners who, crowded into the large amphitheater of the Sorbonne, heard Marey explain with true artistry the mechanisms of life, the laws of ancient and modern dance, the movements of animals; the progression of fish, gaits of horses, and flight of birds and insects. His science was made accessible to this Parisian public. He never tried to impress his listeners with the importance of the enormous contributions he had made to physiology and to medicine. To hear him, one would not have believed that he alone was the author of so much interesting research on the circulation of the blood, respiratory movement, or the beat of

the heart, or that the two physiological registering proce-
dures chronostylography and chronophotography, both
one and the other, owed to him their principal ameliora-
tions. He was a charming lecturer, one who spoke
spiritedly of gymnastics and aviation and who celebrated
with emotion the wings of pigeons and dragonflies.[8]

Richet and Poincaré spoke these words on 3 June
1914 at the dedication of a monument to Marey
commissioned shortly after his death by the Inter-
national Association of the Institut Marey and
erected—after many delays—on the grounds of the
Station Physiologique. The monument itself, how-
ever, bears witness that Marey's inventions consti-
tute his greatest and most lasting contribution. It is
a small blind arch in pale limestone; its outer sur-
face is rusticated, its smooth interior covered with
bas-reliefs. At the base is Marey's name. Marey

himself is depicted measuring the data given by a
graph he has just removed from one of his inscrip-
tors. The horses whose movements his machine has
traced gallop one by one over his head as if in a
dream. Reliefs of the graphic inscriptors and cam-
eras he created are interspersed over the rest of the
arch with reliefs of running men and soaring birds.
There are no allegorical figures or wreaths, just the
array of animate and inanimate machines to testify
to the febrile imagination of their creator.

This small, unremarkable monument has now
been moved to a distant corner behind court one of
the Stade Roland Garros. In a way its obscurity is
an emblem of Marey's own, for the crowds that
come to watch the French open tennis champion-
ships are as unaware of its existence as of the man it
memorializes.

2 The Writing of Life: The Graphic Method

The nineteenth century was marked by profound changes in all the sciences. Medicine and physiology, the areas in which Marey trained and worked, were no exception: medicine was transformed from an art to a science during the nineteenth century, and physiology evolved from a branch of anatomy to a science in its own right. At the beginning of the century, medical practitioners still considered diseases "essences," entities subject to their own laws that were inaccessible to human knowledge; the physician's job was to classify such "essences," following a pattern established by naturalists in the eighteenth century.[1] But by the time Marey arrived in Paris to study medicine in 1849, dependence on received ideas and unproven theoretical premises had been replaced, for the most part, by a diagnostic method based on observable physical phenomena. The effects of experimental physiology and clinical findings based on controlled experimentation and observation had become common enough to bring about the reclassification of disease. Advances in physics (to which clinicians became receptive when they realized that in their work they were depending on innate physical instruments—their fingers for palpation and their ears for auscultation), gains in chemical research that would make possible Pasteur's germ theory of disease, and technological improvements such as the achromatic lens, which increased the precision of the microscope, had all contributed to this radi-

cal change.[2] As a medical student in Paris, the young Marey found plenty of scope for his mechanical gifts and engineering skills in the scientific side of medicine. But it was the new and rapidly developing field of physiology—the study of life functions—that offered him the greatest opportunities.

Physiology had entered the nineteenth century as a second-rate power in the life sciences, dominated by anatomy. Under this domination, physiological study was limited to the localization of life functions one-to-one in specific organs.[3] Not one of the ten sections of the Académie des Sciences was designated for physiology; its practitioners had to find a place in either the Anatomy and Zoology or the Medicine and Surgery section. Until 1821, when François Magendie founded his *Journal de Physiologie Expérimentale,* there was no journal devoted exclusively to the field. In medical faculties throughout France, physiology was taught as a subordinate adjunct to anatomy until 1823. That year an independent chair was created at the Faculty of Medicine of Paris, but the "teaching was theoretical with no practical exercise."[4] At midcentury, however, when Marey turned from medicine to physiology, this hierarchy had begun to change and the domination of anatomy over physiology reversed. Among the reasons for this inversion, three were specially important: the assimilation of physics and chemistry as explanatory models for physiological

processes; experimentation on live animals (vivisection); and the growth of the experimental laboratory.

It was the institution of the laboratory that made France the most advanced nation in physiology in the first half of the nineteenth century (and awarded the supremacy to German physiologists in the second).[5] In the laboratory it was proved that both the normal and the pathological are subject to the same laws, that disease is no more than life under different conditions, and that the findings given by experiments with animals are applicable to man. Largely as a result of these findings, physiology changed in status from a questionable activity to a clearly defined scientific field of study supported by an authoritative institutional base.[6]

The first laboratory of experimental physiology in France was founded by François Magendie (1783–1855) at the Collège de France, where he held the chair of medicine. The Collège, created by François I in 1530 to liberalize education and free it from the stranglehold exerted by the Sorbonne, was the one institution with which almost all the great French physiologists in the nineteenth century, including Marey, were associated.[7] It was the sole official provider of laboratory facilities until the establishment of public physiological laboratories in 1878. At the Collège, Magendie carried out innumerable experiments on animals (for which, in

animal-loving England, he was vilified as "undoubt-edly the most abandoned criminal that ever lived").[8] His commitment to experiment as a way of deter-mining physiological function led him to investigate the action of drugs and poisons on living animals. Magendie's experimental findings proved that they act in exactly the same way on man and on ani-mals. His *Formulaires pour l'emploi et la prépara-tion de plusieurs médicaments* provided physicians, for the first time, with a list of drugs whose dosage could be determined with quantitative precision and whose effects on the organism had been carefully tested.[9] He also produced major findings on the physiological role of the spinal cord and was the first to describe the mechanism of vomiting. Most important, he developed a new concept of organ function: he made the discovery that several organs could participate in performing one function. Magendie was the first physiologist to embody in his science the new order of biology, with its com-mitment to study the whole organism as an inte-grated and adapted structure and to examine the functions of all its parts.[10]

His pupil, the successor to his chair of medicine at the Collège, and the giant of this fecund era was Claude Bernard (1813–78), whose research and concepts laid the foundations for the modern sci-ence of physiology. Bernard came to physiology after trying his hand at pharmacy and play writing, and his early research was done in a damp cellar laboratory with equipment he had put together himself. Like Magendie he was a vivisectionist, and his experiments on live dogs were viewed with the deepest suspicion by the police, and with horror by his family: his wife, with whom he was totally in-compatible, contributed large sums of money to antivivisectionist societies to the end of her life. Bernard discovered the glycogenic function of the liver—the storage and metabolism of starch—for which he coined the term "internal secretion"; he

demonstrated the various functions of the pan-creatic juices; and he made important studies on smooth muscle, the vasomotor mechanism, carbo-hydrate metabolism, and the action of curare and other poisons. His greatest contribution was the concept of the constancy of phenomena indepen-dent of external factors—what he termed the *milieu intérieur,* a concept that is the basis of the biological principle of homeostasis. As a result of his work, we ascribe to him the foundations of experimental medicine.

Magendie and Claude Bernard were not reduc-tionists. They held that man and animals were more than mere machines and that therefore the laws of inanimate nature alone were not sufficient to ex-plain all the manifestations of life. Bernard pleaded for the recognition of special biological or organic laws commensurate with the complexity of biologi-cal phenomena. This is not to attribute to him animistic or spiritual beliefs: while Bernard stated that "manifestations of life cannot be wholly eluci-dated by the physico-chemical phenomena known in organic nature,"[11] he also insisted that the expla-nation of higher causes was not the department of the physiologist. Nonetheless, his belief that "life cannot be characterized exclusively by either a vi-talistic or materialistic conception,"[12] and his in-sistence that biology must retain its own particular concepts and laws, places him in direct opposition to his materialist German counterparts, and ulti-mately to Marey.

Bernard's counterpart in Germany was Jo-hannes Müller (1801–58), a brilliantly versatile man equally eminent in biology, morphology, and pathology. He contributed to the understanding of nerve structure and energy and made important studies of the mechanism of sense perception. Müller began his career as a vitalist—an advocate of *Naturphilosophie,* a scientific extension of the romantic philosophy of Schelling, Herder, and

Fichte. And though he later came to reject it, Müller nevertheless maintained a conscious commitment to the necessity of including the concept of a vital force—a special principle of life immanent in the organs and tissues and ontologically distinct from the conscious mind[13]—in the explanatory models he constructed for physiology. How the organic or vital forces originated, or how matter first became endowed with these special forces, was, said Müller, "beyond the compass of our experience and knowledge to determine," a problem that "is not the subject of experimental physiology, but of philosophy."[14]

Müller's pupils—among the most notable were Hermann von Helmholtz (1821–94), Ernst Wilhelm von Brücke (1819–92), Emil Du Bois-Reymond (1818–96), and Theodor Schwann (1810–82)—violently rejected his commitment to a force not reducible to inorganic nature. They believed that the vital functions examined in their experiments could be successfully explained only by physicochemical laws and that teleological or special organic causes had to be rejected as long as physical ones were possible. They expressed their intent to create a new physiology, an "organic physics," based on a physicochemical foundation, and to this end they joined with a number of physicists and chemists to found the Physical Society of Berlin in 1845. Their common purpose, the investigation of physiological phenomena by the methods of physics and chemistry, drew to their efforts other physiologists of the same rank, including Carl Ludwig (1816–95) and the Weber brothers: Ernst Heinrich (1795–1878) and Eduard Friedrich (1806–71).[15] In their work, animate nature was subsumed in a program of mechanical explanation. Rather than experimenting on living animals, they used machines and measuring instruments both as diagnostic tools and as a way to simulate the functions of life. After the middle of the century, world-wide physiological eminence passed to German laboratories because of their work. Their successes were notable: from Helmholtz's work in thermodynamics and the physiology of the senses to Du Bois-Reymond's foundation of modern electrophysiology and Ludwig's introduction of the graphic method, the mechanistic conception of biology excised the final traces of nineteenth-century vitalism, changed the direction of general physiology, and pioneered the biophysics of the twentieth century.

Marey was introduced to the science of physiology while preparing for the internship competition in medicine in 1854. Dr. Martin Magron, a follower of Bernard's methods and one of the professors who helped prepare the internship candidates, tutored his students, Marey among them, in his well-equipped private laboratory in Paris. Since clinical laboratories were not created in France until 1873 and few scientists could provide the money to maintain private establishments, Magron's fortunate students could engage in what were still rare activities: dissection (with instruments "borrowed" from the nearby Ecole Pratique), microscopic examination, and physiological experimentation on rabbits and frogs. The students were also fortunate in attending Magron's seminars, where discussion was encouraged (an uncommon practice in a milieu where the emphasis was on rote learning) and the material presented went far beyond the required preparatory curriculum. It was in Magron's laboratory that Marey finally found the obvious applications for his particular talents. His manual dexterity and his fascination with every kind of machine (fed by his extensive reading in mechanics and physics) drew him to the investigation of human mechanics—the study of the levers, pulleys, pumps, pipes, and valves within the living body, and of the forces that drive them. He was attracted to problems in cardiology and blood circulation, areas where he could apply his excellent command

of purely mechanical principles such as hydraulics and hydrodynamics. At the time Marey was studying, neither the exact movements of the heart nor the effects of the arteries on the movement of the blood had been ascertained with precision, and Marey directed his efforts to explaining these phenomena. It was the first work he did in what was to become his area of specialty: movement. Marey saw that some light could be shed on cardiological and circulatory processes if they were considered as purely mechanical functions. He also showed that a circulatory system of rubber tubing and glass, constructed according to mechanical laws, would exactly replicate the circulatory and cardiologic functions he was studying and so act as a proof.

To consider life processes as mechanical processes, however, meant treating the body as an animate machine whose laws were those that governed inanimate nature. This was precisely Marey's view. Whereas the vitalists insisted that the organism involves special levels of organization that therefore must dictate special biological laws—they believed, as Marey put it, that passive organs have need of a motor called life, which establishes an inviolable barrier between animate and inanimate machines[16]—Marey believed that "the laws of mechanics are applicable to animated motors."[17] He saw the ultimate reducibility of the processes of life to the laws of inorganic nature, that is, to physics and chemistry. "I do not recognize vital phenomena," he stated in 1868; "I find that there are only two kinds of manifestations of life: those that are intelligible to us—these are physical and chemical—and those that are not intelligible. As to the latter, it is better to confess our ignorance than to disguise it with a pretense of explanation."[18]

Marey's "mechanist" or "antivitalist" views (for that is how they were characterized in this debate) put him at odds with most of his French contemporaries, even with Claude Bernard, who so dominated medicine and physiology in France at midcentury that all physiologists, Marey included, are often thought of as his disciples. But though Bernard's pioneering work certainly eclipsed the career of every other physiologist in France, Marey, for one, shared neither his philosophy nor his methods. Marey's perception of physiology was a natural outcome of his early enthusiasm for physics and thus had more in common with the view of the German organic physicists,[19] that "among the phenomena of life, those which are intelligible are precisely of the physical or mechanical order."[20] Marey had become aware of these ideas from his wide reading and had absorbed them at first hand: he was a friend of both Helmholtz and Ludwig, and he corresponded with the latter until his death in 1895. Like the Germans, Marey believed in an intelligible causality underlying all life processes; he believed that these processes could be measured because they were reducible to physics and chemistry. Furthermore, he believed that by subjecting life processes to ever more scrupulous measurement, the numerical relations that underlie their manifestations could be determined with precision. It was only by this means, he insisted, that physiology would become an exact science, the equal of physics and chemistry.

Marey saw scientific history as deterministic: "Its evolution," he wrote in 1866, "must take place in an order which may be pronounced necessary, each phase preparing the way for another and making possible and productive researches which would have previously been premature."[21] His desire for greater precision in physiology, repeated often in his writings, was linked to the idea of the progress of science. "Science has two obstacles that block its advance," Marey said; "first the defective capacity of our senses for discovering truths, and

then the insufficiency of language for expressing and transmitting those we have acquired. The aim of scientific methods is to remove these obstacles."[22] As Marey saw it, the evolution of physiology would be furthered by the gains made in other scientific fields. He emphasized the mutual dependence or, as he put it, the "solidarity" of all the sciences and their tendency as they developed to an "approximation towards one another, resulting in their reciprocal advancement, since each of them sheds light upon the other."[23]

For Marey, the goal of physiology's evolution was to discover the laws—expressed in mathematical form—governing physiological processes: "The highest point which the natural sciences can reach is the discovery of the laws which govern the phenomena of life."[24] This goal was not to be attained in isolation: the solidarity of the sciences would be echoed in the unity of the laws that governed them. Marey was convinced that the laws of physiology would be found to be identical with those governing all other scientific fields. Moreover, he subscribed to a theory held by the Greeks and still current today, that the reciprocal dependency of all the sciences on one set of laws, or even one law basic to all nature, would emerge. But what exactly were these "laws"? For Marey they were characterized in terms identical to those of Helmholtz: forces in nature that are the causes of the phenomena we observe and are manifested solely through them. Such forces were not occult, nor were they metaphysical forms. Rather, they were the lawlike relations between observable magnitudes that cannot be experienced through the senses but are established by observation and experimentation—arrived at "more or less speedily, according to the exactitude of the methods of investigation to which we have recourse."[25] Consequently, to relate a natural phenomenon to a law of nature *was* to understand

it: knowledge consisted in the discovery of regularities or laws; there was no further or more ultimate form of comprehension beyond what scientific laws provided.[26]

These ideas about scientific determinism and about the aims of scientific method were not unique to Marey but are situated in the wider philosophical context of the positivist writings of the French philosopher Auguste Comte (1798–1857). Comte's positivism put an end to the excesses of romantic idealism by proposing a new vision of reality, one limited to experience and known solely through the senses. Positivism was characterized by at least three major beliefs: a rejection of metaphysics and in its place an affirmation of facts derived from observation; the proposition that science constituted the ideal form of knowledge; and the understanding that scientific explanations of phenomena would, by definition, lead to one or more laws of which an individual phenomenon is an observed instance.[27] The impact of positivism in the nineteenth century was enormous; not only did science display complete confidence in its ability to bring the forces of nature under human control, it now claimed to be able to bring nature under the total control of science.[28] Such confidence can be explained, no doubt, both by the prestige science possessed in the nineteenth century and by a belief in progress—the universal view that there "had taken place, and was taking place, a progressive development of man and society."[29]

Comte's influence on Marey is reflected in his ideas on the development, ends, and progress of science. Citing Comte's doctrine that "the sciences . . . have passed through three successive phases; one *theological*, another *metaphysical*, the last *positive*" (Marey's emphasis),[30] Marey thought it "competent to still further subdivide and specify the phases of the evolution [of those sciences that have for their

object the facts of nature]. We should thus have first the period of nomenclature, next that of the natural classification of beings; still later the analytic study of natural characters would be developed, to be followed by the study of phenomena, leading finally to the establishment of general laws."[31] Marey's belief in analysis and quantification as the sole determinants of our knowledge of reality also owes a debt to positivism. This belief guided both the form and the content of Marey's investigations.

By the middle of the nineteenth century one singularly important discovery seemed to validate the positivist belief that there were laws common to all the sciences. This was the principle of the conservation of energy (later the first law of thermodynamics); it proved that energy can be neither created nor destroyed, only transformed from one form to another. Announced as a hypothesis by four different European scientists (one of whom was Helmholtz) between 1842 and 1847, the principle of energy conservation did much to substantiate the mechanist worldview, since it was demonstrably applicable to both the organic and inorganic worlds. And because it described the world of phenomena as manifesting but a single "force" (or later "energy"), one that could appear in electrical, thermal, dynamic, and myriad other forms,[32] the theory also brought about a profound change in science's image of nature. Nature was no longer thought of as static but became identified with energy and the dynamic. Matter and energy could no longer be seen as distinct; they were now inseparable. Awareness of how greatly society was being transformed by the harnessing of newly discovered forms of energy like electricity and electromagnetism gave added weight to this view. In the organic world, the identification of nature and energy yielded a new perception of the human body. Where it once was imaginable as a static machine or as the locus of a metaphysical vital force, the

body was now perceived as a field of energies whose forms—yet to be discovered—were conceivable in terms of the laws governing light, heat, magnetism, and electricity.[33]

Yet the energies of the body were not infinite. The second law of thermodynamics—discovered shortly after the first—showed that when energy was transformed from one form to another, some irrecuperable loss occurred. The existence of this loss (or entropy) did much to focus physiological inquiry on ways of conserving the body's energy and making it more productive.

When Marey began his career in the late 1850s, the law of energy conservation had already begun to have profound effects on physiology. With the German physiologists in the forefront, the search for the laws governing muscle and nerve functions dominated the investigation of physiological phenomena. Marey, who believed that the conservation of energy was "the most remarkable conception of modern times,"[34] had begun to explore an area that was in a way much more elemental—the area of movement in its own right, the most manifest form of energy. Beginning with the work on the circulation of the blood and the movements of the heart that he had carried out while still a student, the study of motion became Marey's special domain. "From the invisible atom to the celestial body lost in space," he wrote, "everything is subject to motion. . . . It is the most apparent characteristic of life; it manifests itself in all the functions, it is even the essence of several of them."[35]

The difficulty of Marey's undertaking cannot be exaggerated. Tracing the spatial relations (following the changes from one point in space to another through a trajectory), mapping the temporal relations (the duration of the movement, with its speed, uniformity, and variations), and finally describing the force necessary to produce the movement (which differs according to the mass of the body

that is moving, its speed, and the medium it moves through)—all these aspects had to be made apparent if the movement was to be known. If motion is the most apparent characteristic of life, there is no doubt that it is also the most difficult to measure. All motion is by definition transient. Most of the movements in and of the body are invisible, and they have an intricacy—in form, duration, regularity, and amplitude—that defies any attempt to either capture or interpret them. Marey had chosen to explore a domain inhabited by invisible ephemera. Here the unaided senses were powerless, "baffled alike by objects too small or too large, too near or too remote, as well as by movements too slow or too rapid."[36] And if by chance the eye or hand happened to discern one of the myriad motions within the body, there was still no possibility of conserving it for study by others and thus, more important, understanding its real nature. Information given by instruments that extended the senses was equally limited: stethoscopes and manometers, for example, could grasp the main form of the movement of the heart and the pressure of the blood, but not its complexity; they could furnish the symptoms of the disease but not the causes. Even vivisection—a form of investigation that seemed to bring so many benefits to physiology— was deficient in Marey's eyes: the active intervention in and manipulation of body processes was a form of mutilation and as such interfered dramatically with the functions under examination. Because it modified what it was supposed to study, vivisection could give only a partial—or sometimes even a false—picture. There was really no extant technique of studying movement even though, as Marey argued, movement was the essence of the animate machine.

How then to proceed? To Marey it was clear that the answer lay, once more, in the unity of physics and physiology. Since he held that the laws of

motion governing the human body were identical with those governing the physical world, he felt justified in insisting that the most expedient route to their discovery lay in identical modes of investigation: "Whatever the object of his studies, he who measures a force, a movement, an electrical state or a temperature; whether he is a physicist, chemist or physiologist, must have recourse to the same method and employ the same instruments."[37] Marey saw the physiologist as backward, still at the level of those physicists "who have proved that compressed gases diminish in volume, but have not found the numerical relation between their volume and the pressure."[38] To find the numerical relations among physiological phenomena, to elucidate the laws governing such phenomena, the physiologist must have recourse to the methods of physics and chemistry: "The naturalist who is not content with observing the forms, however varied, of organization in animals and plants, must proceed like the physicist and chemist, if he desires to discover the conditions of life."[39] In 1866, when Marey wrote these words, the investigations of physicists (and chemists, to a lesser degree) proceeded mainly according to the laws of theoretical mechanics: in their worlds, matter in motion was the basis of all phenomena. Two methodological strategies had evolved from this use of mechanics as an explanatory model. The first was to submit the phenomena being studied to measurement by machines. The second was to construct mechanical models that would simulate the phenomena under investigation.[40] These were the two strategies that Marey would now apply effectively to physiology. These were the ways, he felt, by which for the first time the motions in and of the body and the laws that governed them would be revealed.

First, then, the instruments, those "indispensable intermediaries between mind and matter."[41] But given the complexity of the subject, construct-

ing an instrument that measured physiological processes was no small feat. The instrument needed to capture the movement without interfering with it or impoverishing it in any way, make it visible without sacrificing its complexity, demonstrate its temporal and spatial dimensions as well as the force that produced it, and write the results out in a permanent form so that they could be interpreted and studied by more than one person. Fortunately, Marey saw, there were already instruments in existence that with some improvements, might be made to do the job. These were graphic inscriptors, instruments developed in physics and recently introduced into physiology.

Using graphs to depict change over time was not new, but applying the graphic method to physiology was. The first noted graphic representations of change were made by Nicole d'Oresme, who in the fourteenth century drew cylinders of varying lengths, each standing for one phase of the subject's movement.[42] The graphic method René Descartes created in the seventeenth century to represent conic sections by a system of x-y coordinates was the basis in following centuries for statistical graphs used to render change in historical dimensions (epidemics, population growth, agricultural production, etc.) as well as variations in chemical and physical phenomena over hours or days. Such graphs, with their rising and falling lines, wrote Marey,

[show] what has really taken place much more clearly than a column of figures, which is tedious and fatiguing to read down. . . . The sum of every kind of observation can thus be expressed by graphs; changes, pressure, weight, or bulk, or variations of intensity of any kind of force. Still more, all kinds of statistics lend themselves to the use of this method, and thus yield at the first attempt results which could only be disengaged by a long and assiduous study. . . . How is it possible not to anticipate with impatience the day when long and obscure descriptions will give place to satisfactory representations?[43]

This effective way of determining and communicating complex quantitative information, however, became more difficult when the changes occurred in fractions of seconds, beyond the reach of memory or the senses. Ideally, such rapid movements could be captured by a machine if it could be made to do three things: have contact without interfering with the movement; transmit its response through space to a recording device onto a recording surface; and convert the various displacements into rectilinear motion.

The machines that answered these requirements were developed through applications in a number of fields. Their evolution saw the joining of odometers and pedometers (the ancient mechanical predecessors of the taxi meter), which measured distance traveled over time but left no permanent written record, to the float and stylus that had been attached to the measuring instruments of meteorology, ballistics, and industry in the late seventeenth and eighteenth centuries.[44] A revolving disk or cylinder provided the surface on which the movement was inscribed; it was covered with paper and—in a later development—soot. The writing instrument was variously a plumed pen (for the paper) or a steel stylus that scratched a sooty plate. Christopher Wren's first inscribing weather clock (constructed by Robert Hooke in 1679) was one of the important successes in this evolution; another was James Watt's "indicator" (ca. 1796), with which he obtained diagrams of the steam pressure produced in a cylinder throughout the piston stroke. Watt's indicator was fundamental to the study and control of steam engine performance; it ushered in the era of the railroad.

Marey's first graphing instrument was also used to graph pressure changes—those that occur in the heart as it undergoes its double sequence of contraction and expansion. This was his sphygmograph, or pulse writer, which he presented to the

Académie des Sciences in 1860. The sphygmograph was one of his most important contributions to the field of cardiology, and it won him an honorable mention in the competition for the Prix Montyon (a prize in experimental physiology awarded by the Academy) as well as an invitation to demonstrate its workings at the court of Napoleon III. A few days after its demonstration Marey's sphygmograph was given an unforeseen endorsement when a courtier, whose pulse Marey had found to be irregular, dropped dead.[45]

Marey's instrument was very simple. It comprised a lever, with one end resting on the pulse point of the wrist and the other connected to a stylus, and a clockwork mechanism that moved a strip of smoke-blackened paper under the stylus at uniform speed, converting the pulsations into a fluid inscription. The sphygmograph graphed the pressure changes by giving visual form to the displacement of the arterial wall as it responded to the blood coursing through it. The expansion of the arterial wall forced the needle upward, and its relaxation was accompanied by a downward movement of the needle (fig. 1). The graph showed the changes as they occurred in real time, translated into a visible expression that had the authority of all graphs. The sphygmograph offered an opportunity to document the rapid sequence of the different phases of the heart's action and the time relations between the cardiac contractions, the externally palpable heartbeat, and the arterial pulse, a much-debated topic in Marey's time.

Marey's sphygmograph was based on the kymograph (1847), an instrument made by Carl Ludwig. Ludwig placed a float and a writing stylus on a mercury manometer linked to a dog's artery,

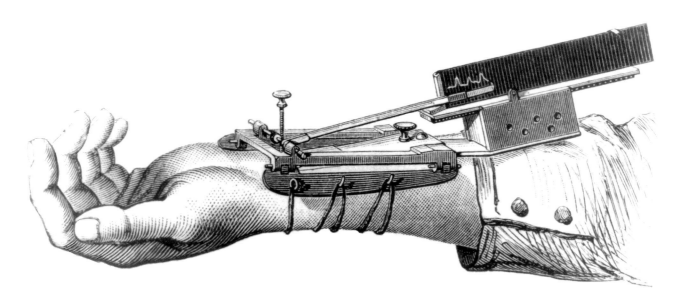

1.
Marey's sphygmograph in use, 1860. *La méthode graphique dans les sciences expérimentales et principalement en physiologie et en médecine.*

brought the stylus against the sooty surface of a drum turned by a falling weight, and thus permitted the animal's own arterial pressure to write out by itself an account of its variations. Ludwig's kymograph was the first application of graphing instruments to physiology—an accomplishment roughly comparable in importance to introducing the telescope into astronomy.[46] The kymograph was, however, limited in its applications: because liquid-filled tubes had to be inserted directly into the arteries of a dog, it was invasive and interfered with the process it was supposed to be inscribing. Marey's instrument was applied to the unbroken skin, which meant it could be used on human subjects and was thus practical in clinical work. The ingenious construction of Marey's sphygmograph was also a radical improvement. Made of very light wood and aluminum, it weighed only 220 grams. Instead of weights and counterweights, Marey used an elastic spring to press on the artery at the wrist, and he replaced Ludwig's steel stylus with a much lighter and more flexible plume pen. Finally, he had the House of Breguet—the most important precision watchmakers in the country—make the clockwork mechanism; this gave his sphygmograph an unprecedented regularity.

Marey's sphygmograph immediately gained wide acceptance in clinical circles; it overcame the difficulty in transposing into words the information received by touch and then communicating it to others.[47] The sphygmograph transformed the subjective character of pulse feeling into an objective, visual, graphic representation that was a permanent record of the transient event, a record that could be studied and criticized by a single physician or by groups of physicians.[48] Marey's instrument helped demonstrate that objective science could replace the eminently personal art of medical touch.

With the widespread acceptance of the sphygmograph, Marey's reputation and confidence grew;

beginning in 1857, he had steadily published his work on circulation and cardiology, and his methods and results were rapidly gaining international attention. His thesis had attracted the notice of the eminent F. C. Donders (1818–89), professor at the University of Utrecht and founder of the second institute of physiology in Europe (the first was Ludwig's at Leipzig). About 1860, Donders visited Marey at his laboratory in the rue Cuvier, and though their meeting did not result in actual collaboration, it did encourage Marey in the solitary direction he had chosen.

Donders was also responsible for one of the most important cooperative ventures in medical history, that of Marey and Auguste Chauveau (1827–1917), the "chef de service" of physiology and anatomy at the Veterinary Institute of Lyons. Their collaboration resulted in the first cardiographic recording. Here is how Chauveau remembered the events that led to his first contact with Marey:

Marey's thesis particularly seduced a foreign physiologist of rare competence, Donders of Utrecht, who was really qualified to appreciate its value and its implications. For Donders it was the revelation of the birth of a real star. Passing through Paris, Donders wished to signal this fact to his friend Claude Bernard, to call his benevolent attention to the young star who had just made such a brilliant appearance in the sky of French physiology. As chance would have it, I had just that morning come from Lyons and found myself with Bernard at the Collège de France as Donders told him about Marey. I was therefore well placed to admire the enthusiasm with which the Dutch physiologist acquitted himself of his task.[49]

Donders was familiar with Chauveau's studies on cardiac dynamics (Chauveau had been investigating the cardiovascular system of donkeys and horses since 1855), and he spoke excitedly of each man's work to the other. Because of Donders's enthusiasm, the two men soon met, and after a period of

adjusting to the distance that separated them and the differences in their habits—Chauveau could work only in the morning, and Marey did his best work in the late afternoon—they settled into a long and fruitful collaboration.

Chauveau's experience in cardiac physiology combined with Marey's skill and knowledge of instrumentation produced a revolutionary monitoring and recording technique: they radically extended the possibilities of cardiac catheterization by using it to record changes in intracardiac pressure.[50] Experimenting on a horse (chosen because of the large size of the animal's heart), Chauveau introduced thin rubber bulbs that Marey had fashioned into two of the horse's heart chambers. Marey had attached each of the two bulbs to another outside the horse's body by means of a long rubber tube and had connected each of these exterior bulbs to a stylus (fig. 2). As one chamber of the heart expanded, the displacement of the first bulb was transmitted to the second and to the stylus, pushing it upward against a sheet of paper wrapped around a cylinder. As the chamber contracted, the line made by the stylus descended, forming the characteristic curve of the cardiogram. The expansion and contraction of the second chamber, alternating with that of the first, was recorded in the same way, and the result was two sinuous lines that not only showed the pressure changes in each of the heart's two chambers, but also recorded their exact sequence. With this procedure, for the first time a reliable indication was given both of the moments of contraction and distension for each heart chamber and of the order in which these changes in pressure occurred. And among their earliest findings was the resolution of the apex beat controversy. The discoverer of the circulation of the blood, the seventeenth-century English physician William Harvey, had shown that the pulsation of the heart was caused not by bulging of the filling heart but by hardening of the

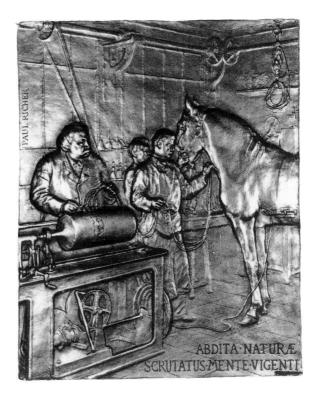

2.
Paul Richer, "Etienne-Jules Marey and Auguste Chauveau," 1863. Bronze medal 5 × 4 cm. Musée de l'Histoire de la Médecine.

contracted muscle. However, Marey's teacher Dr. Joseph-Honoré-Simon Beau, under whose tutelage he had spent his internship at the Cochin Hospital, along with many of his colleagues in the Académie de Médecine, refused to accept this fact and insisted that the visible and palpable pulsation of the heart was due to sudden filling with blood.[51] Now with their cardiograms Marey and Chauveau demonstrated that the beat was indeed caused by the forceful contraction of the heart muscle, not by its expansion.

They published their cardiographic tracings in 1861 and 1862; in 1863, with improvements made to their recording procedures, they published graphs that demonstrated cardiac hemodynamics in complete detail (fig. 3).[52] These remarkable tracings and the accompanying summary table of their experiments on the horse won them the physiology prize given by the Académie des Sciences that year. In later experiments, Chauveau and Marey were the first to attempt to measure intracardiac pressure without opening or perforating the chest, and Marey on his own recorded the first electrocardiograms (in

the frog and the tortoise). The accuracy of their records was surpassed only in 1931 when electronic tracing of human subjects was introduced.[53]

The rubber bulb, rubber tubing system that Marey fashioned for his work with Chauveau marked the successful solution of the final stage in the problem of describing and measuring motion—how to transmit the measurement of movements through space to the stylus. The sphygmograph had been attached directly to the subject's wrist; it measured the pulse through the skin. But a method of relay was required in those cases—and they were the majority—where such direct contact was not possible. Marey had experimented with water-filled lead pipes sealed at each end with a taut rubber membrane, but the force required to send impulses through the water was excessive. A simpler method, transmission through air using hollow, semirigid rubber tubes, was suggested to him by Charles Buisson, who had been a fellow student in the laboratory of Magron.[54] Buisson had stretched a thin rubber membrane over the heads of two funnels, one at each end of a length of rubber tubing. Pres-

3.
Third cardiogram published by
Chauveau and Marey in 1863. *Bulletin
de l'Académie de Médecine* 26, 1863.

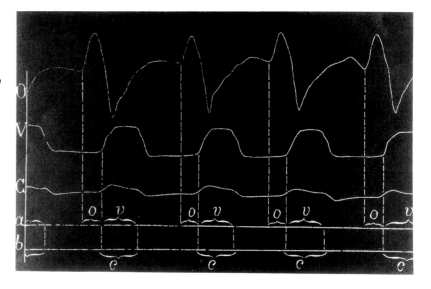

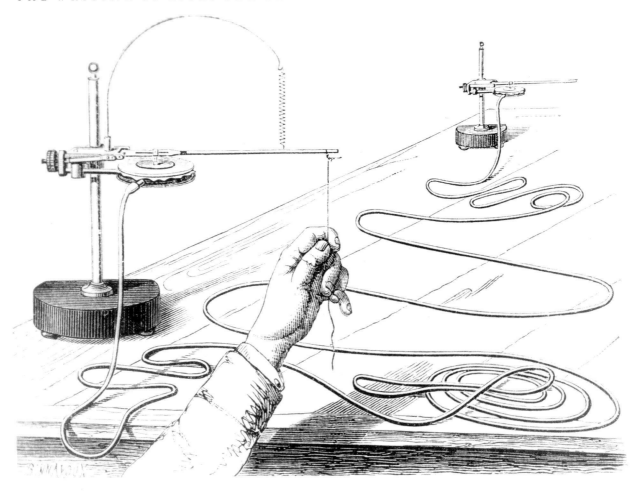

4.
**Tambours and tubes for
the pneumatic transmission of
movement, 1862.** *Méthode
graphique.*

sure on one membrane caused the air in the tube to
push against the other membrane. To this second
membrane was attached a wafer-thin disk sur-
mounted by a stylus. Any impulse given to one
membrane was thus directly transcribed to the sec-
ond, and through it to the stylus attached to it. This
relay method satisfied all criteria: it did not inter-
fere unduly with the movement under study and did
not require excessive force. Marey improved the
sending and receptor mechanisms by contriving tiny
metal drums sealed with a rubber membrane to re-
place the funnels. These *Marey tambours*, as they
soon came to be known throughout the world, were

critical in the evolution of physiological measurement. Until the 1950s, when they were replaced with electronic transducers, they were still one of the common means of recording pressure changes in and movements of organs (fig. 4).[55]

The transmission of movement through space marked the consummation of Marey's analytic method, a method that produced at the same time an innovative research instrument and a means of expressing "the most fleeting, most delicate, and most complex movements, which no language could ever express."[56] He had combined a detector of uncanny sensitivity, a transmitter that did not interfere with the subject, and an inscriptor adapted to graphing. To these he now added a chronograph—a tuning fork whose uniform vibrations were directly transmitted to the recording cylinder and acted as a control for the uniformity of its rotation—and a system of levers and gears with which he could reduce movements that were too large for the recording cylinders and expand those that were too small (fig. 5).[57]

With his graphic method, Marey had effectively found a way to make the phenomena he was studying trace themselves: his needles defied the eye that attempted to follow them, fixed on paper what occurred in a fraction of a second, and reduced complex occurrences to a simple form so that the laws that governed them could be made comprehensible to the trained interpreter. Once the method was arrived at, its applications seemed endless. Served doubly by his taste for mechanics and his gift for engineering, Marey created and constructed instruments that would see, touch, and hear for him as well as mark down what was sensed—that would simultaneously perceive and represent. His instruments permitted the determination of force, the mechanical work produced, and traced the relation between time and space that is the essence of motion. They finally allowed him to penetrate the most

mysterious workings of the animate machine—to make visible the language of life itself. Marey had created one of the most powerful investigative tools of the century. Unfailing and precise, his graphic method was the means by which he would make physiology an exact science, the unquestioned equal of physics and chemistry.

To verify the results given by the graphic inscriptors, Marey adopted the second strategy used by physicists, constructing mechanical models. In physics such model making was envisaged not necessarily as an iconic representation or "picture" of reality, but as a demonstration that phenomena could in principle be represented by mechanisms and that such constructions rendered them intelligible, since the conditions of their existence could be reassembled.[58] It was a mode of synthesis. I have already mentioned Marey's earliest fabrication, the mechanical circulatory system he constructed in 1857 to demonstrate hemodynamic principles (fig. 6); subsequently he made an artificial heart and lung and a mechanical insect and bird. Because it simulated the conditions of flight, Marey's mechanical bird was important to the beginnings of aviation. The zoetrope, a "philosophical toy" used to recombine the phases of movement that Marey adopted to synthesize his photographic work and also the cinema projector he devised in the 1890s were part of this method, and I will discuss them in fuller detail. For Marey, a phenomenon could be known only when it could be simulated: his *schémas*, as he called these models, were indispensable—they were the ultimate proof of his analyses.

In the 1860s Marey expanded his area of study from the heart, the pump that ultimately makes the body move, to a description of the kinds of movements the body makes—their intensity, duration, and form. His investigation of the circulation of the blood led him to problems of heat and respiration. The study of the heart led to studies of the function

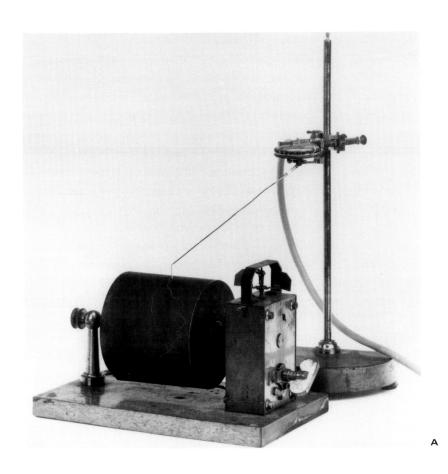

A

5.
(A) Rotating cylinder and inscribing stylus to receive the impulse of the second tambour, 1862. Beaune.
(B) Electrical chronograph to control the uniformity of the rotation of the inscribing cylinder, 1876. *Méthode graphique*.

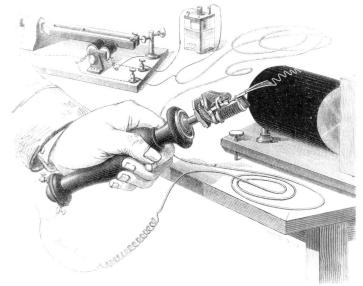

B

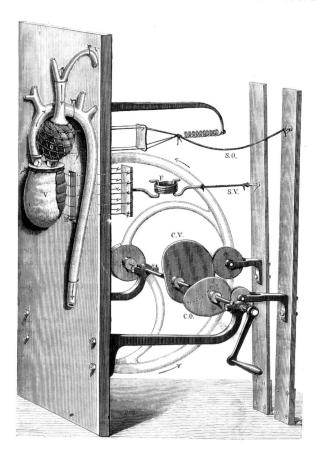

6.
Marey's *schéma* for imitating normal and pathological circulation, 1871. *La Nature,* December 1874. New York Public Library.

of muscle in general and to the nervous and electrical actions that both provoke and accompany movement. Behind all this work, which would occupy him to the end of his life, was his unchanging belief that these occurrences were, "notwithstanding all appearances, . . . of the same nature in the inorganic world and in organized beings."[59] At every step of his steadily expanding investigations, he devised and adapted instruments to explore for him and to write out what they had captured: cardiographs; thermographs (1864) to measure and inscribe the intensity and duration of heat changes in the body; pneumographs (1865) for the study of respiration; and myographs (1864–66) (fig. 7) to follow and trace muscular contractions. The portable polygraphs (1865) he devised for hospital use combined the transcription of "pulse rate, heart and artery pulsation, respiration, and muscular contraction" (fig. 8).[60]

Studies of muscle done with the myograph led to a new direction in Marey's investigations in the late 1860s. Marey's myograph was an improvement on a primitive instrument devised by Helmholtz (its excessive weight had constricted experiments on muscle tremors). With his direct and transmitting myographs and with his myographic "clips,"[61] Marey analyzed the phases and speeds of voluntary striated muscle contractions and their variability according to species and conditions. He measured the action of heat, cold, arterial anemia, fatigue, and the effects of different poisons. In the process he demonstrated that muscular tremors produced sustained contraction, and his work led to research on muscle reflex in different pathological states such as epilepsy. These myographic studies were an important contribution to muscle thermodynamics. They were fundamental steps in determining how mechanical force is produced and deployed in the animate machine—how animal motors convert chemical energy into heat and heat into work. They

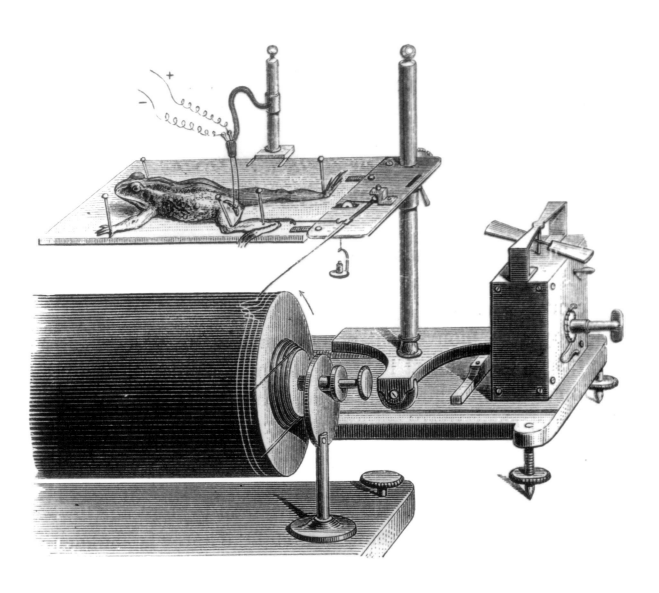

7.
Marey's simple myograph and a graph
of the muscular contractions showing
from bottom to top the progressive
influence of fatigue, 1866. *Méthode
graphique*.

DIAPASON. 100. V.D.

25

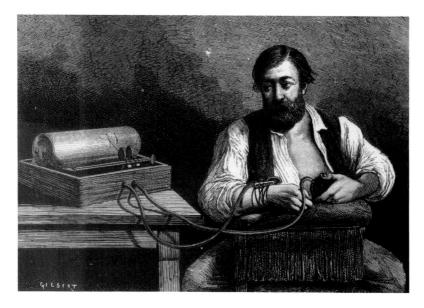

8.
Marey's portable polygraph in use, 1868. *La Nature,* May 1879. New York Public Library.

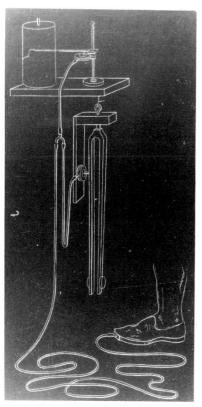

A

B

9.
(A) Experimental shoe connected to the inscribing cylinder and stylus, 1872. *Méthode graphique.*
(B) Experimental shoe with hollow chamber to measure the length and rapidity of the step and pressure of the foot on the ground, 1872. *Animal Mechanism.*

were also among the first investigations to signal the critical importance of fatigue in limiting the energy of the human body.

The myographic analysis of the function of voluntary muscles served as the introduction to more complex acts of movement where Marey could study the conservation or dissipation of energy in the body. In 1867 he turned to the study of human and animal locomotion—the description of the moving parts of the animate machine and of the accumulated forces that propel them through space and time. The locomotion studies of men walking and running were carried out with his own variation of an odograph, a device to record the number, length, and frequency of steps taken by a person walking. Marey also had a special pair of shoes made for his subject (fig. 9). In the toe of each shoe was a hollow chamber connected by flexible rubber tubing to a receiving tambour and stylus. As the foot touched the ground, the air from the chamber pushed the corresponding stylus away from a revolving drum that the subject held in his hands (fig. 10). When the foot left the ground and the pressure was released, the stylus made a mark on the paper. In this way it recorded not only the number of steps as well as their length and rapidity, but also the actual variations in the pressure of the feet on the ground and its duration.[62]

Marey used a similar technique to portray the rhythm of the gaits of the horse. India rubber balls were attached under the horse's shoes and connected to a recording mechanism by rubber tubing fastened along the length of its legs. The rubber balls were so quickly destroyed, however, that it was soon necessary to eliminate them and attach the rubber tubes directly to the horse's cannon bone with a leather bracelet (fig. 11). As the leg moved, the pressure of the bracelet forced air through the tubes to the recording mechanism held in the rider's hands (or, when the horse was galloping, strapped

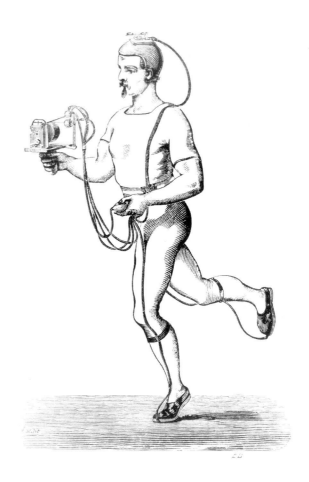

10.
Runner wearing experimental shoes and holding the recording apparatus, 1872. *Animal Mechanism*.

11.
**Leather bracelet for the inscription of
the horse's gait, 1872.** *Animal
Mechanism.*

to the rider's back)[63] (fig. 12). The four writing
needles were in pairs, one pair each for the fore-
and hindquarters, so that the identification of the
gait was simplified. From his inscriptions Marey
created bar drawings depicting the length of time
each hoof had been on the ground as well as the
position of each limb in each pace and the moment
of transition from one pace to another (fig. 13). He
called these bar drawings "synoptical notations":
they were notations of the "sort of music" produced
by the succession of the horse's movements and the
different tones of each hoof, "written by the horse
himself."[64] As with his studies of human loco-
motion, the information Marey provided on the
movements of the horse was the first accurate ac-
count of what the "average" paces actually looked
like. And from the treatment of pathological condi-
tions to speed and endurance training, such infor-
mation was to prove absolutely essential.

As a mode of synthesizing his locomotion stud-
ies, Marey used the zoetrope, an optical toy that
provided a crude form of animation. The zoetrope
was one of the many "philosophical toys," as they
were known in the nineteenth century, descended
from the phenakistoscope (from the Greek word for
"trickery" or "cheating"), an 1833 invention of the
Belgian physicist J. A. Plateau (1801–83). Based on
investigations of the English physicists Peter Roget
(of the thesaurus) and Michael Faraday into the
nature of visual perception, the phenakistoscope
took advantage of the persistence of vision (whereby
the brain retains an image cast upon the retina for
an instant after the object viewed is removed or
changed) to create the illusion of movement, thus
marking one of the basic techniques of cinema.[65]
(An almost identical device was produced at about
the same time, but quite independently, by an Aus-
trian geometrician, Simon Ritter von Stampfer, who
called his apparatus the stroboscope.)[66]

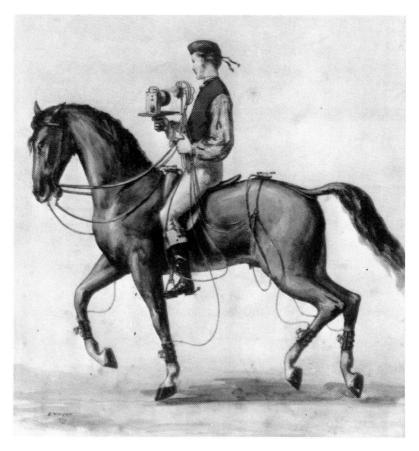

12.
E. Valton, *Horse and Rider with Inscribing Apparatus,* 1872. Watercolor on cardboard, 57.6 × 43.5 cm. Beaune.

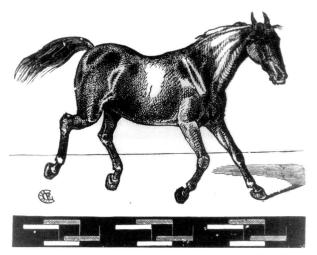

13.
Marey's synoptical bar notations and drawing by Emile Duhousset of the horse at full trot: the white lines represent the right front and rear hooves and the shaded lines the left ones. The white points on the chart correspond to the position of the horse represented in the drawing, 1872. *Animal Mechanism.*

Plateau's instrument was a cardboard disk with a series of figures arranged around its circumference representing successive phases of a movement. When placed behind a second, fenestrated disk and spun (so that each image passed the eye at faster than a tenth of a second), the images drawn on the wheel blended together to give the illusion of a continuous movement. In the zoetrope, the disk became a cylinder open at the top and with slits in the circumference. Pictures were drawn for it on separate and interchangeable strips of paper that were placed along its inner surface. Looking through the slits while rotating the cylinder gave the impression that the subject moved (fig. 14).

Marey seems to have been among the first scientists to see the importance these "toys" had for physiology: "This instrument, usually constructed for the amusement of children, generally represents grotesque or fantastic figures moving in a ridiculous manner. But it has occurred to us that, by depicting on the apparatus figures constructed with care, and representing faithfully the successive attitudes of the body during walking, running, etc., we might reproduce the appearance of the different kinds of progression employed by man."[67] "Appearance" in this case meant showing what the eye usually could not see; slowing the movements with the zoetrope allowed Marey to synthesize the data furnished by his graphing machines.[68]

For the horse, Mathias Duval (1844–1907)—professor of anatomy at the Ecole des Beaux Arts—made drawings from Marey's notations of each phase of the gait on a band of paper. When this band was placed in the zoetrope, the movement of the horse was reconstituted in slow motion.[69] Marey's notations had finally offered proof of a long-suspected fact, which he quickly confirmed with the zoetrope: at one point in both the trot and the gallop, all four of the horse's legs were off the

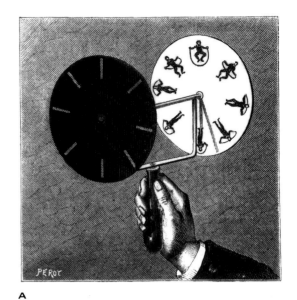

A

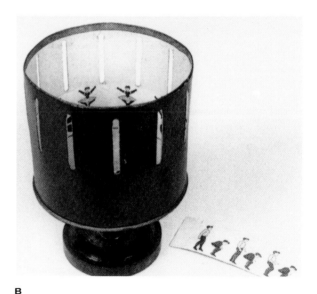

B

14.
(A) Phenakistoscope. *La Nature,* December 1879. New York Public Library. (B) Zoetrope, Beaune.

ground: "the body of the animal is, for an instant, suspended in the air."[70]

Locomotion in the air presented a different set of problems that soon challenged Marey's ingenuity. Neither birds nor flying insects propelled themselves by striking the ground, as terrestrial creatures did, so the rubber ball–tubing–stylus mechanism was inoperative. Moreover, so far Marey had applied the graphic method to movements that took place in a straight line: the contraction or lengthening of a muscle, the vertical and horizontal oscillations of the body during walking, and so forth. The combination of these rectilinear movements with the uniform advance of the cylinder that received the tracing allowed Marey to measure the velocity at each instant of the movement.[71] The movement of a bird's wing during flight was much more complicated; it did not simply go up and down, it also moved forward and backward at each stroke. Undaunted, Marey soon found a way of adapting the instruments to suit the new subjects. (He would also alter the subject to adapt it to the instrument, as we shall see.) The power of the graphic method lay in its flexibility: no matter how varied the movement to be traced, the inscriptors were constructed according to a unifying principle of direct mechanical translation, so they could, with a moderate amount of tinkering—in which Marey was unequaled—adapt to any movement.

When he began in 1868 to decipher the movements of insects' wings, Marey made the insect itself do the writing by brushing its wing tips against the cylinder (fig. 15). The insect "was held by the lower part of the abdomen in a delicate pair of forceps; it was then placed in such a manner that one of its wings brushed against the blackened paper at every movement. Each of these contacts removed a portion of the black substance which covers the paper."[72]

But the rubbing of the wing against the cylinder slowed down the frequency of the movement, indeed interfered with it, something Marey wanted to

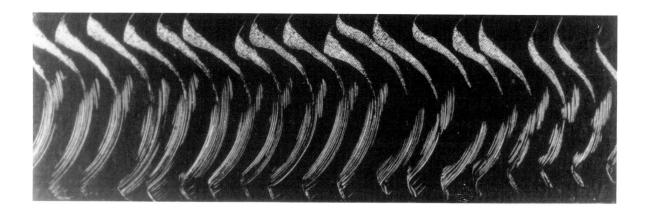

15.
Direct tracings of the movement of an insect's wing in flight, 1868. *Notice sur les titres et travaux scientifiques du Dr. Marey.*

avoid at all costs. So he created a purely optical solution; he gilded the wing tips of a wasp to heighten their visibility and projected a ray of sunlight onto them. The gilded point "passing continually in the same space would leave a luminous trace."[73] The trace, Marey saw, was an extended figure eight. By gilding the upper face of the wing, he was able even to detect the exact changes in the inclination of its plane as it moved. But the double loop he had seen seemed to contradict concrete evidence that insects moved their wings only up and down as they flew. Marey suspected that the figure eight was not controlled directly by the muscles of the wasp. It was, he proposed, created by the resistance of the air acting on the upper and lower surfaces of the wing, with its rigid framework in front and flexible web behind. To prove his theory he built a mechanical insect, a complicated artifice of wings, drums, levers, and an air pump (fig. 16). It confirmed that the up-and-down impulse from the insect was transformed by the wind acting on the unequal flexibility of the wing to create the double loop Marey had seen.

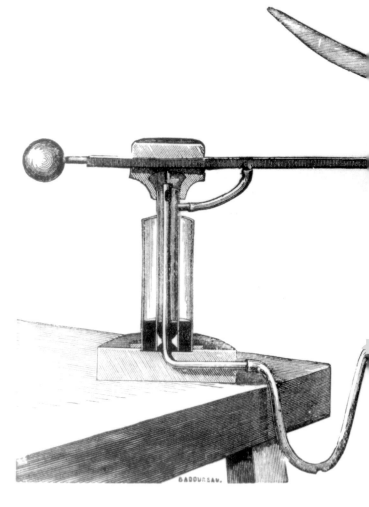

The effect of air resistance on a bird's wing was not resolved so simply. The optical solution Marey had adapted for insects was not possible for birds, because though the movement of a bird's wing is too fast to be followed by the eye, it is too slow to form a persistent impression of its trajectory on the retina of the observer. Nor was it practical to determine the frequency of the wing strokes by having the bird brush the cylinder with its wing tip as the insect had. Yet Marey aspired to nothing less than understanding the nature of the wing's movements in flight: What was the effect of the air in creating or sustaining these movements, and how much muscular force does the bird develop to propel itself through the air? Many theories had been offered to answer these questions. Now the graphic method offered the possibility of proof.

The direction of Marey's experiments with birds was guided by the method he had followed for the insect. Because the motion of the wing in flight was the key to deciphering the interplay of air and wing, he began by measuring the speed of the wing stroke. By substituting electricity for air pressure, he succeeded in transmitting the number of wing strokes to the inscribing cylinder. He attached a small circuit breaker to the tip of each wing, which was opened and closed as the wing was raised and lowered. Marey applied this method to different species of birds to compare the frequency of their strokes;

16.
Mechanical insect, 1869. *Animal Mechanism.*

and more important, because he could register the relative duration of the elevation and depression of the wings, he used it to prove that, contrary to general opinion, the descending period was the longer of the two.

When he could not trace the precise instant of the change of direction of the wing nearer than ¹⁄₂₀₀th of a second, however, Marey reverted to air transmission, placing a myograph over the pectoral muscles to signal their contraction and relaxation to the cylinder. The myographic tracing contained two curves, one longer and more intense than the other, and with further experiment Marey deduced that the different forms signaled the different nature of the resistance each muscle encountered. When he placed the myographic tracings over the electrical tracings, the results seemed to show that the downward stroke was the one that propelled the bird: the muscle acted not on the weight of the wing, but on the resistance of the air (fig. 17).

The next and most difficult step was to find a way of registering all the movements of the wing on an immovable plane as if, as Marey said, a pen attached to the tip of the wing rubbed a piece of

17.
Experiment to determine by electric
and myographic methods simul-
taneously the frequency of the
movements of the wing and the
relative duration of its elevation and
depression, 1869. *Animal Mechanism.*

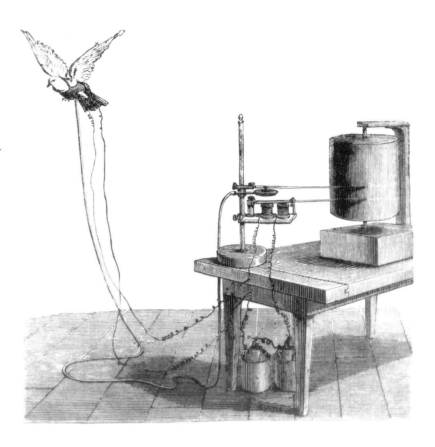

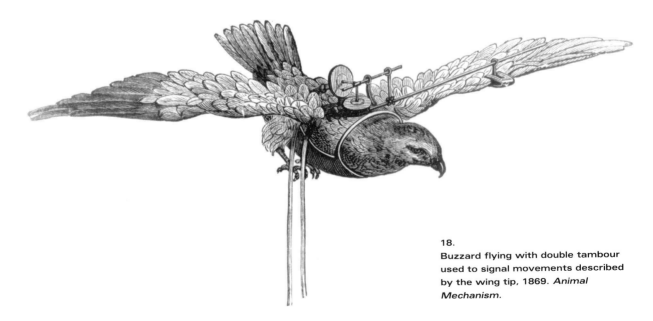

18.
Buzzard flying with double tambour
used to signal movements described
by the wing tip, 1869. *Animal
Mechanism.*

paper by its side. To realize this ideal Marey made his most complex apparatus to date, one that translated both the up-and-down and the back-and-forth movements of the wing simultaneously. It "could transmit to a distance any movement whatever, and register it on a plane surface"[74]—in this case a horizontally moving piece of finely polished glass—but it was heavy and needed a large bird to carry it (buzzards were the ideal subjects) (fig. 18).

After many frustrating attempts and changes—the recording apparatus was extremely fragile and broke at almost every flight—Marey finally obtained a tracing of the wing's trajectory on his glass: the registering lever described it as an irregular ellipse. He then proceeded to modify the bird: rather than allowing it to fly freely, Marey put it into a harness and suspended it from a flexible metal frame by means of a long arm that turned on a central pivot. In this contraption the bird could flap its wings and do everything else it did while flying without leaving the confines of the frame (fig. 19).

By adding a third transmitter, Marey was able to describe again the elliptical trajectory of the wing as it beat the air and even to provide an accurate characterization of the changes in the plane of the wing as it moved through the elliptical path. The tracings showed that the wings swept *forward* and *downward,* then on the upbeat traveled *upward* and *backward* until they began to make the next downbeat. This experiment refuted the theory, previously held, that birds in flight used their wings as one rows a boat, pushing backward and downward and returning forward and upward (fig. 20).

Marey's investigations into the flight of birds were for him the foundation for human flight. "The insect and the bird realize one of the oldest and most unsuccessful aspirations of the ambition of man. All space belongs to them; they go and come in the aerial ocean, while he is chained by his weight to the earth."[75] Marey's concern with flight (which

again recalls that of Leonardo) stemmed from his more pervasive belief that by making visible the mysteries of nature, humans could imitate and thus reproduce them. By studying the flight of birds, they would learn the secrets of aerial locomotion.

About 1870 Marey began to construct mechanical birds, as he had done for the flight of insects, to test and synthesize the results given by his instruments (fig. 21). In 1874 turned the project over to a new assistant, Victor Tatin (1843–1919). Like Marey, Tatin was fascinated by the possibility of mechanical flight. This is how Marey saw their task:

The problem of aerial locomotion, formerly considered a Utopian scheme, can now be approached in a truly scientific manner.

The plan of the experiments to be made is all traced out: they will consist in continually comparing the artificial instruments of flight with the real bird, by submitting them both to the modes of analysis which we have described at such length; the apparatus will, from time to time, be modified till it is made to imitate these movements faithfully. We hope that we have proved to the reader that nothing is impossible in the analysis of the movements connected with the flight of the bird: he will no doubt be willing to allow that mechanism can always reproduce a movement, the nature of which has been clearly defined.[76]

These ornithopters brought Marey into the company of the dreamers and experimenters who for centuries had been searching for a way to give man wings. Marey counted among his friends most of the French pioneers in aviation. Gaston Tissandier (1843–99), author of *La locomotion aérienne,* and Nadar (Félix Tournachon, 1820–1910), an avid balloonist, followed Marey's experiments with intense curiosity.[77] Tissandier, one of those universal amateurs that the nineteenth century specialized in, regularly reported on Marey's progress in the pages of *La Nature,* the popular science journal he

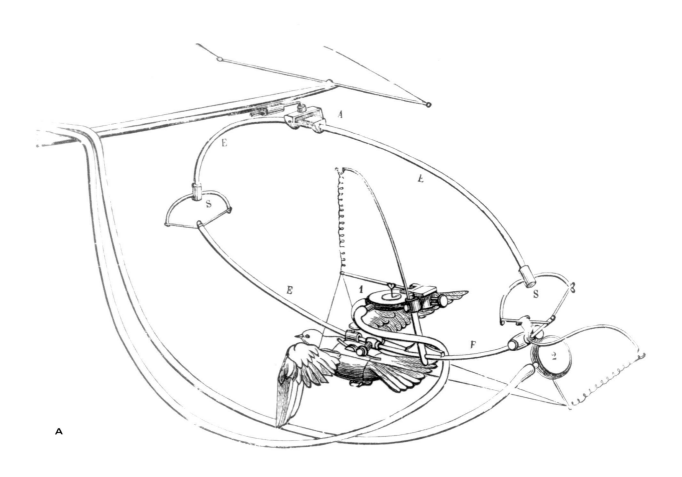

A

19.
(A) Marey's harness to register the
trajectory of the wing in free flight.
(B) The apparatus in use, 1870.
Animal Mechanism.

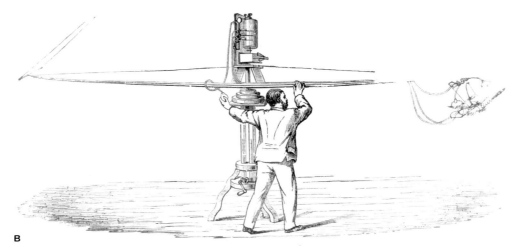

B

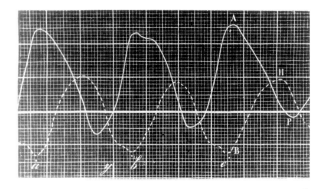

A

B

20.
(A) Tracings of a pigeon's wing made with the apparatus in figure 19. The solid line shows the movement back and forth; the dotted line shows the movement up and down. (B) Graph made from the two trajectories. The dots express the rapidity of the wing's movements, 1870. *Notice sur les titres et travaux scientifiques du Dr. Marey.*

founded in 1873. Tissandier edited the journal and wrote a column on photography covering the latest in processes and images. Like Nadar, one of the most famous photographers of the century, who first approached Marey to ask for his assistance in aviation matters, Tissandier found the combination of aviation and photography irresistible. Then there was Alphonse Pénaud, whom Charles H. Gibbs-Smith, the doyen of aviation history, calls "one of the aeronautical giants."[78] Although he worked with Marey on a successful ornithopter in 1872,[79] Pénaud is known mainly as the inventor who made the first inherently stable model airplane to be seen in public, thus establishing the character of the modern airplane with its fixed wings and rigid body. Finally, Clément Ader (1841–1925), the French pioneer of the telephone, who built and attempted to fly one of the earliest full-scale airplanes, first presented his aviation experiments to the Académie des Sciences through Marey.[80]

The acceptance Marey found in the world of aviation was not at first paralleled in the world of French science. Because he was working in a field that today we would call applied biophysics, in a direction outside the mainstream of French physiology, Marey's entry into the established society of French scientists was accomplished slowly. Claude Bernard, for example, distrusted the complex instrumentation Marey depended on. In 1867, when Marey was appointed *suppléant* to the neurophysiologist Pierre Flourens at the Collège de France and a laboratory was created there for him, Bernard's response indicated his feelings. "Thank you for warning me [of Marey's appointment]," he wrote to his friend Louis-Amédée Sedillot, who was secretary of the Collège, "for it would have been a disagreeable surprise for me."[81] Marey was equally critical of Bernard's methods. He insisted that vivisection interfered with the regular function of life and could not understand why any scientist would

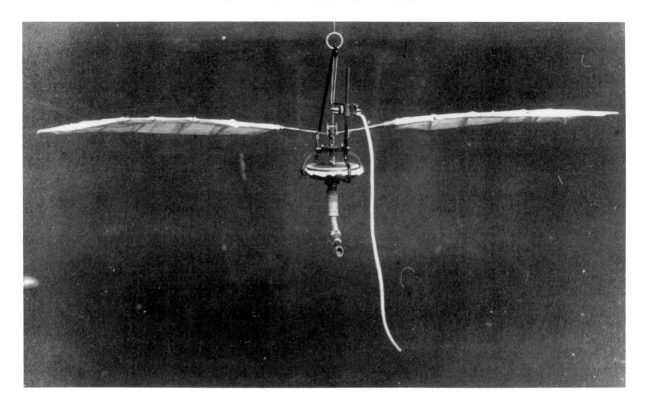

21.
Marey's first mechanical bird with tambour, used to reproduce the data given by his graphic and electric experiments on flight, 1873. Beaune.

mutilate or, worse, destroy what he was attempting to analyze. Vivisection, Marey wrote, "can do no more, so to say, than lay bare the phenomenon simultaneously with the organ which is the seat of it; it reveals to our senses only what they are capable of perceiving." More important, the necessity of directly studying human physiology "obliges us to renounce vivisection, and to substitute the use of apparatus."[82] Bernard's use of poisons as investigative tools came under Marey's fire for the same reasons.

Luckily, however, Marey did find a champion in the French scientific establishment. He was Victor Duruy (1811–94), minister (and reformer) of public education and a crusader for French science. According to a story related in 1901 by Henri de Parville, a journalist and friend of Marey's, Duruy

first met Marey in 1868[83] while visiting the physics laboratory at the Sorbonne where Marey was working. There Duruy spotted Marey amid his fantastic instruments, like an ancient alchemist come to life. After introducing himself, Duruy asked to know more about what Marey was doing, so the scientist brought him back to the laboratory on the rue de l'Ancienne Comédie and introduced him to the full panoply of his apparatus and to his menagerie; he explained the function of each graphing instrument and the work he hoped to accomplish. Fascinated by the single-mindedness of the man and convinced of the importance of his methods, Duruy became a loyal adherent of Marey's cause, a lifelong friend, and the patron that Marey sorely needed.

In 1869 Marey's candidacy for Flourens's now vacant chair of "the history of organized bodies"[84] at the Collège was accepted by Duruy, and that same year Duruy appointed him director of the experimental physiology laboratory at the Ecole Pratique des Hautes Etudes, a state-run research center that Duruy himself had created. This entrance into the French scientific establishment was confirmed by Marey's admission to the Académie de Médecine in 1872[85] and by his winning, in 1874, the Prix Lacaze of the Académie des Sciences for physiology applied to medicine. Claude Bernard, who seems to have put aside for the moment his feelings about the value of Marey's work, was the *rapporteur* of the committee that gave the Lacaze Prize; his report is a perceptive summary of Marey's work and an appreciative assessment of the importance of the graphic method. Here is his appraisal of Marey and the effects of his contribution:

Seeing the infinite variety of the phenomena of life and their great complexity, one can judge the means and the artifices that M. Marey must have had to use to make them accessible to graphic registration. At almost every step M. Marey found himself presented with all kinds of

difficulties that he overcame with sagacity and inventive imagination. . . . The most manifest proof of his success is that the procedures he advocated for observing biological phenomena have been introduced in all the laboratories of physiology in France and abroad and have become the instruments of work and research without which one would no longer be able to manage.[86]

In the meantime, *La machine animale: Locomotion terrestre et aérienne* was published in France in 1873 (and in English as *Animal Mechanism* in 1874). In its opening pages Marey reiterated his positivist and mechanist beliefs and professed his scientific credo: "The hope of reaching the truth suffices to sustain those who pursue [science] through all their efforts; the contemplation of the laws of nature has been a great and noble source of enjoyment to those who have discovered them." At the same time, Marey explained, to the general public science is only a means—it must "lead to some useful application."[87] So he introduced the subject of the book, locomotion, by showing its practical importance. The study of flight, he wrote, will provide man with a means of extending his domain, so that he will one day "travel through the air, as he now sails across the ocean."[88] Similarly, a deepening study of the mechanics of terrestrial locomotion, Marey argued, will put an end to "much discussion and a great deal of conjecture. . . . A generation of men would not be condemned to certain military exercises. . . . One country would not crush its soldiers under an enormous load, while another considers that the best plan is to give them nothing to carry. We should know exactly at what pace an animal does the best service, whether he be required for speed, or for drawing loads."[89] Marey's military example, a reminder of the defeat of France in the war with Prussia three years earlier, was not lost on the Ministry of War. Within ten years it would use his work on human locomotion to lay the groundwork for reforming the French army.

Boldly and cogently argued, *Animal Mechanism* persuasively describes Marey's manner of thinking about and experimenting on machines. The multiple demonstrations of his conviction that mechanical force, heat, and electricity operate in the same way in both the living organism and the inorganic world[90] brought around many of those who had been skeptical of Marey's techniques and of his results.

Five years later, in 1878, Marey's achievements were at last officially acknowledged by his election to the chair in the medical and surgical section of the Académie des Sciences left vacant by the death of Bernard. Four previous attempts to win a seat in the Academy had ended in failure: there was no physiology section, and typically the medical and surgical section dominated by Bernard and his followers did not look kindly on the type of work Marey was doing. As Bernard's pupil Léon Gosselin wrote in 1876, "M. Marey . . . can be considered the creator of a new method of observation called the recording method or the graphic method. . . . In the final analysis, however, its applications are quite limited and force us to conclude that M. Marey is a scientist who is too far removed from investigations related to the study of disease for us to propose him as the most worthy representative of French medicine in [the medical and surgical] section."[91] But by 1878 the importance of physiological instrumentation in clinical work was no longer disputable, and Marey's election to the Academy sanctioned the entrance of his methods into the mainstream of French medicine.

The sanction was affirmed the same year by the acclaim that greeted Marey's new book, *La méthode graphique dans les sciences expérimentales et principalement en physiologie et en médecine*, an encyclopedic summary of all of his research and results so far. It began, as did all Marey's publications, with a scrupulous history in which he enumerated his predecessors and described what he had borrowed from each. He then defined the purposes of his inscribing machines and showed how they were able to describe both movement and force as well as to store the information as material for comparison and research. He described the circulatory and locomotion phenomena he had studied, but this time he focused methods of recording them. He reviewed the function of the mechanical models he had created, and finally he explained the locomotion of humans, horses, birds, and insects and showed the devices for registering their movements. "There is nothing," wrote Marey, "that can escape the methods of analysis at our disposal."

Not only are these instruments sometimes destined to replace the observer, and in such circumstances to carry out their role with an incontestable superiority, but they also have their own domain where nothing can replace them. When the eye ceases to see, the ear to hear, touch to feel, or indeed when our senses give deceptive appearances, these instruments are like new senses of astonishing precision.[92]

Not everyone was convinced of the efficacy of the graphic method, however. The *Bulletin* of the Académie de Médecine records a few skirmishes that erupted over the unorthodoxy of Marey's technique. In one session, after Marey explained some of the results his inscribers could produce, a Dr. Gabriel Colin rose to the attack. Colin argued that the graphic method was useless: it showed absolutely nothing that had not already been noted by simple observation or could not be found by vivisection. Marey's reply, made on the spur of the moment, typifies both his wit and his courage:

By sight and touch alone, Dr. Colin claims he can seize all that the inscribing instruments reveal and more. If he can estimate the duration of acts that only last one hundredth of a second—data furnished easily by the graphic

method—then he must also be able to count globules of blood and do a thousand other amazing things. I dare not argue with people who are so exceptionally gifted; instead I will address myself to others who have no need to reject every new element of certainty in medicine.[93]

Marey's defense did not blind him to the imperfections in his technique. However true his statement that nothing could escape his method of analysis, there were certainly motions for which he had not yet found the perfect inscriptor; in its present state his method could not grasp movements too weak to move a stylus or the movements of subjects that obviously could not be physically harnessed to any measuring apparatus. His graphing instruments could not describe the exterior characteristics of things, such as the form of the bodies in their changing dimensions and their positions in space as they moved. And though these external characteristics could always have been drawn by hand—given that they did not vary in a manner that made observation impossible—such representations were insufficient for depicting change in form or position as it hap-

pened: movement could be portrayed only by showing it in a state of repose. Birds were a particular problem. How could they be made to give up the secrets of their complex motions in the air? Marey's graphing machines had given him partial answers. He had been able to estimate the muscular power exerted during flight, to register the motions the bird's wing makes in space, the frequency of its beat, the variations of its movements during the different periods of flight, and even the moments when it changed direction. But the inquiry had to be restricted. Harnessing birds to the heavy apparatus demanded by their intricate motions meant that only large birds could be used, and their movements were not ultimately free; the space of the laboratory was confining. Moreover, Marey felt that only a visual solution would resolve the aerodynamic aspects of the problem.

And then, in the last month of 1878, in his friend Tissandier's journal *La Nature* Marey saw some photographs of horses in motion that seemed to offer the possibility of such a solution.

3 Reinventing the Camera: The Photographic Method

Like the automobile in our contemporary world, the horse in the nineteenth century was key to some of the most significant economic functions of society: transportation, travel, status, recreation, and war. Curiosity about the animal and its movements was consequently universal. Everyone shared— to varying degrees and to varying ends—an interest in equine anatomy and locomotion. But the movements of the horse were too rapid and too complex ever to be interpreted by the unaided eye; the impossibility of following four legs at once meant that contradictory theories abounded as to how the animal actually moved. The exact sequence of movements of each of the four legs in each gait, the movements that marked transitions from one gait to another, and the effects of different kinds of harness on the animal's paces were all open to question. The methods of inquiry described by Goiffon and Vincent, two eighteenth-century veterinarians Marey often cited as authorities, were still in use in the nineteenth century, and both depended on the unaided senses: the ear was used to distinguish by sound the order of the hooves as they hit the ground, and the eye to decipher the animal's prints in sand or other easily imprintable surfaces. (To see this clearly, each hoof was shod with a distinctly shaped shoe).[1]

Marey had used his graphing inscriptors to characterize the sequence of each gait with unrivaled precision and to discern for the first time the transition from one gait to another; but he could

not give the exact position where each hoof struck the ground except by using the old-fashioned imprinting method. The drawings based on Marey's notations by the renowned horseman Lt. Col. Emile Duhousset, published in Marey's *Animal Mechanism*, showed the attitude of the horse in each of the paces Marey recorded and were more precise than anything seen before; nonetheless, the artist's objectivity could always be called into question. Furthermore, the drawings would have been difficult to accept in an age already accustomed to the products of the camera—the machine, it was believed, that could not lie.

The importance of the horse ensured that the idea of using a camera to capture the animal in motion had a history almost as long as the history of photography itself. Daguerreotypes and calotypes, the earliest photographic processes, were not sensitive enough to record moving subjects; except for a few experiments under special conditions, anything that moved produced a blur on the silver plate or paper negative. This deficiency, perceived as a problem similar to the camera's inability to record color, was addressed almost immediately after the birth of the medium. As early as 1840, the British astronomer Sir John Herschel predicted the instantaneous photograph. By the 1850s the advent of smaller cameras, faster lenses, and primitive shutter systems heralded the first widespread attempts in the photographic conquest of motion. In the 1860s and 1870s improvements in photographic lens mak-

ing, the use of the quick (but cumbersome) wet-plate process,[2] and the invention of mechanical shutters had brought the snapshot within the realm of possibility. It was at this point that men as diverse as the Victorian photographer Gustave Rejlander, the Philadelphia sportsman Fairman Rogers, and the English eugenicist Francis Galton imagined and described possible methods of photographing horses in rapid motion. Their attempts included composite photographs and series photographs,[3] but no one had any success until 1878.

On 14 December of that year Tissandier published five sequences of a horse in motion. Each sequence was made up of six or twelve single photographs, and each photograph in turn constituted one single phase of a particular gait: walk, trot, canter, or gallop (fig. 22). Although the photographs lacked detail—they were really not much more than silhouettes—they were made by a camera, and so for the readers of the journal they had unequaled veracity. They showed aspects of movement never before seen by the eye and gave irrefutable proof of the true nature of the horse's paces. They were the first successive photographs of movement analyzed in real time; the pictures were not merely startling, they were revelations.

The photographer responsible for this unheralded success was an Anglo-American called Eadweard James Muybridge. Muybridge, in addition to sharing Marey's initials, was also his exact contemporary: they were born and died within weeks of

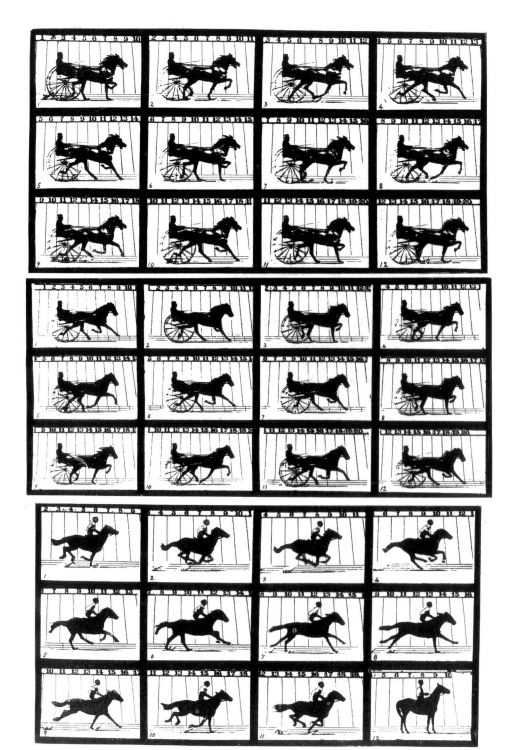

22.
Eadweard Muybridge,
gravures made from
his sequence
photographs of
the trot and the
gallop, *La Nature,*
December 1878.
New York Public
Library.

44

each other. Muybridge had emigrated to America from England in 1851 (changing his name on the way from Edward Muggeridge). Sometime in the early 1860s, after a stint as a bookseller, Muybridge took up photography in San Francisco, and he rapidly established himself as one of the outstanding landscape photographers of the West. His photography of horses had begun five years before the publication of the photographs in *La Nature,* when in spring 1872 he was invited by Leland Stanford, governor of California, to make some photographic experiments on Stanford's horses. Stanford, the builder of the Central Pacific Railroad, had turned his prodigious energy—and wealth—to creating and developing the greatest racing stable in the West. Not one to do things by halves, Stanford diligently acquired the latest scientific research in equine anatomy and locomotion and applied it to the breeding and speed training of his horses. The invitation to Muybridge stemmed from Stanford's becoming embroiled in the "unsupported transit" controversy—whether or not there were moments in the stride of a trotting or galloping horse when it was entirely free of the ground. Stanford believed there were, as did friends in San Francisco, while the opposing view was taken by wealthy sportsmen on the East Coast. Both sides counted newspaper owners among their number, making the argument a highly publicized one.[4]

Using the wet-plate process, Muybridge began the first set of experiments under Stanford's direction at his Sacramento stables in spring 1872. Stanford wanted a single representative photograph of his trotter Occident at full speed, but it is unclear whether Muybridge succeeded in getting one either that year or the following: no photograph from these experiments, or from those done in spring 1873, was ever published.

In 1874 Muybridge's work for Stanford was interrupted: after a domestic quarrel, Muybridge murdered his wife's lover. He was acquitted on grounds of "justifiable homicide" on 5 February 1875, but he nevertheless felt it expedient to leave the country for some time.

Also in 1874, a copy of *Animal Mechanism* had reached Stanford, who, according to Muybridge, read it closely. Stanford must have been struck by Marey's description of the gaits of the horse: Marey (and Duhousset's illustrations) had shown that there was indeed a moment in the trot and in the gallop when the horse was suspended in the air. Stanford must also have been impressed by Marey's use of the zoetrope as a synthesizing instrument, because when Muybridge returned to his employ in 1876 Stanford redirected the experiments. Instead of instructing Muybridge to make single pictures, Stanford determined to have him take a series of photographs that could be synthesized on the zoetrope.

For this new project, carried out at the larger, well laid out track on the nine-thousand-acre farm at Palo Alto that Stanford had just finished building, Muybridge used a battery of twelve cameras, one beside the other, along the horse's path. Each shutter was attached to a wire or thread laid across the horse's path and triggered by the horse as it raced down the track in front of the cameras. The shutters of the cameras thus went off sequentially, each making an image at $\frac{1}{200}$ of a second. Beyond the horse was a fifteen-foot-high fence hung with sheeting vertically marked off in consecutively numbered lines twenty-one inches apart so that "[each] picture's place in the series was indicated by the numbers on the backdrop, which were photographed along with the equine subjects" (fig. 23).[5] After months of experimenting, Muybridge took the first successful serial photographs of the horse in motion in June 1878.

Marey was thrilled by Muybridge's photographs; they verified the results given by his graphic

23.
Muybridge, layout of track and cameras for the work at Palo Alto, 1876–79. *The Attitudes of Animals in Motion,* p. 4. Gelatin silver print, 23.8 × 19.3 cm. Metropolitan Museum of Art, Harris Brisbane Dick Fund, 1946.

tracings of the horse's gait and—with the exception of the gallop, where "the diagrams constructed from chronographic data alone are particularly at fault"[6]—they also replicated Duhousset's drawings; they showed that the camera might be made to provide the visual solution he had been looking for. Marey was not totally unfamiliar with photography, but his experience had led him to believe it was a rather limited medium for his investigations. Two

years earlier he had adopted photography in his attempt to capture and record bioelectrical phenomena or, to put it in more familiar terms, to produce the forerunner of the electrocardiogram. In 1876 Marey had found a way to make visible the electrical charges that existed in muscle by photographing the shadows cast by a column of electrified mercury as it registered the electrical impulses of the tissue.[7] This initiation of the electrographic method was Marey's photographic debut, but he took it no further at that time. He noted that photography could always be used to "inscribe variations in instruments that are incapable of overcoming the least resistance" (like the galvanometer and a similar instrument, the electrometer), as well as for controlling inscribing instruments like his own sphygmograph, but that in both these cases the camera was only translating the phases of a rectilinear movement as a function of time, just as the graphing inscriptors did—no more, no less. Further, the technology was not sufficient to his ends. The wet-collodion process was too slow to compete with the speed of the graphing inscriptors, and Marey found the chemical manipulations involved in making wet collodion plates "long and fastidious."[8]

But by 1878, when Marey first saw Muybridge's photographs, the situation had changed. Marey was aware of the introduction of the dry plate into photography, and he wanted to expand the dominion of the graphic method. Muybridge's photographs showed him that photography "has a greater role to play in science; it allows one to approach extremely complex problems and give a concrete solution with a singular facility."[9] Instead of being a substitute for the graphic method, photography could extend it.

Marey's response to Muybridge's photographs was immediate. Four days after they appeared, Marey wrote this letter to the editor of *La Nature,* his friend and fellow aeronaut Gaston Tissandier:

Dear Friend,

I am filled with admiration for Mr. Muybridge's instantaneous photographs that you published in your next-to-last issue of *La Nature.* Could you put me in touch with the author? I would like to ask him to assist in the solution of certain physiological problems, so difficult to resolve by other methods. For instance, on the question of the flight of birds, I was dreaming of a kind of *photographic gun,* to seize the bird in a pose or, even better, in a series of poses marking the successive phases of the movement of its wings. [The physicist Louis] Cailletet told me he had tried something analogous in the past with encouraging results. It is clearly an easy experiment for Mr. Muybridge. And then what beautiful zoetropes he will be able to give us: in them we will see all imaginable animals in their true paces; it will be animated zoology. As for artists, it is a revolution, since they will be provided with the true attitudes of movement, those positions of the body in unstable balance for which no model can *pose.* You see, my dear friend, my enthusiasm is boundless. Please respond quickly; I support you completely.[10]

Muybridge responded (again in the pages of *La Nature*) to Marey's letter in February, telling Marey that his "celebrated work on animal movement first inspired Governor Stanford with the idea of the possibility of resolving the problem of locomotion with the help of photography." As for Marey's request, Muybridge wrote that photographing birds in flight would be difficult, but that he would "set about it as best we can."[11] Muybridge also sent a collection of his pictures with this letter; then for a while there seems to have been no further correspondence between the two. In California, Muybridge expanded his subject matter to include men and continued to work on his battery-of-cameras system of photography, varying the number of cameras from twelve to twenty-four or thirty and taking simultaneous views from up to five camera positions (fig. 24). He made zoetrope strips of the horses, as

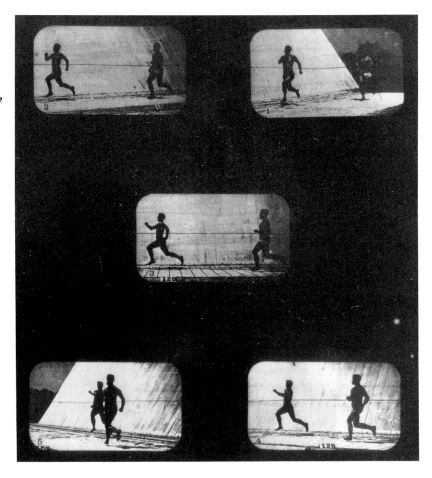

24.
Muybridge, images of two athletes taken simultaneously from five different camera positions, 1879. *The Attitudes of Animals in Motion*, p. 57 (detail). Gelatin silver print, 19.3 × 23.8 cm. Metropolitan Museum of Art, Harris Brisbane Dick Fund, 1946.

had Duval and Duhousset when the photographs were published in France. He copyrighted these without any objection from Stanford and sold them through the newspapers. By late 1879 he had embarked on another profitable venture, this time as an itinerant lecturer. He perfected a projecting phenakistoscope that he called the zoopraxiscope: a magic lantern that illuminated a moving circular disk on which were painted images of the horses made from his photographs (fig. 25). With it he could give moving magic lantern shows—a vastly popular form of entertainment and edification that

preceded and presaged the cinema—on that ever fascinating subject the horse. His flamboyant personality and aggressive marketing sense assured the success of his venture.[12]

Marey, meanwhile, did not immediately pursue the areas opened to him by Muybridge's photographs. The possibility of a large outdoor laboratory for his experiments was in the offing, and he had already started the long and arduous negotiations with state and municipal authorities for land and money. He was also in the midst of experimenting with the effects of poisons on the nervous system

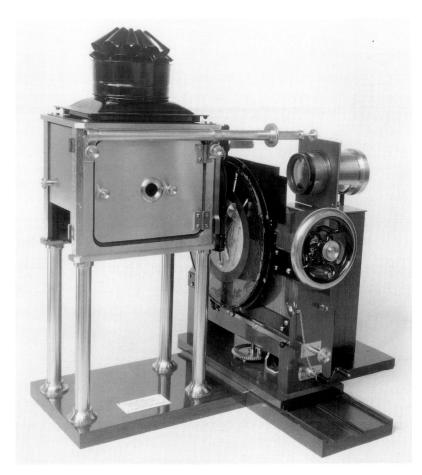

and studying the germ theory of disease, the area Pasteur made central to medicine. His lack of facility with the chemical side of photography—he never did become really expert at it—deterred him from carrying out investigations on his own. Before investing the considerable funds needed for such a system, he would wait and see what Muybridge could provide in the way of photographs of birds.

As he waited for what he hoped would be a new way of analyzing flight, Marey continued to pursue the synthesis of flight with Tatin. A mechanical bird that Tatin built in 1876 had differed from the many others produced at the time by having a double eccentric working two levers connected to the front edge of the wing. The levers conveyed a twisting motion exactly imitating that of a bird's wing.[13] The mechanical bird was used to demonstrate that, contrary to popular opinion, the force needed to move the wings was not as overwhelming as had been presumed and that the energy the soaring bird expended to maintain its flight was about equal to that provided by a small engine. No human, however, could provide that kind of power. Marey proved the Renaissance physiologist Gio-

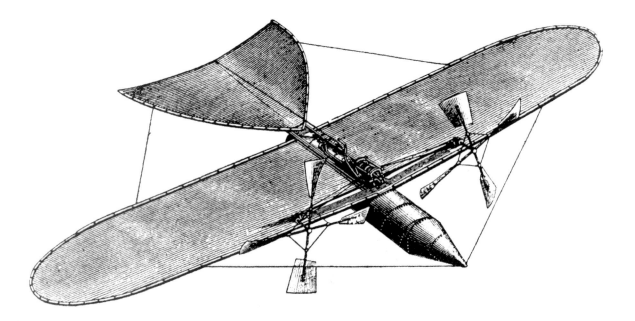

26.
Victor Tatin's air-compressor fixed-
wing airplane, 1879. Tatin, *Eléments
d'aviation,* 1908.

vanni Borelli's thesis that, compared with the bird's, the musculature of a human was inadequate for flying, and so an unexpected result of the experiment was to make evident the futility of the human-driven ornithopter (or mechanical bird) as the future of flight.

Marey's next step was to make a fixed-wing aircraft. In 1879 Tatin constructed a model airplane for him. Made of silk, it had a wingspan of 6.2 feet, or 1.9 meters, and two front-mounted propellers that ran by means of a compressed-air motor mounted in the fuselage (fig. 26). After preliminary testing in the courtyard of the Collège, Marey and Tatin traveled to the military aerostation at Chalais-Meudon, where they continued to experiment. They constructed a round platform forty-six feet in diameter and set the wheels of their model on it. The front and rear of the plane were fastened to strings tethered to a stake in the center of the platform. The compressed air to the engine was turned on, the propellers put the plane in motion, and it took

off, running over the platform until it attained a velocity of eighteen miles per hour. At that point it rose into the air and flew until the power supply was exhausted—usually for about fifty feet.[14]

Because the power of the machine was carefully measured and repeatedly tested, Tatin was able to demonstrate something very important for future experimenters: a full-scale airplane based on this model would fly if its engine could be made to provide a minimum of one horsepower for every 110 pounds of weight of the machine. Of course in 1879, when these experiments were conducted, the four-stroke cycle gasoline engine—the one engine light enough to power such a machine—had been invented only three years earlier, and its use in an airplane was still a dream.

The model airplane Marey and Tatin made had been preceded by those of the English experimenters George Cayley and William Henson, who had devised a fixed-wing propeller model in the 1840s. But Marey's and Tatin's machine was nonetheless crucial. It was the first model that rose into the air by a preliminary run over the ground and stayed airborne by the power of its engine and the lift provided by air pressure under the wings. It demonstrated that 110 pounds could be sustained and driven through the air by the exertion of one horsepower. It established once and for all that a fixed-wing aircraft with an engine powering one or more propellers was the only direction to go—that with this type of machine, man would finally conquer the air.

The success of these experiments also tended to support the importance—insisted on by Pénaud—of an inherently stable airplane, a machine that resisted any forces that would tend to upset its equilibrium and that would automatically return to equilibrium in flight if disturbed. Such an airplane would need the intervention of a pilot only when its direction or altitude required changing. The insis-

tence on inherent stability, an idée fixe with the French inventors, tended to blind them to the fact that the more stability was built into an airplane, the more difficult it would be to control and maneuver once a human pilot was on board. This paradigm of inherent stability so necessary for model flying limited and held back the European aviation pioneers. The Wright brothers at last recognized it as a stumbling block: in 1899 they designed a specially unstable airplane whose equilibrium in the air had to be maintained continuously by the pilot's skill.[15]

With hindsight, it seems logical that at this moment Marey and Tatin would build a full-scale model and begin to experiment with aerial navigation. But Marey did not have the money for such an expansion, and Tatin did not seem keen to scale up his model. The British aviation historian Sir Charles Gibbs-Smith explains this hesitancy as typical of that time; he points out that until the 1890s, the men who appeared on the aviation scene would be of two types: "the academic inventors whose creations . . . were realized only on paper and the model makers who were content to experiment in miniature."[16] Although the two continued a close friendship and would work together again on another airplane ten years later, Tatin left Marey's laboratory in 1880 to pursue his model making.[17] To garner more information, Marey returned to the core of his interest in aviation, the study of birds in flight. That was the state of things when Muybridge arrived in Paris in fall 1881; he brought with him the photographs that Marey had been expecting for three years.

Muybridge traveled to Europe at the expense of his patron Stanford, who had preceded him and paved the way for his introduction to European artists and scientists. In fall 1879[18] Stanford had gone to France with his family to commission portraits: one of his wife from Léon Bonnat, and one of himself from the most popular academic painter of his

time, Jean-Louis-Ernest Meissonier. Meissonier, an acquaintance of Marey's, was unrelenting in his attempts to seize the correct attitudes of the gaits of the horse, and it was through this interest that he came to do Stanford's portrait. Meissonier had at first refused the commission, but he changed his mind when Stanford offered him some of the photographs of horses in motion that Muybridge had taken. The painter's enthusiasm for Muybridge's accomplishment persuaded Stanford to send the photographer to Europe. In late summer 1881, as Meissonier was finishing the portrait, Muybridge left America, first for London, then to join Stanford in Paris.

Muybridge's first encounter with Marey has not been recorded, but on 26 September 1881 Marey invited Muybridge to give the first European demonstration of his zoopraxiscope for a group of scientific luminaries whom Marey had invited to his new home on the boulevard Delessert in the fashionable Passy district of Paris. The Paris *Globe* describes the event:

M. Marey, Professor of the College of France, yesterday invited to his new house in the Trocadero, Boulevard Delessert, some foreign and French savants, together with his intimate friend, our director, M. Vilbort. The attraction for the evening consisted of the curious experiments of Mr. Muybridge, an American, in photographing the movements of animated beings.

Among those invited by M. Marey were M. Helmholtz, whose name ranks high among all sciences; M. Govi, Professor of the University of Naples; M. Bjerknes, a Norwegian, whose great discoveries with respect to the laws of electricity have secured him a place in that Congress; Messieurs Brown-Séquard, Mascart, Angot, d'Arsonval, Terquem, Lippmann, of the College of France and of the Sorbonne, Th. Villard, Municipal Counsellor; Adml. Coste, Col. Duhousset, Capt. Bonnat, Capt. Raabe, Burdeau, Professor at the Lyceum of Louis the Great;

Goubaux of the Alfort School; Salathé, Nadar, Gaston Tissandier, Heim, Editor-in-Chief of the Strasbourg Press (which M. de Manteuffel has just suppressed); etc. . . .

Mr. Muybridge, an American savant, gives us the first experience of something that should be accorded to the whole Parisian public. He projects upon a white curtain photographs showing horses and other animals going at their most rapid gaits. But that is not all. His photography having taken "on the wing" each movement of which each gait is composed shows us the animal in the positions that our eye, taking in only the general ensemble, would not otherwise observe. M. Marey lent his cooperation to Mr. Muybridge and made witty remarks on each tableau.

There was first laid before us, in this manner, the marvelous apparatus employed by Mr. Muybridge. He then showed us the apparatus in position disposed to the number of 24 in a sort of stand. Each seizes upon the image of an animal as it appears before it in an instant—two hundredths of a second. Before this arrangement of apparatus ranged along like canons, 24 in number, the animal passes along on a track, beyond which is a white wall which furnishes an appropriate background for the photography. At each step, the animal breaks a thread, which brings an instrument into play, so that at each stage of its passage no matter how rapid, there remains to us an exact image.

Having no animals to photograph at the apartments of M. Marey, Mr. Muybridge contented himself with giving us results. . . .

Now what conclusion is to be drawn from these curious experiments? First, they give us more intelligent instruction with respect to the movements of animals, and then permit the formulation of laws therefrom; consequently, our artists can gain from the study of this photography, more faithful than the sketches of a master of the art, valuable hints for their work. They will become accustomed, as M. Marey says, to paint after Nature, like the Japanese (in regard to birds), and to thus instruct the public. The sitting was prolonged until late,

but we regretted that the time had come, when it did, to bid adieu to M. Marey and Madame Vilbort, who did the honors of the evening so charmingly. . . .[19]

For Marey, however, the success of the evening was qualified by one major disappointment. The photographs of birds that Muybridge had made at Marey's behest were failures: they were not pictures of the successive phases of the wing, but instantaneous pictures of groups of birds like those Cailletet had already procured. "Apart from the fact that the sharpness of the images was insufficient," Marey recalled three years later, "the photographs were missing the one thing that made the pictures of the gait of the horse so interesting, a series which showed the successive positions of the animal"[20] Muybridge could not achieve what Marey required. His battery of cameras, though adequate for representing large movements like those of the horse, could not successfully capture the movements of smaller animals like birds as Marey wanted. Muybridge had had the horse itself trip the successive shutters of the cameras by breaking wires along the path of its movement. This the birds obviously could not be made to do. More important, the method of having the horse break wires laid across its path meant that the nonuniform movement of its gait was transcribed to the cameras or, worse, that the wires might stretch or contract before they actually broke. The resulting transcription was unreliable for scientific purposes, since the rigorously exact time intervals necessary for this kind of work were beyond the reach of Muybridge's system. As Marey and other scientists now saw, the method was prone to inaccuracy. Since Muybridge used more than one camera, his subjects were not photographed from a constant perspective or from a single point of view. The intermediary phases of the movement were too hard to piece together from the ones pictured, because the distance separating them

was too large. Muybridge had failed to represent the trajectory of the movement. He "could not avoid errors that inverted the phases of the movement and brought to the eyes and spirit of those who consulted these beautiful plates a deplorable confusion."[21]

But if Marey's hopes were dashed, Muybridge's aspirations soared. He was lionized by Parisian society and taken up by its writers and artists. He found himself in the midst of the most sophisticated, urbane company he had ever imagined, and they were all in his thrall. Men whose names were legendary to Muybridge applauded his work and feted him, not as Stanford's technician—his accustomed role in Palo Alto—but as an original contributor to the progress of art and, at first, science. The photographers he met at Marey's reception presently introduced him to the latest in photographic technology, the rapid silver-bromide gelatin dry plate, whose invention meant the photographer no longer had to coat and sensitize the glass plate at the last minute but could buy plates ready for exposure. Marey himself, with his usual generosity, invited Muybridge to his laboratory at the Collège and explained to him the locomotion studies that had been his chief concern for the past ten years.

Marey, who had already left for his annual stay in Italy, did not attend the second "entertainment" for Muybridge in Paris exactly two months later. It was given by Meissonier at his home on the boulevard Malesherbes for an audience composed of "the most famous and influential painters and critics of the official art establishment of the day."[22] Muybridge's photographs and his zoopraxiscope lecture were again a sensation. Meissonier, who had been dumbfounded by the Stanford photographs when he first saw them three years earlier—he had insisted that the apparatus "saw falsely"—now resigned himself to their truth. "From this date, for all the paintings in which horses appear, he based

his studies on chronophotographic documents."[23] The flamboyant Muybridge was more comfortable in Meissonier's circle; he saw himself, and always referred to himself, as an artist. The success he met among the artists at Meissonier's certainly would have allowed him to feel he was one of them. As he put it in a letter written two days after the reception to Frank Shay, Stanford's secretary in San Francisco, "Happily I have strong nerves, or I should have blushed with the lavishness of [the] praises."[24]

While basking in this enormous acclaim, Muybridge also recognized that to sustain the interest of his newfound admirers, he would have to expand his work. There was no doubt about the importance a future project in the domain of animal locomotion would have for his career and for his continued acceptance in the exalted circles he now moved in. But he also must have realized from his visits to Marey's laboratory and his acquaintance with Marey's work that he could not hope to undertake a truly scientific investigation of movement: he simply did not have the background, training, instruments, or knowledge. Muybridge knew this, and soon his scientific friends knew it too. After the original excitement wore off, scientific interest in his work all but vanished.

Painters and sculptors, on the other hand, were still hungry for what his cameras could reveal. Muybridge was aware of the interest of artists, but he could not carry out alone the kind of project that would satisfy that interest. His only income came from the proceeds of his zoopraxiscope lectures and from the sale of individual photographs and zoetrope strips. He had compiled a book from the work done for Stanford, called *The Attitudes of Animals in Motion,* but it was privately printed by him in a small edition, and few copies were sold.[25] He was clearly unable to provide the scientific foundation necessary to make a new project worth funding by outside agencies. He needed a new backer and a new source of funds, and he needed a project worth backing. This meant an enterprise that could be perceived as having scientific or practical value. Stanford could no longer be depended on. He had accomplished what he set out to do and had no desire or reason to support Muybridge in any new venture.

So, for the rest of his European visit, the quest for a new backer became Muybridge's main objective. In the same letter to Shay in which he described Meissonier's reception, Muybridge wrote: "I shall shortly visit England for the purpose of inducing some wealthy gentleman (to whom I have letters of introduction) to provide the necessary funds for pursuing and indeed completing the investigations of animal motion."

A second letter to Shay written on 23 December 1881 revealed what would be the perfect solution: a combination of art, science, and money in the form of a collaboration with Meissonier, Marey, and a "capitalist" friend of Meissonier's (unknown to Muybridge) who would finance the project. According to Muybridge, the idea for the new project originated with Meissonier, who, using photographs Muybridge would make, intended to "edit and publish a book upon the attitudes of animals in motion as illustrated by both ancient and modern artists. He proposes it shall be a most elaborate work, and exhaustive of the subject. It is to be the joint production of Meissonier, Professor Marey, "the capitalist" and myself, and be a standard work on art which as Meissonier says will hand the names of all four of us down to posterity."[26]

A curious reference to his association with Marey is made at the end of this letter to Shay: "If in the course of your travels you should next summer find yourself in Paris," Muybridge writes, "make me a visit to my Electro-Photo studio in the Bois de Boulogne and I will give you a welcome." Shay would not know, of course, but the studio re-

ferred to could only have been Marey's Physiological Station. Marey had told Muybridge that such a space was in the offing, but at the time Muybridge was writing to Shay no "Electro-Photo studio in the Bois" existed. The land had just been ceded to Marey, and the buildings had not even been planned.

The invitation to Shay was a bluff, an example of Muybridge's often dramatic flair for self-promotion and publicity. The idea of Marey's collaboration in the project was wishful thinking: the first time Marey would hear about it was in a letter Muybridge wrote to him a month later requesting his cooperation.[27] Unfortunately for Muybridge, the appeal came too late: Marey had already begun his own photographic investigations of motion, with results that would soon overshadow every other contribution to the field.

Marey was convinced that photography could be used to expand the range of the graphic method, and when he had left France for Italy in October 1881 the thought uppermost in his mind was to find a way of developing a photographic instrument for his work that would overcome the inadequacies of Muybridge's system. The direction he had decided on was one he mentioned in his letter to Muybridge three years earlier, a photographic gun. Marey's dream of a photographic gun was not merely idle reverie. Photographic pistols—small gun-shaped cameras that took a single instantaneous shot—had been on the market since 1860.[28] Marey, however, was more likely thinking of a gun that would make a series of pictures, such as the photographic revolver described in 1873 by his colleague the astronomer Pierre-César Jules Janssen (1824–1907) and used by him to record the transit of Venus across the sun on 8 December 1874. Janssen, who wanted to photograph the moment when planetary and solar disks came into contact, had the idea of taking a series of images so that "the photographic image of this contact would neces-

sarily be included in the series and at the same time it would show the precise instant when the phenomenon occurred."[29]

In Janssen's photographic revolver the lens was in the gun barrel, and behind the barrel were two slotted-disk shutters.[30] The first, which moved continuously, making a complete revolution in eighteen seconds, had twelve slots; the second, which was fixed, had one slot. When the slots of the two overlapped, they exposed to the light a circular daguerreotype plate mounted behind them. This plate moved intermittently, stopping to receive each image (forty-eight in total) and taking seventy-two seconds to make a complete revolution. A clockwork-run gearing system set in motion by a handle operated the revolver, and an image was produced on the plate every second or every 1.5 seconds (fig. 27).[31]

In a prophetic article written in 1876, Janssen had described how his photo revolver would assist physiologists:

The property of the revolver, to be able to automatically give a series of numerous images as close together as one desires . . . , will allow one to approach the interesting question of physiological mechanics related to the walk, flight, and various animal movements. A series of photographs that would embrace an entire cycle of movements relating to a determined function would furnish precious information on the mechanism of the movement. . . . In regard to the still obscure question of the mechanism of flight, for example, one realizes how interesting it would be to obtain a series of photographs reproducing the various aspects of the wing during that action.[32]

But Janssen also understood the limitations of his procedure: "The principal difficulty at the present time comes from the inertia of the sensitive plates, since images of this kind necessitate an extremely short time of impression."[33]

This was the difficulty Marey now had to resolve. He had to make a photographic gun that

27.
(A) Jules Janssen's *revolver photo-graphique,* 1874 model. (B) Cross section. *La Nature,* May 1875. New York Public Library.

A

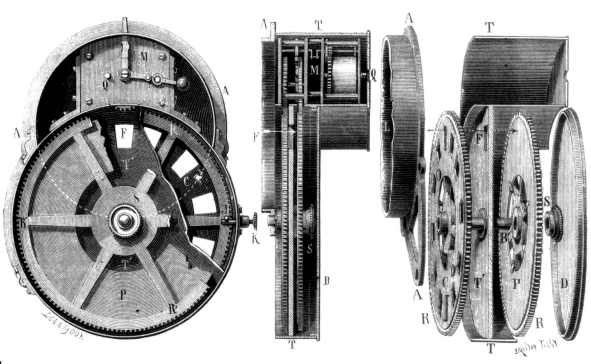

B

would take pictures at least ten times as fast as Janssen's had.

Marey wrote to Janssen for details about his instrument in the fall. By late November, just at the time Muybridge was enjoying the Meissonier fete in Paris, Marey was already on his way to developing his own prototype. He constructed a small portable rifle that took twelve pictures (on a round or octagonal disk seven and a half centimeters in diameter), at intervals of 1/720 of a second. In February 1882 he wrote to his mother, "I have a photographic gun [*fusil photographique*] that has nothing murderous about it and that takes a picture of a flying bird or a running animal in less than 1/500 of a second. I don't know if you can picture such speed, but it is something astonishing." [34]

In March Marey sent an announcement of the instrument to the Académie des Sciences, and in April he published a full description in *La Nature* that included these specifications:

The barrel of this gun is a tube that contains a photographic lens. Behind this, and solidly mounted on the butt, is a large cylindrical breech casing containing a clockwork mechanism. This mechanism is started by pressing the trigger and imparts the necessary movement to the different parts of the instrument. A central axis makes twelve revolutions per second and commands all the parts of the instrument. The first of these is a metal disk pierced with a narrow slot. This disk forms the shutter and lets the light penetrate only twelve times a second for the duration of 1/720 of a second each time. Behind the first disk is another turning freely on the same axis. This disk has twelve openings, and attached to it is the sensitized glass, which can be either round or octagonal. This second disk must revolve in a regular and intermittent manner so as to stop twelve times per second in front of the ray of light that penetrates the lens. A cam placed on the shaft produces this discontinuous rotation by

effecting a mechanism that causes teeth to stop the rotating disk. [35]

Marey's and Janssen's guns worked on the same principle: a light-sensitive plate rotated intermittently behind a lens; the plate stopped long enough for part of its surface to be exposed to light, then moved on; as the next, unexposed segment of the plate moved toward the lens, a slotted-disk shutter blocked the light, and when this new segment reached the lens, the plate stopped and the shutter let the light through to it.

Although modeled on Janssen's gun, the precision mechanics of Marey's version of the instrument made it significantly faster. It was intended to be used with dry plates, rather than the slower daguerreotype or wet plates used in the Janssen model, and it was portable. Marey solved the problem of plate storage and accessibility by devising a plate carrier that was based on those commercially available. Marey's carrier—he called it his "conjurer's box"—was a cylinder that held twenty-five plates and dispensed them into the gun as they were needed without exposing them to light (fig. 28). [36]

Before trying out the gun on birds, Marey made some tests with it to control the accuracy of his results. He photographed the movement of a black arrow sweeping like the hand of a clock around a white ground (fig. 29), as well as a black pendulum that oscillated in front of a white ruler marked off in sections. Then he brought in one of his graphing instruments to control the precision of the gun: he adapted a *tambour* so that it received—and transmitted to an inscribing stylus—a jolt each time the plate stopped and started. In this manner, he wrote, both "the duration of the light impression and the interval of time that separated one image from another were measured with satisfying precision." [37] He constructed a second gun, his *fusil à munition*, that made a single instantaneous image

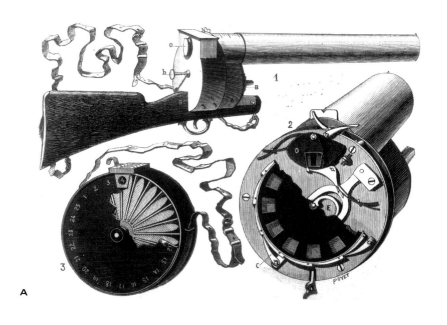

A

28.
(A) Marey's *fusil photographique*:
view of the interior, exterior, and
plate holder, 1882. *La Nature,* April
1882. New York Public Library.
(B) Otto Lund, Marey's mechanic,
practicing with the *fusil photo-
graphique* in Naples, 1882. From
Marey's personal album in the
Collège de France.

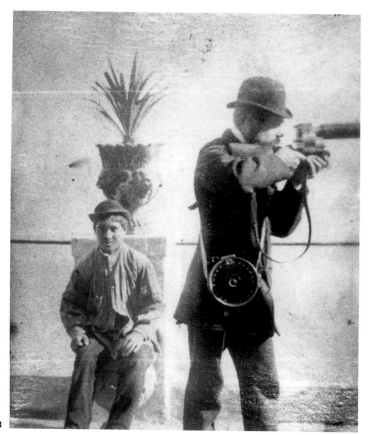

B

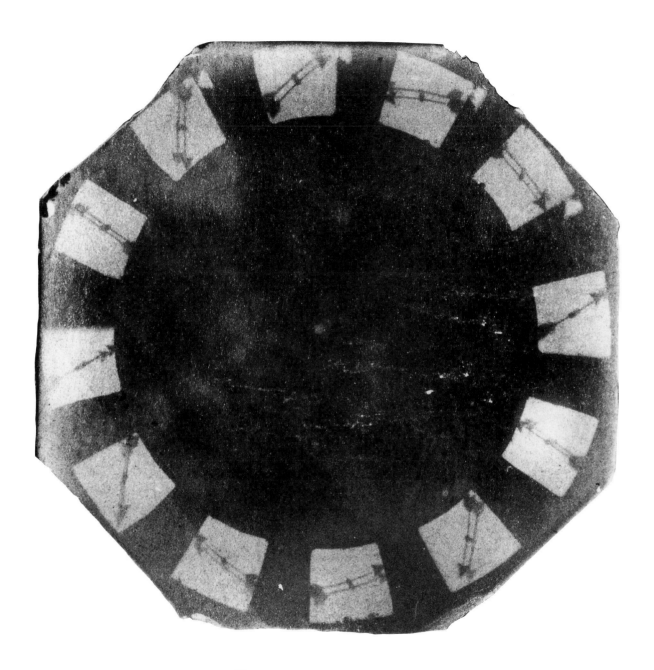

29.
An arrow rotating at five meters per
second taken at a distance of ten
meters with the *fusil photographique*
at $\frac{1}{720}$ second, March 1882. From
Marey's personal album in the Collège
de France.

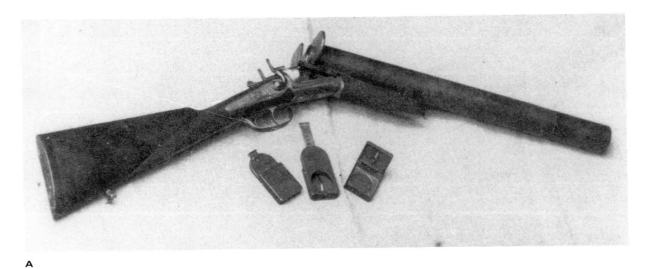

A

30.
(A) The first single-shot photographic gun (*fusil à munition*). Album A, plate 35, Beaune. (B) Flight of gull; a boat in the bay of Naples, 1882. Collège de France.

B

on a small (4 cm square) glass plate. He used it—on birds and ships at sea—to perfect his aim and to learn how to focus quickly on moving targets at different ranges (fig. 30).[38]

Then came the sequence of experiments outdoors. With his *fusil photographique* Marey made sequential photographs of bats and birds in flight, and on his return to Paris in April 1882, of horses and people on the street (fig. 31). In the early summer, on visits to his country house at Chagny, near Beaune, he used the gun as often as he could and familiarized himself with the basic methods of developing, printing, and enlarging.[39] His neighbors, who watched his almost daily forays into the surrounding fields, perhaps found it odd that the good doctor never brought anything home with him after all the hours he spent shooting.

The gun was Marey's first photographic instrument; thus the advance it represents is all the more remarkable: it resolved the problems of inaccuracy inherent in Muybridge's system; it was measurably precise; it worked with unprecedented speed and produced the number of images needed for synthesis—the twelve images it made each second were enough to synthesize the motion on a phenakistoscope. Given the speed at which the gun operated, twelve images a second would also be the maximum that the weight and inertia of the plate would allow. Most important, the gun enlarged the territory of the graphic method.

The advantages of the gun over Muybridge's battery of cameras were evident: a single point of view, and equal as well as verifiable intervals of time; continuous registration on a single plate instead of instantaneous images on multiple plates. The advantages of the photographic method over the graphic method were also clear. Both methods were founded on the same principle—Marey's desire to transcribe the ephemeral world of invisible movement into a visible and permanent trace. The

technique by which he performed such magic also remained invariable: it consisted of an interceptor to capture the movement, a transmitter to relay it, and an inscriptor to make it at once visible and permanent. However, the benefits of the photographic method seemed substantial: it could grasp both the movement and its outward form at the same time. Simultaneous movements were not beyond its reach. Replacing the transmitter with rays of light eliminated any intermediary (like the rubber tubing or the harness) between the moving subject and the surface destined to capture its trace. Finally, no transmitting force was required of the subject, nor would there be any interference from the translating mechanism. Here is how Marey summed up the advantages of photography: "When the object in movement is inaccessible, like a star whose travels one wants to record; when its movements are executed in different directions at once or are of such extension that they cannot be directly inscribed on a piece of paper; then photography supplants the mechanical procedures with great facility; it reduces the amplitude of the movement or, conversely, amplifies it to a more convenient scale."[40]

Nevertheless, there were profound differences between the camera's way of capturing motion and that of the graphing instruments Marey hoped it would supplant. The graphing inscriptors did not make pictures of the movements they were tracing; rather, they furnished Marey with a fluid visual expression for time and motion. The lines that undulated without interruption across a piece of smoke-blackened paper were a kind of writing whose language, as Marey put it, was that of life itself. From this writing he could make interpretations and he could measure; he could calculate the force of the movement and the work expended in executing it. Each surge, squiggle, and loop he deciphered like an "archaeologist . . . deciphering inscriptions traced in an unknown language, . . .

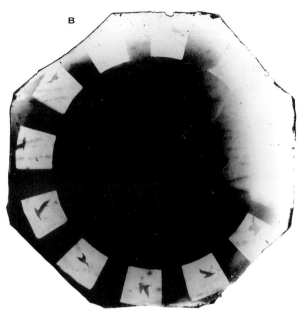

[who tries], turn by turn, several different meanings for each sign."[41] The camera depicted movement in quite a different way; it actually made a picture of the changes that occurred in instants of time, reproducing the outward form of the movement attended by a profusion of pictorial detail. Its reproduction was intermittent, however, and it represented sequential moments in time without the moments in between. The rendering of movement in time as a continuous fluid passage was lost. The graphic method had given movement as a continuity, moving with the movement, echoing its every displacement, but it did so at the cost of concrete detail. The camera provided pictures with as much concrete detail as one would wish, but it did so at the cost of continuity and clear expression.

Thus, for all that it was an astonishing breakthrough, the gun was still far from an ideal photographic instrument. For example, though it gave the successive attitudes of the bird's wing—and Marey was overjoyed to find that these photographs substantiated the elliptical trajectory pattern of the wing first found by the graphing inscriptors—he still had to cut out the individual images, overlap them, and paste them along a horizontal axis on a piece of paper if he wanted to measure the wing's trajectory. This tedium almost effaced the advantages of the camera. In addition, the images produced by the gun had their drawbacks; they were too small—about the size of postage stamps—they lacked detail, there were too few of them, and they were too far apart. The gun did not provide the spatial dimension of the movement; it did not supply an impression of the exact path or distance traversed within the defined time. This meant that the precise speed of the flight could not be determined. Since Marey had already been able to register such factors with his graphing machines,[42] the photographic machine had to be made to provide at least this minimum.

But how could the camera be made to emulate the graphic method and record movement as a con-

C

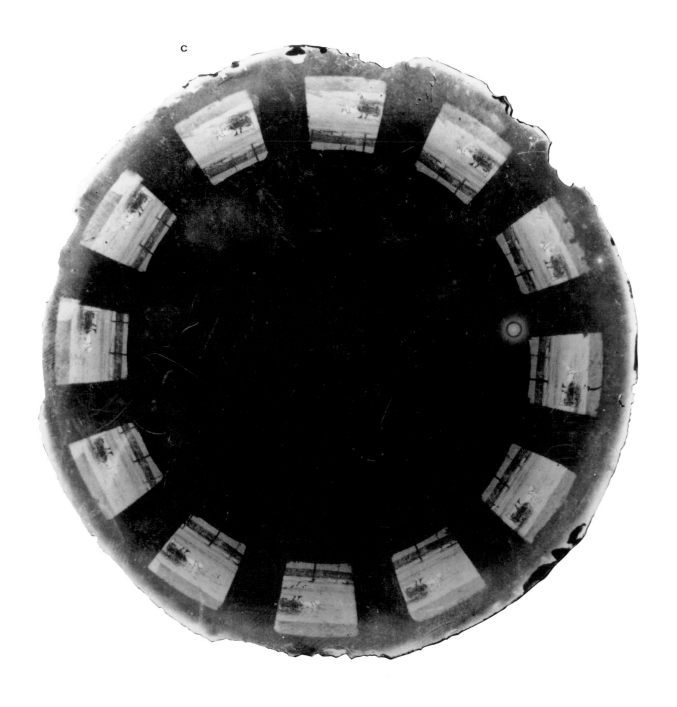

31.
(A) Flight of gulls. (B) Flight of a gull.
(C) Horse pulling a carriage, 1882.
Collège de France.

tinual sinuous passage in time and space? How could each of the images be made to occupy on the photographic plate the corresponding place that each phase of the movement did in space at the moment the photograph was made? One obvious answer was to have the camera make more images, enough to make the trajectory of the movement evident, to show the in-between phases too. When Marey tried to increase the speed of the sensitive glass plate, however, its stopping and starting caused vibrations that blurred the images.[43]

Marey's next steps were typical of his approach to a problem. Usually he could be counted on to see the elements in an instrument that were successful and either rearrange them to overcome the instrument's limitations or use them as the basis of a new instrument. Sometimes, if he could not adapt the instrument to the subject, he would adapt the subject to the instrument. In this case he did both. Before tackling the camera proper, he changed the subject matter. Abandoning birds for the moment, he used a human subject, where the movements were less complex, slower, and best of all, took place in a straight line and on the ground. Then, with a new camera, he succeeded in finding a way of exposing to the light one segment of the photographic plate at a time and having each segment correspond to a different phase of his subject's movements. But this time he did it without moving the plate.

In the photographic gun, the slotted-disk shutter functioned to mask the plate while it moved and then to expose the plate when it stopped. It was this feature of intermittency that allowed Marey to make more than one picture on a single plate, and it was this element that he incorporated into his new camera. The shutter—now a rotating metal disk with a variable-width slot in one of its segments—was placed between the plate and the lens in the new camera, as it had been in the gun, but

the plate did not move (fig. 32), and the camera functioned in a completely different environment. Its lens was left open onto a large black inclined background so that (ideally) no light could enter the lens and make an impression on the rectangular plate fixed behind it. Then, as a man clothed all in white and lit by the sun passed between the camera and the black surface, the slotted-disk shutter alternately exposed and masked the plate. As the slot— or window, as Marey called it—passed the lens, a phase of the movement was registered on the plate; as the subject moved to a new position, the plate was masked by the shutter; and then as the slot passed the lens again, the subject's new position would be registered on a fresh portion of the plate immediately next to the first, and so on. Each time the slot passed in front of the lens, a new phase of the subject's movement was made next to the previous one; this result could be repeated indefinitely, depending on the speed of the disk shutter's revolution. Marey had created a systematic multiple exposure on a single plate, and the result was uncanny: the movement was split and frozen into a series of what were potentially an infinite number of phases spread out over the surface of the same plate (fig. 33).[44]

The experiments that led to this solution show Marey's attempts to incorporate into the photographs both the temporal and the spatial coordinates of the graphs. He started in Naples by hanging a black velvet curtain at an angle so that the sun would not strike it, then pointed the new camera at it and threw a stone wrapped in white paper between it and the camera. The result, a white streak curving across the photograph, was naturally blurred, but it was a blur that represented the trajectory of the movement, showing the successive positions the stone occupied in space. But the trajectory, by Marey's definition, did not show the movement of the object because it gave no notion of

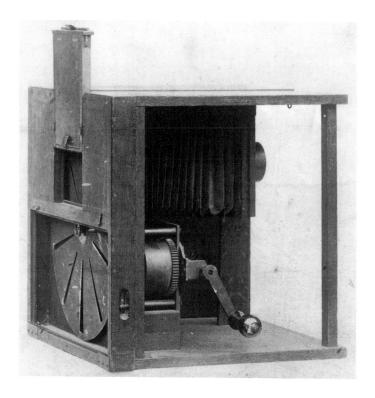

32.
Marey's first fixed-plate chrono-
photographic camera, third version
with ten slots in the disk shutter,
1882. Beaune.

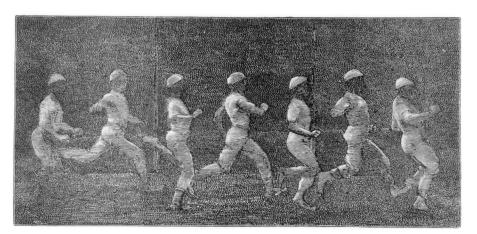

33.
Subject running in front of the first
black background: "similgravure"
made from a chronophotograph,
1882. *Scientific American,* September
1882. Metropolitan Toronto
Reference Library.

time;[45] the trajectory alone could not show whether the stone moved quickly or slowly, or whether the movement was interrupted or uniform. Only when Marey introduced the slotted-disk shutter to interrupt the stone's trajectory at equal and known intervals was the temporal dimension finally incorporated: the interval that separated one phase of a movement from another was exactly proportional to the distance traveled during one rotation of the disk. Marey could now record the different positions in space the subject occupied (the trajectory) as well as define its various positions on the trajectory at each moment; the time intervals separating each pair of images were of constant and known duration, and because the movement was rendered in overlapping forms, even the transition from one phase to another along the trajectory could now be measured with unprecedented ease.

Illustrations of the earliest photographs made with the new camera—it was not yet possible to reproduce photographs themselves—appeared in *La Nature* in July 1882 and in *Scientific American* in September. They showed what seemed at first glance to be a number of men running, but they actually represented simultaneously the different positions a single figure successively occupied in space over time. Their novelty would certainly have been disconcerting to the untutored viewer, because the traditional Western pictorial delineation of time and space would make them hard to read. Since the advent of linear perspective in the Renaissance, the frame of an image has, with rare exceptions, been understood to enclose a temporal and spatial unity. We read what occurs within the frame as happening at a single instant in time and in a single space. Marey's photographs shattered that unity; viewers now had to unravel the successive parts of the work in order to understand that they were looking not at several men moving in single file, but at a single figure successively occupying a series of positions in

space. Viewers had to allow themselves to be led from one figure to another, reading the several images of the single figure as it moved through time and space. The result, a vision that goes beyond sight, was a new reality.

In keeping with his name for the graphic method—chronography, or "time writing"—Marey called his new method of decomposing movement first "photochronography" (*photochronographie*) and then "chronophotography" (*chronophotographie*), or time photography.[46] With chronophotography, Marey could now envisage investigations of enormous breadth. He wanted nothing less than a scientific interpretation of the "range, velocity, and sequence of the various phases of movement, not only in walking, but also in running and jumping,"[47] to find the external conditions that influence these motions and to measure the energy expended at each instant—"the momentum of the opposing forces which represent the power and the resistance in the animal machinery."[48] And the inquiry would not be restricted to human locomotion. As soon as he had realized his photographic method, Marey returned to his investigations of flight and of the horse's gaits. A project of this size needed a degree of accuracy and precision hitherto unknown in photography and a kind of outdoor experimental laboratory that did not yet exist in Europe. Fortunately, by the time he had constructed his first chronophotographic camera other events had occurred that together would make the project a reality. First, the establishment of the laboratory—the Station Physiologique (Physiological Station) in the Bois de Boulogne; then the arrival of a first-rate mechanic, Otto Lund, who would execute Marey's ideas for photographic instruments; and finally, the help of a new and talented assistant, Georges Demeny.

Georges Demeny (1850–1918) (fig. 34) is known today as one of the founders of physical

34.
Georges Demeny, 1893.
Cinémathèque Française.

education in France and was a key figure in the movement that saw physical education and sport as a means of national regeneration, both physical and spiritual. His story and that of the Station Physiologique are closely intertwined.

The defeat of France at the hands of the Prussians in 1870 was followed by a real decline in the birthrate and a perceived decline in the morality and vitality of the French nation. A medical model of deviation and degeneracy became the predominant cultural metaphor to explain this crisis of fin-de-siècle France. The degeneration of the race or, in its medicalized (and popular) form, the disease of "neurasthenia" was thought to be caused in no small part by the grinding life of the urban metropolis. And physicians linked the decline to the other "ills" of modern culture that had exhausted the will of the population and sapped its strength: alcohol and tobacco abuse, prostitution and fornication, crime and madness.

The theory of the conservation of energy in its application to the body formed the scientific support for this model of decadence. The image of the fatigued body, an image of "decline, inertia, loss of will or lack of energy,"[49] was one of the most significant and pervasive cultural manifestations of the scientific thesis that the body was a system of energies that, though capable of being transformed (usually into work), were nonetheless not inexhaustible. Fatigue was the negative aspect of a body conceived as a thermodynamic machine capable of conserving and deploying energy.[50] It was perceived as the limit of the body's mental and physical energies, the horizon of the body's forces; resistance to fatigue and the amelioration of physical endurance were, within this metaphor, the route to the release of latent energy. The result would bring "a productivity without constraint . . . a civilization resistant to moral decay and disorder."[51]

Anson Rabinbach's recent study *The Human*

Motor details the far-reaching consequences of the nineteenth-century obsession with fatigue. One of the first was the search for a physiological source of fatigue, which began in earnest in laboratories throughout Europe after the 1870s. For the most part its investigators were students or colleagues of Marey's—Chauveau, Hugo Kronecker, Angelo Mosso, Charles Fremont—and their methods of measuring the expenditure of energy during mechanical work were based on Marey's graphic and photographic techniques. Indeed, Marey's own myographic studies of human muscle mark one of the first steps in this inquiry. This examination of the limits of the body's energies led to a "distinctive European study of work"[52] grounded in physiology and based on a new image of power that emphasized the expenditure and deployment of energy as opposed to human will, moral purpose, or even technical skill.[53] Its profound effects on the modern organization of work, the worker, and the workplace will be considered in chapter 9.

But as Rabinbach illustrates, the scientific study of fatigue also paralleled the emergence of energy conservation as a social doctrine. Statesmen, economists, and philosophers saw that the new principle had implications for the conservation of energy in society as well as in nature:[54] fatigue was a threat not only to individual well-being but to the future of the industrialized nation as a whole. After 1860 both liberal and socialist thinkers emphasized the importance of fatigue for identifying the limits of productivity, "for demarcating the horizon of exploitation, and for affirming the legitimacy of reform."[55] The importance of clinical investigation into the limits of the productivity of the human motor was not lost on such interests: "Society could be constructed according to the rational deployment of the forces of the body: productivism could be harmonized with the need to conserve

energy and preserve the productive power of society."[56] To combat fatigue, to recover the body's energy and the energy of the body politic as a whole, thus became the vital interest of both science and the state.

In France, physical culture and sport—part of the larger movement for medical hygiene that produced, among other things, Baron de Coubertin and the Olympic revival of 1896—became two of the more appealing and popular means of national recovery.[57] Physical education and gymnastics would bring health and well-being to the threatened generation and return strength and equilibrium to the social body. The healing and energizing properties of exercise would "breathe new life into a fatigued and sensual civilization."[58] The mechanics of this ideal revitalization—what kind of physical education was to be taught, to whom, by whom, and how—was a debate that raged in France until the First World War and involved both Marey and Demeny.

In the democratic Third Republic the weakened and defeated army was the most visible symbol of the fatigued and disordered state; thus the physical reform of the nation had to begin with the reform of the army. The framework for this reorganization was put into place when universal military service was made obligatory in France by a law passed in 1872–73.[59] Based on the Prussian model of an active army backed up by trained reserves always at the ready, the law proposed a vision of military preparedness in the ideal democracy: the army was to be the instrument of the restoration of national discipline as the nation was imbued with the military spirit of energy and vigilance. In the words of the militant republican Léon-Michel Gambetta, "The gymnast and soldier must now work side by side with our teachers until each child, each citizen, is fit to hold a sword, to handle a rifle, to make long

marches, to pass nights under the stars, and to valiantly endure any hardship for the sake of his country."[60]

The next step was to remake the soldier, the individual unit in this equation. Rather than an obedient killing machine of brute force, the new soldier was conceived in terms of the new citizen: physically resistant, morally virtuous, and intellectually developed.[61] Creating this ideal man was no easy task, given that the thousands of young men entering the army and constituting its reserves—the sons of peasants, farmers, and petty bourgeoisie—had already experienced a lifetime of poor hygiene that could not be remedied in a few short years. Consequently the reformers found they had to attack the problem at two levels simultaneously: they had to retain and reeducate the men they were given, and they had to promote physical education among the young to improve the chances of the future combatants. Thus a new law, passed in 1880, made physical education obligatory in all French lycées.

There existed, however, no universal syllabus or any rational methods for physical education instruction, either in the army or in the schools. In the schools teaching was haphazard and had a distinctly militaristic bent: in general the students were subject to repetitive, exhausting paramilitary drills. The poorly paid instructors were mostly retired noncommissioned officers whose experience in teaching the military cadets under their tutelage hardly prepared them to instruct young children. In response to the inadequacy of these efforts, young patriots took things into their own hands: they founded gymnastic societies throughout France, directed to the sort of premilitary training they thought would contribute to national preparedness.

Demeny was one of these young patriots; he had started a *cercle de gymnastique* in Paris in 1880,

one of the many clubs created "to restore to the French their muscles."[62] The same year, Demeny appeared as an auditor at Marey's lectures at the Collège and soon thereafter asked to work with him on the applications of physiology to physical education. The aim of Demeny's work, as he explained in a letter written to Marey in May 1880, was to "develop the human body harmoniously by movement."[63] His guiding idea, though it existed only in embryo at this point, reflected the current obsession: strength should be defined not as muscular strength alone, but as a matter of endurance and resistance to fatigue. The source of such "vigor" could be found only in superb physiology—that is, in a body whose physiological functions—most importantly respiration—were maximally effective and would allow the body to furnish the optimum mechanical work. Health, then, was defined by a smoothly functioning organism whose increased capacity for work over long periods and without exhaustion was the sign of its vitality. And so the goal of physical education was to ameliorate the "functional equilibrium"[64] of the body; or in modern terms, to get the individual into optimal shape.

When Demeny first approached Marey in 1880, however, these ideas were in the future; they would be developed over the next thirty years under three mutually reinforcing influences: Marey himself, the scientists who joined his laboratory to focus on the physiological source of fatigue, and the military and pedagogical reformers whose interest in the optimal function of the individual created the arena for the practical applications of his work. Demeny's immediate plan was to study the "basic functions" of the organism, such as circulation, respiration, and digestion. These were processes that left no mark on the body; they were, as were their effects, invisible—they could be found only through the in-

tervention of measuring instruments. Demeny was familiar enough with Marey's investigations in human locomotion to realize that the most expedient way to his own goal was through Marey's instruments; that Marey's studies might be used, in fact, to rationalize the whole process of physical education and give it a scientific foundation. He saw too that Marey's name and reputation might lend the field a professional status that it needed.

For his part, Marey welcomed the prospect of an eager young man whose interest in the practical applications of his work would free him up to do what he most desired—pure research. Demeny was not the only one to see the importance of Marey's physiological investigations to a formulation of physical education. The Ministry of War had asked him to participate in the reorganization of military training and sought to incorporate his results into the new manuals of exercise instruction that were a projected outcome of the reforms of the late 1870s. But Marey was not interested in doing research solely for the practical applications it might have; his preference was to leave that part of the work to others so that he could devote himself to improving his instruments and experiments. Demeny's request presented a marvelous opportunity for someone to take over the applied side of Marey's research and to work as a liaison with those agencies that wanted specific projects carried out.

Marey took Demeny on as an aide in 1881 and a year later had him officially named his *préparateur,* or assistant, at the Collège de France. Demeny had a talent for mathematics, an area in which Marey was weak,[65] and Marey came to depend on his mathematical skills as well as his aptitude in other areas in which Marey was not an expert, such as developing and printing the photographic experiments. Demeny would become indispensable in front of and behind the camera; he was put in charge of the dynamometers and odome-

ters employed to measure force and distance; and he was responsible for deciphering and collating the complex data these machines furnished.

It was Demeny who would deal with the minor bureaucratic tangles related to the founding and building of the Station Physiologique, its administration during Marey's yearly sojourns in Italy, and the general day-to-day running of its laboratory. (Demeny took up residence at the Station in 1884.) Until 1893 when, as we shall see, the advent of commercial cinema brought with it a rupture of their relationship, their alliance was of benefit to both. Demeny was able to pursue his own interests—among other things, he wanted to undertake a comparative study of national methods of physical education—and to benefit from the official recognition, status, and funding Marey enjoyed. The experiments he did under Marey's direction would ultimately become the foundation for a method of physical education based on physiology that would be diffused throughout the army and the schools. And for his part, Marey had found an able assistant for his experiments, who could take charge of his laboratory in his absence.

Demeny's first major task was to see to the completion of the Station Physiologique. The Station was an enormous achievement, unique in Europe. Its creation reflects both the expanding French official support for scientific laboratories and the burgeoning interest in the possible applications of physiological research on the body to the improvement of the nation. It was founded with public funds through the city of Paris and the Ministry of Public Education but was administratively attached to the chair Marey held at the Collège de France.

Originally, in 1878, Marey had been offered the land where the Eiffel Tower now rises—it had belonged to the state but was soon to be turned over to the Ministry of War, whose General Farre sug-

gested it be given to Marey. Instead, to his disappointment, the tract was given to the city, not the army,[66] and Marey was left to conduct his experiments where he could: in a large lecture hall at the Collège de France, in the middle of which he had installed his equipment for analyzing the flight of birds and insects; at the Luxembourg Gardens, where the gaping crowds drove him to distraction; at various Parisian riding schools; and at the Ecole de Joinville—the training center for military athletes and gymnasts—which, being outside Paris, meant risky transport for his delicate instruments.

Finally, in November 1881 the city came to his rescue: a plot of land in the Bois de Boulogne known as the "Parc des Princes" was donated by the municipal council, at the proposal of Marcel de Hérédia, its president. Hérédia was a friend of Demeny's from the days of the gymnastic circle, and this friendship was a factor in the way the Station was presented to the council for funding: one of its first missions was "research into the conditions for the best use of muscular force in men and animals,"[67] and Marey's proposal for the Station included a plan to create a superior method of gymnastic teaching directed at all Parisian professors, since "there is a real lacuna to fill in this area, for right now absolutely no rational teaching of this science exists."[68]

At first the city had in mind to give Marey temporary title to the park: "If, on the day that the city wants to install its flower garden there, it is put out by these experiments, the authorization for them can be withdrawn."[69] But in December 1881, after a debate about the role of secularized education in the teaching of gymnastics, the municipal council agreed to make the situation more permanent. They gave Marey ten thousand francs to put the terrain in order, a grant of twenty-two thousand for his work, and an annual subsidy of twelve thousand francs to subsidize experiments in "rational gym-

nastics." (As a condition of the funding, Marey was required to present a biennial report on his experiments to the council, together with a selection of photographs to illustrate his findings.)[70] Finally, in August 1882 financing for the necessary buildings (sixty-one thousand francs plus an annual subsidy of six thousand)[71] was voted by the Ministry of Public Education at the request of its head, Jules Ferry, the successor to Marey's champion Victor Duruy. Before he left for Italy in the fall of that year, Marey oversaw the transfer of his Hautes Etudes laboratory, and of all his instruments and materials to the Station. It would remain at the core of his work until his death.

The creation of the Station provided enough space to follow and record the locomotion of man, animals, and birds, and to have a workshop, housing for the animals, a laboratory, and a large experimental field all in one place. At the Station, Marey wrote,

the physician may seek a new means for the diagnosis of certain maladies and for investigating the effects of their treatment; the soldier may study the proper regulation of marching so as to diminish fatigue and use to greater advantage the bodily forces; the educator of youth may learn how to logically direct gymnastic exercises; the artist, how to represent more truthfully the scenes that he wishes to depict; the agriculturist, how to use to the best advantage the strength of animals; the artisan, how to more quickly acquire the skill necessary for his professional labours.[72]

The main building of the Station, a two-story "chalet" finished in December 1882, was big enough to neatly hold the enormous number of instruments Marey was always making or remaking; it had separate rooms for indoor work with men and animals, an office, and a guest room for visiting researchers (fig. 35). The outdoor field in front of the chalet was laid out in two concentric oval tracks

A

35.
Physiological Station at the Parc des
Princes in the Bois de Boulogne:
(A) Interior of the main chalet,
1887. (B) Demeny, young gymnast in
experiment to determine the
physiological benefits of gymnastic
apparatus, 1892. Collège de France.

four meters wide (the outer one for men, the inner
for horses), around which ran a telegraph line. An
electrical relay, attached to telegraph poles placed at
fifty-meter intervals along the outer track, signaled
the passage of the man to an inscribing odograph
(that measured the rate of acceleration over distance
traveled) in the chalet (fig. 36). The number of steps
taken by the pedestrian and their speed was dic-
tated by a mechanical drum in the center of the
field, whose rhythm could be increased or de-
creased. By dividing the distance traveled by the
number of steps taken, Marey could determine the
average length of the stride at different speeds.

Marey had begun his photographic experiments
with the fixed-plate camera at one edge of this field

B

36.
Physiological Station: (A) Arrangement of the track, telegraph relay poles, and indoor odograph, 1882. *La Nature,* September 1883. New York Public Library. (B) Man signaling his passage to the indoor odograph, 1883. Collège de France.

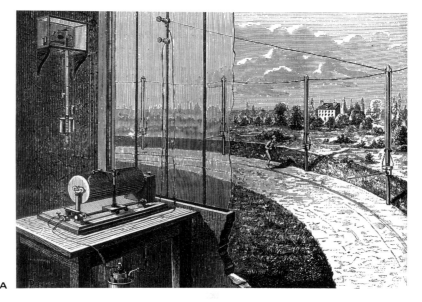

A

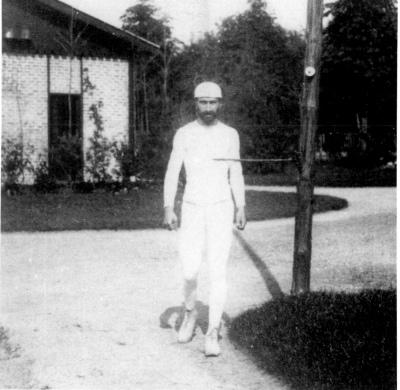

B

in early summer of 1882. He had erected his black background at the rim of the outer oval and placed his camera about forty meters in front of it, so that the angle from which the figures were photographed would not change appreciably and so that the complete movements would be captured as they extended against the entire width of the background. This need also dictated the size of the long, narrow (13 × 2.8 cm) glass-plate negatives he used. Marey's first subjects included Demeny, the soldier-gymnasts from the Ecole de Joinville (continuing a tradition that would last until the beginning of the century), and horses.

The background proved the least satisfactory component of the design; it was a type of lean-to open at both ends, and often too much light entered the camera and fogged the plate (fig. 37). As the illustrations from this period show, the wooden supports holding up the frame were highly visible, and the "plate was notably marked by the successive action of the light"[73] reflected from the screen—light bouncing off a black cloth on the ground all but obliterated the feet of the men and the hooves of the horses (fig. 38). Marey began to study the possibilities for a new background, a structure that would be invisible to the sensitive plate. The chemist Eugène Chevreul had suggested a deep black box to get an "absolute black,"[74] and Marey decided to have one constructed as close as possible to Chevreul's specifications. At the same time he tinkered with the chronophotographic camera shutter, trying to increase the number of exposures it could make each second. He changed it from a one-slot disk to a ten-spoke wheel (which made ten revolutions per second), then back to a large (one meter in diameter) disk that could have up to ten slots, each three centimeters wide, and made eight revolutions per second.

In early winter 1882 Marey left for his annual six-month sojourn in Naples. In what would subse-quently become an unvarying routine after the Station was established, Marey spent the winters in Italy while Demeny compiled the summer's experiments, started others that Marey had left him, and taught gymnastics. Marey seems to have done his most creative work in Naples. He had constructed another black background there for making chronophotographs and a laboratory for himself between his house and the sea. Away from Paris and the pressures of academic and official duties, he had more time to think and write, to design new cameras, and to tinker with the old ones. Otto Lund often was there with him to execute his wishes, and the Neapolitan sunshine let him photograph all winter. Paris was only a day away by mail, so he could still oversee the direction of Demeny's work and keep up to date on the activities at the Station.

A new background—from now on he referred to it as his "black hangar"—was almost finished when Marey returned to Paris the following spring, in 1883 (fig. 39). It was a shed three meters deep, fifteen meters wide, and four meters high—such height, he felt, was necessary to capture the flight of birds. It was oriented so that the sun did not penetrate its depths but did illuminate the subject walking in front of it (fig. 40). He had the interior painted black but then darkened it further by covering the walls and floor with black velvet. (In his published description of the new hangar he also mentions a frame covered with black cloth that could be suspended from the ceiling to confine the area.)[75] By the end of summer 1883 alternating black and white blocks, each one-half meter long, were placed along the track in front of the hangar. Clearly seen in the photographs taken at this time, they served as a handy guide to the distance between two successive images and to "estimating the size of the subject, the amplitude of his reactions and the extent of displacement of each part of his body."[76] A chronometric dial was made to be

37.
(A) Marey's first black background:
four vertical poles two meters high
support movable panels on a frame.
(B) Marey writes his name: one of the
earliest chronophotographs taken
against the first background. Marey,
dressed in black to be invisible, uses a
white-tipped black baton to inscribe
his name in the air, 1882. From
Marey's personal album, Collège de
France.

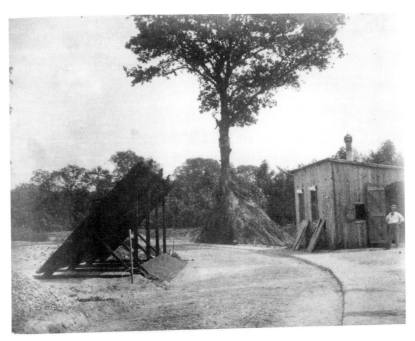

A

B

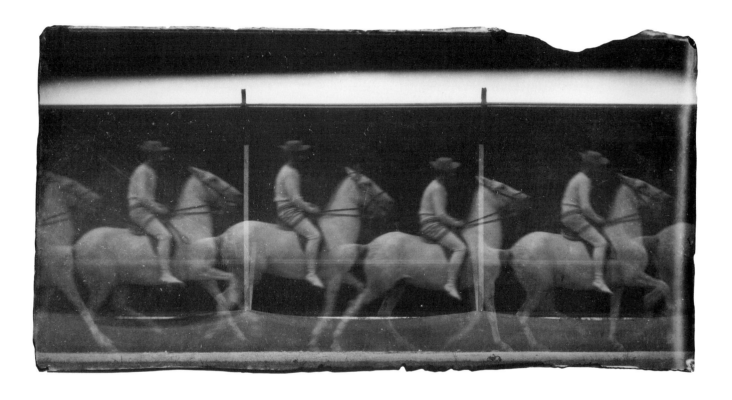

38.
Horse trotting in front of the first
black background, July 1882.
Chronophotograph from Marey's
personal album, Collège de France.

39.
Physiological Station in 1883. Left: second black background or "hangar"; center: first background and mobile camera wagon in front of the main chalet; right: observation post with mechanical drum. Cinémathèque Française.

40.
Subject dressed in white in front of the second black hangar, 1883. Album A, plate 11, Beaune.

placed in view of the camera.[77] A new camera too had been added. Its shutter was 1.3 meters in diameter with a single slot ¹⁄₁₀ of its circumference. The shutter was placed in front of the lens instead of behind it, and the whole apparatus was mounted inside a mobile wagon—like a small railroad car—that ran on an iron track perpendicular to the hangar (fig. 41). As can be seen from the pictures of this period, all these improvements made the images much sharper (fig. 42)—so sharp, in fact, that a new and more vexing problem soon became apparent.

Marey's method of multiple exposure was a consequence of his attempt to make photography represent motion as a continuous passage the way his mechanical inscriptors had done. It was meant to produce the largest possible number of images on one plate so that the most phases of the movement being photographed would be available. But the possibility of multiplying almost indefinitely the number of images the camera could make—the strength of the method—was now beginning to be hampered by the inherent strength of photography—its capacity to reproduce in complete visible detail everything that is in front of the camera. In other words, the surfeit of detail frozen by the camera was obscuring the clear expression of movement. This was particularly true in the case of the motions of very large forms or of anything that moved slowly: his camera produced so many pictures so quickly that the phases overlapped and obscured the overall motion. The resulting photographs, he wrote, "present such numerous superimpositions that the only result is a lot of confusion" (fig. 43).[78] With the graphic method, the frequency and proportion of movement had always been governable. Rapid movements could be slowed down and slow movements speeded up; it was all a matter of adjusting the speed of the cylinder that received the inscriptions. Similarly, through the intervention of rods

A

B

41.
Mobile camera wagon. (A) Front view. (B) cross section: *A*, camera; *B*, disk shutter; *D*, lens; *E*, opening for the camera lens; *C*, system of weights that triggers the shutter, 1882–83. *La Nature*, September 1883. New York Public Library.

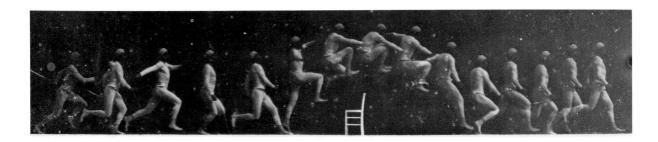

A

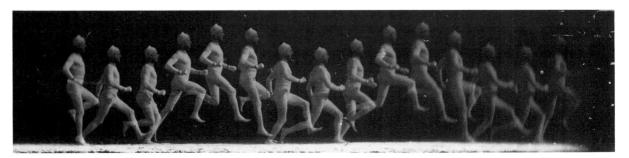

B

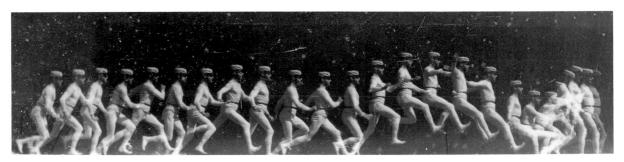

C

42.
(A) Gymnast jumping over a chair,
1883. (B) Demeny, gallop, 1883.
(C) Joinville soldier running and
jumping, 1883. Collège de France.

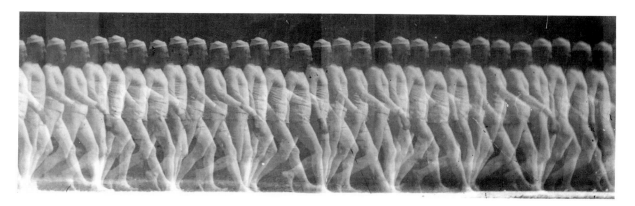

43.
Demeny walking, 1883. Collège de
France.

and levers, small movements could be extended over the cylinder and large movements could be reduced. With photography, however, the prospect was more daunting: Marey could not shrink the men and animals, nor could he make them speed up their actions to suit the camera; and if the camera shutter was slowed down to make fewer images, the number of phases it captured would be impoverished and the intermediate phases lost, which would defeat the whole purpose of the method.

What, then, to do? In the past, when Marey could not change an instrument any further to suit his subject, he would adapt the subject to suit the instrument; the present case was no exception, but his solution had an original twist. He operated on the inherently representative quality of photography. To make the camera "see" what was invisible, he suppressed the field of visibility—what the camera could see. The result was nothing less than ingenious: a method of photographing movement in its own right, detached from the performer.

Working with Demeny as his subject, Marey made half his body disappear by covering it in black cloth (fig. 44). Then, since his real goal was to remove the imprint of flesh and skin so as to reveal the moving parts of the animate machine—the joints, levers, and fulcrums, the rods and pistons of the human body—he concocted a moving skeleton, denuding the body of its flesh and volume. He clothed his subjects all in black, marked their joints with shiny buttons, and connected the buttons with metal bands (fig. 45).

With this artifice Marey was finally able to transform his subject into a graphic notation. Because the surface of the subject was greatly diminished—only the dots and lines made impression on the plate—the number of photographs taken could be greatly augmented. "Instead of ten pictures each second, one hundred can be taken. For that, there is no need to change the speed of the rotation of the disk shutter; instead, rather than pierce the shutter with one window, ten are cut and

81

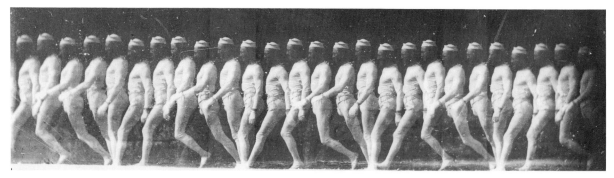

A

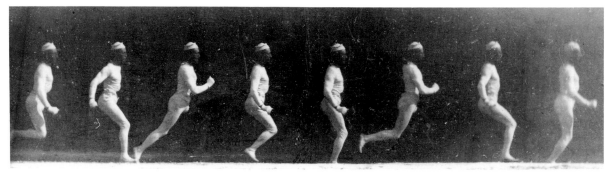

B

44.
(A) Demeny walking, 1883. (B)
Demeny running, 1883. The side of
the body farthest from the camera is
covered in black cloth and thereby
made invisible. Collège de France.

disposed equally around its circumference."[79] If he
made one of the windows in the disk twice the
width of the others, every tenth line imprinted on
the plate would be twice as intense. The brighter
markings, Marey reported, "made the estimation
of time easier and created a reference point from
which to compare the movement of the legs and
arms."[80]

Marey could now make a photographic image
totally without precedent. He had invented an abso-
lutely original, indeed revolutionary, method of
photographing movement by decomposing it and
registering its segments on a single readable plate.
The visual language of angular, overlapping two-
dimensional forms he created with this method is

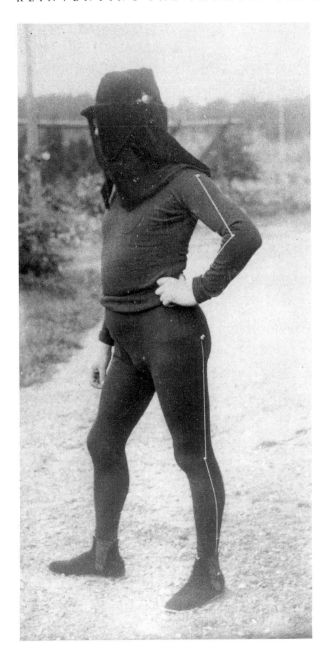

45.
Demeny dressed in black in preparation for geometric chronophotography, costume of 1884. Album A, plate 12, Beaune.

today still synonymous with speed and dynamism (fig. 46).

It might seem ironic that Marey honed the camera into a scientific instrument of precision, the equal of his graphic inscriptors, by suppressing the quality that is believed to be most truly photographic—the camera's ability to picture objects with a mirrorlike profusion of detail. This irony would have been lost on Marey, however; for him the power of any instrument lay in its potential to evolve. Marey, indeed, immediately remarked on a facet of his solution that was unsatisfactory:

In this method of photographic analysis the two elements of movement, time and space, cannot both be estimated in a perfect manner. Knowledge of the positions the body occupies in space presumes that complete and distinct images are possessed; yet to have such images, a relatively long temporal interval must be had between two successive photographs. But if it is the notion of time one desires to bring to perfection, the only way of doing so is to greatly augment the frequency of images, and this forces each of them to be reduced to lines.[81]

Marey's ambition to reconcile the opposing demands of time and space in his photography now became the primary incentive for all subsequent innovations. A deeper and blacker hangar (1886), faster cameras (1887 and 1890), and the substitution of moving film for the glass plates (1888)—each new improvement was dictated by the realization of his goal.

In 1883, his immediate solution to the problem was to choose—when making the geometric chronophotographs—the lines and points that gave the most information about the successive attitudes of the body. But he also experimented with other systems that were variations on his basic principle of displacing the onward movements of a subject onto a successive part of a single plate in a single camera.

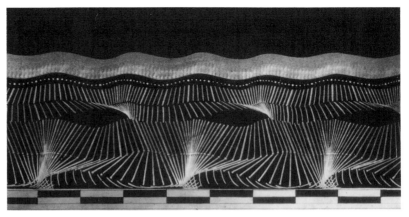

A

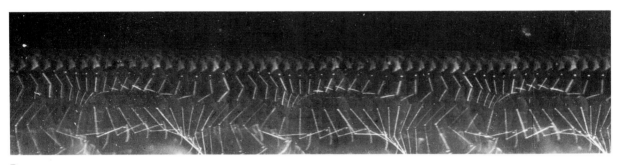

B

46.
(A) Joinville soldier walking, 1883. The
metric measurements at the bottom
of the images have been emphasized
in the negative. (B) Joinville soldier
running, 1883. (C) Joinville soldier
running, 1883. Negative (reversal)
print. Note that in these earliest
examples, the head is not covered,
and the joints are connected with nail-
studded lengths of wood. Collège de
France.

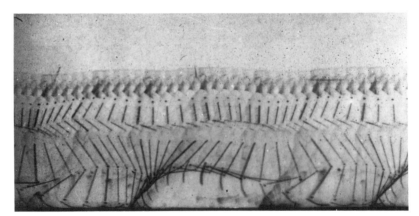

C

84

First, and perhaps most obviously, he tried producing separate instantaneous pictures (whose effect was similar to those Muybridge had made) by moving the plate horizontally behind the lens. In the examples that survive from this experiment (which are all of athletes and gymnasts, suggesting Demeny's hand in the project), the distance between one phase and another is so great that the individual images are of distinct poses, not phases of a single movement (fig. 47). Marey left no record of how he moved the plate, and the experiment was abandoned until 1887.

He also tried a multiple-lens camera, in which the lenses were uncovered one at a time, sequentially exposing the single plate behind them. Muybridge had sent Marey sketches of such an instrument on 17 July 1882,[82] but Marey was already familiar with the multiple-lens camera used by his friend Albert Londe (1858–1917). Londe, one of the nineteenth century's greatest authorities on photographic processes and technology, was a medical photographer who worked in the photographic laboratory of the Salpêtrière Hospital.[83]

The photographic laboratory (Londe was made its director in 1884) was attached to the clinic for nervous diseases, created two years earlier by Jean-Martin Charcot (1825–93), the most famous French neurologist of the century, and the teacher (from 13 October 1885 to 28 February 1886) of the young Viennese psychiatrist Sigmund Freud. At the Salpêtrière Londe worked closely with Charcot's pupil Paul Richer, another colleague of Marey's, who later became professor of anatomy at the Ecole des Beaux Arts.[84]

Londe's job at the hospital was to construct a systematic photographic iconography of nervous diseases, and for this task he had developed a method of sequential photography that combined features of both Muybridge's multilens system and Marey's photographic gun. He required a single

camera, but one in which he could vary the speed between the successive images of any series: the unpredictability of attacks in nervous diseases and the irregularity of their duration made such control necessary. In 1881 he had produced a variable-speed circular-disk shutter in collaboration with the watchmaker Charles Dessoudeix, which he constantly revised and used in all his successive cameras.[85] Working with Marey, in 1883 Londe developed a new camera that had nine lenses; these were arranged in a circle and were uncovered consecutively by a rotating slotted-disk shutter operated by a clockwork mechanism (fig. 48).

For Charcot, Londe took instantaneous and chronophotographic images of pathological movements associated with mental illness for the journal *La Nouvelle Iconographie de la Salpêtrière*, a vast compendium of images of madness.[86] With Richer he made stereo photographs documenting the progressive faradization of facial muscles—images of electrically stimulated muscle contractions. Toward the end of the century Londe and Richer worked together again, this time using Londe's second camera (constructed in 1891), which had twelve lenses in banks of four (fig. 49).[87] They made chronophotographs for Richer's celebrated treatises for artists, *Physiologie artistique de l'homme en mouvement* and *Atlas d'anatomie artistique* (fig. 50). These volumes, both published in 1895, were critical in bringing Marey and chronophotography to the attention of a new generation of artists. Londe and Marey often photographed together, experimenting with different cameras on the same subjects, and Londe became a skillful operator of Marey's chronophotographic cameras (fig. 51).

Only one image—that of Marey throwing a stone—remains from Marey's own version of Londe's camera, constructed in winter 1883 (fig. 52). According to Marey's description in *Développement de la méthode graphique par l'emploi de*

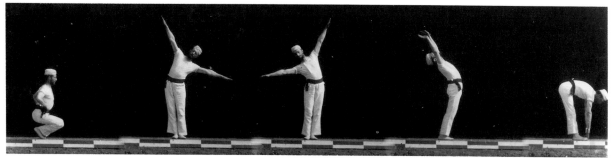

A

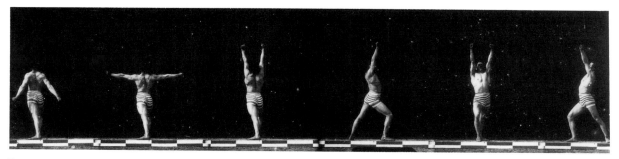

B

47.
(A) Stretching exercises, subject
Demeny, 1883. Collège de France.
(B) Stretching exercises, 1883.
(C) Gymnast on parallel bars, 1883.
Cinémathèque Française.

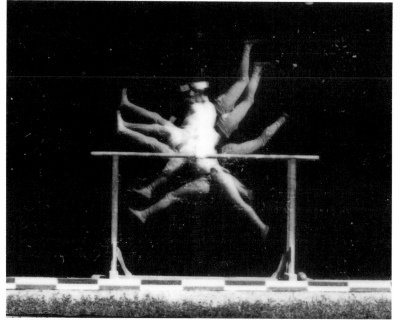

C

48.
Marey, Demeny, and friends in Marey's
mobile camera taken by Albert Londe with his
nine-lens camera, 1887. Société Française de
Photographie.

49.
(A) Albert Londe's twelve-lens camera, 1893. *La Nature,* November 1893. (B) Movements of a tightrope walker taken by Londe with his twelve-lens camera, 1893. Société Française de Photographie.

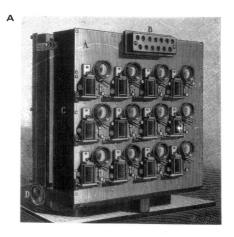

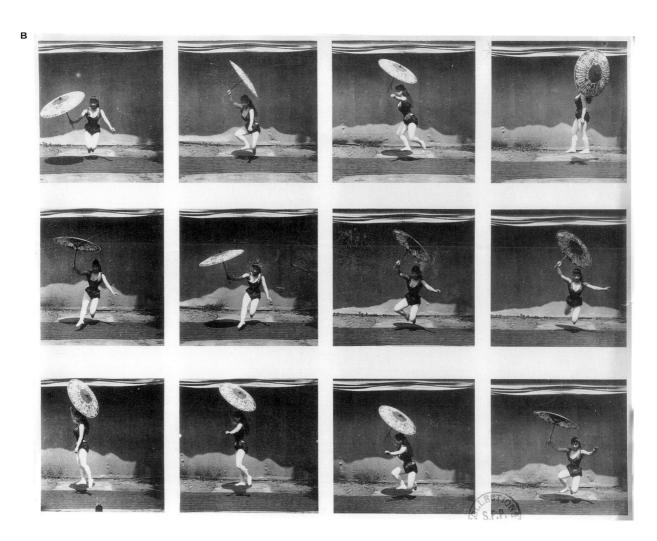

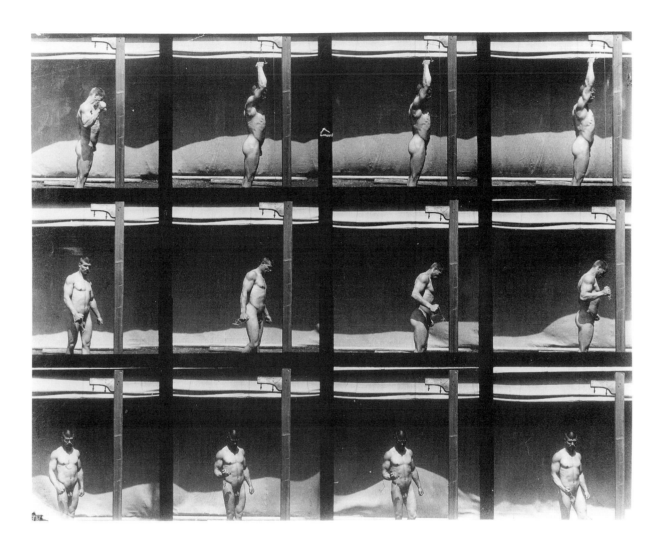

50.
Pulling on a cord (the cord breaks):
figure study by Londe for his
*Physiologie artistique de l'homme en
mouvement,* 1895. Société Française
de Photographie.

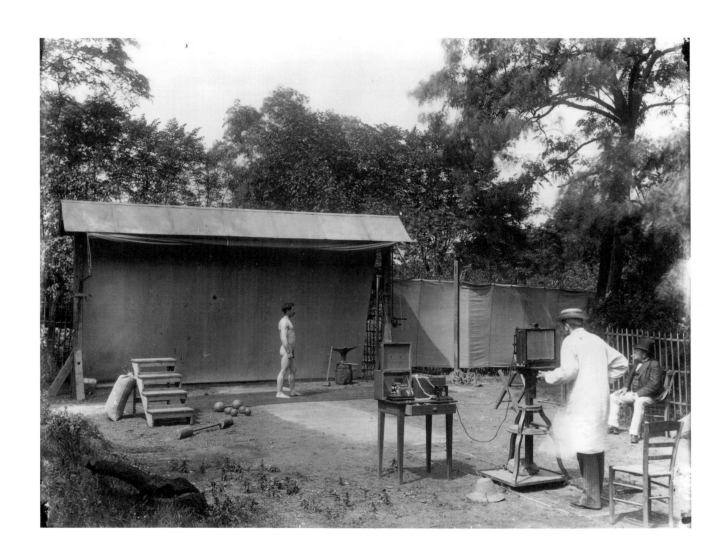

51.
Londe operating his twelve-lens
camera, Marey seated on his right,
1894. Société Française de
Photographie.

52.
Marey throwing a stone, taken with
his six-lens camera, Naples, 1883.
Album A, plate 31, Beaune.

la photographie, in which he assessed the contribution of photography to the graphic method, his version made six images around the circumference of a plate in one-tenth of a second with an exposure time of one-thousandth of a second. With this camera, the biggest difficulty was making sure the light entered each of the lenses only once. As insurance, he needed a second shutter that opened for the duration of the disk rotation and then immediately closed. The way this second shutter operated and its speed caused a "violent shock" that, he wrote, "certainly will compromise the life of the instrument."[88] And the images made by this camera, like those made by the gun, had to be cut out and placed along a horizontal axis if the kind of measurements he required were to be made easily.

Only one image remains from another type of camera Marey tried, one based on the photographic gun. It comprised a single lens, a rotating-disk shutter, and a circular plate that turned uniformly. The camera's construction was suggested by Janssen, and the single photograph, dated 1 January 1884, is a portrait of Janssen himself, his head wrapped in a turban, smoking a cigarette (fig. 53).[89] Even with the very short exposure time given by the rotating disk, the images lacked clarity; Marey remarked that with this procedure only pictures taken at long intervals would be successful.

Geometric chronophotography, however, soon proved to be a considerable advance over any of these methods. It not only could accurately describe the series of motions the human body produces as it

53.
(A) Rotating-disk camera, 1883–84.
(B) Portrait of the astronomer Jules
Janssen, 1 January 1884. Album A,
plates 28 and 30, Beaune.

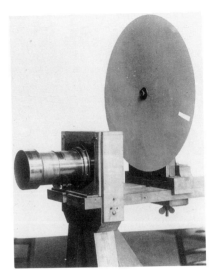

A

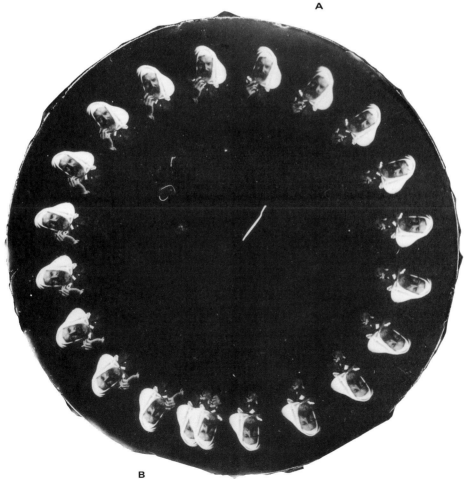

B

moves but could also be used to determine the energy expended at each instant of those acts. From the chronophotographs, Marey could measure exactly the speed of the movement of the different parts of the body; by multiplying the mass of the body and the speed, he could measure, "with a satisfying precision, the energy expended in the different acts of locomotion." "These studies will have to be undertaken for a long time," he wrote, "varying the conditions and operating on a grand number of subjects, but the method has been found." His aim was to compare different gaits and speeds so that, "just as machines are regulated to obtain a useful effect with the least expenditure of energy, men can regulate their movements to produce the desired effects with the least expenditure of energy, and consequently the least fatigue possible."[90]

In 1883 Marey initiated his analysis of human dynamics with ways that we jump because, as he put it, jumping was a movement comparable to those movements studied in ballistics and subject to the same laws; therefore it was easier to analyze than walking or running. With his subjects' limbs, joints, and heads marked with silvered strips and buttons, Marey employed his camera to trace the trajectory of the center of gravity in different kinds of jumps and to show exactly what happens in each part of the body when the shock of the landing is mitigated by the bending knees or, alternatively, when the knees remain stiff and all the force of the jump is carried through to the heels (fig. 54).

In these early experiments Marey dynamographed his subjects as he chronophotographed them. The men were fitted with a pair of shoes whose heels (rather than toes) contained a small air capsule and spring that transmitted the pressure of their feet on the floor to a receiving tambour (fig. 55). He also had Demeny build a dynamographic platform, a large box containing nine or more

india-rubber coils connected to a recording tambour. To record the changes in the elevation of the body during the jump and their relation to the changes in foot pressure, the subject on the platform was connected to yet another dynamometric recorder by means of an elastic thread attached to a tight-fitting cap on his head (fig. 56).[91] The data Demeny and Marey compiled from these studies corroborated the importance Marey had assigned earlier to the movement of the body's center of gravity: they showed that all muscular actions that raise the center of gravity augment the pressure on the ground, and all actions that lower the center of gravity diminish the pressure; bending the knees, in other words, lessens fatigue.

Marey quickly put Demeny in charge of these studies when, in summer 1884, cholera broke out in France. The epidemic—one of many that had decimated the population of Europe throughout the century—temporarily halted Marey's photographic trials and gave him the occasion to apply his methods to the new field of epidemiology. He abandoned his tracing of human and animal movements in order to trace the more sinister flux of the invisible malady. Marey, like Pasteur (but contrary to prevailing medical opinion at the time), believed in the germ theory of disease and saw the epidemic as a chance to gather information that would give the theory further support. At the Académie de Médecine he and Pasteur headed a committee to investigate the causes of the outbreak and find ways of preventing it. Marey and Pasteur were aware that in England the relation between contagion and specific sources of water had been noted, and this is what they set out to study.[92]

Marey's way of approaching the problem was twofold. He suggested a statistical analysis based on information supplied by the doctors in the towns and hamlets where the epidemic was most lethal. He drew up a questionnaire for the doctors that

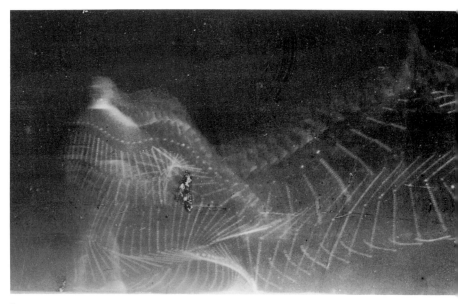

A

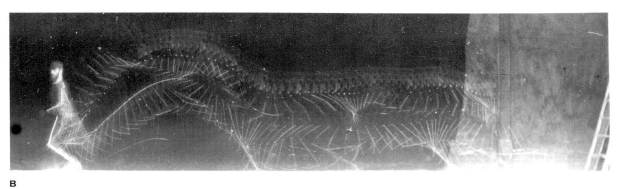

B

54.
(A, B) High jump preceded by a run,
1883. (C) Long jump. (D) High jump,
Demeny standing on left, 1883.
Collège de France.

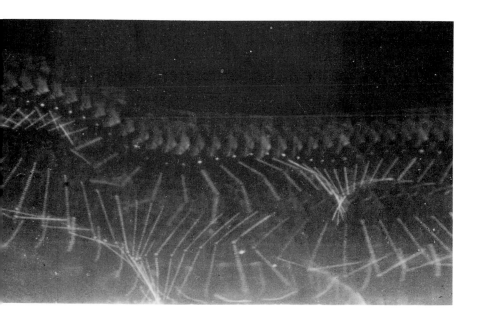

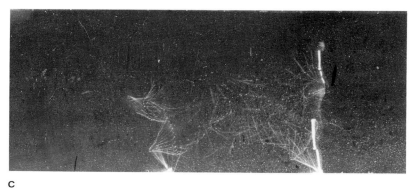

C

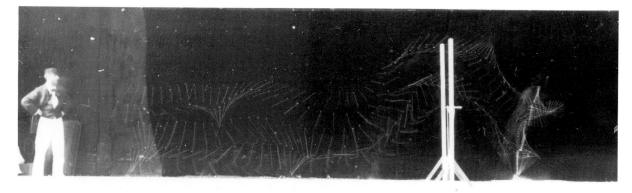

D

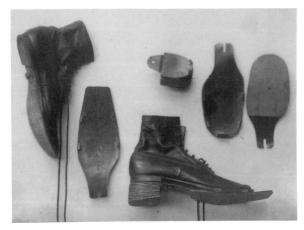

A

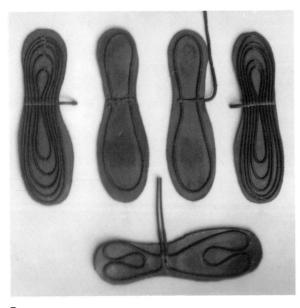

B

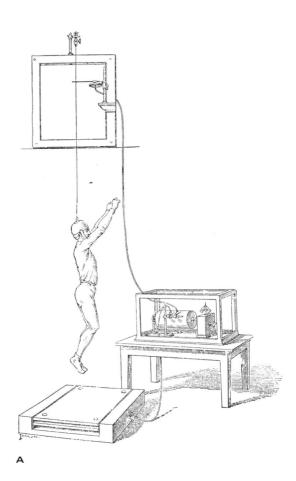

A

55.
Odographic-dynamographic shoes,
1883—84: (A) Air capsule and spring in
the heel. (B) soles with rubber tubing.
Collège de France.

56.
(A) Subject in dynamometric study of
the elevation of the head and its
relation to the pressure of the feet in
a jump, 1883—84. (A) Dynamometric
platform and inscribing cylinder in the
main chalet of the Physiological Sta-
tion, 1883. Collège de France.

B

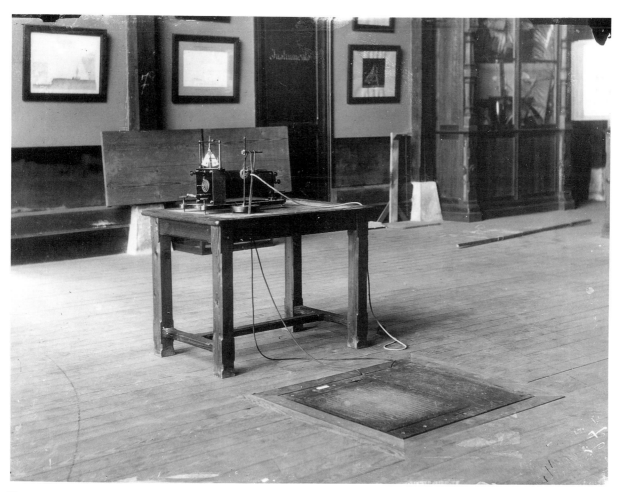

57.
Analysis of the jump, 1884: (A) Jump in place with bent knees. (B) Jump from a height with knees straight. Collège de France. (C) Diagram made from photograph at left. *Movement.* (D) Jump from a height with knees bent to cushion the shock. Collège de France. (E) Diagram made from photograph at left. *Movement.*

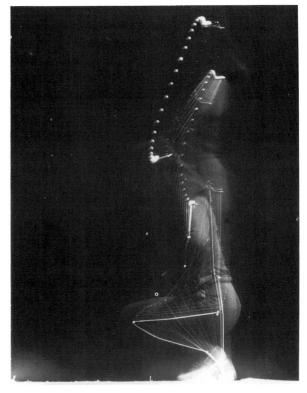

A

asked specifically about the disposition of water sources in the town, how fecal matter was disposed of, the effects of weather changes, hygienic conditions, and the length of incubation of the disease in each of the patients the doctors had attended. Marey's idea was supported by Pasteur, but they had great difficulty in persuading other members of the Academy of the sense of this method. Nevertheless the questionnaire was distributed throughout France, and when the results were compiled two important facts emerged: that the disease was propagated by human excrement, and that its spread could be traced with little doubt to a contaminated water supply. The latter observation was verified by the second action Marey took: he personally mapped out the flow of different water sources through the city, comparing his tracing of their movements with the incidence of mortality. He began in Paris, but when he could not get hold of relevant statistics, he removed his study to his natal town of Beaune, where he was totally familiar with the topography, the course of the river that ran through it, and the villages that surrounded it. It was a painstaking task, comparing lists of the dead, plans of the towns, and the position of each stream, canal, fountain, and sewer, but one that Marey reveled in. And the conclusions of his analyses were unavoidable: for the first time the relationship of infected water and cholera was made visible, and action could be taken against a disease that had systematically and mysteriously killed since the beginning of time.

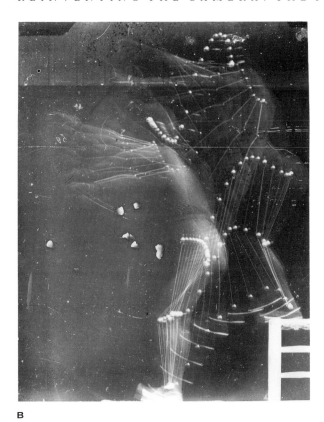

B

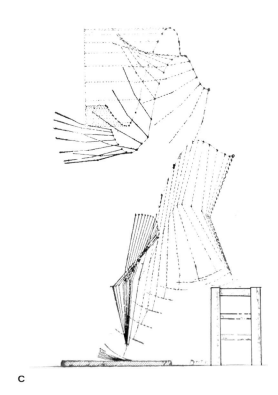

C

After Marey had compiled his lengthy report for the Académie de Médecine, he got back to chronophotography and to the ongoing developments at the Station. His studies of jumpers had turned out beautifully (fig. 57); now he wanted to tackle the muscular forces involved in walking and running.[93]

Working closely with Demeny, whose mathematical skills now became fundamental to this research, Marey set out to estimate the muscular work expended in walking or running along level ground at different speeds. The key was in knowing the movements transmitted in all directions through the body and limbs each time the foot is lifted from the ground—for example, the distance the head lifts or the lower leg swings. Once these distances could be measured—an easy matter when he enlarged the geometric chronophotographs to life size—multiplying the distance by the mass of the moving subject would give him a good estimate of how much force was exerted for each step the man took. (To help in making these measurements Marey again made one of the windows in his disk shutter double the width of the others so that he had a more intense image to use as a reference point) (fig. 58).

In revealing the complicated reality of our basic locomotive functions, Marey and Demeny also arrived at a scientific explanation for some of the instinctive ways we conserve energy. For example, our tendency to break into a run rather than continue walking at too rapid a pace was explained by the fact that after a certain pace—about seventy

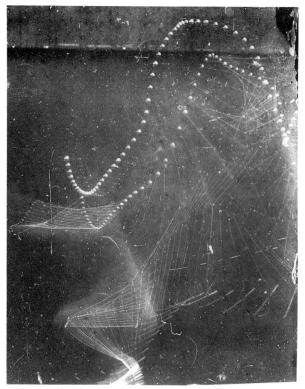

D

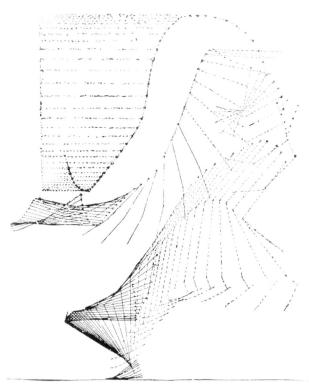

E

steps per minute—it actually takes more muscular force to walk than to run: our natural instinct is to expend the least muscular effort. Indeed, once the data were in, they could prove that for each pace there was an optimum rate of steps per minute—where the speed increases proportionately fastest as energy is expended.

By necessity, the chronophotographic camera could make images of the subject from only one side. But "for a complete study of locomotion," Marey wrote, "the subject must be photographed not only from the side, but also from the front and rear in order to show the lateral oscillations of the different parts of the body."[94] To make an image of the three-dimensional movements of the torso shifting in space as it reacts to the movement of the

limbs, Marey briefly switched from his chrono-photographic camera to a stereoscopic camera, with twin lenses separated by a distance equal to that between the eyes. He placed a metal button reflecting the bright sun on the coccyx[95] of a man clothed all in black, and the camera captured the curves the metal button made as the now invisible man walked away from them; the resulting pictures were looked at through a stereoscopic viewer that reconstituted binocular vision, making the disembodied, undulating lines fixed by the stereo cameras seem like an exotic calligraphy, all the more re-markable in three dimensions. The slotted-disk shutter was eliminated in the operation, since the notion of space, not time, was the important one; this left just the twisting arabesques of the invisible

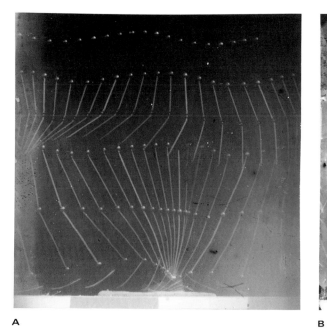

A

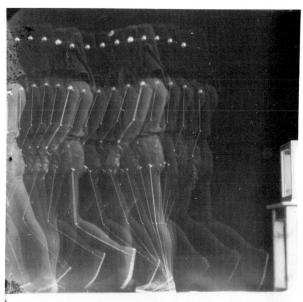

B

58.
(A) Walk with stiffened knees, 1884.
(B) Walk with bent knees, dynamometer on right, 1884. Collège de France.

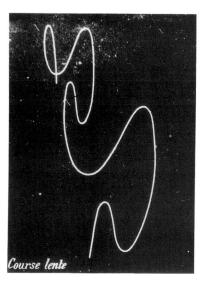

Course lente

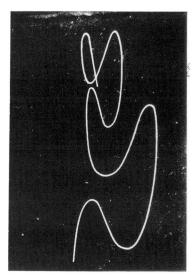

59.
Slow run, stereoscopic photographs of a point on the coccyx of a moving subject, 1885. Cinémathèque Française.

body as white lines on a black ground (fig. 59). Marey made wire models of the trajectories. Both the models and the photographs made quite an impact, no doubt because they offered the first examples of how to isolate one segment of the body in movement from the intricate and almost invisible combinations it was a part of; they showed exactly how one part reacted to the movement of another. The ability of Marey's lens (or lenses in this case) to separate out each of the moving parts of the human machine and bring them under the scrutiny of the trained eye marked an important step in both science and medicine; for one thing, it meant that the precise site of certain locomotive pathologies would now be pinpointed and described more easily than ever before. In 1885 one of Marey's colleagues, J.-L. Soret, who had been working with less success along the same lines, had suggested replacing the metal button with a light source, such as a small electric lamp or a Geissler tube, so as not to be so dependent on the sun.[96] Marey liked the idea and began to work with Otto Lund and Demeny on different light sources and on ways of hooking the subjects up to them. As we know from a letter to Demeny, he even thought about applying such an electrified method to flight; he imagined that he could attach incandescent bulbs to the wings of an old tame crow that he was working with, leaving it to fly freely instead of being confined to the black hangar. It only remained to be seen, he wrote to Demeny, "if the crow would cooperate and would want to fly at night."[97]

Marey started his own survey of pathological locomotion in 1886 by making geometric chronophotographs of crippled and motion-impaired patients from Parisian hospitals.[98] But by the following year he had succeeded in implementing Soret's idea: he attached tiny electric bulbs connected to a generator to the patients' joints and then followed their light with his camera as each

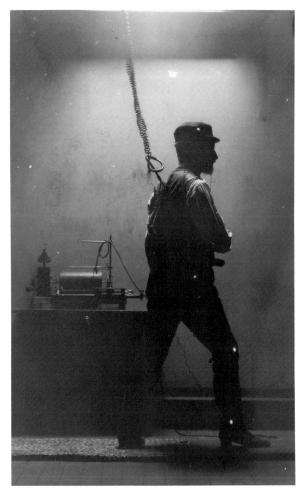

A

lamp unmistakably revealed the otherwise invisible consequences of accidents, war, old age, and disease. These experiments, continued over the next two years by the surgeon Edouard Quénu and Demeny, produced a full description of each condition and of how other parts of the body had adjusted in order to accommodate its impact (fig. 60).[99] They had widespread consequences affecting courses of physiotherapy and also the making of prosthetic devices, but one of the most interesting applications of the technique was to appear in

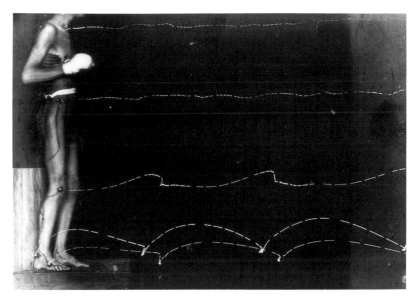

B

60.
Pathological locomotion:
(A) Demeny in electrical harness,
1888. (B) Locomotor ataxia, 1887.
(C) Club foot, Beaujon hospital,
1888. Collège de France.

C

America about ten years after Marey's death when the industrial engineer Frank Bunker Gilbreth filmed the trajectory of an electric bulb he had attached to a worker's moving wrist or finger. Gilbreth's application, however, was stimulated by an altogether different context than the one Marey had worked in. Marey was accurately charting for the first time the basic movements the human body could make, whereas Gilbreth intended his analysis of motion to be the key factor in improving the mechanical efficiency of a basic industrial element—the human being.

In summer 1886 a new black hangar had been constructed at the Station opposite the part of the circular track occupied by its predecessor (which was painted white and used as a background for making instantaneous photographs and, from 1888, films) (fig. 61). The new hangar was ten meters deep and ten meters wide and was outfitted with movable valences to reduce its height to what was strictly necessary for making chronophotographs. Its increased darkness allowed Marey to reduce his exposure times to 1/2,000 of a second, a reduction that dramatically increased the clarity of his images. Over the hangar Marey erected a pylon whose interior supports are clearly visible in the images made from 1886 onward; the pylon was surmounted by a platform intended for a camera to take pictures from overhead. During the next two years Marey continued to improve the hangar. He hung curtains on each side to diminish the working area and suspended a wooden bar from the ceiling that marked the number of images made per second; he covered the interior of the hangar and the track directly in front of it with wooden cobblestones to keep down the dust; and he stretched white threads from floor to ceiling every two meters to measure the space his subjects traversed.

The improvements effected by the new hangar can be seen in the 1886 studies of Franck, Morin, Pradelle, Schenkel, and Viala, top members of the Parisian gymnastic societies and some of the best military cadets from the Ecole de Joinville, whose names we know from the notations Marey and Demeny made on the chronophotographic negatives (fig. 62). The cadets had been sent to the Station under the auspices of the Ministry of War, where the potential applications of Marey's analyses of normal locomotion had generated a great deal of interest. Marey's findings, it was now clear, could provide an objective, scientific foundation for the reform of the army. With his cameras and graphing instruments, he had assessed the muscular energy expended in different ways of walking and running and had shown that certain cadences and paces lessened fatigue. These methods could be used to determine the pace at which the soldier could march over the greatest distance with the least fatigue or, conversely, the pace that would cover a certain distance in the shortest time. Marey's data also provided a rational foundation for choosing one kind of drill or exercise over another and for developing the endurance of the individual soldier. The army, in fact, soon decided that it would be in its interest to send Marey more Joinville athletes to study and even to fund further work. By 1888 it pressed him to expand the work to a larger number of more "average" men, who would be more representative of the new soldier, and to study the influence of such additional factors as their height and weight, the uniforms they wore, the weight they carried on their bodies, the nature of the ground they traveled over, and the number of rest periods they took. Demeny, whose interest in developing the "vigor" of the human body was so close to the army's interest in developing the endurance of the individual soldier, soon found himself acting as the liaison between the Station and the Ministry of War for this new set of experiments, which continued until the early 1890s.

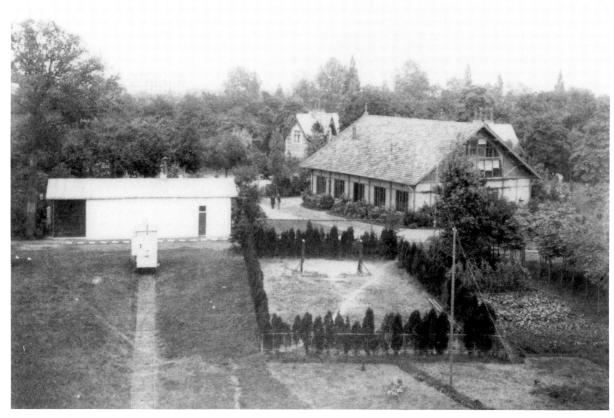

A

61.
(A) The second hangar, painted white,
1886. Album A, plate 4, Beaune.
(B) The third black hangar, 1886.
Album H, plate 4, Beaune.

B

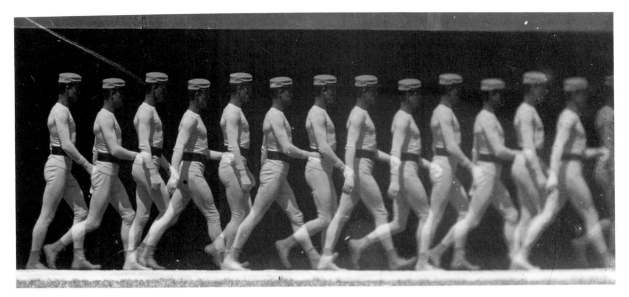

A

62.
Chronophotographs made with
"improvements to the photographic
processes," July 1886: (A) Schenkel,
walk. (B) Morin, walk. (C) Morin, run
up incline. (D) Schenkel, high jump.
(E) Schenkel, high jump. Collège de
France. (F) Schenkel, long jump.
Cinémathèque Française.

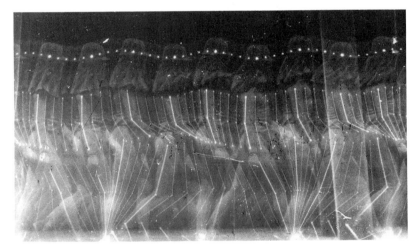

B

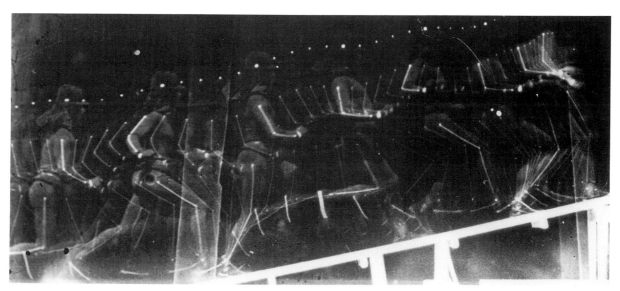

C

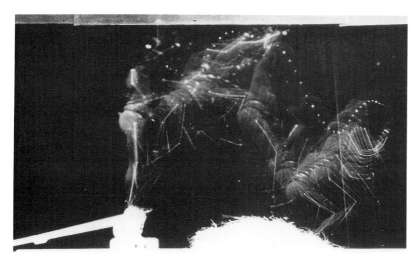

D

107

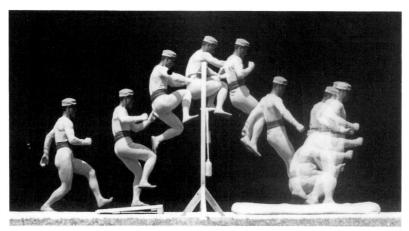

E

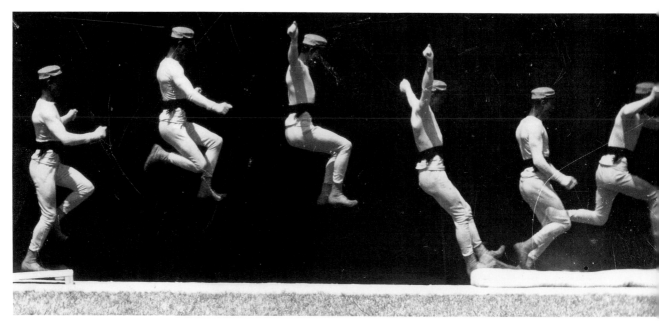

F

108

Out in the field, the ordinary recruits were subjected to odographic and dynamographic measurements at the same time as they were being chronophotographed, so that muscular force and the fatigue effect of all variations of the walk, march, run, and jump were charted (fig. 63). At the Station, the Joinville athletes were chronophotographed in every kind of exercise including fencing, boxing, and pole vaulting (fig. 64). These pictures, "which express better than language the way in which the movement is executed and allow the different phases to be followed with ease," were used to teach: "Guided by photographs of this sort, it is easy to imitate . . . the person who serves as a model. It would be much more difficult to imitate these movements by merely watching the instructor, because, especially in rapid movements, the motions are so transitory as to escape observation. If an attempt is made to teach them by executing them slowly, their whole character is completely changed." [100]

The complete reform of army training methods and the rewriting of both army and civil gymnastics manuals were among the fruits of this research. They put Marey and Demeny in the vanguard of physical education and France in the vanguard of military and athletic training; they ultimately changed the way we think of our bodies, from the hidden locus of unknown forces to the site of scientific explanation and thus, finally, to control.

Even while he was engaged in his exhaustive study of human locomotion, Marey still experimented on other subjects at the same time and with the same intensity. The large open space of the Station made an ideal background for the study of horses, and Marey had used part of the summer of 1885 to return to photographing these animals—for him, "the most interesting of the quadrupeds." With a white mare as his first subject, he took in-

stantaneous photographs that he hoped would demonstrate the most characteristic attitudes of its trot and gallop. Otto had built him a camera that took single images at one-thousandth of a second. Thanks to these brief exposures, he wrote, and to the extreme sensitivity of the new photographic plates he was able to buy, "the figures have a vigor and clarity that has never been obtained before (fig. 65). [101] Once more, however, he had to sacrifice this detail when he wanted to make a sequential series of the horse's paces: the chronophotographs he made presented him with the same difficulties he had encountered chronophotographing human movements (fig. 66). The length of the mare's body and the superimposing of its four legs on the glass plates created even more confusion than working with the two legs of the human subjects. Marey rejected the idea of draping black cloth and pinning buttons on the mare, but he found ways of modifying this technique that gave him the same results. He coated three of her legs with lampblack and then photographed the oscillations of the single white limb that remained visible (fig. 67). Changing his subject from a white horse to a dark one, he used lampblack to dim the reflective luster of its coat and photographed the trajectories made by small white pieces of paper, each a different shape, that he glued to its joints (fig. 68). Marey used the same technique on three other dark horses in 1886 to illustrate how the different sizes and shapes of their legs affected the paces of each horse. [102] On the enlarged images he drew lines connecting the joints marked by the white pieces of paper to indicate the position of the skeleton. This was a "troublesome task," he said, "on account of the number of joints and because the images of the hind-quarters were superimposed on those of the fore-quarters." [103] And though the diagrams were "occasionally rather complicated," they did prove that geometric chro-

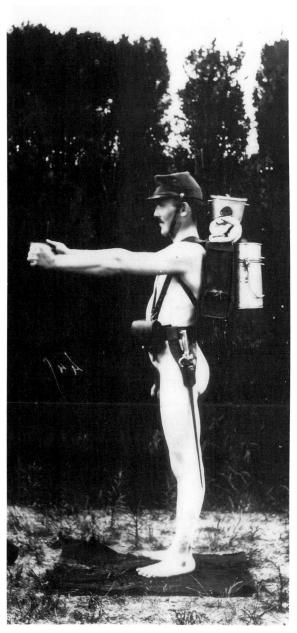

A

B

63.
(A) Soldier in preparation for experiment, 1889. (B) Soldier in preparation for experiment at the Station, 1891. (C, D) Soldiers walking with packs, 1891. Collège de France.

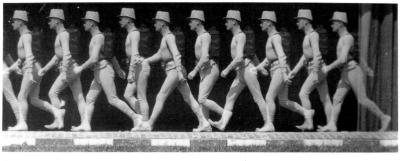

C

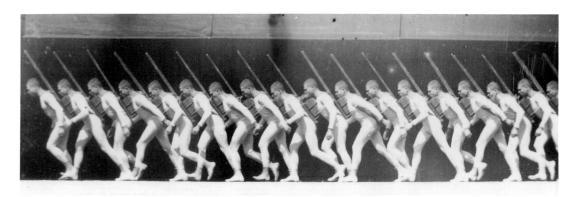

D

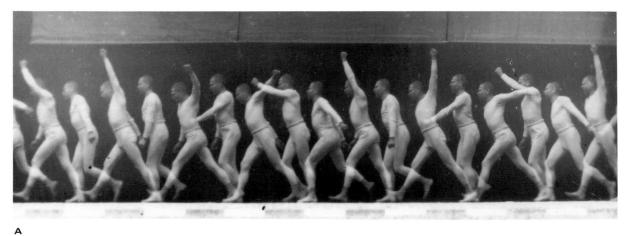

A

64.
(A) Walking and swinging arm.
(B) Sideways run. (C) Sideways jump.
(D) Repeated jumps. (E) Hopping.
(F) Long jump. (G) High jump.
(H, I) Pole vaulting. (J, K) Swinging
on rope. All 1890—91. (A, B, E, F, G,
H, I, J, K) Collège de France.
(C, D) Cinémathèque Française.

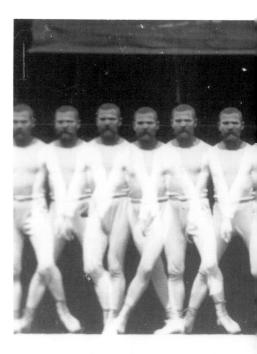

B

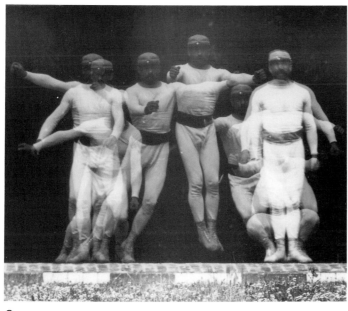

C

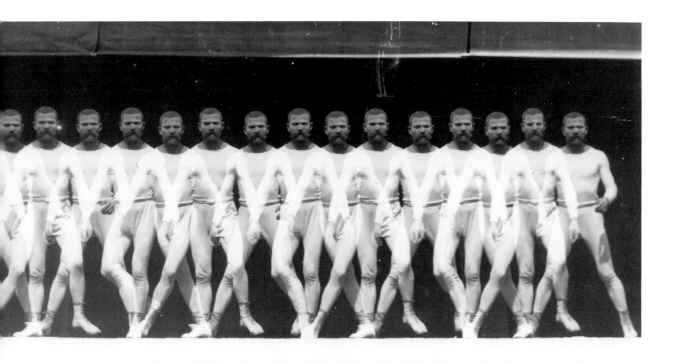

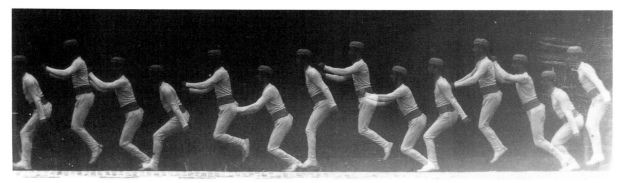

D

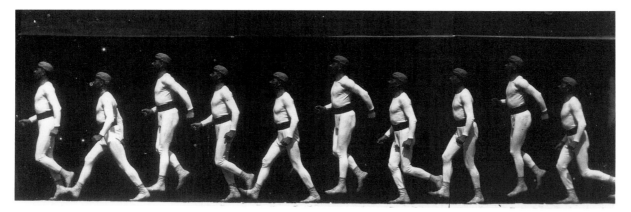

E

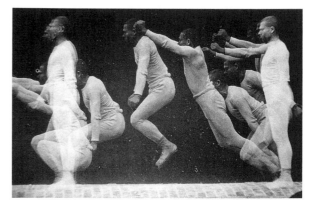

F

114

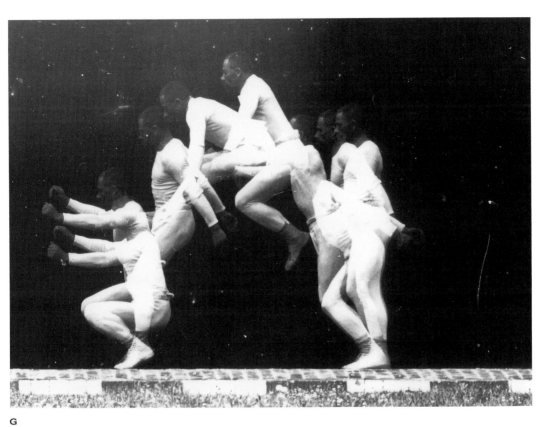

G

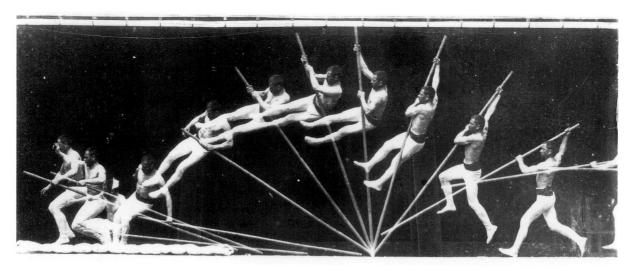

H

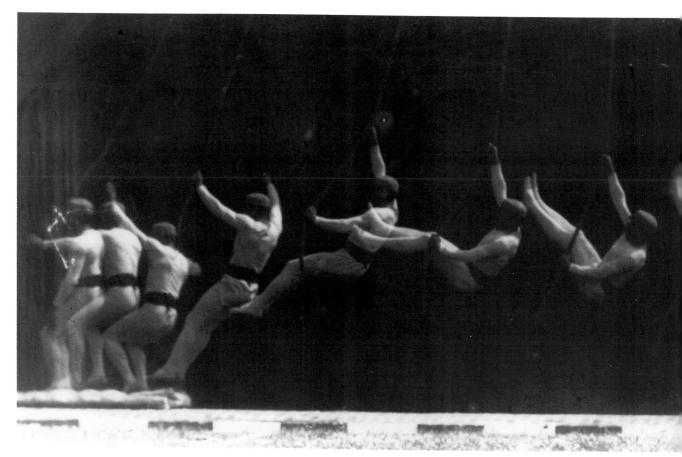

J

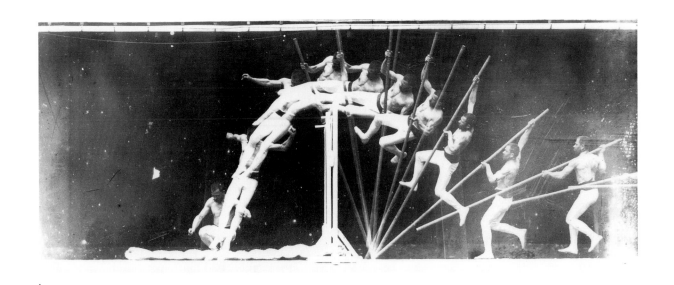

I

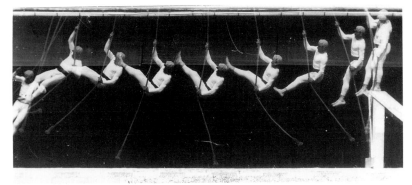

K

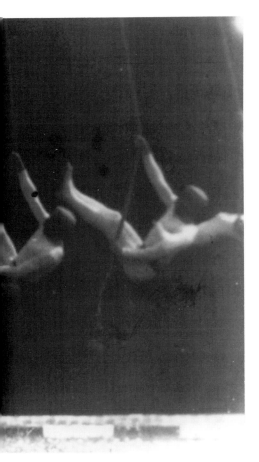

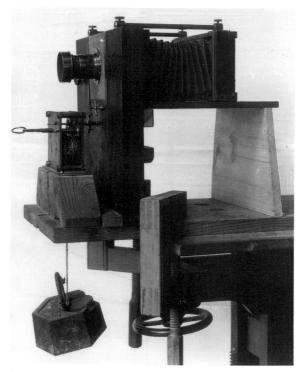

65.
(A) Camera making an instantaneous image at $\frac{1}{1000}$ of a second, 1885. Collège de France. (B, C, D) Instantaneous images of drapery movements, 1885. Cinémathèque Française (E) Instantaneous image of a mounted horse, gallop, third phase, 1885. Collège de France.

A

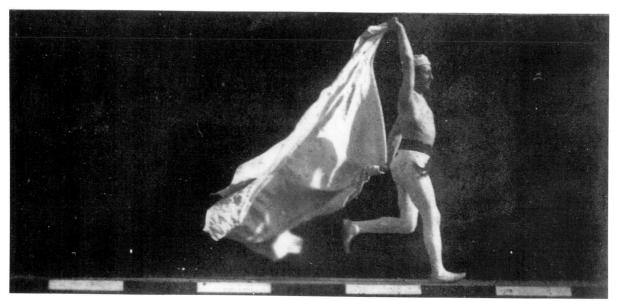

B

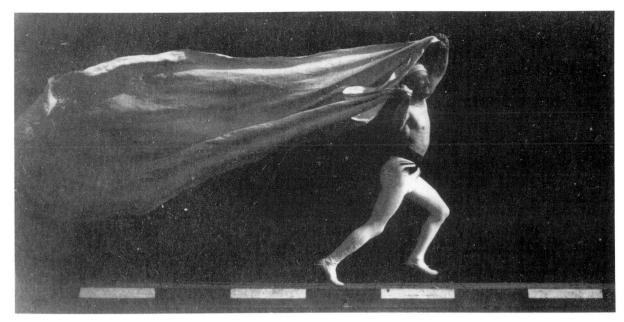

C

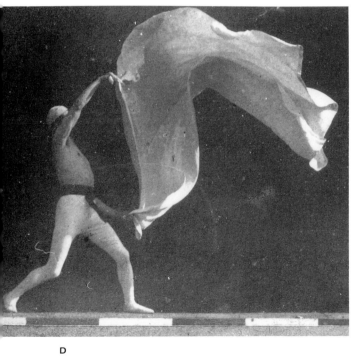

D

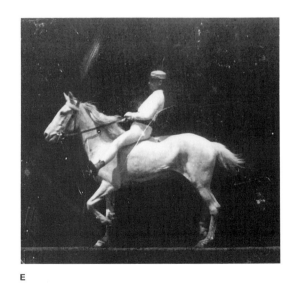

E

119

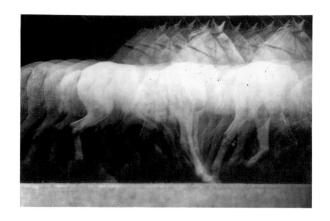

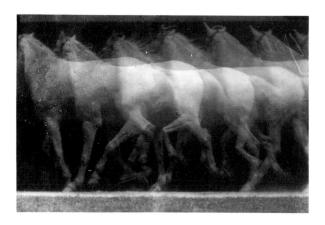

66.
Movements of a white horse,
1885—86. Collège de France.

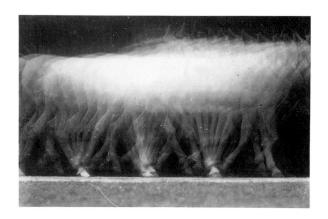

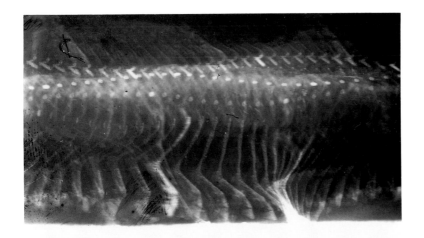

A

67.
(A) Oscillations of the leg in the canter, 1885. Collège de France.
(B) Drawing made from a chrono-photograph of the oscillations of the front leg in the trot, 1885. Album F, plate 71, Bibliothèque Nationale.

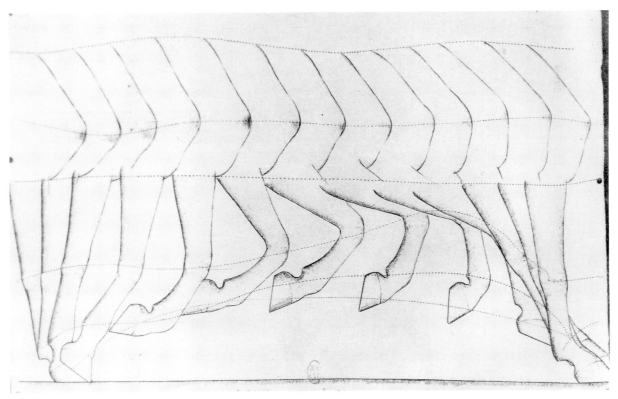

B

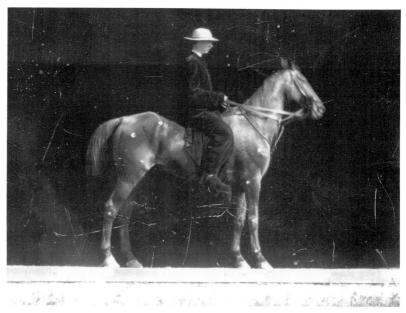

A

68.
(A) Horse and rider marked for chrono-
photography. (B) Same, in motion,
1885. (C, D) Movements of an
unmounted horse; the joints are
marked with white papers, 1886.
Collège de France. (E) C. Pagès,
diagram of the right legs of a horse at
a walking pace, 1886. *Movement*.

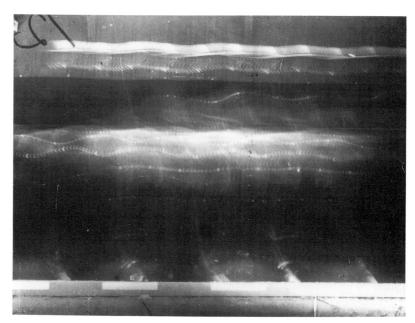

B

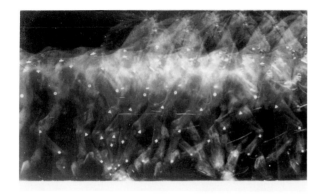

C

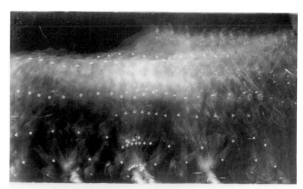

D

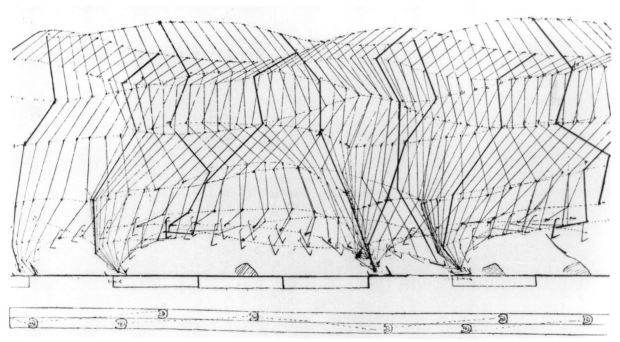

E

nography could be instrumental in explaining the "real significance of the various shapes of the bones and muscles."[104]

In summer 1887 Albert Londe had brought four Arabian horses—complete with their Arab riders in flowing native dress—to be chronophotographed (fig. 69), and then for a while the Station was host to more exotic quadrupeds. Two elephants and a water buffalo arrived from the zoo, borrowed to act as subjects in Marey's comparative anatomy study; their joints too were suitably marked with dots, crosses, and other shapes cut out of white paper before they were made to walk and amble for his camera (fig. 70).[105]

Marey's belief in the identity of the laws that governed animate and inanimate nature and his desire to demonstrate the universality of chronophotography as a method of scientific analysis had prompted him in 1886 to begin to compile a sort of illustrated mechanics: pictures of the motion of balls and of batons as they were dropped from a ladder or thrown across the black hangar. Chronophotography convincingly illustrated how much the differently shaped trajectories these projectiles made depended on the direction of the propelling force and the resistance of the air (fig. 71). In a later study he showed how the method could be used to measure the vertical acceleration of falling bodies (fig. 72). There is a series of photographs of Marey shaking a long, thin rod to show the form its tip describes as the rod moves and another series, begun in 1887, that treats pure geometry: he photographed the solid figures engendered by a thin cord or an arched band of bristol board as it vibrated in space around a central or oblique axis (fig. 73). He used a stereo camera for some of these studies, envisaging this manner of making diagrams in relief as a replacement for the usual cones, cylinders, hyperboloids, and spheres created with string over metal

A

69.
(A) Arab horse and rider: Albert Londe appears on left, 1887. Collège de France. (B) Arab horse, gallop, 1887. Album G, plate 67, Hôtel de Ville, Paris.

armatures that students and teachers alike depended on. He was pleased to note that the figures he created with his camera recalled the experimental origins of the "now purely speculative science of geometry."[106]

It was the absolute blackness of his hangar and the increased sensitivity of his plates that enabled Marey to begin photographing flight again, a subject he had not treated since 1883. Then the chronophotographs had given visible proof of the forward-and-backward, up-and-down motion of the wing, which he had so valiantly traced with his graphing inscriptors; now he hoped for even more spectacular results. Comparing the chronophotographs of 1883 with those he began to take in 1886, Marey wrote that, finally, "the pivoting of the large feathers on their longitudinal axis is perfectly visible and so are the movements which the up-and-down motion of the wing transmits to the bird's body."[107]

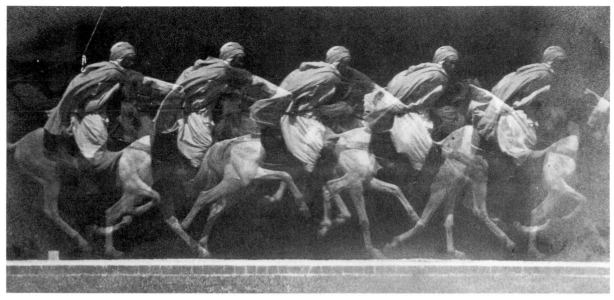

B

Marey could also get pictures that clarified the different wing positions in takeoff and landing and showed how the individual feathers operated during flight. The primary feathers (the large upper feathers at the edge of the wing) cup the air during the lowering stage of their beat, and at the end of the lowering stage the primaries fan out so that the wind can pass through them more easily and thus make elevation of the wing swifter. That the feathers fan out had been deduced from anatomy, but now Marey proved it with his camera (his findings were reconfirmed by high-speed film). Most important to the concerns of would-be aviators, Marey's camera revealed critical aspects of the bird's navigation in the air: it showed how its center of gravity shifted and how the tips of the primaries (together with the tail) were used to regulate its movements (fig. 74).[108]

Marey's results were verified in pictures made by the photographer Ottomar Anschütz (1846–

1907) of Lissa, a Prussian town now in Poland. Anschütz began making single instantaneous pictures in 1882 after the example of Muybridge, and he used the same system of up to twelve cameras side by side. Anschütz's version of the battery of cameras was more accurate than Muybridge's: in 1884 he was able to take instantaneous pictures of pigeons and storks in flight possessing a "sharpness and considerable size, which had not been attained before that time."[109] Judging from the exchange of bills and receipts for each other's equipment and photographs found at the Institut Marey in 1979, Anschütz and Marey seemed to have been in regular contact. Marey would have been particularly interested in the experiments on equine and aerial locomotion that Anschütz had undertaken for the Prussian army beginning in 1885 (fig. 75); his photographs of birds corroborated Marey's own findings about the movement and shape of the wing in flight, but the larger format of Anschütz's photo-

A

70.
(A) Elephant marked for chrono-
photography: Marey on right,
1887. (B) Elephant walking.
(C) Water buffalo walking, 1887.
Collège de France.

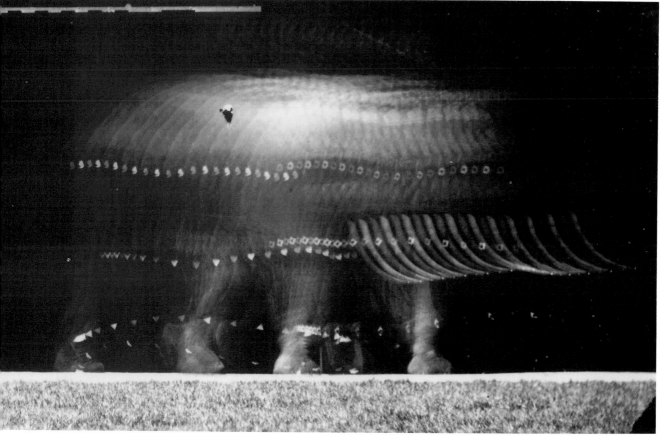

B

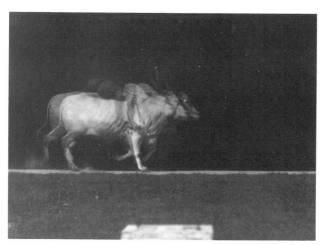

C

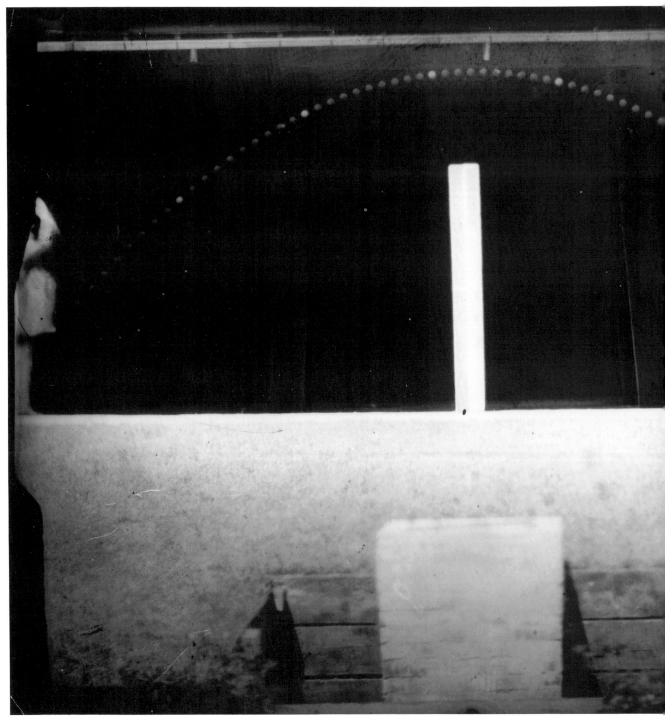

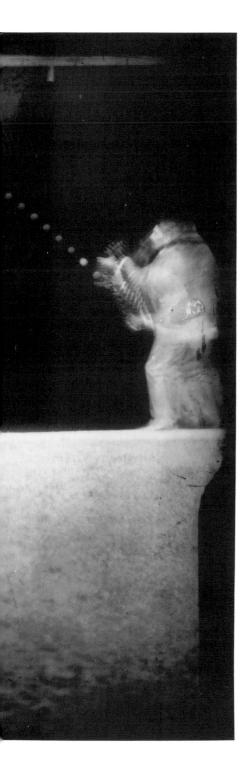

71.
Ballistics: (A) Trajectory of a
ball, 1886. (B) Trajectories of two
balls of unequal diameter, 1888.
(C) Trajectory of a baton, 1888.
Collège de France.

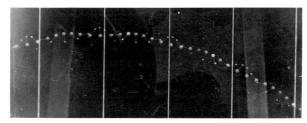

B

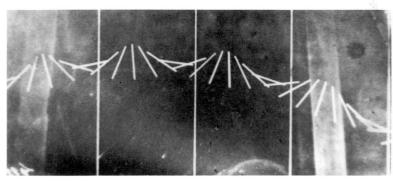

C

A

72.
Ballistics: (A) Marey dropping a
baton, 1887. Collège de France.
(B) Fall of ball, Naples, 1890. Beaune.

B

A

73.
(A) Marey shaking a rod, 1886. Album
A, plate 22, Beaune. (B) Conic figure
engendered by a string, 1887. Album
H, plate 55, Beaune.

B

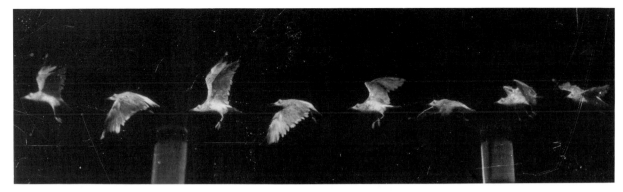

A

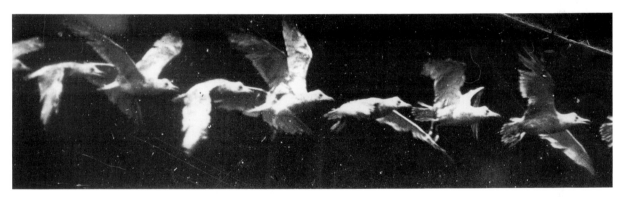

B

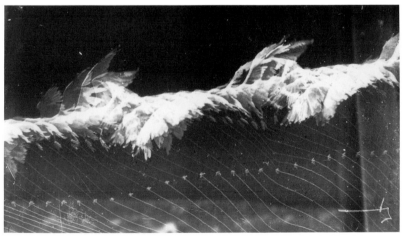

C

74.
(A, B, C) Flight of gull, 1886. (D) Flight of crested heron, 1886. (E) Flight of pelican, 1887. (F) Flight of pigeon taken with a chronophotographic camera that has two alternatively demasked lenses, 1887. (G, H) Flight of duck, 1888. Collège de France.

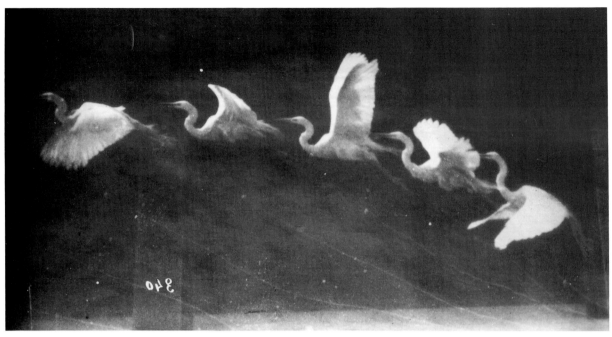

D

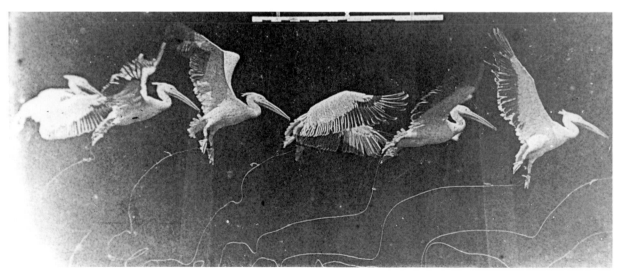

E

134

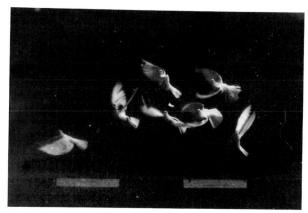

F

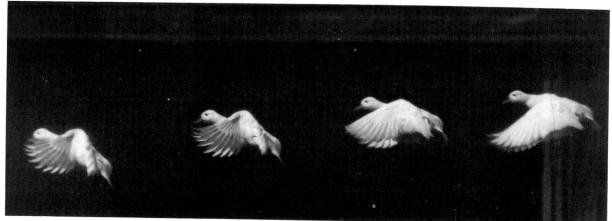

G

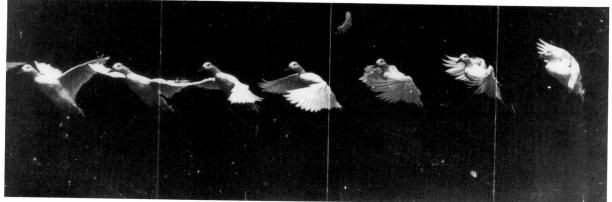

H

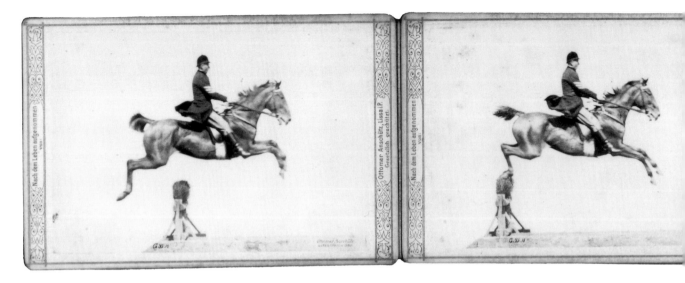

graphs provided details that were beyond even Marey's camera. So as soon as he got back to Paris in 1887, Marey began to intensify his own analysis of flight, a subject that seemed to provide the starting point for every technological innovation he made.

As was typical of his methods, Marey made the transition from describing the movement to measuring the forces that determine it. To assist in his understanding of the mechanism of the wing in relation to the movement of air and the effects of air pressure on the wing, Marey wanted to photograph the wing's movement in three dimensions.[110] In July 1887 he put a new camera on the pylon, and in August he oversaw the completion of a second small hangar erected at right angles to the first.[111] The camera took a thirteen-by-nine-centimeter negative and could be used for making both chronophotographs and instantaneous images (fig. 76). His idea was to make pictures from above the bird, which would then be coordinated with those he made parallel and perpendicular to the axis of its flight (fig. 77). Perhaps Muybridge was the inspira-

tion for using more than one camera at the same time on the same subject. The photographs Muybridge had been taking in Philadelphia since 1885 (they will be discussed in detail in chapter 6) were made with three banks of cameras working simultaneously at three different angles from the subject. Marey would no doubt have been aware of the work, but in his version he hardly ever operated three cameras simultaneously as Muybridge did: it was, Marey claimed, too expensive.[112] And though it remains unclear precisely how he worked in this case, it seems that he usually used only one camera at a time.

The applications of this study were extraordinary: from the data furnished by the different sets of photographs he sculpted plaster models of the gull and the pigeon in flight. Each model, slightly smaller than life size, depicted a single phase of the wing as it moved through one complete revolution. He then mounted the sculptures into a very large zoetrope, to make what he called his "synthesis in relief." As the zoetrope was spun, he could view the bird's flight from various aspects and reconstruct

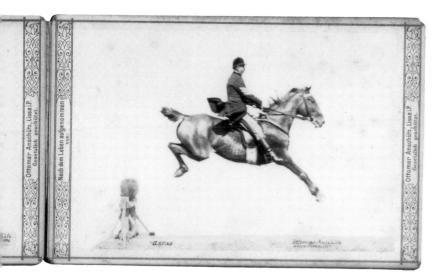

75.
Ottomar Anschütz, three images from a sequence of sixteen photographs of a horse and rider, 1886. No. 2128/78. Trustees of the Science Museum, London.

the revolution of its wings, invisible to the naked eye, in three dimensions in slow motion (fig. 78). He also took the models with him to Naples and had them cast in bronze. Three of these sculptures still survive. Two represent the phases of the wing's movement in separate figures; in the third Marey has melded the overlapping wings and bodies of the gull into one sinuous wave (fig. 79).

The human figure was also subjected to the overhead camera (fig. 80) and to sculptural synthesis, but perhaps because Marey did not trust his own artistic skill in depicting human subjects,[113] he had a well-known academic sculptor, Georges Engrand, produce bas-reliefs. Each relief depicted a single phase of the run; but though academically and scientifically correct, unlike Marey's bird sculptures they hold little aesthetic appeal today (fig. 81). Like a single frame from Muybridge's work, the first impression of the figures in the bas-reliefs is of both awkwardness and a prosaic stillness. Marey's presentation of the reliefs to the Académie des Sciences in 1888 was accompanied by his comparisons of correct and incorrect representations of human

locomotion in art—in 1878 he had similarly compared representations of the horse. In both cases, he pointed out, only the ancient Greeks came close to "seeing" motion correctly and to incorporating that vision into their art. Photography, he showed, now enabled us to return to that original true vision.

Marey's goal was to photograph free flight with the same accuracy he had attained in the field of human locomotion. With the fixed-plate camera, however, only those animals (and people) that could be made to perform in front of his black screen or connected to electrical apparatus could leave their imprint on the photographic plate. Thus, though the number of his possible subjects might have seemed at first infinite, eliminating parts of the surface of the subject by blacking them out could not be applied with equal success to all living creatures. Wild animals and insects and fish were still outside the range of his photographic instruments. Movement on the spot could not be photographed, nor could movements in the optical axis of the camera. That is, the technique of the fixed-plate camera functioned precisely because each new location of

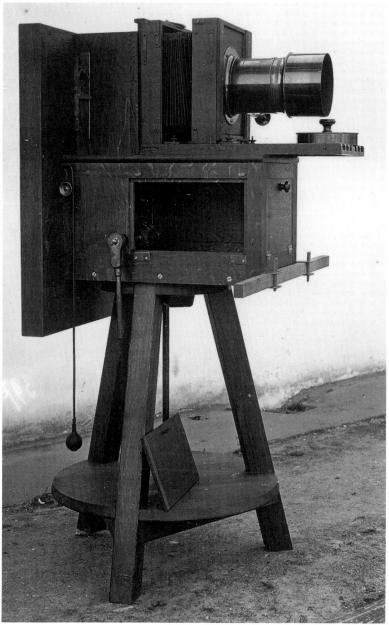

A

B

76.
(A) Chronophotographic camera of
1887. (B) From rear with disk shutter
demounted. (C) Pylon and camera
platform added to third black hangar
to make overhead views, 1886.
Album C, plate 6, Hôtel de Ville,
Paris. (D) The smaller hangar built in
1887 for three-dimensional studies.
Album H, plate 5, Beaune. (E) Flight
of gull taken from overhead, fifty
images per second, 1887. Collège de
France.

C

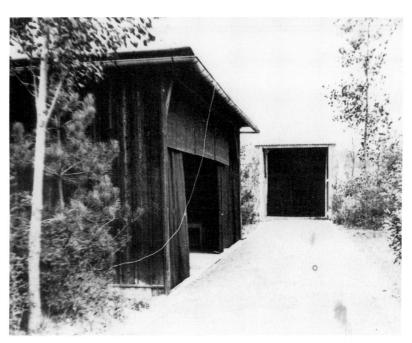

D

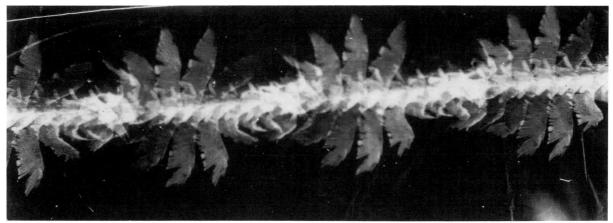

E

139

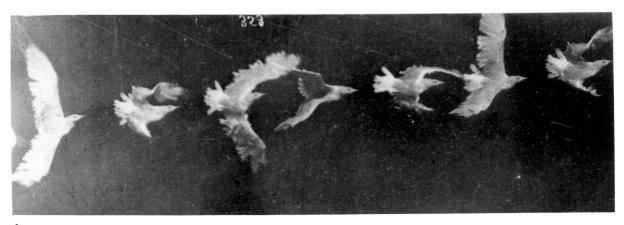

A

77.
(A) Flight of gull taken from over-head, 1887. Collège de France.
(B) Drawings made from the chrono-photographs of gulls taken from three different axes, 1887.
Movement.

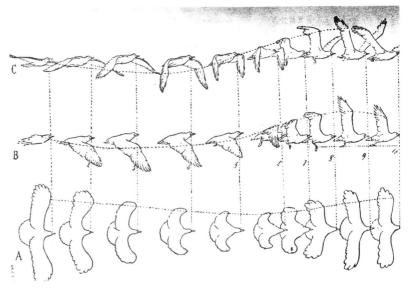

B

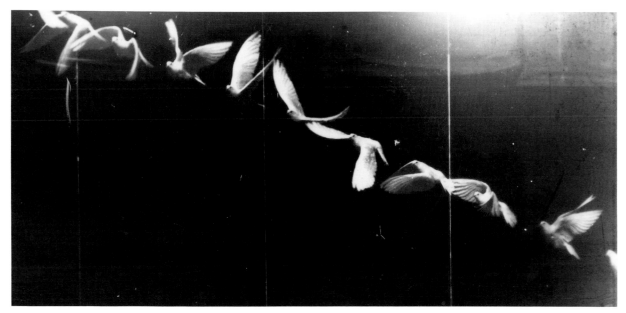

A

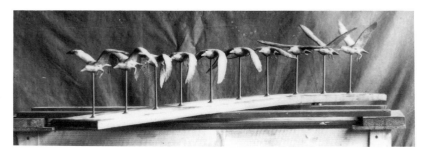

B

78.
(A) Flight of pigeon, 1888. (B) Bronze
sculptures of a gull's flight, 1887.
(C) Three-dimensional zoetrope with
pigeons, 1887. Collège de France.

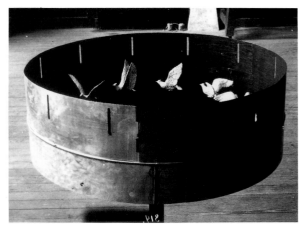

C

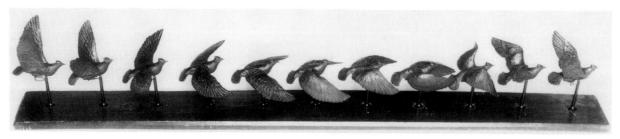

A

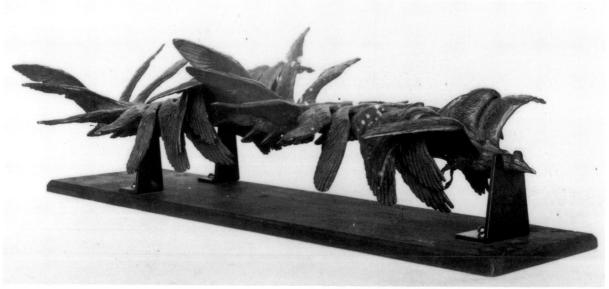

B

79.
(A) Flight of pigeon. 1887. Bronze, 134 × 20 × 26 cm. Collège de France. (B) Flight of gull, 1887. Bronze. 60 × 18.8 × 23 cm. Beaune.

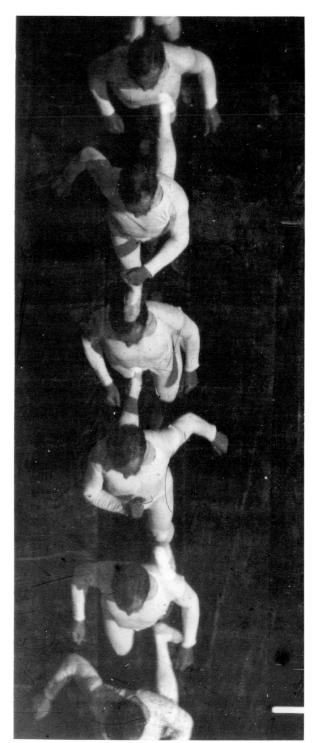

A

B

80.
(A) Run, overhead view, 1887.
Cinémathèque Française. (B) Demeny
in an apparatus to register oscillations
of vertebral column, shoulder, and
hip, 1887. Album H, plate 20, Beaune.
Same, in movement: (C) side view,
(D) overhead view, 1887. Collège de
France.

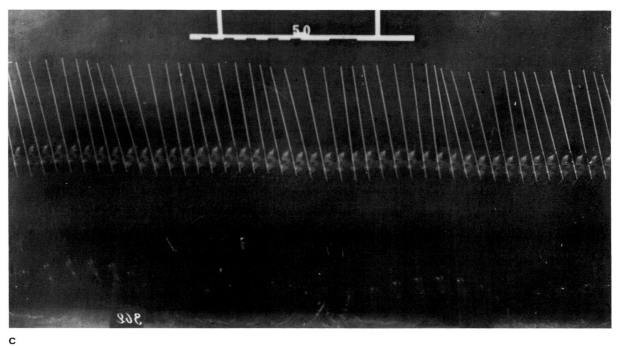

C

D

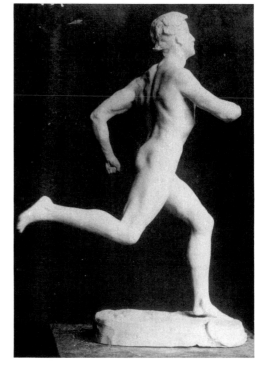

81.
(A) Georges Engrand, single phase of
the run made from a chronophoto-
graph, plaster, 1887. Album H, plate
10, Beaune. (B) Fast run; single phase
from a chronophotograph, 1886.
Collège de France.

A

144

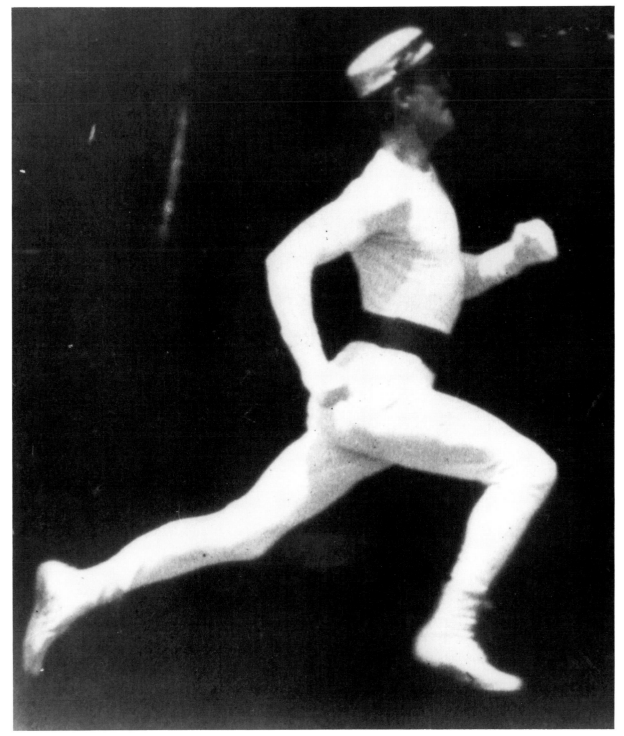

B

145

the subject in space was captured on a new location on the plate: the shutter was left open for the duration of the movement, and as the subject crossed the black stage it was frozen into precise segments by the rotating slotted-disk shutter. This meant that a man walking toward the camera or an immobilized bird flapping its wings would, under these conditions, be recorded as nothing but blur on the photographic plate.

It had been ten years since Marey had felt the need to go beyond the graphic method; then, he had made the camera into a scientific instrument of unprecedented accuracy and created the most brilliant advance in photographic technology to date. Now he again needed a new technology, one that allowed him the infinite possibilities of recording "free movement" in the natural world, away from the confines of his black hangar. Because he insisted on the principle of a single camera making images from a single point of view, he saw that there were really only two ways to avoid superimposition and confusion: either the sensitive surface that received the images had to be mobile so that the images would be imprinted on successive parts, or the image of the object had to be translated so that it was imprinted on different parts of the fixed plate. In his search for a solution, he reviewed methods tried earlier: he began in Paris in late summer 1887 by designing a way of moving the plate along its horizontal axis; but the inertia and weight of the glass combined with the speed of its displacement made the method untenable; we can see from the photographs that remain (of Demeny playing the violin and of a duck flying toward the camera) that he could find no way to move the plate evenly (fig. 82). Conversely, he tried moving the lens of the camera around its vertical axis and keeping the plate still, but this too was ineffective. In 1888 in Naples he even picked up the photographic gun again. He had received from the chemist Georges Balagny some

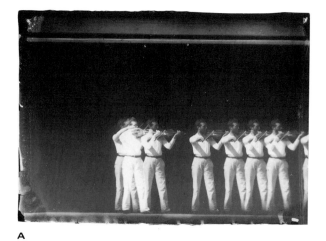

A

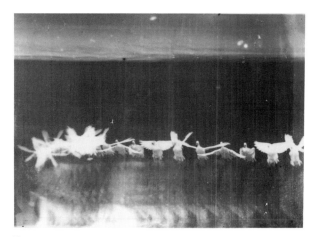

B

82.
Experiments in moving the plate, with unsuccessful results, 1887:
(A) Demeny playing the violin.
(B) Flight of duck toward camera.
Collège de France.

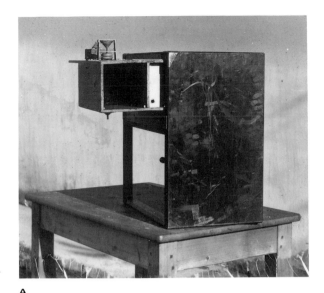

A

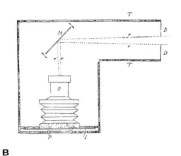

B

83.
(A) Chronophotographic camera with oscillating mirror, 1888. Collège de France. (B) Cross section, 1888. *Movement.*

extremely sensitive gelatin-collodion negatives, which he cut into circles and glued onto ebonite disks for the gun. Their light weight—Marey wrote that they had "about two times less mass" than the glass plates—meant they could be rotated much faster, and more images could be made. But the increased number of images still were not enough to show all the positions of the wing; moreover, the images were limited by the same deficiencies as the original glass plates: they only provided a succession of poses; they expressed neither the positions of the bird in space nor the speed of its translation.[114]

Marey had more success with a camera that incorporated an oscillating mirror; the mirror separated the movement into phases by reflecting the image onto a different and successive part of the plate each time it moved (fig. 83). It was used in conjunction with an aquarium to study the movement of eels and fish (fig. 84) as well as to study human locomotion (fig. 85). Yet this system was not feasible when the duration of the movement was prolonged, when a large number of images were

required, or when the dimensions of the plate could not contain the number of images needed.

Finally, in late 1888, sensitized photographic paper films reached the French market from America and put an end to Marey's search. These films consisted of long paper strips coated with a light-sensitive gelatin emulsion. The emulsion was stripped off after exposure and development, leaving a negative as clear and sharp as that made on glass. The "stripping films," as they were called, had been developed by George Eastman in 1884 as a cheaper substitute for the unwieldy glass plates he had been manufacturing in his factory in Rochester, New York. Eastman introduced the films and a roll holder to keep them firmly fixed in the back of the camera in 1885; they were the critical elements in his revolutionary "Kodak," which combined within itself camera, roll holder, and stripping film. The appearance of these films completed an era of photographic history and opened the floodgates of industrialized photography. And they were the key to Marey's invention of the technology that made motion pictures possible.

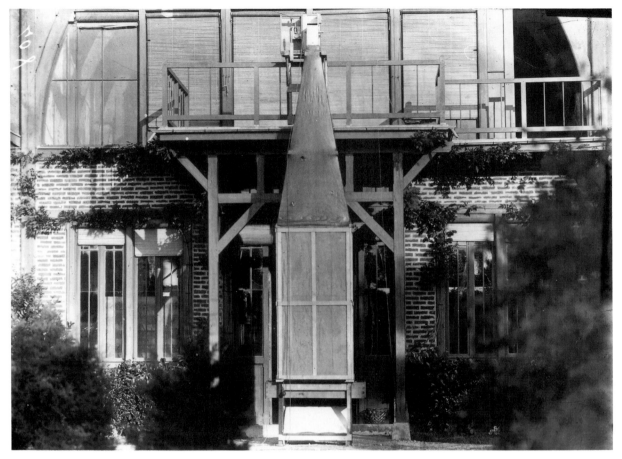

A

84.
(A) Arrangement for making chrono-
photographs of marine life, 1888: a
reflecting mirror is at the bottom
of the tentlike structure and the
oscillating-mirror camera is at the
top. (B) Movements of two eels,
1888. (C) Movements of a fish, 1888.
Collège de France.

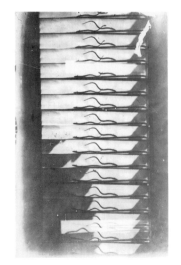

B

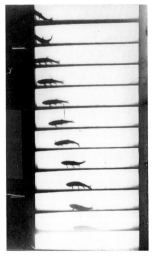

C

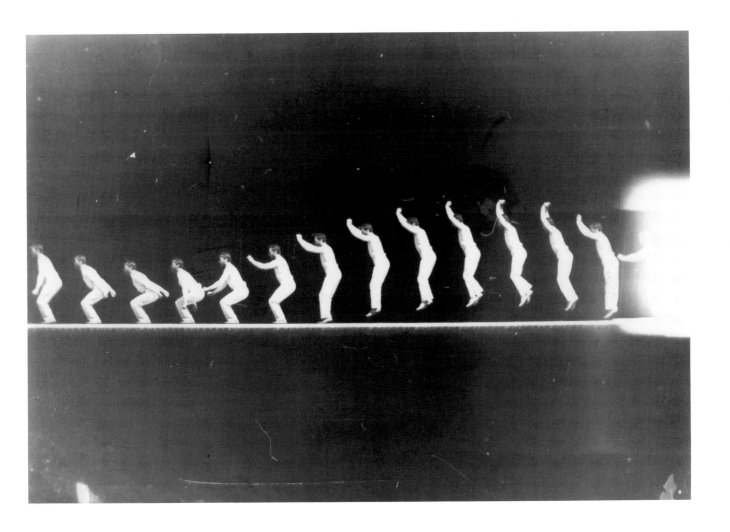

85.
Jump: chronophotograph made with
oscillating-mirror camera, 1888.
Collège de France.

4 *Animating Images: The Cinematographic Method*

The history of motion pictures is not a straight-forward narrative of technological invention. If it were, Marey's contribution would be easy enough to categorize: he was the first to use a single camera to produce photographs on a strip of sensitized film in real time, rapidly enough for the illusion of movement to be reconstituted for more than a single viewer at once. Marey however, had no interest in constructing an illusion of movement, or any other illusion, and the great industry of spectacle that is motion pictures was founded on the willingness of thousands of people to pay for the pleasure derived from such illusions. So a true history of motion pictures would have to include more than the history of technology and the scientific inventions that provided the material base for cinema. It would have to take into account such factors as the industrial practices of the nineteenth century, which led to the standardization and mass production that stimulated cinematic invention and adopted its products for commercial gain. The immense popularity of optical toys like the zoetrope, and other forms of diversion and edification like the magic lantern show, the music hall, and the popular press, conditioned acceptance of the earliest films; thus they would also have to be considered in any history—as would the aestheticization of the visible, which the early cinema wholeheartedly adapted from these entertainments. Marey's cinematic inventions were an extension of his attempt to analyze movement in real time; he never desired to

reproduce what the eye could already see. Nevertheless Marey was a vital, if inadvertent, contributor to the larger history of motion pictures: the machines developed in his laboratory constitute the technological foundation of commercial cinematography. The irony of this fact is central to this chapter, which attempts to do two things: to trace the history of Marey's cinematic inventions and to show the part those inventions played in the industrial and representational practices that constitute motion pictures as we know them today.

Marey's contribution to the history of motion pictures began on 15 October 1888 with an announcement to the Académie des Sciences, the forum for all his presentations. Before he described his photographic experiments with the revolving mirror, he declared his intention to make a series of images on a long band of sensitized paper, "animated by a rapid translation with stoppages at the moment of pose."[1] Two weeks later he presented the members of the Academy with the first series pictures he had made. The paper bands, about fifty centimeters long, that his colleagues passed around were greeted with interest and pleasure. One showed the flight of a pigeon, the other the opening and closing of a hand; the images had been made at a speed of about twenty per second at an exposure time of 1/500 of a second. They were the earliest filmed images of movement ever seen in public (fig. 86).

In Marey's usual manner of working, he had re-vised and improved an existing instrument so as to evolve a more advanced technique for recording movement. To make the images on these strips Marey had used his fixed-plate chronophotographe, but he had replaced the sensitized glass plate behind the lens with a roll of light-sensitive paper. About one meter long and nine centimeters wide—a width determined by the dimensions of the diapositives Marey used to illustrate his lectures[2]—the roll was fed from one rotating spool or bobbin and taken up by a second. Clockwork gearing moved the bobbins, while a clamping mechanism immobilized the paper for a split second against the lens. Stopping the paper was absolutely necessary, Marey announced, to take a clear image. The clamping device operated electromagnetically: an electrical contact was made each time the slot of the disk shutter made a revolution in front of the lens. In the earliest model the pack containing the stripping film and the system that fed it was exposed, so that the whole camera had to be used from within a darkroom; but by early 1889 Marey had made a box to contain the bobbins, the feeding mechanism, and the stripping film (fig. 87). Even then the light-sensitive bands still had to be loaded and unloaded in the darkroom, slowing down the number of experiments that could be made in any one day, until Marey had the idea of fixing one end of the stripping film to a fifty-centimeter band of black paper and the other end to red paper. This not only protected the film from light but also made it impos-

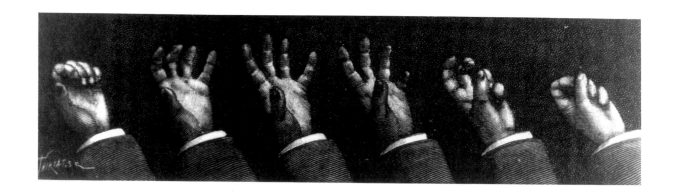

86.
Movements of a hand: Gravure made
from one of Marey's first films, 1888.
Archives de Physiologie, July 1889.

87.
First film camera with film pack in
a box, 1888. Drawing. *Musée
retrospectif du groupe. I. Education
et enseignement à l'Exposition
Universelle de 1900.*

sible to confuse a bobbin of exposed paper with one that had not been used. His single improvement on this system resulted in daylight-loading film: he rolled the whole strip up with a long band of black paper (slightly wider than the film itself) that had one red end (fig. 88).[3]

By summer 1889 Marey could get two kinds of transparent strips for his new camera that he used in place of the fragile paper bands (fig. 89). The first, made by Georges Balagny (and eventually manufactured by the Lumière family of Lyons, the largest commercial manufacturers of photographic supplies in France), had a light-sensitive gelatin emulsion supported by a collodion base, while those produced by Eastman and sold through Nadar had a nitrocellulose base. These primitive "films" (the word now meant any flexible, light-sensitive support) were made in lengths of only about 1.10 meters. They were scarce and difficult to work with; they were not of a consistent thickness; the gelatin sometimes became detached from its base; and often the films were marked by frilling

88.
Letter from Marey to Demeny with drawing showing daylight-loading film, 18 June 1891. Cinémathèque Française.

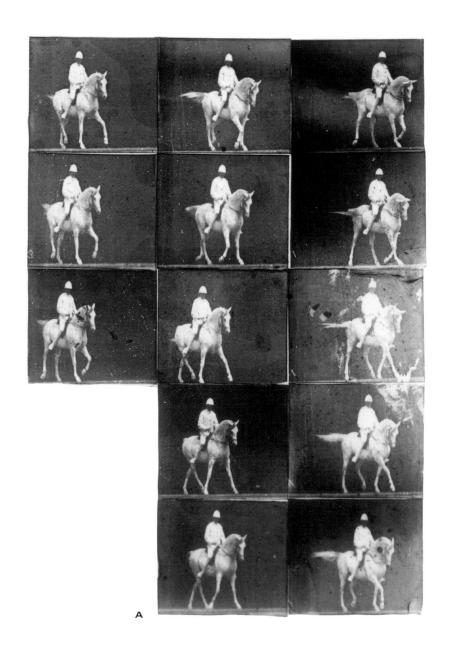

A

89.
(A) Horse, mounted, walk. (B) Horse,
mounted, canter: images taken on
Balagny's collodion-gelatin film
rephotographed on a glass plate,
1889. Collège de France.

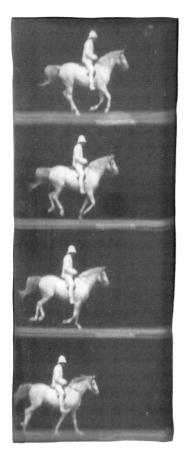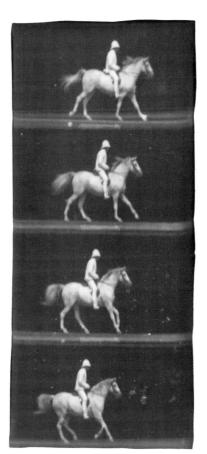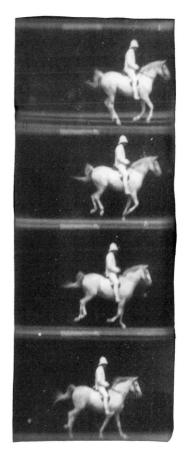

B

and static electricity. The continuing search for a satisfactory support on which to take a long series of rapid images would not be concluded until the large-scale commercial manufacture of celluloid film was introduced by Eastman in the early 1890s. Since it was sufficiently strong, thin, and pliable to permit the intermittent movement of the film strip behind the lens at considerable speed and under great tension without tearing, the new film stimulated the almost immediate solution of the essential problems of cinematic invention.[4] But the resolution of such problems belongs to the history of the cinema industry, and as far as Marey was concerned in

1889, the problems with the film strips were irritating but almost minor compared with the frustration caused by his apparatus.

Here the most immediate and pressing difficulty was in stopping and starting the film evenly so that images were made at equidistant intervals. The take-up spool of the film-feeding mechanism operated by friction around a constantly moving axis, and it often malfunctioned, either not holding the film firmly enough so that it slipped by and the image was blurred, or winding on too energetically, in which case the film ripped. Worse, the electrically operated clamper that held the film against the back

of the lens for an instant as an image was being made was not dependable: the tremendous speed of its operation—it could stop the film up to sixty times a second—militated against its regularity. Sometimes the placement of one image on the film band differed by as much as a centimeter from its neighbor, at other times the images overlapped. Nonetheless, the film camera represented so great a gain in Marey's quest for the perfect analytical tool that in spite of these difficulties the camera—and films taken with it, which he synthesized on an electric zoetrope—held pride of place in his part of the photography exhibit at the Universal Exposition of 1889.

Not far away from Marey's pavilion at the exposition was the Pavilion of Electricity, where Thomas Edison displayed his many inventions; and nearby, in the Palace of Liberal Arts, Emile Reynaud's animated film bands were projected to a delighted audience. Reynaud (1844–1918) was the inventor of the projecting praxinoscope, one of the many modified projecting zoetropes and phenakistoscopes that proliferated at the end of the nineteenth century. His Théâtre Optique (fig. 90), patented in 1888, was an evolution of this praxinoscope: instead of projecting zoetrope strips, he projected long bands (up to fifty meters) on which he had laboriously painted the images: these were the first animated films to be seen by the public. Reynaud's method of moving these bands in front of the magic lantern was highly original and, in light of subsequent events, extremely important: the bands were dragged along in front of the lantern by bobbins whose teeth engaged holes punched on either side of the bands. These "sprocket" holes ensured the evenness of the film's movement, and they would have solved Marey's problem of equidistance had he adopted them. Marey knew of Reynaud's method of moving the bands, but after some experiments he had decided against perforat-

ing his film stock, because it would both limit the working surface of the image and prevent him from using films of interchangeable widths. Using sprocket holes, in other words, would have made it necessary to standardize his cameras. The large expense necessary to adapt his machines was beyond his means even had it been desirable. Marey wanted to vary the width of the film strips he used according to the camera they were used in, and he wanted to vary the height of the images according to the demands of the subject and the experiment.[5]

In 1890, the year when he published *Le vol des oiseaux*, a recapitulation of his extensive work on flight, Marey announced an improved film-feeding system to the Academy; in fact, he had reconstructed the whole camera.[6] The one slotted-disk shutter became two—one revolving five times to the single revolution of the second—and the two shutters were now placed inside the lens housing. More important, the bobbins and the film-feeding and clamping mechanism were integrated into the camera and joined to the workings of the shutters rather than being operated from within their own separate box at the back of the camera. Marey replaced the electromagnetic relay with clockwork-run gearing whose movements were coordinated with the movements of the two shutters (fig. 91).

One year later Marey announced his *chronophotographe à double usage* ("double-use camera"),[7] a camera constructed so that either the film pack or the glass plates could be placed behind its lens (fig. 92). The advent of this instrument underlines the fact that when Marey invented chronophotography on moving film he did not abandon chronophotography on fixed plates. Indeed, the speed of the double-use camera meant that Marey could finally realize his ambition of making images on the glass plates in which both the temporal and spatial dimensions of the movement were fully defined. The close proximity of each

A

B

90.
(A) Emile Reynaud's projecting
praxinoscope, 1879. *La Nature,*
September 1880. (B) Emile Reynaud's
Théâtre Optique, 1889. *La Nature,*
June 1890. New York Public Library.

A

91.
(A) Marey's 1890 film camera. *La Nature*, November 1890. (B) Film-feeding mechanism, 1890. *Revue Générale des Sciences*, November 1891.

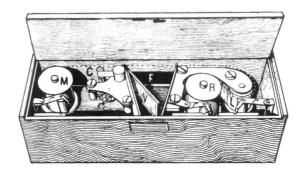

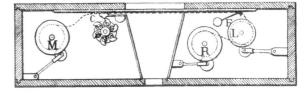

B

movement's phases on the plates allowed him to measure the subtle shifts that had occurred much more easily than he could from the markedly distinct images on film. The fixed plate was more useful, too, when he wanted to record the movements of bones or joints. His 1893–94 recordings of the movements of the jaw in speech or mastication (fig. 93) and of the expansion of the thorax during respiration are examples of such uses. Often he took chronophotographs on film and on plates for the same experiment, as in the work with the Joinville athletes done throughout the 1890s (fig. 94).

In Naples, after he made some tests on waves hitting the rocks, rowing, and the movements of fencers (fig. 95), it was again the turn of marine life to come under the gaze of Marey's film camera. He had set an aquarium into a window opening so that the sun would allow him to film all winter the idiosyncratic motions of the jellyfish, shrimp, starfish, and sea horses he had borrowed from the Naples aquarium (fig. 96).

When the beautiful undulating motion of the skate proved difficult to follow—the fish either stayed immobile at the bottom of the tank or swam to the top and disturbed the surface of the water—

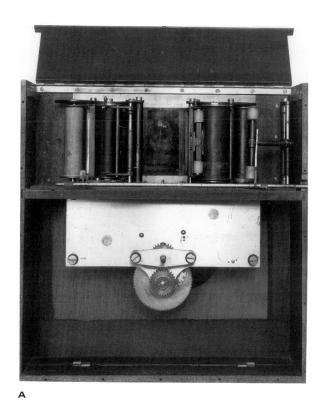

A

92.
Marey's double-use camera, 1891.
(A) Film-feeding mechanism. (B) With
glass-plate negative holder. Beaune.

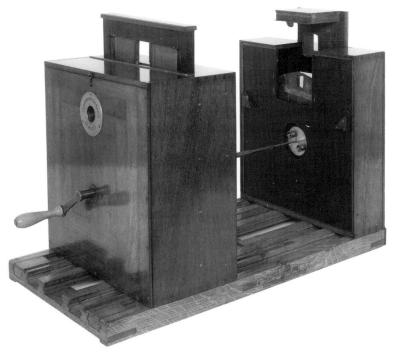

B

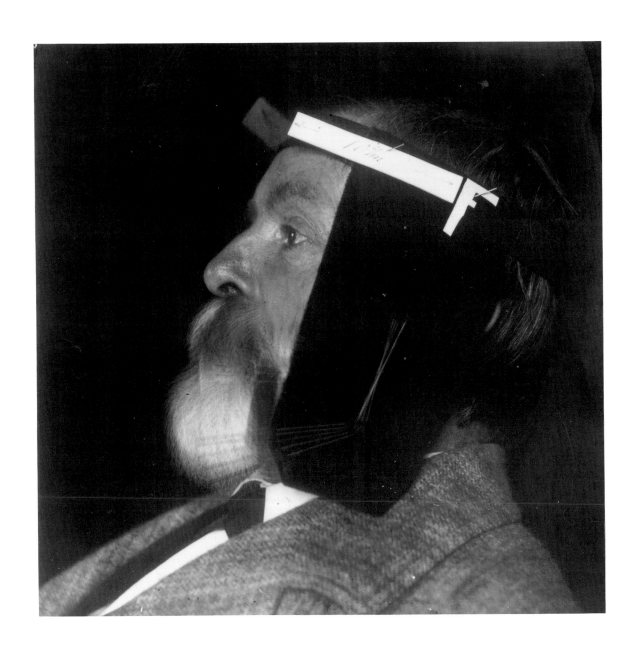

93.
Movements of the jaw, 1893,
Beaune. The subject is Marey.

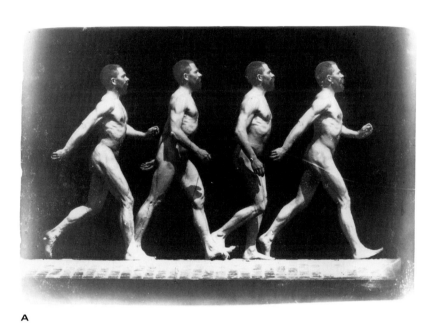

A

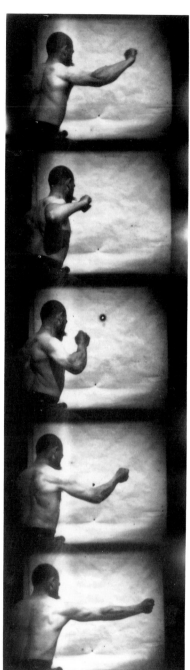

94.
Chronophotographs taken in 1891 with
the double-use camera: (A) Walk.
Collège de France. (B) Movements of
the arm. Cinémathèque Française.
Chronophotographs taken in 1895
with the double-use camera: (C) Sub-
ject before experiment. (D, E) Same,
flexioned run. Collège de France.

B

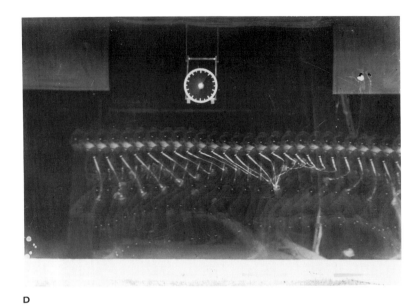

D

C

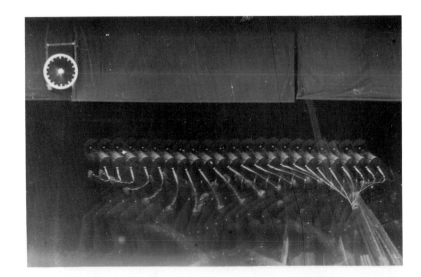

E

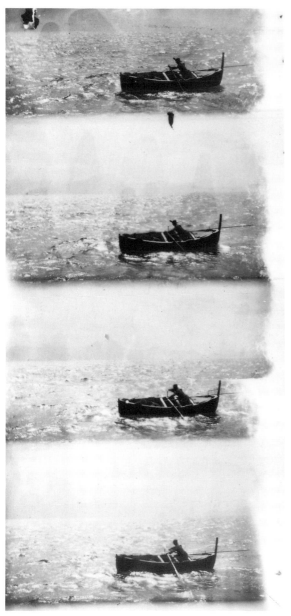

A

95.
(A) Rowing a boat and (B) fencing,
Naples, 1890. Nos. 403/58, 404/58.
Trustees of the Science Museum,
London.

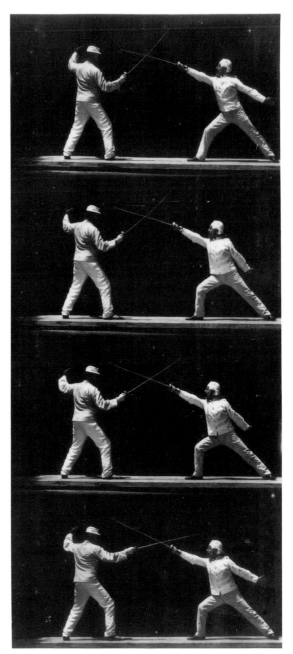

B

96.
Camera and aquarium for filming the
movements of sea animals, 1890.
Movement.

tying all but the fins to a frame and then tickling
the fish produced the required movement for the
camera. By turning the frame to the axis of the
camera, Marey filmed the fins head on, and he
noted a striking similarity between the way the
skate's fins strike the water and the way a bird's
wing strikes the air: both movements have the same
effect of propelling a fluid by the oblique movement
of an inclined plane (fig. 97).[8]

Back in Paris, Marey devised a method of film-
ing crawling insects (fig. 98). He could reveal the
way a spider scurries across walls, for example, by
illuminating it from both above and below so that

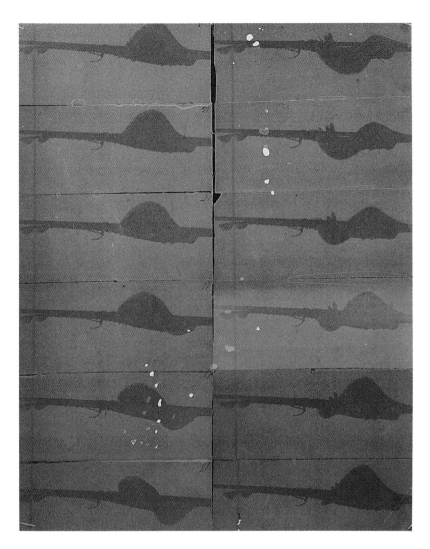

97.
Movements of a skate's fins, 1892.
Gelatin silver print from negatives
made on film, 24.6 × 19.3 cm, Galerie
Michèle Chomette, Paris.

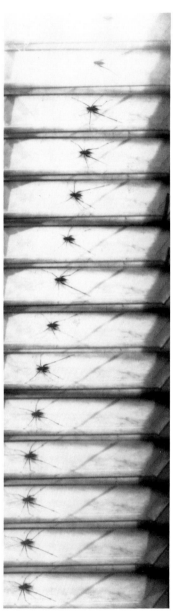

98.
Movements of a water spider, 1892.
Cinémathèque Française.

its shadow was projected at the same time as it was shown in silhouette. To take pictures fast enough to record the wing movements of tinier flying insects, he created the first high-speed films; he narrowed the shutter slots to 1.5 centimeters, then concentrated the light of a heliostat onto the camera lens. The insect, which Marey held between the condensing lens and the camera by a small pair of tweezers clamped lightly around its abdomen, was filmed at 1/25,000 of a second. But because, as Marey admitted, his method of holding the insect was "not very successful with all kinds of insects,"[9] he devised a cardboard box with a glass bottom and top. In the box, which was placed between the camera and the condensing lens, the insect could fly freely (fig. 99).

By 1891, while Demeny continued his intensive analysis of the locomotion of soldiers, Marey had even started to penetrate the movements of the microscopic world. Because the intense light needed generated enough heat to damage the curious forms of locomotion of these tiny creatures, he transformed the camera lens into a condenser lens: the microscopic slide was put not in front of the camera, but behind the slotted-disk shutters, which cut the illumination into intermittent intervals of about 1/10,000 of a second. The film pack and the second lens were placed behind this slide.

Outdoors at the Physiological Station, everything and everybody was put into the camera's service. By the end of 1892 the Station had been transformed into a combination of farm and aviary. A dog, a goat, a donkey, horses, chickens, sheep, and rabbits, along with ducks, pigeons, and sea gulls were housed, fed, and filmed (fig. 100). In 1894 even the gardener's cat was made to perform. It was entrusted with the special mission of contradicting Newton's law stating that once an object is in motion only an external force can change the direction of that motion. Marey had the camera provide visible proof that the animal always lands

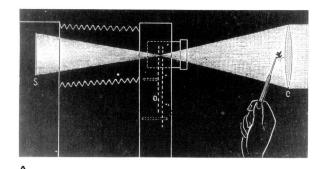

A

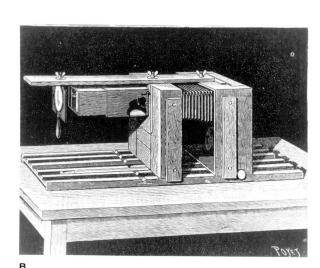

B

99.
(A) First and (B) second apparatus for filming insects. *Movement*.

166

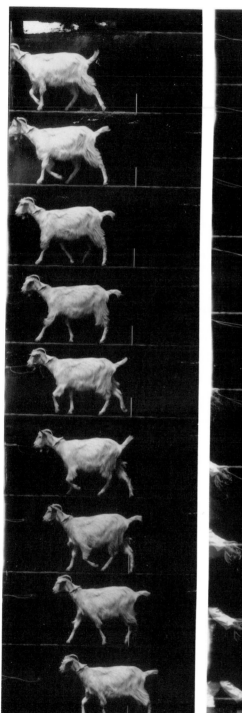

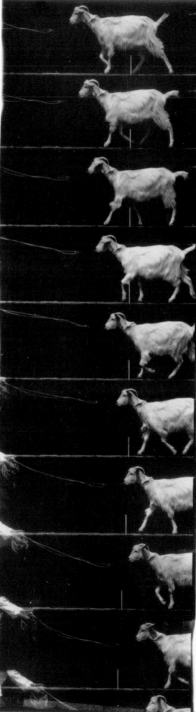

100.
Films made in 1893–94: (A) Goat, walk. (B) Pigeon, landing. (C) Horse, mounted, canter. Cinémathèque Française.

A

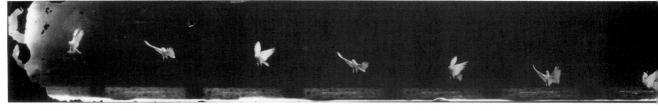

B

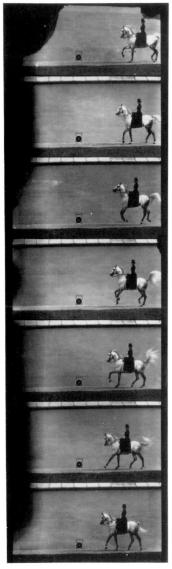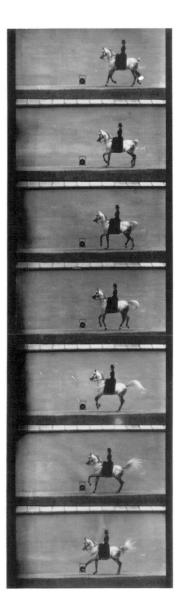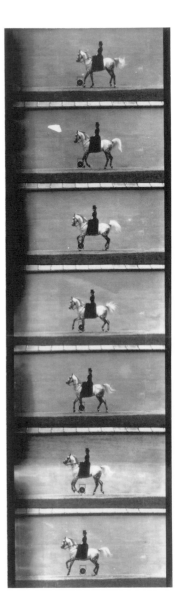

C

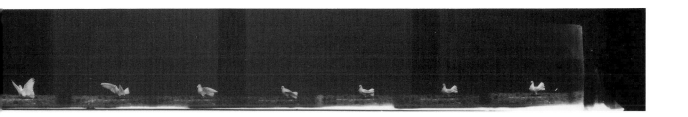

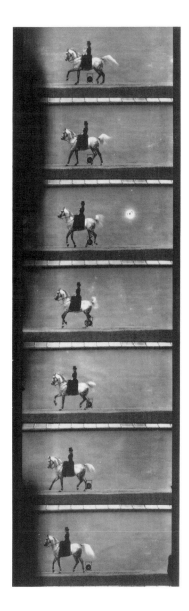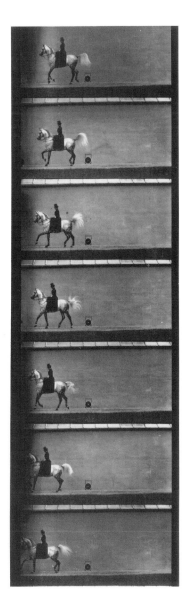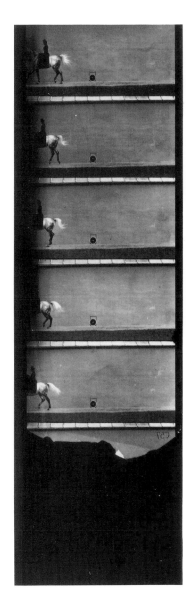

169

on its feet. As he held the cat upside down by its paws and then dropped it onto a landing cushion below, the camera recorded how the animal was able to use the weight of its own body to twist around and land right side up on all fours (fig. 101). This apparent exception to mechanical law provoked quite a fuss and was reported widely in England and America.[10] Chickens, rabbits, and puppies were subjected to the same test. Only the rabbits seemed to come out on top (fig. 102).

On his return to Naples in fall 1891 Marey continued to modify his cameras to correct the unequal spacing between the individual images of his films. Although in May he wrote to Demeny that he believed he had found "the solution for a perfect camera which will make equidistant images,"[11] it seems that the ideal instrument remained just beyond his reach. The problem of equidistance was most crucial when the images were synthesized. Marey had cut apart the pictures that made up these earliest film bands and recomposed their movements in slow motion in an electric zoetrope to confirm his analysis in real time. By this means he had been able to extend the complete revolution of the gull's wing, which occurs in one-fifth of a second, into a whole second—slow enough to be made visible but still fast enough to give the impression of continuous movement. Another method of synthesis Marey used had the purpose of duplicating the overlapping trajectories that were automatically produced by the fixed-plate camera. He cut apart the frames of the film, overlapped them onto a glass plate, then enlarged and rephotographed them. (Or in the later version illustrated, he projected each frame, traced it onto paper, overlapped the next one along the same horizontal axis, traced it, and so forth) (fig. 103). But since all these methods were time consuming and could not be used to synthesize more than a few phases of movement at a time, he set to work on a mechanical projector. "I have

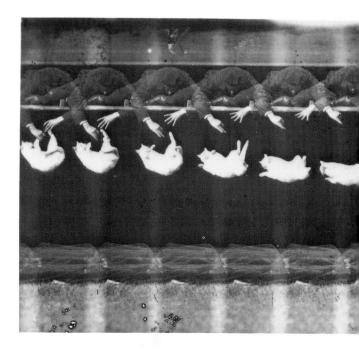

101.
Demonstrating how a cat always lands on its feet, 1894. Cinémathèque Française.

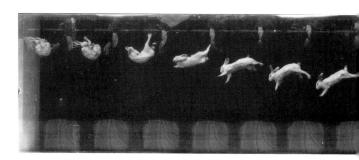

102.
Fall and landing of a rabbit, 1894. Cinémathèque Française.

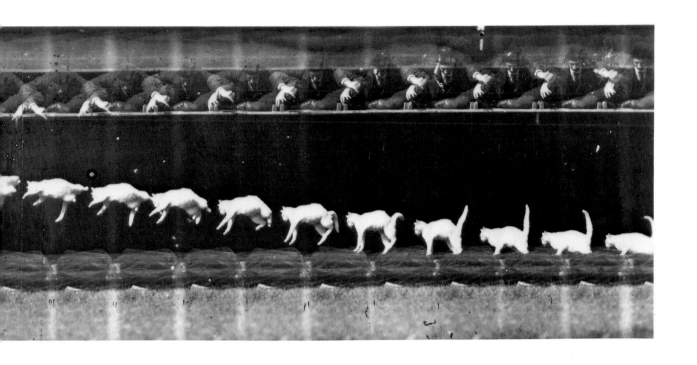

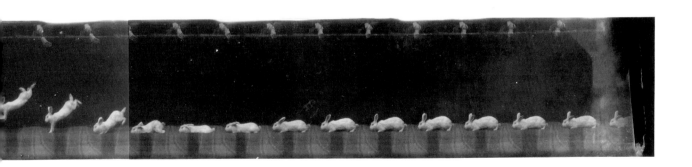

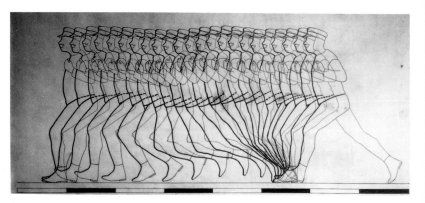

A

103.
(A) Flexioned march, 1895. Re-
photographed tracings made from
projected and overlapped filmed
images. Collège de France.
(B) Flexioned march, subject
Commandant De Raoul, 1895.
Cinémathèque Française.

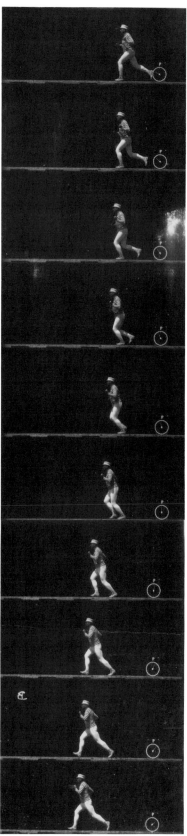

B

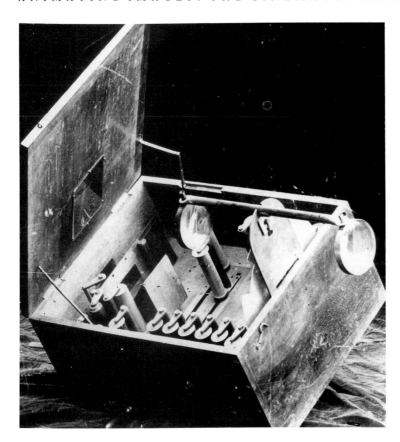

104.
Marey's first film projector, 1892.
Beaune.

made an apparatus for a camera to project the movements," he wrote to Demeny in December. "It is yet only a study on paper, but I think it will work. It will be an affair of eight to ten days to construct it summarily."[12]

Marey's idea for a projector was based on the principle of reversibility. He intended to adapt the mechanism of his slotted-disk shutter camera and combine it with a lantern to project positives made from his films. Developing a machine that could be easily adapted to either take or project moving pictures was a critical step in the invention of cinematic technology, but the positives Marey projected with his first projector in 1892 incorporated the irregular spacing of his negatives, so that

once more he was hampered by the problem of equidistance. On 2 May 1892 he wrote to the Académie des Sciences describing the principles of his projector and stating his intention to demonstrate it at an upcoming meeting, but the demonstration never materialized. As we know from a letter Marey wrote to Demeny a month earlier, he was projecting the images, but he was doing so by cutting them apart and attaching them individually (and as evenly as he could) to a rubberized fabric strong enough to withstand the push and pull of the apparatus (fig. 104).[13] Marey, in fact, would not produce a satisfactory method of projecting until 1896, a full year after the advent of public film projections.

But screening films for the public was not

Marey's goal. He was working on a projector whose sole function would be to mechanically synthesize the results of his analyzer, slowing down some movements and speeding up others. He was not after a machine that would replicate the continuity of perceived movement: such an apparatus would have been of no use to him in his work. The idea of reproducing movement as the unaided eye grasps it would be absurd since, as he wrote, the movement "would be attended by all the uncertainties that embarrass the observation of the actual movement."[14] Marey's lifelong desire to make visible what the unaided senses could not perceive would effectively bar him from avenues of research whose end was duplicating sensory perception, no matter how aesthetically pleasing the result. Nevertheless, although Marey chose to ignore the replication of what the eye could see, others very quickly understood the commercial possibilities of cinematic illusion. One of the first of these was his own assistant, Georges Demeny.

Given the success Demeny found in the newly emerging field of physical education, it seemed inevitable that sooner or later he would tire of his position at the Physiological Station. He wanted to make a name for himself beyond its confines, to be recognized as one of the leaders in gymnastics training, to be more than merely Marey's *préparateur*.[15] But most of all, he wanted to be financially independent. Working with Marey had enabled him to put his hands on funds and materials that would otherwise have been beyond his reach, but as Marey's *préparateur*, his was always an officially inferior position. The absence of degrees and titles to attach to his name excluded him from state recognition and funding and from membership in that exclusive society of academicians and scientists to which Marey belonged. Because the structure of French science at the end of the nineteenth century was so markedly institutionalized, the position of

one as ambitious and talented as Demeny was bound to be difficult.

Marey's attitude toward Demeny, as far as is revealed by their correspondence, was one of paternal affection. Marey was concerned about Demeny's financial situation, and he often proposed ways that Demeny could make more money. "We have to create resources for you," he wrote in 1884:

Your salaries from the Collège and the Station are something, but at the Station we are a little like a bird perched on a branch. The municipal council can cut it off if they economize, it can even topple over if the political situation becomes too radical. The current government leans to the side of moderation. Therefore it's necessary to create a resource for you. I think that the publication of a good treatise on gymnastics, fully illustrated, could bring you some money. We will discuss the form if you want, and we will see to the way of doing it.[16]

Marey also supported Demeny's professional ambitions,[17] pushing him to obtain higher degrees so that he could consolidate his scientific position, editing his manuscripts for publication, and ensuring his placement on the official commissions formed to investigate athletics and sport. But there were disagreements.[18] While Marey was in Naples, Demeny did not always report on his work at the Station promptly enough; by 1889 Marey was becoming impatient with Demeny's repeated periods of silence. That year, after a heated argument over the kinds of exercises that should be illustrated in Demeny's new gymnastics manual, Marey wrote him this letter:

A man who works needs to expand and follow his own path at a certain age. If this moment has arrived for you, I will do everything in my power to create an independent and satisfying situation for you . . . but it is also right that after a lifetime of work and as my forces diminish, I find the assistance of someone younger who will help me

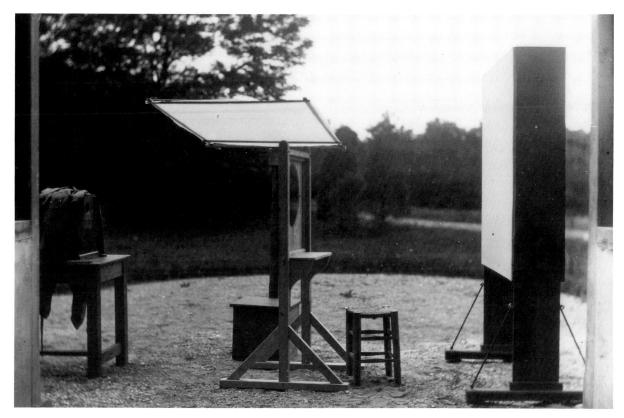

A

105.
(A) Demeny's arrangement of camera
and light reflector for making images
of speech, 1891, Beaune. (B) Demeny,
subject speaking, 1891. Ciné-
mathèque Française.

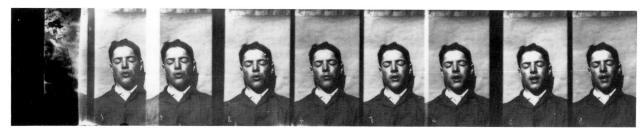

B

to finish the program I have set out to do. In a word, I need an aide, one who would feel a responsibility to me, which I, for my part, would make as light as possible.[19] Demeny's response to this reprimand has not survived; however, we know from Marey's next letters to him that their immediate differences were resolved. Their working relationship continued amicably, at least for five more years.

In 1891 Marey turned over to Demeny a project that would be his introduction to moving pictures—a study of the mechanics of speech initiated at the request of Hector Marichelle (1862–1929), professor and director of the National Deaf-Mute Institute, who saw the possibility of using filmed speech for the education of deaf children.[20] Marichelle thought that by imitating the movement of the lips the students not only would be able to learn lip reading, but might actually learn to produce the sounds formed by the lips. Moreover, he believed it was useless to teach the deaf to speak by imitating static vowels one by one. He thought the sounds should be taught dynamically, as they are used within words—so as to know the difference, for example, between the pronunciation of the *a* in "fat" and in "father"—and he wanted films to demonstrate the mechanism of the lips and tongue in full movement in order to make his point. Demeny had difficult moments with this project: the pictures had to be taken in close-up, and the intense light (a mirror reflected bright sunlight straight onto the face) required to make the movements of the tongue discernible for the camera made the speaker uncomfortable (fig. 105). Also, the shortness of the existing film strips limited what could be spoken. Nevertheless, by the end of summer Demeny had succeeded in filming close-ups of the utterance of short phrases—and he had himself filmed declaiming "Je vous aime" and "Vive la France"—at rates of from fifteen to twenty-four images per second (fig. 106).[21]

To use the film strips as Marichelle intended, however, Demeny had to synthesize them so that the movements would be continuous and easy to follow. He first synthesized the pictures in a zoetrope but soon developed an enhanced version of Plateau's phenakistoscope. He contact printed the film strip, made the positive band transparent by oiling or waxing, cut apart the positive images on it, and placed them in slots cut around the corona of a metal disk. Behind this disk he installed a second slotted disk and, behind that, a light source. The twenty-four images around the first disk revolved in a continuous movement, while the light was suppressed by the second disk shutter as one image was supplanted by another. This "photophone" (as Demeny called it) was made for one viewer at a time, and it served its purpose in the education of deaf-mutes with some success, though it seems that the movement of the tongue was still not clear enough and thus "all sounds demanding

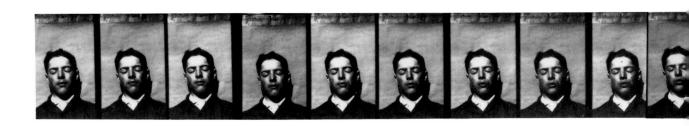

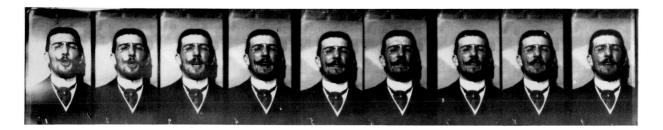

the indispensable assistance of that organ escaped the subject."[22]

The educational purpose of the machine was soon to be left behind when Demeny constructed an improved model of his photophone and found himself suddenly on the verge of celebrity. In his new machine the positives were printed around the circumference of a glass disk rather than a metal one, and the images could be viewed both by an individual and by small groups—when the images were projected by the light of an oxyhydrogen lantern. He called the new model a phonoscope and presented it (in a communication introduced by Marey) to the Académie des Sciences in July (fig. 107).

It was widely acclaimed in the press all over Europe and in America and was hailed by more than one newspaper as the "optical equivalent of the phonograph"—high praise indeed, since Edison's phonograph was the most popular entertainment novelty of the time. Demeny gave lectures with the

106.
(A) Demeny pronouncing "Je vous aime," 1891. Cinémathèque Française. (B) Phonoscope disk made from the film, 1892. Collège de France.

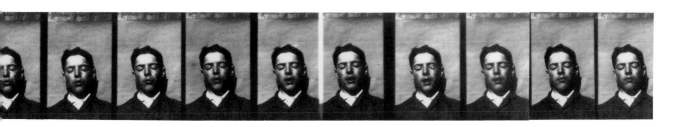

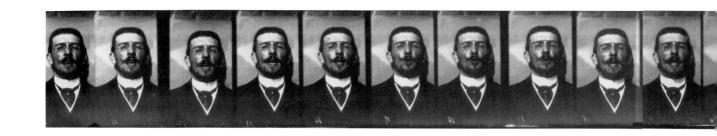

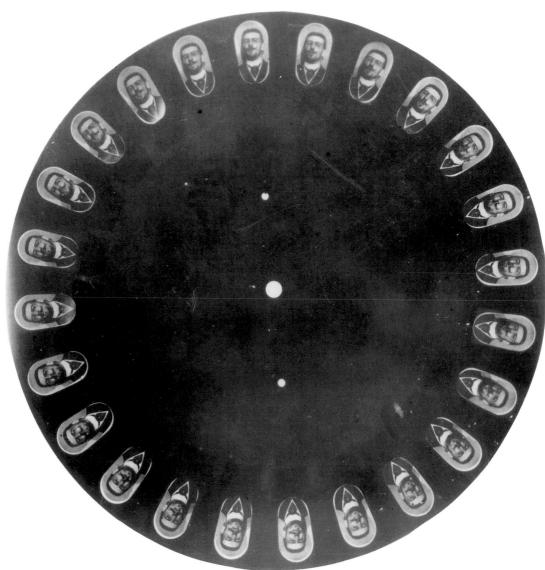

B

178

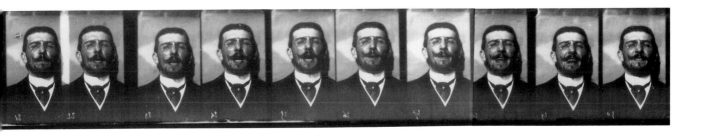

A

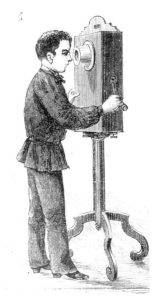

B

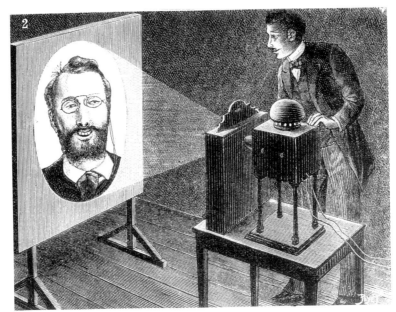

C

107.
(A) Demeny's phonoscope. (B) Viewing the images on the phonoscope.
(C) Projecting the images on the phonoscope. *La Nature,* April 1892.
New York Public Library.

phonoscope to crowds of up to twelve hundred curious spectators, and he gave successful demonstrations of his machine at the first International Photography Exposition, which opened in Paris in May 1892. By that time he had also patented it.[23]

It may have seemed presumptuous of Demeny to patent a machine whose principles derived from the work of others in which he had no part, and one that was conceived in a laboratory where he held a collaborative position. Perhaps, though, Demeny was just following the general practice of his patron, for Marey himself had patented his sphygmograph and with the proceeds had set up his first private laboratory, and he had even patented the film-feeding mechanism of his improved chronophotographe of 1890. Not presumptuous, but odd, is the fact that Demeny patented a machine that was—except for its exclusive devotion to portraiture—basically nothing more than a projecting phenakistoscope and not much of an improvement on previous models such as Muybridge's zoopraxiscope (1879) and Ottomar Anschütz's electrical tachyscope (1889) (fig. 108).[24]

Marey, in the meantime, responded to the news of Demeny's accomplishment with pride. "It is probable," he wrote, "that [the success of the phonoscope] will provide you with new opportunities for making yourself known, and someday perhaps I will have the pleasure of going to applaud you."[25] His letters to Demeny conveyed congratulations for the "almost perfect zoetrope," for the conference Demeny had given on the photography of movement at the Conservatoire des Arts et Métiers illustrated with the phonoscope, and for the diploma Demeny had won for the machine at the Photography Exposition. (The phonoscope was shown in the scientific photography booth together with Marey's cameras and his films of birds and fish.) Of course Marey's pleasure in the phonoscope derived from what he understood to be the instru-

ment's educational use. And perhaps at first those were Demeny's ambitions for the machine as well. But after its clamorous reception at the Photography Exposition, and after Demeny received a number of offers from carnival operators who wanted to rent his machine at one hundred francs a day, he realized that the phonoscope might be the way of making the name and fortune he longed for; that in addition to being used for the education of the deaf it could be made to provide a lucrative source of entertainment. He began to imagine what the world would be like with a phonoscope in every parlor, an animate family album: "The future will replace the static photograph, fixed in its frame, with the animated portrait that will be given life with a turn of a wheel. The expression of physiognomy will be preserved as the voice is preserved by the phonograph. One will even be able to add the latter to the phonoscope to complete the illusion."[26]

By fall 1892 the phonoscope had attracted international attention in the press, not all of it serious; for example, this piece from the London *Globe:*

A beginning has been made with the articulation of the words "I love you," which, it appears, can be vocalised in at least two dozen kinds of ways. We should say that that number might be multiplied indefinitely. A skeptical observer says that these twenty-four illustrations are not very luminous and informing, but he hopes for better things, which, no doubt, will come. And if they do, some good may issue from them. Photography may be turned into a means of inter-communication. We may have a language of "cartes-de-visite," as well as of flowers. We shall be able to propose by "cabinet picture." If one can say "I love you" in a photograph, one can also say, "Wilt thou be mine" and the lady in return can vouchsafe one "yes" or a "no." The photograph, in fact, will become, if all goes well, a silent phonograph; it will supply, in literal truth, a "speaking" likeness. A trade journal thinks

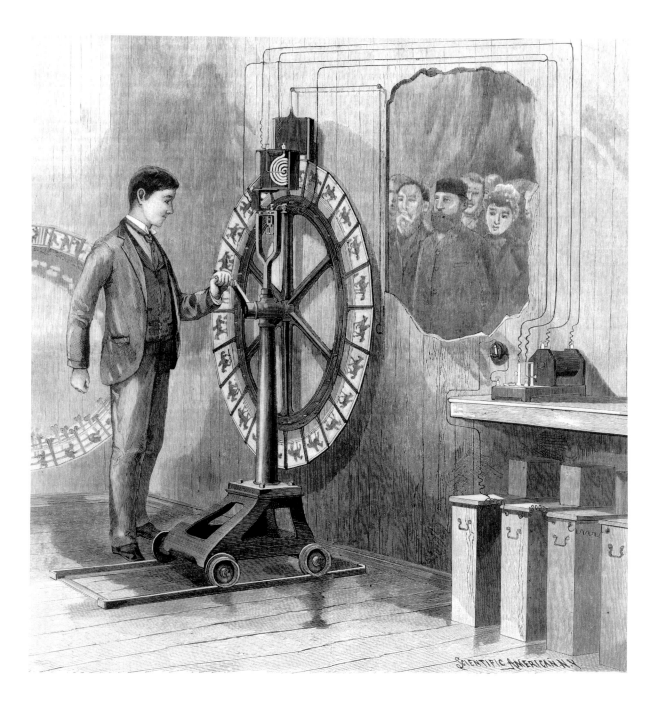

108.
Ottomar Anschütz's electrical
tachyscope, 1889. *Scientific
American,* June 1889. New York
Public Library.

that this "taking" of expression during "speech" points to many strange possibilities. We are sure of it. How nice to be able to send your enemy your photograph, on which he may be able to read, without bringing an action for libel, your opinion of his conduct and personal appearance.[27]

The phonoscope also attracted potential investors with more grandiose ideas than Demeny's. On 20 December 1892 the "Société Générale du Phonoscope" was founded to capitalize and market the machine. The Société envisaged uses for the phonoscope that seemed to have no limits: animated portraits, moving projection, a penny-in-the-slot machine, and a combination phonoscope/phonograph. The large potential profit from the phonograph made this last combination highly desirable. In America Edison was working on such a device, and reports of his progress were widely circulated in Europe—Demeny had read about it in an article of July 1891 in *La Science Illustrée*, parts of which he had underlined. The article described a kinetograph, a cylinder covered with microscopic images that could be viewed in synchrony with Edison's phonographic cylinder. As we know now, the machine described owed more to Edison's powers of imagination than to reality, but the concept impressed Demeny enough that he included a similar apparatus (similarly unworkable) in an addition to his own patent, which he took out on 25 August 1892. The speed with which he applied for this addition can be attributed to his familiarity with the two elements involved: the chronophotographic camera to make the images and Edison's phonograph, which was very like Marey's inscribing cylinder with wax substituted for the smoke-blackened paper.

The Société Générale du Phonoscope had two problems standing in the way of its commercial suc-cess. In the first place, it was impossible to think of mass-producing the disks. Each one had to be constructed by hand: cutting up the negatives, placing them around a circle of fenestrated paper, then contact printing them onto a glass disk. And though Marey assisted Demeny in the search for a solution to this first difficulty,[28] the second problem was Marey himself. For no matter how the negatives were made, the machine that made them belonged to Marey. Before June 1893 it belonged to him in a moral sense. But in June Marey took out a patent for his double-use camera[29] that essentially covered all the different aspects of rapid image making that Demeny needed; thus, in one way or another, Marey had to be included in the commercial operation Demeny envisaged.

Marey may have taken out the patent to protect himself against Demeny. When Demeny's letters originally suggested selling or licensing Marey's cameras to the Société, Marey concurred; there were no disagreements in the correspondence of that winter. Marey's letters were full of present and future projects, possibilities for selling the machines, and news of the progress he was making in developing a good projection machine. By spring, however, Marey had become suspicious of Demeny's increasing silence and his refusal to clarify the proposed use of the phonoscope and the cameras that made its images. In June, when Marey arrived in Paris and sat down to negotiate with the Société, the level of commercial applications they envisaged and the role they wanted him to play became all too apparent. For Marey, it was one thing to receive royalties from scientific instruments, quite another to have his name and the name of the Physiological Station associated with fairground entertainment. It was insulting, too, to be asked to be a minor part of a group effort exploiting a machine based on principles that were his sole invention.

Thus on 23 July all negotiations between Marey and the Société came to a halt. On the twenty-fifth, Marey asked for Demeny's resignation.[30] At the time, the request was made with no bitterness or rancor on Marey's part, and indeed for the whole of the following year he negotiated ways to effect Demeny's departure without loss of his pension or reputation; Marey wanted Demeny to vacate the position of *préparateur* but was perfectly willing to have him continue his research in gymnastics at the Station and even made an application to the municipal council for funding on his behalf.

The phonoscope society was dissolved, but Demeny used his stay to find a way of circumventing Marey's camera. By fall he had succeeded: in October 1893 he patented an improvement on the film-feeding mechanism. It was not an insignificant addition: the circular bobbin that received the film was mounted eccentrically so that its irregular motion was transmitted to the film winding onto it (a later addition to his patent transferred the eccentric motion from the receiving bobbin to a cam or "beater" adjacent to it). The resulting stop-and-start action made the film immobile long enough for an image to be taken—and this meant that Demeny could effectively do away with Marey's clamping mechanism, which had contributed in large part to the irregular placement of the images. Since the basic principles of the camera—the single lens, the slotted-disk shutter, the band of sensitive material passing from one spool to another—were in the public domain because of Marey's ongoing presentations to the Académie des Sciences, Demeny's improvement made him virtual possessor of the whole machine.[31] In fact, all subsequent cinema cameras and projectors, including those of Edison and Lumière, were, like Demeny's, based on the principles of Marey's chronophotographe; therefore all subsequent patents taken out on such cameras

were restricted to variations in the film-feeding and film-stopping mechanism.

In 1894, a year after Demeny patented his improvement on Marey's camera, Marey published *Le Mouvement* (the English translation, *Movement*, appeared in 1895), his vast survey of the results and possibilities of chronophotography. The very last lines of the book that conclude a short chapter on the synthesis of images make direct reference to the situation at the Station: "Having arrived at this point in our researches, we learned that our mechanic had discovered an immediate solution to this problem, and by quite a different method; we shall therefore desist from our present account pending further investigations."[32] Demeny finally left the Station in July of that year. He set up his own studio in the Paris suburb of Levallois-Perret, where he made "living portraits" and short films of clowns and magicians (fig. 109). But on his own he had no way of mass-producing or marketing his work; the phonoscope society, now dissolved, had cost him forty thousand francs and left him almost penniless; it was inevitable that his next step would be to search for a commercial enterprise that would manufacture phonoscopes for him. On 6 October 1894 he wrote to the Lumière family of Lyons, who furnished the Station with photographic and film supplies:

I have constructed models of simplified cameras in which the workings are easy and sure enough to be put into the hands of an amateur; that is, they can be removed from the laboratory. These instruments are of two kinds: a photographic series camera giving one to twenty images per second, successive or interrupted series. The second camera is what I have named the phonoscope. It is the synthetic machine, inseparable from the first. It has several applications; it allows the viewing of glass positives with complete detail or the enlargement by projection of

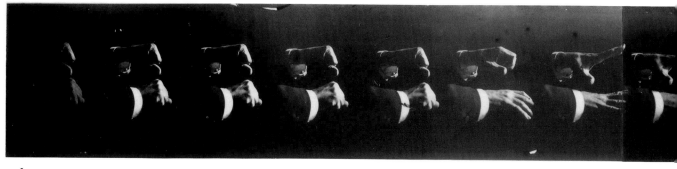

A

109.
(A) Demeny, hands of a magician,
1893. Cinémathèque Française. (B)
Demeny's amateur chronophoto-
graphe, 1894. (C) Portrait made by
Demeny with his amateur chrono-
photographe, 1894. *Scientific Ameri-
can Supplement,* October 1894.
Metropolitan Toronto Reference
Library.

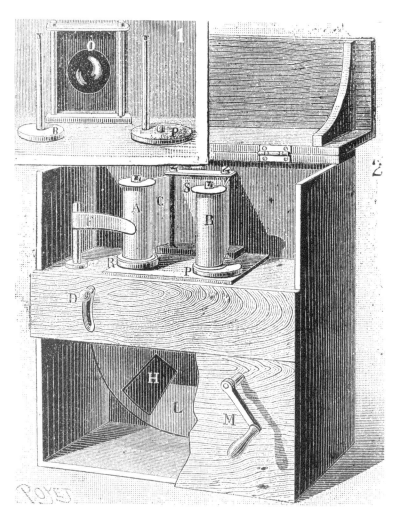

B

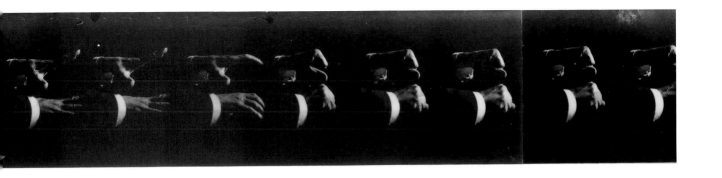

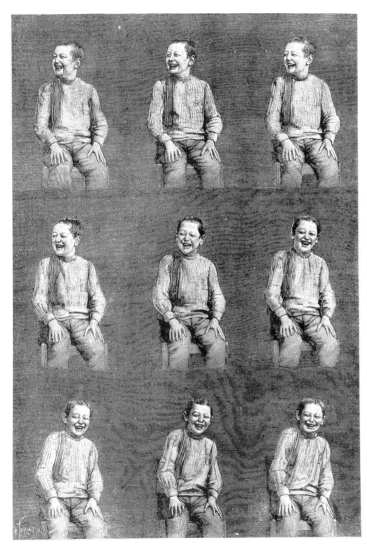

C

the images of movement. This latter application offers the greater interest from the point of view of the living portrait that I inaugurated.[33]

Louis Lumière's response to Demeny was written on 9 October:

We are in possession of your letter of the sixth and have taken into consideration its contents. In effect, the matter you speak of seems interesting to us, and we shall certainly come to see you the first time we get to Paris. At the present however, it is impossible to give you the probable date for such a journey. We will examine the statutes you have sent and will write you again on this subject.[34]

In November Louis Lumière met Demeny in Paris, but nothing seems to have come of their encounter. In fact, it is difficult to understand the precise reason for the Lumières' interest in Demeny's camera and viewer since, as is clear from the following letter written by Louis Lumière to Demeny on 28 March 1895, they were already working on their own motion picture camera:

I received your letter only this morning . . . and regret not having thought to send you a card for my conference. [The conference, given 22 March, was the first demonstration of the Lumière Cinématographe; it was held at the offices of the Société d'Encouragement pour l'Industrie Nationale for a group from the Société Française de Photographie. Marey was president of this body and was present at the demonstration.] I was so busy preparing everything and was in Paris for such a short time that it completely slipped my mind.

I regret it even more because at this meeting I showed a chronophotographic series of eight hundred images [about fifty seconds] obtained and projected with the help of a new, reversible camera that we have patented. This camera, as I had told you, was already under consideration when I had the pleasure of seeing you, and it has a different aim, I believe, than does the one you have constructed to get large images in relatively short series.

As I also told you, the future is in reversible cameras—if I can express myself thus, and to our eyes that has a capital importance.[35]

Demeny then turned to Léon Gaumont, director of the Comptoir Général de la Photographie. Like the Lumière brothers, Gaumont astutely saw that there was more money to be made from projecting films for a paying audience than in animated portraits; and after Demeny realized that others such as the American inventors Francis Jenkins and Thomas Armat had adopted his cam in their projectors for just this purpose, he was easily persuaded to redesign the machine for projection.[36]

But he was too late. Unable to market the machine himself, and overwhelmed by the competition, Demeny ceded all rights to Gaumont in 1896 and left the field of invention, though he continued to write articles on "living portraiture," which he had always claimed was the true scope of his invention. In the end he returned full time to his original field, physical education. In 1900 he was named *rapporteur* for the International Congress of Physical Education held in conjunction with the Universal Exposition. The congress reiterated the importance of a scientific base for physical education; the Ministry of War, heeding the findings of the congress, transformed the Ecole de Joinville into a national institute of physical education with a center for research and a program for training teachers. In 1902 Demeny was named its first professor of applied physiology and given the directorship of the research laboratory. Besides his teaching and research, he was also responsible for compiling a new manual of exercise for the military and the schools. This *Nouveau règlement sur l'instruction de la gymnastique militaire,* published in 1902, embroiled Demeny in a new controversy that lasted almost ten years. His pioneering work was at the center of an acrimonious debate on the rival merits

of systems of physical education, and his enemies brought up again the unsavory circumstances surrounding his departure from the Station.[37] He spent the last years of his life defending himself against such accusations, trying at the same time to get some compensation for the beater he had invented, which was now being used worldwide. He died in penury on 26 December 1917.

In the first decades of this century, when the arguments about who invented the cinema took up reams of newsprint, Demeny always claimed that his improvement on the film-feeding mechanism made him the true inventor of cinematography. In his pamphlet *Les origines du cinématographe* (1909), he described his invention in Archimedean terms, implying that the resolution of the problem of equidistant images (central to Marey) was his goal all the time. It was not. Demeny needed a rapid, instantaneous series camera to take pictures for his phonoscope that could be manufactured and licensed without interference from Marey. Had equidistance been his goal (and had he had the mechanical facility he attributed to himself), he would have understood the implications of a point he had underlined in the *Science Illustrée* article on Edison in his possession: Edison perforated the sides of his film strips.

Demeny also insisted he could project a band of images made with his chronophotographic analyzer, yet no evidence for such a claim exists; up until the time he ceded his rights to Gaumont he seems not to have been interested in using his analyzer as a film projector.[38] Demeny insisted on one object as the scope of his work: the animated portrait; he wanted to manufacture phonoscopes to be used by ordinary people in their homes as the phonograph was. Demeny's single-mindedness can be understood in the light of one event: the enormous excitement created in Paris by the appearance of

Edison's Kinetoscope two months after Demeny had left the Station in 1894.

The Kinetoscope was an optical instrument that, though it animated photographed scenes of action and not portraits, nevertheless functioned for only one viewer at a time. Like Demeny, Edison had become interested in motion pictures because he wanted to visually record speech, to combine pictures with the sounds emitted from the phonograph he had invented in 1877. Edison, however, was a brilliant industrialist who had made a fortune on his patents for the electric light bulb and the phonograph; thus the outcome of his interest in motion pictures was quite different from either Marey's or Demeny's: it would be the cornerstone of commercial motion pictures. But since Marey's scientific work was vital to the commercial developments pursued by Edison—as it had been to Demeny and would also be to the French industrialists Auguste and Louis Lumière—the evolution of Edison's motion picture work bears looking at in some detail. Not only does it demonstrate the different aims of science and industry in the late nineteenth century, a period that saw the increasing interdependence of the two, but it also provides an early example of how an instrument conceived in the laboratory for scientific purposes is soon appropriated by industry for commercial exploitation.

A meeting with Muybridge on 27 February 1888, after a lecture he gave two days earlier in Orange, New Jersey (a Newark suburb near Edison's laboratory in West Orange), probably was the immediate stimulus for Edison's interest. Muybridge suggested coupling his own zoopraxiscope with Edison's phonograph, a suggestion that Edison, in his fight to control the burgeoning motion picture industry in America during the first decade of the twentieth century, would later deny.[39]

At first Edison, in fact, was not particularly in-

terested in moving pictures per se—the motion picture part of the union would always remain secondary to him. But he was convinced that joining pictures and sound would help him exploit the commercial potential of the phonograph. This idea of coupling images to the phonograph determined the physical form of the machine he imagined would be feasible—a cylinder covered by images instead of wax—and it determined the commercial form as well: an entertainment to be enjoyed by one person at a time. He was not interested in projection;[40] he wanted to manufacture single viewing machines and sell them for use in both public arcades and private homes. And he intended the films for his apparatus to be bought separately from his viewer, just as the cylinders for the phonograph were to be purchased on their own, thus ensuring a constantly expandable market for both.

Edison's wish to make a machine that would do for the eye what the phonograph did for the ear was granted by William Kennedy Laurie Dickson (1860–1935), a Scot born in France who was an accomplished amateur photographer. In one way the collaboration of Edison and Dickson parallels that of Marey and Demeny: it began in 1883, after Dickson wrote to Edison asking to be taken on as an assistant in his laboratory, and it came to grief in 1895 over the beginnings of cinema. In another way, however, their collaboration was quite different: as Gordon Hendricks makes clear in his pioneering work *The Edison Motion Picture Myth*, it was Dickson, not Edison, who was ultimately responsible for producing motion pictures at West Orange.[41]

In late 1883 Edison put Dickson to work testing and experimenting on electrical apparatus and made him his official photographer; in 1887, as he rose in the ranks of the West Orange laboratory, Dickson began to work with Edison on an ore milling scheme. This project, dear to Edison's heart (he

spent more than twenty thousand dollars of his own and others' money on it), was Edison's attempt to electromagnetically separate gold from other metal.[42] In 1888, in what was supposed to be his spare time, Dickson was given the motion picture project. Besides being adept at photography Dickson was also a gifted tinkerer, and he was eminently suitable to the task Edison now presented him with.

Edison's earliest ideas for a moving picture machine were sketched out in four caveats (descriptions of ideas, not specifications), which allowed him to effectively prevent others from poaching on the same imaginative territory for one year. On 8 October 1888 he filed the first of these. The second, filed 25 March 1889, and the third, filed 5 August (but written the previous 20 May), followed closely along the same lines as the initial description. In the first caveat Edison proposed an invention—he named it the Kinetoscope in the second caveat—that "consists in photographing continuously a series of pictures occurring at intervals . . . greater that [sic] 8 per second [twenty-five images per second were specified later in the document] . . . on a continuous spiral on a cylinder or plate, in the same way as sound is recorded on the phonograph."[43]

Edison intended to use an electromagnetic device incorporating a tuning fork to move the cylinder, which would be halted at the moment the image was made and advanced while "the light is cut off by a shutter." The cylinder was "a shell made of any substance [covered with] collodion or other photographic film . . . flowed over it to produce a positive. If it is desired to take a negative, a glass cylinder is used. . . . The permanent cylinder may even be covered with a shell and thin flat film or transparent tissue sensitized by wrapped [sic] around it." Each image, Edison specified, would be "about ¹⁄₃₂ of an inch wide."[44]

For viewing the positive images, a "microscope stand and objective would be substituted for the

photograph recording devices." Edison also suggested the possibility of "microphotographic projection or enlargement" of the images, but since it was impossible to make a positive from a glass cylinder, he had to settle for projecting negatives: "the cylinder being revolved and the source of light inside the cylinder, negative records being only recorded."[45]

The apparatus was impracticable. Apart from the challenge of the photographic manipulations involved in flowing collodion over a cylinder, it was mechanically unworkable, its very construction impossible at the time. Edison was proposing a machine capable of starting and stopping twenty-five times a second for twenty-eight continuous minutes. This was to be achieved by the intermittent movement of a ratchet and pawl of such size as to make anything more than a start and stop of more than two or three times a second for a period of two or three seconds quite out of the question.[46]

Following the direction of Edison's ideas, however, Dickson got to work—at first in a somewhat desultory fashion. He experimented with microscopic images (on various substances including daguerreotype plates) placed around the surface of a cylinder, with inconsequential results until 1889. That year two things happened. In June Dickson got hold of a piece of celluloid—a sensitive surface that actually could be wrapped around a cylinder.[47] And in August Edison went to Paris, where he saw Marey's film camera and electric zoetrope in action.

The Universal Exposition of 1889 where Edison exhibited all his inventions from the electric light bulb to the phonograph had opened in Paris in May. His visit to the capital, which was primarily to advance sales, licenses, and patents for his products, also included meetings with European colleagues. On 23 August, Jules Janssen interrupted a communication of the chemist Marcelin Berthelot to introduce Edison to the Académie des Sciences, and he was subsequently feted by many of the same

luminaries, including Marey, who had welcomed Muybridge to Paris precisely eight years earlier. Together Marey and Edison visited the exposition (where they would have seen Reynaud's Théâtre Optique and Anschütz's electrical tachyscope in action), and Edison traveled to the Physiological Station, where Marey brought him up to date on his own work. Edison must have been fascinated not only with Marey's achievements on display at the exposition—his bronze sculptures of birds, the electric zoetrope, drawings, chronophotographs, and the cameras for both glass plates and sensitized strips of paper and film[48]—but with Marey himself. Marey's strictly scientific scope of research no doubt would have seemed rather limited to the industrialist, who explored avenues of invention solely where economic opportunity seemed greatest.

Out of that brief visit with Marey came Edison's famous Kinetoscope—the first commercially feasible motion picture viewer.[49] In *Two Reels and a Crank*, Albert Smith describes Edison's reaction to what he had seen:

Some time later Edison was to tell me of a visit in Paris with E. J. Marey, the distinguished French physiologist. . . . In Paris, Marey took him into his shop and there revealed his motion-picture camera, utilizing pictures in sequence, one under the other as they are today. "I knew instantly that Marey had the right idea," Edison told me. On his return trip aboard ship, he said, he penciled out a mechanical draft of a machine and immediately upon his arrival at Orange he ordered a halt on all work on the cylinder idea and the new project was launched.[50]

Marey's account of the meeting was published in his "Nouveaux développements de la chronophotographie":

For my part, as soon as I had realized chronophotography on moving film, I put long series of positive images in a zoetrope, and from this I got results that were satisfying

enough. M. Edison, to whom I showed them at the ex-position of 1889, was inspired by them, doubtlessly, to create his Kinetoscope.[51]

A month after Edison returned to America in October 1889, he wrote his fourth motion picture caveat: he abandoned the notion of a cylinder and for the first time substituted for it a long film band "passing from one reel to another" as the surface for the images. He also abandoned his earlier proposal to illuminate the images by an electric spark; now he described a constant source of illumination intermittently cut by a rotating-disk shutter. As he wrote out this last caveat, Edison had at hand Marey's *Le vol des oiseaux,* recently sent to him by the author; the book included the technical specifications for all the cameras Marey had been using.[52]

It seems likely that Edison and Dickson had seen published reports of Marey's photographic work even before Edison went to France. Translations of Marey's 29 October 1888 announcement to the Académie des Sciences with descriptions had appeared in English in the 5 January 1889 issue of *Wilson's Photographic Magazine.* Although Edison did not read French, Dickson read it fluently; his favorite journal was *La Nature,* and a subscription to the *Comptes Rendus* of the Académie des Sciences was part of the laboratory's list of journals. That Edison had to actually see Marey's machine in action before recognizing its principles is curious. But then, Edison was deeply involved with his ore milling scheme; the motion picture work was of minimal consequence to him, in fact, until the patent wars of the early part of this century obliged him to rewrite cinematic history, especially concerning his interest in the work Dickson was doing. As for Dickson, he too was consumed by separating gold from dross; until 1890 the time he spent on the Kinetoscope was so minimal that we can forgive him for ignoring the solution to the problems Edison posed.

In terms of a workable machine, Edison's fourth caveat was not a great improvement over the others. It described a viewing machine only, operating at ten images per second; its function was limited to microphotography; it involved engineering and machining applications that were at the time a practical impossibility; and Edison still proposed synchronizing the machine with the phonograph. But by fall 1890 Dickson was working almost exclusively on the motion picture account. On 10 February 1890 the English photographer William Friese-Greene (1885–1921) had written to tell Edison he had sent him a paper describing a "Machine Camera for taking 10 a second." Friese-Greene's paper seems never to have arrived, but its announcement, and the subsequent publication of Friese-Green's motion picture camera in the *Photographic News* on 28 February 1890 and in *Scientific American* on 19 April would certainly have stimulated Edison to speed up the motion picture work.[53] During the following year a series of events culminated in Edison's filing for a patent. On 10 January 1891 the disposition of Marey's new camera was given in the *Scientific American Supplement.*[54] By March, Dickson had a fifty-foot length of Blair's coated celluloid to work with.[55] In July, descriptions and illustrations of Demeny's phonoscope reached America (at the same time as extravagant claims for Edison's apocryphal kinetograph were being made in French journals). And at the end of the summer Dickson began to experiment with thirty-five-millimeter-wide lengths of Eastman's celluloid film, which he made by splitting in two the roll of film that came with Eastman's popular Kodak 2 camera and doubling its length.

Finally, on 24 August 1891, Edison applied for patents for a kinetograph camera and a Kinetoscope viewer. The application for the Kinetoscope covered a peep-show machine in which a looped band of images was passed over rollers and under a magnifying viewer. A constant illumination was in-

terrupted by a revolving spoked shutter that had a slit in the periphery of one of the spokes; through this slit the viewer caught a fleeting glimpse of each picture as it came into position (fig. 110). Most of the patent application for the Kinetoscope was disallowed in light of previous inventions, and it was not until 14 March 1893 that a patent for the "exhibition of photographs of moving objects" was granted to Edison on the basis of his method of transporting the film over the rollers to the viewer.[56] As for the camera that made these images, the details of its construction are unclear, and except for the device used to stop and start the moving film, which was granted a patent in 1893, all the parts of the application describing the camera were ultimately disallowed because of previous inventors' claims.[57] Edison did not attempt to patent either his camera or his viewer outside America. He must have understood that his claims would have been impossible to substantiate in the light of Marey's well-known motion picture work.

In both kinetograph and Kinetoscope the problem of equidistance was resolved by using perforations in the film strip and a serrated roller to move the strip along. Edison had described these perforations for the first time in the fourth motion picture caveat (where only one side of the film was perforated), and they were an important advance even though, once more, they were not original—in France Emile Reynaud had patented the perforations used to move his animated film band in 1888, and in England in the same year Louis-Aimé Le Prince published a description of perforations that he used in his "film ribbons."[58] Years later Edison did admit to knowing that the perforations had been in common use, although he stated he did not know who had invented them.[59]

Like Muybridge's zoopraxiscope, Anschütz's electrical tachyscope, and Demeny's phonoscope, the Kinetoscope confined the spectator to a limited number of images illuminated by a constant source of light that was made intermittent by a revolving shutter. (Anschütz got the same result by using the intermittent flash of a Geissler tube.) But the Kinetoscope images were on a film loop, which meant that whereas Demeny and Anschütz were able to make projections of only approximately four seconds, Edison's Kinetoscope film lasted for up to forty, certainly an important advance.[60]

Thus, in one sense, insofar as it was the product of scientific knowledge freely disseminated, Edison's machine was nothing new. But in another sense the Kinetoscope was unique: Edison had the financial clout, the labor, and the space to mass-produce Kinetoscopes for license. Thus the dissemination and commercial exploitation of the Kinetoscope were in great part responsible for the enormous progress made in creating a motion picture industry during the following three years, as its immense popular and financial success attracted the attention of other manufacturers and industrialists.

The Lumière family were just such industrialists. But they—the father, Antoine, and his two sons Auguste (1862–1954) and Louis (1864–1948)—saw that the future of animated photography lay precisely in film projections for large audiences, such as those who turned out to see magic lantern shows or Reynaud's Théâtre Optique. This was the avenue taken neither by Demeny, who saw his animated family album as a household item, nor by Edison, who wanted a product whose profits would accrue through the amassing of individual pennies (or nickels).[61] The Lumière Cinématographe was a reversible camera/projector used to throw images onto a screen. Its public debut for a paying audience on 28 December 1895 at the "Salon Indien" in the Grand Café on the bouvelard des Capucines made everyone forget the success of Edison's Kinetoscope.

Antoine Lumière was an amateur singer and

A

110.
Edison's Kinetoscope, 1894: (A) Exterior. (B) Cross section: *V* is a rotating-disk shutter with one slit *F* moving between the light bulb and the viewer *O*. (C) The film, about forty-five feet in length, is in the form of an endless loop moving continuously. *La Nature,* October 1894. New York Public Library.

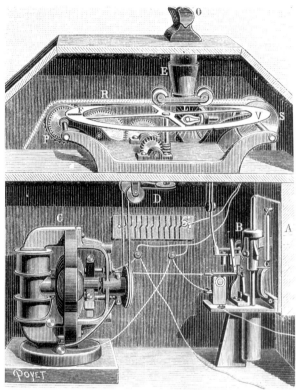

B

painter who had taken up professional photography in 1860. He seems to have been a success behind the camera, but in 1878 when he read about dry plates in the photographic journals, he saw an even greater opportunity to make his fortune.[62] Assisted by Louis, a talented chemist, he concocted an ammonia-based formula of exceptional quality for coating glass and paper, set up a factory to mass-produce both in 1882—the year Marey took up photography—and soon became one of the largest manufacturers of photographic supplies in the world.

As Louis Lumière had written to Demeny, the family's interest in motion pictures predated their meeting in the fall of 1894. And though, like Edison, the family is the subject of so much myth-making hyperbole that it is hard to decipher exactly what was the origin of this interest, it is generally agreed that the Kinetoscope was a decisive factor. By one account, the two brothers had already been approached by a Parisian Kinetoscope-parlor owner who wanted them to produce films for the Edison machine so that he could circumvent the high price charged by Edison's French agents.[63] Another story

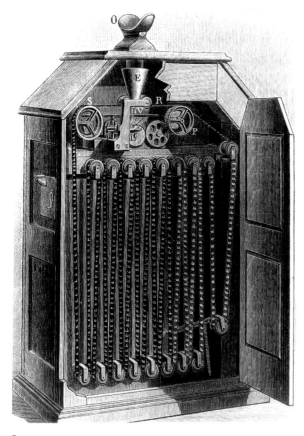

c

attributes their interest to a suggestion made by the mechanic Clément Maurice to Antoine,[64] while a third suggests that Louis Lumière himself was inspired by a brief glimpse of a Kinetoscope in a shop window to make his own machine in one sleepless night of inspired labor.[65]

But if Edison's Kinetoscope was the source of the Lumières' interest in the idea of motion pictures, it was not the source, contrary to the accounts above, of the actual machine they produced to make that idea a reality. What they had in mind, as Louis states in his letter to Demeny, was a re-versible chronophotographic camera that would be used for projection, not for single viewers. In fact, the Lumières did not need to have seen the Kineto-scope at all; what they needed was the two things Demeny had needed, Marey's camera and a way to stop and start the film that would ensure the equidistance of the images so that they could be projected.

The Lumière family knew Marey well, and they knew his work. As the major photographic suppliers of the Physiological Station, they would have kept abreast of the cameras being constructed there. Given their prominence in photographic circles, they would have also been aware of Marey's inventions from his frequent publications in the *Bulletin de la Société Française de Photographie* and from the expositions and congresses where their products were often displayed together with Marey's instruments and findings.[66] By one account they even had one of Marey's chronophotographes in their possession.[67]

By late fall 1894, the Lumière brothers had made the prototype for a commercially exploitable reversible camera. They had combined Marey's camera, perforated film, and their own original film-feeding mechanism. They solved the problem of equidistance by employing a tooth-and-claw mechanism that engaged a single perforation on either side of the film, pulled it down behind the lens, held it long enough for an image to be made, then withdrew and moved up—past the now stationary film—to be inserted into the next set of perforations. The tooth-and-claw mechanism was smooth and quiet and functioned with the regularity of a sewing machine needle—which was in fact its source (fig. 111).[68]

On 13 February 1895 Auguste and Louis Lumière took out a patent in both their names for a "projecting chronophotographe."[69] At the end of March they took out an addition that included an

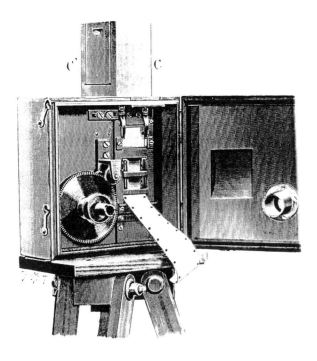

111.
The Lumière Cinématographe. *Revue du Siècle*, May 1897.

improvement to suppress the jumpiness of the images in their films (those we see today have been rephotographed). The new patent also included a new name. It was now called a "Cinématographe," an appellation originating in a patent delivered to Léon Bouly in 1892 that had, by a curious coincidence, expired that March for nonpayment of fees.[70] The private showing on 22 March was the first the Lumières gave with this new instrument; the second was on 17 April at the Sorbonne, and the third on 12 June in Lyons at a reunion of the Union Nationale des Sociétés Photographiques de France. In December they showed their films to the public, and the motion picture industry was born.

Although that year Marey was the president of the Société Française de Photographie, he was not present at the gathering of the Union Nationale des Sociétés Photographiques in Lyons or, as far as we know, at either of the private projections of the Cinématographe that took place in July and November in Paris.[71] In almost all contemporary accounts, however, his name was always associated with the wonderful advances now being made in animated photography. At Lyons, Auguste Lumière filmed some of the delegates, including Janssen,[72] disembarking from a boat on their arrival and showed the films the next day, after the showings of the first Lumière films (including "Exit of Workers from the Lumière Factory," "Train Arriving at La Ciotat," etc.) (fig. 112). Then Janssen gave a talk, recalling to the audience his own revolver and Marey's transformation of it and joining these achievements to the Lumières'.[73]

Marey's absence might suggest at least strained relations between the scientist and the Lumière family, but if so, the strain was never made public in his lifetime. Marey continued to work on his own version of a projector, keeping its "primitive character, that is, not perforating the films and producing very large pictures so as to be able to cover a great expanse with [the] projections."[74] Marey argued that though perforating the film ensured the equidistance of the images in such machines as the Lumière Cinématographe, the solidarity of the film with the pieces that produced its intermittent motion also contributed to the shakiness of the images and accounted for the very small dimensions of the projection.[75] Even after the success of the Cinématographe, Marey still did not seem to consider his projector in terms of widespread commercial applications—it was directed at scientific filmmakers who, he imagined, would be using it as he would— yet he did hope to sell enough machines to recoup the cost of having any new version made.[76] His "reversible chronophotographe" of 1896 introduced two loops into the film-feeding mechanism (one on

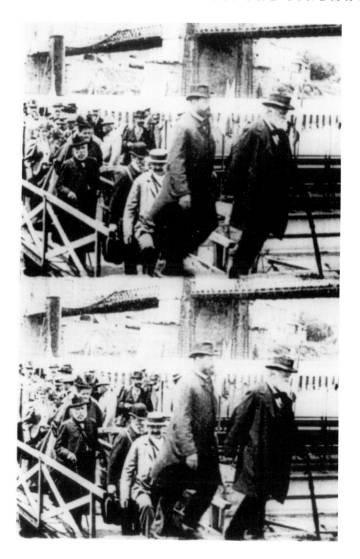

112.
Auguste Lumière, Jules Janssen (on far right) disembarking at Lyons, 11 June 1895.

each side of the compressor that pressed the film against the back of the lens) and an eccentric cam that regulated the movement of the compressor (fig. 113).[77] This advance diminished the abrupt way the film halted, but Marey does not seem to have demonstrated it until 1899. On 5 May that year he demonstrated a new thirty-five-millimeter-camera/ projector for "any film, perforated or not" to the Société Française de Photographie.[78]

The last instrument Marey made in this series was certainly the most futuristic. It was a portable electric gun camera (*fusil électrique*) presented at the 1900 Universal Exposition. The camera took a band of thirty-five-millimeter-film twenty meters long and was powered by a light generator or battery that had to be carried by an assistant (fig. 114). As Michel Frizot points out, all other cinema cameras at this time were fixed on a tripod, so it is strange that this model—the ancestor of the portable cameras of today—passed completely unnoticed and was not even copied.[79]

It was usually Marey's habit in his publications to make laudatory reference to the Lumières' exploit as the satisfactory resolution to reproducing the illusion of movement:

The Lumières found, in 1895, the much-sought-after solution. Although they borrowed one of Edison's means, the perforation of the films, they nonetheless discovered an original procedure for taking and projecting images on film. . . . [This invention], under the name Cinématographe, attained considerable success, and its name, which is only that of a particular chronophotographe, will long remain associated in memory with all syntheses of movement.[80]

To be sure, this was not an area of overwhelming interest to Marey: it was to capturing the invisible rather than reconstituting the visible that he had dedicated his life. Far more important to him were slow-motion and high-speed cinematography,

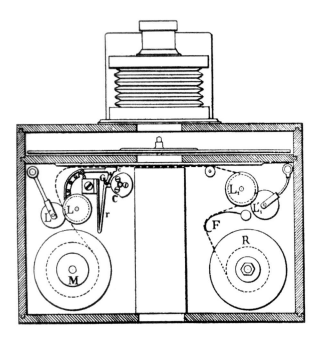

113.
Cross section of Marey's *chrono-*
***photographe reversible,* 1896.** *Bulletin*
de la Société Française de
Photographie, **1897.**

acute, [chronophotography] is the instrument of scientific knowledge.[81]

Thus, even though his name was coupled with the Lumières' in the many articles treating animated photography, Marey insisted on the differences between the scientific and commercial applications of cinema. The Lumière family, on the other hand, in their aspirations to benefit from the prestige of the scientific establishment, emphasized the scientific importance of the Cinématographe and tended to diminish its entertainment value. This, among other reasons, was why their first showings were to groups of scientists. Indeed, by 1900, when the sales of their Cinématographe and of the films made for it established the preeminence of their photographic supply firm and put it on a more secure financial basis than ever, the Lumière family sold their camera rights to Charles Pathé and yielded their domination of the cinema industry in France to follow more orthodox scientific ventures.[82]

Marey's perceived distinction between the scientific and commercial applications of chronophotography, however, was officially echoed at the Universal Exposition of 1900 that took place in Paris. The exposition marked a century of scientific progress. The Lumière contribution was represented by a giant Cinématographe that projected their films onto a fifteen by twenty-meter screen, made transparent so that the images could be seen from both sides simultaneously.[83] Marey was named president of the "Musée Centennal de la Classe 12" —the photography pavilion. His task was to choose the photographic and chronophotographic instruments and subjects to be displayed. The jury of Class 12, over which Marey presided, included not one member of the Lumière family, even though their Cinématographe was to be exhibited in the pavilion and their film showings attracted huge audiences every day.

two aspects that are still used to enter into worlds otherwise invisible to us.

The absolutely perfect projections that naturally arouse the enthusiasm of the public are not those, speaking personally, that captivate me the most. *The most appealing chronophotography is not the most useful* [Marey's emphasis]. Chronophotography provides greater assistance, perhaps, in its simple analytic form than in its synthetic, however satisfying and astonishing that resurrection of movement may be. I make an exception for those cases when, in projecting the representative images of a movement's phases, we modify the conditions of speed in which the movement was produced. . . . It is only there that, facilitating human observation and making it more

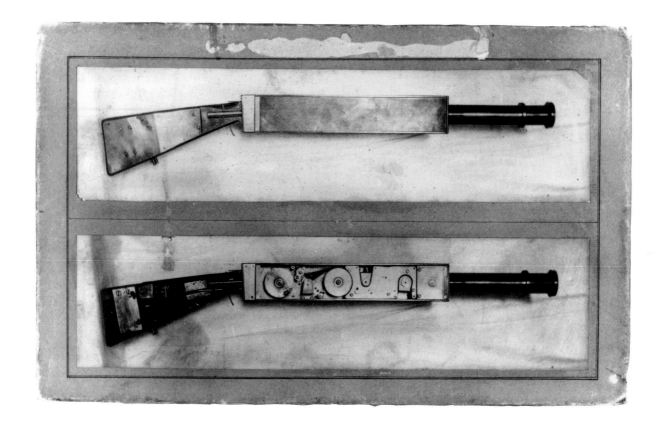

114.
Marey's *fusil électrique,* 1899.
Beaune.

The absence of the Lumière family on the jury
was not inadvertent; they were the most highly
visible representatives of the interests of cinema at a
time when it was a low form of fairground enter-
tainment, the heir of popular entertainments like
the music hall, variety theater, and the circus.[84] Nei-
ther was Marey's presidency a token honor for such
an esteemed scientist. It was, rather, a ministerial
assertion of the centrality in official circles of the
scientific tradition of photography and cinema-
tography, stated through the figure of the most
famous representative in the field—a scientist,
moreover, who was above the patent and licensing
wars that by that time had already begun. The
honor being given to Marey was that of constituting
the history of the medium: he would choose what

instruments and developments were worthy of display and describe their part in the history of chronophotography (fig. 115).

The exclusion of the Lumières seemed unfair both to them and to their supporters, and pressure was put on Marey to redress this injustice. Marey's response was to write to the ministry asking to be excused from the jury:

There is a name that everyone regrets not seeing on the list of the jury of Class 12, that of one of the heads of the Lumière enterprise of Lyons, the most important in France and even in Europe.

The Lumières are not only first-class manufacturers and merchants, but also very distinguished savants. Inventors of the Cinématographe, they have made important discoveries in chemistry too; they apply their fecund activity to the most varied research. It would be difficult to find more competent jurists to appreciate the diverse products of Class 12.

On the other hand, because of the multiple duties that I have rather imprudently accepted, the functions of

jury member that you have honored me with have become heavy indeed.

As president of the hygiene and physiology commission, I must follow the athletic competitions all through the summer, and this would mean often having to choose between incompatible duties.

If you would accept, minister, replacing me as titular member of the jury with M. Louis Lumière, you would be doing two good turns: first to the jury, which would gain in its competence, and then to myself, whom you would render capable of serving more usefully the interests of physical education and hygiene for which my work has particularly prepared me.[85]

The ministry was only partly swayed by Marey's letter. In a judgment worthy of Solomon, it accepted Louis Lumière as a member of the jury but also reconfirmed Marey's presidency. These events marked the prologue to a battle over the invention of motion pictures that would explode into a war of words twenty years later.

115.
Part of Marey's Class 12 display at the Universal Exposition of 1900. *Musée retrospectif du groupe I: Education et enseignement à l'Exposition Universelle de 1900.* Courtesy Hagley Museum and Library, Wilmington, Delaware.

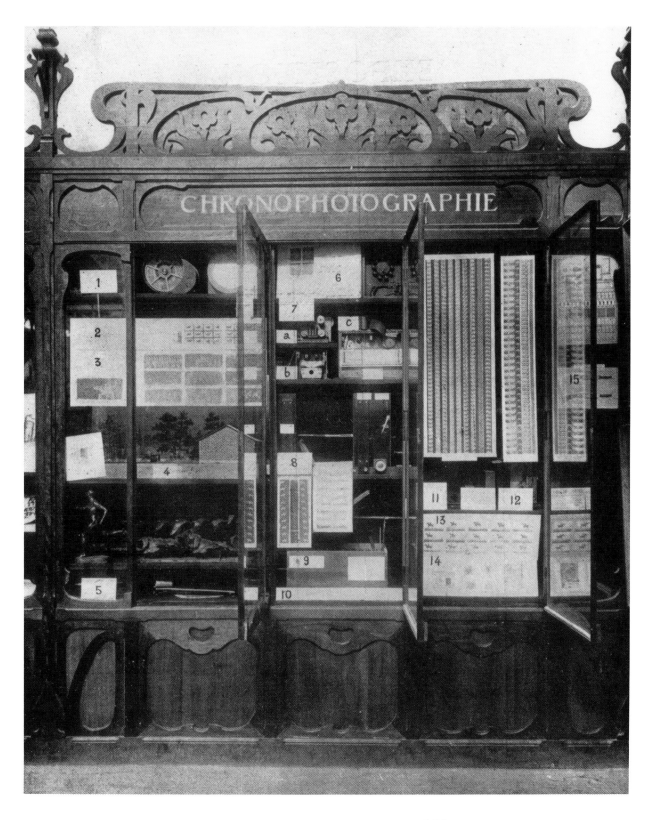

5 *The Last Work*

There is no doubt that at the turn of the century Marey's claim of overwork was true. In addition to his duties as the president of Class 12 at the Universal Exposition of 1900, he had an important role to play in two other events that summer: he was vice president of the International Congress of Aeronautics and the *rapporteur* of the commission on hygiene and physiology for the "Concours Internationaux d'Exercices Physiques et de Sport," a watered-down version of the Olympic Games held practically on his doorstep in the Bois de Boulogne from May to October.[1] The work on all three committees was extremely demanding, but it seems most fitting that Marey, who had contributed so much to the development and growth of photography, aviation, and the study of human locomotion should be the representative of the achievements of those three fields at the exposition. After all, it celebrated the dawn of a new century, one that would see aviation become an accepted mode of transport, photography its most powerful art, and cinema and organized sports its most universal entertainments.

The human locomotion studies Marey had done were so fundamental to understanding how we move that as gymnastic education became universal and as organized sports made headway from England into the French educational system, Marey was frequently called on to design experiments to investigate the effects—both positive and negative—of these different types of movement on the body and to be on committees established to find

the proper way of training future generations. At first, as I described in chapter 3, the aims of gymnastics education in France were military preparedness and national revitalization. As the century drew to a close there was a change in this stance, from pure militarism to a more diffuse form of patriotism; the search was on for exercise and activity that would have the greatest possible benefits for the entire population rather than for an elite group of potential soldiers.

In 1894 the question of the benefits of cycling came up in one of the sessions of the Académie de Médecine. Marey had been studying the effects of the sport since 1891: he had chronophotographed his subjects mounting and dismounting in order to teach these maneuvres (fig. 116) and had investigated the comparative muscular development of cyclists and pedestrians. In 1894 he was called on first to give an opinion on the benefits of the pastime and then to chair a committee that would undertake a study of cycling, the most exciting (and egalitarian) pastime of the day.

The bicycle had been known in France since the 1860s, but it had been a plaything of the elite, an expensive luxury only a few could afford. When Marey first turned his attention to cycling, however, the bicycle was in the throes of being converted "from a luxury object—one with which an archesthete like Robert de Montesquiou did not disdain being photographed—to a solid investment accessible to middle—and lower-middle-class budgets"[2]

and, one might add, accessible to both sexes. The advent of replaceable pneumatic tires in 1889 made the machines lighter and cheaper. After 1891, cherished and publicized by the press, cycling became the most popular of sports.[3] By 1897 there were 300,000 cyclists in France, and their number increased every year. Cycling was a mania with significant side effects: a new tourist industry created as cyclists left the city to roam the highways and byways of the country; the founding of the Touring Club de France, which mass-produced maps and guides and indirectly affected the quality of inns and hostelries;[4] the improvement of the roads the cyclists had to ride on; and the establishment of associations that, if at first devoted exclusively to cycling, had the additional merit of soon drawing their members to related forms of exercise.

Although he was not, as he put it, a "practitioner," Marey was all for the sport: it was, he said, a beneficial form of exercise that did not bore young people the way the more standard repetitive gymnastics exercises did. Cycling gave its enthusiasts "both a common form of transport and a way to amuse themselves." As for the effects of fatigue, Marey noted, the machine "uses up less energy than walking because the body's center of gravity does not have to be raised at each step." The only drawback was a minor one: "like all exercise, the bicycle puts only certain muscles into action."[5]

Marey's experiments were focused on finding the best machine for the would-be cyclist, the ve-

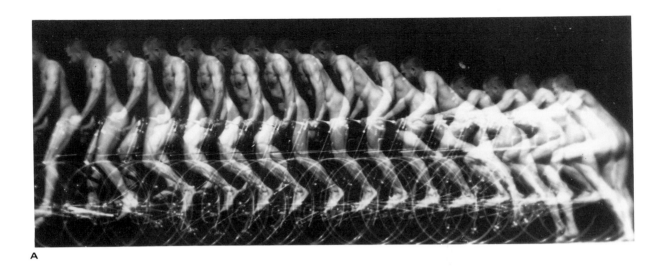

A

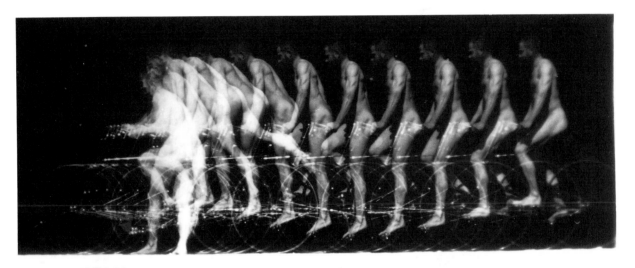

B

116.
Bicycling: (A) Mounting, 1891.
Collège de France. (B) Dismounting,
1891. (C) Pushing a cart, 1891.
(D) Riding a tricycle, 1891. Ciné-
mathèque Française.

202

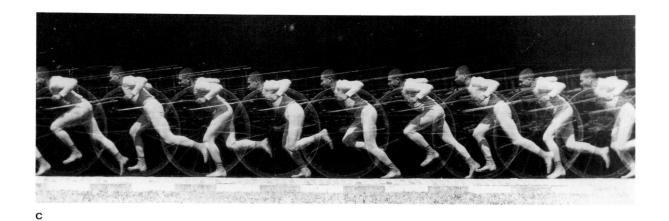

C

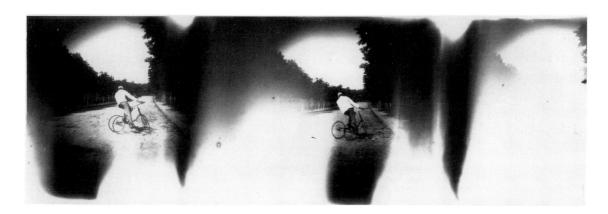

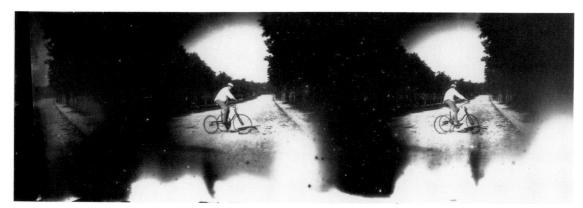

D

hicle that was easiest to learn to use and caused the
least fatigue to the rider. For this purpose he ana-
lyzed the effects of different models on the riders.
As with practically all his experiments in loco-
motion, the cyclists he photographed were the
well-trained athletes from the Ecole de Joinville. He
had them maneuver both two- and three-wheelers-
—the latter, still very popular, were thought to
exercise the upper body as well as the legs—so that
he could analyze which muscles were primarily used
in the sport and how those muscles could best be
trained. He also had the riders work with a dyna-
mometric bicycle he had fabricated that measured
the muscular work of various pedaling actions (fig.
117). Both plates and films were adopted for the
investigation. The findings—among them the fact
that the farther back the seat was from the pedals,
the more fatiguing the ride—were reported both in
the scientific journals and in the popular sports
magazines that had made the sport such an obses-
sion with the public.

The sports and athletes that Marey studied at
the 1900 Olympics or, more correctly, the "inter-
national competition of physical exercises and
sports" (in 1900 the Olympics "foundered before
the antagonisms of rival or unsympathetic cliques
and for the only time since 1896 the Games turned
into a mere series of athletic events, symbolically
presided over by the president of the Union des
Sociétés de Tir")[6] could in no way be compared
with cycling and its adherents. Cycling had become
a pastime open to all classes and both sexes; the
Olympic Games were the province of an elite. The
founding of the modern Olympics in 1896 by the
herculean efforts of Baron Pierre de Coubertin is an
important part of the history of sports in France.
Sports—the term reflects its English source—were
introduced there in the 1880s by Anglophiles like
Coubertin as an agency of moral rearmament.
These pioneers hoped to transfer with the English

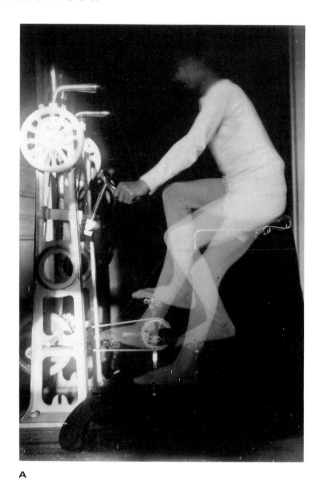

A

117.
(A) On the "home trainer," a dyna-
mometric machine for the study of
the muscular work used in cycling,
1895. (B) Marey's dynamometric
bicycle with inscribing cylinder in the
main hall of the chalet, 1894.
Cinémathèque Française.

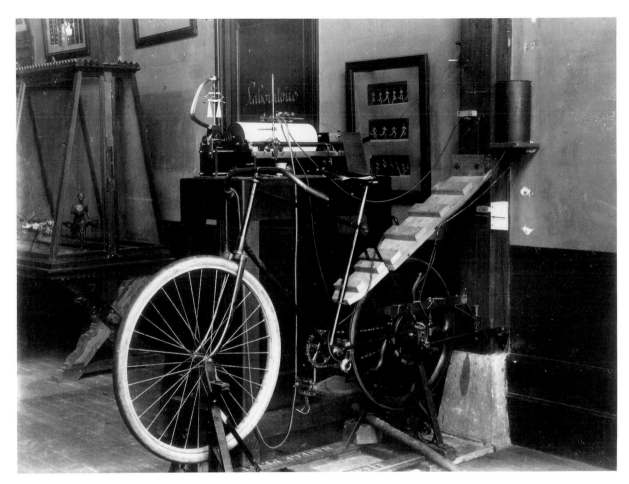

B

games (particularly running and ball games) what they perceived to be the English recipe for national greatness: "physical fitness, self-reliance, initiative and adjustment to the modern world."[7] This desire to create superior human beings did not coincide with the aims of the physical education enthusiasts whose goal was a universally prepared nation; nor were its representative specimens to be plucked from the sons of the masses. Although some of the newly accepted sports like rugby and soccer would, after the First World War, become games that everyone could and did play, the men who would

form the backbone of such groups as the Union des Sociétés Françaises de Sports Athlétiques (formed in 1889 for the practice of tennis, soccer, rowing, and running), the spawning ground of the French Olympic athlete, belonged exclusively to the upper and upper-middle classes.

Marey's study of the athletes who took part in the 1900 games was a particular pleasure for him. All his life he had tried to make images of the "elite" subject, "for example the prize-winners at athletic sports. These champions," he wrote, "will thus betray the secret of their success, perhaps

unconsciously acquired, and which they would doubtless be incapable of defining themselves."[8] Now he was surrounded by examples of such ideal specimens from all over the world, and he was about to find out, he hoped, just what made them so special.

Marey's task was to investigate the "precise methods and the effects of different sports on the organism and to compare their value from a hygienic standpoint."[9] In an enormous testing program that included anthropometric measurements as well as information gained from Marey's spirometer (which measured oxygen consumption), graphing instruments, and chronophotography, the commission sought to determine the relation between an individual's physical conformation and his aptitude for certain sports. In their plan for an answer they intended to measure the changes in the form and frequency of the heartbeat, respiration, and evaporation and the changes in the volume of the organs involved before and after competition. They also intended to study movement itself as well as the athlete, to analyze the motions from the point of view of both kinematics and dynamics, and to have the subjects fill out a questionnaire (treating heredity, age, life-style, and nutrition), which Marey hoped would lead to an understanding of the aptitude of some men for particular sports. It turned out to be a rather daunting assignment.

There were complications in transporting the instruments to the events, which took place in many different venues, and the athletes themselves were none too keen. They were unhappy about undergoing such a battery of tests before they competed, and they were uninterested afterward. With the many track and field events that took place at the Paris Racing Club,[10] Marey had no trouble; the directors of the club allowed his assistants to set up "measuring instruments, dressing rooms, an enclosure for the anthropometric photographs, and

large canvases for backdrops for the chronophotographic photographs."[11] For the rest, Marey found that by offering the athletes films and photographs of themselves (taken by Paul Richer and Lucien Bull, who were assisting him) as a reward for their participation, he could get the winners of the different meets to come to the Station, repeat their performances, and undergo his tests.

The films made of the athletes, in Marey's words, "gave up the secret of the superiority of one champion over another; they are a precious guide for those who would have similar success."[12] The films also explained a rather perplexing fact: although the tests had determined that the French athletes were indeed in better shape—that is, their basic physiological functioning provided optimal endurance (thus validating the ideal of physical training that Marey and Demeny had espoused)— the Americans won most of the events. They beat the French in the hurdles, shot put, discus, long jump, and high jump (an American named Sweeney had made a record high jump of 1.97 meters). The American prowess was a result of the introduction of sports in the early education of its young men. Their techniques, conscious or otherwise, were more sophisticated than those of the other competitors. In the hurdles the Americans leaned over as they jumped, whereas others held their torsos perpendicular; for the shot put and discus they wound up their throws by spinning their bodies and using their arms in a whiplike action, whereas the others used their arm muscles alone in the manner represented by Myron's *Discobolus* (fig. 118); and in the long jump the Americans used their arms to increase the velocity of the whole body. Their method of attacking the high jump was a revelation to the Europeans: instead of throwing the whole body over at once, the American champion let one leg lead. All of this was revealed by the camera. It could show the minute variations on running and

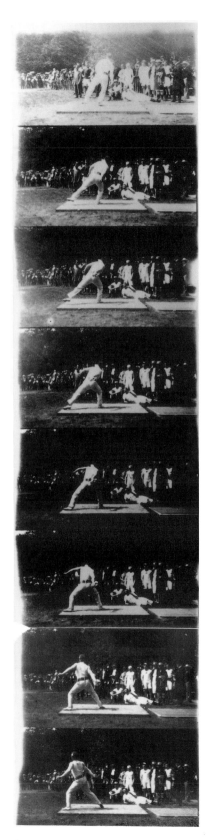

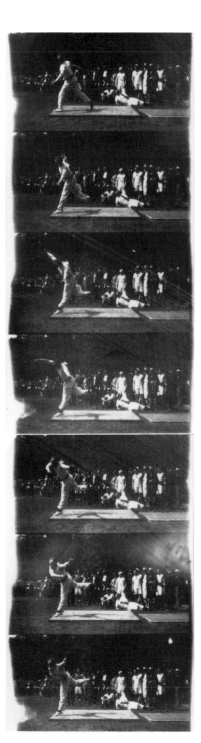

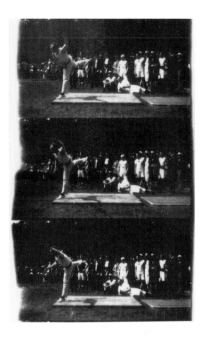

118.
Discus throwing at the International
Games of 1900 in Paris: (A) Member
of the Racing Club. (B) French
athlete. (C) The American athlete
McCracken. Cinémathèque Française.

A

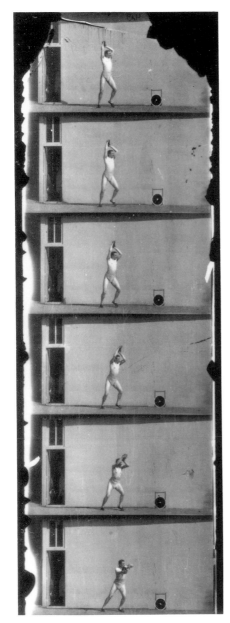

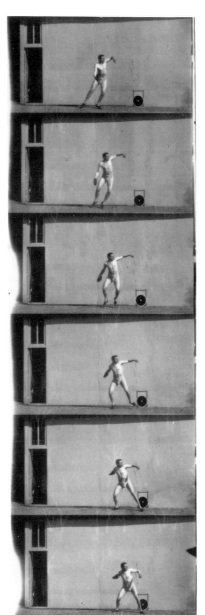

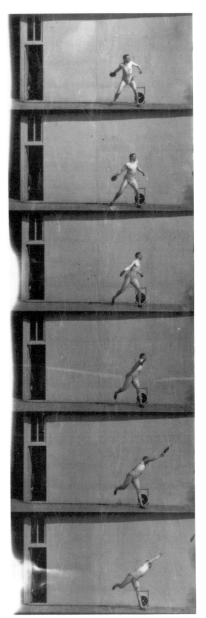

B

208

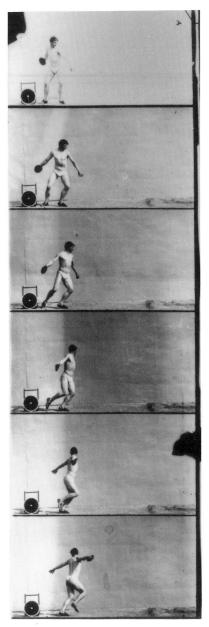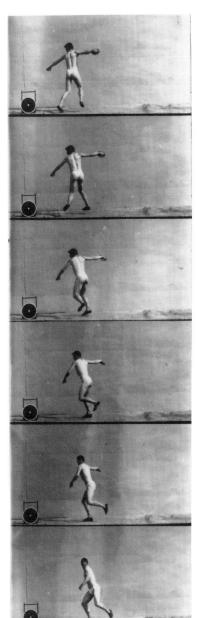

C

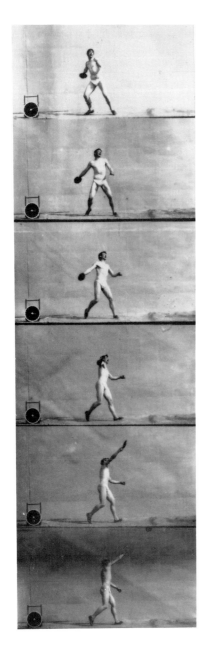

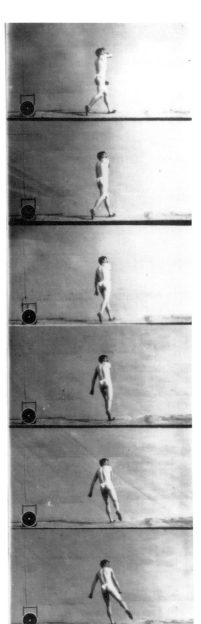

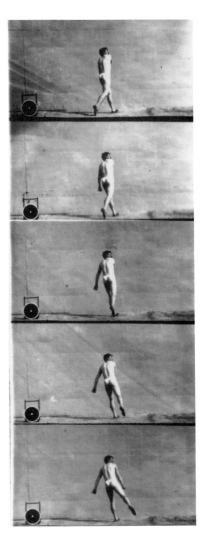

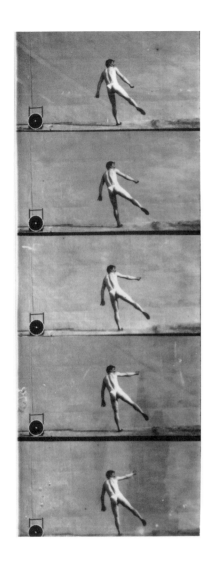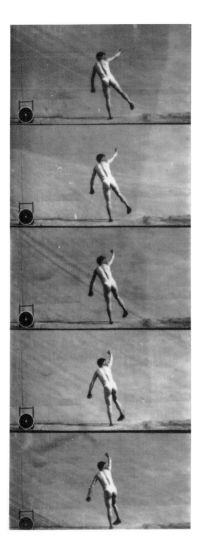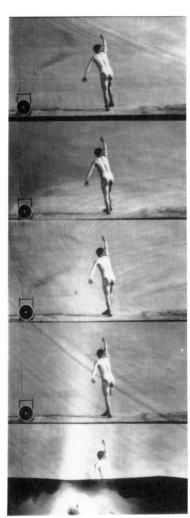

211

jumping and throwing techniques that gave the Americans their enormous advantage. As Marey reported: "Chronophotography shows that the Americans have a real advantage over the others thanks to ingenious tricks that the rules did not prohibit, that they did not even foresee, but that make comparisons among the different competitors of the form they use in the same sport impossible."[13]

But the films did not merely show the advantageous "tricks" of the Americans; they also helped in training the French athletes. They exposed the movements that best developed those muscles most in play in each sport, and they showed what movements or stances caused or increased the effects of fatigue. Filming the athletes was an ingenious way of studying a problem, since each movement could be analyzed in the most profound detail, phase by phase in slow motion. Modern video cameras have taken up this task; today no athlete would do without the assistance of what the camera reveals, both in assessing his or her own performance and in analyzing the strengths and weaknesses of competitors.

The testing and filming of the Olympic athletes continued while Marey took up his duties as vice president (Janssen was the president) of the International Congress of Aeronautics in August.

In the 1890s, the possibility of a practicable heavier-than-air flying machine had seemed only slightly out of reach. Ornithopters were no longer considered feasible by would-be aviators, yet the problems to be resolved with fixed-wing aircraft still seemed prodigious. The first major difficulty was to create a power plant for the machine (and to translate the power into forward motion). Although there were many possibilities for engines, a lightweight steam engine still appeared to be the logical choice, because the difficulties of the internal combustion engine were, until the early years of the

twentieth century, too great to consider its inclusion.

The second challenge to aviation researchers was to extend and correct the limited and often erroneous knowledge that prevailed in the area of aerodynamics. Here the design of a viable wing was the most important goal. Both the wing surface necessary to support a given weight and the correct shape for a wing were investigated. The virtues of the cambered wing—one with a slight convex curve to its upper surface—had been proved by, among other experiments, Marey's investigations of bird flight, but it remained to understand how it functioned effectively in the air. The problem of controlling the aircraft in motion was also related to the aerodynamic aspects of flight. Unlike a body moving on land, which operates on two axes, an airplane involves three axes of motion.[14] To control all three was to prove one of the most daunting obstacles to man's dream of wings.

By 1900 there were generally three ways of tackling these problems, although the methods were not systematically carried out: creating and building model aircraft; constructing full-scale machines (which, because they concentrated attention on the development of a suitable aeronautical power plant and not on aircraft control, were doomed to failure); and flying full-scale gliders.[15] Glider flying, unlike the first two approaches, focused on flight control in the air; it proved the most popular and was ultimately the most fruitful. The successful flights made by the German Otto Lilienthal between 1880 and his death in a gliding accident in 1896 were the "greatest single factor in building popular enthusiasm for aeronautics."[16] However, until the breakthrough in 1903 of Wilbur (1867–1912) and Orville (1871–1948) Wright, who were the first men to fly successfully, none of these approaches was carried to a satisfactory conclusion: no model maker scaled up his craft, nor did the glider pilots add engines to their machines. The

Wright brothers succeeded by combining a glider that they had learned to control in the air through repeated trials with a small gas engine they themselves had constructed for the purpose.

Marey was the éminence grise of French aviation; after his publication of *Le vol des oiseaux* in 1890, his role as an experimenter had slowly given way to that of consultant and adviser. His writings on flight remained the firm foundation for all aeronautical research in France and abroad, but French aviation itself was static by the end of the century. Model making was still in the forefront of French experimentation, and since model airplanes would not fly successfully unless they were inherently stable, the search for stable aircraft dampened any progress that could have been made. Marey continued to report the results of many experimenters to the Académie des Sciences, and he was the first to introduce the famous aeronaut Clément Ader to this august body. Ader belonged to the group of pioneers Gibbs-Smith aptly calls "chauffeurs," those who conceived of flying an airplane as steering an airborne automobile. Their opposites, "true airmen" in Gibbs-Smith's parlance, thought primarily in terms of control in the air.[17] Ader succeeded in constructing a full-scale machine powered by a steam engine. Unfortunately, his ignorance of control in the air ensured disappointment. His 1890 *Eole* flew for a few seconds and was the first piloted powered airplane to raise itself from the ground without assistance,[18] but his 1897 *Avion III* did not even leave the ground.

In America, meanwhile, the 1890s saw a tremendous increase in aviation experimentation and research, and it was from across the ocean that a new stimulus would come for Marey's final aviation studies. At the center of the American enthusiasm was the man "responsible for propelling American aeronautics from folk technology to the status of an engineering discipline"[19]—Octave Chanute (1832–

1910), an American engineer born in Paris. Chanute's early interest in aviation was born out of a trip to Europe in 1875. In Europe, Chanute realized, the possibility of heavier-than-air flight was attractive to men of science and vision. In America at that time, aviation was mostly the obsession of cranks. On his return to America Chanute began to convert all who would listen. He was subsequently responsible for making European endeavors known in America and reporting American undertakings, especially those of the Wright brothers, in Europe.

Even before the two men met in Paris at the Aeronautics Congress of 1889, Chanute had been an ardent supporter of Marey and an enthusiastic promoter of his studies of flight. Chanute's familiarity with Marey's *Vol des oiseaux* ensured that the vital information it contained reached American proponents of aviation. Chanute's *Progress in Flying Machines*, published in 1894, an exhaustive and popular compendium of aviation experiments to date, provided the first detailed description in English of Marey's and Tatin's achievements.

It was through Chanute's proselytizing that Marey's work on flight became known to Samuel Pierpont Langley (1834–1906). Langley, an astronomer and astrophysicist, had been converted to the idea of heavier-than-air flight by Chanute in 1886 and from that time had directed all his prodigious energy to achieving mechanized flight. Throughout 1887, while head of the Allegheny Observatory in Pittsburgh, Langley had experimented with the effects of air pressure on different shapes of plane surfaces attached to a whirling arm. But according to the aviation historian Tom Crouch, Langley's research left something to be desired: as with most of his aeronautics work, the findings of his whirling-arm experiments (performed in secret under the heading "pneumatics") were largely erroneous, the result of too much enthusiasm and not enough science.[20]

In November 1887 Langley was made third secretary of the Smithsonian Institution in Washington, D.C. This appointment gave him access to increased funding for his aviation work; it also meant he could take advantage of the Smithsonian's carpentry and machine shops, which he immediately turned into research and development facilities aimed at producing a successful flying machine.[21]

Langley's first project was to build some thirty or forty models powered by twisted rubber bands, based on Pénaud's 1872 model. By 1891, however, Langley's experiments had led him to believe that a larger model powered by a steam engine was in order. He began to build and test full-scale steam-powered machines—he used the malaprop "aerodromes"—throughout 1892 and the following years, even though he still had little experimental evidence that a large airplane could be flown. Langley was the American counterpart of Ader; like him and the other "chauffeurs," Langley was interested in a power plant, not in pilot control. He had endless trouble with his machines, and at the end of 1894 he voiced his disappointment that "what might be called a real flight had not yet been secured."[22]

In the midst of these failures he first wrote to the photographic chemist Louis-Alphonse Davanne in June 1895 about purchasing one of Marey's photographic guns to study the flight of birds. Davanne passed the letter on to Marey, who replied that he no longer used the photographic gun but that his film camera, "superior to [the gun] in every way," would suit Langley's purpose and that he would have one constructed according to Langley's specifications.[23] When Langley went to Europe in late summer he met Marey and discussed with him the latest advances in aeronautical research in France. It is unclear whether this meeting had a direct effect on the direction of Langley's experiments, but soon

afterward he switched to building tandem-wing machines, and one year later, in May 1896, he successfully launched a tandem-wing airplane. It was catapulted from a houseboat in the Potomac River and stayed up in the air for almost two minutes—a time sufficient to demonstrate that the plane had unquestionably flown.[24]

In spring 1897 Langley received a letter from Marey inquiring about the availability of Smithsonian subsidies for his research at the Physiological Station. "The creation of the chronophotographic cameras," Marey wrote, "has appreciably diminished my personal resources. The budget for the Station has been reduced to nine thousand francs. Under these conditions I can carry out only very slowly the studies I have begun on animal locomotion and on the physiology of bicycling. These researches demand expensive apparatus. If the Smithsonian Institution would come to my aid, I could effectively use the years of activity that remain to me to be consecrated to science."[25]

In his response, Langley asked if Marey had any investigations in mind that could be funded under the terms of the Hodgkins bequest, money left to the Smithsonian to be used in "the investigation of the properties of atmospheric air."[26] He urged Marey to apply for a Hodgkins grant, but Marey had doubts about his capabilities: "My insufficient knowledge of mathematics prohibits me from leaving the experimental field. Sometimes I am even quite embarrassed by my inability to interpret certain experimental results like those of the smoke fillets in the experiments that I have spoken to you about. They proceed very slowly."[27]

The "smoke fillets" Marey mentions were part of his chronophotographic studies of the movement of air currents around plane figures of different shapes. They were a new development in his aerodynamics experiments, and they interested Langley very much. When the two men met again in Paris at

the 1900 Aeronautics Congress,[28] Langley once more urged Marey to use the Hodgkins money to expand his research; "I personally would be very glad," he wrote again in November, "to be the means of associating this Institution with your eminent researches."[29] Evidently this time Marey let himself be persuaded, for the grant was finally awarded to him at the end of that month. With the money from the Hodgkins fund Marey expanded his work with the "smoke fillets" and, in so doing, created one of the first wind tunnels for visualizing airflow.

All his life Marey had been attempting to knit physiology to physics, hence his photographic experiments on such phenomena as hydraulics, the fall of bodies, the resistance of the air, and the vibrations of rods and strings. Toward the end of the century he had entered more deeply into the domain of physics proper; he had concluded his analysis and synthesis of the movements of practically every kind of animal that stirred on the earth or in the air or water. Now Marey turned his cameras on the invisible media through which the movers moved to make visible the motion of water and of air.

Marey's experiments on the movement of air evolved out of an 1893 study of the movements of liquids; that study in turn began with his 1888 investigation of aquatic locomotion. In that year he had built a special aquarium to help him capture the sinuous horizontal progression of the eel (see fig. 84). He had outfitted the usual glass-sided tank with a black backdrop and a transparent bottom and put a mirror at a forty-five-degree angle underneath the tank, which directed the rays of the sun onto the swimming animal. He then constructed a large opaque box, enclosing the whole aquarium in one end of it and his oscillating-mirror camera at the other. This arrangement eliminated all other light and rendered the water invisible; it turned the

eel into a silhouette and made its movements dramatically clear.[30]

Marey adopted the same arrangement in 1893 to further clarify the mechanism of the locomotion of fish, this time making the images with his double-use camera on a glass plate. He ended by tracing the movement of the water itself (fig. 119).

Through the camera Marey could see a very brilliant fine line marking the surface of the water, and he recorded the undulations of this line, noting the variations in its contour and changes in its velocity. He created the undulations he photographed by plunging a solid form or a small propeller into the tank just outside the camera's view. He also created and recorded the movement under the water's surface by tossing small silvered balls of wax and resin into the tank; their trajectories revealed the inner rhythm of the liquid's rise and fall.[31]

The next experiment in this series was designed to produce currents and eddies for the camera. Marey placed a sheet of glass at a forty-five-degree angle to the stream with its edge to the camera. The little resin pearls (called molecules by Marey) were then photographed as they moved around the glass, and since the camera made instantaneous images at equal and known intervals, Marey could even measure the speed of the current he had so ingeniously made visible. When he immersed a rectangular glass box in the water, his camera caught the swirls and eddies created behind the box by the flow of water over its surface. The loss of energy represented by the turbulence of the water behind the box was a measure of its resistance. By varying the shapes of the objects he immersed, Marey could take photographs that would handily make apparent which ones offered the least resistance (the pisciform) and which the most (the rectangle) (fig. 120).[32]

In one sense these experiments in hydraulics revert to the earliest work Marey did on the movement of liquids, that on the circulation of the blood.

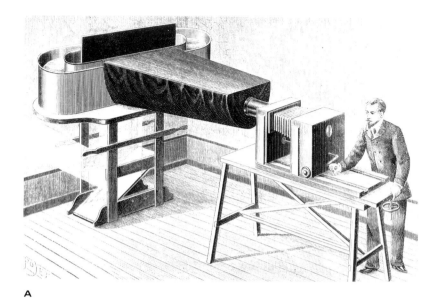

A

It is an instructive notion, for it demonstrates the almost incredible gains he had made since 1859. With his early recording instruments, such as the sphygmograph, Marey could record the movement only indirectly; for example, he could trace the action of the blood by registering the expansion and compression of the arterial wall as the blood moved through the vessel. Now he could make the movement of liquid directly visible.

Marey's study of the movement of air followed the same lines as his study of water. Guided by his perpetual ambition to clarify the action of the bird's wing on the air, he began by photographing the wing moving through the air and ended by photographing the air moving around the wing. Complaining in 1891 that engineers dealt with "values and components of air resistance only for thin and rigid planes" and that they experimented only with "simple geometric forms" and "inclinations of constant angles,"[33] Marey had decided to try to photograph the movements of a small paper plane model whose flexibility would provide more complex variations and responses to the pressure of the air as it

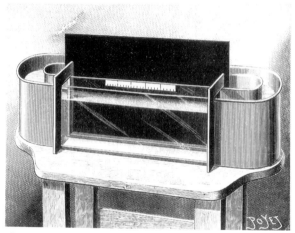

B

119.
(A) Aquarium and camera for studying the movements of fluids.
(B) Disposition of the aquarium, 1893. *Movement.*

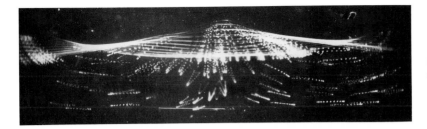

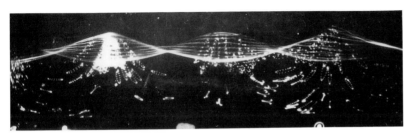

A

120.
(A) Studies of the movement of waves.
(B) Studies of the velocity of currents,
1893. Glass diapositives. Collège de
France.

flew. The photographs he produced of the paper airplane revealed one of the most critical events affecting control of an aircraft—stall. When the curved surface was brought to the horizontal position and the angle of attack was zero, the center of pressure moved quickly to the rear, forcing the airfoil (a surface made to be moved through the air so as to keep the aircraft up or control its movements), and consequently the aircraft, to dive suddenly and precipitously (fig. 121).[34] This is what would kill Lilienthal in 1896.

The physical phenomena that kept the models, gliders, and large-scale experimental airplanes in the air (or caused them to crash) were for the most part unknown, and Marey was convinced that if he could make the movements of the air visible he could understand such phenomena. In his presentation on the movement of fluids to the Académie des Sciences in 1893, and again in his book *Movement*, Marey commented that "chronophotography might . . . be applied to the study of movements in air when one wanted to find the resistance offered by a body of a particular shape to a current of

greater or less velocity. For this purpose a number of light and luminous objects would have to be set floating in the air."[35] The idea of using "light and luminous objects" floating in the air (he had thought of small bundles of down) was evidently not feasible: no record of such experiments exists. But then Marey began to work with an idea he had first read about in 1886. Here is how he had described it that year to Demeny: "A memoire on the action of a wing beating the air has interested me very much. The author has made the air visible by means of smoke fillets or phosphorous vapors, a method for seeing the invisible which quite seduces me."[36]

By 1900 Marey had succeeded in producing his own version of these smoke fillets; he had also found a way of introducing them into a glass box like the aquarium he had constructed to photograph the movement of liquids. In other words, Marey constructed a wind tunnel, the grandfather of those still in use today to visualize how air flows around an airplane wing. He built a ventilator to propel the smoke—made by burning tinder and

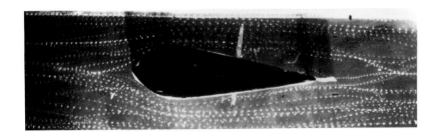

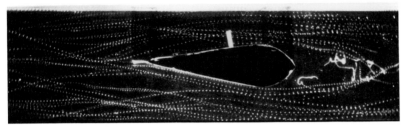

B

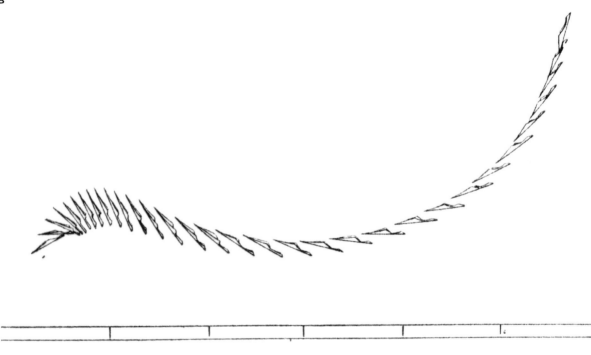

121.
Movements of a model airplane
showing stall. Drawing made from a
chronophotograph, 1890. *CRAS*,
November 1891.

cotton in a small furnace above—through twenty small tubes into the glass box. The smoke passed from the tubes through a fine-mesh cloth and then over different shapes that Marey put inside the box. The camera, placed in front of the apparatus, recorded the movement of the smoke as it passed over the variously shaped planes. The pictures were made with a magnesium flash that lasted about $\frac{1}{50}$ second, a burst of light that "surprises the fillets of smoke as they meander capriciously in the places where the eddies are formed."[37]

The earliest experiments he conducted demonstrated that air and fluids behave in substantially the same way; his photographs gave proof of the shifting center of air pressure on the wing with changes in the angle at which the wing cut the air. When he placed an inclined plane at right angles to the airflow, he saw that the air currents divided exactly in the middle, showing that the center of pressure is at the midpoint of the surface. But, as with his model airplane, when he increased the angle of attack the center of pressure moved forward to the leading edge of the plane (fig. 122).

In July 1901 Marey sent his latest results and photographs to Langley in Washington.[38] He had used the Hodgkins money to completely rebuild his apparatus. He increased the size of the box and the number of smoke fillets, which were now aspirated through the box instead of ventilated into it, and he replaced the filtering cloth with a fine silk gauze of absolutely equal weft. Marey had also arrived at a way to measure the speed of each smoke fillet as it moved around the objects he had placed in the box: an electric vibrator made the fillets vibrate regularly ten times a second, and Marey placed a ruler in the glass box, against which the distance the fillets traveled each tenth of a second could be measured (fig. 123). The images he made with this new arrangement seemed to him full of promise. He could infinitely vary the form and dimensions of the

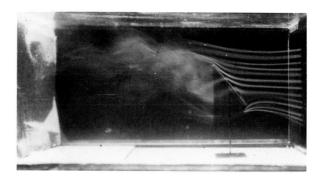

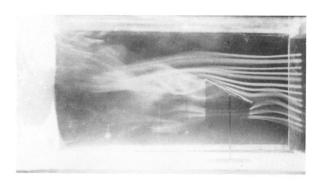

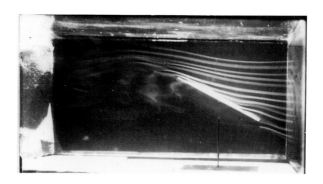

122.
First studies of the movements of the air, 1900. Collège de France.

bodies he plunged into the air current, and he could augment or diminish the speed of the air flow. He experimented with different wing shapes, showing the amount of drag produced by each one (visible in the photographs by the amount of turbulence the smoke formed behind the wing), and he introduced parallel shapes into his box to simulate the wings of the triplanes and biplanes that were so popular with researchers at that time. The method can be used, Marey wrote, "by all those concerned with aviation, propulsion in fluids, ventilation, everything, in fact, that has to do with the movement of air."[39]

In October 1901 Marey asked Langley if there were specific problems he wanted investigated, and Langley replied with a sketch of his latest "aerodrome" wing, asking Marey to experiment with its shape in his wind tunnel. These were the first and, as it turned out, the last experiments Marey would do for his friend. Langley had been testing a quarter-scale airplane, and his results were still inconclusive. But despite his lack of concrete data, exactly one year later Langley catapulted into the air an airplane containing his hapless assistant Charles Manly. The machine was structurally and aerodynamically unsound; Manly ended in the Potomac River, and the government funding Langley had been receiving since 1898 was now definitively cut off. Vilified and ridiculed, he abandoned his further work in aviation; he died in 1906, heartbroken and alone.

On 17 December 1903, just one year after Marey had completed the wind tunnel experiments that crown his lifelong investigation of flight, the Wright brothers finally proved what he and so many others had believed for years: humans can fly. Marey perhaps would not have heard of their feat; he was terribly ill with what was probably liver cancer and would be dead within five months. The Wright brothers, however, had heard of Marey.

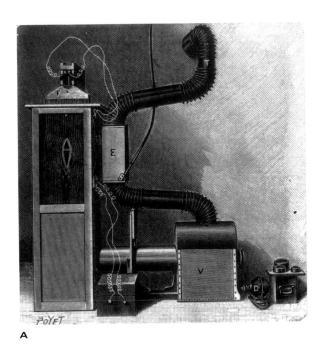

A

123.
(A) Marey's wind tunnel, 1901. *La Nature*, September 1901. New York Public Library. (B) Studies of air movements, 1901. Beaune.

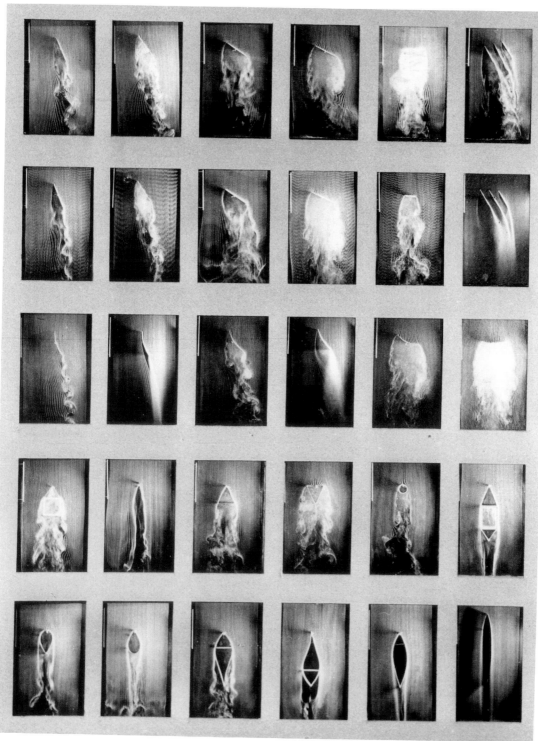

B

Here is how Wilbur Wright described the first beginnings of their incredible triumph:

My own active interest in aeronautical problems dates back to the death of Lilienthal in 1896. The brief notice of his death which appeared in the telegraphic news at that time aroused a passive interest which had existed from my childhood, and led me to take down from the shelves of our home library a book on *Animal Mechanism* by Prof. Marey which I had already read several times. From this I was led to read more modern works, and as my brother soon became equally interested with myself, we soon passed from the reading to the thinking, and finally to the working stage.[40]

As it had for so many other investigators, a study of Marey's work on the flight of birds marked the inception of the Wrights' journey into the skies. Later, through Chanute, they had learned of the experiments on the effect of air pressure on the bird's wing reported in *Vol des oiseaux*, a volume Chanute had brought to their camp in August 1901. The thoroughness of Marey's research and the clarity of his results—his unsurpassed descriptions of the complex interrelations of wing movement, motive power, and air pressure—shaped the direction the Wrights' own long and arduous experiments would take.

In one of his last letters to Langley, Marey mentions the pleasure he would take in Langley's next visit to Paris, because "I would be pleased to show you and take you around a new establishment that the physiologists have founded for me."[41] The Institut Marey, the new establishment in question, was the realization of Marey's last great ambition; it was established to standardize the recording instruments employed in physiological research. The need for such a monitoring facility existed, Marey felt, because although the graphic method constituted "a kind of universal language eminently favorable to

the progress of our science, . . . there is no common scale used to evaluate durations and intensities of phenomena, and this makes it difficult to compare different physiological tracings with one another. More important, since the construction of some instruments is not submitted to any kind of control, several of them give defective graphs."[42] What was required, according to an impassioned speech Marey had made to the International Congress of Physiology at Cambridge, England, in 1898, was the establishment of a common scale "for the graphic expression of physiological phenomena"; the construction of prototype instruments against which all future production would be compared; and the establishment of a "kind of bureau of control for the existing instruments."[43]

His closing words to the congress set his request in a familiar context as he repeated yet again his desire to make physiology the equal of physics and chemistry: "Similar commissions have made tremendous progress for other sciences. In taking the same route, physiology will put itself at the level of the most precise sciences."[44] Marey's plea had an overwhelmingly positive response;[45] physiologists worldwide proclaimed the utility of the idea and offered their aid. No doubt the overall increase in standardization throughout the sciences, which was in part prompted by the industrial need for measurements, material, and tools in order to mass-produce goods cheaply, played a role in Marey's reception. For example, the International Congress of Electricity held in 1881 had adopted a uniform system for the names and measurements of electrical phenomena; the newly created International Bureau of Weights and Measures provided the world with another system of invariables; and the standardization of world time that had first been proposed in 1884 was "in the air."

But Marey's desire to standardize physiological instruments was not just conforming to current no-

124.
Institut Marey, 1902. Beaune.

tions; it was an idea that goes back to his earliest conceptions of his science, one that had been his most constant dream throughout his life. The establishment of the institution he envisaged would bring him that much closer to the full realization of that dream. Making physiology an exact science had always depended for Marey on making precise measuring instruments: the accuracy of these "intermediaries between mind and matter" ensured the exactness of the data they furnished. Now he called for the creation of instruments that would control other instruments in a kind of self-regulating universe where the interference of human subjectivity and error would become ever weaker.

In 1899 eighty thousand francs from the French government voted toward improvements to his Station "in view of the exposition of 1900" allowed

the creation of the new institute, and contributions from all over Europe and America rapidly followed.[46] The construction of a building to house both instruments and personnel began in 1900; the third black hangar and pylon stood at its center, dominating the two side wings (fig. 124). In 1901, in recognition of the creator of the graphic method and his contribution to the growth of precision methods in physiology, the international association of physiologists unanimously voted to give the new institution Marey's name. The very first instrument to be tested, legend has it, was his own sphygmograph.

Also in 1901 Marey was named president of the Scientia conference, an international body founded fifteen years earlier to pay respect to the most illustrious representatives of science. Previ-

ous holders of the title had included Chevreul, Berthelot, Pasteur, Janssen, Lister, and Kelvin. His accession into this esteemed company was celebrated at a banquet where over one hundred colleagues and friends came to pay him homage. "All the physiologists of today are your pupils," his assistant and friend Charles Richet declared; "the precision of their research and the perfection of their techniques are due to you and to the admirable machines that, in the domain of our science, you have known how to create."[47] In his response to these words, Marey spoke with concern about the one thing uppermost in his mind: he renewed his efforts on behalf of the new institute, insisting on the necessity of eliminating the useless arguments over experimental results that resulted through the misunderstanding of data given by faulty instrumentation. In closing, he stressed the importance of the institute in uniting physiologists in a common direction and purpose.

The following year, in 1902, Marey's fifty years at the Collège de France were commemorated by a ceremony and by the presentation of a medal designed by his friend, the artist Paul Richer, illustrating Marey's achievements (fig. 125). Again surrounded by his oldest and dearest friends and students, Marey made one last appeal for solidarity and union in physiology by means of uniformity in the instruments used. "If I succeed," he said, "all my life will have been only a preparation for this final success. And if I am granted the fortune of seeing it happen, I will be truly happy; I will feel that I am not unworthy of the honors that you have given to me today."[48] At the end of that year, because of his efforts, enough money had been raised for the completion of the Institut Marey, for the purchase of materials, and for salaries. It was the crowning achievement of a career whose importance was now celebrated throughout the world.

125.
Paul Richer's medal made to celebrate Marey's jubilee at the Collège de France, 1902. Bronze, 5 × 4 cm. Beaune.

Marey was granted his wish of seeing the completion of his last great project, but his waning strength did not allow him to have the pleasure of working in the institute that bore his name; it was left to those he had painstakingly trained to carry on in the tradition he had founded. The next year, too weakened by the ravages of cancer even to attend a ceremony in honor of his dearest friend, Chauveau (who would succeed him as director of the Institut Marey), he did what little work he could from his bed. When he felt well enough he could call on a multitude of assistants to relay his queries and thoughts to the Station or the institute and to bring back news of the ongoing experiments conducted there. With the assistance of Charles François-Franck, who had taken over his lectures at the Collège, he was even able to see three papers through to publication. These went back to his earliest interests: the relation of organs and functions, the circulation of the blood, and the energies of the body.

Marey died on 15 May 1904. His students, who now taught in or administered physiological laboratories of their own from Moscow to Boston, mourned with those who remained to carry out his work in Paris at the Physiological Station and the

Institut Marey; as the unknown writer of his obituary in the *British Medical Journal* put it, "To know his work was to respect and honour the man; to know the man was to love him."[49] He was buried with civil, not religious rites, and more astonishingly, for someone from such a devout Catholic family, he was cremated. He had made these requests in his will; also according to his instructions, his ashes were transported to the Père Lachaise cemetery. As I described earlier, they were transferred to the base of the monument erected to his memory on the grounds of the Physiological Station before war broke out in 1914.

Although the First World War would change the face of Europe, it would not halt the ever-widening effects of Marey's investigations. His study of motion would be applied to the rehabilitation of crippled soldiers, to ergonomics (the study of work), to painting, sculpture, and photography, and it would remain fundamental to the future developments in medical instrumentation, rapid- and slow-motion cinema, and aviation. And yet, as his ideas came to inform the modern world, awareness of Marey the man faded. The creator became absorbed in his creations.

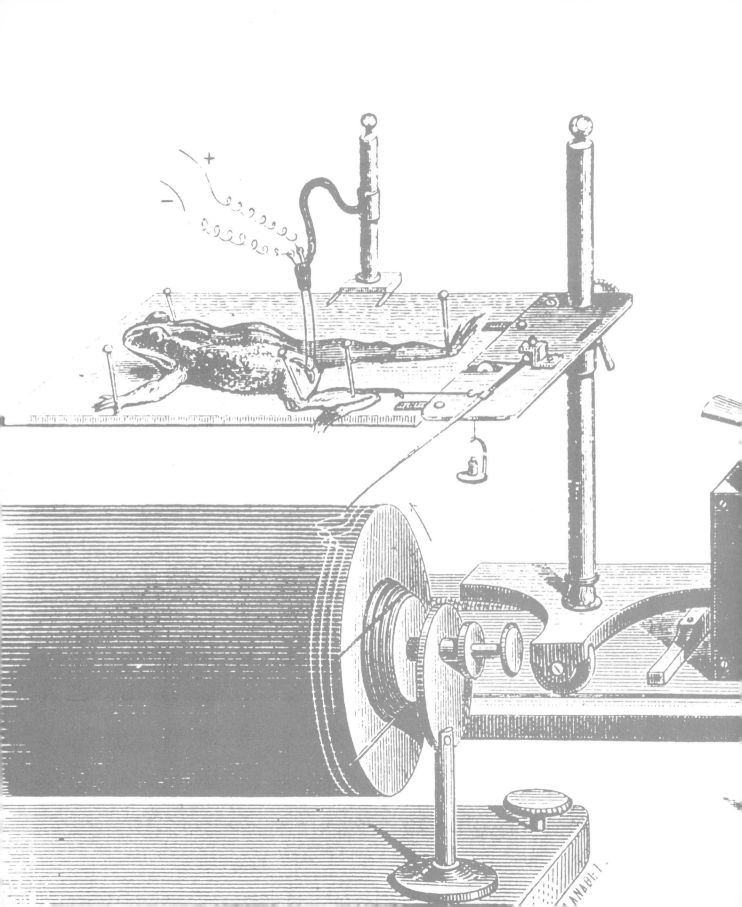

Part Two

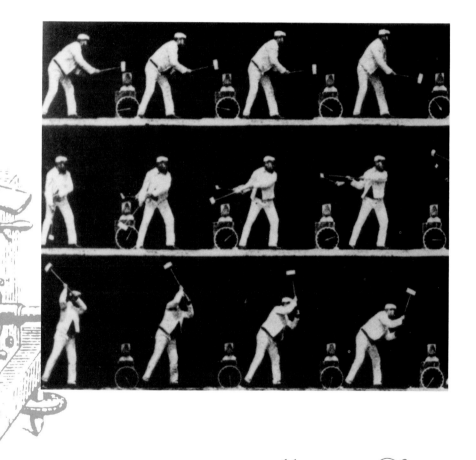

Marey's Legacy

6 *Marey, Muybridge, and Motion Pictures*

The names of Marey and Muybridge are inextricably linked. Their photographic studies began interdependently; they both pioneered the use of instantaneous photography to study movement; their investigations revolutionized the relation between art and photography; and their results mark the beginnings of cinema. Muybridge, of course, has always been the better known, even in Europe. His flamboyant personality, his melodramatic life, his photographic expeditions to exotic locales, and his association with Stanford and the settlement of California are the stuff of romantic legend. The excitement that greeted his photographs of horses—the first photographed sequences of their movements ever seen by the public—made him a household word during his lifetime. His entertaining lecture tours and the wide availability of his pictures kept his name alive. The frequent reissue of his photographs in book form, begun in his lifetime and continuing to this day, has made his fame endure.[1]

Marey's life by contrast seems dull, devoted as it was to his instruments and his science. His peccadilloes remained hidden; his wranglings with scientists and bureaucrats in France simply could not compare with murder and mayhem in California. Because his photographs were either kept in his laboratory at the Physiological Station or sent to those agencies like the municipal council of Paris that funded his work, they were rarely to be found in the hands of collectors or in museums.

Muybridge's fame as a photographer has had an effect on how we perceive Marey, just as Marey's reputation as a scientist, though much less defined, has affected our view of Muybridge. In the first instance, particularly in North America, it is usually assumed that, as for Muybridge, photography was Marey's central interest, his profession. Conversely, it is always assumed that Muybridge's contribution to the study of locomotion, like Marey's, was a scientific one; objective, measurably accurate, analytic, and systematic. Both these assumptions are wrong. A close look at Muybridge's *Animal Locomotion*, the work he did after his return to America, reveals the profound differences between the achievements of Marey and of Muybridge. Muybridge's *Animal Locomotion* is a good example of how vulnerable are our assumptions about the very nature of photography: it demonstrates the dangers of believing what we see.

After his triumphant visit to Paris, Muybridge left for London in February 1882 and spent the month of March garnering invitations to and lecturing before the Royal Society, the Royal Academy, and the Savage Club—always on the lookout for the person or institution that would support an expansion of his work (fig. 126).

At first he met with the same success he had found in Paris; but the acclaim was abruptly ended one day by an embarrassing incident that brought his "promising career in London . . . to a disastrous close."[2] On 20 April the London science journal

Nature noted the appearance in America of *The Horse in Motion as Shown by Instantaneous Photography, with a Study on Animal Mechanics, Founded on Anatomy and the Revelations of the Camera, in Which Is Demonstrated the Theory of Quadrupedal Locomotion;* its author was one "J. B. D. Stillman, A.M., M.D.," and it was "executed and published under the auspices of Leland Stanford." Five of Muybridge's photographs and ninety-one lithographs made from the rest of the pictures he had taken in California appeared in *The Horse in Motion,* but not Muybridge's name—at least not anywhere on the title page. He had been relegated by Stanford to the role of technician. Worse, Stillman, Stanford's handpicked authority, had consigned the lengthy introduction Muybridge had written for publication with his photographs to the wastebin. Funding from the Royal Society, which Muybridge had hoped would be his as an independent investigator of locomotion, was now out of the question. The enormity of the blow to his pride can only be imagined. Hastily, he booked passage on a ship for America, where he would initiate a suit against Stanford for copyright infringement.[3]

Muybridge's last hope in Europe lay with Marey and Meissonier. On 30 May 1882, just before sailing for New York, once again Muybridge wrote Marey to ask for his collaboration:

During your absence in Italy M. Meissonier became very much interested in my photographs of animal movements

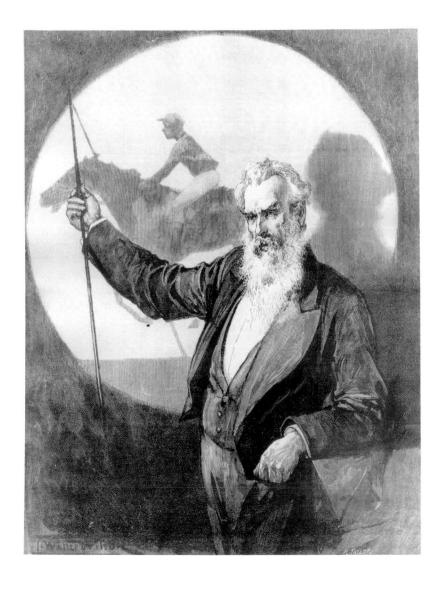

126.
Muybridge lecturing with his zoopraxiscope. *Illustrated London News,* May 1889. Metropolitan Toronto Reference Library.

and expressed his willingness to associate himself with me, or with you and me, in the production of an elaborate work on the subject of the results of my investigations. However, M. Meissonier finds it difficult to decide, or to act promptly. I have delayed publishing the photographs excepting in the form of the large volumes of which I have sold a few for $100, or £21 and if I can make any arrangement with you alone, or with you and M. Meissonier, I will delay publishing in the other man-

ner. I am satisfied a book containing a good selection of subjects, an edition de luxe, at a price of about 100 francs, will have a very large sale.

I am willing to enter into any equitable arrangement with you and if you wish will give you the exclusive right to use the subjects you select for illustration, on the continent, and will accept in return the exclusive right to your text for England and America. . . .

If you cannot secure the aid of M. Meissonier I am

perfectly willing to make an arrangement with you alone.[4]

In July Muybridge wrote once more, from America, introducing one Robert C. Johnson, who was "interested enough in the subject of animal mechanism to try and find money" for Muybridge's work:

It was my hope that M. Johnson would have arranged to induce both yourself and M. Meissonier to contribute to the publication of a book much upon the scale I projected and which M. Meissonier approved would perhaps have cost 75 to 100,000 francs to get up. He was willing to enter into this, not only from his desire to contribute to science but also from his friendship for me and his wish to thwart the contemptible tricks of a man whom I thought was a generous friend, but whose liberality turns out to have been an instrument for his own glorification. . . .

Now whether Robert C. Johnson joins me or not I am now resolved to publish the results of my investigations. I should have preferred for you to have joined in the preparation of an elaborate and comprehensive work. If that cannot be I will publish the photograph results alone and without any analysis.

M. Meissonier has very kindly offered to write a preface to the book, on the association of the results with *art* and their possible relation and influence with art; and if your numerous and important occupations will permit may I beg the favour of your writing me an introduction from a scientific point of view. If you will do this I shall not fail in my endeavours to reciprocate by all means in my power.

I have made arrangements to give a course of public lectures illustrated with Zoopraxiscope, in the various cities of the United States, commencing in August, and if you will permit me to announce my intended publication with an *introduction by you* it will aid me very much and I shall be much gratified by the receipt of such manuscript as you may feel inclined to write as early as the value of your time will permit. (Muybridge's emphasis)[5]

But the collaboration never materialized. Marey was evidently hesitant to involve himself in such a potentially volatile project when he had just started to realize the possibilities offered by his own fixed plate camera.

On his own again, Muybridge had great success with the public lectures he mentions[6]—in America no one seemed bothered by the omission of Muybridge's name in the Stanford publication—and this success gave him increased confidence. By March 1883 he had already produced a prospectus for "a new and elaborate work upon the attitudes of man, the horse and other animals in motion." The new work was to include "photographs of actors performing their respective parts, works of art from the Museums, Picture Galleries and Libraries of Europe," photographs of "trajectory curves" that Muybridge would make using Marey's "photographic revolver," and an essay by Marey. Finally (if all this was not enough), the subscriber could "send a horse or other animal or subject to my studio for a special photographic analysis of its movements which will be illustrated without extra charge." The photographs promised to the subscriber were to be positive prints made from negatives, Muybridge carefully noted, not lithographic reproductions, which were "absolutely worthless for scientific or artistic use."[7] The Stillman-Stanford publication had included primarily lithographs.

At last, in 1883, Muybridge found his patron: the University of Pennsylvania. Muybridge had lectured in Philadelphia on 13 February at the Franklin Institute and on the twelfth and sixteenth at the Academy of Fine Arts. There he had met the realist painter Thomas Eakins (1844–1916), an accomplished photographer in his own right: Eakins photographed his family and friends, models to be used as aide-mémoires for his paintings, and he also used the camera in his teaching at the Pennsylvania Academy of Fine Arts.[8] In fact, when Muybridge's

pictures of movement first appeared in late 1878, Eakins did not have to be convinced of their importance for art and artists; he immediately wrote to Muybridge congratulating him and showing him how the pictures might be made more accurate. Eakins urged Muybridge to use a scale of measurement in the background of the photographs, which would make it easier for an artist to copy the positions of the horse in their correct perspectival relationship.[9]

Eakins's appreciation of Muybridge's achievement was shared by another Philadelphian, the sportsman and scientist Fairman Rogers, then head of the Pennsylvania Academy of the Fine Arts. Like Eakins, Rogers had constructed zoetrope strips from the first photographs Muybridge had published (to "determine if the photographic analysis was correct").[10] In 1879 Rogers commissioned Eakins to paint a portrait of him together with his family and domestics in his carriage, pulled by his own famous four-in-hand. The difficulty of portraying eight pairs of legs in motion according to the data given by Muybridge's California photographs (and Eakins's own photographic and sculptural studies) was not inconsiderable. The painting *A May Morning in the Park* was a qualified success.[11]

It was Rogers, seconded by Eakins, who persuaded William Pepper, provost of the University of Pennsylvania, to put the grounds of the veterinary hospital at Muybridge's disposal and give him money to undertake a new photographic study of locomotion. An invitation from the university was issued to Muybridge on 8 August 1883. With five thousand dollars' initial outlay guaranteed by a committee of the university,[12] Muybridge began taking pictures at an outdoor studio that was built for him in June 1884 and finished the following summer. The result, offered for publication by subscription in 1887 under the title *Animal Locomotion: An Electro-photographic Investigation of*

Consecutive Phases of Animal Movements, was made up of eleven volumes containing a total of 781 plates assembled from 19,347 single images. Its scope was identical to that of Marey's investigations in Paris, but its substance was radically different.

To begin with, Muybridge was not trusted to carry out his investigations on his own. The university prescribed both the nature of the experiments and the conditions under which they would take place. It appointed a commission to oversee Muybridge: "It was represented to the Trustees of the University that several individuals appreciating the importance of the proposed work to art and science would unite in guaranteeing all expenses connected with the investigation if a University Commission would be appointed to supervise the entire affair and thus *insure its thoroughly scientific character*" (my emphasis).[13] This was a highly unusual procedure. Perhaps it was necessary because of concern about using nude human beings as subjects for either scientific or artistic investigations. (Eakins, for example, would be fired from the Academy of the Fine Arts in 1886 for having a naked man pose for a mixed drawing class.) It is also possible that the university had misgivings about Muybridge's character. His past would have been no secret. Muybridge accepted the commission with aplomb: "I am neither a physiologist nor an anatomist . . . [therefore, they] are assisting in the work to give it additional weight and value."[14] Yet the attempt by the university to ensure the scientific accuracy of the project would not be completely successful.

Muybridge began the Philadelphia work in June 1884. His preliminary setup was similar to the one he had used to carry out his experiments for Stanford. Facing a shed whose interior was covered with black cloth, he placed a bank of twenty-four cameras; to these he added four more, two on each side of the subject, to make foreshortened views. Muybridge also employed a single camera incor-

porating two slotted-disk shutters rotating counter to each other. Eakins worked alongside Muybridge for most of that first summer, using his "Marey-wheel" camera, a single-lens camera with a single revolving slotted-disk shutter that he had built in early 1883. Here is how Thomas Anshutz, a pupil of Eakins and his successor at the Academy, described the initial stages of the work:

Maybridge [sic] as you know is carrying on his scheme over at the University. He has a small enclosure . . . also a machine for taking views on one plate, of moving objects, by opening and closing the camera rapidly at the rate of about 100 exposures per second. This shows the moving object not as a continuous smeer [sic] but shows one clear view at every 2 or 3 inches of advance. The exposures are made by two large discs with openings cut around their circumferences. They run in opposite directions and are geared to run very fast, the exposure is while the two openings meet. The lens remains uncapped until the object has reached the edge of the plate.

Eakins, Godley and I were out there yesterday trying a machine. Eakins had made one of the above design except he had only one wheel. We sewed some bright balls on Godley and ran him down the track. The result was not very good although you could see the position of the buttons at every part of the step.

But afterwards Muybridge took him with his machine and got a very good result even showing his black clothes.

Eakins is on the committee which superintends Muybridge. He is of course much interested in the experiments. Muybridge has not made very rapid progress and the University people seem to be losing faith in him. But he showed a good result yesterday on the machine.[15]

Eakins had problems with light fogging the plates and with superimposition, the same difficulties Marey had encountered in 1882, which he had resolved with the artifice of the geometric man (fig. 127). Eakins tried a camera based on the prin-

ciple of Marey's photographic gun, which he used to make a series of images on a revolving octagonal plate. According to Professor Marks, one of the authors of a book on Muybridge's work at the university, Eakins's camera was "devised from investigating the class of movement in one place, as that of a man throwing a stone, where, in the Marey [fixed-plate] camera, the images would superimpose" (fig. 128).[16]

Like Marey, however, Eakins wanted each phase of the movement to be in correct spatial position relative to all the others; he soon abandoned his experiments with a moving plate[17] and, by late August 1884, started making serial images with an improved Marey-wheel camera. His latest machine was an elaboration of the two-disk camera Muybridge had used in June. Eakins's version was remarkably accurate, the exposure time was cut to one-eighth of what he had previously attained, and in the images he made, "the velocity of motion can be determined . . . with very great precision, as also the relative motions of the various members of the body" (fig. 129).[18]

Muybridge, meanwhile, had begun to use a single-disk machine in work on abnormal movements for Dr. Francis Dercum, but with limited success:

[Muybridge] has not yet done any work with his series of lenses and I hear they do not work. The shutters are too clumsy and slow. The University people are dissatisfied with the affair as he cannot give them the result they expected. Which was to photograph walk of diseased people paralytics etcr. so that by means the zoopraxiscope (help!!!) they could show peculiarities to the medical student. This it seems however cannot be done even with the best known contrivances So they would like to fire the whole concern but they have gone too far to back out.[19]

Muybridge seems not to have been interested in working with Eakins's improved Marey-wheel cam-

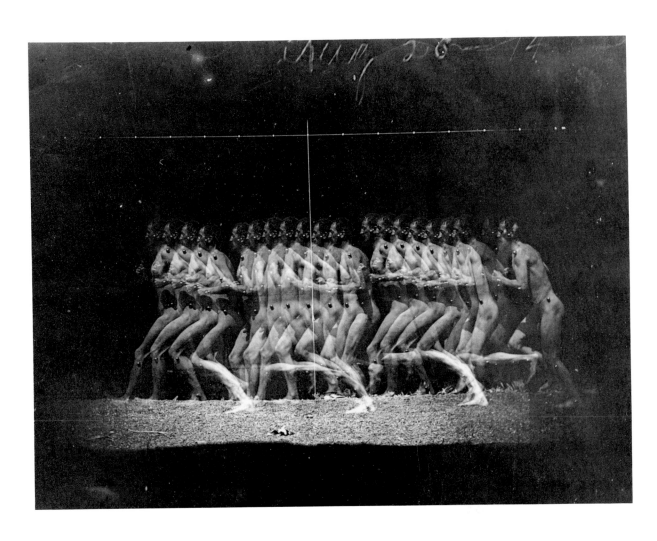

127.
Thomas Eakins, Jesse Godley, 1884.
4¹³⁄₁₈ × 3¾ in. chronophotograph
taken with a single-disk "Marey-
wheel" camera. Philadelphia Museum
of Art. Gift of Charles Bregler.

234

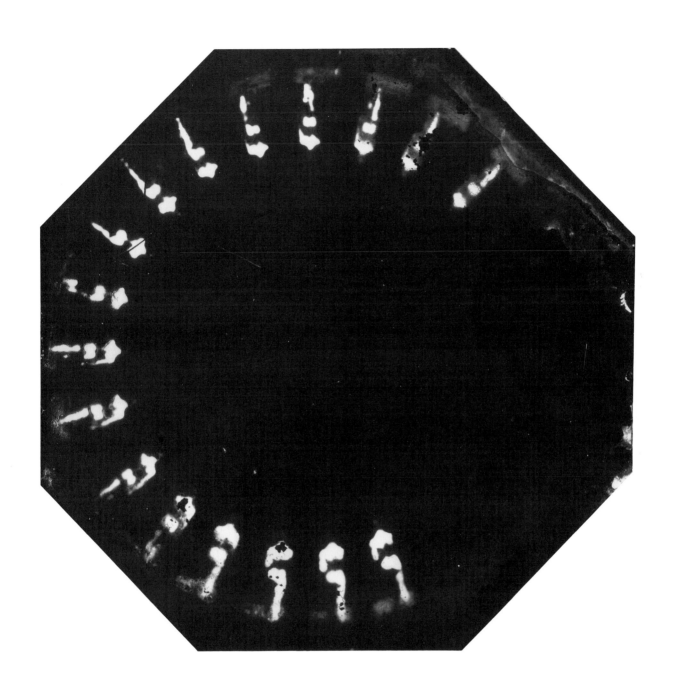

128.
Thomas Eakins, J. Laurie Wallace
walking away from the camera,
1884. Chronophotograph taken on a
moving plate, 9¾ in. diameter.
Courtesy of the Franklin Institute
Science Museum, Philadelphia.

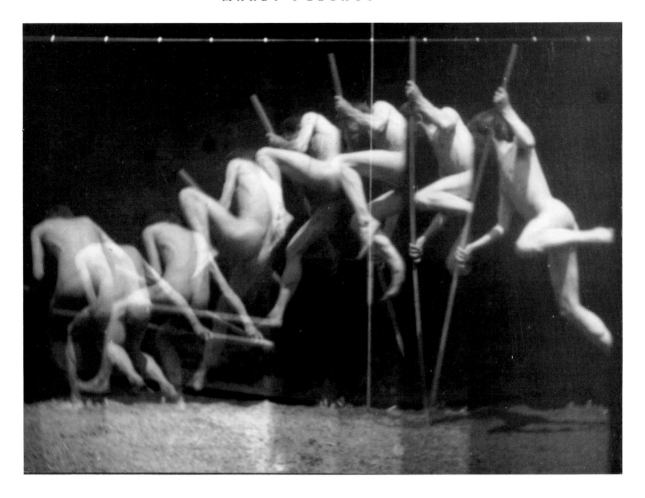

129.
Thomas Eakins, George Reynolds,
1884 or 1885. Chronophotograph
taken with a two-disk "Marey-wheel"
camera, 5¹/₁₆ × 6⁷/₈ in. Philadelphia
Museum of Art. Gift of Charles
Bregler.

era. Although Muybridge gave no reason that we know of, we do know that he was not one to follow in another's footsteps. He craved to be perceived as original in all senses of the word. Perhaps the challenge of getting his battery of cameras to produce readable images engaged him more than the scientific accuracy Eakins urged. Also, Muybridge was an enthusiast. Perhaps the sheer pleasure of setting up and handling his complicated arrangement of cameras, shutters, and backdrop thrilled him more than Marey's single camera. Whatever the reasons for Muybridge's intractability, Eakins soon got "disenchanted," fed up, "with Muybridge's method

and, one feels, with Muybridge himself whose showmanship was so at odds with his own public reticence."[20] He left Muybridge and continued to photograph motion on his own. In 1886, his investigations of human locomotion completed, Eakins abandoned chronophotography.[21]

Muybridge spent the winter of 1884–85 improving his multiple camera system, and with the mechanics at the university assigned to assist him, he perfected an electromagnetic device to operate the shutters. The following summer he began all over again. He had his subjects (the first were human subjects—university athletes and male and female models) move along a track in front of a roofless enclosure that was painted black inside and marked off in a grid with white threads. He photographed these models with up to three batteries of twelve cameras each; one series was parallel to the subject, and the other two were at angles of sixty degrees or ninety degrees to it (Muybridge called the parallel series "laterals" and the others "foreshortenings"). Late in the summer he added a single camera with a row of twelve lenses (plus a thirteenth used for focusing), which could substitute for one of the batteries of twelve cameras. In August he moved his apparatus to the zoological gardens to take pictures of birds and wild animals, and in the fall he moved to the Gentleman's Driving Park in Belmont near Philadelphia, where he photographed the locomotion of horses.

Although the 781 plates he compiled from this work have always been perceived as scientific studies, there is much about them that cannot be reconciled with any notion of disinterested scientific inquiry. This becomes most clear when they are compared with Marey's chronophotographic plates. To begin with, Muybridge's multiple camera system cannot convey a sense either of the space traversed by the subject or of time passing. Each photograph was made by a different camera (in tandem with the

moving subject) against the same background as the one before and after it, but from a different vantage point. As a result the subject and the camera seem to move in unison and thus effectively cancel out the sense of movement; the only aspects that change are the gestures of the subject, and any sense of movement must be constructed by the viewer from these gestures, frame by frame.

The primary aid in this reconstruction is the sequential structure of the final print: it governs our perception of the relations among the individual images within it. Muybridge took the single negative images made by each camera and arranged them in rows. The resulting assemblage, which contained from one to six of these rows (combining both lateral and foreshortened views in various arrangements), was then rephotographed and printed.[22] He intended the print to be read both horizontally (from left to right for the most part) and, in most cases, vertically. The horizontal sequence supposedly reproduced the temporal succession, while the vertical row displayed a spatial ordering of the figure seen from two or three different points of view that supposedly had been taken simultaneously. I say "supposedly" because the relationship of the images, in some 40 percent of the plates, is not what Muybridge states it to be.

In fact, the sequential ordering of the images on the plate dictates our perception of the relation among the individual images even when there is no relationship. The sequence endows its component parts with movement because we believe any sequence to be inherently orderly, logical, and progressive. It is the sequence that cues us to believe that the action represented was ongoing and that it took place in exactly the order we see reproduced. The sequence invites us to cooperate in creating the illusion of motion, to dissolve in our imaginations the black borders marking off each individual part and then to fill in the gaps between the separate

phases of the movement given by each single image. Our faith in the sequence allows us to suspend our disbelief. But the fact is that the pictures were arranged.

In his prospectus for *Animal Locomotion* Muybridge noted the temporal intervals between one image and the next and also the exposure times.[23] In the same pamphlet are general and specific caveats he appended to these measurements. First he made a general disclaimer that "perfect uniformity of time, speed and distance was not always obtained."[24] Then, among the twenty-four reference notes to the plates, he enumerates eighteen possible irregularities in the exact measurements of the intervals between the phases of the movement. But besides these noted irregularities, there are an additional 10 percent of the plates in which the images could not possibly have been taken at the stated temporal intervals. Such gaps, noted or not, are evident only from an examination that discards the sequence and tries to recreate the relation between one single frame and the next. Otherwise the sequential structure has the effect of making them invisible.

Although there is absolutely no possibility of knowing Muybridge's motives, he did employ certain strategies in his sequential arrangements to ensure that any gaps or inconsistencies would not be seen. From his daily notebooks we know that with six exceptions he always made twelve lateral and twenty-four foreshortened views of each subject; yet only about half of the published prints contain thirty-six intact images. When a phase of the movement was missing—perhaps a camera failed or a negative broke or was fogged—Muybridge assembled the negatives that remained, gave them internal consistency, and renumbered them to appear consecutively in the print (fig. 130).[25] At times he even went so far as to compile a sequence whose

individual elements came from separate picture-taking sessions (fig. 131).

The factors that Marey taught were imperative in the analysis of locomotion—recording a complete movement, capturing all its phases, making an exact rendering of time elapsed and space traversed—Muybridge sacrificed for a pictorially acceptable final print. The results were intriguing. Where gaps between phases were most blatant, the leftover pieces were still assembled, numbered consecutively, and titled "miscellaneous" (fig. 132). Another way of masking gaps in a series or an incomplete series was to make the lateral and foreshortened views congruent on the page. This was accomplished by replacing a missing image with uncropped images (in other words, using one image to fill the place of two) (fig. 133), printing one image in the series twice (fig. 134), removing the central section of an image and abutting the remaining parts (fig. 135), or even substituting a view of the empty backdrop taken from a viewpoint consistent with the rest of the series (fig. 136). These tactics—insertion, expansion, contraction, and substitution—are all useful in making one series look as if it belonged with another as well as making it seem logical in its own right; the uniformity in the (re)numbering of the images supports this seeming consistency. That such disjunctions have remained largely unnoticed until now is not too surprising. The backgrounds are all identical, each image is the same size (except for those I have just noted), and the series are aligned with each other and on the page. They are sequences: any cues that would prompt us to compare more closely the images within them or the relations among them are obliterated.

There are also sequences in which no movement at all has been recorded but that nonetheless look as if some motion were occurring. Some of these sequences are compilations of poses; they re-

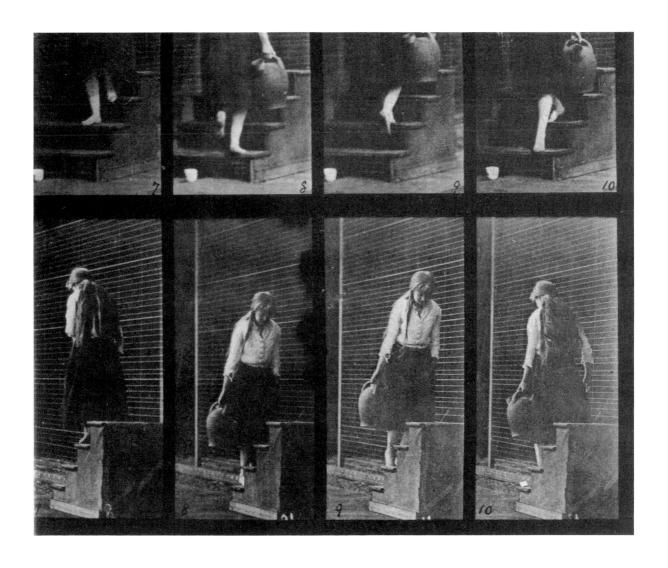

130.
Muybridge, *Animal Locomotion,* plate
504: "Ascending and Descending
Stairs." Negative numbers 8, 10, 11,
and 12 seen in white have been
renumbered consecutively (black
numbers) in the print.

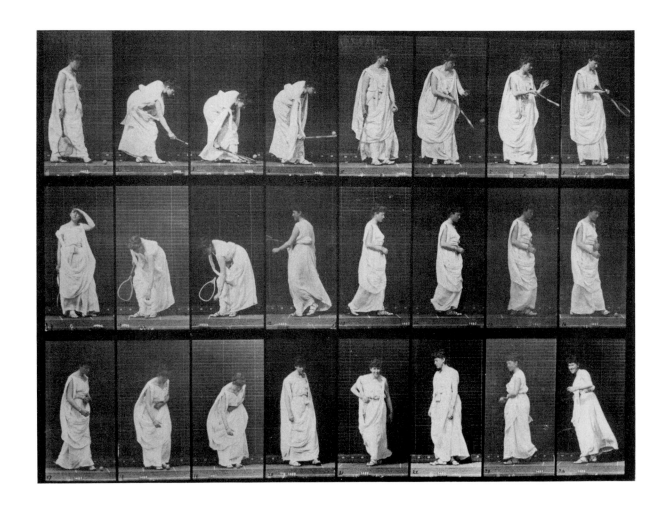

131.
Muybridge, *Animal Locomotion,* plate
299: "Playing with Ball." This plate is
a compilation of three different
picture-taking sessions, 1482, 1483,
and 1485, some with racket, some
without. The notebooks show that
four out of twelve cameras failed
during session 1482.

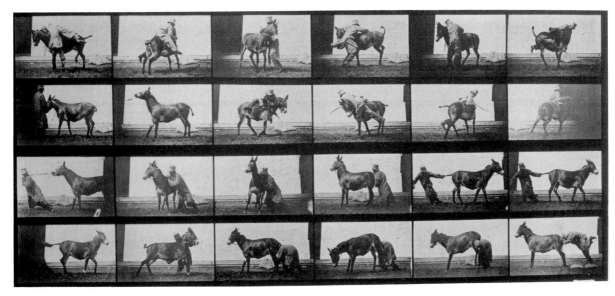

A

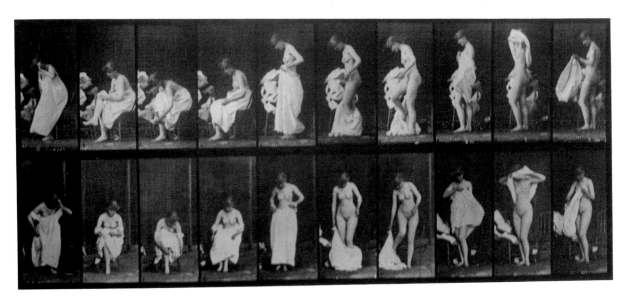

B

132.
(A) Muybridge, *Animal Locomotion,* plate 662: "Denver,
Refractory." This is an assemblage of unconnected
images, sequentially arranged and consecutively
numbered. (B) Plate 498: "Miscellaneous Phases of the
Toilet." The model, Miss Blanche Epler, has removed her
chemise by the seventh frame, only to find it on again in
the eighth. Miss Epler was Muybridge's favorite model;
she undresses in plates 415, 425, 493—95, and 497.

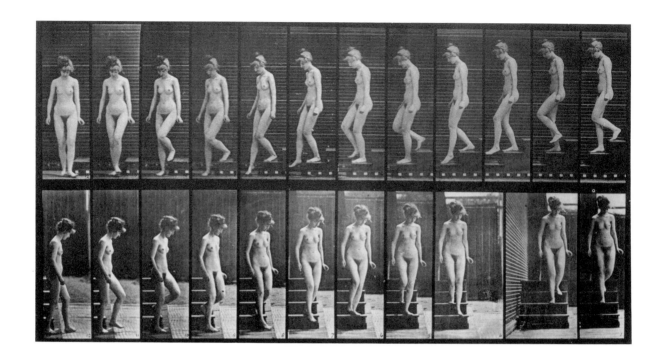

133.
Muybridge, *Animal Locomotion,* plate 137: "Descending Stairs and Turning Around." The second and third negatives in the bottom row have not been cropped for the print, so that they take up the space left by the missing negative.

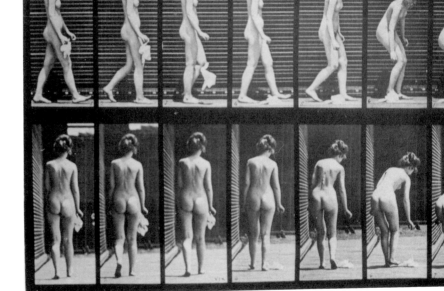

134.
Muybridge, *Animal Locomotion,* plate 202: "Dropping and Lifting a Handkerchief." Comparing the third lateral and foreshortened views shows that the handkerchief's position differs. The third fore-shortened view is a reprint of the first.

242

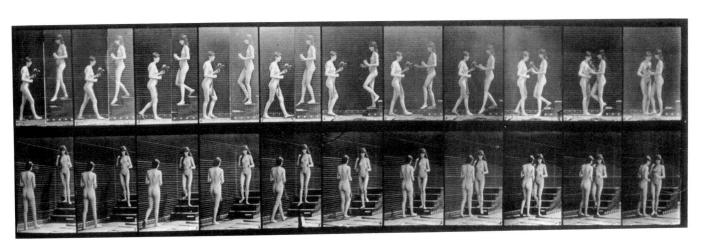

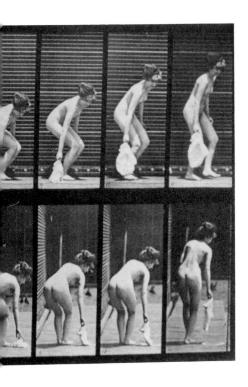

135.
Muybridge, *Animal Locomotion,* plate 448: "Woman Descending Stair with Goblet Meets Another Woman with a Bouquet." To make the lateral and foreshortened views congruent, the central portion of the first five laterals has been removed and the remaining sections have been abutted and printed.

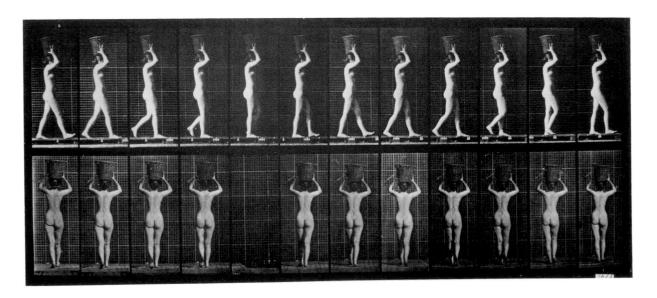

136.
Muybridge, *Animal Locomotion,* plate 34: "Walking and Carrying a Fifteen-Pound Basket on Head, Hands Raised." A view of the background has been inserted to substitute for the missing foreshortened view in frame 5.

sist any attempt at a reading for chronological succession. Although the vertical relations may seem intelligible, the horizontal series is dictated not by time, but by the formal qualities of the figure and by the symmetry with which Muybridge has arranged poses—that is, by aesthetically rewarding juxtapositions. Another of this type emulates the cinematic "tracking shot." In this case the cameras were arranged in a circle around the subject, then triggered simultaneously to provide a 180-degree view of a single position. The subject has not moved from one image to the next, and these series in particular make our assumptions especially vulnerable (fig. 137).

They *look* as if they are representing a series of movements because the structure in which they are ordered dictates a progression, because any clues that would prompt us to read the pictures more closely have been obliterated by the arrangement on the page, and because we presume that if one sequence is "right"—and many of them are—then the rest must be too.

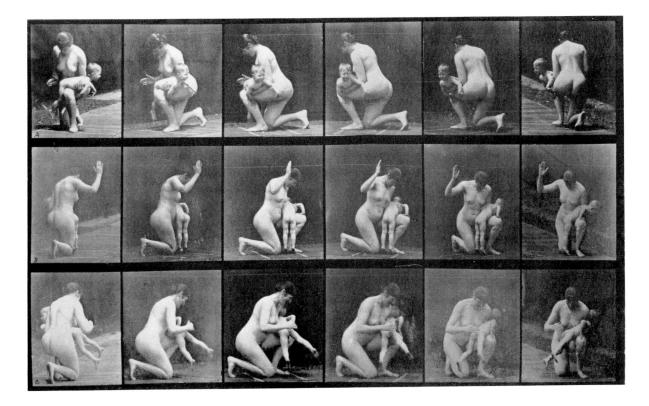

137.
Muybridge, *Animal Locomotion*, plate
527: "Spanking a Child." Some
movement may be read into the
picture by following the vertical
sequence, but the subject was posed.
All such "track shots" were made in
summer 1884. The grid background
was not yet in place, and only six
cameras were being used.

Although each sequence determines our percep-
tion of the images it contains, the structure of the
whole plate—Muybridge's disposition of more than
one series on the page—determines our perceptions
of the relations among sequences. The most com-
mon arrangement (a lateral series printed on one
line with a rear foreshortened view beneath it and a
front foreshortened view under that) is only one of
thirty-six variations he has devised. These variations
dictate what to look for and what to overlook. For
example, when the continuity of a lateral series is
interrupted on the plate by a foreshortened series,
reconstructing the event in time is made difficult,
and the viewer is thus persuaded to focus on the
vertical (or spatial) relations. This may in fact be
precisely the point, because missing phases, renum-

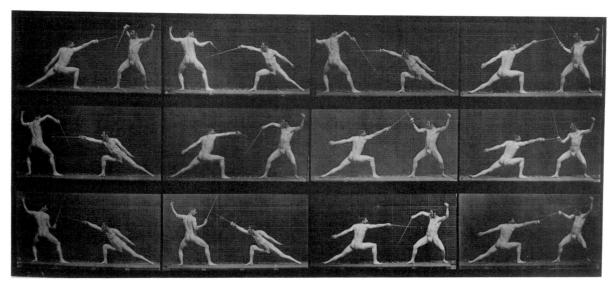

A

138.
Muybridge, *Animal Locomotion.*
(A) Plate 349. (B) Plate 350: "Fencing."
The irregular foreshortened views are
printed on a separate plate so that
comparison with the laterals cannot
be made.

bered or unnumbered images, and disjunctions
between frames are then less visible. The opposite
operations are involved in those cases where the
front and rear foreshortened views are printed to-
gether but on a different plate than the laterals
to which they originally belonged. Since they are
printed on separate plates, they cannot be com-
pared (fig. 138).

Perhaps this extraordinary variety of arrange-
ments could be explained in terms of a common
narrative structure: the chronological succession of
events differs from the path the author chooses to
disclose those same happenings. In other words,
what we may have is the equivalent of the literary
distinction between "plot" and history: Muybridge
may be telling a story.[26] Indeed, in these pictures we
cannot, by visual perception alone and without ad-
ditional contextual information, be sure that what
we see is not a narrative tableau—preconceived and
choreographed gestures of what continual move-
ment would look like in fragmentary stages por-
trayed by actors and actresses. Since so many of

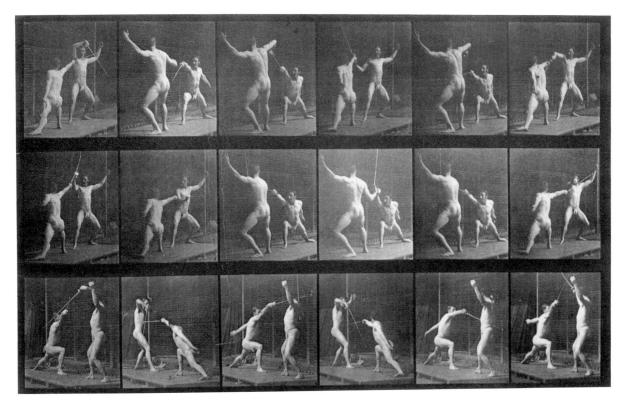

B

these pictures are demonstrably fragments, what guarantee do we have that any of them were made either simultaneously or sequentially? What guarantee is there that the images in these plates were not made hours, days, or even weeks apart and then assembled to approximate the way we would expect the photographic notation of movement to look?

In spite of the anonymity of the gridlike background in these pictures, the seeming objectivity of the camera and authenticity of results, and even the evident seriousness of the direction under which the work was carried out,[27] these pictures are inconsistent with what we understand to be a scientific analysis of locomotion. The unsystematic and incongruent aspects of Muybridge's photographs effectively obscure any knowledge of the underlying laws governing the mechanics of movement. In many cases the moving limbs are hidden by drapery. The very movements chosen for scrutiny, in the human realm at least, are often unrepresentative. The scientific purpose served by a study of one woman chasing another with a broom or a girl falling into a pile of hay (fig. 139) is impossible to fathom without directions. Are we to understand that there are constant factors that govern "Fancy Dancing" (the subject of Muybridge's plates 187–89 and 191–94) or numerically expressed laws that can be derived from "Chickens Being Scared by a Torpedo," the final plate in *Animal Locomotion?*

In short, the cosmetic, aesthetic, and narrative requirements of the photographs have triumphed over the need for analytically verifiable data. But

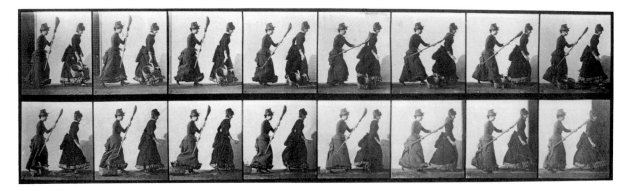

A

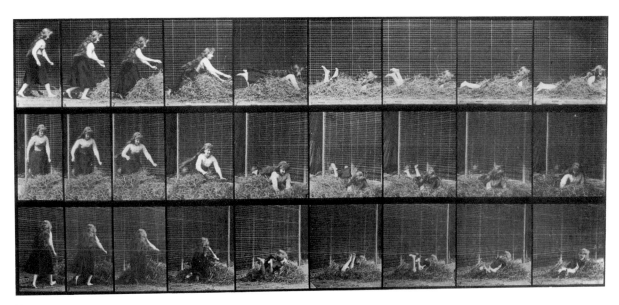

B

139.
Muybridge, *Animal Locomotion*.
(A) Plate 464: "Woman Chasing
Another with a Broom." (B) Plate
455: "Throwing Self on a Heap of
Hay." The subject is again Miss Epler.

though the photographs may not be scientific experiments in the mechanics of locomotion, they are certainly a treasure trove of figurative imagery, a reiteration of contemporary pictorial practice, and a compendium of social history and erotic fantasy. Most often Muybridge was not using his camera as an analytic tool at all but was using it for narrative representation, and the results are at least as absorbing as what he was ostensibly producing. Take, for example, sexual difference. In these pictures both men and women walk, run, jump, and lift objects (men concentrate on big rocks and poles, while women spend an exaggerated portion of their time with jugs and vases).[28] Both men and women are depicted throwing buckets of water (Muybridge's fascination with "freezing" drops of water in midair provides an obsessively recurring motif), but the men also wrestle, box, play baseball, fence, and do "men's work": carpentry, bricklaying, and horseshoeing. In addition, they play leapfrog and tip their hats with evident seriousness and enjoyment. As we might expect, the women sweep, dust, wash, and scrub floors or, more passively, dance, arrange their drapery, flirt with their fans, dress and undress extensively, stumble and fall.

But this going about the occupations deemed natural to each sex by social mores is only part of the story. The women also engage in particularly awkward or ungainly actions and what were, at that time, certainly forbidden activities. Like Marey, Muybridge used his camera to disclose those aspects of human activity that usually remained unseen: not because they were invisible to the naked eye, as in Marey's case, but because social conventions and morality dictated that they remain concealed except in the imaginative world of private fantasy. The photographs objectify erotic impulses and extend voyeuristic curiosity in a language we now recognize as taken from the standard pornographic vocabulary.[29] Naked women kneel in supplication

and crawl around on their hands and knees or on all fours. They meet and kiss, disrobe each other, pour water down each other's throats, and dump buckets of it over each other's heads (fig. 140). They also smoke—a practice confined at that time to actresses or other "loose" women. And "smoking" is the only description given in Muybridge's notebooks for these plates, even though the titles of the published plates describe other activities (fig. 141).

Muybridge's concern, then, is with narration, not with movement, and we are invited to share in this concern. The familiar three-dimensional construction of the setting in which the photographs were made becomes (especially in the photographs of women, where the illusion of space is more pronounced) a schematic decor easily transformed into a bedroom, bathroom, or parlor. The space stimulates more than just an interest in the rhythms of gesture and posture. Each sequence and each single image within the sequence invites us to transform the models into dramatis personae frozen into unaccustomed poses of beguiling attraction. We are not limited to a purely formal consideration of the contours of the body or the shape of any action but are impelled beyond, into the world of dramatic narrative and biography. Light and perceived depth, strong modeling and vigorous foreshortening call our attention to the stories being played out. The faces demand scrutiny; the concentration with which they go about their tasks and the sheer individuality of each cajole us into psychological identification with them. We are compelled by the subjects' fascination with their own performance before the camera and by Muybridge's fascination with them. The depth of his fascination is also evident in his prospectus. Male models were cataloged by profession (including the photographer himself as an "aging athlete") and females by marital status, weight, and age. In the notebooks Muybridge kept on the work, one can also find hip, bust, and shoe

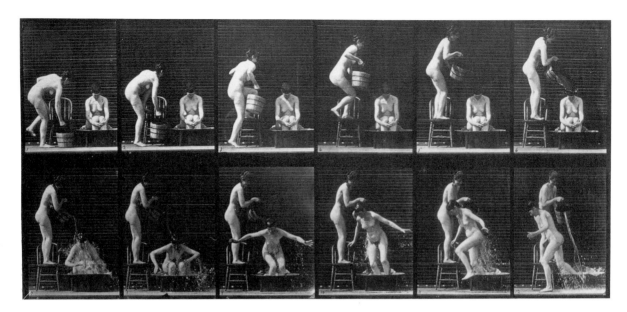

A

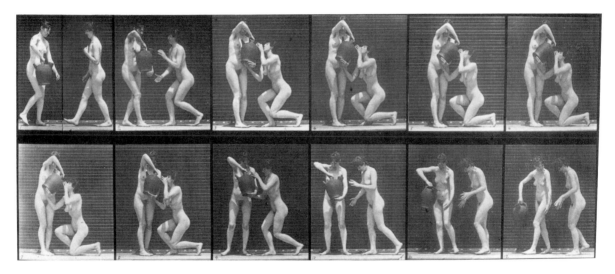

B

140.
Muybridge, *Animal Locomotion.*
(A) Plate 406: "Woman Pouring a
Bucket of Water over Another
Woman." (B) Plate 452: "Woman
Kneels and Drinks from the Water
Jar of Another Woman and Both
Walk Off."

size. The theatrical bent of Muybridge's imagination is revealed too in his descriptions of the costumes and the scenarios he concocted for his models. "Inspecting a Slave (White)," and "Ashamed" (the published plate titles are "One Woman Disrobing Another" and "Turning Around in Surprise and Running Away," respectively) carry us into the realm of erotic fiction (fig. 142). "Peasant" and "Greek" girls, "Crossing a Brook over a Stepping Stone," "Walking in a Gale," and "Relinquishing Drapery for Nature's Garb"—Muybridge's notebook title for almost every sequence of a woman undressing—invite us to share in his fantasies.

We have always assumed that Muybridge was photographing movement in time, that his objective was synonymous with Marey's. But what seems evident in that he was telling stories in space—giving us fragments of the world, fragments that could be expanded into stories, into dramas or jokes or fantasies—so that we would immediately recognize what we had never seen before. Muybridge, under the guise of offering us scientific truth, has, like any artist, made a selection and arranged his selection into his own personal truth.

No author writing on Muybridge in this century has commented on this aspect of his work.[30] First, *Animal Locomotion* was carried out under the rubric of science, funded by the University of Pennsylvania as a scientific undertaking, and was always thought to be a scientific analysis of locomotion. Second, as I have noted, when we look at the pictures contained in *Animal Locomotion,* their sequential structure determines our perception of the images contained within it; the images forbid close scrutiny, at least of motion. The contract between the viewer and the single photograph, based on the

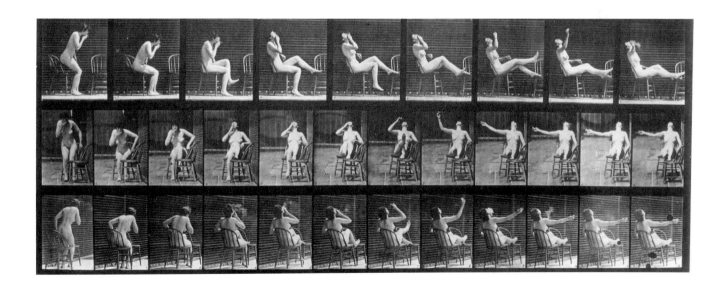

141.
Muybridge, *Animal Locomotion,* plate 247: "Sitting down and Placing Feet on Chair."

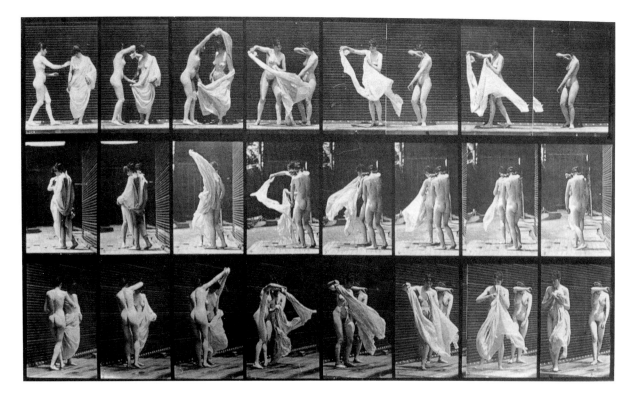

A

142.
Muybridge, *Animal Locomotion*.
(A) Plate 429: "One Woman Disrobing
Another." Muybridge's notebook title
for this was "Inspecting a Slave
(White)." (B) Plate 73: "Turning
around in Surprise and Running
Away." Notebook title: "Ashamed."

unshakable belief that the camera cannot lie, has
been extended by the viewer to include the arrange-
ments Muybridge has made of the images. Muy-
bridge's claim to science, a claim that has never
been challenged, rests on the viewer's unquestioning
acceptance of the structure of the sequence. As
such, it is suspect. But if the explanations and rep-
resentations of movements that make up *Animal
Locomotion* are not scientific, they are still the
most convincing *illusion* of natural movement that
had hitherto been achieved. They call for shifting
our belief in the nature of the work so that Muy-
bridge the artist might rival Muybridge the scientist.

Muybridge's artistic language, the syntax of
conventions he uses to portray his narratives, is re-
alism. In the conventions of realism, the real is
equated with the visible; the goal of a realist artist

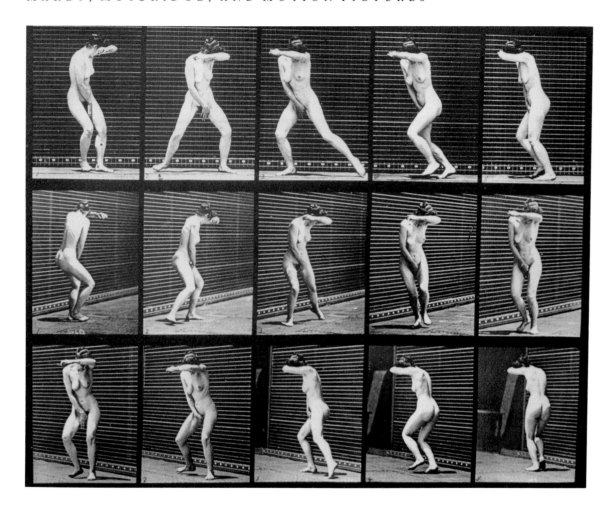

B

was to represent visible reality in such a way as to seemingly efface any artistic mediation between it and its representation. The artist's subjectivity was held at bay; rather, the creative role was to direct the attention of the viewer (or reader) to objects and ideas contained in the work, seen as if through a window. Naturally enough, the invention of photography both fed the desire for realism and increased its scope. The camera produced an image that accorded with a traditional system of monocular perspective governing the representation of

space, and it did so automatically. The camera was understood to imitate exactly what nature really looks like—when the way nature really looks is somehow given by the eye—if one knows how to look. In this sense the photographic image is a more robust version of the visible world, confirming what the unaided eye could see if it were trained, and at the same time enriching vision by showing things that usually go unnoticed. Muybridge's use of the camera emerges from and depends on this conventional notion of photography, a notion that insists

on the hegemony of the eye and its superiority over all the other senses in apprehending reality. What Muybridge produces with his camera seems real and familiar to us, to such a degree that even when he shows us phases of movement never seen before, the authority of the camera makes them acceptable—after the initial shock of their unfamiliarity has worn off. They adhere closely to what, at least since the Renaissance, a picture should look like. Each frame encloses a single unit of time and space, and an illusion of three dimensions has been created on a two-dimensional surface through light and dark. In portraying invisible phases of motion, the camera has expanded the visibility of nature and incorporated the hitherto unseen into the "nature" or "reality" that the artist will then try to imitate. Academic artists who held that being true to nature was more important than artistic convention were the most interested in and the most affected by what Muybridge's camera revealed; they studied the pictures and adjusted their representations accordingly. On the other hand, artists like Rodin, for whom subjective expressivity was not secondary to imitative skill, felt that "it is the artist who is truthful and it is photography which lies."[31] Rodin's view was amplified by critics who found the camera's vision menacing to the hegemony of the eye; but I will leave these arguments until the next chapter.

Compared with Muybridge's *Animal Locomotion,* Marey's studies of human and animal movements are everything that Muybridge's are not: disinterested, accurate, analytic, and systematic. Although they both used the camera, Marey's chronophotographic analyses of movement reflect little of traditional photographic practice: Marey sought not to represent nature but to discover the laws that governed it. For him the real and the visible were not synonymous—in fact, quite the opposite. Rather than insisting on the camera's ability to duplicate human vision, Marey used it to create a

new, superhuman eye: vision, like all sense perception, was for him subject to error. The camera had a privileged position in the hierarchy of investigative instrumentation Marey developed, not because it could reproduce what the eye sees and hold the viewer's belief that the reproduction is identical with normal vision, but precisely because it could go beyond the eye. In the early geometrical photographs, Marey's method played against the realistic nature of the medium; he repressed the visibility of his models and had his camera record the lines and points he created on their bodies so that "the illusion of the senses has faded but it has made way for the satisfaction of the intellect."[32] In his later photographs and in his films, the models were described with more volume so that the changes in muscular form as they moved could be recorded, but they nonetheless remain anonymous and depersonalized. Marey's analyses of movement produced a flat, two-dimensional calligraphy. He used his camera to work directly against a code of perspective, built on the model of the scientific perspective of fifteenth-century Italy. In the images he made there is no measured-off backdrop to suggest space, and no clue to depth or recession can be perceived within the frame. Not only is the illusion of three-dimensional space negated, but each phase of movement is given within the same frame as all the others; the overlapping forms effectively destroy the Renaissance canon of a single frame—single time/space continuum. Marey used photography to devise a visual expression for movement as it occurs along the double axis of time and space, just as he had done with his graphing machines.

The difference between Muybridge's and Marey's locomotion studies is echoed in the difference between their contributions to the genesis of cinema. In the appearance of cinema after 1895 we can see the fruition of all attempts at realistic representation such as Muybridge's: cinema was iden-

tified with life itself. The ongoing desire for the representation of what is visible, the viewer's disavowal of the gap between the standard forms of representation and the real, and finally the belief that what we see reproduced has been created by a machine that functions in exactly the same way the eye functions (which indeed guarantees the identity of the visible with the normality of vision) all culminate in cinema.

Marey's positivist belief in objective quantification as the sole determinant of our knowledge of reality would effectively bar him from avenues of research that aim solely to duplicate sensory perception, no matter how entertaining the result. Why bother to replicate the mere surface of nature when cinema could reveal its dynamic essence? "Cinema produces only what the eye can see in any case. It adds nothing to the power of our sight, nor does it remove its illusions, and the real character of a scientific method is to supplant the insufficiency of our senses and correct their errors. To get to this point, chronophotography should renounce the representation of phenomena as they are seen by the eye."[33]

Yet as we have seen, the photographic techniques Marey devised to "supplant the insufficiency of our senses"—a single camera/single point of view, making instantaneous photographic images on a band moving intermittently between two reels—form the technological base of cinematography; the technological base, in other words, of an industry devoted to fulfilling Muybridge's narrative fantasies, to duplicating exactly those illusions Marey tried all his life to avoid.

But Marey represents the nineteenth-century scientific tradition that attempted to solve theoretical problems through techniques developed in the laboratory. Like others of his kind he was a *bricoleur*, a gifted tinkerer, working on his own or with one or two assistants to develop each single instrument according to the demands of his re-

search. Scientists such as Marey were for the most part without direct ties to industry; their finances and the sophistication of their laboratories depended on the beneficence of bureaucracies. The large-scale financing needed for machining precision tools to replicate the identical components necessary for mass production were beyond their reach. Edison and the Lumière family, on the other hand, made cinema commercially viable: they embodied a new science, one geared to mass production, whose goals were linked to those of business, which worked with and for industrial concerns. The Kinetoscope and the Cinématographe mark not only the birth of the cinema industry in America and France, but also the birth of the corporately owned research laboratory, where invention became a response to marketing feasibility rather than pure research, and where successful inventions could, because of the sophistication of the laboratory and its personnel, be mass-produced and brought to market in extremely short order.[34] Neither the Lumières nor Edison worked alone: Edison oversaw a group of researchers who constituted a factory of invention. And since products of their research were the subject of patents and, potentially, of large profits, they operated in secrecy; information was not freely disseminated as it was in the scientific community. The labor of these entrepreneurs was primarily directed toward refining earlier mechanisms invented by others; it was financed in turn by the profits made from other profitable patents they held. Edison's successful record of producing commercially viable "inventions," such as the electric light and the phonograph, enabled him to draw on considerable financial backing, while the profits from Antoine Lumière's dry-plate process were ample enough to underwrite his sons' cinema production.[35] As a result, the financing needed for large-scale machine production of interchangeable parts, and for the standardization that is synony-

mous with the manufacturing of film and film cameras, was accessible to both the Lumières and Edison. (As it was, one must add, to George Eastman, whose mass production and sales of celluloid film were as important to the commercial and economic history of cinema as were Edison's sales of the Kinetoscope.) Inevitably, Marey's invention of cinema succumbed to the floodtide of industrialization and standardization, to the businessmen and entrepreneurs who invented the movie industry.

The difference between Marey's science and that of Edison and Lumière brings us again to the complex history of the invention of motion pictures. Though it might seem evident that the variety of disciplines and practices that contributed to the conception and birth of movies would preclude any single individual's claiming the title of sole inventor, it is also inevitable that, given the fortunes to be amassed from the patent rights over the various components of the medium, such claims would be made. And they were, over and over again, in print and in the courts. The subsequent debates over the relative merits of the rival claimants involved both the living and the dead, and personal as well as national honor.

The debate over who invented the movies, the claims and the ensuing lawsuits over paternity, have had a profound effect on defining the medium and determining what constitutes its history. As a result of this polemic, the history of cinema has until very recently been constructed as a nationalistic and linear chronicle of inventions and inventors whose goal was "movies," meaning both the industry and the fulfillment of a supposedly centuries-old dream to replicate reality. One important result of the constitution of this deterministic history and the arguments leading to its creation was the impact it had on the way Marey and his work were, and to some extent still are, seen. Forced to become a claimant in the rivalry to establish the paternity of

motion pictures, he was made out to be an "inventor" whose work was, as the film theorist André Bazin puts it, of merely "indirect assistance to the cinema,"[36] because he somehow did not see in his cinema work the possibility of "an integral realism, a recreation of the world in its own image, an image unburdened by the freedom of interpretation of the artist of the irreversibility of time."[37] In France itself the polemic around the birth of cinematography was so lengthy and bitter that those who wished to defend Marey's contribution to the medium ended up by narrowing down the broad scope of his inquiry to his cinematic investigations and making them the goal and pinnacle of all his work: Marey's defenders had to make Marey knowingly want to invent motion pictures, and they had to reconstitute his work in the study of motion so that it would inexorably lead to his motion picture achievements.[38]

If the prologue to these battles occurred over Marey's presidency of Class 12 at the Universal Exposition in 1900, then the first shot can be said to have been fired in February 1904, three months before Marey died, when a biographical article on Demeny in *Le Gymnaste* claimed for Demeny both the invention of cinema and the foundation of the Physiological Station. Marey's reply, written in anger from his sickbed, was the first and last public utterance he made on his relationship with Demeny, which had been severed ten years earlier:

I met M. Demeny when he became an auditor of my course at the Collège de France. He explained that he wanted to make a scientific study of physical exercises, and he asked me to admit him so that he could follow my work. Having ascertained that, in the absence of medical studies and serious training in physiology, he had some background in mathematics and capability as a draftsman, I took him on as my aide.

I even thought it warranted to get him an exemption from his bachelor of sciences diploma. What brings this

fact to mind is the care taken in the article to attribute this parchment to a date anterior to my relations with M. Demeny, a minor error that it would be useless to bring up if it did not characterize the whole misrepresentation from start to finish. It would not take much, effectively, to go from there to the point where M. Demeny becomes the founder of the Physiological Station.

In fact, when this establishment was founded for me and when it was linked to my chair at the Collège de France, I had M. Demeny appointed as my *préparateur* at a salary of three thousand francs, and I later raised this to five thousand from the credit I had at my disposal. *All the work in which he took part was signed with his name next to mine.* [Emphasis and that below is Marey's.]

He refused to follow me when my studies extended to various modes of locomotion, although this research was indispensable for the solution of the problem of animal mechanism and would have ameliorated his very precarious physiological training.

In my opinion I let him limit himself too exclusively to the things that interested him, even though my views on physical exercises were not very favorable to the orientation M. Demeny wished to give them. But since I nonetheless considered the material itself very interesting, I wanted to do everything I could to facilitate M. Demeny's work.

I had him named to a mission to Sweden and as secretary to a commission of which I was president, created by the Ministry of Public Instruction to perfect physical education. In neither of these instances can I say that I was entirely pleased with M. Demeny's methods.

Nevertheless he continued to work at my side until the day when I could no longer accept certain methods of his. I learned that he had taken it upon himself to modify, so that he could patent and *exploit in his name, one of my instruments of which I had given the description and that was consequently in the public domain.* And though legally acceptable, this manner of action is not one that, in the scientific world, can be considered permissible.

The instrument in question was none other than the

chronophotographe. M. Demeny thus attributes its paternity to himself. Today M. Demeny thinks he can do anything he pleases; he carried off a quantity of documents from the laboratory, which he now publishes as his personal work. I hasten to say that these documents appeared to me to be without interest; but removing them is the gravest indelicacy a functionary attached to a laboratory can commit. M. Demeny has written that he separated from me over a difference of opinion; he seems to have forgotten that a ministerial revocation precipitated this separation.

Having thus reestablished the facts, it only remains to me to give you my thanks.[39]

Le Gymnaste refused to print the letter. But five years after Marey's death, when the Demeny-Marey quarrel resurfaced in its pages, the aviation journal *L'Avion* had no such qualms. On 7 February the editorial page of *L'Avion* had been devoted to the story of aviation precursors, and it included a biography of Marey outlining his work on cinematography. Three weeks later the journal published an anonymous letter it had received in response to the biography, claiming, "It is not Doctor Marey who is the inventor of the Cinématographe, but M. Georges Demeny." Outraged at the idea of this anonymous accusation of plagiarism, Marey's son-in-law sent Marey's letter to the editor of *L'Avion*, who published it.

The letter was printed again in 1910 in the journal *Revue des Jeux Scolaires et d'Hygiène Sociale*. Its founder and editor, Philippe Tissié (1852–1935), a partisan of the Swedish system of physical education, used the pages of his journal to accuse Demeny of radically modifying the Swedish system of athletic training, a system he had previously championed and that, in large part because of his efforts, had become since the 1890s the dominant method of teaching gymnastics and physical education in France. Demeny's eclecticism[40] was,

Tissié declared, the "bastardization" of the Swedish method by someone "more or less knowledgeable." With his "acrobatics," Demeny had dealt a moral blow to "a just idea"; it was "the death of a rational method by which the race would have rapidly been renewed."[41] His patriotism and moral integrity were attacked in the lengthy debate, and Marey's letter was proffered as yet another example of Demeny's habit of betrayal. As noted earlier, the year before this quarrel erupted Demeny had attempted to resubstantiate his claim as the inventor of cinema in *Comment j'ai inventé le cinéma?* a pamphlet developed out of a lecture he had given at the Ligue Française de l'Enseignement on 1 February 1909. It contained extracts from Marey's letters that, Demeny hoped, could be construed to demonstrate the master's dependence on his assistant for cinematic investigation and development. The little book does not seem to have made much impact on historians, but perhaps it succeeded in assuaging some of Demeny's justified resentment at being left behind in the now burgeoning cinema industry.

Demeny was still alive on 3 June 1914, when Marey's monument was inaugurated at the Physiological Station and when, in the attendant ceremonies, Marey was proclaimed by Charles Richet as the inventor of cinema:

In science those who are important, those whose names must be glorified, are those who carried out the first experiment, no matter how embryonic that was, those who gave birth to something. It's nothing to perfect a discovery; the essential thing is to discover.

Well! We, the pupils of Marey, can proclaim with legitimate pride that it was Marey who invented the Cinématographe. It was physiology that had been for aviation, as for cinematography, the fecund inspiration.[42]

But Demeny was not present at the ceremony, nor did he publicly protest this claim made on Marey's behalf. He must have felt himself outnumbered: even the Lumière brothers had contributed to the cost of the monument. But their effort to maintain what, on the surface at least, had been their esteem for Marey would not be sustained either. By the 1920s, the history of motion pictures had to be rewritten, and as a result the question of Marey's and the Lumières' respective contributions to motion pictures became the basis of a full-scale verbal war.

The First World War had devastated the French film industry and created a vacuum that was filled by American films. Coupled with this flood of American films was the promulgation in France of Edison's name as the inventor of the medium, a not unnatural affiliation considering the highly publicized court battles Edison had waged to assert his claim, but an intolerable assertion to French historians and to those working in the once glorious but now almost defunct industry.[43] A popular campaign began—almost imperceptibly at first—to substitute a French name for the American's. Since the campaign arose from within the film industry, the name put forward was that of Lumière, founder of the French industry and familiar to every amateur photographer.

On 9 October 1923 a request was made to the municipal council of Paris by one of its agencies, the commission of Vieux-Paris, that a memorial plate be placed on the site of the first public showing of the Cinématographe, 14 boulevard des Capucines. The proposed plate read: "Here, on 28 December 1895, the first public projection of animated views by means of the Cinématographe, a French invention of Louis Lumière, took place."[44] The municipal council, which had been the major funding agency for Marey's Physiological Station, found the proposal unacceptable. And so, while in Lyons a newspaper described a project to erect a "pantheon of film" in that city "to show film was created at Lyons and nowhere else,"[45] in Paris the Vieux-Paris

commission modified their proposal in the following year to read: "Here, on 28 December 1895, the Cinématographe, invention of the Lumière brothers, made possible the first public projections of animated photography."[46] One brother had become two, and animated views became animated photographs, to account for the well-known fact that between 1892 and 1900 Emile Reynaud had successfully projected animated views with his Théâtre Optique for over 500,000 viewers at the Musée Grevin.

The Parisian supporters of Marey, led by Pierre Noguès, at that time director of the Institut Marey, and by Charles Richet, brought the proposition to the attention of the Académie de Médecine at the meeting of 12 March 1924. The Academy registered its strong opposition to the claims of Lumière, protesting "the grand injustice committed against the illustrious French physiologist Etienne-Jules Marey by those who claim to contest the merit of his having created the cinema method and invented the first Cinématographe,"[47] and pointing out that all the principal elements of his machine had been invented by Marey. This was the clarion call to the Lumière faction. Immediately a war of words exploded in the press, in scientific journals, and in privately printed pamphlets.[48]

On 28 March yet a third text was suggested by the Vieux-Paris commission, and on 18 April the Société Française de Photographie attempted to bring the two sides together. The Société approved the latest suggestion of the commission: "Here on 28 December 1895 the first public projections of animated photography took place, with the aide of the Cinématographe, a machine invented by the Lumière brothers,"[49] but it also proposed a plate for Marey's house on the boulevard Delessert. The appoved Lumière plate was, after more dissension, finally put in place a year later on 15 March 1925. It was not formally unveiled, however, until 17

March 1926, and the ceremony accompanying its unveiling did nothing to soothe the feelings of Marey's adherents. For the boulevard Delessert memorial, a Marey committee submitted a text to the Société Française de Photographie that described Marey as the "inventor of chronophotography, perfected and vulgarized under the name cinematography."[50] Vehement protestations by the Lumière faction were followed by compromise: on 22 December 1928, a plate was placed on Marey's home that described him as the "creator of chronophotography, the technical base of cinematography."

In the 1930s the battle heated up again; the ostensible causes were Marey's centenary (1930), the memorial tablet placed on the house where the Lumière brothers were born in Besançon (1931), and the fortieth anniversary of the birth of the Cinématographe in 1935. The ceremony accompanying the anniversary festivities at the Sorbonne was somewhat dampened by Marey's adherents, who stood outside the building and distributed a pamphlet denouncing the festivities going on inside. At the Universal Exposition of 1937, the Marey committee put one of Marey's chronophotographes (borrowed for the purpose from the Conservatoire des Arts et Métiers) outside the entrance to the "cinema palace," where the busts of Louis Lumière, Gaumont, and Pathé were placed; upon Louis Lumière's being proposed for the Nobel Prize in physics, the committee united to stop what they felt was an undeserved honor and publish what they saw as the truth about his contributions to the birth of cinema.

Before the First World War, the Lumière brothers had felt justified in asserting that theirs was the first practicable and commercially exploitable machine: "As one tends a little too much to forget today, we allow ourselves to insist on this point and to repeat that whatever was the historical and documentary value of the previous attempts, from the

practical point of view cinematography dates from the invention and vulgarization of [our] machine."[51] In the 1920s, however, the assertion was made that the Cinématographe was a totally original instrument devised by Louis Lumière in the few short months after he (or his father or his brother Auguste—the accounts differ), had seen Edison's Kinetoscope. This is what most outraged the scientists, including many from outside France, who had become supporters of Marey. They insisted that Marey's chronophotographic camera formed the principles for all cameras and projectors used in motion pictures.

Part of the vehemence with which the arguments were made can no doubt be explained by Louis Lumière's desire to be perceived as a scientist rather than an industrialist—a class much less prestigious in France than in America, where the striving for success of the "self-made man" was seen as "the indispensable ingredient of human progress."[52] Thus the Lumière faction's insistence, after the First World War, that the Cinématographe was an important and original contribution to scientific progress rather than commercial exploitation: "My work has been directed toward scientific research," Louis Lumière emphasized in an interview with historian Georges Sadoul; "I have never engaged in what is termed production."[53] The subtle disparagement of industry and industrialists also explains in part why Lumière's scientific pose was supported only by the cinema industry there, and why the scientific community was solidly against him and in support of Marey—one of their own.

The Lumière claims for originality, advanced by Louis Lumière himself from behind the scenes,[54] were based initially on the fact that their Cinématographe was the first projecting apparatus to incorporate perforated film (and, as a corollary, that Marey had never used perforations) and that it projected images—for a paying public (whereas

Marey had arrived at a satisfactory projecting system only in 1899). The importance of projection in the Lumière case was quickly relegated to the background, however, when it was publicly pointed out that Emile Reynaud had projected images for a paying public from 1892 to 1900, and that he had included perforated bands in his 1892 patent for the Théâtre Optique. Arguments that the Lumières had been the first to project animated *photographs* for a paying public were also rebutted, by claims made for the precedence of Jean A. LeRoy (the Cinématographe LeRoy made its public appearance on 11 February 1895 in New York), Eugène Lauste (Eidoloscope, 20 May 1895, New York), Carl and Max Skladanowsky (Bioscope, 1 November 1895, Berlin), and C. Francis Jenkins and Thomas J. Armat (Phantascope, September 1895, Atlanta, Georgia).

Against these counterclaims the Lumière faction employed a new strategy, negating the value of Marey's innovations. The usual charge either minimized the commercial importance of his inventions or suggested that his contributions were at best unoriginal and at worst plagiarized. The evolution of Marey's photographic gun from Janssen's photographic revolver was the usual example cited, and as we have seen, Janssen himself did not belie this opinion; but the suggestion was also made that Demeny did most of Marey's cinematic work.[55] There was a climax in this type of innuendo in 1929 when, toward the celebration of the centenary of Marey's birth,[56] the Lumière faction used Marey's own words to advance their cause. Insisting on a close family friendship with the scientist, the Lumières' followers offered evidence where, it could be interpreted, Marey himself had acknowledged the originality of the Cinématographe. The "evidence" was to be found in those writings where he praised the Cinématographe as the solution to the perfect illusion of movement. A transcript of the letter con-

taining Marey's request that he be replaced as president of Class 12 of the Universal Exposition in 1900, in which he described the Lumières as the "inventors of the Cinématographe," was widely disseminated by the Lumière adherents, as were excerpts from Marey's publications after 1897 where he praised the Lumières' innovative machine.[57]

The Lumière case for invention gained (and to this day maintains) a strong foothold in France. G. M. Coissac's *Histoire du Cinématographe*, written in 1925, summed up the arguments on their behalf, and the book soon became the standard reference on the subject. The 1926 publication in America of Terry Ramsaye's *A Million and One Nights*—a supposedly objective history of cinema that insisted it was Edison and no one else who "invented" motion pictures—gave fresh urgency to French claims and caused a new rash of publications.[58] *The Cinema: Historical, Technical and Bibliographical*, written by M. Jackson-Wrigley and E. Leyland and published in England in 1939, marked the late arrival of those who championed the English photographer William Friese-Greene; the book did nothing to allay the concerns of the French writers.

The arguments continued after the Second World War. In 1946 Georges Sadoul's *L'invention du cinéma*, the first volume of his *Histoire générale du cinéma*, made its appearance; it claimed the invention of cinema for Louis Lumière and for France. Revised in 1973, it was the first history to be oriented toward the problem of invention in terms of social and technological history.[59] Subsequently, in the 1960s, other multivolume histories were published that addressed the many claims for priority according to a nationalistic bias.[60]

In 1955 a massive exhibition created by Henri Langlois was mounted at the Musée d'Art Moderne in Paris to celebrate "the 125th anniversary of J. E. [*sic*] Marey and the 60th anniversary of cin-

ema." For Langlois, Marey was the "trunk that unites the roots of the genealogy of cinematography; from it grow all the branches that represent its development."[61] Langlois's 1963 "Hommage à Etienne-Jules Marey," an exhibition at the Musée de Cinéma in Paris, celebrated the beauty of his chronophotography and its aesthetic influence on modern painters. His cinematic inventions were portrayed as the culmination of his career.

In the past twenty years, with two exceptions, European work in the history of cinema has tended to skirt questions of priority, though now and again partisan histories still continue to appear in the form of monographs defending one inventor or another. The two exceptions were both published in 1985. Virgilio Tosi's *Il cinema prima di Lumière* and Léo Sauvage's *L'affaire Lumière* reconstruct the events leading to the appearance of the Lumière Cinématographe. Tosi's work is primarily a history of scientific film in which Marey is the central character, and the author has no difficulty in attributing the "invention" of film to him. Sauvage's book, written in 1977, but without a publisher in France until 1985,[62] is a brilliant sustained attack against the claims of the Lumière faction, bringing the polemic up to date and incorporating those American studies that appeared after the 1950s. (In America itself, Hendricks's *The Edison Motion Picture Myth* effectively put an end to books of myth and legend about early American contributions; little work on the subject has been done since, with the exception of three monographs, including one written by Hendricks himself, that claim Muybridge was the father of the moving picture.)[63]

Scholarly analyses of the sources and documents related to the histories that surround the birth of cinema—those of popular entertainment and narrative and those that investigate the ideology of the cinematic apparatus, its modes of representation, and the economics of its develop-

ment[64]—are in the forefront of cinema history today. The chronicle of filmic invention itself has been made into a separate and minor field of study: a history of primitives or an archaeology of cinema.[65] In his landmark *The Emergence of Cinema* (1990), Charles Musser creates a model for uniting these separate histories into a history of the screen from the seventeenth century. He argues for an understanding of the constantly changing inter-relationship of the technology, representational

strategies, and social-cultural functions of "screen practice." Musser, however, focuses on Edison and the early American cinema, and in the absence of any other encyclopedic history the older deterministic chronicles are still being read and will be taught to later generations. Accordingly, the context in which Marey labored has been all but lost, and errors in understanding his use of cinema in the analysis of movement proliferate.

7 Marey, Modern Art, and Modernism

The extraordinary pictures that resulted from Marey's investigations into movement constituted his raw scientific data, the stuff from which the secrets of the body could be known, measurements taken, and practical applications derived. Yet quite aside from their author's intentions or use, these scientific analyses had an enormous impact on the fine arts—probably greater than any scientific work has had since the discovery of perspective in the Renaissance.

The influence of Marey's chronophotography on art was felt most strongly after his death. In the first decades of this century, a "series of sweeping changes in technology and culture created distinctive new modes of thinking about and experiencing time and space."[1] A truly modern way of depicting the new experience of space and time was called for, one that could reflect the sensation of simultaneity, speed, and dynamism that engulfed Western consciousness. Marey's images became the key visual source of this aesthetic modernism; today, in fact, we are probably most familiar with his chronophotography in the guise of works of early modernist art. Marcel Duchamp's *Nude Descending a Staircase* and Giacomo Balla's *Girl Running on a Balcony* (both painted in 1912) are just two examples of paintings that have adapted the rhythmical parallel shapes of Marey's chronophotographs and made them into the dominant twentieth-century pictorial convention for the dynamic sen-

sation of time. How and why Marey's work was adapted to these ends is the focus of this chapter.

While Marey was still alive the aims of art, like those of science, reflected the enormous impact of positivism. From the middle of the nineteenth century, realist artists had sought to emulate scientists in their quest for truth: truth to the facts, to perceived and experienced reality.[2] Naturally Marey's own views on art reflected these positivist tenets. He held that the artist was by necessity confined to the accurate observation and notation of empirical phenomena, to descriptions of how, "not why, things happen."[3] Consequently, for Marey there was no question but that the artist would need to use the revelations of science to get the facts straight. He rightly assumed that the descriptions of movement beyond the realm of visual perception given by his graphing instruments would be of real service in sharpening the visual acuity of painters and sculptors. The drawings Duhousset made from Marey's graphic notations of the gaits of the horse, for example, were used by both authors to illustrate their popular treatises on the locomotion of the animal, and these were intended for artists. The drawings were also published to great acclaim in the *Gazette des Beaux Arts* between 1882 and 1883 and incorporated into preparatory studies by academic artists such as Meissonier. These graphic notations "have no other pretensions than to be correct as regards the position of the members," wrote Marey; how-

ever, they provided artists with a "simple and sure means of representing a horse in any pace and in any phase of the steps in that pace." And though "it would be the artist's duty to add elegance of form, [their] employment would give to the artist the double advantage of representing the pace with truthfulness and of varying them to an extent almost illimitable."[4]

In 1878 Marey concluded a lecture on equine locomotion by comparing the accuracy with which artists throughout history had represented horses' gaits with the results provided by the graphic method. Using a collection of paintings, drawings, and etchings of horses that Duhousset had compiled from the history of art, Marey demonstrated "how, in a general manner, art has progressed, proceeding from simple forms to more masterly delineations."[5] Because the gallop was usually the most poorly rendered pace (the artist represented the horse prancing on its two hind feet, an action the graphic method showed did not exist), Marey was full of admiration for the sculpture of the Greeks. Two casts from the Parthenon frieze he had seen had represented the gallop "with equal correctness," and at first, he said, he was led to believe that their accuracy proved "that in the age of Phidias, artists were in possession of the science of paces." A subsequent examination of reproductions of the entire frieze, however, convinced him he was wrong: the "results were obtained by a happy chance, for the

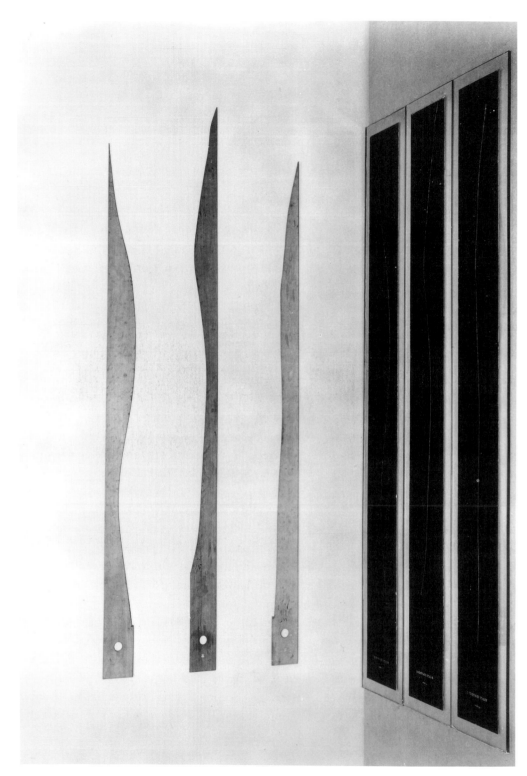

A

266

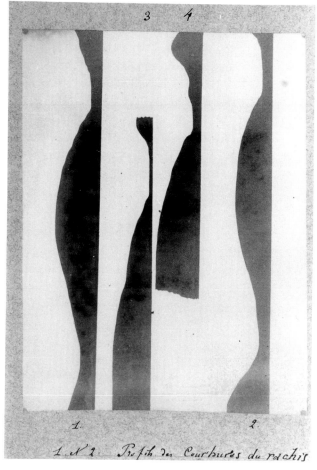

B

143.
(A) Marcel Duchamp, *Three Standard Stoppages*, 1913–14. Three threads glued to three painted canvas strips, each mounted on a glass pane, and three wooden slats. The Museum of Modern Art, Katherine S. Dreier Bequest. (B) Marey, profiles of vertebral curves and of the neck and thorax, 1888. Album I, plate 58, Hôtel de Ville, Paris.

greater number of the horses are represented in false attitudes, which is all the more to be regretted in contemplating the exquisite elegance of their forms."[6]

Marey was the first to admit, however, that no matter how accurate, no drawing could surpass the veracity of the photograph; when Muybridge's photographs of horses appeared in 1878, Marey immediately noted with pleasure the benefit photography would bring to art: It would finally provide artists, he wrote to Muybridge in the pages of *La Nature*, with the true attitudes of movement. Later, as we have seen, Marey practiced what he preached, employing his not inconsiderable artistic talents to sculpt birds from his chronophotographs as a mode of verifying his analysis of their flight. The sculptures Georges Engrand made from Marey's chronophotographs of a running figure served a similar purpose. In his 1888 note to the Académie des Sciences that accompanied the presentation of Engrand's casts, Marey specified the service that detailed chronophotography provided for art. Although he was disappointed in the quality of the photographs from which Engrand had made his casts—Marey complained that his cameras were still unable to render the modeling of the muscle groups clearly—he nonetheless hoped his photographs would still provide sufficient information for the artist who wanted to make the presentation of "animated beings" more exact:

Certain artistic representations of walkers or runners are sometimes bothersome to the physiologist familiar with the succession of movement in human locomotion. The impression is somewhat analogous to what we feel in front of those landscapes painted when the laws of perspective were observed less than they are today. The difficulty artists find in representing men or animals in action is explained when we realize that the most skilled observers declare themselves incapable of sei-

zing the successive phases of locomotive movements. To this end, photochronography seems called to render services to art as it does to science, since it analyzes the most rapid and most complicated movements.[7]

His 1891 double-use camera finally gave Marey the clear visual modeling he felt was necessary for artists. In 1893 he and Demeny published *Du mouvement de l'homme,* the first in a projected series of works entitled *Etudes de physiologie artistique faites au moyen de la chronophotographie.* This large-format portfolio was conceived as an artist's handbook, providing models to assist in the artist's representation of human locomotion, and it included images of a male nude pulling a rope, throwing a ball, waving a staff, and running. The images—all except that of the runner had been made on film—were similar in format to Muybridge's *Animal Locomotion* photographs, but clearer and sharper (fig. 144). Indeed, the similarity seems to have been deliberate: Demeny was responsible for preparing the portfolio for the publisher, and it is clear that he wanted to capitalize on the market for Muybridge's earlier work. In a letter of 1891 he even suggested to Marey that they use Muybridge's title, a suggestion Marey firmly rejected. *Du mouvement de l'homme* was intended to be the first in a series of portfolios for artists, but Demeny's departure from the Physiological Station put an end to any further volumes. The 1895 appearance of *Atlas d'anatomie artistique* and *Physiologie artistique de l'homme,* both written by Albert Londe and Paul Richer and both illustrated with chronophotographs made by Londe, capitalized on the popularity of Marey's volume. All three editions sold widely; they became basic reference tools for artists, supplanting the illustrated model books that artists had depended on since the Middle Ages.

In *Movement,* Marey dedicated a chapter to "Locomotion in Man from an Artistic Point of View," which enumerated the ways artists could use chronophotography. He noted that the artist often attempts to reproduce the most characteristic aspect of a movement, usually the phase that is visible to the naked eye when the direction of movement has just changed. It is precisely here, he argued, that chronophotography can assist by determining which of the phases is most visible: the phase will appear on the photographic plate as the most intense, having had the longest exposure time. To illustrate his argument, Marey borrowed an image of a fencer from Demeny's work (and in this rare instance made a point of ascribing the photograph to Demeny). The point is worth mentioning because the image, habitually ascribed to Marey himself, is revealingly unlike his own: in Marey's imagery the contours of each overlapping phase are sharp and distinct; the blurring of the intermediary phases of the movement in Demeny's picture, in this case more suitable as a model for artists, falls short of the lucid structural analysis that was the hallmark of Marey's work (fig. 145).[8]

In the same chapter of *Movement,* Marey recommended a judicious use of photographs, one that melded the scientific truth they revealed with the aesthetic truths of artistic individuality and tradition. He considered that the artist ought, "while taking Nature as his model, to make an independent choice" of the most expressive attitude of the body in motion among the many offered by the chronophotograph—usually the one that showed the moment of greatest muscular effort—and should make that the basis of his depiction.[9] The "faithful expression of the actions of the muscles" captured in the chronophotographs might also be used by painters or sculptors to give their figures a dynamic sense of onward progression. As Marey

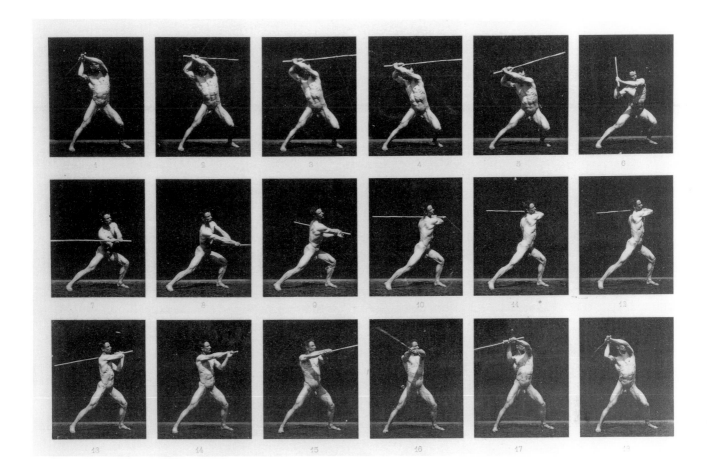

explained, "The standing out of muscles in action has an individual expression, just as is the case with the facial muscles. . . . It might be said that the modelling of a limb could not only express the action of the time being but could suggest to a certain extent its immediate successor."[10]

Marey's own aesthetic sensibilities informed his acknowledgment that the artist's and the scientist's approach to reality might differ. Although he saw photography as an "education of the eye" that had "taught us to discover attitudes in Nature which we are unable to see for ourselves," he understood the

144.
"Un coup de bâton," 1892. Plate I of *Etudes de physiologie artistique faites au moyen de la chronophotographie, vol. 1, Du mouvement de l'homme,* 1893. Société Française de Photographie.

269

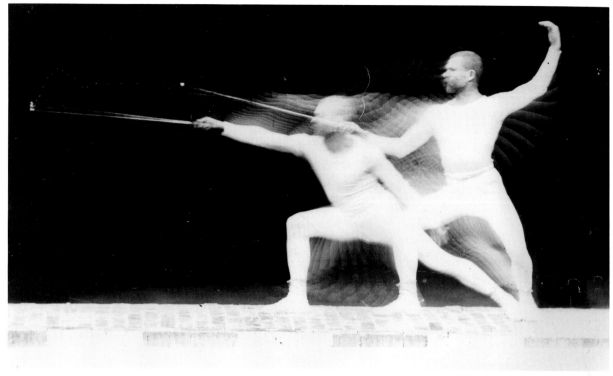

A

145.
(A) Demeny, movement of a fencer,
1890. Cinémathèque Française.
(B) Demeny, movement of a boxer.
1890. (C) Demeny, movement with
staff, 1890. Collège de France.

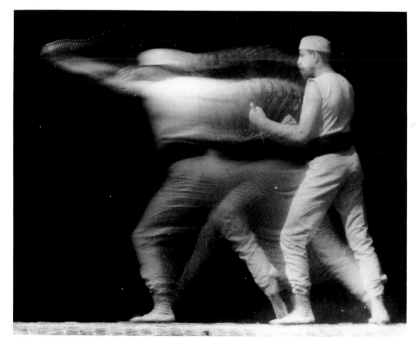

B

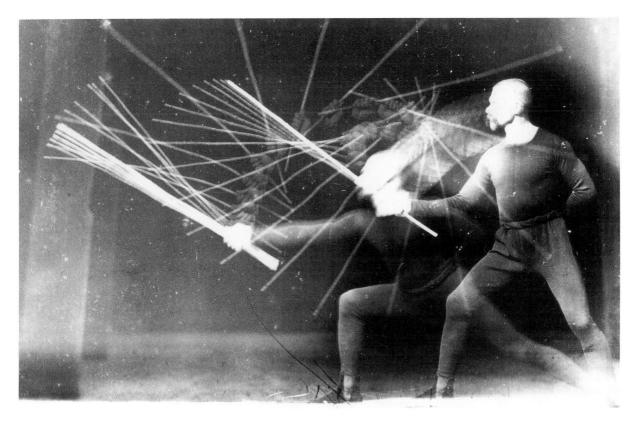

c

difficulty artists or critics might have in accepting the attitudes shown by the camera. The difficulty occurred, in his words, because "the ugly is only the unknown and [the] truth seen for the first time offends the eye."[11]

Marey was no doubt aware of the outcry among critics and writers over the pernicious influence photography was having on artists. From the moment Muybridge's photographs of movement appeared in 1878 they, and subsequently Marey's own chronophotographs, were hardly ever out of the public eye, and their influence on artists was the subject of great controversy.

The influence of both Marey's and Muybridge's photography of movement could already be seen in the work of late nineteenth-century painters and sculptors. Muybridge's photographs were critical for academic artists such as the group Meissonier had invited to his reception. Their members wanted to capture the appearance of visible reality, and the hitherto unseen phases of movement seen in Muybridge's detailed photographs could be used to guarantee the accuracy of their representations. Meissonier himself, for example, had changed the positions of the legs of his galloping horses in *Friedland, 1807* (1875) to accord with the evidence supplied by Muybridge's California experiments. Similarly, Jean-Baptiste-Edouard Detaille worked directly from enlarged frames of Marey's films for the correct position of the horses' legs in his 1905 Pantheon mural *La chevauchée vers la gloire*.[12] Although the extremely awkward positions shown by

the camera were at first difficult to accept—they contradicted both the forms seen by the naked eye and those provided by artistic tradition—they were perceived by these academic painters as scientifically objective and therefore to be accomodated if one wished to remain "true to nature."[13]

Painters such as Edgar Degas (1834–1917) and Georges Seurat (1859–91), on the other hand, had no such positivist objectives for their art. Degas, a gifted photographer himself, knew Marey's and Muybridge's work from *La Nature*. After the publication of Muybridge's *Animal Locomotion* in 1887, Degas made two drawings from the plate "Annie G. in Canter" and used the photographs for his wax models of horses.[14] His studies of dancers, done in the 1890s, include images that echo both the work of Marey—where the bodies are overlaid in dynamic laminates—and the separated figures of Muybridge (fig. 146). Seurat, introduced to Marey's work both by Mathias Duval, who was professor of anatomy at the Ecole des Beaux Arts while Seurat was there, and by the writings of the psychoaesthetician Charles Henry,[15] incorporated the ornamental, repetitive rhythms and the flattened space of chronophotography in his *Chahut* (1889–90) (fig. 147). Both Seurat and Degas, however, were more interested in creating an artificial world with its own visible order[16] than in using the photographs as a guide to the scientifically verifiable facts of nature.

Acceptance of the camera's version of reality was anything but universal. Rodin's opinion on the primacy of artistic truth was widely shared and was just one of the criticisms leveled against Muybridge's photography. Other writers rejected the artist's use of Muybridge's studies because they saw that the superiority of the camera's eye denied both the normality and the limits of normal vision. If the goal of the artist was to imitate the visible, and if the visible was defined as what the eye could see,

then the camera's version of reality was a false one: it represented attitudes and poses that the eye could not see unaided, and furthermore, it did so in ways contrary to what were thought to be normal modes of vision. As long as good art was defined by the accurate transcription of the concrete facts of visible reality, then the slavish imitation of photography was seen as both irrelevant and dangerous.

The scientific theory of the persistence of vision—the retention of one image on the retina even while the eye takes in another—was used to prove the disparity between physiological reality and what the camera rendered. Such treatises as Eugène Véron's *L'esthétique*, published in 1878 just as Muybridge's photographs appeared in France (but probably before Véron had seen them), judged instantaneous photography to be an anathema because, according to the theory of the persistence of vision, the eye never sees instants of immobility but perceives a fluid, blurred movement as one image displaces the next. As he argued: "Photography doesn't give movement precisely because it only seizes fixed attitudes. . . . The first obligation of art is to accommodate the physiological conditions of humanity."[17]

In 1882 the question of persistence of vision was again taken up by the critic Georges Guéroult in the *Gazette des Beaux Arts* when he posed the problem whether artists should paint exactly what they see as it is seen—which, according to the theory of the persistence of vision, would be a blur—or whether they should choose a moment appropriate to the exigencies of art among the impressions given to the eye. Guéroult made direct reference to Muybridge's photographs and to those "American painters" (whom he does not name) who accepted them as a revelation in depicting locomotion. The Americans err, Guéroult explained, because

ocularly speaking, . . . Muybridge's photographs are

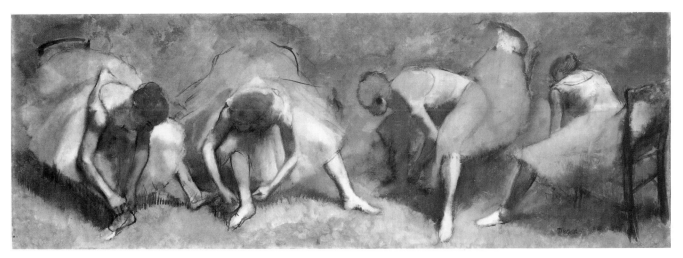

A

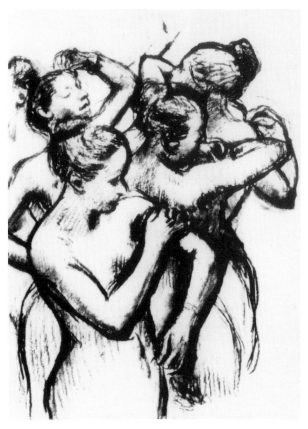

B

146.
(A) Edgar Degas, *Frieze of Dancers*, ca. 1895. Oil on canvas, 27¾ × 79 in. Cleveland Museum of Art, Gift of the Hanna Fund, 46.83. (B) Edgar Degas, *Dancers, Nude Study*, ca. 1897. Charcoal on paper, 30¾ × 22⅞ in. Private collection.

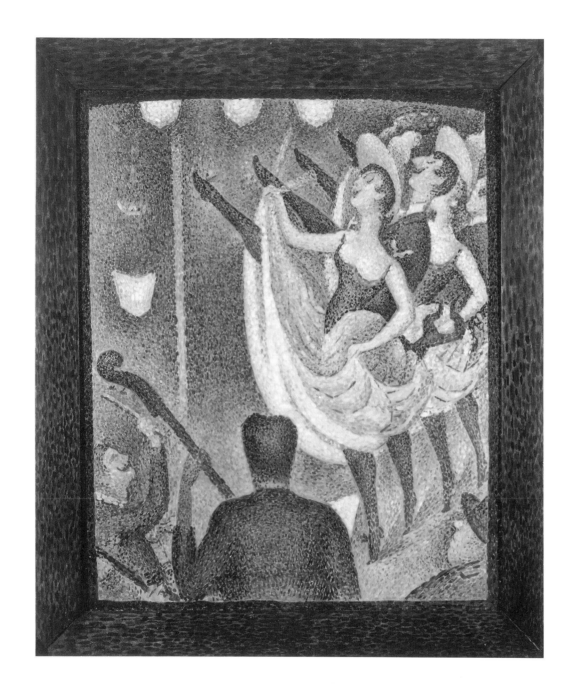

147.
Georges Seurat, last study for
Chahut, 1889. Oil on canvas, 21⅞ ×
18⅜ in. Albright-Knox Art Gallery,
Buffalo, New York. General Purchase
Funds, 1943.

false, since they give us a sharp image at the moment when, on account of the speed and the persistence of the impressions on our retina, we only see a confused image whose form participates in the preceding and following positions at the same time. In the way the human eye is constituted, it is certain that it has never seen and will never see the horse galloping as it is shown in these drawings.[18]

Guéroult's arguments were directed specifically at Muybridge's instantaneous photographs. Those who attacked Marey's motion studies had to alter or even abandon the argument of the persistence of vision, for in point of fact there was a way Marey's fixed-plate chronophotography provided a visual analogue for the theory: Each "form participates in the preceding and following positions at the same time," as Guéroult would have it. Marey himself had proposed his fixed-plate chronophotographe as a mechanical model of the ideal eye:

If one considers the physiological property of the human eye, one sees that this organ represents, from the point of view of dioptrics, a camera with its lens and black box; the eyelids form the shutter, whereas the retina, on which the real images of exterior objects come to be formed, would be the sensitized plate. . . . Far from being permanent, as are the images on the photographic plate, the retinal images are fugitive; nevertheless they persist for some moments, thus prolonging the apparent duration of a phenomenon.[19]

Thus for the critics who attempted to dismiss the photography of movement, Marey's decompositions of motion posed a problem that could be solved only by a willful confusion of his work with Muybridge's. In *Les questions esthétiques contemporaines* (1904), Robert de la Sizeranne initiated his diatribe against photography by describing work that is clearly Marey's:

For some years we have been seeing wise photographers armed with a large quantity of documents coming toward our artists and teaching them their job. They have invented a number of very clever and swift instruments with which to surprise nature: disks pierced with windows that quickly turn and take hundreds of successive views of a man before he can say ouf! then boxes enclosing wasps whose wings have been powdered with gold so that the trajectory the wings form as they fly can be registered; revolvers and guns with lenses that they turn on birds. . . . Art has ignored movement: science is going to explain it.[20]

Sizeranne posited the truth of the photograph as a scientific artifact and used the word "chronophotography" as a generic term for movement photography. As he continued, explaining why this scientific truth was different from artistic truth, he avoided discussing the overlapping images Marey produced and proffered instead the example of Muybridge's instantaneous photographs. Here Sizeranne blurs the distinction between the two approaches in order to construct his argument:

The truth of science is a truth of detail; the truth of art is a truth of ensemble. When chronophotography brings us a print noting one of the thousand phases of which a movement is composed, we respond: That is a part of movement, it is not movement. It is true that one can find the attitude you discovered in a movement, but it is no less true that there are hundreds of others and that *it is the result of all these attitudes—each one immobile during an instant of reason—that forms what we call movement.* My eyes perceive only the ensemble; your camera perceives only a part. (Emphasis in original)[21]

The writings of the aesthetician Paul Souriau, however, show quite a different appreciation of Marey's chronophotography. Souriau's perceptions mark a new phase in the relationship between art and chronophotography, one that echoes the advent

of an art that stresses the subjective rather than the objective.

Souriau's *L'esthétique du mouvement* (1889) is an inquiry into the sources and kinds of aesthetic pleasure we take in movement (beginning with the movement of our own bodies) and in the depiction and perception of movement in works of art. Souriau would have the artist depict movement in a way that judiciously blends truth (for Souriau, the camera's version of reality) with the literal representation of appearance through the persistence of retinal images (the eye's version). He illustrated his arguments with references to Marey's photographic studies and found Marey's camera "an ideal eye that sees everything at one glance and permanently retains what it has seen." Far from preventing artists from observing nature directly, it permits them to observe it more fruitfully.[22] The only thing to be avoided, to Souriau's mind, was the literal reproduction of chronophotographs. Since blurring—the "luminous tracing that moving objects leave behind them"—is the predominant given of visual perception, the true token of movement as perceived by the eye is missing in chronophotography. This does not mean, however, that the painter should blur forms. Echoing Marey's words, Souriau argued that the painter should make a "choice among truths," because "the literal representation of appearances would be no less implausible than that of the truth. For the watching eye, the flying bird does not have two wings, it has at least four; the trotting horse does not have four legs, it has at least eight, since, in any rapid alternating movement, the eyes conserve at the same time the image of both extreme phases of the oscillation."[23] Twenty-one years later the first futurist manifesto on painting would almost exactly replicate Souriau's description of the trotting horse. Significantly, the futurists chose to represent movement with rapid alternating rhythms, using Marey's chronophotographs as the major source for their pictorial revolution.

Through the Italian painter and theorist Vittore Grubicy the futurists were familiar with Souriau's treatises, including his second work, *La suggestion dans l'art* (1893). This book contained a key chapter on movement and how it can be suggested (as opposed to depicted) in a painting. Right at the outset, Souriau argues that chronophotography is the most useful model for the accurate depiction of figures in motion. He explains that it is only traditional representation or illusionism that causes one to consider photographic images awkward: "We compare the attitudes not to reality, but to tradition; and now it is tradition that makes us smile, the ancient paintings of the hunt and battle have something quite amusing."[24] Souriau also proposed a totally original method for suggesting motion in a picture: the artist should copy the successive phases of one movement from the chronophotographs, using a different figure in the painting to illustrate each phase. According to Souriau, the movement of the viewer's eye would then bestow movement on the figures in the painting, producing an illusion similar to the one given by the zoetrope (or the Cinématographe in the 1909 edition of the book). In other words, as the viewer's eye moved over the figures it would operate as a projector, putting them into motion.

The second part of Souriau's argument concerned the formal qualities of painting and their perception by the viewer. Souriau wrote that movement must be suggested through a vivacity of stroke, a softness of outline, and the inner organization of the painting itself. His stress on the self-contained unity of the work of art, rather than the fidelity to nature of the objects it contained, may have been a result of the camera's perceived threat to the hegemony of the eye. But it also signals a

shift in emphasis at the end of the nineteenth century, from an aesthetic truth based on empiricism to an aesthetic truth based on formal harmonies in the work itself and determined by subjective response. This shift, propelled by an artistic notion that reality might be more than something apprehended by the senses and reason—that it might be discovered by the imagination—echoes shifting philosophical assumptions about the nature of reality and time; it culminates in the emergence of abstract art in the early twentieth century.

Although it formed no part of his intentions, Marey's work in chronophotography had a seminal influence on early twentieth-century abstract art. After his death his studies were to be used and interpreted by many different artists, according to their individual purposes, to express a new vision of modernity. Ironically, his imagery, so grounded in positivism and so rigorously analytical, served those very artists who vociferously rejected positivism and its claims to a higher form of knowledge. Just as his scientific method was the basis for the motion picture industry, Marey's scientific chronophotography provided a fertile vocabulary for the expressive language of abstraction. His photographs contributed one of the essential components in the evolution of abstract art: models for an iconography of the subjective visualization of time. Marey contrived to decompose movement into a multiplicity of equal and discrete units, seizing each element from the current of time in order to fix it in space. But his "decompositions" came to be reread as a means of portraying a different reality, one whose essence was duration—the unstoppable, unending flow of time. This reading necessitated, however, obscuring the analytic component of the pictures as the experience of time changed from a linear atomistic abstraction to a web of personal sensations.

In the nineteenth century, the concept of his-

torical transformation came to dominate the natural sciences. The earth and its inhabitants were no longer perceived as fixed elements in a static order ordained by divine providence but were seen as entities to be studied as they evolved within a continuum of time. Charles Lyell's *Principles of Geology* (1830), for example, showed that the history of the earth was one of continuous evolution and change on a hitherto unimagined temporal scale, while Darwin's *On the Origin of Species* (1859) convincingly argued that man had a history reaching far beyond the biblical Genesis.

By the century's close, time was no longer just the container within which the transformation of nature and humanity occurred. Time itself had become one of the primary objects of both scientific and artistic investigation.[25] In classical physics the transformed perception of time from an absolute and atomistic entity to one of relativity and flux had already begun in the late nineteenth century. In 1883 Ernst Mach rejected Newton's view of absolute time as an "idle metaphysical conception,"[26] and the Morely-Michelson experiments of 1888 led to hypotheses about a slowing down of time from its movement through the ether.

The concept of space as a fixed three-dimensional category also found itself under assault as the complex spatial possibilities suggested by popular writings on the fourth dimension as well as the curved space of non-Euclidean geometry captured the public imagination.[27] In his essay "On the Origin and Significance of Geometrical Axioms" (1870), published in his *Popular Lectures on Scientific Subjects* in 1881, Helmholtz defended a purely empirical view of geometrical axioms. The ensuing debate brought the well-known French mathematician Henri Poincaré into the fray and gave non-Euclidean geometry a currency among intellectuals in Paris.[28] Poincaré argued that the fundamental hy-

potheses of geometry are neither experimental facts, analytic judgments, nor synthetic a priori judgments but are mere conventions,[29] and that any notion of space thus has to be a relative one. The philosophical influence of these theories and their dissemination in popular literature was profound (in fantasy novels such as H. G. Wells's *The Time Machine* (1895), time itself is treated as the fourth dimension). As Linda Henderson points out in *The Fourth Dimension and Non-Euclidean Geometry in Modern Art*, it substantially shook the foundation of mathematics and science and contributed in no small measure to the demise of traditional positivism. As a result, optimistic belief in our ability to acquire absolute truth gradually gave way during the later nineteenth century to a recognition of the relativity of knowledge.[30]

Rapid changes in technology and culture also contributed to new modes of thinking about and experiencing time and space. With the invention of the telephone (1876) and the wireless telegraph (1894), the average person's sense of time was inevitably changed, since one could experience many distant events at the same time. In 1884 the twenty-five-nation Prime Meridian Conference in Washington on the creation of world standard time began working toward the measurement of a uniform public time. The assault on private time created by this development was explored in a number of literary works, such as the operation of the double time scheme in Oscar Wilde's *Picture of Dorian Gray* (1890). The personal and cultural experience of time also became central to the investigations of sociologists and psychologists. Jean Guyau's *La genèse de l'idée du temps* (1890) explored the individual psychology of time. The social relativity of time was studied in the writings of Emile Durkheim, beginning with *Primitive Classification* in 1903. And while Sigmund Freud investigated the importance of the personal past and its existence in the present, an even more direct access to the past was given through photography and the phonograph.

The most popular synthesis of the new experience of time and space was given by the French philosopher Henri Bergson (1859–1941), the most influential thinker of his day. Bergson synthesized many of the current and contradictory ideas about time and space prevalent in the turbulent period before World War I. In particular he gave voice to a growing disillusionment with positivism and the view of the world as a sum of discrete objects that can be known only through observation and measurement. Bergson gave a philosophical framework to the science of his age; he posited time—heterogeneous flux—as the only reality and established the grounds for rejecting positivist concepts of the real. In Western Europe and America, articles in popular magazines as well as in literary and aesthetic journals were given over to the review and discussion of Bergson's books as they appeared. In his native France he was a celebrity: the crowds at his lectures at the Collège de France were always overflowing, even when the largest auditorium in the building was set aside for him.[31] He wrote with a transparent and deceptively effortless style, and he spoke as he wrote, with simplicity and clarity, making his notions all the more compelling for their seemingly rudimentary content. Bergson became the chief source of the ideas of time, space, and motion that have been embraced and expressed by the artists and writers of this century.

Movement, according to Bergson, is reality itself. It is continuous change, an undivided fact, a passage from rest to rest, and it is absolutely indivisible.[32] Pure time has no separate or distinct moments; its parts do not begin and end, strictly speaking, but each of them prolongs and continues itself in all the others. Matter, for Bergson, is best conceived of as energy, and energy is the ultimate form of motion; thus the shapes of material objects

are not properties of those objects but are "snap-shots taken by the mind of the continuity of becoming"[33]—the misleading data provided by ordinary and inadequate perception. "All division of matter into independent bodies with absolutely determined outlines is an artificial division."[34] Like our ordinary perception of space and time and motion, form is a principle of division and of solidification introduced into the real (which is neither solid nor divisible), with a view to action and not with a view to knowledge, which attributes to things a real duration and a real extensivity.[35] Objects, then, or matter in general, cannot be known through analysis, which is the way positivist science approaches them: analysis gives form to objects by fragmenting them, and thus through analysis we can know only parts. What is real is a unity, and this can be known only through intuition: a disinterested, self-conscious instinct, a form of empathy by which we place ourselves within the object and break down the barrier that our spatialization of time puts up. Analysis is the very negation of intuition.[36]

Bergson's concept of intuition inspired not only the popular imagination, but also a generation of artists who felt that the forms of the world as given to the eye alone were no longer adequate for their expressive needs. The five books that Bergson published before 1909 (*Essai sur les données immédiates de la conscience* [1889, translated as *Time and Free Will*]; *Matière et mémoire* [1896, *Matter and Memory*]; *Le rire* [1900, *Laughter*]; *Introduction à la métaphysique* [1903, *An Introduction to Metaphysics*]; and *L'évolution créatrice* [1907, *Creative Evolution*]) provide the most cogent articulation of the demise of empiricism and the exaltation of reality beyond the seen. Bergson's vocabulary soon found its way into artists' writings, and the terms *durée* ("duration," Bergson's concept of lived time), "force-lines," "fusion of objects,"

"multiplicity of conscious states," "simultaneities," and the "dynamic" turn up repeatedly in the informal and formal tracts of almost every painter of the early twentieth-century avant-garde. Almost immediately upon publication his ideas, albeit simplified or misconstrued, became a general source and a specific point of reference for a variety of artistic projects.

Bergson's tenure at the Collège de France overlapped Marey's by four years, from 1900 until Marey's death in 1904.[37] During those years Bergson taught a course on the idea of time while for his personal research he "dedicated himself to biology"[38] in preparation for writing *Creative Evolution*. There is no doubt that he knew Marey's work in this field; he certainly knew Marey personally. They both belonged to a small group organized by the Psychological Institute of Paris to study psychic phenomena. The group, which included Marey's close friend Arsène d'Arsonval and, later, Marie Curie, met to investigate the "manifestations of yet undefined forces" through "strictly scientific research." Marey's graphing instruments were central to their investigations. They conducted séances, attempted to measure the radioactivity and electrical discharge produced by hysterics, and studied "mental suggestion, telepathy, levitation, and so forth."[39]

However closely Bergson and Marey were acquainted, their ideas of the nature of reality were hardly compatible. Underlying Marey's need to grasp and measure was a view of reality as constituted by discrete functions, invisible matter that could be probed and analyzed by the instruments he devised. Bergson's view was, of course, just the opposite: the solid contours of the closely knit images we call the material world, he said, are only a necessary invention of our senses. In reality, matter is in the flux of constant becoming. Whereas Marey believed we can know the world through the exten-

sion and refinement of our senses and thereby subsequently determine the laws that underlie nature, Bergson thought we can know duration only through intuition, that act of "pure" perception that grasps things in their essential being.

Both the modes of perception and the limitations of the sensory apparatus were central to the thought of each man, but their conclusions could not have differed more sharply. The senses, especially the eye, were inadequate for Marey because so much of the world lay beyond their reach. That is why a machine was needed to overcome these frailties—like a camera, for example, which could stop all the invisible phases of a movement and fix them in their entirety. Marey suggested not that reality was unknowable, but that human perception was limited. Only by substituting machines for the senses would we gain scientific knowledge. For Bergson reality, or time, could never be known by being made visible; any attempt to do so limited true knowledge, or intuition. Hence, in his view, the senses were deficient by the very fact of their being too much like a camera: they automatically stopped and fixed objects that flowed into their realm of action. They provided us with an incomplete and artificial view of reality. Conversely, the camera could never capture reality because it operated just like sensory perception: it immobilized; it halted and separated the indivisible flux, extracting immobile views from a mobile spectacle; it falsified the real.[40]

Bergson's attack on the camera reveals a hitherto neglected source of one of the most pervasive metaphors he uses in his work to characterize the "normal" perception of time. For though Bergson's philosophy made no visible impact on Marey's thinking, Marey's photographic experiments had a profound effect on Bergson's writing. Although Bergson never mentions Marey by name, *Matter and Memory, Creative Evolution* and *Introduction*

to Metaphysics are nonetheless riddled with references to Marey's chronophotographic analyses. They represent for Bergson the kind of perception that "manages to solidify into discontinuous images the fluid continuity of the real."[41] Marey's images are symbols of an incorrect, insufficient, and invalid way of perceiving movement. They are, Bergson insists, the visible analogies of the way our consciousness operates to spatialize time. In ordinary perception, "quasi instantaneous views will be taken, views which . . . will condense an infinity of elementary repetitions and changes. In just the same way the multitudinous successive positions of a runner are contracted into a single symbolic attitude . . . which becomes for us all the image of a man running. The glance which falls at any moment on the things about us only takes in the effects of multiplicity of inner repetitions and evolutions."[42]

Chronophotographs are images not of movement through time, according to Bergson, but of position and succession. They are the consummate visual model for the "routes of common consciousness" that spatialize time—stop and fix it for our gaze. "With partial views put end to end, you will not make even a beginning of the reconstruction of the whole, any more than, by multiplying photographs of an object in a thousand different aspects, you will reproduce the object itself."[43] Because for Bergson succession or continuity is not reducible to mere instantaneous juxtapositions in space,[44] Marey's models became the perfect examples for demonstrating just what reality is not. "Consider," writes Bergson,

the variability which is nearest to homogeneity, that of movement in space. Along the whole of this movement we can imagine possible stoppages; these are what we call the positions of the moving body, or the points by which it passes. But with these positions, even with an infinite number of them, we shall never make movement. They

are not parts of the movement, they are so many snap-shots of it; they are, one might say, only supposed stopping-places. The moving body is never really in any of the points; the most we can say is that it passes through them.[45]

Nor, to Bergson's mind, does chronophotography have any artistic value. Using the example of the Parthenon frieze (which Marey had so earnestly praised for the scientific accuracy of its description of the gallop), Bergson writes:

Of the gallop of a horse our eye perceives chiefly a characteristic, essential or rather schematic attitude, a form that appears to radiate over a whole period and so fill up a time of gallop. It is this attitude that sculpture has fixed on the frieze of the Parthenon. But instantaneous photography isolates any moment; it puts them all in the same rank, and thus the gallop of a horse spreads out, into as many successive attitudes as it wishes, instead of massing into a single attitude, which is supposed to flash out in a privileged moment and illuminate a whole period.[46]

Although Bergson's use of the image of the camera as the ultimate emblem of false construction seems to demolish any case that could be made for the aesthetic appeal of chronophotography, artists who wished to give form to the new experience of time Bergson so articulately voiced were drawn to Marey's pictures. They were an irresistible and particularly fecund visual source. For artists the attraction of the photographs lay in one important particular: they were the first images to effectively rupture the perspectival code that had dominated painting since the Renaissance. Marey's pictures depicted chronological succession within a single frame. Chronophotography provided a language for representing simultaneity—what was popularly understood to be Bergson's idea of time.

By the end of 1907 the transformation of the spatial and temporal conventions in the fine arts

was accomplished in the realm of painting with the advent of cubism. A name given to the discoveries of Pablo Picasso (1881–1973), Georges Braque (1882–1963), and their followers, cubism was the first style to deny the visual model of linear, one-point perspective and the spatial illusionism of tonal modeling. It was also the first to utilize the two-dimensional surface as the locus for the inter-penetration of time and space, to depict chrono-logical succession in a way that could be perceived simultaneously. In analytic cubist imagery, several views of an object are combined into a single impression on the canvas, allowing one to become aware of the passage of time implied through the physical shifts of perspective. Quite unlike the displacements of form to be found in chronophotography, however, these shifts are the result of the painter's moving, either physically or mentally, around a still object rather than the object's moving before the painter. The resulting "interpenetrations of forms, the transparent superimpositions, the simultaneous occupation of a single area by two different objects, or by two aspects of one object (and the consequent ambiguity of spatial relations)"[47] included objects that were inaccessible to the eye from a single fixed viewpoint.

The attention of Picasso, Braque, and their followers was directed toward the idea of spatial simultaneity, not temporal succession: the integration of points of view that originally had separate temporal and spatial origins was central to their methods.[48] The cubists decomposed the appearance of immobile objects in order to reconstitute them and stress their permanence. In this way of decomposing to recompose, of breaking down and analyzing to gain further knowledge, the underlying direction in their work parallels Marey's earlier investigations, albeit with a different aim. The cubist canvas was the locus where the painter simultaneously presented several aspects gathered successively

with the purpose of suggesting a higher reality. Movement, however, was only a means to an end, and time played only "a supporting role, allowing the artists to accomplish the physical or mental movement necessary to form an idea of an object's total dimensionality."[49] This total dimensionality (or "higher reality" or "fourth dimension"—all terms used interchangeably by painters, writers, and critics in and around the movement), implied through overlapping transparent planes, is absent from Marey's pictures, just as the illusion of real movement is absent from the cubist paintings.

The obliteration of the distinctions between space and matter, which is key to cubism and is most fully developed in the hermetic phase of 1911–12, may owe something to Bergson's influence. Theoreticians of the movement claimed Bergson's authority for their work (though he himself denied it).[50] Marey's role in the development of cubism is, however, certainly very limited and unspecific, if it exists at all; from the evidence of the paintings of this period, it seems clear that chronophotography was a language that did not correspond to the expressive needs of the movement.

The differences between the cubist representation of chronological succession and that to be found in Marey's chronophotography did not go unperceived by the artists who took up the investigations into a new time-space continuum. They would find Marey's imagery the key to finally overcoming what the composer Arnold Schönberg lamented was "the inadequacy of present language to deal with the reality of higher dimensions."[51] The specific use of Marey's single point of view rather than the mobile perspective of the cubists can be documented in the work of František Kupka (1871–1957), a Czech artist who arrived in Paris in 1896, the year after the birth of the Lumière Cinématographe. In 1906 he settled next to his friend, the painter Jacques Villon, in the Parisian suburb of

Puteaux and became part of the animated group of artists who moved in the orbit of the three Duchamp brothers: Villon, Raymond Duchamp-Villon, and Marcel Duchamp. The goal of the Puteaux group—which also included the writer Alexandre Mercereau and the painters Jean Metzinger, Albert Gleizes, Henri Le Fauconnier, Robert Delaunay, and Fernand Léger—was to breathe new life into cubism by adding to it a mathematical discipline, vigorous color, and new ideas. They consciously aimed their researches toward the goal of abstraction.

Kupka was a decade older than Picasso, Braque, and the other cubist painters and, unlike them, was steeped in mysticism, astrology, and the occult. This deeply spiritual side of the artist was joined to an equally profound interest in science—he was well versed in theories of color, perspective, and optics, in the natural sciences, and even in physiology.

Kupka's familiarity with motion photography probably predates the visit he is known to have made to Marey's Class 12 display at the Universal Exposition of 1900 (where Kupka himself won a gold medal): according to Margit Rowell, Souriau's *La suggestion dans l'art*, with its references to Marey's chronophotography, "remained in Kupka's library until his death."[52] Kupka's earliest incorporation of movement is in his drawing *Les cavaliers* (1901–2); it appears to be a transcription of the effect of a Reynaud praxinoscope (fig. 148).[53] But in 1908 when Kupka needed help in solving the problems of kinetic visualization, he turned to Marey's photographs for assistance. He was trying to paint his wife's daughter Andrée throwing a ball; the frustration he felt in his inability to capture a sense of movement prompted him to experiment with two separate series of drawings and pastels (1909–11), both directly inspired by Marey's chronophotographs. The first series, of a woman picking

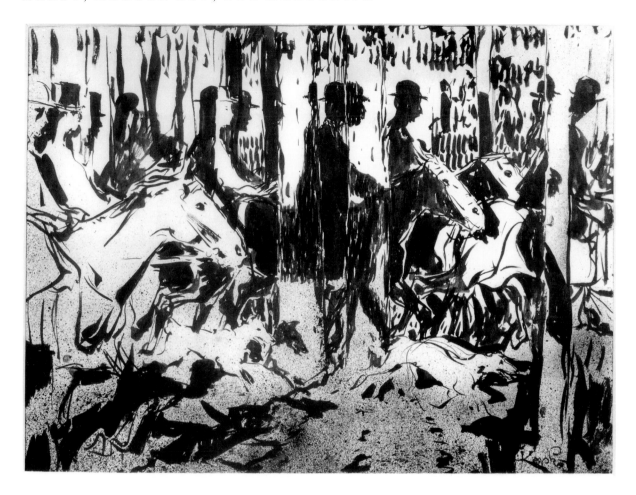

148.
František Kupka, *Les cavaliers*,
1901—2. India ink on paper, 16 × 21¼
in. Musée National d'Art Moderne,
Paris.

flowers, culminated in a group of large pastels now
in the Musée d'Art Moderne in Paris. In cinematic
progression a woman rises from a chair to a stand-
ing position, then bends forward to pick flowers.
Her body is reduced to outlines, and these outlines
are repeated and superimposed in an undulating
succession across the canvas.[54] As a result of his re-
search in color and motion, Kupka has adopted the
graduated colors of the prism to structure both
space and movement into a closely knit network of
flat tinted planes. The color also serves as the means
to illustrate one of Marey's descriptions in *Move-
ment*, a book that Kupka likely would have known.

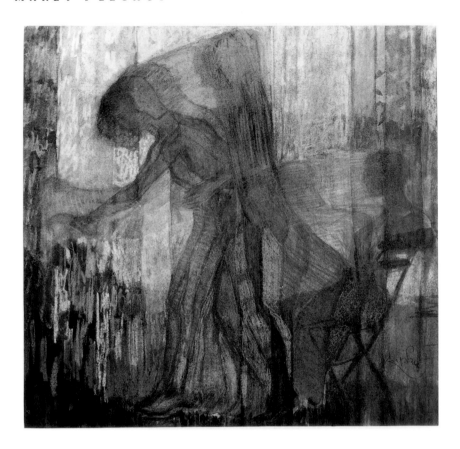

149.
František Kupka, *Woman Picking Flowers*, 1909. Pastel on paper, 17¾ × 18¾ in. Musée National d'Art Moderne, Paris.

In an almost literal rendering of Marey's suggestion that artists emphasize the "dead points" of the action visible to the eye when the direction of movement changes, Kupka has intensified both the color and contour of the three primary moments—sitting, standing, leaning—and softened and blurred the intermediary phases of the motion (fig. 149).

Describing movement in three dimensions while simultaneously denying any depth to the picture plane is further elaborated in Kupka's next series, *Planes by Color* (1910–11). The idea was to show a figure whose arms (one hand on the hip and one raised) rotate in space toward the spectator, while at the same time negating the sensation of depth. Kupka's solution was ingenious. Beginning again

with Marey's sequential technique in his drawings, Kupka shows the overlapping contours of the body sequentially arranged, but in the oil that completes the series he ends with the dissolution of the forms into the colors of the prism and the enclosure of each silhouette in a flat colored plane emphasized by vertical boundaries (fig. 150).

In these works Kupka treats movement as Marey's camera represents it: as a progression of separate but interpenetrating moments or static instants. He also identifies these consecutive instants with a consecutive unfolding of chromatic hues. Kupka wrote of movement in terms that evidently evolved from the photographic imagery he worked with: "Movement is no more than a series of differ-

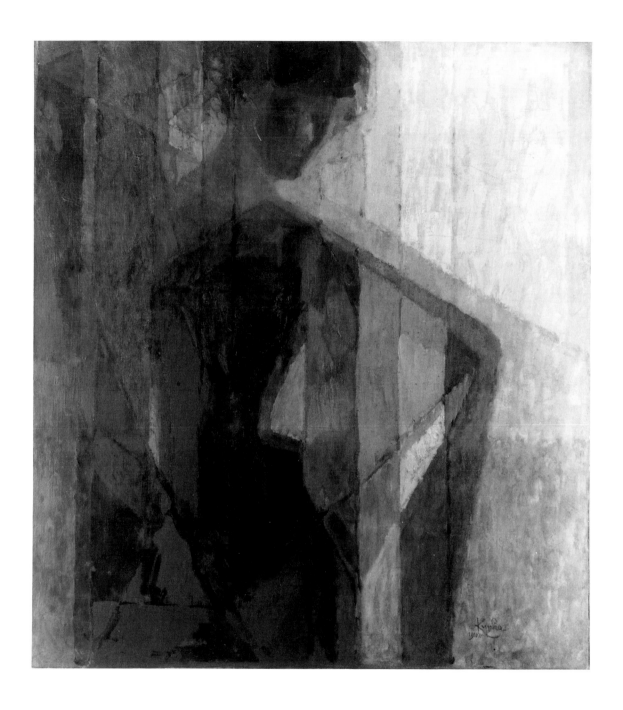

150.
František Kupka, *Planes by Colors*,
1910—11. Oil on canvas, 43⅜ × 39⅜
in. Musée National d'Art Moderne,
Paris.

285

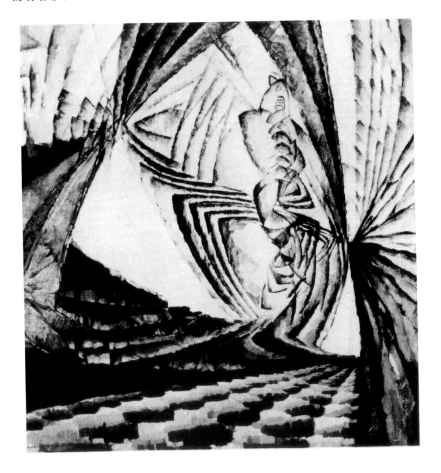

151.
František Kupka, *Organization of Graphic Motifs I,* 1912–13. Oil on canvas, 78¾ × 76⅜ in. Private collection.

ent positions in space. . . . If we capture these positions rhythmically, they may become a kind of dance."[55] And he found little contradiction in conjoining Marey's work with current ideas about the fourth dimension. To accompany a sketch of four geometric figures done from Marey, he wrote: "Three-dimensional displacement takes place in space, whereas four dimensional displacement [takes place] through an exchange of atoms. But to capture [fix, arrest] a gesture, a movement in the space of the canvas . . . capture several consecutive movements."[56]

By 1911 Kupka had abandoned the analysis of temporal progression for a more organic interplay of colored planes "which would act as both spatial and temporal referents." But he did not abandon the use of sequential forms. For example, in such works as the 1911–13 series *Organization of Graphic Motifs,* the abstract colored forms are caught in a web of overlapping contours, and it is these repeated consecutive intervals that convey the dynamic rhythms of the canvas (fig. 151).[57]

Kupka's alternative to cubist syntax, arrived at through the assimilation of Marey's chrono-

photography, was paralleled by the three Duchamp brothers. The sculptor Raymond Duchamp-Villon, who had been a medical student at the Salpêtrière hospital while Albert Londe was carrying out his photographic investigations into movement there with Paul Richer, incorporated the overlapping forms in his *Song* (the first plaster cast dates from 1908) and *Horse* (1914).

Kupka's closest friend and nearest neighbor in Puteaux, Jacques Villon, had worked since 1894 as a newspaper illustrator and lithographer before he came under the influence of cubism in 1911. A year later, in *Little Girl at the Piano* (1912) and *Soldiers on the March* (1913), Villon had already gone beyond the static depictions of cubism, moving toward the incorporation of a kinetic dimension by repeating sequential forms. Although there is little doubt that Kupka's earlier studies were influential in Villon's research, as were the contemporary investigations of his brother Marcel Duchamp, these visual sources were mingled with other ideas derived from his reading. Villon was familiar with Bergson's writings, especially *Creative Evolution*, and he knew Paul Valéry's *Introduction à la méthode de Léonardo de Vinci* (1894), whose description of motion engendering form encapsulates both Marey's experiments and Leonardo's demonstration that movement is best depicted through overlapping contours. After 1914 Villon's search for rhythmical continuity led him to explore other avenues of research, but there were echoes of Marey's photographs in at least two of his later works. His 1921–24 studies for *Jockey* (1924) (fig. 152), combined overhead and perpendicular views, and the right hand of his brother in the portrait *Marcel Duchamp* (1951) is fragmented into overlapping wedges to suggest motion.

The style of Marcel Duchamp also underwent a radical transformation with the advent of cubism. It was the technique, with its fragmentation and dislocation, rather than the spirit of the movement that attracted him, and as had occurred in the work of Kapka, the mobile perspective of the cubists was soon supplanted in Duchamp's work by the juxtaposition of forms seen from a single point of view. His exploration of simultaneous imagery provoked a period of intense work lasting almost a year. The starting point was his 1910 drawing *Encore à cet astre* of an overlapping series of figures ascending, which he did to illustrate the poems of Jules Laforgue. Duchamp's *Dulcinea* of 1911, which shows five separated but overlapping figures of one woman, was intended, he states, "to de-theorize Cubism in order to give it a freer interpretation."[58] This was followed by an interpretation of cubist dislocation in *Magdeleine and Yvonne Torn to Tatters,* in which the faces are shredded (*déchiquetées*) and overlapped on one plane. The same avenue of research was continued in *The Chess Players* and *Coffee Mill* (November and December), and the paintings also mark his first attempts to incorporate machine imagery into a painting. Finally, the investigation culminated in a "formal decomposition; that is, linear elements following each other like parallels and distorting the object. The object is completely stretched out as if elastic."[59] It was worked out first in *Sad Young Man on a Train* (November–December) (fig. 153), and then in *Nude Descending a Staircase* (first version in December 1911 and final version in January 1912) (fig. 154).

Duchamp's stated intention in these latter works was to create a static image of movement through the use of "elementary parallelism," a notion of movement (and of technique) again very close to Kupka's. Duchamp cites his reading of Marey's *Movement* as one of the sources for this artistic direction: "In one of Marey's books I saw an illustration of how he indicated the fencers or

152.
Jacques Villon, *Study for the Jockey
no. 7,* 1921. Pencil, pen, and black ink
on tracing paper, 26.8 × 42.5 cm.
Yale University Art Gallery, Gift of
Collection Société Anonyme.

153.
Marcel Duchamp, *Sad Young Man on
a Train,* 1911. Oil on cardboard,
39⅜ × 28¾ in. Peggy Guggenheim
Collection, Venice. The Solomon R.
Guggenheim Foundation, New York.
Photo: Carmelo Guadagno.

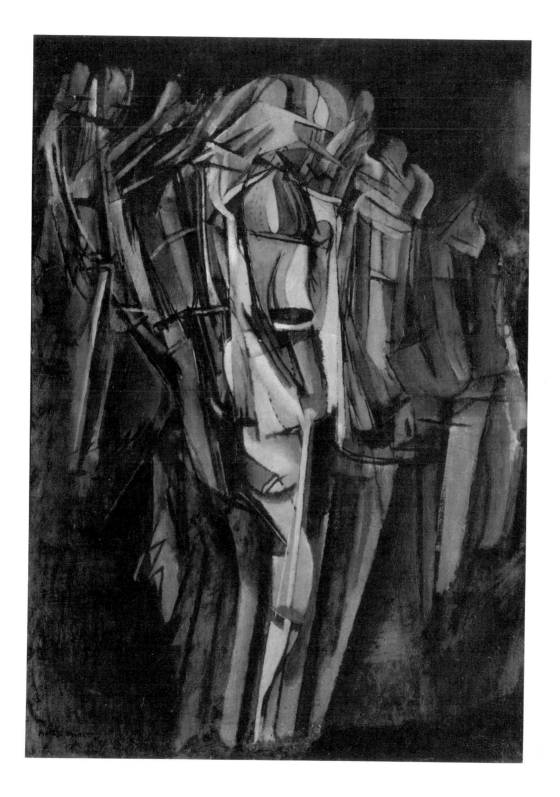

289

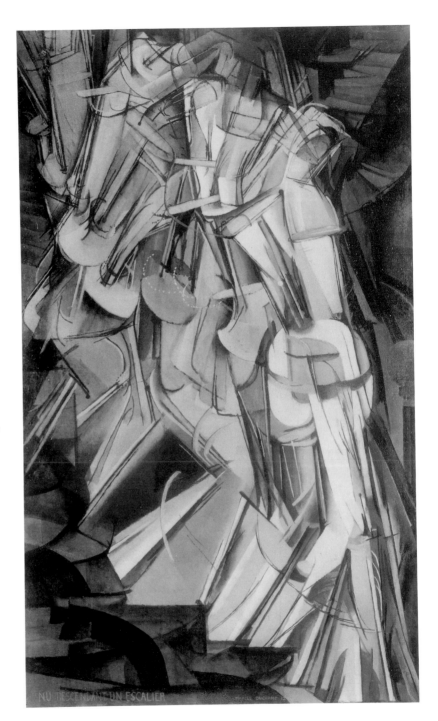

154.
Marcel Duchamp, *Nude Descending a Staircase no. 2,* 1912. Oil on canvas, 58 × 35 in. Philadelphia Museum of Art, Louise and Walter Arensberg Collection.

galloping horses with a system of dots delimiting the different movements. . . . As a formula it seems very pretentious but it's amusing."⁶⁰

The points and lines of movement captured by the camera must have been singularly appealing to Duchamp. As a systematic modification of cubism, they were ready made; they contained both the mechanical and the scientific elements that were central to his work, and they were literally made by machine. The lack of color in these black-and-white images heightened their graphic quality, providing a more calligraphic form of abstract pattern than that given by the cubist pictures. Duchamp, who was interested in the nature of movement and wanted to give an exact and scientific foundation to painting, transcribed these signs directly to the canvas. The geometric chronophotography of Marey is the source for the dotted lines around the hip and leg indicating the articulation of the joints in the *Nude,* and the fan formation of the leg.⁶¹ In more general terms, chronophotography introduced Duchamp to the idea of mechanization as an alternative to sensible beauty. In the photographs "there was no flesh, just a simplified anatomy, the up and down, the head, the arms and legs. It was a sort of distortion other than that of Cubism."⁶² This new code would assist Duchamp in putting painting at the service of the mind, for the signs, once deciphered, were to be considered as significant as the lines and colors that make up retinal painting—or more so.

Inevitably, the next step in his constantly changing style was to incorporate machine imagery into the painting to supplant the imagery made by machines. The creation of the mechanomorphic universe that followed in 1912–13—the *Swift Nudes, The King and Queen, The Passage from the Virgin to the Bride*—also demonstrated a shift in Duchamp's ideas on the interpenetration of time and space in a painting. In fact, the subject of these works is no longer movement. As a group, the

paintings and drawings still give a sense of movement in space, but the subject was now meant to be seen as a metaphysical change from state to state through the passage of time, and this could no longer be depicted through "elementary parallelism." Duchamp's steady absorption with theories of the fourth dimension now came to the fore in his art, and with *The Large Glass* (1915–23) he combined the study of non-Euclidean geometry with an investigation into mathematics and scientific perspective, which finally led him to abandon painting altogether—but not Marey's images, as I will show below.

At the same time the Puteaux group were conducting their investigations in France, the Italian futurists were proclaiming the dynamic sensation of the passage of time to be the central subject of the work of art. The futurists, a group of painters, sculptors, and architects led by the poet F. T. Marinetti (1876–1944), exalted everything dynamic: motion, speed, and energy, especially those forms of energy that were produced by and manifested in the machine and the modern urban environment. The painters Umberto Boccioni (1882–1916), Gino Severini (1883–1966), their teacher Giacomo Balla (1871–1958), Luigi Russolo (1885–1947), and Carlo Carrà (1881–1966) wanted to create pictures that would involve spectators emotionally as well as intellectually, draw them into the simultaneous actions depicted in the paintings, and make them experience the dynamic sensation of motion. Just how this was to be accomplished—a fusion of science and metaphysics, spiritualism, the fourth dimension, and contemporary philosophy—was described in the manifestos, both printed and proclaimed, that they churned out with alacrity.

In *La pittura futurista: Manifesto tecnico (Futurist Painting: Technical Manifesto)*, published 11 April 1910 in Milan,⁶³ the futurists outlined their "program for the renovation of painting,"

grafting a Bergsonian notion of movement to a scientific analysis of sight (a syncretic strategy that would be sorely tested by the different directions taken by Boccioni and Balla). For example, "The gesture which we would reproduce on canvas shall no longer be a fixed *moment* in universal dynamism. It shall simply be the *dynamic sensation itself*" calls Bergson to mind, while the following paragraph, echoing Souriau, situates the visual ground of the idea more precisely in the familiar scientific terms of the persistence of vision theory: "Indeed, all things move, all things run, all things are rapidly changing. A profile is never motionless before our eyes, but it constantly appears and disappears. On account of the persistency of an image upon the retina, moving objects constantly multiply themselves; their form changes like rapid vibrations, in their mad career. Thus a running horse has not four legs but twenty and their movements are triangular."[64]

The pictures produced in 1910, however, do not reflect the heightened oratory of the manifesto; a pictorial equivalent to the reconciliation of positivism and idealism had not yet been found. The painters were still dependent on the visual language of symbolism and art nouveau; their technique was a kind of modified impressionism—a combination of symbolist and divisionist color theory in which the breakdown of matter is achieved through separated brushstrokes of pure color. It was only toward the end of the following year, 1911, that their canvases began to embody at least some of the ideals that characterize the writing and to exude an inherent dynamic effect. This change in the pictorial syntax of the futurists—a change created through fragmented space, overlapping parallel forms, and repeated oblique or diagonal lines moving across the picture plane—is usually attributed to their first contact with cubism in Paris: Boccioni, Russolo,

and Carrà visited the city in October 1911; Severini was already in residence there. It is true that in the futurist painting of 1911 the division of form was added to the division of color, and traditional perspective was discarded in favor of emphasizing the flatness of the picture plane, but not in every case is the source of this transformation to be found in cubism alone. The influence of Marey's chronophotography is equally, and in some cases more, distinct. For the futurists as for Duchamp, the confrontation with cubism brought a heightened awareness of chronophotography.[65] Cubism introduced the painters to the rejection of traditional perspectival space. But cubism alone could not provide acceptable forms to fill this space: its mobile perspective was too static for the Italian painters. They needed to deform the cubist syntax and elaborate its classical vocabulary to express their own particular ideas of space and time.

Thus it was Marey's chronophotography, both scientifically accurate and lyrically graceful, a ready-made coherent system of signs, that they adopted to express the kinetic and emotional dimensions of the subject and override the stasis of cubist juxtaposition. Linear, calligraphic, and two-dimensional, the chronophotographs provided a visible demonstration of the invisible "force-lines"—the phrase comes from Bergson—that joined together objects in space, their absolute and virtual movement, and the speed, noise, and sensation that they absorbed and that emanated from them. The paintings of 1911–12 are virtually painted copies of any number of Marey's images. The second version of Carrà's *Funeral of the Anarchist Galli* (fig. 155) and Severini's *Dynamism of a Dancer* (fig. 156) (the most cubist-inspired work of this group) display the frenzy of motion through repeated overlapping linear forms; Boccioni's *Elasticity,* Russolo's *Memory of a Night,* and Carrà's

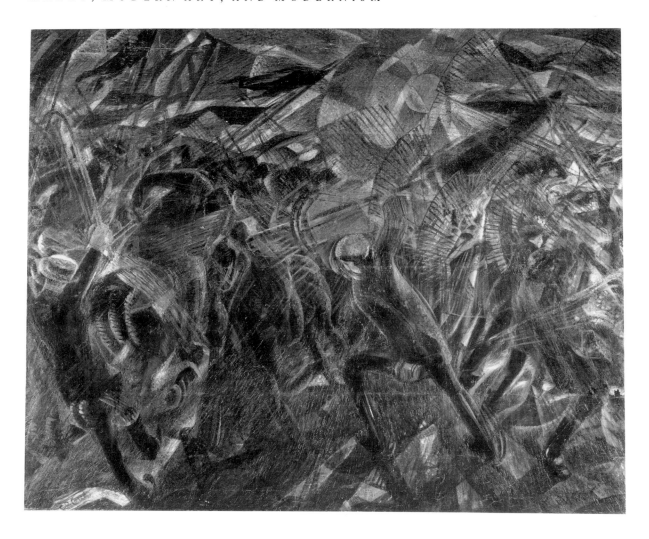

155.
Carlo Carrà, *Funeral of the Anarchist
Galli*, 1911. Oil on canvas, 6 ft., 6¼ in.
× 8 ft., 6 in. Museum of Modern Art,
New York, Lillie P. Bliss Bequest.

small watercolor *Horse and Rider* (1913) include
the multilegged quadruped mentioned in the mani-
festo (fig. 157).

Marey's photographs had been widely dissemi-
nated in Italy, but they did not, with one exception,
make any impact on the futurists before 1911. In
Italy, where Marey spent each winter from 1870,
the images had been reproduced almost with the
same regularity as in France[66] in scientific journals,
popular reviews, and photography magazines. The
Neapolitan newspapers gave ongoing reports of the

156.
Gino Severini, *Dynamism of a Dancer,*
1912. Oil on canvas, 60 × 45 cm.
Riccardo and Magda Jucker
Collection, on loan to Pinacoteca of
Brera, Milan.

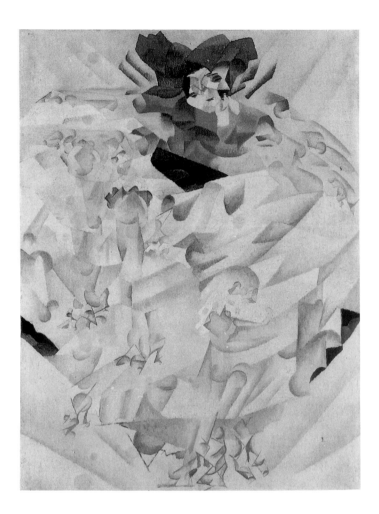

157.
(A) Umberto Boccioni, *Elasticity,* 1912.
Oil on canvas, 100 × 100 cm.
Riccardo and Magda Jucker Collec-
tion, on loan to Pinacoteca of Brera,
Milan. (B) Luigi Russolo, *Memory
of a Night,* 1911. Oil on canvas,
100 × 101 cm. Private collection,
New York. (C) Carlo Carrà, *Horse and
Rider,* 1913. Ink and tempera on
paper pasted on canvas, 26 × 36 cm.
Riccardo and Magda Jucker Col-
lection, on loan to Pinacoteca of
Brera, Milan.

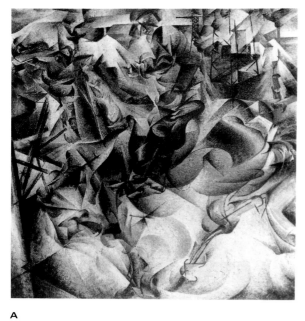

A

B

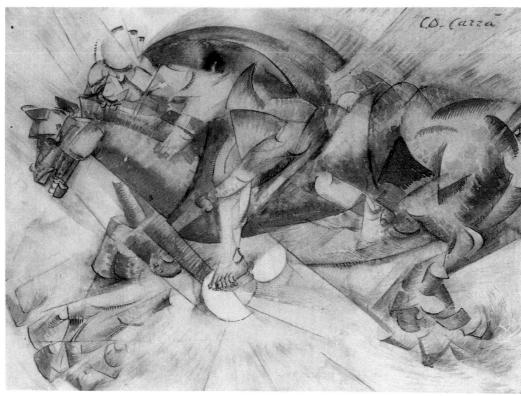

C

experiments and lectures Marey conducted at his Villa Maria. Marey was a frequent visitor to Turin, where Balla lived until 1895. The Turin Institute of Physiology was directed by one of Marey's collaborators, Angelo Mosso, and the University of Turin published the complete catalog of Marey's writings in 1904. The first National Photographic Congress held in Turin in 1898 included examples of Marey's chronophotography, and in 1901 he lectured there on his work. In Milan, his chronophotographs had been shown at the International Exposition of 1906.

Marey's photographs continued to be widely published and exhibited after the constitution of the futurist group. They could be seen in Rome at the International Photography Exposition, which was one of the many manifestations of the fiftieth anniversary of the unification of Italy held in the spring of 1911. (Balla was in charge of installing a painting exhibition there.) From 24 to 30 April 1911, the Third National Photographic Congress was held in Rome, with talks on the relation of movement and photography in art. Boccioni's lecture at the Circolo Artistico in Rome a month later, issued subsequently as "The Exhibitors to the Public," refers to the linear attributes of objects in a way that conjures up Marey's work at the exhibition:

What is overlooked is that all inanimate objects display, by their lines, calmness or frenzy, sadness or gaiety. These various tendencies lend to the lines of which they are formed a sense and character of weighty stability or of aerial lightness. Every object reveals by its lines how it would resolve itself were it to follow the tendencies of its forces. . . . In the pictorial description of the various states of mind of a leave-taking, perpendicular lines, undulating and as it were worn out, clinging here and there to silhouettes of empty bodies, may well express languidness and discouragement. Confused, and trepidating lines, either straight or curved, mingled with the outlined hurried gestures of people calling one another, will express a sensation of chaotic excitement.[67]

And by 1911 the futurist painters would be reminded of Marey from yet a different source, a new adherent to the futurist cause, Anton Giulio Bragaglia.[68]

Bragaglia (1890–1960), a talented writer who would become a leading avant-garde set designer and theater and film director, was critical in focusing the attention of the futurists on Marey's chronophotography. From age sixteen he had worked as an assistant producer for his father, a pioneer in the Italian film industry. An interest in the occult led to his first photographs—attempts to capture parapsychological phenomena on dry plates—and to his writings on photography in the Turin journal *Fotografia Artistica*. Then, the year following Marinetti's proclamation to the world of his intent to drag Italy into the twentieth century and modernity, Bragaglia began his experiments in what he would call futurist photodynamism. With the assistance of his brother Arturo,[69] Bragaglia made about twenty pictures between 1910 and 1913 (the negatives have been lost, so the exact number is unknown) and sent many of them to friends and family in the form of postcards. The images were of moving figures, with the intermediary phases of the motion blurred, achieved by having the subject move while the lens of the camera was left open (fig. 158). The photographs were accompanied by a polemical treatise, his attempt to "carry out a revolution . . . in photography, by purifying ennobling and truly elevating it to art."[70] The theoretical writing first appeared in 1911 in the form of a pamphlet, *Fotodinamismo futurista*, which was disseminated in typewritten copies until its publication in Rome in 1913. Written in the first person plural, *Fotodinamismo futurista* championed the futurist vision of modern life and claimed that photography was the means of its apotheosis in art.

Bragaglia insisted on the futurist painters' experiments in dynamism as the source for his own

A

158.
Anton Giulio Bragaglia, (A) *Self Portrait,* 6⅞ × 5 in. (B) *Portrait of Arturo Bragaglia,* 6½ × 4¹¹⁄₁₆ in.
(C) *Changing Position.* 5 × 7 in. Gold-toned silver photodynamist photographs, 1911. Gilman Paper Company Collection, New York. Photos: Robert Mates.

B

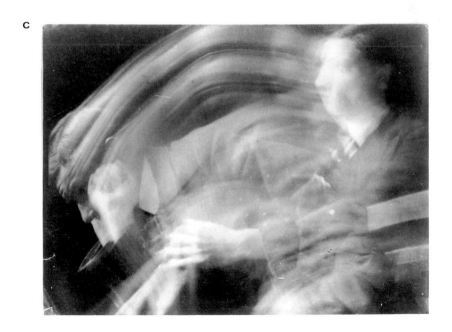

C

studies and declared his affinity with their aims. Like the painters, Bragaglia thought the artist should convey the "expression and the vibration of modern life" by depicting a transcendental reality that was movement, and he saw the way to this depiction as a fusion of positivist science and idealism. His originality, however, lay in his claim that photography was a medium that could accomplish this end. Naturally Bragaglia did not mean "ordinary photography," which produced a "precise, mechanical, glacial reproduction of reality." In fact, at the outset he insists that "it is a pleasure to observe that I and my brother Arturo are not *photographers* and could not be further from that profession."[71] Instead, his photodynamism aimed to capture what superficially cannot be seen, movement in its metaperceptive modality, movement beyond the visible: "With photodynamism we have freed photography from the indecency of its brutal realism, and from the craziness of instantaneity, which, considered to be a scientific fact only because it was a mechanical product, was accepted as absolutely correct."[72]

According to Bragaglia, documentation of objects in motion was the means by which the artist would move beyond the visible. Because it dematerialized objects and exposed the "interior essence of things," movement could not be grasped by vision alone. Only by depicting movement could the artist create a relationship between individual and environment and interpret and express the modernity of modern life. The spectator would be enmeshed in the field of forces through which the dynamic would be made evident.

Bragaglia believed that movement could be expressed by "trajectories." The artist should begin with real movement, an action or a gesture; recording its trajectory, he wrote, will show that the gesture is not made up of stoppages or points in space, but of a continuum that is captured through the rendering of the intermovement phases. In the traces left would be found the dynamic sensation of life: "the pulsing rhythm of the blood, the unceasing breath, the vibrant energy of gestures, for actions."[73]

Bragaglia's idea of transcendence derived from a combination of his strong interests in spiritualism, Bergson, Herbert Spencer, William James (whose notion of time, however, was atomistic rather than fluid), and the ever-present fourth dimension. He felt that art and science were synthesized in his work, and he congratulated himself for having scientifically demonstrated things only intuited by the futurist painters: "that movement effectively destroys bodies . . . that light too destroys bodies and breaks down the colors of images."[74] He was convinced both that photodynamism provided the connection between science and spiritualism[75] and that his investigations with the camera would establish a scientific basis for the futurist movement as a whole.

Bragaglia proposed that photodynamism offered the only true art of motion. It was distinct from instantaneous photography, which "ridiculously kills live gestures: in its desire to grasp the whole gesture it blocks and immobilizes only one of its hundred thousand fleeting *states*."[76] Bragaglia also distinguished photodynamism from chronophotography, which broke up the action and missed its intermovement fractions. He saw Marey's studies as an intermediary phase between instantaneous photography and the photodynamic unification of the fracture that existed between analytical procedures and the homogeneous character of duration: "Ten figures in a Marey chronophotograph can partially [provide the dynamic sensation of motion] already; the synthesis of those ten figures in our own photodynamism can do it completely."[77] Marey at least reconstructed motion "instead of signifying it in the narrow-minded way that one does

through ordinary photography," Bragaglia wrote, and this makes it a step forward: "*one state* can only mean *stasis,* no matter how figurative it is, while ten can describe the action, if not yet the motion."

Nevertheless, according to Bragaglia, because photodynamism does not separate movement into its constituent parts, but rather restores its fluidity, it transcends chronophotography. "I deny that I analyze action," he wrote, "and I deny that I make the equivalent of one hundred instantaneities; I insist and I can prove that we are directed toward the synthesis of the action, which, because it is pure movement, that is, trajectory, is completely different from . . . stasis and completely different from an analytic scientific reconstruction."[78] To Bragaglia's mind, chronophotography metaphorically "marks the half hours, cinematography marks the minutes, but photodynamism marks not only the seconds, but also the intermovement fractions existing in the passages between seconds. This becomes an almost infinitesimal calculation of movement."[79]

Although Bragaglia cites Bergson as his authority on these matters, if we look at the images themselves the differences between photodynamism and chronophotography are clearly those of degree, not kind. Bragaglia's trajectories, extensive blurs made by a moving subject on an exposed photographic plate, are in fact closer to Demeny's style of chronophotography: instead of clear lines demarcating one phase from another, the first and final position of the moving subject are emphasized and the intermediary phases are melded together. But these similarities were lost on his contemporaries. Bragaglia's acceptance in the futurist enterprise was swiftly accomplished. Marinetti, the spokesman of the movement, was interested enough in Bragaglia's work to support it financially, and by autumn 1911 Bragaglia was giving lectures in Rome and in Civitavecchia as a kind of futurist entrepreneur.[80] In

December he announced his plans to publish his essay on photodynamism, and the following year an exhibition of his pictures was given in Rome.

Bragaglia's ideas were realized literally in Russolo's *Music* (1911) (fig. 159), where disembodied grimacing faces extend from elongated streaks meant to denote a ghostlike dynamism. But Marey's analytical discontinuity is also present in the clarity with which the multiple hands of the pianist are delineated. Closer to Marey are other paintings Russolo completed between 1911 and 1913: *Revolt* (1911), *The Solidity of Fog* (1912), *Dynamism of a Car* (1912–13), and *Plastic Synthesis of a Woman's Movements* (1913) (fig. 160).

Both Bragaglia's photodynamism and Marey's chronophotography found their greatest intellectual acceptance in the work of Giacomo Balla, a painter who had undergone a different artistic formation than had his students Boccioni and Severini. Balla's father was a gifted and passionate amateur photographer who numbered among his close friends Count Giuseppe Primoli, a noted photographer of the period. In Turin, like so many of his generation, Balla had been drawn to the ideas of Cesare Lombroso, an apostle of scientific positivism. This influence fostered a more analytical side in Balla—painting for him included a scientific analysis of form, light, and color. His early paintings, with their cropping, partial framing, instantaneous gestures, and monochrome condensation of luministic values, reflect his interest in still photography as part of this positivist culture.

Balla was also familiar with motion photography. On a trip to Paris in 1900 he, like Kupka, had visited Marey's pavilion at the Universal Exposition and was directly influenced by the chronophotographs he saw there. After his visit Balla had immediately tried to introduce into his painting an image of movement, a woman walking, "which will interest artists because I have made a special study

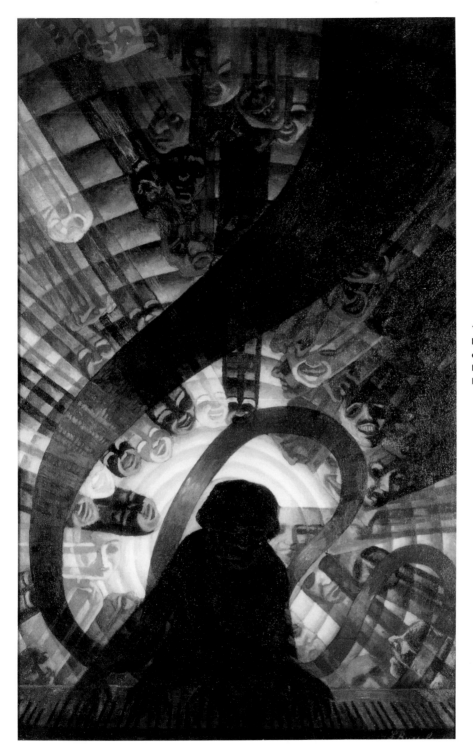

159.
Luigi Russolo, *Music,* 1911. Oil on canvas, 225 × 140 cm. Eric Estorik Family Collection, London. Photo: Herbert Michel.

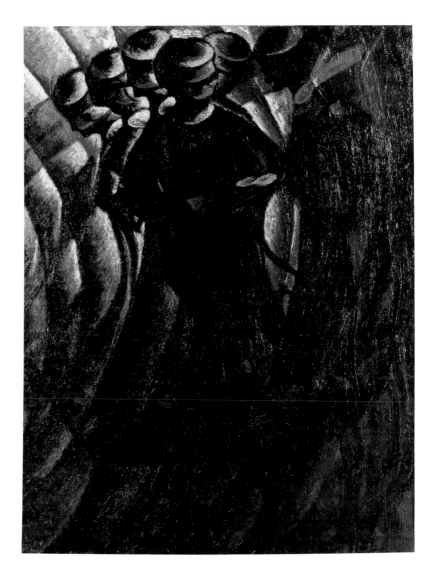

160.
Luigi Russolo, *Plastic Synthesis of a Woman's Movements,* 1913. Oil on canvas, 86 × 65 cm. Musée de Grenoble. Photo: André Morin.

of the way that this young lady walks and in fact I have managed to convey the illusion that she advances."[81]

In 1912 motion photography served as a model for the realization of Balla's futurist ideas. It was for him an experimental but concrete language with which he could reconstruct pure sensation in objective terms. Balla executed three paintings that year that continued the direction of his earlier analytic work while elaborating the futurist concern with visualizing motion. These were *Dog on a Leash, Girl Running on a Balcony,* and *Rhythms of the Bow.* The paintings bring together Balla's diverse concerns: his interpretation of futurism, Marey's chronophotography, and Bragaglia's photodynamism.

Balla and Bragaglia frequented the caffè Aragno in Rome, where they may have initially been attracted to each other by their shared interest in photography. Balla attended at least one of Bragaglia's lecture demonstrations and had posed for him in 1911 (for *The Two Master Notes,* in which Balla's hands are seen strumming the guitar), and again in 1912 (for *The Futurist Painter Giacomo Balla,* where he stands beside his painting *Dynamism of a Dog on a Leash*) (figs. 161, 162).

Bragaglia's antipathy to Marey's scientism may have influenced the direction of this painting, which depicts the successive stages of a dog trotting alongside a pair of feet. The positions of the feet of both dog and mistress are broken into overlapping segments, but the segmentation is not clearly articulated—or, rather, it is modulated by brushstrokes that blur the intermediary positions like Bragaglia's trajectories. Distinct positions of the tail are more clearly marked than those of the feet, but the four positions of the leash are joined by continuous lines of dots (fig. 162).

Balla's allegiance to Bragaglia's antichronophotography stance, however, is not so clear in *Girl Running on a Balcony* (fig. 163). This picture, be-

161.
Anton Giulio Bragaglia: *The Two Master Notes* (Balla playing guitar), 1911. Photodynamist photograph from *Fotodinamismo futurista,* Antonella Vigliani Bragaglia Collection, Centro Studi Bragaglia, Rome.

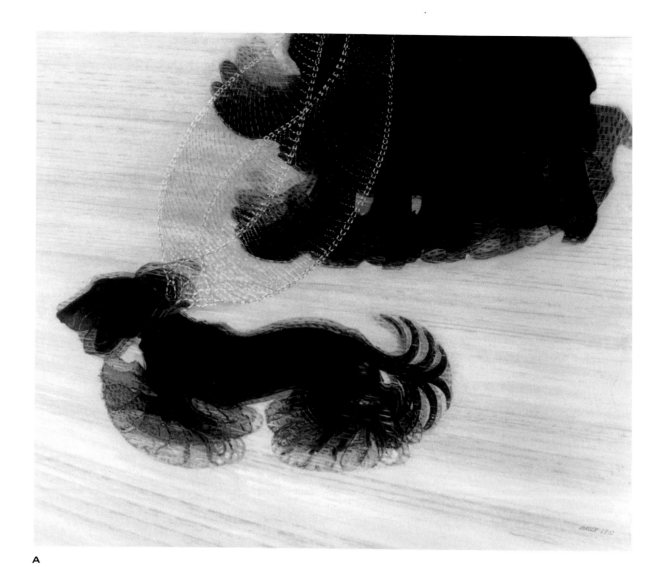

A

162.
(A) Giacomo Balla, *Dynamism of a Dog on a Leash,* 1912. Oil on canvas, 35⅜ × 43¼ in. Albright-Knox Art Gallery, Buffalo, New York. Bequest of A. Conger Goodyear and gift of George F. Goodyear. Photo: Thomas Loonan. (B) Anton Giulio Bragaglia, *The Futurist Painter Giacomo Balla,* 1912. Photodynamist photograph from *Fotodinamismo futurista.* Antonella Vigliani Bragaglia Collection, Centro Studi Bragaglia, Rome.

B

163.
Giacomo Balla, *Girl Running on a Balcony,* 1912. Oil on canvas, 125 ×
125 cm. Civica Galleria d'Arte
Moderna, Raccolta Grassi, Milan.

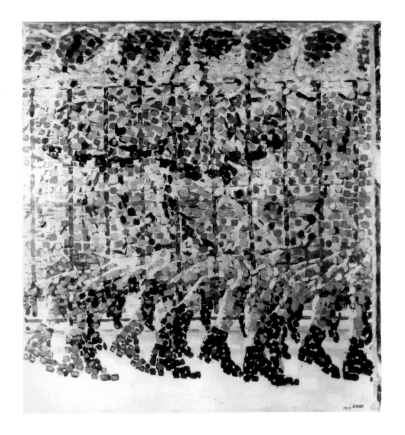

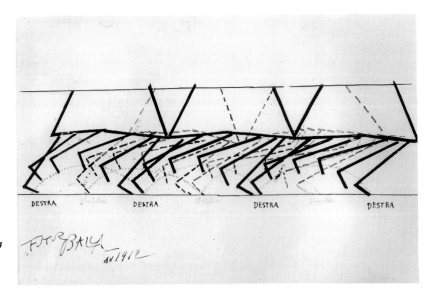

164.
Giacomo Balla, study for *Girl Running
on a Balcony*, 1912. Ink on paper,
17 × 24.5 cm. Civica Galleria d'Arte
Moderna, Raccolta Grassi, Milan.

gun between two trips to Düsseldorf in July and
November 1912, is more oriented to Marey, that is,
toward the effect of analytical decomposition instead
of the synthetic continuity advocated by Bragaglia.
The drawings made in preparation for this work
show that Balla had closely examined Marey's geo-
metric chronophotographs. In each study, Balla
uses solid and dotted lines to construct a geometric
pattern and to distinguish between the left and right
leg and foot of the running girl (fig. 164). The final
oil demonstrates that Balla's notions on discon-
tinuity applied to color as well—the separation of
form is joined to a study of chromatic discontinuity.

In the final work of this trio, *Rhythm of the
Violinist* (fig 165), Balla arrives at a synthesis. He
combines his own analytical studies of Marey with
Bragaglia's suggestions about "intermovementality."
It is the most resolved of the three paintings and the
only one that embodies the idea of the object and
the environment as an indivisible unit—a futurist
theoretical concern. In it the contours of the violin-
ist's hands are made both discontinuous in the

upper part of the picture and continuous in the
lower. The modulated divisionist brushstroke melds
together the contours of hands and instrument and
joins these with the background, as if to give the
sensation of endless vibration. The synthesis arrived
at in this painting is sustained in Balla's later depic-
tions of movement, the many studies and paintings
of the flight of swifts that he worked in 1913, cul-
minating in the oil *Swifts: Paths of Movement +
Dynamic Sequences* (fig. 166). A vibrant tribute
to the imagery of Marey, it melds Marey's chrono-
photography of birds seen simultaneously from
above and from the side, undulating white lines
(*linee andamentali*)[82] that have their source in Ma-
rey's stereoscopic trajectories of the moving coccyx,
and blurred interstitial forms that suggest motion.
After 1913 Balla turned away from the literality of
both Marey and Bragaglia, but his research on the
photography of movement was integrated into
his subsequent work. Combining abstraction and
an investigation of chromatic separation, the paths
of movement that Balla inscribed on his subse-

165.
Giacomo Balla, *The Hand of the
Violinist* or *Rhythm of the Violinist,*
1912. Oil on canvas, 52 × 75 cm. Eric
Estorick Family Collection, London.
Photo: Herbert Michel.

A

166.
(A) Giacomo Balla, *Swifts: Paths of Movement + Dynamic Sequences,* 1913. Oil on canvas, 38⅛ × 47¼ in. Museum of Modern Art, New York. Purchase. (B) Marey, Flight of gull, 1886. Collège de France.

B

167.
Giacomo Balla, *Abstract Speed,* 1913.
Oil on canvas, 332 × 260 cm. Private
collection, Rome.

quent canvases, whether of an automobile or of
the planets, developed out of his earlier depen-
dence on the photographic tracings of bodies in
motion; they augment the trajectories that con-
tained the overlapping parallel forms of the earlier
work (fig. 167).

Balla's desertion owed something to the dra-
matic events surrounding the publication of Bra-
glia's *Fotodinamismo futurista* in 1913. This was
the second edition of the work but the first time the
manifesto had actually been published. Its appear-
ance, including examples of the photodynamic
experiments, was noted on 30 June 1913 by the

journal *Lacerba,* the Florentine mouthpiece of fu-
turism. Within four months, on 1 October, *Lacerba*
had published this notice: "Given the general igno-
rance in matters pertaining to art, and to avoid
equivocation, we futurist painters declare that
everything referring to *photodynamism* concerns in-
novations in the field of photography exclusively.
These purely photographic researches have abso-
lutely nothing to do with the *plastic dynamism*
invented by us, or with any dynamic research in the
dominion of painting, sculpture, and architecture."
The text was signed by Boccioni, Carrà, Russolo,
Balla, Severini, and the painter Ardegno Soffici

(1879–1964), a latecomer to the movement. Marinetti's signature was absent, though he transmitted the message to the journal, just as he had transmitted Bragaglia's first announcement of futurist photodynamism.

Boccioni, the most vehement antagonist of Bragaglia's photography, was without doubt the moving force behind this official futurist disclaimer. Earlier in September Boccioni had written to Giuseppe Sprovieri, the futurist gallery owner in Rome, with this interdiction:

[Photodynamism] is a presumptuous uselessness that damages our aspiration to liberate art from the *schematic* or *successive* reproduction of stasis and motion. [The work] Balla *has done* can serve as an elementary initiation. What he will do will be certainly superior. . . . Imagine if we need the graphomania of a positivist photographer of dynamism . . . Experimental dynamism. To me [Bragaglia's] little book seemed simply monstrous, and to our friends also. The pompousness and the infatuation with the nonexistent was grotesque—(keep what I'm telling you about Bragaglia to yourself, because personally I find him sympathetic).[83]

Boccioni's attack and his desire to see Bragaglia's official expulsion from the futurist movement were excessive, and there was more than one reason for this ferocity. Boccioni criticized Bragaglia's technique, yet he himself was not independent of such means for his own pictorial method. Boccioni's desire to be free of "schematic or successive reproduction" is a telling indication that he felt encumbered and frustrated by it at the time. In fact, he had used successive repetition to objectify motion, and he had been sharply criticized for the resemblance of his paintings to photographs. Here was how the critic Henri des Prureaux, writing in *La Voce* in October 1912, characterized Boccioni's work:

So here we have photography, instantaneity! One starts by consulting it and ends by copying it; one gets used to the monstrosity of its perspective, of its mechanicalness; even worse, its ugly lie ends by taking the place of reality. [From photography derive] these characteristic attitudes [that we find] in many modernists, these eccentric coagulated movements no one has ever seen, since the essence of movement is continuity in duration, of which photography immobilizes an instant, while we see only the synthesis of instants. And so it is from instantaneous photography that such grotesque affirmations as this one derive: "A trotting horse has twenty pairs of legs." . . . Instantaneous photography and its aggravator, the cinema, which disrupts life, which jumps in a precipitous and monotonous rhythm; would these be, by chance, the two new classics in favor of which the futurists proscribe the masters of the museums?[84]

Boccioni's only defense against such accusations was to immediately illegitimize any assistance photography gave to the solution of purely pictorial problems, to deny any influence it might have, and to insist on the originality of the painters' investigations. The problem, then, did not lie exclusively with Bragaglia or with his work but rather involved his use of the camera to attain his ends. There were no grave differences between the theoretical grounds of plastic dynamism and photodynamism. But photodynamism proposed the emotional coexistence of object and subject through the medium of photography and thus was ultimately not acceptable. Bragaglia worked outside the system of those arts that futurism—in spite of declaring itself partisan to all things modern—had revalidated: the old hierarchy of painting, sculpture, and architecture. If photography or any reproductive mechanical technique could produce dynamic sensation, then there would be serious consequences for the traditional arts. Bragaglia was dangerous because he situated

himself in a position near to Boccioni's own, gave it a theoretical support to which Boccioni subscribed, but worked in a medium that was too modern. For despite his declarations of modernism, Boccioni was really more at home on a horse than in an automobile, no matter how much he protested the beauty of the latter;[85] he, and the futurist painters in general, were finally not modern enough to admit the camera to their artistic pantheon.

By 1913, too, the public was understandably getting rather tired of the latest round of futurist goings-on, and Boccioni was simultaneously concerned with asserting his leadership of the movement and setting it apart from contemporary French investigations, which to him were the epitome of analytic verism. To do this, he moved toward the construction of a solid theoretical base for the movement, one that would justify the preeminence of the direction of his own work. The analytical paintings Balla had done throughout 1912 and into 1913, however, seemed to Boccioni to rival the direction his work was taking; this threat may explain why Balla was subject to such scathing criticism from his former pupil. Balla was, nevertheless, Boccioni's teacher and master. To justify the direction of his own art, and to justify as well the expulsion of Bragaglia's photography and the containment of Balla's painting, therefore, Boccioni would need an authoritative source. This he found in Bergson.

Like the other artists of his time, Boccioni had absorbed Bergsonian ideas in a general way. Bergson's writings were widely publicized in Italy, and Giovannni Papini, editor of *La Voce,* a futurist mouthpiece, was also Bergson's translator. Boccioni became more deeply involved with Bergson's ideas in the second half of 1912 and in 1913,[86] as is reflected in his writings of 1913–14. Boccioni's readings of Bergson clarified for him the differences between relative and absolute motion and the role of intuition and memory in putting the spectator at the center of the picture. Most important, they lent his dismissal of photography a force it otherwise would not have had. This is how he saw the problem in 1913:

[Distances] between one object and another are not merely empty spaces but continuing materials of different intensities which we reveal with visible lines that do not correspond to any photographic truth. . . . Any accusations that we are merely being "cinematographic" make us laugh—they are just vulgar idiocies. We are not trying to split each individual image—we are looking for a symbol, or better, a single form, to replace these old concepts of division with new concepts of continuity.

Any dividing up of an object's motion is an arbitrary action, and equally arbitrary is the subdivision of matter. Henri Bergson said: "any division of matter into autonomous bodies with absolutely defined contours is an artificial division," and elsewhere: "Any movement viewed as a transition from one state of rest to another, is absolutely indivisible."[87]

Boccioni's campaign had its effect. Shocked and wounded by the treatment accorded him, Bragaglia gave up photography and turned to writing, theater, and films; he did not even sign the futurist cinema manifesto of 1916. (Marinetti, ironically, did.) In 1918 he reestablished his official links with the futurists (Boccioni's untimely death in the war in 1916 probably made this easier) with the opening of an art gallery, the Casa d'Arte Bragaglia. His first showing was of Balla's paintings—they had remained friends throughout the period.[88]

In spite of Boccioni's censure, the enormous influence of futurism on the rest of European art brought in its wake Marey's overlapping sequential forms. In Russia, for example, the Russian futurists Kazimir Malevich (1878–1935) (fig. 168) and

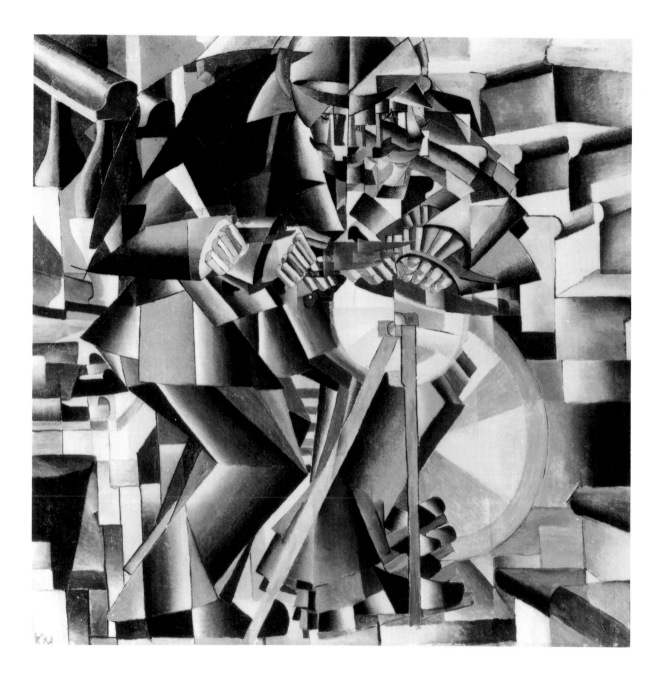

168.
Kazimir Malevich, *Knife Grinder*,
1912–13. Oil on canvas, 31⅜ × 31⅜
in. Yale University Art Gallery. Gift of
Collection Société Anonyme.

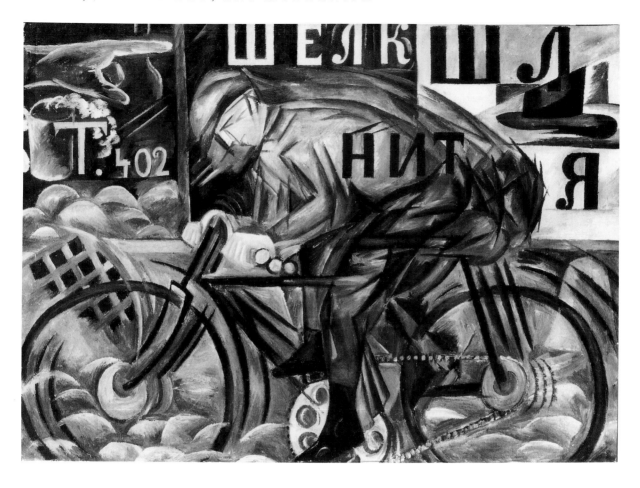

169.
Natalia Goncharova, *The Cyclist*,
1913. Oil on canvas, 78 × 105 cm.
State Russian Museum, Saint
Petersburg.

Natalia Goncharova (1881–1962) (fig. 169) ex-
ploited the imagery in their work, as did painters all
over the Continent. In all cases, however, it was a
passing phase, a transitional device used to expand
and elaborate on cubist syntax.

With the waning of the futurist aesthetic, differ-
ent kinds of images Marey produced were absorbed
into art. Dada ruptured forever the hierarchy of the
arts that Boccioni hoped to preserve, and images
made by the camera became integrated into the
common language of artistic expression. Duchamp,
who had abandoned "the representation of move-
ment in favour of a personal mythology of me-

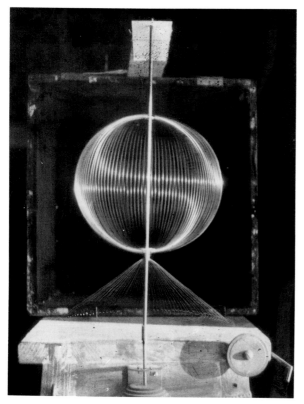

A

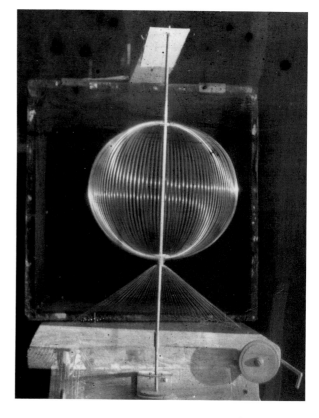

chanical apparatus,"[89] turned to illustrations of graphic enregistering instruments in Marey's *Animal Mechanism* for sources for his *Large Glass* (*The Bride Stripped Bare by Her Bachelors, Even* (1915–23). Ironically, as Ivor Davies makes clear, *Animal Mechanism* provided Duchamp "with a most suitable vehicle for Bergson's mockery of the mechanical."[90] Marey's chronophotographs of lines engendering geometric solids also provided Duchamp with a source for his *Rotating Glass* and *Rotating Demi-sphere* (fig. 170)—the work that led to the *Anemic Cinema* (1925).[91] The surrealist Max Ernst (1891–1976) translated Marey's 1901 aerodynamic studies into the haunting *Blind Swimmer* series of 1934 (fig. 171). Ernst also incorporated illustrations of Marey's work published in *La Nature*

170.
(A) Marey, Stereoscopic chronophotographs of volumes engendered by the revolution of a string (*below*) and a polished brass arc, 1891–92. Beaune. (B) Marcel Duchamp, *Rotating Glass,* 1920. Five painted glass plates of different lengths mounted on a metal axis electrically operated, 47½ × 72½ in. Yale University Art Gallery, Gift of Collection Société Anonyme.

171.
Max Ernst, *Blind Swimmer I. The Effect of Touch,* 1934. Oil on canvas, 36¼ × 28⅞ in. Collection of Mr. and Mrs. Julien Levy, Bridgewater, Connecticut. © 1992 ARS, New York/ SPADEM/ADAGP.

into his surrealist collages (fig. 172). In Ernst's hands the positivistic atmosphere in which the images were born is restored to them while it is simultaneously parodied; its nature is now so remote, however, that the instruments seem to be artifacts left over not just from a different epoch, but from a different universe.[92]

Since chronophotography made visible the underlying laws of nature, Marey assumed it would assist artists in depicting the real world more accurately. But the artists who were drawn to Marey's analytic decompositions of time, space, and motion used them to create a different reality, the reality of the imagination. And in using Marey's positivistic images as a source for the first abstract works of art, they ultimately brought the authority of nineteenth-century positivism to an end.

Ironically, Marey's work has had a profound influence on the visual arts, but in a manner completely opposite from what he intended. Although the imagery of chronophotography is for the most part absent from painting and sculpture, it is still a vital part of the visual language of popular culture. In advertising, videos, illustration, cartoons, and caricatures, Marey's repeated overlapping forms remain the single most important means of representing time, speed, and motion.

172.
Max Ernst. (A) " . . . you won't be poor anymore, headshaven pigeons, under my white dress, in my columbarium. I'll bring you a dozen tons of sugar. But don't you touch my hair." Collage published in *Rêve d'une petite fille qui voulut entrer au Carmel* (Paris, 1930). Translated as *A Little Girl Dreams of Taking the Veil* by Dorothea Tanning (New York: George Braziller, 1982). (B) "The unconsciousness of the landscape becomes complete." Collage published in *La femme 100 têtes,* (Paris, 1929). Translated as *The Hundred Headless Woman,* by Dorothea Tanning (New York: George Braziller, 1981). © 1992 ARS, New York/SPADEM/ADAGP.

A

B

173.
Naum Gabo, kinetic sculpture
Standing Wave, 1920. Tate
Gallery, London.

nace, the body was an immense reservoir of energy; its potential force was limited only by the specter of fatigue.

By the end of the nineteenth century social scientists, philosophers, and liberal reformers alike had seized on the practical applications of these physiological discoveries.[3] The wealth of nations depended on the output of the laboring body—the harnessing of the body's energies to perform valuable work. If the body could be treated as a virtual motor, then science could subject the work it produced to the same quantification and measurement as that produced by other motors, away from the moral sphere of idleness and the exercise of the will: "No matter how powerful the action of our will, the transformation of forces and conservation and use of our energies follows the same physical laws, passes by the same necessary phenomena, as those other, properly called machines."[4]

Science could provide work with a rational, objective basis. Detached from the interests of labor and capital, it could determine the optimum use of the body's energies and analyze the physiological limits of physical and mental labor. Its findings would contribute an impartial solution to the economic and political conflicts that ravaged modern industrialized society.

These ideas, colored by the positivist equation of scientific knowledge with truth, gave birth to a new science of work in Europe at the end of the century. Uniting medical, social, and political inter-

ests, it aimed both to increase the well-being of the working body and to realize the productive potential of the nation by discovering the most energy-efficient methods of work and determining the laws of fatigue that limited its production. These were the aims that Marey's instruments and methods were now called on to serve.

Marey's own muscle studies belong to the beginnings of this new science. With his myograph, Marey had made some of the earliest tracings of fatigue. He had graphed the movements of muscle tissue excited by electrical impulses and had shown that repeated stimulation gave tracings whose amplitude diminished little by little as their duration was augmented. These, Marey observed, marked the intervention of fatigue, which he admitted was a universal and inevitable fact, "observed in all muscles and all animals."[5]

The myograph had also introduced Marey to the importance of muscle elasticity, a theme he returned to at the end of his life. The elasticity of muscle tissue—indeed, the elasticity of all living tissue—seemed to him a salient feature of the body's efforts to conserve energy. The body's movements are by nature irregular: the up-and-down motion of the foot leaving and touching the ground in the walk, for example, imparts to the body an intermittent propulsion and slowing. Yet because such shocks are absorbed by the body's inherent elasticity, its movements are effected "without jolts, without noise, totally different conditions than

174.
Luncheon for the Association of the Institut Marey, 1902. With Marey are some of the founders of the European science of work. *Left to right:* Angelo Mosso, inventor of the ergograph; Augustus D. Waller, English pioneer of electrocardiology; Marey's daughter, Francesca Gallone; Georges Weiss, a student of Chauveau's; Hugo Kronecker; Marey, with his son-in-law, Noël Bouton, directly behind him; Mariette Pompilian, a student of Marey's; Professor N. Mislawsky, University of Kazan; and an unidentified young man.

those seen in the majority of ordinary machines."[6] This observation led him to investigate how elasticity might facilitate the external work done by men and animals. In one early experiment he harnessed himself to a cart to show that an elastic element introduced into the otherwise rigid harness lessened the shocks transmitted to the body by the intermittent movement of the cart (and by the unevenness of the pavement that was transmitted through the cart).[7] He demonstrated that any kind of elastic connection between a load and a motive

force produces better utilization of force; in short, he proved that less energy was needed to pull the cart and less damage was inflicted on the muscles by the shocks transmitted to them. The resulting "economy of work and diminution of fatigue" seemed to Marey "to constitute an important application of physiology to the amelioration of the fate of men and animals."[8]

In these experiments and in those that followed on the effects of adding an elastic element to the harness of workhorses, Marey had employed his inscribing traction dynamometer (fig. 175), essentially a spring-and-piston arrangement placed between the moving force and object being moved, which registered the effects of pressure and transmitted them through a tambour to an inscribing stylus. This and the other dynamometers that Marey used to graph the play of forces on different parts of the body as they moved would become the fundamental investigative tools in all subsequent studies of work and fatigue. Researchers in both the laboratory and the workplace would refine them and adapt them to the study the physical and mental effort and the specific movements particular to different forms of labor.

The 1883–85 dynamometric and chronophotographic analyses of walking, running, and jumping

had shown Marey that bending the knees to cushion the shock imparted to the foot by its contact with the ground and to lower the body's center of gravity maximized muscular effort and energy. In an 1895 study carried out at the Station by Commandant De Raoul, pictured in figure 103, and Félix Regnault, these findings were applied to military paces. Their results gave scientific validity to the belief that the military "flexioned march"—in which the soldier kept his knees artificially bent and his feet close to the ground to minimize the vertical oscillations of the body—was the least fatiguing.[9] In 1910 the ergonomist Jules Amar (1879–1935) again verified Marey's data. He took instantaneous photographs to document how laborers instinctively lowered their center of gravity by bending their knees more when they had heavier loads to carry or push or when, toward the end of the work day, they were excessively tired.[10]

In the 1890s the increasing number of his students and colleagues who used his techniques to study work and fatigue encouraged Marey to lay out the areas he thought would be most fruitful for such experiments. He believed the study of human labor (which would be easier than studying the work of animals because "it was more regular in its application") should be carried out in the work-

175.
Marey's traction dynamometer, 1878.
Movement.

shops and on building sites as well as in the laboratory. He saw one difficulty, however: "The only complication we can expect in the study of the work of man will come from the extreme diversity of the effects produced and the extreme variety of the tools used in the different trades. But if the difficulty is great, the importance of the expected results justifies the consecration of great efforts."[11]

Marey proposed that the specific motions skilled workers used to accomplish their tasks might be chronophotographed or filmed and then used, as were his films of athletes, to communicate the superiority of those movements to others less adept. The images, he wrote, "would show how the stroke of a skillful blacksmith differed from that of a novice. It would be the same in all manual professions."[12]

He also proposed adopting his graphic and chronophotographic instruments to analyze how specific tools are actually used in working. With these instruments physiologists would discover how to make the forces used in work more equal and prolonged, he said; they would find the laws that "regulate the mass of different tools, the length of their handles and even the dimensions that each should have according to the size and the force of the man who is using them."[13]

In 1894, in what was the first application of chronophotography to a specific trade, Marey and the engineer Charles Fremont (1855–1930) analyzed the movements of blacksmithing. Fremont, who was particularly interested in the history, development, and proper use of tools, had both an artistic and a scientific aim for these studies. First he wanted images that could be used by artists, and for these he made films of the smith hammering at an anvil. Second, he wanted to clarify both the trajectory of the movement and the successive positions of the hammer and the hands of the smith; for these, he used fixed-plate chronophotography to

turn the movement, as Marey had done, into a graphic notation (fig. 176).

Fremont adopted chronophotography and cinematography for all his subsequent studies—of filing, hammering, and riveting—and he used these methods as Marey had done, in conjunction with dynamometers. Fremont's primary interest, however, was in the effect of the technology of the tools used (whether they were old or new, cheap or good, etc.) and the varying skill of the men using them, rather than in the way energy was expended or conserved in their use.[14]

The experiments of Marey's friend Auguste Chauveau, who upon Marey's death had become director of the Institut Marey, focused instead on the thermodynamics of muscle elasticity. Chauveau redefined muscular work; he showed that any muscular contraction involved the transformation of chemical energy into elastic forces and heat and thus consumed energy even if no external work was accomplished. Besides showing this difference between the internal and external work of muscles, Chauveau classified the external work as either static, where the muscles merely sustain an object, or dynamic—where the muscle is used to move an object (which he defined as positive work) or resist it (negative work). Chauveau compared the energy consumption for each of these types; he found there was no fixed relation between the total quantity of interior work expended when the muscle acquires its elasticity through nervous stimulation and the exterior work that derives from it. Indeed, he argued that the human motor was not at all like an inanimate machine, because the exterior work furnished by the former was only a fraction, and a variable fraction at that, of the total energy the organism expended.

To determine the most economical way of executing a given amount of work, Chauveau measured (in calories used, liters of oxygen absorbed, or

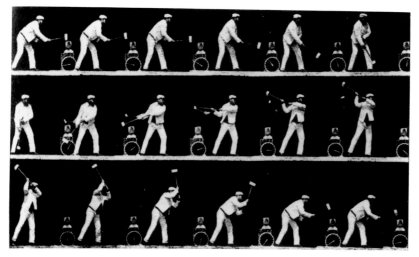

A

176.
Marey and Charles Fremont:
(A) Hitting hot iron, 1894. *Le Monde
Moderne,* February 1895. (B) Hitting
directly, 1894. Gelatin silver print,
16.3 × 20.2 cm. Metropolitan
Museum of Art. Purchase, the Horace
W. Goldsmith Foundation Gift and
Rogers Fund, 1987.

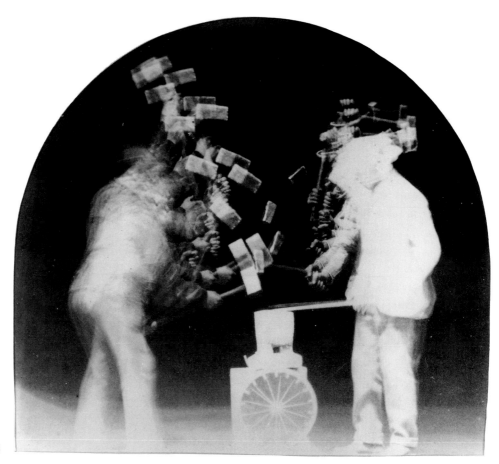

B

kilogram-meters [the force needed to move one kilogram one meter]) the energy consumed by a man who was progressively loaded with ten-kilogram weights while using a Hirn's wheel.[15] From his data, and from a similar study in which he measured the efforts of the flexor and extensor muscles as the arm lifted different weights to different heights and at different speeds,[16] Chauveau was able to show that up to a critical threshold where fatigue intervened, there was an ideal load and an ideal speed that provided maximum economy of effort in working: that moving a smaller weight at a faster rhythm consumed less energy than moving a large load at a slow pace. The outcome of all these experiments was Chauveau's demonstration that the mechanical "law of least effort" applied to the human motor as well: once the initial effort needed to overcome inertia is accomplished, "our muscles function so as to economise their stores of energy, and adapt their effort and their speed with an inimitable precision and certainty to this end."[17]

From his study of the optimal conditions for work, Chauveau proceeded to question the relation of the human motor's efficiency to the quantity and quality of food that fuels it. Chauveau used Marey's spirometer to measure the effects of different foods on energy expenditure, modifying it by means of a special valve that allowed him to measure his subjects' respiratory exchanges.[18] He showed that the absorption of oxygen used in combustion was least when the subjects ate primarily carbohydrates, was more for fats, and was most for proteins. This study opened up an important new area of inquiry. It was extended into the late 1920s by his students and was paralleled by a large body of work undertaken in both Europe and North America to determine the optimal diet and caloric requirements for different social classes and different types of work.

By 1900 Marey's pioneering instrumentation and Chauveau's laws of muscle thermodynamics

had opened the doors to a science of fatigue. Identified by both Marey and Chauveau as the key to the efforts of the human motor, the centrality of fatigue to the new science of work was reflected in both the amount of literature and the number of laboratories devoted to its study all over the Continent. The identification of fatigue as a specific physiological phenomenon and an important subject for experimental analysis was the work of the Turin physiologist Angelo Mosso. Mosso was "first fired with the desire of applying [himself] to the study of fatigue"[19] on a trip in 1873 to Leipzig, where he watched the experiments in muscle thermodynamics being carried out by the German physiologist Hugo Kronecker (1839–1914). Kronecker urged Mosso to go to Paris to meet Marey—Kronecker had studied with Marey and was using Marey's myograph in his vast study of muscle function. When Mosso arrived at the Physiological Station in 1874, Marey, who had just published *Animal Mechanism*, was able to show him firsthand the centrality of the graphic method for the experiments on muscle that Mosso now had in mind. Mosso was quick to recognize the importance of Marey's studies and instruments, and this visit, the first of many, marked the beginning of a long collaboration between the two scientists. In the early 1890s, when Mosso had all but concluded his experiments in fatigue, it was Marey who directed his attention to the importance of physical education and sport for their salutory effects on the body destined to work in the modern world. Marey "inoculated [Mosso] with the love of those problems," wrote one of his biographers,[20] and with happy results: he dedicated himself to the study of sport and training, their effects on the organism, and the reform of physical education in Italy, tasks made easier by his election to the Senate in 1904.

Mosso's great contribution to fatigue study was the ergograph (from the Greek word for "work"),

an experimental graphing instrument he devised in 1884 that was the first adaptation of Marey's dynamometer to be applied directly to the study of human fatigue. Mosso's ergograph recorded the muscle contractions of the forearm when the middle finger (the other fingers and the wrist were immobilized) lifted and dropped a weight at different predetermined rhythms. A stylus was attached to the cord that joined the finger and the weight; as the effects of fatigue lessened the intensity of the contractions, a corresponding descending series of curves was traced onto a rotating cylinder (fig. 177). Mosso's instrument served a dual purpose: it measured both the mechanical work performed in kilogram-meters and individual endurance—the time taken to produce complete fatigue.[21] The ergograph was soon applied to the study of different muscles used in controlled working conditions in the laboratory, and even to intellectual effort. Mosso used Marey's polygraph and pneumograph in tandem with his ergograph to correlate the increase of heart and respiratory activity with muscular and psychic fatigue. His data revealed "the various conditions governing the optimum of work with regard to the weight to be lifted, the speed of contraction, intervals for rest, etc."[22] Mosso and his students also confirmed that fatigue, defined as a regular and consistent lessening of muscular force,

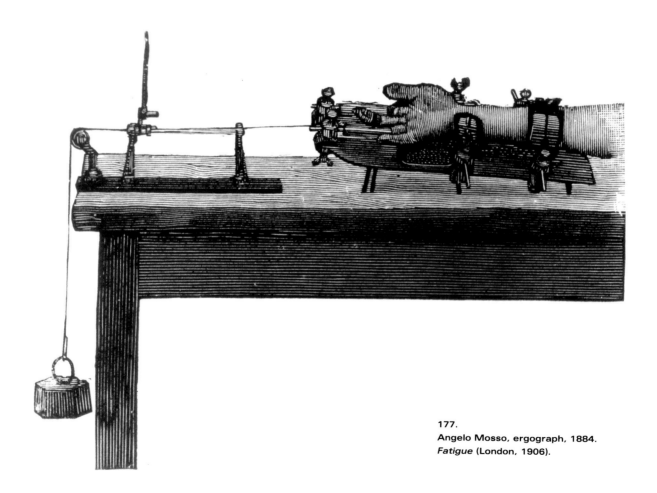

177.
Angelo Mosso, ergograph, 1884.
Fatigue (London, 1906).

was not a subjective condition but an objective physiological reaction subject to its own laws. Mosso's 1891 summary of his experiments, *La Fatica* (translated as *Fatigue*, 1904), "placed the study of fatigue firmly within the canon of modern science."[23]

The simplicity and effectiveness of Mosso's ergograph opened the floodgates for studies of the conditions and factors that produced fatigue. At first such studies followed subjects engaged in simple, repetitive, and often artificial movements executed within the controlled conditions of the laboratory. But the ergograph also set the stage for a development in the science of labor that Marey had anticipated, the study of the actual work done by men and women in the fields, offices, factories, and workshops of Europe. This application took two forms: further physiological experiment on different kinds of workers in laboratories, where the conditions of their work environment were simulated, and actual intervention by scientists in the workplace and in working conditions.

The workers studied by Jules Amar, a pupil of Chauveau's, were the natives of the French colonies in North Africa and the inmates of the prison of Biskra in Algiers. Amar's detailed investigation, sponsored by the French Ministries of Labor and Public Instruction and stimulated by the War Ministry's project to conscript colonial natives, was the first to be applied to a such a large sample. Between 1907 and 1909 Amar had laborers, masons, porters, and farm workers—many of whom had been imprisoned, Amar was at pains to explain, only for minor infractions—carry burdens of forty to sixty kilograms under preset conditions in his laboratory. He wanted to calculate the maximum work they could do before becoming exhausted and the exact amount of rest they needed in an eight-hour workday. He was also able to determine the energetic effects of the kinds and amounts of food his subjects ate by using Chauveau's modified spirometer

to measure their respiratory exchanges as they pedaled an "ergometric monocycle," an adaptation of the dynamometric bicycle Marey had devised in 1894.[24] This study convinced Amar of the importance of diet—especially the superior value of couscous over bread—in the men's capacity for work. His results also caused him to question the dearth of physiological knowledge among those to whose care these lives were entrusted, colonial administrators and officers who "have at their disposal an energy of which they methodically regulate neither the conservation nor the expenditure; they presume it to be indestructible."[25] His analysis of the relation of ethnic origins to aptitude for particular work also encouraged him to denounce the wasteful use of labor under colonial rule.

In 1913, at the behest of a committee that included Amar himself, Chauveau, Charles Richet, Armand Imbert, and Henry Le Châtelier, which had been constituted to coordinate the statistics and data supplied by the now burgeoning study of work and fatigue, the French government created the Laboratoire de Recherches sur le Travail Professionnel at the Conservatoire National des Arts et Métiers. Amar was appointed its director, and in that capacity he began a study of metal filing, his first detailed analysis of skilled work. His results were published in 1914 in *Le moteur humain* (translated as *The Human Motor*, 1920), an effective synthesis of all earlier investigations of the functioning of the human motor and of their application to work. Amar aimed at defining optimum productivity, and he clearly distinguished between a mechanical optimum (the maximum of work produced) and an economic optimum (the minimum of energy needed to produce work). Only from the latter, he felt, would scientists succeed in establishing general laws for the scientific organization of work.[26] He investigated every factor affecting the worker, including psychological, religious, moral, and professional

influences as well as the effects of clothing, diet, hygiene, and environment, and he insisted on the necessity of distinguishing between "first class" workers and their inferiors (fig. 178).

His studies of metal filing that complete *The Human Motor* revealed the breadth of the field that was open to the graphic method. The files were connected to Marey tambours and recording cylinders "so that the speed or muscular activity of the work would be measured."[27] The filers were subject to dynamographic, pneumographic, and ergographic tracings. Their movements were decomposed "right down to their internal physiological economy,"[28] and postures, pauses, and gestures were analyzed so that all unnecessary movements could be eliminated and the most productive—from the point of view of energy expenditure—could be charted. Amar's data allowed him to prescribe the most energetically economical mode of working, one that would at least double each filer's output: the exact speed at which the filer should work, the amount of pressure each of his arms should bring to bear, the position of his feet and his center of gravity, and the number of rests he should take every hour (fig. 179).

Amar's work on filing also was the first realization of Marey's desire to see the graphic and chronophotographic methods used as tools of instruction for workers. For the apprentice filer, or the unskilled, the graphic method "will instruct and discipline," wrote Amar:

[It will] fulfill, better than speech or writing, the office of correcting the beginner's faults, correcting his mistakes, and securing his attention. Dynamographic tracings, which can easily be obtained with a little ingenuity, should constantly be exhibited to the pupils, so that they may judge for themselves of their irregularity, in the case of a beginner, or their regularity and uniformity in the case of a skilful worker. Disorderly and useless move-

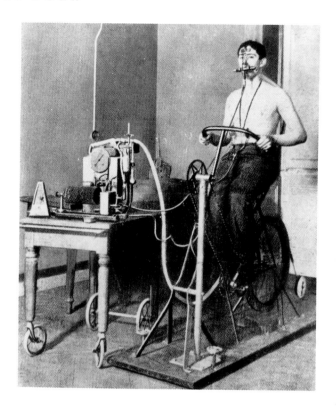

178.
Jules Amar, subject using dynamometric bicycle and spirometer, 1912. *The Physiology of Industrial Organisation and the Re-employment of the Disabled* (London, 1918).

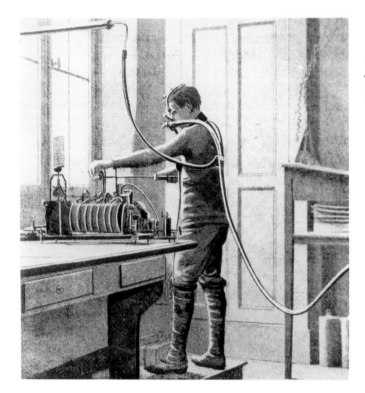

179.
Jules Amar, filer using spirometer, 1912. *The Human Motor* (London, 1920).

ments, which inevitably give rise to premature fatigue, will be reproduced by means of the cinematograph, exaggerating them if need be. Films which in this manner display the awkwardness of beginners . . . will be of considerable value for purposes of apprenticeship and re-education. In view of this teaching by example, a few characteristic films relating to the practice of the principal handicrafts will be preserved in the schools.[29]

The graphic method presented itself as an equally powerful tool for psychological investigation, and with the work of Jean-Marie Lahy (1872–1943) it took its place in the panoply of techniques applied directly in the workplace to determine workers' aptitude and innate propensity for different types of work. The use of Marey's graphic method to register bodily reactions to different auditory, visual,

and physical stimuli supported a physiological and experimental basis for psychology that by the end of the century had supplanted the psychology of introspection.[30] The three psychology laboratories created at the Ecole des Hautes Etudes in the 1890s demonstrated official support for this tendency. The first, dedicated to physiological psychology, was given over to Alfred Binet, founder of the intelligence test. The second, for the physiology of sensation, was led by Georges Seurat's champion Charles Henry, an admirer and friend of Marey's who not only shared his interest in cycling but also took Marey's graphic and dynamographic studies of movement as his model for the rationalization of visual sensation. Edouard Toulouse, director of the third laboratory, dedicated to experimental psychology, also modeled the direction of his studies on

Marey's. Toulouse's 1904 work *Technique de psychologie expérimentale,* a small encyclopedia of techniques for the "measurement of psychic processes,"[31] was to psychology what Marey's *La méthode graphique* was to physiology.

A physiologist by training, Jean-Marie Lahy worked in Toulouse's laboratory, where he took charge of the work study program.[32] Lahy's early work was similar to Marey's youthful oeuvre in its concern with blood pressure and with the application of the graphic method in physiology and psychology.[33] His study of the professional trades began in 1905 with typists, whom he tested to determine what physiological and psychological qualities constituted an aptitude for their work. Between 1908 and 1913 he tested gemstone engravers, gunners, tram drivers, and linotype compositors, the last at the invitation of their union. Lahy observed them for fifteen days in the workplace, subjected them to a battery of psychophysiological tests, and had them account precisely for everything they did over a twenty-four-hour period. In his attempt to define the technical superiority of one worker over another as a function of resistance to fatigue, Lahy separated the contribution of physical and professional factors from that of factors related to the actual organization of the work: he argued that "there is almost a necessity to replace the word fatigue with another term because the idea of muscular exhaustion is so attached to it. We must actually consider that the more monotonous and exacting the work is, the more it is injurious."[34]

Lahy's investigations mark the first time science intervened in a labor conflict. Analyzing on site the work of female linotypists who were paid less than men, accepted piecework (while the unions strove to make salaried day work universally applicable), and were often used as scab labor in strikes—with the excuse that they belonged in the home, not in the dangerous environment of the workplace—

Lahy proved that the quality and quantity of the women's work was equal to or better than that of the men and that the union, the employer, and society as a whole had no excuse, from a scientific viewpoint, to treat them differently.

The emerging role of the science of work as an arbiter in social conflict had gathered its initial momentum with the establishment of Ernst Solvay's Energetics Institute in Brussels in 1900. Solvay saw the importance of combining the psychological investigations of intelligence and mental fatigue with the physiological investigations of Marey and Mosso to construct a new social science whose findings would, ideally, influence the direction of social and political reform. One of the most important studies of industrial fatigue was carried out by the director of the Solvay Institute, Josefa Ioteyko. She showed that the onset, intensity, perception, and influence of fatigue differed widely not just among individuals, as Mosso had believed, but within each individual according to changing conditions of work or environment. Ioteyko understood fatigue as a defense of the body's economy that could be regulated by training—essentially a way of protecting the muscle by habituating it to fatigue—a slower pace, or more rest. The malleability of fatigue led Ioteyko to insist that it would really be understood only by investigating large numbers of workers in the industrialized workplace and studying the conditions of their work. By taking this route, she wrote, pure science would provide its "authoritative support in its noble desire that the working classes may benefit by the physiological and psychological discoveries of our century."[35]

A program for "submitting the working of the bodily organs to experimental tests with a view to discover their best working conditions, to detect fatigue and to lay down a scientific basis for industrial work"[36] was made the order of the day at the 1903 International Congress of Hygiene and De-

mography held in Brussels, one of the many international conferences, organizations, and journals that directed the medical, physiological, and psychological concern with fatigue toward more practical social and political involvement.[37] The program was all-inclusive. It included observing the conditions of work that yielded the best return; studying the effects of overwork and the contribution of machinery to the overfatigue of workers; and submitting the worker on the job to a plethora of tests with graphing machines to determine sensitivity to pain, the curve of nervous effort during work, the tempo of reflex response, chromatic sensitivity, capillary pulse change, and reaction time in the fatigued and nonfatigued body.

The scientists' desire to see their findings affect social policy on work and reform in the workplace was again stressed at the 1907 International Congress of Hygiene and Demography held in Berlin. One of the participants, the Montpellier physician Armand Imbert (1850–1922), saw the seemingly irremedial incompatibility of capital and labor as creating a need for intervention by experimental science. The industrialist was justifiably interested in the output of the worker, stated Imbert, while the worker's own self-interest was based on the "real expenditure of all kinds of internal energy." Science was "neither socialist in its essence nor capitalist in its nature; it is simply the truth."[38] Imbert proffered his own studies as a concrete illustration of the role science could play in the current debate over the length of the workday and the prevention of accidents. From 1903 to 1906 he had undertaken, with an official of the French Office du Travail (founded in 1891), a statistical analysis of the frequency of accidents among different professions in the Hérault region. He showed that the increase in accidents both during certain times of day and on certain days of the week was not the result of worker negligence or malingering but was directly

related to the accumulation of fatigue. In a study of dockworkers at the port of Sète, whose accident claims were so far above the norm that they were accused by their insurers of faking accidents or injuring themselves on purpose, Imbert demonstrated that the increase in number of accidents was directly related to fatigue: there were fewer men working at Sète than at the other ports, and they were doing more intense labor for the hours they worked. Rather than "a battle between labor and capital," the situation was the result of "a physiological fact that the most simple inquiry allowed to be discovered."[39] Imbert saw the claim for a shortened workday and frequent rest periods as nothing less than a biological and economic necessity.

Like the studies of dockworkers, those of carters, vine cutters, and filers that Imbert carried out between 1905 and 1908 were done on site and were the "first to show the use that could be made of the graphic method to register the efforts of the workman's muscles on his tools."[40] The study of carters was commissioned by the Office du Travail as part of its investigation of adolescent labor. Imbert compared the force needed to lift, balance, support, push, load, and unload the *cabrouet,* a two-wheeled cart, and the wheelbarrow.[41] He fitted the vehicles' handles with intricate dynamometric inscribing devices that would respond to the pressure of the workers' hands and had the workers wear Marey's dynamometric shoes.[42] The legislation on the work enacted in 1908 reversed his findings (though Imbert proved the *cabrouet* was much more energy efficient than the single-wheeled barrow, the government outlawed the *cabrouet*), yet he nonetheless saw the government's reliance on physiological experiment in enacting work reform legislation as a necessary and positive step in social reform.[43]

For his inquiry into the work of women who cut vine slips in Montpellier, Imbert attached a metal bar to their secateurs that relayed the cutting

movements to a receiving tambour and stylus. The tracings he made were coordinated with intelligence and aptitude tests that he gave the women. The combined data showed that the superior skill of certain workers was dependent not only on the speed of their cutting but, more important, on their total gestural conception of their task—the way they stood and their economy of body and hand movements. Imbert's data also supported the women's claim for a wage increase based on the size of the slips. Measuring the differences in energy needed to cut small and large slips, Imbert found that a universal price proportional to overall effort was indeed justified.[44]

As a result of his studies, Imbert concluded that in general good workers are accurately attuned to their own physical and mental limits and that they naturally find the way of doing their work that requires the minimum expenditure of energy; their whole way of working, in fact, demonstrated the "law of least effort." Moreover, Imbert contested, the skilled professional, more often than not, had a better grasp of the actual effort involved in any particular job than did the employer, and for these reasons he argued for workers' participation in the international meetings on work and hygiene. Most important, Imbert was one of the first work scientists to understand that the nature of work as it was organized in the modern factory imposed radically new conditions on the organism. Not the individual nor the employer, but the machine now regulated both the intensity and the tempo of labor, and this regularity had to be internalized by the worker. For Imbert this meant that time-and-motion measurement, "the direct, experimental, microscopic study of occupational work itself,"[45] must take its place beside the measurement of fatigue.

Imbert's experiments and, similarly, those of the doctors, physiologists, and psychologists who aimed to define the conditions under which the worker would produce the "maximum effective result with a minimum production of fatigue,"[46] rested on the unquestioned belief that the physical and mental well-being of workers was the foundation for the wealth and productivity of the nation. Their investigations of the effects of the duration of work, its rhythms and rests, the operative gestures of workers and their choice of tools, and the criteria (morphological, physiological, or psychological) that would determine the aptitude of different workers for different kinds of work reflected the positivistic ideal that science could solve social problems. Between 1898 and the First World War, the experiments undertaken in work reform by a few forward-looking industrialists;[47] the contribution of government to statistical measurement in such studies as Imbert's; and the legislative debates in France, Germany, and England on the duration of the work week and length of the workday, the necessity for rest periods, health and accident protection, medical hygiene, and the reform of the army and of physical and technical education indeed seemed to herald more active cooperation between science and the state.

But ultimately the scientists' desire for reform measures based purely on objective physiological or psychological assessment was idealistic, and their call for increased state intervention and supervision of the workplace was premature. The orientation of their investigations toward the evaluation of physiological work ignored the social relations constituting every work situation. The strict scientism of their projects ignored the fact that most employers' desire for increased profits through cheaper labor and higher productivity overrode all other considerations. Moreover, as Marey had warned, "the extreme diversity of the effects produced and the extreme variety of the tools used" were indeed a stumbling block. To be effective, experiments had to be carried out on large numbers of men and women

and had to take into account a multiplicity of factors, not least of which was the specificity of each job. Their results were not universally applicable, nor did they promise an immediate lowering of costs or increase in productivity. On the contrary, the investigations took a long time and a lot of money—money that could just as easily be spent, from the employers' point of view, on newer and faster machines.

In the first decade of this century, the rationalization of work carried out on the shop floor in America under the name scientific management seemed to offer the solutions to these problems. Like the European science of work, scientific management claimed to transcend conflicts of interest in the name of science. But its practitioners—called "efficiency engineers" or "industrial engineers"—were not concerned with finding the laws that governed movement, fatigue, the best use of tools, or the aptitude of the worker; nor was their primary consideration the physical and psychological well-being of the labor force. Rather, scientific management sought to increase productivity by making the work process more efficient, and it guaranteed efficiency by removing control of the work process itself from the worker and placing it in the hands of the manager. This shift in the aims of a science of work, from a means of discovery and social development to a "system of social control designed to limit union influence, to train unskilled workers rapidly, to create a new professionalism and promote the interests of the middle class,"[48] was a consequence of the changing mode of production that took place in American industry in the early twentieth century, and it was implemented by the evolution of a new managerial class, professional engineers.

During the first half of the nineteenth century the American pattern of producing and marketing manufactured goods already contained the basic elements of modern mass production: first, the practice of quantity manufacture of standardized products characterized by interchangeable parts; second, the use of a growing array of machine tools and power to substitute simplified and, as far as possible, mechanized operations for the draftsman's arts. Parallel developments in the organization of productive effort and in the new methods necessary to market standardized products in quantity went hand-in-hand with the technical advances.[49] Known in Europe as the "American system," this pattern approached both production and distribution with an emphasis on the systematic organization of the flow of work so that labor costs were reduced and profits maximized. Regarded with envy by its European competitors, the system was viewed as a product of the differences between the New World and the Old: "The nature and diffusion of education in America; the absence of rigidities and restraints of class and craft; the freedom from hereditary definitions of the tasks or hardened ways of going about them; the high focus on personal advancement and drives to higher material welfare; and the mobility, flexibility, adaptability of Americans and their boundless belief in progress."[50]

After the Civil War, unprecedented economic expansion gave rise to intense industrial competition.[51] By the end of the century corporate ownership had emerged as the most successful response to this competition, functioning to control as much of the market and the production process as possible. By means of consolidations, mergers, trusts, holding companies, trade associations, and government regulatory agencies, the corporations struggled to regulate production processes and stabilize prices. Within the corporation itself, maximum profitability was essential. Expensive factories had to be used at full capacity, and factory, company, and intercompany activities had to be strictly coordinated. Because the potential of each new technological de-

velopment had to be immediately realized, both modern technology and the production processes it made possible had to be rationalized. Standardization was the key to these operations: the standardization of scientific terminology and methods, the regularization of patent procedures, the efficient organization of scientific research, and the systematic production of technical manpower.[52]

The union of science and industry provided one of the most historically important factors in the growth of the modern corporation in America. The last two decades of the nineteenth century were a watershed in the changing role of science, from "the province of amateurs, 'philosophers,' tinkerers, and seekers after knowledge to its present highly organized and lavishly financed state."[53] Advances contributed by the adaptation of scientific discoveries and methods to the electrical and coal-petroleum industries showed that scientific research was a commercially valuable occupation, and the haphazard discoveries of science were swiftly used to meet the practical ends of the corporation.

The welding of science to the aims of industry properly began in Germany, where already by the 1870s, firms like Krupp at Essen were employing university-trained scientists in research laboratories that would become models for corporate research everywhere.[54] But the lessons of Germany were not lost on the emerging American corporate state. In America, Edison's establishment at Menlo Park, New Jersey, was the first organization set up (in 1876) for the specific purpose of systematic invention. It was succeeded after the turn of the century by other centers that, in a more modern fashion, brought together men from different disciplines who pooled their knowledge and directed their research to technological innovation and ultimately to profits.

As we have seen in the case of Edison's (and the Lumières') struggle to control cinematic invention,

the industrial monopoly over science first took the form of patent control—control over the *process* of scientific production by means of organized and regulated industrial research. Ultimately, industry became entirely science based, systematically applying scientific knowledge to commercial ends, developing the institutions necessary for producing both scientific knowledge and knowledgeable people, and integrating these institutions into a corporate system.[55] This new scientific revolution meant that the development of modern technology became the prerogative of industry rather than science. The spontaneous innovations, adaptations, or refinements made to his own technology by a scientist like Marey, for example, were in this new world supplanted by the planned progress of technology and product design that we are accustomed to expect from the modern industrial plant.

The union of scientific methods and commercial enterprise was personified by the engineer, a new, primarily middle-class professional who became the representative of modern technology within the corporate environment. At the beginning of the twentieth century engineering had become, after teaching, the largest profession in America. Its twentieth-century practitioners, however, were quite different from the nineteenth-century skilled craftsmen and builders, whose empirical methods were the product of intuition and practice. The founding of engineering schools and institutes of technology after 1862, and the parallel development of professional engineering societies, had created a formal discipline out of a craft and had grounded the respectability and status of this discipline in scientific education. Indeed, science gave engineers their identity and helped emphasize their separation from the shop-culture tradition of their predecessors. But if engineers belonged to science, they also belonged to industry, which had now become the only organized social medium for applying their science. Be-

cause they were employed by the corporation and thus driven by its economic imperatives, engineers had come to identify their professional status with their corporate status. In effect they were at the same time scientists, executives, and corporate employees. Their job was to rationalize production through the scientific method; their goal was to ensure maximum profits for their employers.

Standardization in industry was the key to corporate prosperity and, since the corporations were the locus of technological innovation, to scientific progress as well. With their massive investment in research and development, plants, machinery, and manpower, the large corporations could be profitable only through large-scale, continuous production. Such continuous production (and large-scale consumption) in turn necessitated uniformity throughout the system: uniformity in machining necessary for interchangeable parts, uniform standards of quality, and uniformity of the labor process.

Standardizing the technical side of industry was the prerogative of the engineering profession, from the definitions of technical terms universally used to quality and quantity specifications, testing, ratings, and safety procedures. Inevitably, engineers soon turned their attention to standardizing the work and the worker: it was only one step from engineering things to engineering people. That step occurred as engineers came to assume their rightful role in the corporation, that of managers. As the director of the Taylor Society recalled, engineers were those most prepared to meet the challenge of fashioning the structures essential for the efficient administration of newly won business empires.

The first coherent public expression of concern with management problems came from the engineers. They were the initiators of the "management movement" and it was they who continued to give it vigor. The first highly

trained minds to go into industry were products of the engineering schools. They were trained as technicians and went into industry as technicians, but many of them speedily became operating executives and focused their trained minds on managerial problems. . . . ; the management movement arose out of the impact of a group of highly trained engineering minds on an industrial situation of engineering complexity.[56]

And as they rationalized procedures in manufacturing, finance, and marketing and created the formal administrative structures for their corporate employers, it was natural that engineers would attend to the smooth running of the human element in the process as well.

The scientific management movement that began in America about 1900 and spread to Europe ten years later was the most significant manifestation of the engineering management of the work force. It shaped modern business and industry by ensuring systematic and detailed control over the processes of work. At its core was the "organized study of work, the analysis of work into its simplest elements and the systematic improvement of the worker's performance of each of these elements."[57] It began within the large corporations, where the conditions for its development were firmly in place: a centralized workplace and the breakdown of the multiple processes involved in manufacturing a product into many operations, each performed by a different worker.

Frederick Winslow Taylor (1856–1915) is usually thought of as the father of scientific management, though as with so many "fathers," Taylor's claim to paternity is based on his synthesizing and consolidating ideas already current in the United States and Great Britain.[58] The well-educated son of an upper-class Philadelphia family, Taylor was prevented from studying law by a mysterious eye ailment, and rather than languish in boredom at

home he began an apprenticeship as a patternmaker and machinist. At twenty-two Taylor was hired as a laborer at the Midvale Steel Works, owned by a banker friend of his father's (and by William Sellers, cousin of Coleman Sellers, one of the sponsors of Muybridge's work at the University of Pennsylvania). At Midvale Taylor advanced through the ranks until he was appointed gang foreman in the lathe department. His notion of management came out of his three-year conflict with the machinists under him over his insistence that they increase their daily output. Taylor broke the opposition by bringing in outside laborers, especially trained by him to work more efficiently and committed to work harder, and by introducing a system of rewards (usually pay incentives) and punishments.

While at Midvale, Taylor had acquired a night-school degree in engineering, a field at that time not yet closed to ambitious and intelligent young men who lacked formal training.[59] In 1898 he left his job as chief engineer at Midvale and set up shop as a "management consultant." In this role he reorganized the machine shops at Bethlehem Steel according to his ideas of "scientific management." From his experience at Midvale, Taylor understood that if an employer was to realize the full potential inherent in the labor power of the worker, control over the labor process had to be taken away from the worker and given to management, which must determine not only each step of the process but also the way each step was performed.

Taylor's reorganization of Bethlehem Steel allowed him to construct a rational base for his ideas. He studied how the machines functioned and analyzed the "motions" and "time" involved in the tasks the men performed. Taylor's guiding idea was that, to increase productivity, labor and materials had to be combined more efficiently, wages had to be tied to performance, and accurate records had to be kept of all procedures. He believed that by re-

search and on-site analysis, management could accumulate all the information, skills, and techniques that had traditionally belonged to the worker and the foreman, transform them into systematic laws and formulas written down on paper, determine optimum standards of performance, for which a premium wage would be paid, and then "scientifically" reapply the standards by reorganizing the way work was done. This reorganization, which included reordering the physical layout of the factory and distributing standardized tools, primarily consisted of minutely dividing the components of the work into segments, timing the most proficient worker of each segment with a stopwatch (Taylor would later begin a small industry in stopwatches made expressly for this purpose), and insisting that other workers follow suit. Those who could not either quit or were fired. Taylor succeeded in separating responsibility for the execution of work from its planning or conception with these methods; he effectively abolished training and education costs, because once the worker learned to use one machine or one tool the training was over. Taylor thus also erased the difference between skilled and unskilled labor: since both were now doing the same repetitive tasks, their work could no longer be distinguished. And he made speed the sole measure of successful work.

A high-speed steel process that Taylor had devised at Bethlehem revolutionized machine production in the United States and brought him and his methods worldwide recognition.[60] Between 1901, when he left Bethlehem Steel, and 1909, when he won government contracts to reorganize the federal arsenals, this recognition continued to grow. He had gathered around him a few like-minded men who introduced his system of shop management into other industries, and in 1905 he was elected president of the American Society of Mechanical Engineers, which ensured him an international

forum for his ideas. In 1911 the highly publicized Eastern Rate Case, where the claims of scientific management (the first time the name was given its official title) were used to undermine the railroads' case for rate increases, transformed Taylorism "overnight from an obscure obsession of certain middle class engineers to an amazing and highly publicized nostrum for all the ills of society."[61]

But the scientific aspect of Taylor's scientific management was soon called into question. Taylor relied on psychologically crude pay-incentive schemes or on simple coercion to spur workers to greater productivity. He refused to deal with the unions and had no idea of the subtleties of psychology or sociology and their possible use as management tools.[62] His conception of the worker as a simple "economic man," and his belief that efficiency could be improved by standardizing each element of the job inevitably brought him difficulties with both labor and management. In 1911 these conflicts culminated in a strike over the installation of his system at the Watertown Arsenal. Even the government was unable to sustain wholesale support of his methods. Taylor's contempt for the workers was thinly disguised, and his desire to make workers mute extensions of their machines, forcing from their labor every ounce of potential profit without any consideration of their well-being, could not be tolerated. A government investigation after the Watertown strike showed that his scientific management was not so scientific after all. His stopwatch time studies were open to widespread abuse; they were carried out by people who often knew nothing about the work they were timing, and under conditions that affected the outcome of their observations.

In France, where Taylor's ideas gained currency after 1910, opposition came not only from the workers in the industries where his methods had been applied, but also from those work scientists who saw his system as totally opposed in method and conception to their own work.[63] The spread of Taylorism in France, which came on the heels of its American success, was in large part due to proseletyzing by the engineer Henry Le Châtelier.[64] Le Châtelier, an eminent metallurgist and a professor at the Collège de France, was an early advocate of the collaboration of engineers and industrialists. He had translated Taylor's *The Art of Cutting Metals* in 1907 and *The Principles of Scientific Management* in 1913 and had used *La Revue de Métallurgie*, a journal he founded in 1904, to diffuse Taylor's methods. Le Châtelier's laudatory article "Le Système Taylor," published in *La Technique Moderne* in June 1913, as a series of devastating strikes against the introduction of time-motion study exploded across France—at Renault in Paris, Arbel in Ivry, Berliet in Lyons, and elsewhere— finally provoked the ergonomists to define their positions in regard to Taylorism.

Jules Amar's position was the most conciliatory. He had met Taylor in 1911 through Le Châtelier and was drawn both by Taylor's messianic personality and by Le Châtelier's influential position—Le Châtelier had sat on the commission that created the work-study research laboratory Amar was appointed to at the Conservatoire National des Arts et Métiers in 1913 and had had written the introduction to Amar's *Le moteur humain* in 1914. Amar felt that Taylor's system complemented the science of work. Although "the American doctrine does not take the physiological data into account, nor does it define the normal output of the human motor,"[65] wrote Amar, "Taylor's system, supplemented by due consideration to physiological conditions, and applied patiently, wisely and tactfully, gives a scientific solution of the social problems of industry, the relations between capital and labour. Its principles must be accepted, and its practice applied."[66]

In contrast, Jean-Marie Lahy's position was the

most critical. He attacked Taylor's conception of labor for being "spoilt by a threefold error: psychological, sociological and industrial." [67] He decried Taylor's ignorance of basic physiology, the unscientific way his system was conceived and implemented, and the lack of originality in Taylor's methods. "The idea of measuring a worker's movements in order to fix the value of his work is not Taylor's innovation," [68] wrote Lahy:

Studying the value of a gesture from the point of view of its duration, direction, and adaptation to an end is the physiologist's means of perfecting the muscular activity of man. More than thirty years ago, Marey created the method that permits such a study, and he brought it to a degree of perfection that has not been surpassed since. . . . If no one has realized the practical consequences inherent in this work, and if the path that it opened has not been followed by Marey's collaborators, it is because on the one hand they did not make the superproduction of the worker their single end, and on the other hand the encouragement and the indispensable material funds were not there. [69]

Taylor's ignorance of the work of Marey and his followers astonished Lahy, especially since Taylor's movement study was far "from being as precise as Marey's own." [70] Taylor's system of timing the fastest worker, or the one with the most brute force, then forcing all the others to do their work at the same rate Lahy dismissed as "an empirical method without great value. It is applicable only to a few specific tasks, such as moving loads; it ignores physiological, psychological, and social factors and is dependent for its success on eliminating all poor workers, isolating the others from one another, and forbidding them moments for talk: its results are more the product of selection and surveillance than chronometric study." [71] Marey (and Imbert), Lahy insisted, wanted to know the most effective gestures and use them to the exclusion of others in a manner

that would precisely adapt a professional activity to its practical ends. Taylor, on the other hand, used time and motion study to perfect just one element of professional work—speed. [72]

For the fatigue expert Josepha Ioteyko, the true scientific merit of Taylor's system was still to be determined. Ioteyko decried the absence of scientific information concerning the fatigue of the workers; she faulted Taylor's theory of pay incentives, which "makes it probable that, to a certain extent, overwork is almost sure to prevail." [73] And she condemned Taylorism on moral grounds: "This freedom of the individual to overwork is opposed to eugenics and to all those sciences which have for their aim the betterment of the race. . . . The reward to those who work the best is not a proceeding to be advocated from the moral point of view, for those who are trained on such a principle make it the mainspring of their actions under other conditions." [74] But though Taylor's system "exhibits numerous faults and gaps," and though the solutions it presents are "only empirical," [75] Ioteyko was not willing to dismiss it totally: "Scientific Management of labour is an inevitable necessity . . . it remains to be proved whether Taylor's system . . . is that which was impatiently awaited by all those who wished to see science penetrate into the region of industrial labour, in order that it might be reorganized for the greater benefit of society." [76]

As we know, the criticisms leveled at Taylorism in America and France did not cause the demise of the scientific management movement: its rewards were too obvious to abandon. But Taylor's followers and his colleagues—among them Henry L. Gantt, Carl Barth, Horace K. Hathaway, and Frank and Lillian Gilbreth—did moderate the worst of his excesses. They expanded the base of labor management to include the social sciences; they insisted on obtaining the cooperation of the work force; and they emphasized the importance of contented work-

ers. To them is owed the worldwide expansion of Taylorism.

Frank Bunker Gilbreth (1868–1924) and the psychologist Lillian Moller (1878–1972), whom he married in 1904, were the most important figures in this revisionist movement, and their approach provided the greatest challenge to Taylor's leadership. Like Taylor, Gilbreth had abandoned his education (in this case engineering at MIT) to work in the construction business, and Gilbreth's ideas similarly grew out of his own observations. His earliest experience was in the ancient art of bricklaying, where, after watching and analyzing the common methods of the trade, he was able to suggest improvements (bringing the bricks closer to the worker, changing the shape of the trowel, and eliminating most stooping and reaching movements) that more than doubled the normal output. His changes were aimed primarily at reducing unnecessary motion; he saw that by streamlining movement he could minimize the fatigue workers ordinarily were prone to and so increase the amount of work they could do each day. As an apprentice, Gilbreth had joined the bricklayers' union; this contact gave him a more sympathetic view of the individual worker than Taylor's. He was convinced that the workers' mental and physical disposition were important in determining output and that workers' cooperation and happiness were necessary to the implementation of any managerial plan. These considerations were reinforced by—and many writers believe originated with—his wife, Lillian. It was through her "that the tools of industrial psychology became the tools of Scientific Management."[77]

From his experience in bricklaying Gilbreth concluded that the sequence and manner in which each movement of the work was done modified the time it took, so his system of management focused on standardizing the movement, not the time. His aim was to find the "one best way" to get work done, and his method, though he never acknowledged it, was Marey's chronophotographic method of temporal decomposition in space. Gilbreth's engineering of the "human element," as he put it, was geared to understanding both the internal and external causes of worker motivation. He approached motion study from what he considered the most scientific point of view by "dividing work into the most fundamental elements possible; studying these elements separately and in relation to one another; and from these studied elements, when timed, building methods of least waste."[78] He began by reducing and describing in writing the motions currently in use and the variables involved in each—there were forty-two of these, and they included everything from the anatomy, contentment, and creed of the workers to their equipment and tools, the color of the plant, the rules of the union, and the components of each movement. Next, "best" practice was similarly reduced and described with its variables. Gilbreth never precisely defined what this "best" consisted of, but it is clear that he intended a model where the movements were radically limited, reduced to what he considered a necessary minimum to do the work quickly, with the least fatigue for the worker, which as a result increased output and reduced costs. His overriding goal, restated many times throughout his writing, was to standardize all the elements involved, both "material" and "human": "Once the variables of motions are determined, and the laws of underlying motions and their efficiency deduced, conformity to these laws will result in standard motions, standard tools, standard conditions and standard methods of performing the operations of the trades."[79] When the motions of every individual, no matter what the work might be, had been studied and standardized, Gilbreth was convinced, prodigious savings in hu-

man energy, in time, and in money would be produced, and inefficiency and human waste would be eliminated forever.[80] Indeed, the promises held out by motion study touched on national destiny: "Motion study is a problem of the most vital importance to the world. Some day an intelligent nation will awake to the fact that by scientifically studying the motions in its trades it will obtain the industrial supremacy of the world. We hope that that nation will be the United States."[81]

Although his first analyses of the movements used by workers in the bricklaying and concrete trades were done by writing and his results were transmitted by instruction cards given to each worker, Gilbreth was soon using a camera for both analysis and instruction. In his early days on the construction site, he had used photography as a method of record keeping "where progress pictures taken at frequent intervals present accurate records of the surroundings, equipment and tools that affect records of output of various stages of development."[82] Then, as he moved to more intense study of particular trades, he added the motion picture camera to his work, finding it "advantageous to photograph the various positions in which the hands, arms, feet, and other parts of the body involved in the operations were placed, and to record the time taken in moving from one position to another by one method, as related to the time taken in moving from the same first to the same second position by another method."[83]

Sometime between 1911 (when he noted in his book *Motion Study* that the "stereoscopic camera and stereoscope, the motion picture machines, and the stereopticon enable us to observe, record, and teach as one never could in the past")[84] and 1913, when he finished organizing the work at the New England Butt Company, Gilbreth had come to depend on photography as the key to his study of motion. His "micro-motion method," begun at New England Butt, consisted of "recording motions by means of a motion picture camera, a clock that will record different times of day in each picture of a motion picture film, a cross-sectioned background, and other devices for assisting in measuring the relative efficiency and wastefulness of motions."[85] Much like the ancient Greek sculptors, who used more than one model, Gilbreth filmed many workers to arrive at an ideal movement he hoped they could then imitate.

The micro-motion record, however, did not give "the continuous path of a cycle of motions,"[86] and it was hard to use as an instruction device because workers had trouble visualizing and then imitating the movements they saw in the films. He addressed this problem at his next job (for the Hermann, Aukam Company, handkerchief manufacturers), first with his "cyclegraph method" and then with his "chronocyclegraph method." The former, named because the cycle was the unit of measurement to be recorded, consisted of putting the worker in a blacked-out room and tracking with a still camera a light bulb attached to the hand. The chronocyclegraph method incorporated the temporal element; again Gilbreth fastened tiny electric light bulbs to the operator's fingers, or "to any part of the operator or of the material whose motion path it is desired to study. . . . If the direction, relative time, and relative speed are to be noted, the path of light, through controlled interruption of the circuit, is made to consist of dots or dashes, or a combination of the two, with single pointed ends, —the points showing the direction" (fig. 180).[87] Gilbreth and his wife carried out the studies in a laboratory he had created for the experiments, which included a luminous background grid to aid measurement and a "penetrating screen." Gilbreth used an ingenious method of double ex-

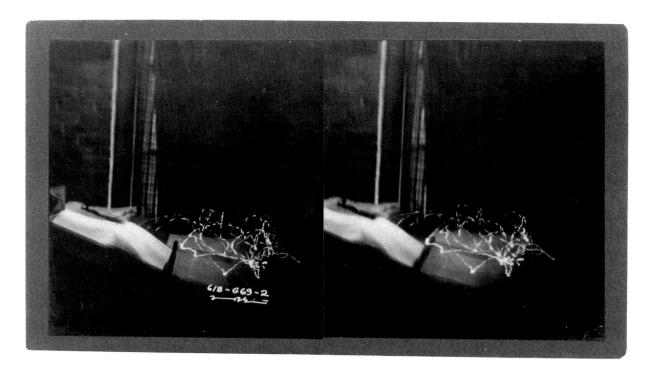

180.
Frank Gilbreth, girl folding
handkerchiefs, stereoscopic
chronocyclegraphs made for the
Herrmann, Aukam Company,
1913–14. Beaune.

posure: He first placed his cross-sectioned screen where needed (in the plane in which the worker was to perform, in front or in back), photographed it, and then removed it and made a photograph of the work being done on the same negative.

In 1915 Gilbreth published "Motion Models: Their Use in the Transference of Experience and the Presentation of Comparative Results in Educational Methods," where he described three-dimensional wire models he had fashioned from both cycle-graphs and chronocyclegraphs. (The spots made by the light bulbs in the chronocyclegraphs were repre-sented on the white wire models by black and gray spots.) These wire models—exactly the same as those Marey devised to show the movement of the coccyx in three dimensions—were also, like Marey's, based on stereo photographs; but Gilbreth's were intended exclusively as standards

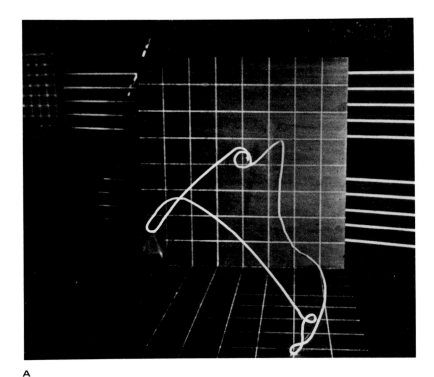

A

181.
(A) Frank Gilbreth, untitled motion model, n.d. Reprinted with permission of Special Collections, Purdue University Library, West Lafayette, Indiana 47907. Photograph courtesy Mike Mandel. (B) Marey, slow walk, stereoscopic photographs of a point on the coccyx of a moving subject, 1885. Cinémathèque Française.

the individual would be taught to attain. Workers learning the movement (or unlearning an incorrect one) would attempt to emulate the motion model; their motion would be chronocyclegraphed, a second model made, and the two compared (fig. 181).

Gilbreth applied for a patent on the chronocyclograph method in spring 1913. The patent was granted in fall 1916, although his method of attaching light bulbs to the subject and using a still camera to track their movement was an exact emulation of the system Marey had devised, and Demeny had elaborated, to study pathological movement in 1887. Marey had not taken out any patent in France or America for his system. Gilbreth also applied for a patent that included a stereo camera in its specifications for photographing movement; this too had been anticipated by Marey.

There is no doubt that Gilbreth knew about

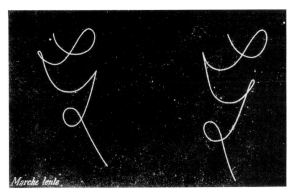

B

Marey's earlier achievements in tracking movement. He reanalyzed many of Marey's subjects, such as soldiers and fencers (fig. 182), and his thoughts on the way motion study should be approached are often a direct echo of Marey's. For example, in his belief that increased accuracy is the foundation of such work, Gilbreth calls for a government bureau of standards, for universal forms of measurement, and for precision instruments that "will record mechanically, with the least possible interference from the human element, in permanent form, exactly what motions and results occur. For permanent use the records must be so definite, distinct and simple that they may be easily and immediately used, and lose none of their value of helpfulness when old, forgotten or not personally experienced by their user."[88]

On his many trips to Great Britain, France, and Germany between 1910 and 1914, it would have been difficult for him to avoid contact with practioners in his field who knew Marey's work.[89] He had been to the Institut Marey—a picture of Gilbreth and Lucien Bull standing together outside the institute is in Gilbreth's papers at Purdue—and he had "visited [Marey's] successors' [*sic*] work," and had become "fast friends" (fig. 183). A Christmas card sending best wishes from the Gilbreths in chronocyclegraphic writing is among Marey's papers now in Beaune, as are the stereoscopic chronocyclegraphs of women folding handkerchiefs done in 1912–13, sent no doubt to the successor of the man who had inspired him (fig. 184). In 1914 Gilbreth had met Le Châtelier in Paris, and Le Châtelier introduced him to Amar.[90] On his return to America that fall, Gilbreth described Marey's work in a management seminar he held, and his portrait is full of Marey's accomplishments.[91] Finally, Gilbreth undertook a study that had nothing to do with his own work and everything to do with Marey's. Among Gilbreth's papers is a rough sketch

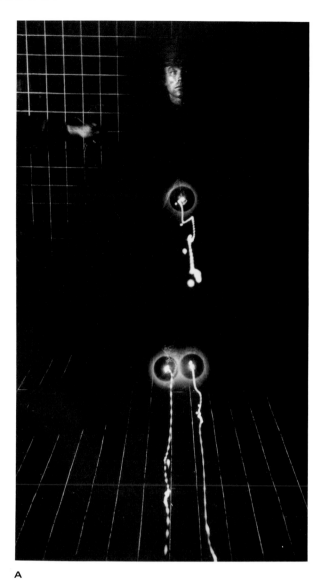

A

182.
(A) Frank Gilbreth, movement of soldier in regulation uniform, carrying a pack and wearing ill-fitting shoes, causing a limp, ca. 1916 (description and photograph courtesy Mike Mandel). Special Collections, Purdue University Library, West Lafayette, Indiana 47907. (B) Marey, pathological locomotion, 1886–87. Collège de France.

B

345

183.
Frank Gilbreth, on the right, and
Lucien Bull at the Institut Marey, ca.
1914. Reprinted with permission of
Special Collections, Purdue University
Library, West Lafayette, Indiana
47907. Photograph courtesy Mike
Mandel.

184.
"Lillian Moller Gilbreth / / and / Frank
B Gilbreth / send greetings to / You,"
n.d. Stereoscopic chronocylegraph
greeting card. Probably sent by the
Gilbreths to Lucien Bull at the Institut
Marey. Beaune.

of an apparatus for determining the direction of the wing motion in insects, which he made before 1912. It shows a revolving-disk shutter and a quartz lamp behind it that illuminates an insect. The insect is attached to a miniature car moving along a track; in the handwritten description below, Gilbreth notes that the insect has a piece of silver foil on the tip of its wing.

Unfortunately, Gilbreth's desire to be considered original in everything he did has created some confusion over just when he became familiar with Marey's work. Where Marey habitually cited those on whose work he based his own, Gilbreth seems to have had difficulty acknowledging any antecedent work.[92] Indeed, Marey was, Gilbreth declared in an unpublished typescript of a management seminar, "the man I wish had never been born."[93] In his published work Gilbreth mentions Marey only once, to note that "as for motion study, Marey, with no thought of motion study in our present use of the term in his mind, developed, as one line of his multitudinous activities, a method of recording paths of motions, but never succeeded in his effort to record directions of motions photographically."[94]

As far as Gilbreth was concerned, when he approached the subject, there was "absolute pioneer work to be done in inventing devices that would record times, paths, and directions of motions simultaneously."[95] Because Gilbreth took out a patent on every device he used for motion study, and because he stood to gain financially as much from his patents as from his consulting jobs, it was not in his interest to admit that any parts of his system had been anticipated. Thus, as with the "inventors" of cinema, his mention of Marey's work is disparaging; the best he would say of Marey's work was that his work was impractical. And here is how Gilbreth sums up that work: "[Marey] was just an every day, wise man. He liked to do things that other people could not do, whether they were prac-

tical or not. He had so many babies to take care of that he did not have enough time to do anything but get them started. He did not finish anything that he did."[96]

Thus, though there is indisputable evidence that Gilbreth was aware of Marey's work and techniques, we will likely never know exactly how much he knew or when he came across it. What is interesting however, is the way Marey's techniques show up, yet again, in the hands of someone who used them for purposes unforeseen by Marey. On the surface Gilbreth's work seems closer in subject and form to Marey's than any other we have seen. And yet Gilbreth's agenda was deeply, radically different. Gilbreth's motion studies signify a conclusion, albeit unforeseen by Marey, to the latter's study of movement. In Gilbreth's work, Marey's desire to account for the laws that govern movement and force, and his belief that their discovery would ameliorate the fate of humanity, was transformed into a desire for control and uniformity. Although both Gilbreth and Marey were guided by the scientific discourse of their times, the content and context of that discourse governed a radically different outcome in each study. What for Marey constituted a linked series of disinterested discoveries aimed at revealing natural laws became for Gilbreth a method of appropriating the potential energy of a dormant labor force and making it serve the pecuniary ends of the corporation. The object of the fatigue studies that captured Marey's mind was completely transformed. Marey saw human energy as a dormant wellspring made available by the scientific study of the laws governing human motion and used for the betterment of physical and psychological health. Under Gilbreth such energy was perceived as unrealized labor potential: it was management's duty to eliminate waste and fatigue from the job so workers could be free to enjoy more "happiness minutes." Whereas Marey studied fatigue to increase the

endurance of the individual, Gilbreth aimed at determining the standards for maximizing labor efficiency for the benefit of the company. Implicit, therefore, in Gilbreth's "science" was the removal of such potential from the individual's own control. For Marey, science would unleash the energy of the animate machine. For scientific management, workers were part of a larger mechanism. Their potential was for the accumulation of capital; it could be made available only by fixed hours, systematic control, and the reorganization of labor.

Marey did not foresee the extent to which his methods would be instrumental in the drive for the uniformity and standardization of work and the worker. Nor could he have anticipated that his in-

vestigation of human movement would one day be applied to the creation of machines that would replace the humans he had studied. Factories today are no longer temples to the efficiency of human labor. Robots carry out the monotonous, repetitive gestures once performed by men and women. Now efficiency experts and ergonomists concentrate on mental, not physical, fatigue. The love affair with the machine that began with the joyful discovery that the functions of both animate and inanimate nature could be explained by the laws of theoretical mechanics has resulted in creating machines to free the body, but it has left us with the problem of enslaved and robotic minds.

Conclusion: Inventing the Inventor

It is no exaggeration to say that Marey is a crucial figure in more areas than one man can usually lay claim to. His graphic method made him one of the most original scientists of the nineteenth century; the applicability of the method is a milestone in medical diagnostic techniques. His single-lens, slotted-disk shutter camera is the technical base of cinema, and the images he made with his chronophotographic camera were integrated wholesale into the paintings of artists who sought a visual expression for the sensation of time and motion with which they would define modernity. His studies of energy and fatigue became the foundation of a science of work and ultimately a method to increase productivity by improving workers' efficiency. By showing that the changes in the form of the wing modify its resistance to air, he provided one of the most important mechanical requirements for the development of manned flight.

Why, then, have his life and work remained relatively obscure? One important reason, it seems to me, is that Marey had one core interest—movement—and never strayed from it. Nor did his methods ever change. He always approached the study of movement from a mechanical point of view, and he always sought to explain its attributes by proven physical laws. His desire to translate the movements of humans and animals into a visible language that could be deciphered and interpreted by the trained reader governed the course of his whole career. As a doctor, he foresaw the applicability of his graphic method to the diagnosis of illness and thus the betterment of humanity. As a positivist, he saw the hunt for and capture of the body's most imperceptible motions as a contribution to the increasing precision of the relatively new

scientific field he had chosen to work in. The instruments he invented or refined, including his cameras, were the key to his study. Marey was an indefatigable *bricoleur* who, by means of what can only be called a form of *bricolage* close to genius—slightly changing a piece here or adding a piece there, modifying the instrument to suit the subject or the subject to suit the instrument—could devise ever more advanced practical solutions to problems raised by his own investigations. With his tinkering, photography became the servant of analytical science.

The products of Marey's interest, had he pursued any one of them, were such that they would have made him as well known as the Lumières, Gilbreth, Edison, or the Wright brothers, all of whom are known as the fathers of one thing or another, and all of whom owe something to Marey. But Marey chose not to follow the more utilitarian applications of his study. And from the sparse documentation that survives, it is worth noting how little Marey seems to have cared. He was a scientist with an almost inhuman lack of interest in the fact that the work was his, concerned only with furthering the work itself. Even his patents were taken out not to make a fortune but to ensure himself enough money to continue working. His ego was so unobtrusive as to be invisible. He never seemed interested in pointing to his work in pride; he wanted only to raise money for the next instrument or the next stage of investigation.

Indeed, his lack of interest in commercial applications has led to common misperceptions about him. Frank Gilbreth's view that he "had so many babies to take care of that he did not have enough time to do anything but get them started" is worth

dwelling on, because it is not only a typical way of viewing Marey, but also typical of those who adopted the scientist's work in one way or another and yet somehow were blind to the true nature of either the work or its originator. For Gilbreth (and for Edison or Duchamp or the Wright brothers) Marey was the source of methods, instruments, images, or ideas to be used freely and modified freely to suit his own needs. Gilbreth did not see that there was a single guiding idea governing so many different "babies"—that each instrument Marey devised was developed into a better one, capable of even more precision or refinement as needed for the next part of his investigation, and that each study he undertook was part of a larger project, nothing less than bringing into being a new reality.

Toward the end of my work, I was struck again and again by the similarities between Marey and that other great inventor, Leonardo da Vinci. Leonardo's work was never taken up by those around him; the helicopters and tanks he imagined, for example, had to wait until this century to become a reality. In fact, so many of his inventions remained unknown until long after his death that we are able to go back and isolate very clearly his astonishing vision. Because they remained almost intact, his investigations allow us to identify the man's genius. The opposite is true of Marey. Whereas Leonardo's five thousand pages of notes and sketches lay unread for 250 years and his inventions (really applications of his scientific insights) continue to astound us today for their prescience and foresight, making our idea of the man ever more vivid, Marey's discoveries became so much a part of a general knowledge that we have largely forgotten who discovered them.

Marey lived in an age that was extraordinarily rapacious both for new ideas and for practical applications of them. He was a scientist at a time when science was enormously popular, and its power, responsible for recently discovered ways of harnessing and transforming energy, was believed to lead to the progress of society. But science also served the increasingly mechanized industrial world of the nineteenth century, and inventions were quickly swallowed up by a buoyant and expansive commerce. Marey's methods were totally absorbed and used immediately; because so many people fought to claim authorship of the applications of his work, the size of his achievement has never been obvious.

The subject of Marey's interest seems relatively unimportant to us now. We forget there was once a time when we did not know how we walk or run or how a horse gallops or a bird flies. Today, because of high-speed film and modern computers, the mechanics of locomotion on land, on sea, and in the air no longer hold the secrets they did when Marey set out to describe them. But to ignore Marey because we are no longer interested in his subject is to belittle his work and lose sight of its significance. Before him there was no consistent or reliable way of mapping the changes and fluctuations that occur within and outside the body. Today we take for granted the machines used to write out critical body functions like the beating of the heart or the electrical impulses of the brain, but one must imagine a time when diagnosis had to be made with such actions totally inaccessible to touch and sight. Despite, or rather because of, the narrowness of his focus, this is the world Marey utterly changed.

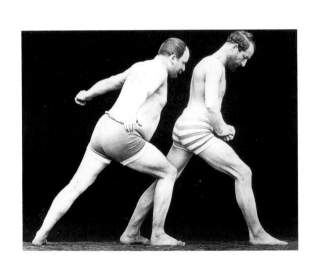

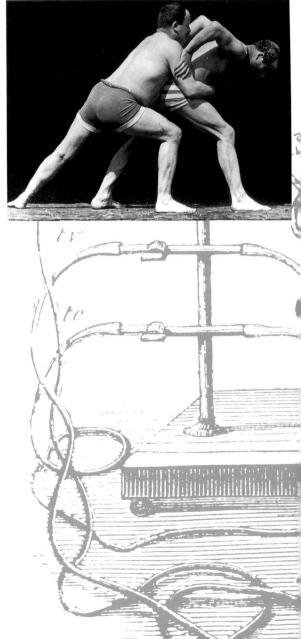

Appendix

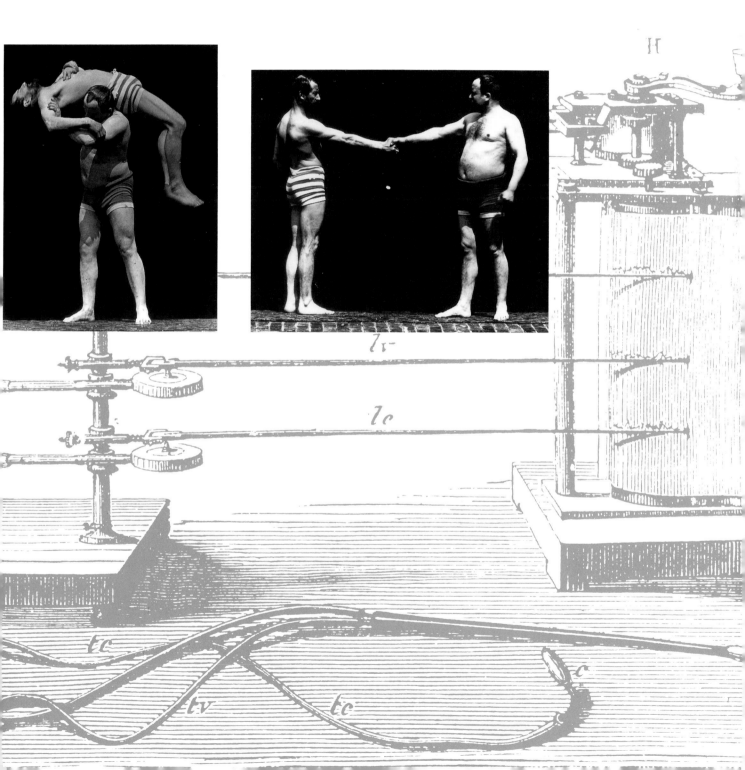

This appendix consists of two catalogs that bring together the 1,355 negatives on glass and flexible film plates discovered in 1979 with the 630 belonging to the Musée Marey, the Cinémathèque Française, and the film archives of the Centre National de la Cinématographie. A third catalog lists Marey's films.

Catalog 1: Photographic Negatives and Prints

This catalog lists a series of 13 × 18 cm glass-plate negatives and corresponding prints made by Marey and Demeny between 1882 and 1889. Unlike the rest of the negatives discovered in 1979, these were numbered, and when brought together they constituted a loosely chronological compendium of the methods used and investigations carried out at the Physiological Station during that period. They include enlargements of what Marey thought were the most salient images from his original chronophotographic experiments listed in catalog 2, the drawings and diagrams made from those experiments, and diverse instantaneous photographs.

Also, unlike the rest of the negatives, this series had been printed. The prints, including many duplicates, were bound into ten albums intended as an official record of the work at the Station. Seven of these albums were kept at the Station, and three were sent to the municipal council of Paris to justify its annual subsidy. The last album was produced in 1889. That year the council reduced Marey's budget but then, on appeal, gave him a subsidy in perpetuity; he was thus no longer required to submit his results. Primarily for this reason, he stopped compiling the albums, and he never made prints in such quantity again. In 1973–74 the seven albums belonging to the Station and a number of loose prints that had originally been in them were cataloged by Bernard Marbot, curator in charge of early photography in the Department of Prints and Photography at the Bibliothèque Nationale. They were subsequently divided between the Musée Marey, the Bibliothèque Nationale, and the Collège de France. The other three albums remained in the possession of the library of the municipal council and were virtually unknown: I was led to them by the suggestion of Sylvain Pelly, curator of the Société Française de Photographie.

Apart from the photographs in these albums, the pictures used to illustrate his articles and books, some two hundred diapositives for his lectures, and some fifty enlargements that were framed and hung in the main chalet of the Station, Marey made almost no other prints. His scientific data are contained in his negatives; they were the foundation of his measurements, drawings, and diagrams. The series below is thus extremely important; it directs our understanding of the evolution of his work, it shows Marey's choice of the most important features of his investigations at the Physiological Station, and it contains the only records that remain of certain apparatus, instruments, experiments, and constructions that he created there.

The albums grouped the negatives into periods; more precise dating was based on Marey's writings, notations on the negatives themselves, and dates found for those original chronophotographic experiments listed in catalog 2 to which the enlarged negatives correspond. Apart from the exceptions noted in the location entry, the negatives are now in the archives of the Collège de France; unless otherwise described, they are single instantaneous images.

Key to Entries

Negative number (in boldface); description and date, with publication data in parentheses (figure numbers refer to this book); album and plate numbers of prints; location of negatives and additional prints

Abbreviations

CIn	Cinémathèque Française
Mn	Musée Marey, Beaune
P	No negative has been found: the negative number is written on or under the print
Bpr	Print in the Bibliothèque Nationale
Mpr	Print in the Musée Marey, Beaune
Tpr	Print in the Musée National des Techniques
Unknown	No negative or print has been found

Album Designations

A *Méthodes et techniques, 1882–1886.* 44 plates remain of 68 originals. Marbot number 158, Musée Marey, Beaune.

B *Station Physiologique, Méthodes installations et instruments, 1882–1886: Etudes des phéno-*

mènes mécaniques chez les êtres animés. Méthodes de recherche inaugurées à la Station Physiologique fondée en 1882 et rattachée au Collège de France (Laboratoire de M. Marey). 63 plates remain of 73 originals. Marbot number 162, Musée Marey, Beaune.

C *Ville de Paris: Station Physiologique, 1882– 1886.* 59 plates. Bibliothèque du Conseil de Paris, Hôtel de Ville, Paris.

D *Station Physiologique: Locomotion humaine, 1886.* 42 plates remain of 75 originals. Marbot number 159, Musée Marey, Beaune.

E *Station Physiologique: Méthodes et appareils, 1886.* 79 plates remain of 81 originals. Marbot number 163, Collège de France, Paris.

F *Station Physiologique: Méthodes et appareils, 1886.* 67 plates remain of 72 originals. Marbot number 164, Bibliothèque Nationale, Paris.

G *Ville de Paris: Station Physiologique, 1887.* 63 plates. Bibliothèque du Conseil de Paris, Hôtel de Ville, Paris.

H *Station Physiologique: Mélanges, 1887–1889.* 55 plates. Marbot number 161, Musée Marey, Beaune.

I *Ville de Paris: Station Physiologique, 1888.* 36 plates remain of 38 originals. Bibliothèque du Conseil de Paris, Hôtel de Ville, Paris.

J *Anatomie comparée.* 61 plates. Marbot number 160, Musée Marey, Beaune.

1 Chronophotographic apparatus and instruments. *Fusil photographique* for taking twelve images a second of any object in movement; front view, 1882: A6, B4, E2, F4: Mn Mpr

2 Chronophotographic apparatus and instruments. *Fusil photographique*, rear view, 1882: C2, E3: Mn

3 Chronophotographic apparatus and instruments. Plate holder for the *fusil photographique*, 1882: A7, B5, C3, E4, F5: Mn

4 Animal location. Bird: twelve images of the flight of a gull taken with the *fusil photographique* at an exposure time of 1/720 second, 1882 (*La Nature*, 22 April 1882, 329): A8, B6, C4, E5, F6: Mn[1]

5 Chronophotographic apparatus and instruments. Chronophotographic fixed-plate camera, with five window disk shutter making ten revolutions per second; rear view showing disk shutter, 1882 (*C.R. Association Française pour l'Avancement des Sciences*, 1886, 60): A10, B7, C5, E12, F8: P, Tpr 9820.0001.002

6 Chronophotographic apparatus and instruments. Chronophotographic camera above, front lateral view, 1882: A9, E13, F7: Mn, Tpr 9820.0001.001

7 Human location. Subject dressed in white standing in front of the second black hangar, 1883 (*La Nature*, 29 September 1883, 276). **Fig. 40:** A11, B8, C7, D11, E15: P

8 Human skeleton: J1, 2, 3, 4

9 Human locomotion. Run: gymnastic steps. Enlargement of a chronophotograph, 1883 (*La Nature*, 29 September 1883, 277): C9, D10, E17: Mpr

10 Human locomotion. Walk: complete successive images, subject from Joinville Academy. Enlargement of a chronophotograph, 1883 (*La Nature*, 29 September 1883, 277): C8, D2, E16: Mn

11 Unknown.

12 Human locomotion. Walk: parade steps, subject Viala, Joinville. Enlargement of chronophotograph IIH3.2, 1883: C10, D3: P

13 Human locomotion. Fast run, five images per second, subject Viala, Joinville. Enlargement of a chronophotograph, 1883: C11, D13, E18: Mpr

14 Human locomotion. High jump, subject Viala, Joinville. Enlargement of a chronophotograph, 1883: C13, D19, E28

15 Human locomotion. Run: kinematic analysis, sixty images per second. Enlargement of a geometric chronophotograph, 1883 (*CRAS* 96 [1883]: 823): A24, E27, F16: CIn, Tpr 9820.0002.015

16 Human locomotion. Walk: kinematic analysis, fifty images per second. Enlargement of geometric chronophotograph IIH2.3, 1883. **Fig. 46(A):** A25, C17, E26, F15

17 Human locomotion. Slow walk and slow run, two stereoscopic trajectories of a point on the coccyx, 1885

1. A 27 cm diameter print of this negative for use in a praxinoscope is in the Musée National des Techniques, no. 98205/2.

(*CRAS* 100 [1885]: 362, 1361) **Figs. 59, 181(B)**: A26, C15, D39, E23, F23, H26

18 Human locomotion. Walk: analysis of the oscillation of the lower leg in the walk; Diagram from a geometric chronophotograph IIH7.6, 1884. (For run see negative 192): C19, D7, E32, F17: Mpr

19 Human locomotion. Walk: kinematic analysis of the movement of the first step of the walk. Diagram from a geometric chronophotograph, 1884: C20, D14, E33: Tpr 9820.0002.017

20 Human locomotion. Fast run: kinematic analysis of the leg. Diagram from a geometric chronophotograph, 1884: A25, E37, G16: Tpr 9820.0002.011

21 Human locomotion. Jump: high jump preceded by a run. Diagram from a geometric chronophotograph, 1884: A27, B17, C22, D20, E29, F18

22 Human locomotion. Jump: determination of the trajectory of the center of gravity in a high jump with feet together. Diagram from a geometric chronophotograph, 1884 (*CRAS* 101 [1885]: 490):[2] C21, D28, E31, F21: Mpr, Tpr 9820.0002.016

23 Human locomotion. Jump: long jump preceded by run, lower leg. Diagram from geometric chronophotograph IIH8.2, 1884: C23, D22, E37: Tpr 9820.0002.021

24 Human locomotion. Jump: from stool onto heels, stiffened muscles. Diagram from geometric chronophotograph IIH8.16, 1884 (*C.R. Association Française pour l'Avancement des Sciences,* 1886, 67). **Fig. 57(C)**: B18, C24, D26, E35

25 Human locomotion. Jump: momentary suspension of the body by the abrupt flexion of the legs. Diagram from geometric chronophotograph IIH8.22, 1884: C26, D29, E34, F19

26 Human locomotion. Jump: high jump preceded by run, analysis of the leg, subject Pradelle, Joinville. Diagram from a geometric chronophotograph, 1884: C27, D23, E38: Tpr 9820.0002.019

27 Human locomotion. Jump: jump from a height, knees bent. Diagram from geometric chronophotograph IIH8.17, 1884 (*C.R. Association Française pour l'Avancement des Sciences,* 1886, 66). **Fig. 57(E)**: C25, D25, E36: Tpr 9820.0002.020

28 Dynamography. Dynamometric platform and registering cylinder for receiving traces of the pressure of the foot in function of time, 1883. **Fig. 56(B)**: A38, B26, C40, E42, F34: Tpr 9820.0001.009

29 Dynamography. Dynamometric platform: interior, 1883: A39, B25, C39, E41, F33: Tpr 9820.0001.010

30 Dynamography. Dynamometer: experimental apparatus for simultaneous inscription of the vertical displacement of the body and the corresponding variation in the pressure of the feet on the ground in vertical jumps. Drawing signed by Demeny, 1883–84: A40, B28, E43, F37: Tpr 9820.0001.008

31 Dynamography. Dynamometer: apparatus above in use. Drawing, 1883–84. **Fig. 56(A)**: A41, C41, E44, F36

32 Dynamography. Jump: successive jumps with complete extension of the legs and without the aid of the arms. Enlarged dynamometric tracing, 1884: C42, D63, E47: Mpr, Tpr 9820.0001.026

33 Dynamography. Jump: complete jump with preparation (balancing of arms and flexion of lower extremities). Enlarged dynamometric tracing, 1884: C43, D55, E46

34 Dynamography. Jump: movement of head during jump with feet together. Enlarged dynamometric tracing, 1884: A43, C44, D56, E45, F38

35 Dynamography. Jump: two simple jumps from a crouching position showing two forms of impulsion: incomplete extension of legs and complete extension of legs. Enlarged dynamometric tracings, 1884: B29, C45, D53, E48: Tpr 9820.0002.018

36 Dynamography. Jump: vertical jump in place; movement of the body owing to the displacement of the center of gravity by the flexion of the limbs during their suspension in the air during a jump. Enlarged dynamometric tracing, 1885: B30, C49, D60, F39

37 Dynamography. Jump: different forms of the curve of the pressure of the feet on the ground in characteristic marches. Three graphs, 1885: A42, C46, E49, F35

38 Dynamography. Inscribing traction dynamometer used to measure the mechanical work expended in pulling a vehicle, 1878: A44, C57, E50, F40: Mn; Tpr 9820.0001.011

2. A second negative, 23.5 × 8 cm, is in the Collège de France.

38 bis Dynamography. Dynamometer above, photographed from a different angle: E_{50} bis

39 Dynamography. Dynamometric tracings comparing rigid and elastic traction. Enlarged dynamometric tracings, 1878: A_{45}, B_{34}, C_{58}, E_{51}, F_{41}: Mpr, Tpr 9820.0002.027

40 Dynamography. Interior of inscribing traction dynamometer. Drawing, 1878.

40 bis Same as above. Positive on a glass plate.

41–43 Unknown.

44 Instruments and apparatus. Apparatus for the direct measure of the vertical oscillations of the body during the walk and for indicating the variations of horizontal speed of the trunk, subject Demeny, 1886: A_{47}, B_{41}, E_{66}, F_{57}, G_{18}: P

45 Unknown.

46 Human locomotion. Walk: complete analysis of locomotion. Enlargement of a geometric chronophotograph, dynamographic and odographic tracings, 1886: C_{47}, E_{60}, F_{55}

47 Human locomotion. Walk: variations in the horizontal speed of thigh, knee, and ankle during a complete step at different cadences from forty to ninety steps a minute. Graph, 1886: C_{48}, D_{70}, E_{61}

48 Human locomotion. Walk: variations of mechanical work expended in a step at different cadences and in relation to the speed of progression. Graph, 1886: A_{42}, C_{53}, E_{71}

49 Human locomotion. Walk and run: relative duration of the phases of support, double support, and suspension of the foot in the walk and the run at increasing cadences, subject Demeny. Graph, 1885: B_{40}, C_{28}, D_{71}, E_{68}, F_{54}: Mpr, Tpr 9820.0001.023

50 Human locomotion. Walk and run: relation of the length of the step to the vertical oscillations of the trunk at various cadences from 40 to 140 steps a minute.[3] Graph, 1885 (*CRAS* 101 [1885]: 913): $B_{38}(A)$, C_{50}, E_{57}: Tpr 9820.0001.022

51 Human locomotion. General laws of human locomotion: relative values of the work expended in walking and running in the different acts that constitute a step. Graph, 1885 (*CRAS* 101 [1885]: 911): C_{52}, E_{69}, F_{58}: Tpr 9820.0001.025

52 Human locomotion. Walk and run: variation of energy expended in walk and run at increasing cadences at a specified rhythm. Graph, 1885 (*CRAS* 101 [1885]: 915): C_{51}, E_{70}: Tpr 9820.0001.024

53 Apparatus and instruments. Instrument used to demonstrate the influence of elasticity on the absorption of shock by a mass, 1886: A_{46}, B_{35}, C_{59}, E_{52}, F_{42}

54 Appratus and instruments. A double pendulum for studying the oscillation of the leg in movement, 1886: A_{49}, B_{42}, E_{67}, F_{56}, G_{19}

55 Odography and dynamography. Soles that relay the duration of the heel and toe contact with the ground and the pressure of the foot, 1883. **Fig. 55(B):** A_{59}, B_{39}, C_{29}, D_{53}, E_{59}, F_{52}

56 Odography. Odograph connected with the sole of a shoe, giving the variation in the number of steps over a specified time, 1883: A_{50}, B_{47}, C_{30}, E_{58}, F_{47}

57 Odography. Fixed odograph in main chalet and the mechanism that regulates the rhythm of steps for the moving subject, 1883: A_{51}, B_{43}, C_{31}, E_{53}, F_{43}

58 Odography. Telegraphic pole with electric relay at the Physiological Station. Bar with circuit breaker, 1883: A_{53}, B_{45}, C_{33}, E_{54}, F_{45}

59 Odography. Ordinary relay at the Physiological Station that signals the passage of a subject, 1883: C_{34}, D_2, E_{55}

60 Odography. Subject signaling his passage to the fixed odograph by moving a bar across his path to interrupt a closed electrical circuit, 1883 (*La Nature*, 24 January 1885, 120). **Fig. 36(B):** A_{54}, B_{44}, C_{32}, F_{44}

61 Odography. Walk and accelerated run: two tracings made with the fixed odograph, subject Demeny, dated Sunday, 22 June 1884:[4] A_{54} bis, B_{46}, E_{56}, F_{46}, G_{56}: P

62 Unknown.

3. A_{48} is a direct inscription of the vertical oscillations of the trunk in the walk.

4. C_{35} shows a similar trace made on 5 October 1884. Other odographic tracings are D_{73} (influence of the form of the shoe on the length of the step); D_{74} (influence of the form of the shoe on the length of the step, subject Marey, 30 October 1884); and D_{75} (influence of the pack weight on speed and progression of a marcher, subject Otto Lund, 30 October 1884). See negative 141 for odographic tracings of the run.

63 Odography. Shoes with flexible soles and heels to determine the influence of the length and rigidity of the sole and the height of the heel on the length of the step, 1883. **Fig. 55(A):** *A*58, *B*50, *C*36, *E*62, *F*53

64–66 Unknown.

67 Odography. Portable odograph registering the speed of progression in a continuous manner, second model with subject, 1886:[5] *C*38, *E*65, *F*49: P

68 Respiration. Instrument to count respiratory movements, fixed around the thorax and activated by the dilation that takes place during inhalation, 1886: *A*68, *B*57, *F*61, *G*49

69 Respiration. Thoracic compass, arranged to measure thoracic diameters and their variations at different positions of the arms as well as during respiration, 1886: *A*67, *B*56, *F*60, *G*50: P

70 Respiration. Subject using a registering spirometer (seen alone in negative 390) that measures the amount of air inhaled and exhaled in a 300-liter canister, 1884: *A*65, *B*54, *F*59: P

71 Comparative anatomy. White male skeleton: P, Mpr

72 Chronophotographic apparatus and instruments. First version of the single-shot photographic gun, to estimate the accuracy of aiming at a mobile object, 1882. **Fig. 30A:** *A*35, *B*23, *F*30: P

73 Unknown.

74 Human locomotion. Footprints of subject with muscular atrophy before and after a four-kilometer walk, 1886: *B*73, *E*63, *G*41: P

75 Unknown.

76 Animal locomotion. Horse: gallop, successive positions of the skeleton. Drawings, 1886:[6] *B*61, *C*56, *E*74, *F*72

77–84 Unknown.

85 Animal locomotion. Bird: transverse flight of a pigeon, ten images per second. Enlargement of a chronophotograph, 1886 (*La Nature*, 5 December 1887, 8): *B*68, *E*79, *F*64, *G*78(C), *H*52

86 Animal locomotion. Horse: trot, mounted, taken at 1/1,000 second, 1885: *A*33, *B*58, *E*72, *F*28: P

87 Human locomotion. Walk: partial successive images: the side of the body farthest from the camera is covered in black cloth. Enlargement of chronophotograph

IIH1.9, 1883 (*Développement de la méthode graphique*, 1885, 33): *A*18, *B*14, *C*16, *E*24, *F*11: P, Bpr G68101, Tpr 9820.0002.004

88 Chronophotographic apparatus and instruments. Camera with circular rotating plate for dissociating successive images for the analysis of movement on the spot. front view, 1884.[7] **Fig. 53(A):** *A*28, *E*9, *F*24: Mn

89 Chronophotographic apparatus and instruments. Camera with rotating plate, rear view, showing the mechanism that forces the sensitized plate to turn and stop twenty-four times in one complete revolution; each stop of the plate corresponds to the passage of the window of the slotted disk, 1884: *B*19, *E*10, *F*25: Mn

90 Human locomotion. Run: fast run, ten images per second, subject Franck of the Alsace-Lorraine Gymnastic Society. Enlargement of a chronophotograph dated 18 July 1886: *C*12, *D*12, *E*20, *G*32(C)[8]: P, Tpr 9820.0002.010(*A*)

91 Chronophotographic apparatus and instruments. Camera used to take an instantaneous image in 1/1,000 second, 1885. **Fig. 65(A):** *A*32, *B*21, *E*6, *F*27

92 Apparatus and instruments. Chronograph to measure the speed of camera shutters, 1885: *A*37, *B*24, *E*8, *F*29

93 Human locomotion. Transition from the run to the walk without change of cadence, forty images per second, subject Demeny. Diagram from a geometric chronophotograph, 1886 (*C.R. Association Française pour l'Avancement des Sciences*, 1886, 65): *D*18, *E*39: Mpr

94 Human locomotion. Transition from walk to run: twenty-five images per second, subject Demeny. Diagram from a geometric chronophotograph, 1886: *D*17, *E*40, *G*17: Tpr 9820.0002.012

95 Human locomotion. Run, subject from Joinville. En-

5. A57 bis shows original traces made with this odograph.

6. This negative and negatives 93, 94, 108, and 116 measure 23.5 × 18 cm.

7. The first portrait of Janssen made with a different version of this camera is found in Marey's personal album in the Collège de France, page 37.

8. G32(C) is a contact print from the original 9 × 6 cm chronophotograph.

largement of geometric chronophotograph IIH2.1, 1883 (*CRAS* 96 [1883]: 1829 [diagram]). **Fig. 46(C)**:[9] A25: CIn

96–105 Unknown.

106 Marey throwing a stone: six successive images taken at very short intervals on the same plate by means of a slotted-disk shutter turning in front of six lenses placed in a circle, 1883 (*Développement de la méthode graphique*, 1885, 21):[10] Mn

107 Animal locomotion. Bird: transverse flight of a pigeon. Enlargement of a single phase of chronophotograph IIO10.1, 1887: Mn, Mpr, Bpr G68138

108 Human locomotion. Displacement of the center of gravity, fourteen instantaneous photographs, copy negative of series IIH13.1–14, 1886: B36, F22: Mpr

109 Animal locomotion. Horse: Lasalle, gallop, movement of the right lateral biped. Diagram made from a geometric chronophotograph, 1886: B65, E77, F68: P, Mpr, Tpr 9820/6/6

110 Animal locomotion. Horse: gallop, oscillation of front leg, 25 images per second. Drawing from a chronophotograph in series IIC5, 1885 (*C.R. Association Française pour l'Avancement des Sciences*, 1886, 72). **Fig. 67(B)**: B62, E76, F69, G66: Mn

111 Animal locomotion. Horse: instantaneous image of dark horse marked with white paper in preparation for experiment seen in negative 129. Enlargement of IIC11.2, 1886) *C.R. Association Française pour l'Avancement des Sciences*, 1886, 73): B63, F66: Mn

112 Human locomotion. Fast run, five images per second, subject Pradelle. Copy negative from an enlarged chronophotograph, 1886 (*C.R. Association Française pour l'Avancement des Sciences*, 1886, 62): B10, D11, E19, F9, I15: Mn

113 Animal locomotion: Bird: transverse flight of gull, two enlarged images from a chronophotograph taken at 1/2,000 second showing the beginning of the phases of the ascent and descent of the wings. Retouched negative, 1886: B67, E78, F62: Mn, Bpr G68119

114–15 Unknown.

116 Human locomotion. Kinematic analysis of the transition from walk to run. Diagram made from a geometric chronophotograph, 1886: Mpr

117 Unknown.

118 Animal locomotion. Horse: gallop, first phase mounted, taken at 1/1,000 second, 1886 (*C.R. Association Française pour l'Avancement des Sciences*, 1886, 69): C54: Mn, Tpr 9820/6/2

119 Animal locomotion. Horse: gallop, second phase, mounted, taken at 1/1,000 second. Enlargement of IIC6.2, 1885 (*C.R. Association Française pour l'Avancement des Sciences*, 1886, 70): B60, C55, E73: Mn

120 Animal locomotion. Horse: gallop, third phase, mounted, taken at 1/1,000 second, 1885 (*C.R. Association Française pour l'Avancement des Sciences*, 1886, 70): B59: Mn, Tpr 9820/6/1

121 Human locomotion: gymnastics, movement with rifle. Enlargement of a single image from a series made by horizontally transposing the photographic plate behind the lens, 1883: Mn

122 Ballistics: vibrations of an elastic rod. Enlargement of a chronophotograph, 1886 (*C.R. Association Française pour l'Avancement des Sciences*, 1886, 59 [reversed]). **Fig. 73(A)**:[11] A22, B12, E22, F12, G12: Mn, Tpr 9820/3/1

123 Ballistics: parabolic trajectory of a ball. Enlargement of a chronophotograph, 1886 (*C.R. Association Française pour l'Avancement des Sciences*, 1886, 58): A20, B13, F13, G11: Mn

124–25 Unknown.

126 Animal locomotion. Bird: transverse flight of gull, from left to right, showing the extreme phases of the ascent and descent of the wings. Enlargment of a chronophotograph, 1886 (*La Nature*, 5 December 1887, 8): B69, F63, G71(A): P, Bpr G68115(A)

127 Human locomotion. Jump: long jump preceded by a run, ten images per second. Enlargement of a chronophotograph, 1886 (*C.R. Association Française pour*

9. A positive on glass also bearing the number 95 is in the Collège de France. The earliest print of this image is found in the Marey's personal album, page 31.

10. In this negative the individual images made with the multilens camera have been cut out and arranged horizontally.

11. Seven prints in the Musée National des Techniques: 9820/3/2, 3, 4, 5, 6, 7, and 8 belong to this experiment.

l'Avancement des Sciences, 1886, 62): B11, F10, G32(G)[12]: P, Tpr 9820.0001.010(*B*)

128 Unknown.

129 Animal locomotion. Horse: successive images of signs corresponding to the movements of a lateral biped (horse in negative 111 above in movement). Enlargement of geometric chronophotograph IIC10.3, 1886: *B*64, *F*67: Mpr

130 Physiological Station. Third black hangar and pylon in 1886 (see also negative 324). **Fig. 76(C):** *A*5, *C*6, *E*14

131 Physiological Station. White screen for use in instantaneous images with exposure times less than 1/1,000 second, 1886. **Fig. 61(A):** *A*4, *B*3, *F*2, *G*2: Tpr 9820.0001.005

132 Physiological Station. Bird's-eye view of the principal buildings, 1886: *A*3, *B*1, *F*1, *G*1

133 Unknown.

134 Animal locomotion. Bird: transverse flight of gull. Enlargement of a chronophotograph, 1886: *F*63

135 Human locomotion. Walk: subject M. Schenkel of the Alsace-Lorraine Gymnastic Society. Enlargement of chronophotograph IIH11.3, 1886 (*C.R. Association Française pour l'Avancement des Sciences, 1886, 63*): *C*14, *D*1: Tpr 9820.0002.005

136 Unknown.

137 Animal locomotion. Bird: flight of gull toward viewer. Enlargement of a chronophotograph, 1886: *B*70, *G*72: Bpr G68112(*B*)

138 Animal locomotion. Horse: gallop, theoretical representation of the oscillation of the right front leg, twenty-five images per second. Diagram from a chronophotograph, 1885 (*CRAS* 103 [1886]: 546): Tpr 6820/6/4

139 Animal locomotion. Horse: trot, theoretical representation of the oscillation of the right front leg, twenty-five images per second. Diagram from a chronophotograph, 1885 (*CRAS* 103 [1886]: 544).

140 Animal locomotion. Horse: walk, theoretical representation of the oscillation of the right front leg, ten images per second. Diagram from a chronophotograph, 1885 (*CRAS* 103 [1886]: 540): Tpr 9820/6/5

141 Odography. Run: comparison of two runners, odographic tracings made with the fixed odograph, dated 22 June 1884 (see negative 61 for tracings of the walk): *G*56

142 Odography. Interior mechanism of the odograph shown in negatives 67 and 144, 1886: *A*57, *B*49, *F*50, *G*55

143 Respiration. Pneumograph: Demeny posing with pneumograph on chest, 1885: *A*62, *B*51, *G*44: P

144 Odography. Portable odograph registering the speed of progression in a continuous manner, second model, 1886 (see negative 67 for this odograph in use): *A*56, *B*48, *G*53: P

145 Animal locomotion. Bird: transverse flight of a gull, wings raised. Enlargement of a single phase of a chronophotograph, heavily retouched, 1883: Mn

146 Animal locomotion. Bird: transverse flight of a gull, wings at beginning of descent. Enlargement of a single phase of a chronophotograph, heavily retouched, 1883: *B*66: Mpr

147–55 Comparative anatomy. Skeletons of birds and mammals: *J*53–61: Mpr

156 Unknown.

157–58 Comparative anatomy. Bird skeletons.

159 Comparative anatomy. Goat skeleton: Mpr

160–61 Comparative anatomy. Bird skeletons: *J*7–9

162 Comparative anatomy. Kangaroo skeleton.

163 Human locomotion. Variations in value and speed of a vertically projected movement, comparison of the trajectories of head, shoulder, and hip, subject Demeny. Four graphs based on chronophotographic and dynamographic data, dated November 1884: *B*38(*B*), *D*67

164 Human locomotion. Variations in vertical speed, enlarged. Correlation of dynamometric indications and the kinematic data given by chronophotography, subject Pradelle, rhythm 85, example 13. Three graphs, dated 29 September 1884: *D*68

165 Human locomotion. Jump: movement of the head, variations in vertical speed as a function of time, subject Demeny. Two graphs, 1884: *D*69

12. G32(G) is a contact print from the original 9 × 6.5 cm chronophotographic negative.

166 Respiration. Effects of training on the modification of the rhythm and amplitude of respiratory movements. Two pneumographic tracings, 1884: *A*64, *B*53, *F*60 verso, *G*45: P

167 Respiration. Effect of training on breathing of singers Dubulle and Giraudet. Simultaneous inscription of the expiration of air and the movements of the thorax and abdomen in professional singers emitting musical sounds. Pneumographic tracings, signed by Demeny, dated 1884: *A*66, *B*55, *G*48: P

168 Respiration. Effects of breath training on a singer: movements of expansion and depression of thorax and abdomen of Boudouresque singing an aria from *Robert le Diable*. Pneumographic tracing, 1884: *A*63, *B*52, *G*46: P

169 Dynamography. Jump: abrupt lowering of arms from above head to horizontal position. Enlarged dynamometric tracing, 1884: *D*47: P

170 Dynamography. Jump: elevation of arms with abrupt halt at the horizontal position. Enlarged dynamographic tracing, 1884: *D*45: P

171 Dynamography. Jump: complete preparation for jump, lowering of body and arms, immediate return to upright with abrupt halt of arms at the horizontal position. Enlarged dynamometric tracing, 1884: *D*52: P

172 Dynamography. Jump: preparation, impulsion, and suspension in a long jump with feet together, subject Demeny. Diagram made from a chronophotograph, dated December 1884: *D*21: P

173 Unknown.

174 Dynamography. Jump: simultaneous elevation of body and arms in the jump. Enlarged dynamographic tracing, 1884: *D*46: P

175 Dynamography. Jump: simple jumps of different heights. Enlarged dynamographic tracings, 1884: *D*57: P

176 Dynamography. Jump: successive jumps aided by arm movements. Enlarged dynamographic tracings, 1884: *D*64: P

177 Dynamography. Jump: two jumps of different heights. Enlarged dynamographic tracings, 1884: *D*58: P

178 Dynamography. Jump: abrupt lowering and raising of body in the jump. Enlarged dynamographic tracing, 1884: *D*48, *D*51

179 Dynamography. Jump: simple high jump with vertical elevation of arms. Enlarged dynamographic tracing, 1884: *D*54

180 Dynamography. Jump: lowering and raising of body in jump, slow movement. Enlarged dynamographic tracing, 1884: *D*50

181 Dynamography. Jump: jumps of different heights with feet together. Enlarged dynamographic tracings, 1884: *D*59

182 Dynamography. Jump: successive jumps without aid of arms. Enlarged dynamographic tracings, 1884: *D*61

183 Dynamography. Jump: successive jumps with complete movements of arms. Enlarged dynamographic tracings, 1884: *D*65

184 Dynamography. Jump: simultaneous lowering of body and arms in jump, abrupt movement. Enlarged dynamographic tracing, 1884: *D*49

185 Dynamography. Jump: successive jumps with incomplete extension of legs. Enlarged dynamographic tracings, 1884: *D*62

186 Dynamography. Walk: variation in the normal pressure of the foot in military marches at a constantly increasing pace. Graph signed by Demeny, 1884: *D*43

187 Dynamography. Run: variation in the normal pressure of the foot in run at a constantly increasing pace. Graph signed by Demeny, 1884: *D*44

188 Human locomotion. Pathology: unidentified tracing.

189 Dynamography. Jump: variation in the speed of the vertical movement of the head in an elastic jump, subject Demeny. Two graphs, 1885.

190 Respiration. Pneumograph: *A*61, *F*59 verso, *G*43

191 Unknown.

192 Human locomotion. Run: analysis of the movement of the leg in the run. Diagram from a chronophotograph, 1884: *D*16

193 Dynamography. Experiment showing that the body can be momentarily suspended in the air by the rapid movement of the legs; simultaneous inscription of vertical movement of head and corresponding pressure of feet on the ground. Enlarged dynamometric tracing and drawing, 1884: *B*31, *D*30: Mpr

194 Dynamography. Instrument recreating the preceding experiment, 1884: *B*32, *D*31

195–205 Comparative anatomy. Skeletons of mammals and tortoise: *J*20–36

206–7 Unknown.

208 Comparative anatomy. Goose skeleton: *J*11

209 Comparative anatomy. Bird skeleton: *J*15

210 Comparative anatomy. Bird skeleton: *J*16

211 Comparative anatomy. Kangaroo skeleton: *J*17

212–18 Comparative anatomy. Animal skeletons: *J*40–47

219 Comparative anatomy. Human skeleton, adult white male: Mpr

220 Comparative anatomy. Human skeleton, adult black male: Mpr

221 Comparative anatomy. Animal skeleton: *J*19

222 Comparative anatomy. Elephant skeleton: *J*48

223 Comparative anatomy. Animal skeleton: *J*49

224 Comparative anatomy. Human skeleton, four-year-old child: P, Mpr

225–27 Comparative anatomy. Animal skeletons: *J*50–52

228 Comparative anatomy. Bird skeleton: *J*10

229 Comparative anatomy. Elk skeleton: *J*6

230 Comparative anatomy. Animal skeleton: *J*19

231–33 Comparative anatomy. Animal skeleton.

234 Comparative anatomy. Horse skeleton: *J*18

235 Human locomotion. Run: relative movement of the oscillating limb in relation to the hip, subject Demeny. Diagram from a chronophotograph, 1884: Mpr

236 Human locomotion. Walk: relative movement of the oscillating limb in relation to the thigh. Diagram from a chronophotograph, 1884: Mpr

237–40 Comparative anatomy. Animal skeletons.

241 Animal locomotion. Bird: transverse flight of crested heron. Enlargement of a chronophotograph (see also negative 340): Mn

242 Animal locomotion. Bird: flight of a gull from above, superimposed images. Drawing from a chronophotograph, 1886 (*CRAS* 104 [1887]: 327): Mn, Bpr G68124

242 bis Animal locomotion. Bird: transverse flight of a heron from left to right. Enlargement of a chronophotograph, 1886: *G*76(*A*): Mn, Bpr G68131

243 Animal locomotion. Bird: transverse flight of a gull, twenty-five images per second. Drawing from a chronophotograph, 1886 (*CRAS* 104 [1887]: 212).

244 Unknown.

244 bis Animal locomotion. Bird: oblique ascending flight of a gull, twenty-five images per second. Drawing from a chronophotograph, 1886 (*CRAS* 104 [1887]: 326): Mn, Bpr G68125

245 Animal locomotion. Bird: flight of a gull from three different axes. Drawings from chronophotographs, 1886. (*CRAS* 104 [1887]: 328) **Fig. 77(B)**: *B*71: P, Bpr G68123

246 Unknown.

247 Comparative anatomy. Muscle of bird's wing: P

248 Human locomotion. Pathology: walk, Mme Leblanc, ankylosis of the knee, extreme shortening of leg. Diagram from a geometric chronophotograph, 1886: Mn

249–52 Unknown.

253 Human locomotion. Pathology: walk, Mme Dallot, ankylosis of the right knee, Diagram from a geometric chronophotograph, dated 23 September 1886: *G*39: P

254 Human locomotion. Pathology: Mme Leblanc, Diagram from a geometric chronophotograph, dated 23 September 1886: *B*72

255–57 Unknown.

258 Human locomotion. Pathology: walk, Mme Berthauche, left leg amputated at the thigh, wooden leg. Diagram from a geometric chronophotograph, dated 23 September 1886: *G*40: P

259 Human locomotion. Pathology: walk M. Gaspard Laroque, fracture of the left leg. Diagram from a geometric chronophotograph, dated 23 September 1886: P, Tpr 9820.0002.014

260 Animal locomotion. Bird: transverse ascending flight of a gull, superimposed images. Enlargement of chronophotograph II03.2, 1886: Mn, Bpr G68108

261 Animal locomotion. Bird: transverse flight of a gull. Enlargement of two phases of a chronophotograph, 1887: Mn

262 Animal locomotion. Horse: gallop, mounted, taken at 1/1,000 second, 1885.

263 Animal locomotion. Horse: trot, mounted, taken at 1/1,000 second, 1885 (*C.R. Association Française pour l'Avancement des Sciences*, 1886, 69): E7

264 Animal locomotion. Horse: trot, mounted, taken at 1/1,000 second, 1885.

265 Ballistics: parabolic trajectory of ball. Enlargement of chronophotograph IIB1.1, 1886, E21: Tpr 9820/4/3

266 Dynamography. Jump: disposition of dynamographic experiment to show that the separation of the body from the ground is due to the speed imparted to its mass by the tension of the extensor muscles. Drawing of a figure and apparatus, 1886: B37, D38

267 Dynamography. Walk and run: the pressure of the feet in the paces used by the army, normal march, change step, cadenced step, gymnastic step, run. Enlarged dynamometric tracings, 1886: B27, D41, G23: P

268 Dynamography. Jump: normal component of the pressure of the feet on the ground. (1) in a fall with stiffened muscles, (2) in a fall with leg flexion. Enlarged dynamometric tracings, 1885: D66, G25

269 Animal locomotion. Horse: walk, movement of the front leg. Diagram from a geometric chronophotograph, 1886.

270 Animal locomotion. Horse: trot, movement of the front leg. Diagram from a geometric chronophotograph, 1886.

271 Animal locomotion. Horse: gallop, movement of the front leg. Diagram from a geometric chronophotograph, 1886.

272 Animal locomotion. Bird: flight of a gull toward viewer (negative 137 reversed). Enlargement of a chronophotograph, 1886 (*C.R. Association Française pour l'Avancement des Sciences*, 1886, 77): Bpr G68113

273 Dynamography. Walk, run, and jump: different forms of the tangential component of the pressure of the feet on the ground. Enlarged dynamometric tracings, 1885: B27, D42, G24

274 Apparatus and instruments. Pathology: room at Beaujon Hospital and electrical apparatus used for chronophotographic studies of pathological locomotion, 1888: H25

275 Animal locomotion. Outstretched wing of a bird.[13]

276 Unknown.

277 Animal locomotion. Outstretched wing of a bird.

278–79 Unknown.

280 Animal locomotion. Outstretched wing of a bird.

281–89 Comparative anatomy. Various skeletons. Positives of illustrations from an unidentified book.

290 Unknown.

291 Comparative anatomy. Outstretched wing of a bird. Positive of an illustration from an unidentified book.

292–95 Comparative anatomy. Bones.

296 Unknown.

297–306 Comparative anatomy. Single human bones.

307 Comparative anatomy. Skeleton of a bird.

308 Apparatus and instruments. Mechanical bird, 1887: Bpr G68105

309 Apparatus and instruments. Parachute, 1887: Bpr G68104

310 Unknown.

311 Apparatus and instruments. Pathology: electrified harness for chronophotographic studies of pathological locomotion, 1887: G37

312 Apparatus and instruments. Pathology: device to convey electricity to different points on the body for chronophotographic studies of pathological locomotion, 1887: G36

313 Geometry: conic figure engendered by a moving string. Enlargement of a chronophotograph, 1887 (*Paris-Photographe* 3 [1893]: 101). **Fig. 73(B)**: G13, H55

314 Animal locomotion. Bird: transverse flight of a gull. Copy negative from an enlargement of three chronophotographs; the first series is an enlargement of

13. Six prints in the Bibliothèque Nationale, G68090, 091, 092, 093, 094, and 095 (a drawing), belong to this series of photographs of the wings of different birds. The study of wing morphology and anatomy was given over to Pierre Noguès in the late 1880s; it is part of Marey's aviation investigations.

IIO3.5, the second of IIO3.6, 1886: E80, G73: Bpr G68107, Bpr G68118

315 Unknown.

316 Animal locomotion. Bird: transverse flight of a gull, ten images per second, 1/2,000 second. Enlargement of two phases of negative IIO3.7, 1886 (*C.R. Association Française pour l'Avancement des Sciences*, 1886, 75): G71(B): Tpr 9820/5/3

317 Animal locomotion. Goat: before experiment, dated 5 May 1887: P, Mpr

318 Animal locomotion. Outstretched buzzard's wings.

319 Apparatus and instruments. Zoetrope with three dimensional figures of pigeons, 1887. **Fig. 78(C)**.

320 Animal locomotion. Bird: outstretched wings of two birds.

321 Animal locomotion. Bird: flight of a gull, experiment to determine center of gravity in flight. Drawing from a chronophotograph, 1887 (*CRAS* 104 [1887]: 325).

322 Animal locomotion. Bird: trajectory of flight of a gull. Five graphs, 1886.

323 Human locomotion. Run: enlargement of a single phase of negative 112, 1886 (*Revue Générale des Sciences* 2 [1891]: 706). **Fig. 81(B)**: G9

324 Physiological Station. Overhead pylon and third black hangar, side view, 1886: G4: P, Tpr 9820.0001.006

325 Animal locomotion. Bird: trajectory of gull's humerus in flight. Graph, 1886.

326 Animal locomotion. Elephant, right rear leg, rapid movement. Diagram from geometric chronophotograph IIE2.1, 1887 (*CRAS* 105 [1887]: 154).

327 Animal locomotion. Elephant, right rear leg, walk. Diagram from geometric chronophotograph IIE2.2, 1887 (*CRAS* 105 [1887]: 151).

328 Human locomotion. Jump: high jump preceded by run, subject Viala, Joinville. Enlargement of a chronophotograph, 1883: Mpr

329 Human locomotion. Jump: long jump, both feet together, subject Demeny. Enlargement of a chronophotograph, 1883.

330–32 Unknown.

333 Animal locomotion. Bird: flight of a gull taken from above, fifty images per second. Enlargement of a chronophotograph, 1887: G75(B): Bpr G68111, Bpr G68122

334 Animal locomotion. Bird: flight of a gull taken from above, fifty images per second. Enlargement of a chronophotograph, 1887: G75(A)

335–36 Unknown.

337 Animal locomotion. Bird: transverse flight of a heron. Enlargement of a chronophotograph, 1886 (*La Nature*, 5 December 1887, 8): Mpr, Bpr G68130(B)

338 Animal locomotion. Bird: transverse flight and landing of a heron. Enlargement of chronophotograph IIO5.3, 1886: Bpr G68132

339 Animal locomotion. Bird: descending transverse flight of a heron. Enlargement of chronophotograph IIO5.1, 1886: Bpr G68110(B)

340 Animal locomotion. Bird: transverse flight of a crested heron. Enlargement of chronophotograph IIO7.1, 1886 (*La Nature*, 5 December 1887, 9 [reversed]) **Fig. 74(D)**: G76(B): Bpr G68129, G68130(A)

341–42 Unknown.

343 Animal locomotion. Bird: overlapping sculpture representing the flight of a gull, 1887. (*Revue Scientifique* 42 [1888]: 294). **Fig. 79(B)**: G80: Bpr G68110(A)

344 Animal locomotion. Bird: as above. Positive on a glass plate, 1887.

345 Unknown.

346 Animal locomotion. Bird: transverse flight of a white heron, superimposition of wings, fifty images per second. Enlargement of a chronophotograph, 1886.

347 Animal locomotion. Bird: transverse flight of a white heron, superimposition of wings, fifty images per second. Enlargement of a chronophotograph, 1886.[14]

348 Animal locomotion. Outstretched wing of a bird.

349 Unknown.

350 Animal locomotion. Bird: transverse flight and landing of a pelican. Enlargement of chronophotograph IIO9.1, 1887: G77(B): Bpr G68135

14. The negative is marked 247.

351 Animal locomotion. Bird: transverse descending flight of a pelican. Enlargement of a chronophotograph, 1887.

352 Unknown.

353 Animal locomotion. Bird: flight of a gull, taken from above. Enlargement of a chronophotograph, 1887 (*La Nature*, 5 December 1887, 9). **Fig. 77(A)**: G75(C): Bpr G68115(B)

354 Human locomotion: Fast run: taken from above. Enlargement of a chronophotograph, 1887 (*CRAS* 105 [1887]: 546 [drawing]): G20(C), H22(C): P, Tpr 9820.0002.008

355 Human locomotion. Walk: taken from above. Enlargement of chronophotograph IIH14.1, 1887: G20(A), H22(A)

356 Human locomotion. Gymnastic walk: taken from above. Enlargement of chronophotograph IIH14.4, 1887 (*CRAS* 105 [1887]: 544 [drawing]): G20(B), H22(B): Tpr 9820.0002.006, 007

357 Human locomotion. Walk: economical ways of traveling a specific distance in a given time, subject Demeny. Four graphs, 1886: D72, G33

358 Apparatus and instruments. Suspended scale to assist in measuring the movement of the center of gravity. 1887.

359 Physiological Station. Interior of main chalet from above, 1887: H2

360 Physiological Station. Interior of main chalet, 1887. **Fig. 35(A)**.

361 Physiological Station. Interior of main chalet, grand hall, 1887: G3, H1: P

362 Human locomotion. Run: subject in apparatus shown in negative 365. Enlargement of a chronophotograph, 1887 (*CRAS* 105 [1887]: 548 [drawing]). **Fig. 80(C)**: G22(B).

363 Human locomotion. Run: subject in apparatus shown in negative 365. Enlargement of a chronophotograph, 1887 (*CRAS* 105 [1887]: 548 [drawing]): G22(A), H23(A): Tpr 9820.0002.013

364 Human locomotion. Run: subject in apparatus shown in negative 365 taken from above. Enlargement of chronophotograph IIH14.3, 1887 (*CRAS* 105 [1887]: 546 [drawing]). **Fig. 80(D)**: G21(A), H21

365 Apparatus and instruments. Demeny posing in apparatus consisting of white sticks marking the axes of the vertebral column, shoulder, and hip. **Fig. 80(B)**: G21(B), H20

366–67 Unknown.

368–73 Comparative anatomy. Rabbit: leg and muscle, normal and pathological conditions (*CRAS* 190 [1887]: 449): G60–61, H13–18, J5: Bpr G68096–100

374 Animal locomotion. Bird: crested heron, wings lowered. Enlargement of a single phase of negative 340, 1886.

375 Animal locomotion. Bird: pelican, wings lowered. Enlargement of a single phase of negative 350, 1887: Bpr G68136

376 Animal locomotion. Bird: crested heron, wings lowered. Enlargement of a single phase of negative 340, 1886: Bpr G68133

377 Animal locomotion. Bird: crested heron, wings raised. Enlargement of a single phase of negative 340, 1886: Bpr G68134

378 Animal locomotion. Outstretched wing of a crested heron.

379 Comparative anatomy. Bird and human skeletons, positive of an illustration from an unidentified book.

380–83 Comparative anatomy. Studies of animal muscle.

384 Anthropometry. Thoracimeter mounted on stand, 1888: H33, I49

384 bis Anthropometry. Thoracimeter, duplicate of negative 384.

385 Anthropometry. Thoracimeter to measure horizontal sections of children's thoraxes, 1888: H32, I50

386 Unknown.

387 Anthropometry. Thoracimeter and subject, 1888: H35, I52: P

388 Anthropometry. Inscriptor of spinal profiles with subject, 1888: I57

389 Anthropometry. Inscriptor of spinal profiles, 1888 (Demeny, *Archives de Physiologie*, 5th ser., 1 [1889]: 587 [drawing]: H38, I56

390 Respiration. Registering spirometer attached to 300-liter canister, to measure the quality of air inhaled

and exhaled in a respiratory act; the measurement is compared with the indications given by the pneumograph.[15]

391 Dynamography. Walk: comparison of normal and pathological locomotion. Enlarged dynamographic tracings.

392 Animal locomotion. Bird: wing of bird.

393 Animal locomotion. Bird: wing of bird.

394 Chronophotographic apparatus and instruments. New chronophotographic camera, front view, 1887. **Fig. 76(A):** $G6$: Mn, Tpr 9820.0001.007

395 Chronophotographic apparatus and instruments. New chronophotographic camera, rear view, 1887: $G7$: Mn

396 Chronophotographic apparatus and instruments. New chronophotographic camera with disk shutter demounted, 1887. **Fig. 76(B):** $G8$: Mn

397 Chronophotographic apparatus and instruments. New chronophotographic camera, profile, 1887: Mn

398 Chronophotographic apparatus and instruments. Double-lens chronophotographic camera used for both stereoscopic and alternate-lens chronophotography, 1887–88: $H7$, $I17$

399 Animal locomotion. Outstretched wing of a bird.

400 Human locomotion. Run: sculpture of a single phase of the run by Georges Engrand, 1888. **Fig. 81(A):** $H10$: Mn

401 Respiration. Thoracic sections taken from different heights and superimposed to form a figure in relief, 1888: $H43$, $I55$

402 Chronophotographic apparatus and instruments. Camera with oscillating mirror, 1888. **Fig. 83(A):** $H48$, $I8$

403 Unknown.

404 Respiration. Transverse cross sections of the thoraxes of a thirty-five-year-old man and a twelve-year-old child. Drawing, 1888: $H37$, $I53$

405 Respiration. Transverse cross sections of the thoraxes of a twelve-year-old boy, a fourteen-year-old girl, and a thirty-seven-year-old man. Drawing, 1888: $H36$, $I54$

406 Respiration. Influence of age on the average increase in size, weight, and lung capacity of children from six to fourteen years of age. Graph, 1888: $H44$, $I59$

407 Anthropometry. Vertical section of the median axis of the body obtained with the spinal inscriptor shown in negative 389, and profiles of the anterior part of neck and thorax. Drawing, signed by Demeny, 1888. **Fig. 143(B):** $H39$, $I58$

408 Instruments and apparatus. Arrangement of aquarium and oscillating-mirror camera, 1888. **Fig. 84(A):** $D22$, $H45$, $I36$

409–10 Unknown.

411 Ballistics. Baton: parabolic curve described by a baton thrown into the air. Enlargement of a chronophotographic negative, 1886.

412–19 Unknown.

420 Ballistics. Balls: parabolic curve described by two balls of unequal diameters connected by a wire. Enlargement of a chronophotograph, 1888: $H6(A)$, $I6(A)$: P

421 Animal locomotion. Bird: transverse flight of a gull, overlapping images. Enlargement of chronophotograph IIO3.10, 1887 (*Revue Scientifique*, 42 [1888]: 290): $H12(A)$, $I27$: Bpr G68106, G68114

422 Ballistics. Baton: parabolic curve described by a baton thrown into the air. Enlargement of a chronophotograph, 1888 (*Paris-Photographe* 1 [1891]: 7). **Fig. 71(C):** $H6(B)$, $I6(B)$: P

423–26 Unknown.

427 Animal locomotion. Eel: progressive phases of the movement of an eel, Drawing from a chronophotograph made with camera arrangement shown in negative 407, 1888 (*CRAS* 107 [1888]: 644): $H46$, $I37$

428 Anthropometry. Thoracic instrument to determine with precision the exterior form of the thorax, the extent of respiratory movements, the dimensions and movements of the torso, and the amount of air inhaled and exhaled, 1888: $H40$, $I47$

429 Anthropometry. Another view of the instrument above: $I48$

430–31 Unknown.

432 Animal locomotion. Bird: transverse flight of a

15. Graphs made with the spirometer are shown in G48.

pigeon, comparative analysis, five series. Heavily re-touched negative made from original filmed images, 1888: *H52(B)*: Bpr G68162 (Balagny phototype)

433 Unknown.

434 Respiration. Pneumograph: *H42*

435 Respiration. Seated subject using registering spiro-meter seen in negative 390: *H41*

436 Human locomotion. Variations in the length of the step and the speed of progression as a function of ca-dence, subject Demeny. Graph, 1888.

437 Unknown.

438 Physiological Station. Exterior of main chalet:[16] *A1*, *C1*, *E1*: CIn

439 Human locomotion. Pathology: incandescent lamps give the trajectories of the shoulder, thigh, knee, and ankle of a subject with atrophy of the femoral tri-ceps. Chronophotograph made at Beaujon Hospital, dated 7 March 1888:[17] *G38*, *H28*: Mpr

440 Instruments and apparatus. Pathology. Demeny demonstrating electrical apparatus for chronophoto-graphic study of pathological locomotion, 1888 **Fig. 60(A)**: *H27*

441 Human locomotion. Walk: Locomotor ataxia, sub-ject Biederker, Hôtel-Dieu Hospital, five windows in disk shutter, five revolutions per second. Diagram from a chronophotograph, signed by Demeny, 1889: *H29*

442 Human locomotion. Walk: normal, subject Morin. Diagram from a chronophotograph, dated 18 July 1886: *H31*: Mpr

443 Human locomotion. Run: subject Schultze, five windows in disk shutter, five revolutions per second. Dia-gram from a chronophotograph dated 11 April 1889: *H30*

444 Animal locomotion. Horse: walk, mounted, six-teen images made with film camera and assembled on a glass plate, 1889: *H52(A)*

445 Nude soldier with pack before experiment, 1889. **Fig. 63(A)**.

446–49 Unknown.

450 Anthropometry. Thoracimeter, 1888.

451 Anthropometry. Thoracimeter above, slightly open, 1888.

452 Anthropometry. Two thoracimeters as in negative 451 above, open, 1888 (Demeny, *Archives de Physiologie* 5 ser., 1 [1889]: 589 [drawing]).

453 Anthropometry. Thoracic compass, different view of negative 69: *G23*, *H21*

No corresponding negatives have been found for the fol-lowing prints.

A12, B15, F14 Human locomotion. Demeny dressed in black with joints, arms, and legs marked in white for chronophotographic experiments shown in negatives 15 and 16, 1884 (*C.R. Association Française pour l'Avance-ment des Sciences*, 1886, 63). **Fig. 45.**

A29 Instruments and apparatus. Drapery movements taken with the camera shown in negative 91, 1885. **Fig. 65(B)**.

A30, B20, F26 Instruments and apparatus. Chrono-photographic portrait of Janssen on a circular plate taken with camera shown in negative 88, 1884. **Fig. 53(B)**.

A31, Bpr G68151 Instruments and apparatus. Marey throwing a stone, taken with the six-lens camera shown in negative 106, 1883. **Fig. 52.**

A55, B33, C37, E64, F48 Odography. First model por-table odograph with subject, 1884. Negative 67 shows the second model.

B22 Instruments and apparatus. Drapery movements taken with camera shown in negative 91, 1885. **Fig. 65(D)**.

C6, H3 Physiological Station. Third black hangar and pylon taken from a different angle from that shown in negative 130, 1886.

C18, E25, F20 Human locomotion. Jump: kinematic analysis of the lowering of the torso by the flexion of the legs. Enlargement of IIH8.5, 1884.

16. IIS1.1–6 are additional (unnumbered) negatives in the Cin-émathèque Française that show the main chalet of the Station under construction. Prints from these negatives are in Marey's personal album.

17. IIH18.1–15 are additional (unnumbered) negatives from this experiment.

E75, F70, G64, Tpr 9820/6/3 Animal locomotion. Horse: walk, oscillation of right front leg in the walk. Drawing from a chronophotograph in series IIC5, 1885 (*C.R. Association Française pour l'Avancement des Sciences, 1886, 71*).

E81, F65 Animal locomotion. Bird: transverse flight of a gull. Drawing from a chronophotograph, 1886 (*CRAS* 104 [1887]: 211).

F3, Tpr 9820.0001.004 Physiological Station. Third black hangar and pylon, taken from a different angle from that shown in negative 130, 1886.

F31 Instruments and apparatus. Single-shot photographic gun, second version, 1883. The first version of this gun is shown in negative 72.

F32 Instruments and apparatus. Enlarged photographs of gulls in flight taken with the single-shot gun, second version, 1886.

F71, G65 Animal locomotion. Horse: trot, oscillation of right front leg. Drawing from a chronophotograph in series IIC5, 1885. **Fig. 67(B).**

G26 Instruments and apparatus. Suspended scale with subject, 1887. Negative 358 shows the scale alone.

G29 Human locomotion. Gymnastic movements: simple, natural movements of the torso and limbs, six 3 × 13 cm contact prints of a series of images taken by horizontally transposing the glass negative behind the lens, 1883.

G30 Human locomotion. Gymnastic movements: analysis of movements from the military gymnastics manual; four 3 × 13 cm contact prints of a series of images taken by horizontally transposing the plate behind the lens, 1883. The prints include one made from negative IIH5.22, in the Cinémathèque Française. An enlarged single image from the series is in the Bibliothèque Nationale, no. G68150.

G31 Human locomotion. Gymnastic movements: analysis of correct and incorrect execution of gymnastic movements including exercise on rings and parallel bars, subject Demeny; five 3 × 13 cm contact prints of a series of images taken by horizontally transposing the plate behind the lens, 1883.

G32 Human locomotion. There are seven contact prints mounted on G32: (A) Swinging Indian clubs. (B, C) Fast run. (D, E, F, G) Jump. The chronophotographic nega-

tives for A, C (the original for negative 127) and G (the original of negative 90) are lost. B, D, E, and F were printed from negatives in the series IIH11, dated 14 and 18 July 1886.

G35 Human locomotion. Pathology: subject at Physiological Station connected to electrical apparatus before experiment in pathological locomotion, 1888. See also negative 440.

G54 Odography. Second model portable odograph; a different view of odograph shown in negative 67.

G59 Comparative anatomy. Leg muscles of white and black men (*CRAS* 190 [1887]: 448 [drawing]).

G67 Animal locomotion. Horse: mounted Arabian horse, gallop, ten images per second. Enlarged chronophotograph, 1887 (*Revue Générale des Sciences* 2 [1891]: 691). **Fig. 69(B).**

G74, Bpr G68116, 17 Animal locomotion. Bird: transverse flight of a gull. Enlarged chronophotograph, 1886.

G77(A) Animal locomotion. Bird: transverse flight of a pelican. Enlarged chronophotograph, 1886 (*La Nature*, 5 December 1887, 9).

G78(A) Animal locomotion. Bird: flight of an unidentified bird. Chronophotograph taken by transposing the plate horizontally behind the lens, 1887.

G78(B) Animal locomotion. Bird: eleven sculptures representing the flight of a pigeon, 1887. Contact print of O10.6.

G79, Bpr G68154 Animal locomotion. Bird: ten sculptures representing the flight of a gull, 1887.

G81, Bpr G68128, Tpr 9820.0001.003 Instruments and apparatus. Zoetrope containing three-dimensional figures of gulls, 1887 (*La Nature*, 5 December 1887, 12). The zoetrope with pigeons is shown in negative 319.

H4, I4 Physiological Station. Third black hangar showing curtains used to reduce the area, 1886. **Fig. 61(B).**

H5, I5 Physiological Station. Third black hangar and smaller hangar built at right angles to it for three-dimensional studies, 1887. **Fig. 76(D).**

H8 Animal locomotion. Bird: transverse ascending flight of a pigeon. Enlargement of IIO10.2, 1886.

H9 Animal locomotion. Bird: transverse ascending flight of pigeon. Enlarged chronophotograph, 1886.

H11 Animal locomotion. Bird: transverse flight of a gull. Enlargment of O3.11, 1886.

H12(B) Animal locomotion. Bird: transverse flight of a pigeon taken from overhead, 25 images per second. Enlarged chronophotograph, 1887 (*Revue Générale des Sciences* 2 [1891]: 714).

H91(A, B) Animal locomotion. Goat: before experiment, two photographs taken the same day as negative 317.

H26 Instruments and apparatus. Electrical device shown in negative 312, turned on its side, 1887.

H34, I51 Anthropometry. Thoracimeter shown in negative 387 without subject, 1888.

H47(A, B) Animal locomotion. Fish. Two contact prints of chronophotograph taken with camera arrangement shown in negative 408, 1888. (B) is a contact print of IIP1.3.

H47(C) Animal locomotion. Eel. Contact print of IIP2.1 taken with camera arrangement shown in negative 408, 1888.

H49(A), I10(A) Human locomotion. Walk. Enlarged chronophotograph taken with the oscillating-mirror camera shown in negative 402, 1888.

H49(B), H51(B), I10(B) Human locomotion. Jump. Enlarged chronophotograph taken with the oscillating-mirror camera shown in negative 402, 1888.

H50 Human locomotion. Walk: movement of the foot. Enlarged chronophotograph taken with the oscillating-mirror camera shown in negative 402, 1888.

H51(A) Human locomotion. Swinging Indian clubs. Enlarged chronophotograph taken with the oscillating-mirror camera shown in negative 402.

H53 Animal locomotion. Horse: walk. The images shown in negative 444 have been mounted around the circumference of a circular glass plate and printed for use in a phenakistoscope, 1889.

I9 Duplicate of H50 enlarged for use in a zoetrope.

I12 Duplicate of H51(A) enlarged for use in a zoetrope.

I13 Human locomotion. Walk: first half of series in H49(A) enlarged for use in a zoetrope.

I14 Human locomotion. Walk: second half of series in H49(A) enlarged for use in a zoetrope.

I18 Animal locomotion. Bird: enlarged stereoscopic image of a gull in flight taken with camera shown in negative 398, 1888.

I26 Animal locomotion. Bird: flight of duck toward the camera. Enlargement of IIO2.8 made by transposing the plate horizontally behind the lens, 1888.

I28 Animal locomotion. Bird: transverse flight of duck. Enlarged chronophotograph, 1888.

I32 Pathology. Limping caused by pain. Enlarged dynamometric tracing, 1888.

I33 Dynamometry. Limping caused by pain. Enlarged dynamometric tracing, 1888.

I38(A, B) Animal locomotion. Eel. Contact prints of IIP2.14 and IIP2.15 taken with camera arrangement shown in negative 408, 1888.

I39 Duplicate of H47(B).

I40 Animal locomotion. Frog. Contact print of IIG1.7 taken with camera arrangement shown in negative 408, 1888.

Bpr G68152 Geometric form engendered by a string. Enlarged stereoscopic chronophotographs from flexible film plates taken with camera in negative 398, 1892 (*Paris-Photographe* 3 [1893]: 102).

Tpr 9820/5/4, 5/5 Animal locomotion. Bird: transverse ascending flight of a pigeon. Enlarged chronophotograph, 1886.

Catalog 2: Original Chronophotographic and Photographic Experiments

This catalog lists Marey's and Demeny's original negatives on glass and flexible film plates made at the Physiological Station between 1882 and 1901. They are arranged chronologically by technique, subject, and experiment. Apart from the exceptions noted in the location entry, the negatives are now in the archives of the Collège de France; unless otherwise indicated they are chronophotographs.

Key to Entries

Technique, subject, and number of negatives in each group; date; measurements of the negatives in centimeters (width × height); description, with publication data for single images in parentheses (figure numbers refer to this book); location

Abbreviations

I Chronophotographs made with the *fusil photographique* and single-shot photographic gun

II Chronophotographs and photographs made with fixed-plate cameras

D Experiment published by Demeny alone

CI Cinémathèque Française

AF Archives du Film, Centre National de la Cinématographie, Bois d'Arcy

M Musée Marey, Beaune

I1.1–5: 1882: 7.5 dia.: Movements of a wave, boats, a breakwater, a tower, a monument against the sea, and a view of roofs. Sequential images on circular plates taken in Naples in early spring 1882.

I2.1–3: 1882: 7.5 diam.: Flight of gulls taken at 1/720 second. Sequential images on octagonal plates taken in Naples in early spring 1882. **Fig. 31(A, B)**.

I3.1–15: 1882: 7.5 dia.: Horses pulling carriages. Sequential images on circular plates taken in Paris in early summer 1882. **Fig. 31(C)**.

I3.16: 1882: 12.5 × 9: Enlargement of a single image of a horse and carriage (*Développement de la méthode graphique*, 1885, 21).

I4.1–5: 1882: 4 × 4: Three instantaneous images of a gull and two of boats in the Bay of Naples, taken with a single-shot photographic gun, first version. **Fig. 30(B)**.

I5.1–4: 1887: 7.5 dia.: Flight of gulls. Sequential images on a collodion-gelatin emulsion made for Marey by Georges Balagny (*Vol des oiseaux*, 1890, 135).

Human Locomotion
H (Homme): Man

IIH1.1–20: 1883: 13 × 2.8: Walk and run. Chronophotographs taken with the first fixed-plate camera in the second black hangar while it was being constructed in summer 1883; the subjects are Demeny and an unidentified gymnast. In nos. 9–12 half of Demeny's body is covered in black cloth. **Figs. 42(B), 43, 44**: CI: 19–20

IIH2.1–9: 1883: 13 × 2.8: Walk, run, and jump. The first geometric chronophotographs taken in the second black hangar after its completion in late summer 1883. The subject is dressed in black but not hooded; wooden strips studded with metal buttons are attached to the arms and legs. No. 1 is reproduced in Marey's personal album in the Collège de France, page 29. **Fig. 46(B)**.

IIH3.1–7: 1883: 13 × 2.8: Walk, run, and jump. Chronophotographs taken in late summer 1883. A chronometric dial is visible in nos. 9 and 10. **Fig. 42(A, C)**: CI: 6, AF: 7

IIH4.1–14: 1883: 13 × 2.8: Run and jump. Geometric chronophotographs made in late summer 1883. Nos. 1–7 are marked with the subject's name, Roche (no. 14: *Revue Générale des Sciences* 2 [1891]: 703 [diagram]). **Fig. 54**.

IIH5.1–23: 1883: 18 × 3.5: Gymnastic and military movements. Series of images made by moving the plate horizontally behind the lens; the subjects are Demeny and an unidentified gymnast. **Fig. 47(A, B)**. CI: 3–23

IIH6.1–3: 1883: 13 × 3.3: Chronophotographs of a gymnast on parallel bars. **Fig. 47(C)**:[18] CI: 1–3

IIH7.1–16: 1884: 6 × 9: Walk and run. Geometric chronophotographs of Demeny and a gymnast named Pradelle dressed in black and hooded, with metal balls attached to head, shoulder, hip, and knee as well as strips of reflecting material along arms and legs. The subject is connected to the registering dynamometer in nos. 7, 8, and 11–16. **Fig. 58.**

IIH7.17: 1884: 8.4 × 9: Run, as above.

IIH8.1–28: 1884: 6 × 9: Various jumps. Geometric chronophotographs of Demeny and Pradelle dressed as above and connected to the inscribing dynamometer. Nos. 1, 3 and 12 are dated September 1884. **Fig. 57 (A, B, D).**

IIH8.29: 1884: 4.4 × 7.5: Jump, as above.

IIH9.1–4: 1886: 9 × 6.5: Walk and run up and down an incline. Geometric chronophotographs taken in front of the third black hangar; subjects Demeny, Morin, and Schenkel, dressed as above. **Fig. 62(D).**

IIH10.1–11: 1886: 9 × 6.5: Jump from an incline onto the ground or a pile of hay. Geometric chronophotographs; the subjects and arrangements are the same as those above.

IIH11.1–15: 1886: 9 × 6.5: Walk, run, and jump. Nine chronophotographs and six geometric chronophotographs of Morin, Schenkel, and Franck, dated 14 and 18 July 1886. **Fig. 62(A, B, C, E, F)**: CI: 8–15

IIH12.1–26: 1886: 9 × 6.5: Pathological locomotion. Geometric chronophotographs.

IIH13.1–15: 1886: 12 × 9: Fourteen instantaneous images of postures used to determine the center of gravity of the body in exercise and one instantaneous image of Demeny on a slant board.

IIH14.1–11: 1887: 13 × 9: Walk, run, and jump. Chronophotographs taken from overhead. In no. 3 the subject is in an apparatus to trace the vertical and horizontal axes of the body. **Fig. 80(A)**: CI: 11

IIH15.1–9: 1887–88: 12 × 9: Demeny playing the violin. Chronophotographs made by moving the plate behind the lens. **Fig. 82(A).**

IIH15.10–16: 1887–88: 9 × 6.6: Demeny playing the violin. Chronophotographs of bowing movements.

IIH16.1–2: 1888: 12 × 9: Walk and jump. Chronophotographs taken with oscillating-mirror camera. **Fig. 85.**

IIH17.1–15: 1887: 12 × 9: Pathological locomotion. Chronophotographs of a single subject whose joints are marked with incandescent bulbs. **Figs. 60(B), 182(B).**

IIH18.1–15: 1888–89: 13 × 18: Pathological locomotion; geometrical chronophotographs taken at the Beaujon Hospital in January and February 1888 and at the Hôtel-Dieu Hospital in March and April 1889; the patients' joints are marked with incandescent bulbs. **Fig. 60(C).**

IIH19.1–2: 1890: 12 × 9: Infant walking.

IIHD20.1–11: 1890–91: 12 × 9: Boxing and fencing movements and movements with a staff. The black hangar has been floored with cobblestones, and black and white wooden blocks mark off its front edge; the subjects are Sandoz (a Joinville boxer) and an unidentified gymnast (no. 2: Demeny, *La Nature*, 11 April 1891, 296; no. 5: ibid., 31 January 1891, 136 [drawing]; no. 6: ibid., 11 October 1890, 289). **Fig. 145.**

IIH21.1–7: 1890–91: 12 × 9: Jump. Same subjects as above. **Fig. 64(F, G).**

IIH22.1–13: 1890–91: 12 × 9: Walk and run. Same subjects as above. **Fig. 64(A, B).**

IIH23.1–9: 1890–91: 12 × 9: Walk, run, and jump. Chronophotographs of a single gymnast: CI: 6–9

IIH24.1–8: 1890–91: 12 × 9: Jump, pole vault, and run. Chronophotographs of a single subject from a gymnastic society (nos. 3, 4: *Revue Générale des Sciences* 2 [1891]: 702). **Fig. 64(H, I)**: CI: 6–8

IIH25.1–15: 1890–91: 12 × 9: Walk, run, jump, and hop. Chronophotographs of a single gymnast. **Fig. 64(C, D, E)**: CI: 8–15

IIHD26.1–5: 1890–91: 13 × 18: Jump. Instantaneous photographs of a single gymnast. CI: 1–5

IIH27.1–6: 1890–91: 12 × 9: Swinging from a rope. Chronophotographs of a single gymnast. **Fig. 64(J, K).**

IIH28.1–18: 1891–92: 12 × 9: Walk and run. Chro-

18. A lost negative belonging to this experiment was enlarged and printed by Paul Nadar; the print is no. G68164 in the Bibliothèque Nationale.

nophotographs and one instantaneous image of soldiers from Joinville with backpacks. **Fig. 63(B, C, D)**.

IIH29.1–2: 1891: 12 × 9: Walk and run, Sandoz, nude (*Revue Générale des Sciences* 2 [1891]: 691, 692). **Fig. 94(A)**.

IIH30.1–15: 1891: 12 × 9: Bicycling and pushing a cart. **Fig. 116(A, B, C)**: CI: 3–15

IIHD31.1–64: 1891: 12 × 9: Wrestling. Instantaneous images.

IIHD32.1–14: 1891: 12 × 9: Gymnastic exercise. Instantaneous photographs of exercises for thoracic muscles and for breathing (Demeny, *Les bases scientifiques de l'éducation physique* [Paris: Alcan, 1893], 123 [drawings]).

IIHD33.1–14: 1891: 12 × 9: Gymnastic exercises. Instantaneous photographs of children (Demeny, *Bases scientifiques de l'éducation physique*, 1893, 242 [drawings]).

IIHD34.1–5: 1892: 13 × 18: Gymnastic exercises with apparatus. Instantaneous images of children (no. 1: Demeny, *Guide du maître chargé de l'enseignement des exercices physiques dans les écoles publiques* [Paris: Lamarre, 1899], 104; no. 2: Demeny, *Mécanisme et éducation des mouvements* [Paris: Alcan, 1903], 183). **Fig. 35(B)**: CI: 4–5.

IIHD35.1–7: 1892: 25 × 18: Gymnastic movements and movements with a staff. Each plate contains two instantaneous images of a child.

IIHD36.1–2: 1892: 13 × 18: Gymnastic postures, seated. Instantaneous images belonging to the series above: CI: 1–2

IIHD37.1–4: 1892: 13 × 18: Stretching and swimming movements. Instantaneous images: CI: 2–4

IIHD38.1–7: 1892: 25 × 18: Gymnastic, boxing, and lunging movements. Each plate contains two instantaneous images of a single gymnast.

IIHD39.1–27: 1892: 13 × 18: Boxing movements and movements with a staff. Instantaneous images: CI: 10–27

IIHD40.1–73: 1892: 13 × 18: Stretching exercises with partners. Instantaneous images: CI: 61–73

IIHD41.1–9: 1892: 13 × 18: Movements of the hand. Instantaneous images: CI: 9

IIHD42.1–9: 1892: 13 × 18: Exercise on parallel bars. Instantaneous images of a single gymnast: CI: 1–9

IIHD43.1–21: 1892: 13 × 18: Portraits of male athletes and gymnasts. Instantaneous images: CI: 18–21

IIH44.1–16: 1893: 9.5 × 9: Movements of the head and arm. Chronophotographs on flexible film plates: M: 9–16

IIH45.1–6: 1893: 9 × 7.5: Movements of the jaw and joints. Geometric chronophotographs on flexible film plates. **Fig. 93**: M: 2–6

IIH46.1–5: 1894: 9 × 7.5: Respiration. Chronophotographs on flexible film plates.

IIH47.1–11: 1894: 13 × 18: Bicycling. Six instantaneous images of dynamometric bicycles and five instantaneous images of the bicycles in use. **Fig. 117(B)**: CI: 1–11

IIH48.1–3: 1895: 13 × 18: Bicycling. On the "home trainer." **Fig. 117(A)**: CI: 1–3

IIH49.1–8: 1895: 12 × 9: Tricycling. Instantaneous images: CI: 1–8

IIH50.1–16: 1895: 12 × 9: Military paces: ordinary and flexioned march and run. One instantaneous image and fifteen geometric chronophotographs of Regnault, Duval, de Raoul, and others dated June and July 1895. A chronometric dial is visible in the pictures, surmounted by a letter designating the pace. **Fig. 94(C, D, E)**: CI: 14–16

IIH51.1–9: 1895: 12 × 9: Military paces: run. One instantaneous image, one chronophotograph, and eight geometric chronophotographs of a single subject from Joinville. Chronometric dial as above: CI: 9

IIH52.1–6: 1895: 12 × 9: Military paces: Run. One instantaneous image and five geometric chronophotographs of a single subject from Joinville. Chronometric dial as above.

IIH53.1–7: 1895: 12 × 9: Walking up and down an incline. Geometric chronophotographs. Chronometric dial as above: CI: 3–7

Animal Locomotion

Bu (Buffle): Water Buffalo

IIBu1.1–2: 1887: 12.5 × 8: Instantaneous images of a water buffalo and its keeper with Marey.

IIBu2.1–3: 1887: 9 × 6.5: Locomotion of a water buffalo. **Fig. 70(C)**.

C (Cheval): Horse

IIC1.1: 1882: 8 × 4: Gallop, mounted. Chronophotograph taken against the first black background.

IIC2.1: 1883: 13 × 4: Instantaneous image of a horse mounted by a rider dressed in black and hooded.

IIC3.1–8: 1883: 13 × 4.5: One instantaneous image of a mounted horse marked with white papers and seven geometric chronophotographs of the horse and rider in motion taken against the second black background.

IIC4.1–20: 1885: 9 × 6.5: Three instantaneous images of a mounted horse and seventeen geometric chronophotographs of the horse in motion. **Fig. 68(A, B)**.

IIC5.1–10: 1885: 9 × 6.5: Walk, trot, canter, and gallop, legs only. **Fig. 67(A)**.

IIC6.1–2: 1885: 9 × 6.5: Gallop, mounted. Instantaneous images made at 1/1,000 second. **Fig. 65(E)**.

IIC7.1–12: 1885–86: 9 × 6.5: Two instantaneous images of a mounted white horse and ten chronophotographs of the horse in motion. **Fig. 66**.

IIC8.1–17: 1886: 9 × 6.4: Walk (nos. 1–8), trot (nos. 9–12), and gallop (nos. 13–17), mounted. Geometric chronophotographs. The gait and the number of images per second are noted on the negatives.

IIC9.1–18: 1886: 8.8 × 6.5: Walk (nos. 1–4), trot (nos. 5–11), and gallop (nos. 12–18), unmounted. Geometric chronophotographs. The gait and the number of images per second are noted on the negatives. **Fig. 68(C, D)**.

IIC10.1–8: 1886: 9 × 6.5: Walk, trot, and gallop, unmounted. Geometric chronophotographs. The gait and number of images per second are noted on the negatives.

IIC11.1–2: 1886: 12 × 9: Instantaneous images of a mounted and unmounted dark horse marked with white papers on joints.

IIC12.1–9: 1887: 9 × 5.5: Four instantaneous images and five chronophotographs of horses with riders in Arab costume, taken with Albert Londe. **Fig. 69(A)**.

IIC13.10: 1887: 12 × 9: Locomotion of horse with rider in Arab costume.

IIC14.1–9: 1896: 12 × 9: Three instantaneous images and six chronophotographs of a maquette of the skeletal structure of a horse (no. 3: *C.R. Congrès des Sociétés Savants, Revue des Travaux Scientifiques, Section des Sciences*, 1897, 139).

Cn (Chien): Dog

IICn1.1–12: 1894: 9.5 × 9: Movements of the joints of a dog. Chronophotographs taken on flexible film plates: M: 1–12

E (Eléfant): Elephant

IIE1.1–8: 1887: 12.5 × 9: Instantaneous images of two elephants, mounted. **Fig. 70(A)**.

IIE2.1–8: 1887: 9 × 6: Locomotion of an elephant. Geometric chronophotographs. **Fig. 70(B)**.

G (Grenouille): Frog

IIG1.1–8: 1888: 9 × 12: Locomotion of a frog. Chronophotographs taken with oscillating-mirror camera.

O (Oiseau): Bird

IIO1.1: 1887: 12 × 9: Cockatoo, transverse flight.

IIO2.1: 1886: 9 × 6.5: Duck, transverse flight.

IIO2.2–5: 1887: 9 × 13: Duck, transverse flight.

IIO2.6: 1887: 9 × 8.5: Duck, transverse flight; continuation of series above. **Fig. 74(G)**.

IIO2.7–8: 1888: 12 × 9: Duck, flight toward the axis of the camera. Chronophotograph taken by moving the lens horizontally behind the plate. **Fig. 82(B)**.

IIO2.9: 1888: 13 × 9: Duck, transverse flight; hangar marked off at half-meter intervals by vertical white lines. **Fig. 74(H)**.

IIO2.10–14: 1888: 9 × 13: Duck, transverse flight; hangar marked off as above.

IIO2.15: 1888: 9 × 11.5: Duck, transverse flight, hangar marked off as above.

IIO3.1–14: 1886: 9 × 6.5: Gull, transverse and oblique flight. **Fig. 74(A, B, C)**.

IIO3.15: 1886: 11 × 9: Gull, ascending flight. **Fig. 166(B)**.

IIO3.16–19: 1887: 13 × 9: Gull, transverse flight.

IIO3.20: 1887: 12.5 × 9: Gull, flight, taken from overhead. **Fig. 76(E)**.

IIO3.21–23: 1887: 12 × 9: Sculptures representing the flight of a gull. Instantaneous images. **Fig. 78(B)**.

IIO4.1: 1888: 9 × 7.5: Small gull (*mouette*), transverse flight; hangar marked off at half-meter intervals by vertical white lines.

IIO4.2–6: 1888: 13 × 9: Small gull, transverse flight; hangar marked off as above.

IIO4.7: 1888: 9 × 13: Small gull, transverse flight; hangar marked off as above.

IIO5.1–4: 1886: 9 × 6.5: Heron, transverse flight and landing.

IIO6.1: 1886: 9 × 6.5: White heron, transverse flight.

IIO7.1–4: 1886: 9 × 6.5: Crested heron, transverse flight, ten images per second. CI: 4

IIO8.1: 1886: 9 × 6.5: Owl, transverse flight.

IIO9.1–2: 1887: 12 × 9: Pelican, transverse flight. **Fig. 74(E)**.

IIO10.1: 1887: 10.5 × 9: Pigeon, transverse flight, taken with double-lens camera. **Fig. 74(F)**.

IIO10.2–3: 1888: 12 × 9: Pigeon, transverse ascending flight; the third black hangar is marked off at half-meter intervals by vertical white lines. **Fig. 78(A)**.

IIO10.4–5: 1888: 13 × 9: Pigeon, transverse flight; hangar marked off as above.

IIO10.6–7: 1888: 13 × 9: Instantaneous images of sculptures representing the flight of a pigeon (no. 1: *La Nature*, 5 December 1887, 12).

P (Poisson): Fish

IIP1.1–14: 1888: 9 × 12: Locomotion of fish. Chronophotographs taken with oscillating-mirror camera. **Fig. 84(C)**.

IIP2.1–17: 1888: 9 × 12: Locomotion of eel. Chronophotographs taken with oscillating-mirror camera. **Fig. 84(B)**: CI: 16–17

Various Subjects
A (Anatomie): Anatomy

IIA1.1–6: 1888: 12 × 9: Instantaneous images of frog muscle.

IIA2.1–30: 1898: 12 × 10: Instantaneous images of human and animal skulls.

IIA3.1–5: 1898: 12 × 10: Movement of the jaw. Geometric chronophotographs of a prepared skull.

Ai (Aile): Artificial Wing

IIAi1.1–4: unknown: 9 × 6.5: Trajectories of the movements of the wing of an artificial insect.

IIAi2.1–25: unknown: 9 × 12: Trajectories made by an incandescent bulb, related to the study of the insect wing.

IIAi3.1–10: unknown: 12 × 9: Trajectories of a flexible rod surmounted by a metal ball, related to the study of the insect wing.

IIAi4.1–28: unknown: 10 × 8: Trajectories of a flexible structure surmounted by a metal ball, related to the study of the insect wing and marked *aile* (wing).

Ai5.1–3: 1894: 10 × 8.5: Instantaneous images of insects' wings.

B (Balistique): Ballistics

IIB1.1–11: 1886: 9 × 6.5: Trajectories of a single ivory ball (nos. 1–4), a baton (nos. 5–6), two ivory balls (nos. 7–11), thrown across the black hangar. **Fig. 71(A)**.

IIB2.1–7: 1887: 13 × 9: Trajectories described by balls ejected from a miniature catapult. Chronophotographs taken at fifty images per second.

IIB3.1–2: 1888: 12 × 9: Trajectories of a ball and a baton, and of two balls of unequal diameter joined together thrown across the black hangar; vertical lines divide the space of the hangar. **Fig. 71(B)**.

IIB4.1–4: 1887: 12 × 9: Demeny dropping a disk from a ladder.

IIB5.1–4: 1887: 12 × 9: Marey dropping a baton from a ladder. **Fig. 72(A)**.

IIB6.1–6: 1888: 12 × 9.5: Parabolas engendered by the motion of a ball attached to a string.

IIB7.1: 1890: 9.5 × 9: Trajectory of a ball thrown across the black hangar.

IIB8.1–5: 1890: 9 × 8.4: Fall of a ball, taken in Naples. Chronophotographs on flexible film plates (no. 1: *Paris-Photographe* 3 [1893]: 96). **Fig. 72(B)**: M: 1–5

F (Fumées): Aerodynamics[19]

IIF1.1–9: 1900: 9 × 12: Instantaneous images of fillets of smoke ventilated through a box and moving around a plane set at different angles. **Fig. 122.**

IIF2.1–24: 1901: 5 × 10: Instantaneous images of fillets of smoke aspirated through a box and moving around figures of different shapes. The negatives are numbered on the emulsion side.

IIF2.25–33: 1901: 5 × 10: Instantaneous images of vibrating fillets of smoke; continuation of series above.

IIF3.1–12: 1901: 9 × 12: Instantaneous images of fillets of smoke aspirated through a box and moving around figures of different shapes; a meter bar marks the side of the box.

IIF3.13: 1901: 9 × 12: Instantaneous image of vibrating fillets of smoke; continuation of series above.

IIF4.1–11: 1901: 8.5 × 12: Instantaneous images of fillets of smoke aspirated through a box.

IIF4.12–15: 1901: 8.5 × 12: Instantaneous images of vibrating fillets of smoke; continuation of series above.

G (Géométrie): Geometry

IIG1.1–20: 1891–92: 8.5 × 7.8: Geometric figures engendered by the movement of a string. Chronophotographs on flexible film plates. **Fig. 170(A):** M: 1–20

IIG2.1–22: 1891–92: 8.5 × 7.8: Geometric figures engendered by the movement of a strip of bristol board. Chronophotographs of flexible film plates: M: 1–22

L (Liquides): Liquids

IIIL1.1–4: 1893: 9 × 7.5: Movements of liquids. Chronophotographs taken on flexible film plates: M: 1–4

M (Mécanique): Mechanics

IIM1.1–2: 1892: 9 × 7.5: Movement of an oscillating rod in a model boat. Chronophotographs taken on flexible film plates.

S: Station Physiologique
(All are instantaneous images)

IIS1.1–6: 1882–83: 13 × 18: Main chalet under construction: CI: 1–6

IIS1.7: 1887: 9 × 12: Second black hangar painted white. CI: 1

IIS2.1: 1900: 9 × 12: Institut Marey: CI: 1

V: Various Negatives Made from Films

IIV1.1–4: 1889–90: 13 × 18: Horse: walk, trot and gallop. Rephotographed film images. **Fig. 89.**

IIV1.5: 1889–90: 13 × 18: Horse: walk. Filmed images cut apart and mounted on a glass plate.

IIV2.1–2: 1893: 13 × 18: Eel, spider, scorpion: locomotion. Rephotographed film images (*La Nature*, 2 September 1893, 217).

IIV3.1: 1894: 12 × 9: Cat: walk. Drawing made from film CT 1 below.

IIV4.1–7: 1894: 12 × 9: Sheep: walk and trot, rear leg. Drawings of the rear skeleton superimposed on drawings made from films in series M below (no. 3: *C.R. du Congrès des Sociétés Savantes: Revue des Travaux Scientifiques*, 1897, 137).

IIV5.1–11: 1894: 12 × 9: Dog. Rephotographed films from series Cn below.

IIV5.12: 1894: 12 × 9: Dog: walk, rear leg. Drawing made from film. *C.R. du Congrès des Sociétés Savantes: Revue des Travaux Scientifiques*, 1897, 135).

IIV6.1–2: 1894: 12 × 9: Horse: walk. Rephotographed films from series C below.

IIV7.1–6: 1895: 13 × 18: De Raoul, military paces. Drawings made from films H15–17, 27, and 31 below. **Fig. 103(A).**

IIV8.1–15: 1898: 13 × 18: Horse: walk, trot, and gallop. Drawings made from films of the rear skeleton superimposed on the rear leg (no. 8: *La Chronophotographie*, 1899, 37).

19. Eight negatives by H. Hele Shaw, University of Liverpool, were found with these aerodynamic studies (see p. 409, n. 38). Hele Shaw introduced planes of different shapes into tubes of colored glycerin compressed pressed between two sheets of glass. His images were published in Lucien Bull, "Des mouvements invisibles," *La Nature*, 7 September 1901, 248.

Catalog 3: Films

This catalog lists original chronophotographic experiments on collodion-gelatin and nitrate film made between 1891 and 1902 by Marey assisted by Demeny (for the group Hj and Hp), Lucien Bull (for the films of athletes at the 1900 Olympics), and Félix Regnault (for the films made at the African Village at the 1900 Universal Exposition). Films marked AF are in the Archives de Film, Centre National de la Cinématographie, Bois d'Arcy; those marked L are in the Science Museum, London; those marked T are in the Photography Humanities Research Center, University of Texas. Otherwise the films are in the museum of the Cinémathèque Française. The films were originally cataloged by Lucien Bull and, except for those donated to the Centre National de la Cinématographie, were given by Bull to the different collections in the late 1950s and early 1960s. In 1987 the Cinémathèque Française had its films copied and printed; at that time they were recataloged by Olivier Meston of the Cinémathèque. I have dated the films according to the information given by Bull and from material found in Marey's letters, publications, and bills.

Key to Entries

Letter assigned by Lucien Bull, with location; description, with subject and date (figure numbers refer to this book); approximate number of images; images taken vertically (V) or horizontally (H) on band; width of images, in millimeters. A dash means information was not available.

Abbreviations

C Chronometric dial can be seen in the image

R Subject is Rousselet, who, according to receipts found at the Institut Marey, was paid for his work in 1892 and 1893

P Original positive print on paper

Human Locomotion H (*Homme*)
H: Man

H 1: Run, nude, 1891: 7: V: 86

H 2: Run, nude, 1891: 11: V: 86

H 3: Run, nude, 1892, C, R: 9: H: 86

H 4: Run, nude, 1892, C, R: 11: H: 85

H 5: Run, nude, 1892, C, R: 18: H: 86

H 6: Run, legs only, 1893: 20: V: 86

H 7: Run, legs only, 1893: 22: V: 86

H 8: Run, legs only, 1893: 13: V: 86

H 9: Run, Legs only, 1893: 22: V: 86

H 10: Run, Legs only, 1893: 27: V: 86

H 11: Run, Joinville, 1892: 12: V: 86

H 12: Run, Joinville, 1892: 18: V: 87

H 13: Run, with gun and sack, Joinville, 1892: 20: V: 87

H 14: Run, with gun and sack, Joinville (two men), 1892: 27: V: 87

H 15: Flexioned run, de Raoul, 1895, C: 18: V: 87

H 16: Flexioned run, de Raoul, 1895, C: 12: V: 87

H 17: Flexioned run, de Raoul, 1895, C: 12: V: 86

H 18: Run, nude, 1893, C: 13: H: 86

H 19: Run, 1894, C: 32: V: 87

H 20: Run, de Lostalot, 1894: 12: V: 87

H 21: Run, long steps, 1894: 14: V: 89

H 21 bis: Run, subject in striped sweater, 1894, C: 16: V: 86

H 22: Walk, nude, 1893, 1893, C, R: 31: H: 85

H 23: Walk, nude, 1893, C, R: 21: H: 86

H 24: Walk toward camera, nude, 1893, R: 23: H: 85

H 25: Walk away from camera, nude, 1893, R: 20: H: 85

H 26: Walk, nude, 1893, R: 21: V: 84

H 27: Walk, military step, de Raoul, 1895, C: 25: V: 86

H 28: Walk, normal, 1895, C: 26: V: 87

H 29: Walk, normal, 1895, C: 33: H: 86

H 30: March, with sword, 1892: 17: V: 84

H 31: Flexioned march, de Raoul, 1895, C, **fig. 103(B)**: 16: V: 86

H 32: Flexioned march, two men, Joinville, 1892: 18: V: 87

H 33: March, legs only, 1893, C: 26: V: 86

H 33 bis: March, legs only, 1893: 24: V: 89

H 34: Walk up an inclined plane, 1894, C: 16: V: 87

H 34 bis: Walk up an inclined plane, 1894, C: 18: V: 87

H 35: Walk down an inclined plane, 1894, C: 12: V: 87

H 36: Climbing stepladder, nude, 1893, R: 21: V: 83

H 37: Walk, legs only, 1893: 21: V: 83

H 38: Run, two men, 1893: 20: V: 87

HAF 1: Walk nude, 1892, P: 12: H: 80

HAF 2: Walk, nude, from behind, 1893, R: 10: H: 86

HAF 3: Walk, nude, from behind, 1893, R, C: 36: H: 85

HAF 4: Run, nude, 1892, R, C: 19: H: 86

HL 1: Run, nude, 1892: 14: H: 85

HL 2: Walk, nude, 1892, R, C: 30: H: 85

HL 3: Flexioned walk, de Raoul, 1895: 14: V: 87

Ha: Male Athletes

Ha 1: Arm movements, nude, 1893, R: 20: H: 84

Ha 1 bis: Movements with baton, nude, 1893, R: 19: H: 83

Ha 1 ter: Blowing into pipe, nude, 1893, R: 24: H: 83

Ha 2: Climbing on chair, nude, 1893, R: 4: H: 83

Ha 3: Lifting arms, nude, 1893, R: 5: H: 84

Ha 4: Pulling on rope, nude, 1892, R: 23: H: 82

Ha 5: Planting stake, nude, 1893, R: 15: H: 84

Ha 6: Throwing stone, nude, 1892: 22: H: 85

Ha 7: Pulling load, 1894: 14: V: 87

Ha 7(1): Pulling load, 1894: 13: V: 87

Ha 7(2): Pulling load, 1894: 11: V: 87

Ha 7 bis(1): Pushing load, 1894: 16: V: 87

Ha 7 bis(2): pushing load, 1894: 14: V: 87

Ha 8: Throwing discus, 1900, **fig. 118(B)**: 26: V: 88

Ha 9: Throwing discus, member of Racing Club, 1900, **fig. 118(A)**: 23: V: 88

Ha 10: Throwing discus, McCracken, American, 1900, **fig. 118(C)**: 38: V: 88

Ha 11: Shot put, McCracken, 1900: 45: V: 88

Ha 12: Shot put, Sheldon, world champion, 1900: —: — : —

Ha 13: Shot put, member of Racing Club, 1900: 23: V: 89

Ha 14: Shot put, member of Racing Club, 1900: 36: V: 89

Ha 15: Shot put, docker, 1900: 29: V: 88

Ha 16: Shot put, docker, incorrect throw, 1900: 40: V: 88

Ha 17: Swiss wrestlers, 1900: 62: V: 89

Ha 18: Belly movements, Sheldon, 1900: 37: H: 88

Ha 19: Hurdling at Racing Club, 1900: 14: V: 89

Ha 20: Hurdling at Racing Club, 1900: 19: V: 88

Ha 21: Hurdling at Racing Club (two hurdlers), 1900: 19: V: 89

Ha 22: Hurdling (two hurdlers), 1900: 40: V: 89

Ha 23: Long jump, by Sweeney at Physiological Station, 1900: 28: V: 89

Ha 24: Long jump, 1891: 42: H: 84

Ha 25: Long jump 1891: 34: H: 84

Ha 26: High jump, feet together, nude, 1892, C, R: 29: H: 85

Ha 27: High jump, feet together, 1895: 31: V: 87

Ha 28: High jump, feet together, nude, 1893, R: 11: V: 86

Ha 29: High jump, feet together, 1894: 20: V: 85

Ha 30: High jump, Sweeney at Racing Club, 1900: 26: V: 88

Ha 31: High jump, Sweeney at Racing Club, 1900: 22: V: 88

Ha 32: High jump, American at Physiological Station, 1900: 24: V: 88

Ha 33: High jump, Schonfield, American, 1900: 24: V: 88

Ha 34: Somersault, 1891: 40: H: 85

Ha 34 bis: Somersault, 1891: 40: H: 84

Ha 35: Skipping rope, 1892: 21: H: 85

Ha 36: Throwing discus, nude, 1892, R: 24: V: 82

HaAF 1: Lifting weights, Sandow[20]: 53: H: 88

HaAF 2: High jump: 14: V: 85

HaAF 3: Swiss wrestlers, 1900, C: 60: V: 89

HaAF 4: High jump, P: 13: V: 83

HaAF 5: Long jump, P: 23: V: 83

HaAF 6: Throwing weight, P: 6: V: 90

HaAF 7: Shot put, 1900, C: 18: V: 87

HaAF 8: Striking with pick, 1892: 30: V: 55

HaAF 9: High jump, 1893, R, C: 27: H: 85

HaAF 10: Athlete: 4: —: 88

HaL 1: Lifting weights, Sandow: 30: H: 90

HaL 2: Lifting weights, Sandow, 1901: 17: H: 90

HaL 3: High jump, Sweeney, 1900: 26: V: 90

HaL 4: High jump, feet together, Ewry, American, 1900: 28: V: 90

HaL 5: High jump, Bull, 1900: —: V: 90

HaL 6: Long jump, Kranslein, 1900: 26: V: 90

HaL 7: Shot put, Sheldon, 1900: 39: V: 90

HaL 8: Hurdling, Kranslein, 1900: 24: V: 88

HaT 1: Striking with pick, nude, 1892: —: H: 85

HaT 2: Jump, nude, 1892: —: —: —

Hc: Bicycling
(1894)

Hc 1: Bicycling, nude: 23: H: 87

Hc 2: Bicycling, nude: 27: H: 87

Hc 3: Bicycling, nude: 27: H: 87

Hc 4: Bicycling, nude: 25: H: 87

Hc 5: Bicycling, nude: 26: V: 86

Hc 6: Bicycling, nude: 26: V: 86

Hc 7: Bicycling, moving toward camera: 50: H: 56

Hc 8: Tricycling: 7: H: 86

Hc 8 bis: Tricycling, **fig. 116(D)**: 4: H: 85

Hc 9: Tricycling: 45: H: 56

HcAF 1: Bicycling, nude, 1891, C: 26: H: 85

HcAF 2: Bicycling, nude, 1892, R: 25: H: 85

HcAF 3: Bicycling, nude: 32: V: 85

Hd: Human Locomotion, Various Types

Hd 1: Gymnast on rings, 1892: 12: H: 87

Hd 1 bis: Gymnast on rings, 1892: 13: H: 87

Hd 2: Boxing, nude, rear view, 1892, R: 23: H: 85

Hd 3: Respiration, nude, profile, 1893, R: 20: H: 83

Hd 4: Respiration, 1893, R: 23: H: 83

Hd 5: Respiration, front view, 1893, R: 18: H: 83

Hd 6: Descending an inclined plane, 1894, C: 32: V: 88

Hd 7: Lifting dumbbells, 1892: 16: H: 88

Hd 8: Lifting dumbbells, nude, 1893, R: 20: H: 86

Hd 9: Lifting dumbbells, nude, 1893, R: 20: H: 83

Hd 10: Throwing javelin, nude, 1892, R: 23: H: 84

Hd 11: Throwing javelin, nude, 1892, R: 20: H: 83

Hd 12: Throwing brick, nude, ,1892, R: 22: H: 84

Hd 13: Throwing brick, nude, 1892, R: 22: H: 83

Hd 14: Picking up and throwing ball, nude, 1892, R: 25: V: 84

Hd 15: Swinging ax, 1892: 18: H: 86

Hd 16: Swinging ax, 1892: 19: H: 86

Hd 17: Shoveling, nude, 1892, R: 23: H: 84

Hd 18: Shoveling, nude, 1892: 5: V: 83

Hd 19: Shoveling, 1892: 18: H: 86

Hd 20: Driving stake, nude, 1893, R: 23: H: 84

Hd 21: Snapping whip, nude, rear view, 1892, R: 19: H: 83

Hd 22: Snapping whip, nude child, front view, 1892: 22: V: 84

Hd 23: Pulling on rope, nude, 1893, R: 22: H: 84

Hd 24: Housepainter: 25: H: 87

Hd 25: Climbing tree, Joinville, 1892: 17: H: 87

Hd 25 bis: Climbing tree, Joinville, 1892: 17: H: 87

Hd 26: Smoking, Demeny, 1893: 17: H: 85

Hd 27: Two men in conversation, 1893: 11: H: 85

Hd 28: Shot put, 1900, C: 25: V: 88

HdL 1: Striking with ax, 1892: 26: H: 85

20. Eugene Sandow was a famous strongman, also filmed by Thomas Edison and W. K. L. Dickson.

HdL2: Rowing, two oarsmen, 1890: 7½: H: 85

HdL 3: Rowing, **fig. 95(A)**: 24: V: 85

HdAF 1: Rowing, two boats, Naples, 1890: 12: H: 85

HdAF 2: Lifting weights, 1893: 156: H: 85

HdAF 3: Rolling wheel, nude, 1892: 24: H: 80

He: Fencing
(All the images were taken in Naples in 1890)

He 1: Fencers: 18: V: 85

He 2: Fencers: 8: V: 85

He 3: Fencers: 13: V: 85

He 4: Fencers: 20: V: 87

He 5: Fencers: 8: V: 85

He 6: Fencers: 28: V: 85

He 7: Fencers: 19: V: 85

HeAF 1: Fencers: 10: V: 85

HeL 1: Fencers, **fig. 95(B)**: 19: V: 85

Hj: Games
(1892)

Hj 1: Skipping rope, girl, 1892: 24: V: 84

Hj 2: Playing with ball, nude boy, 1892: 23: V: 85

Hj 3: Throwing ball, nude boy, 1892: 12: V: 85

Hj 4: Playing paddleball, nude boy, 1892: 21: V: 85

Hj 5: Run, nude (beginning), 1892, R: 15: V: 83

Hj 6: Run, nude child, front view, 1892: 23: H: 83

Hj 6 bis: Run, nude child, front view, 1892: 9: H: 83

Hj 7: Run and return, nude child, 1892: 22: V: 84

Hj 8: Man, picking up child, nude, 1892[21]: 21: V: 85

Hj 9: Group of women and children, 1892: 7: V: 88

HjAF 1: Standing up, nude child, 1892: 20: H: 87

HjAF 2: Juggling with baton, man, 1890: 10: H: 85

Hm: Movement of Limbs

Hm 1: Arm flexion and extension, nude, 1892, R: 22: H: 83

Hm 2: Arm, flexion and extension, 1891: 14: V: 86

Hm 3: Arm, flexion and extension, 1891 (Demeny, *CRAS* 113 [1891]: 658): 15: V: 86

Hm 4: Arm, flexion and extension, 1891, **fig. 94(B)**: 13: V: 86

Hm 5: Arm, flexion and extension, 1891: 35: V: 59

Hm 6: Arm, flexion and extension, 1891: 14: V: 86

Hm 7: Arm, hitting table with awl, 1891: 31: V: 56

Hm 8: Foot, flexion and extension, 1891: 17: H: 88

Hm 9: Foot, flexion and extension, 1891: 21: V: 43

Hm 10: Hand, opening and closing, 1893: 19: H: 16

Hm 11: Hand, opening and closing, 1893

Hm 12: Hand of magician, opening and closing, 1893: 22: H: 85

Hm 13: Hands of magician, opening and closing, 1893, **fig. 109(A)**: 19: H: 85

Hm 14: Hand, opening and closing, 1893: 20: H: 83

Hm 15: Making a fist, 1892, R: 19: H: 84

Hm 16: Hand, writing "Demeny," 1893: 10: H: 86

Hm 17: Hand, writing "Demeny," 1893: 12: H: 85

Hn: People of the African Village at the Universal Exposition of 1900

Hn 1: Walk, man: 20: V: 88

Hn 2: Walk, man, C: 38: V: 87

Hn 3: Walk, man, C: 35: V: 87

Hn 4: Walk, man, C: 22: V: 88

Hn 5: Rapid walk, man, C: 37: V: 87

Hn 6: Walk, legs only: 23: V: 86

Hn 7: Walk: 23: V: 86

Hn 8: Walk, two men: 19: V: 87

Hn 9: Walk, two men, C: 38: V: 87

Hn 10: Walk, three men, C: 30: V: 88

Hn 11: Walk, three men, C: 32: V: 88

Hn 12: Walk, woman: 19: V: 87

21. In a letter to Demeny written 10 August 1892, Marey rejected this film out of hand because "the large man with long hair who runs up to the child has the air of a pederast about to drag away his victim." Cinémathèque Française.

Hn 13: Walk, woman: 22: V: 87

Hn 14: Walk, woman with child on back: 47: V: 87

Hn 15: Walk, woman with child on back, C: 30: V: 87

Hn 16: Walk, group of children: 26: V: 87

Hn 17: Walk, child, C: 44: V: 87

Hn 18: Walk, group of children: 20: V: 87

Hn 19: Run, slow and fast, man, C: 24: V: 87

Hn 20: Run, man: 15: V: 87

Hn 21: Run, man, C: 28: V: 87

Hn 22: Run, man, long steps: 20: V: 87

Hn 23: Run, man, C: 30: V: 87

Hn 24: Run, man: 13: V: 88

Hn 25: Run, man: 22: V: 86

Hn 26: Slow run, man: 23: V: 86

Hn 27: Slow run, man: 20: V: 87

Hn 28: Fast run, man, C: 36: V: 87

Hn 29: Run, legs only: 18: V: 86

Hn 30: Run, legs only: 13: V: 85

Hn 31: Run, two men, one stops: —: —: —

Hn 32: Fast run, child, C: 31: V: 80

Hn 33: Jump, three men, C: 32: V: 87

Hn 34: Palanquin bearer, rear view: 23: V: 87

Hn 35: Slow run, with palanquin: 26: V: 87

Hn 36: Fast run, two men with palanquin: 23: V: 87

Hn 37: Climbing, Gambian: 26: H: 87

Hn 38: Climbing, Gambian: 20: H: 87

Hn 39: Climbing, Gambian: 15: H: 87

Hn 40: Run, three children: 28: V: 87

Hn 41: Run, three children: 22: V: 87

Hn 42: Walk, woman carrying child on head: 27: V: 87

Hn 43: Walk, woman carrying child on head: 24: V: 87

Hn 44: Walk, woman with calabash: 22: V: 87

Hn 45: Pounding, woman: 31: H: 88

HnAF 1: Run, C: 36: V: 87

HnAF 2: Fast walk, Félix Regnault, C: 37: V: 85

HnAF 3: Walk: 21: V: 85

HnAF 4: Walk: 19: V: 85

HnAF 5: High jump: 26: V: 90

HnAF 6: Walk, woman carrying calabash on head: 26: V: 85

HnL 1: Slow run: —: V: 85

Hp: Movements of Speech
(1891–92)

Hp 1: Speaking, Demeny, **fig. 106(A)**: 36: H: 57

Hp 2: Speaking, unidentified boy, **fig. 105(B)**: 34: H: 56

Hp 2 bis: Speaking, unidentified man: 35: H: 57

Hp 3: Speaking, unidentified man: 32: H: 59

Hp 4: Speaking, Demeny, **fig. 34**: 12: H: 87

Hs: Movements with Rifle
(Joinville, 1894)

Hs 1: Soldier, isolated poses: 43: H: 87

Hs 2: Soldier, presenting arms: 25: H: 85

Hs 3: Soldier, swinging arm overhead: 21: H: 85

Hs 4: Soldier, swinging arm overhead: 20: H: 84

Hs 5: Soldier on knees, firing: 15: H: 85

Hs 6: Soldier, presenting arms: 27: H: 86

Animal Locomotion
A (Ane): Donkey
(1893)

A 1: Walk: 25: V: 87

A 2: Walk: 32: V: 86

A 3: Walk, C: 34: V: 86

A 4: Step: 31: V: 86

AAF 1: Trot: 28: V: 85

C (Cheval): Horse
(The films of Bixio were taken in 1890 and 1891; Mistigris, 1892; Mireille, 1894; Bob, 1895; Gatine's horses, 1895; Odette and Tigris, 1898; bay horse, 1899. The other films were taken between 1890 and 1895.)

C 1: Walk, mounted, Bixio: 28: V: 87

C 2: Walk, legs only, Bixio, C: 60: V: 87

C 3: Trot, mounted, Bixio, C: 14: V: 87

C 4: Trot, mounted, Bixio, C: 16: V: 87

C 5: Trot, legs only, Bixio, C: 40: V: 87

C 6: Trot, legs only, Bixio, C: 46: V: 87

C 7: Trot, legs only, Bixio, P: —: —: —

C 8: Canter, legs only, Bixio, C: 48: V: 86

C 9: Walking backward, Bixio, C: 22: V: 87

C 10: Walk, mounted, Odette: 15: V: 86

C 11: Spanish walk, mounted, Odette: 17: V: 86

C 12: Stamping, Odette: 15: V: 87

C 13: Jump, mounted, Odette, C: 14: V: 87

C 14: Jump, mounted, Odette: 16: V: 87

C 15: Jump, mounted, Odette: 22: V: 87

C 16: Jump, mounted, Odette, C: 17: V: 87

C 17: Double jump, mounted, Odette, C: 27: V: 87

C 18: Double jump, Odette, C: 28: V: 87

C 19: Jump, Odette: 11: V: 87

C 20: Jump, Odette, C: 15: V: 87

C 21: Jump, Odette, C: 20: V: 87

C 22: Jump, Odette: 11: V: 87

C 23: Jump, Odette, C: 16: V: 86

C 24: Jump, mounted, Odette, C: 13: V: 86

C 25: Spanish trot, mounted, Odette: 19: V: 87

C 26: Jump, mounted, Mireille, C: 20: V: 87

C 27: Jump, mounted, Mireille, C: 16: V: 87

C 28: Jump, Mireille: 27: V: 87

C 29: Jump, Mireille: 17: V: 87

C 30: Kicking hind legs, Mireille: 18: V: 87

C 31: Walk, mounted, cob, C: 16: V: 86

C 32: Walk, legs only, cob, C: 24: V: 86

C 33: Walk, legs only, cob, C: 47: V: 86

C 34: Walk, legs only, cob, C: 54: V: 86

C 35: Trot, legs only, cob, C: 48: V: 87

C 36: Trot, legs only, cob, C: 50: V: 87

C 37: Gallop, legs only, cob, C: 30: V: 87

C 38: Gallop, legs only, cob, C: 34: V: 87

C 39: Standing with white paper marking joints, Tigris: 13: V: 87

C 40: Walk, Tigris: 12: V: 87

C 41: Trot, Tigris: 22: V: 87

C 42: Trot, Tigris: 16: V: 87

C 43: Trot, Tigris: 18: V: 87

C 44: Trot, Tigris: 22: V: 87

C 45: Slow trot, Tigris: 24: V: 86

C 46: Trot and stumble, Tigris: 26: V: 87

C 47: Walk, mounted, Mistigris, front view: 34: H: 86

C 48: Walk, mounted, Mistigris, front view: 11: H: 85

C 49: Walk, mounted, Mistigris: 12: V: 87

C 50: Trot, mounted, Mistigris, front view: 17: H: 85

C 51: Trot, mounted, Mistigris: 12: V: 87

C 52: Canter, front view, Mistigris: 15: H: 85

C 53: Gallop, Mistigris, rear view: 14: H: 85

C 54: Different gaits, mounted, Mistigris: 12: V: 87

C 55: Trot, mounted, bay horse, C: 41: V: 89

C 56: Trot, mounted, bay horse, C: 38: V: 89

C 57: Canter, mounted by a woman, C, **fig. 100(C)**: 40: V: 89

C 58: Gallop, mounted, black horse, C: 29: V: 89

C 59: Jump, mounted, C: 13: V: 87

C 60: Two bay horses following each other, C: 45: V: 89

C 61: Canter, mounted, black horse: 31: V: 87

C 62: Canter, mounted, black horse, C: 13: V: 89

C 63: Walk, Musany: 25: V: 86

C 64: Gallop, change of lead, C: 21: V: 89

C 65: Jump, mounted, Bob, C: 16: V: 87

C 66: Gallop, change of lead, Bob, C: 9: V: 89

C 67: Horse harnessed to wagon: 36: V: 86

C 68: Jump: 19: V: 87

C 69: Jump, mounted, C: 22: V: 87

C 70: Jump, mounted: 16: V: 87

C 71: Trot, mounted, Gatine's stallion: 26: V: 87

C 72: Trot, mounted, Gatine's stallion, C: 21: V: 89

C 73: Trot, Gatine's stallion: 16: V: 88

C 74: Pivoting in place, Gatine's stallion: 32: V: 87

C 75: Walk, mounted: 8: V: 86

CAF 1: Gallop, legs only, cob: 65: V: 85

CAF 2: Walking backward, Gatine's mare: 30: V: 85

CAF 3: Moving from right to left, mounted by a woman: 16: V: 90

CAF 4: Gallop, mounted, black horse: 25: V: 90

CAF 5: Trot, mounted, two bay horses: 34: V: 90

CAF 6: Horse, mounted: 12: V: 85

CAF 7: Jump, mounted, Gardon: 21: V: 85

CAF 8: Jump, Midos, mounted by Ledrit, C: 13: V: 88

CAF 9: Jump, Mireille, mounted by Bertren, C: 25: V: 86

CAF 10: Quichs, mounted, C: 13: V: 85

CAF 11: Gallop, mounted, 1892, P: 22: V: 78

CAF 12: Gallop, mounted, 1892, P: 12: V: 83

CAF 13: Trot, mounted, 1892, P: 4: V: 83

CAF 14: Trot, mounted, 1892, P: 13: V: 85

CAF 15: Trot, mounted by a woman, P: 20: V: 90

CAF 16: Trot, mounted by a woman, P: 4: V: 85

CAF 17: Trot, mounted by a woman, P: 3 ½ :V: 85

CAF 18: Walk, to gallop, Mistigris, mounted: 20: V: 90

CAF 19: Walk, mounted, cob: 60: V: —

CAF 20: Walk, mounted: 20: V: 59

CAF 21: Walk, white horse, 1889: 23: V: 54

CAF 22: Trot, white horse, 1889: 19: V: 55

CAF 23: Walk, black horse: 25: V: 55

CAF 24: Trot, white horse: 7: V: 57

CAF 25: Trot, mounted: 40: V: 59

CAF 26: Walk, mounted, white horse moving toward camera: 32: H: 85

CAF 26 A: Walk, mounted, white horse moving away from camera: 25: H: 85

CAF 27: Walk, mounted, white horse, from front: 2: H: 85

CAF 28: Walk, mounted, white horse: 2: V: 85

CAF 29: Walk, white horse, C: 23: V: 90

CAF 30: Walk, mounted, bay horse: 26: V: 85

CAF 31: Walk, mounted, Bixio, C: 30: V: 85

CAF 32: Walk, mounted, Bixio, C: 23: V: 86

CAF 33: Gallop, legs only, C: 58: V: 60

CAF 34: Jump, Buttercup: 14: V: 85

CAF 35: Trot, mounted by Thérèse Rentz, C: 90: V: 90

CAF 36: Tigris, skeleton, right side: 35: V: 87

CAF 37: Tigris, skeleton, left side: 52: V: 87

CL 1: Walk, mounted, cob: —: V: 86

CL 2: Walk, mounted, cob: —: V: 86

CL 3: Walk, legs only, cob: —: V: 86

CL 4: Walk, legs only, cob: —: V: 86

CL 5: Trot, mounted, cob: 21: V: 86

CL 6: Trot, mounted, cob: —: V: 85

CL 7: Gallop, mounted, cob: —: V: 85

CL 8: Gallop, being led, cob: —: V: 86

CT 1: Jump, Odette: —: V: 85

Cr (Chèvre): Goat
(1894)

Cr 1: Walk: 54: V: 87

Cr 2: Walk, **fig. 100(A)**: 18: V: 86

Cr 3: Trot: 19: V: 87

Cr 4: Trot: 31: V: 87

Cr 5: Trot: 38: V: 87

Cr 6: Walk: 18: V: 8

Cn (Chien): Dog
(1894)

Cn 1: Walk: 16: V: 86

Cn 2: Walk, C: 49: V: 87

Cn 3: Trot, C: 42: V: 85

Cn 4: Trot, C: 38: V: 86

Cn 5: Trot, Tom, C: 57: V: 86

Cn 6: Trot: 15: V: 86

Cn 7: Trot, C: 13: V: 86

Cn 8: Trot, C: 16: V: 86

Cn 9: Trot: 14: V: 86

Cn 10: Trot: 16: V: 86

Cn 11: Trot: 18: V: 85

Cn 12: Gallop, greyhound: 12: V: 84

Cn 13: Gallop, C: 41: V: 86

Cn 14: Walk, poodle: 7: H: 86

Cn 15: Turn while falling: 55: H: 87

Cn 16: Jump, black poodle, 1892: 33: H: 59

Cn 17: Going up and down stairs, black poodle, 1892: 64: H: 59

CnAF 1: Waiting for sugar: 20: V: 85

CnAF 2: Jump, black poodle: 35: H: 59

CnL 1: Slow walk, Tom, C: 63: V: 86

CnL 2: Gallop, Tom, C: 29: V: 86

CnL 3: Trot, Tom, C: 18: V: 86

CnL 4: Trot, Tom, C: 36: V: 86

Ct (Chat): Cat
(1894)

Ct 1: Walk: 18: V: 86

Ct 2: Walk: 28: V: 86

Ct 3: Trot, C: 17: V: 87

Ct 4: Trot: 25: V: 87

Ct 5: Fall and landing: 38: H: 85

Ct 6: Fall and landing, **fig. 101**: 19: H: 87

Ct 7: Fall and landing: 19: H: 86

Ct 8: Fall and landing: 27: H: 87

Ct 9: Fall and landing: 21: H: 86

Ct 10: Fall and landing: 23: H: 87

Ct 11: Landing: 19: H: 86

CtL 1: Fall and turn: 24: H: 85

CtL 2: Fall and turn: 35: H: 85

I (Insecte): Insect
(1890–92)

I 1: Dragonfly in flight: 18: H: 85

I 2: Bees in flight: 10: V: 87

I 3: Insects?: 20: H: 85

I 4: Crane fly: 5: H: 87

I 5: Large insect: 18: H: 87

I 6: Large insect: 7: H: 87

I 7: Water spider, **fig. 98**: 25: H: 85

I 8: Spider: 15: V: 85

I 9: Scorpion: 25: V: 86

I 10: Insect?: 28: V: 85

IAF 1: Honeybee: 11: H: 30

IAF 2: Spider: 27: V: 85

IAF 3: Spider: 27: V: 85

IAF 4: Scorpion: 33: V: 85

L (Lapin): Rabbit
(1893)

L 1: Walk: 21: V: 86

L 2: Walk: 25: V: 87

L 3: Walk and halt: 60: V: 86

L 4: Walk: 60: V: 86

L 5: Walk and halt: 43: V: 87

L 6: Run: 45: H: 86

L 7: Turning after falling: 34: H: 87

L 8: Turning after falling: 41: H: 86

L 9: Fall and incomplete turn: 41: H: 86

L 10: Turning: 42: H: 86

L 11: Turning: 20: H: 86

L 12: End of fall after landing: 25: H: 86

L 13: Turning: 19: H: 86

L 14: Horizontal turn: 37: H: 86

L 15: Vertical turn: 52: H: 86

L 16: Turning, view from rear: 24: H: 86

L 17: Turning, blindfolded, C: 47: H: 85

L 18: Straight fall and turn: 57: H: 86

L 19: Fall and landing, C: 43: H: 86

L 20: Fall and landing: 48: H: 86

L 21: Fall and landing: 44: H: 86

L 22: Fall and landing: 48: H: 86

L 23: Fall and landing: 29: H: 86

L 24: Fall and landing: 21: H: 86

L 25: Fall and landing, **fig. 102**: 21: H: 86

L 26: Fall and landing: 21: H: 86

L 27: Fall and landing: 22: H: 86

L 28: Fall and landing: 33: H: 87

L 29: Fall and landing: 22: H: 86

L 30: Fall and landing: 42: H: 86

L 31: Fall and landing: 38: H: 86

L 32: Fall and landing: 37: H: 86

M (Mouton): Sheep
(1893–94)

M 1: Gallop, C: 14: V: 85

M 2: Trot, C: 23: V: 86

M 3: Trot, C: 20: V: 86

M 4: Trot, C: 38: V: 85

M 5: Trot: 17: V: 85

M 6: Trot: 22: V: 86

M 7: Trot, front view, C: 25: V: 86

M 8: Trot, front view, C: 20: V: 86

M 9: Walk, front view, C: 21: V: 86

M 9 bis: Rear view, C: 19: V: 86

M 10: Walk, C: 14: V: 85

M 11: Walk, C: 56: V: 86

M 12: Walk, C: 26: V: 86

M 13: Walk, C: 24: V: 86

M 14: Walk with lowered head, C: 25: V: 86

M 15: Walk with lowered head, C: 25: V: 86

M 16: Walk with lowered head, C: 26: V: 86

MAF 1: Walk, C: 50: V: 85

MAF 2: Trot, C: 50: V: 85

O (Oiseau): Bird

O 1: Pigeon landing, 1894, **fig. 100(B)**:[22] 14: H: 57

O 2: Pigeon flying, 1894, C: 60: H: 86

O 3: Pigeon flying, 1894: 23: V: 89

O 4: Pigeon flying, 1894: 26: V: 89

O 5: Duck plunging into water, 1895: 20: V: 87

O 6: Ducks plunging into water, 1895: 28: V: 86

OAF 1: Pigeons flying, 1893: 62: V: 88

OAF 2: Pigeon flying, 1893, P: 19: V: 41

OT 1: Pigeon flying, 1894: —: H: 86

Pn (Poisson): Fish

Pn 1: Skate, movement of fins, 1892: 33: V: 59

Pn 2: Skate, movement of fins, 1892: 28: V: 59

Pn 3: Skate, movement of fins, 1892: 16: V: 59

PnAF 1: Eel, movements, 1890: 42: V: 85

PnAF 2: Eel, movements, 1890: 42: V: 87

PnAF 3: Eel, movements, 1890: 33: V: 87

PnAF 4: Eel, movements, 1890: 33: V: 85

PnAF 5: Eel, movements, 1890: 44: V: 85

PnAF 6: Starfish, 1890: 114: H: 35

PnAF 7: Small crustacean, movements, 1890: 13: H: 85

PnAF 8: Crab, movements, 1890: 40: V: 85

PnAF 9: Crab, movements, 1890: 21: H: 85

PnAF 10: Jellyfish, 1890:[23] 19: V: 85

PnAF 11: Jellyfish with spread tentacles, 1890: 14: H: 87

PnAF 12: Jellyfish with spread tentacles, 1890: 39: V: 87

PnAF 12bis: Skate, movement of fins, 1892: 33: V: 56

PnAF 13: Skate, movement of fins, 1892: 16: V: 60

PnAF 14: Newt: 34: V: 85

PnAF 15: Newt: 34: V: 82

PnAF 16: Tadpole, 1894: 50: H: 35

PnAF 17: Seaworm, 1894: 204: H: 35

P (Poule): Chicken
(1894)

P 1: Walk: 35: V: 86

P 2: Walk, rooster: 63: V: 86

P 3: Fall and landing: 26: H: 86

P 4: Fall and landing: 23: H: 86

P 5: Fall and landing: 19: H: 87

P 6: Fall and landing: 21: H: 87

22. A print of the fall and landing of a pigeon is in the Bibliothèque Nationale, no. G68137.

23. A print of this film is in the Bibliothèque Nationale, no. G68139.

PAF 1: Walk: 52: V: 85

PL 1: Walk: 34: V: 86

R (Reynard): Fox

RAF 1: Run, 1894, C: 13: V: 90

*Mm: Microscopic Movements
(1891)*

MmAF 1: Protozoa: 21: V: 85

MmAF 2: Protozoa: 11: V: 85

MmAF 3: Protozoa: 12: V: 85

MmAF 4: Protozoa: 17: V: 85

MmAF 5: Protozoa: 17: V: 85

MmAF 6: Protozoa: 12: H: 85

MmAF 7: Protozoa: 21: H: 85

MmAF 8: Protozoa: 12: H: 85

V: Various Subjects

VAF 1: Naples, view of boat: 18: V: 85

VAF 2: Movements of wave, 1889: 10: H: 85

VAF 3: Movements of wave, 1889: 16: H: 85

VAF 4: Views of Paris: 14: V: 35

VAF 5: Views of Paris: 15: V: 35

VAF 6: Views of Paris: 44: V: 35

VAF 7: Place de la Concorde: —: V: 17

VAF 8: Gare Saint Lazare, P: —: V: 35

VAF 9: Bois de Boulogne, Porte Dauphine: —: V: 35

VAF 10: Pont d'Iéna, Universal Exposition of 1900: 13: V: 35

VAF 11: Pont d'Iéna: —: V: 35

VAF 12: Pont d'Iéna: —: V: 35

VAF 13: Cabriolet: 21: V: 85

VAF 14: Calèche: 13: V: 85

VAF 15: Carriages in front of the Marine Ministry: 74: V: 85

VAF 16: Circle line train: —: V: 35

VAF 17: Arrival of circle line train at Auteuil station: —: V: 35

VAF 18: Circle line train at Auteuil station: —: V: 35

VAF 19: First reunion, Institute Marey, 1902: 175: V: 85

VAF 20: Portrait of Marey's daughter: 27: H: 85

VAF 21: Portrait of woman, 1892: 63: H: 83

VAF 22: Portrait of child, 1892: 17: H: 86

VAF 23: Horseman, horsewoman: —: V: 33

VAF 24: Monastery garden: —: V: 33

VAF 25: *Mimosa pudica*: 20: H: 88

VAF 26: Glider: 51: V: 35

VAF 27: Fluids: 30: V: 84

VAF 28: Fluids: 13: H: 85

VAF 29: Fluids: 13: H: 85

VAF 30: Fluids: 14: H: 85

VAF 31: Fluids: 22: V: 85

VAF 32: Fluids: 19: V: 85

VAF 33: Fluids: 30: V: 85

Notes

Abbreviations

BSFP *Bulletin de la Société Française de Photographie*
BAM *Bulletin de l'Académie de Médecine*
BJP *British Journal of Photography*
CRAS *Comptes Rendus des Séances de l'Académie des Sciences*
Beaune Musée Marey, Beaune

Introduction

1. On Langlois and the foundation of the Cinémathèque, see Richard Roud, *A Passion for Films* (New York: Viking, 1983).

Chapter One

1. See John E. Lesch, *Science and Medicine in France: The Emergence of Experimental Physiology, 1790–1855* (Cambridge: Harvard University Press, 1984).

2. Nadar [Félix Tournachon], "Le nouveau président de la Société Française de Photographie," *Paris-Photographe* 4 (1894) : 4

3. Marie-Joséphine moved in with Marey upon Claude's death in 1862 and lived with him until her own death in 1897, seven years before Marey's.

4. Reptiles, serpents, amphibians.

5. The letters are now in the archives of the Institut de France.

6. For information on Marey's life see H. A. Snellen, *E. J. Marey and Cardiology: Physiologist and Pioneer of Technology, 1830–1904* (Rotterdam: Kooyker Scientific Publications, 1980); Henri Savonnet, "Flash sur la vie d'Etienne-Jules Marey," *Société d'Archéologie de Beaune* (Côte d'Or), *Mémoires, années 1973–1974* (Beaune, 1975), and Charles François-Franck, *L'oeuvre de E. J. Marey* (Paris : Doin, 1905).

7. Charles Richet, "L'oeuvre de Marey," *BAM* 103 (1930): 714.

8. Raymond Poincaré, "Discours," in *Inauguration du monument élevé à la mémoire de Etienne-Jules Marey* (Paris: Gauthier-Villars, 1914), 3–4.

Chapter Two

1. For which see Michel Foucault, *The Birth of the Clinic: An Archaeology of Medical Perception* (New York: Random House, 1973).

2. Robert Nye, *Crime, Madness and Politics in Modern France* (New Haven: Yale University Press, 1982), 39. See also the following three books by Jacques Leonard on the subject: *La France médicale: Médecins et malades au XIXe siècle* (Paris: Gallimard, 1978); *La vie quotidienne du médecin de province* (Paris: Hachette, 1977); and *La médecine entre les savoirs et les pouvoirs: Histoire intellectuelle et politique de la médecine française au XIXe siècle* (Paris: Aubier, 1981). For the background of the growth of physiology in France, see John E. Lesch, *Science and Medicine in France: The Emergence of Experimental Physiology, 1790–1855* (Cambridge: Harvard University Press, 1984).

For the history of the influence of physiology on medicine, see Joseph Schiller, "The Influence of Physiology on Medicine," *Episteme* 6 (1972): 116–27, and Joel Reiser, *Medicine and the Reign of Technology* (Cambridge: Cambridge University Press, 1978).

3. Schiller, "Influence of Physiology on Medicine," 118. On the history of French physiology see Georges Canguilhem, "La constitution de la physiologie comme science," in *Physiologie*, ed. C. Kayser (Paris: Editions Médicales Flammarion, 1963).

4. Ibid., 116. The first chair of experimental (general) physiology was created for Claude Bernard at the Sorbonne in 1854. It was transferred to the Museum of Natural History in 1869. In Germany chairs of physiology separate from anatomy were created for Helmholtz, at Königsberg in 1849, and for Ludwig, at Leipzig in 1869.

5. Joseph Schiller, "Physiology's Struggle for Independence in the First Half of the Nineteenth Century," *History of Science* 7 (1968): 67.

6. Lesch, *Science and Medicine in France*, 95.

7. J. T. Fitzsimons, "Physiology during the Nineteenth Century," *Journal of Physiology* 263, no. 1 (1976): 16–25.

8. J. M. Olmsted, *François Magendie, Pioneer in Experimental Physiology and Scientific Medicine in Nineteenth Century France* (New York: Schumann, 1944), 143. The antivivisectionist sentiment in Britain retarded the foundation of a school of physiology there until the end of the century.

9. Lesch, *Science and Medicine in France*, 91. François Magendie, *Formulaires pour l'emploi et la préparation de plusieurs médicaments, tels que la noix vomique, la morphine, l'acide prussique, la strychnine, la vératrine, les alcalis des quinquinas, l'iode, etc.* (Paris, 1821).

10. Lesch, *Science and Medicine in France*, 122.

11. Claude Bernard, *An Introduction to the Study of Experimental Medicine*, trans. H. C. Green (New York: Collier, 1961), 69. See also Everett Mendelsohn, "The Biological Sciences in the Nineteenth Century: Some Problems and Sources," *History of Science* 3 (1964): 48.

12. Claude Bernard, *Leçons sur les phénomènes de la vie commun aux animaux et aux végétaux*, vol. 1 (Paris, 1878), 38–39.

13. Lesch, *Science and Medicine in France*, 65.

14. Everett Mendelsohn, "Physical Models and Physiological Concepts," *British Journal of the History of Science* 2 (1965): 204. P. B. Medawar and J. S. Medawar's *Aristotle to Zoos: A Philosophical Dictionary of Biology* (Cambridge: Harvard University Press, 1983), 277, defines the contemporary view of vitalism: "It is virtually impossible to think of any observation or experiment, except perhaps the total synthesis of some living organism, that could falsify the notion of vitalism or an inference drawn from it. Until this has been done, as one day it may well be, the concept of vital force or 'élan vital' must be judged outside science. But no one strikes attitudes about the matter any more: vitalism is in the limbo of that which is disregarded. Modern biologists do not find it necessary to appeal to a disembodied vital principle. . . . The state of being alive seems to us to be best described as an emergent property."

15. Fitzsimons, "Physiology during the Nineteenth Century," 21. Ernst Heinrich Weber was professor of anatomy and physiology at Leipzig until 1866, when the chair was divided and the physiology chair was given to Ludwig, "one of the greatest teachers of physiology of any age." Eduard Friedrich Weber worked on sensation; he succeeded in measuring the velocity of the pulse wave in 1825. They "actively and successfully applied physical techniques and models of thinking to physiology for two

decades." P. F. Cranefield, "The Organic Physics of 1847 and the Biophysics of Today," *Journal of the History of Medicine* 12 (1957): 421.

For the philosophy and political implications of German materialism see A. Culotta, "German Biophysics, Objective Knowledge and Romanticism," *Historical Studies in the Physical Sciences* 4 (1974): 3–38, Frederick Gregory, *Scientific Materialism in Nineteenth-Century Germany* (Boston: D. Reidel, 1972), Everett Mendelsohn, "Revolution and Reduction: The Sociology of Methodological and Philosophical Concerns in Nineteenth-Century Biology," in *The Interaction between Science and Philosophy*, ed. Yehuda Elkana (Atlantic Highlands, N.J.: Humanities Press, 1974), and Oswei Temkin, "Materialism in French and German Physiology of the Early Nineteenth Century," *Bulletin of the History of Medicine* 20 (1946): 322–27.

16. Marey, *La machine animale: Locomotion terrestre et aérienne* (Paris, Baillière, 1873). Translated as *Animal Mechanism: A Treatise on Terrestrial and Aerial Locomotion*, 3d ed. (New York: Appleton, 1884), 1.

17. Marey, *Animal Mechanism*, 59.

18. Marey, *Du mouvement dans les différentes fonctions de la vie: Leçons faites au Collège de France* (Paris: Baillière, 1868), 65.

19. At a banquet in 1901 honoring his contribution to physiology, Marey's acceptance speech included his unorthodox—for the French, at least—version of the history of physiology: "I was almost at the birth of physiology with Magendie, Flourens and Jean Müller. I saw physiology develop with Ludwig, Wolkmann, Helmholtz, and Bernard." The importance given to the Germans is not inadvertent. Marey, "Discours," in *Hommage à M. Marey* (Paris: Masson, 1902), 15.

20. Marey, *Animal Mechanism*, 7.

21. Marey, "Cours au Collège de France en 1867 de M. Marey, professeur suppléant à la chaire d'histoire naturelle de corps organisés. Evolution historique des sciences: L'analyse et la synthèse dans les sciences; loi en biologie; appareils enregistreurs; contraction musculaire," *Revue des Cours Scientifiques de la France et de l'Etranger* 4 (1866–67), translated as "Natural History of Organized Bodies," *Annual Report of the Board of Regents of the Smithsonian Institution for 1867*, 1868, 282.

22. Etienne-Jules Marey, *La méthode graphique dans les sciences expérimentales et principalement en physiologie et en médecine* (Paris: Masson, 1878), ii.

23. Marey, "Natural History of Organized Bodies," 284.

24. Ibid., 299. For the argument below I have relied on Maurice Mandelbaum, *History, Man and Reason* (Baltimore: Johns Hopkins University Press, 1971).

25. Marey, *Animal Mechanism*, 8.

26. Mandelbaum, *History, Man and Reason*, 297.

27. Ibid., 11.

28. Anson Rabinbach, "The Body without Fatigue: A Nineteenth-Century Utopia," in *Political Symbolism and Modern Europe: Essays in Honor of George L. Mosse*, ed. Seymour Drescher, David Sabean, and Allan Sharlin (New Brunswick, N.J.: Transaction Books, 1982), 57.

29. Mandelbaum, *History, Man and Reason*, 12.

30. Marey, "Natural History of Organized Bodies," 282.

31. Ibid.

32. Thomas Kuhn, *The Essential Tension: Selected Studies* (Chicago: University of Chicago Press, 1977), 68.

33. Thus the search for the forces of the body, particularly in muscle physiology, now appeared in the forefront of scientific investigation and as noted above, of primary interest to German physiologists. "The search for the laws of the muscles and nerves and the attempt to discover the forces at work in emotions, became the leitmotif of the new science of the body." Rabinbach, "Body without Fatigue," 47.

34. Marey, *Animal Mechanism*, 15. "One should recall that two of the formulations of that principle—those of Mayer and of Helmholtz—had originated within the context of physiological problems: in fact, Helmholtz's essay on the subject stemmed from his opposition to the vitalism of Stahl." Mandelbaum, *History*, 291.

35. Marey, *Animal Mechanism*, 9.

36. Marey, "Natural History of Organized Bodies," 286.

37. Marey, *Méthode graphique*, 113.

38. Marey, *Animal Mechanism*, 8.

39. Marey, "Natural History of Organized Bodies," 287.

40. P. M. Harman, *Energy, Force and Matter: The Conceptual Development of Nineteenth-Century Physics* (Cambridge: Cambridge University Press, 1982), 9.

41. Marey, "Natural History of Organized Bodies," 286.

42. Siegfried Gidieon, *Mechanization Takes Command* (New York: Norton, 1948), 16.

43. Marey, "Lectures on the Graphic Method in the Experimental Sciences, and on Its Special Application to Medicine, Delivered at the Medical Congress in Brussels, September 21st, 1875," *British Medical Journal*, 15 January 1876, 66.

44. Besides the history of the graphic method that Marey gives in his *Méthode graphique*, an indispensable account of graphic recording is found in the following series of articles by H. E. Hoff and L. A. Geddes: "Graphic Recording before Carl Ludwig: An Historical Summary," *Archives Internationales de l'Histoire de Science* 12 (1959): 3–25; "Graphic Registration before Ludwig: The Antecedents of the Kymograph," *Isis* 50 (1959–60): 5–21; "The Technological Background of Physiological Discovery: Ballistics and the Graphic Method," *Journal of the History of Medicine* 15 (1960): 345–63; "The Capillary Electrometer: The First Graphic Recorder of Bioelectric Signals," *Archives Internationales de l'Histoire de Science* 14 (1961): 275–87; "The Beginnings of Graphic Recording," *Isis* 53 (1962): 287–310; "The Early History of Cardiac Catheterization," *Archives Internationales de l'Histoire de Science* 15–16 (1962–63): 377–404; "A Historical Perspective on Physiological Monitoring: Sherrington's Mammalian Laboratory and Its Antecedents," *Cardiovascular Research Centre Bulletin* (Baylor) 13 (1974): 19–39; "A Historical Perspective on Physiological Monitoring: Chauveau's Projecting Kymograph and the Projecting Physiograph," *Cardiovascular Research Centre Bulletin* (Baylor) 14 (1975): 3–35.

See also Kenneth D. Keele, *The Evolution of Clinical Methods in Medicine* (London: Pitman, 1963); Edward R. Tufte, *The Visual Display of Quantitative Information* (Cheshire, Conn.: Graphic Press, 1983); and Laura Tilling, "Early Experimental Graphics," *British Journal for the History of Science* 8 (1975): 193–213.

45. Edouard Toulouse, "Nécrologie—Marey," *Revue Scientifique* 1, no. 22 (1904): 673.

46. Paul Cranefield, *Two Great Scientists of the Nineteenth Century: The Correspondence of Emil Du Bois-Reymond and Carl Ludwig* (Baltimore: Johns Hopkins University Press, 1982), viii. Ludwig's innovation, in turn, consisted of attaching the hemodynamometer (one of the earliest blood-pressure takers) of J. L. M. Poiseuille (1799–1869) to a stylus. The sphygmograph of Karl Vierdort (1818–84) preceded Marey's; it was applied to the unbroken skin, but it too was workable only under

special conditions; it was large and was so heavy that it falsified the pulse.

47. Christopher Lawrence, "Physiological Apparatus in the Wellcome Museum: I. The Marey Sphygmograph," *Medical History* 22 (1978): 196–200.

48. Reiser, *Medicine and the Reign of Technology*, 102–3. Reiser explains some of the difficulties in interpreting the data given by Marey's instrument.

49. Auguste Chauveau, "Discours," in *Inauguration du monument élevé à la mémoire de E. J. Marey*, 5.

50. Before this, Bernard had catherized both sides of the heart in order to measure and compare the temperatures of the two sides. H. A. Snellen, *Marey and Cardiology* (Rotterdam: Kooyker Scientific Publications, 1980), 14. See also Snellen, introduction to *La méthode graphique et l'exploration cardiovasculaire*, exhibition catalog (Cachan: Medtronic, 1980).

51. Ibid., 3

52. Together Marey and Chaveau published: "Détermination graphique des rapports du choc du coeur avec les mouvements des oreillettes et des ventricules, expériences faite à l'aide d'un appareil enregistreur (sphygmographe)," *CRAS* 53 (1861): 622–25; "Détermination graphique des rapports du choc du coeur avec les mouvements des oreillettes et des ventricules," *CRAS* 54 (1862): 32–35; "De la force déployée par la contraction des différentes cavités du coeur," *Comptes Rendus de la Société de Biologie* 4 (1862): 151–54; *Tableau sommaire des appareils et des expériences cardiographiques de MM. Chauveau et Marey*, Pamphlet (Paris, 1863); "Appareils et expériences cardiographiques: Démonstration nouvelle du mécanisme des mouvements du coeur par l'emploi des instruments enregistreurs à indications continues," *BAM* 26 (1863): 268–319.

53. C. J. Wiggers, "Some Significant Advances in Cardiac Physiology," *Bulletin of the History of Medicine* 34, no. 1 (1960): 10.

The Marey-Chauveau collaboration has been documented in detail in: Raul Espinosa, R. Vlietstra, and R. Mann, "J. B. A. Chauveau, E. J. Marey and Their Resolution of the Apex Beat Controversy through Intracardiac Pressure Recordings," *Mayo Clinic Proceedings* 58, nos. 3–4 (1983): 197–202; V. Donnet, "Un mécanicien nommé Marey," *Marseille Médicale* 101, no. 10 (1964), 1–8. Michel Rousseau, "A l'origine du cathéterisme cardique, deux oubliés: Chauveau (avec Marey) et Desliens," *Nouvelle Presse Médicale* 7, no. 36 (1978):

3270–72; J. Lequime, "Marey et la cardiologie," *Acta Belgica Medica Physica (Journal Belge de Médécine Physique et de Rehabilitation)* 6, no. 4 (1983): 181–85; and J. Bost, "L'histoire des premiers enregistrements cardiographiques," *Histoire des Sciences Médicales* 4 (1970): 37–52.

54. Buisson, in turn, invented his method while working with Marey's sphygmograph in 1860. See Marey, *Physiologie médicale de la circulation du sang basée sur l'étude graphique des mouvements du coeur et du pouls artériel, avec application aux maladies de l'appareil circulatoire* (Paris: Delahaye, 1863), 51n.

55. I am grateful to Dr. Ralph Sonnenschein for this information.

56. Marey, *Du mouvement dans les différentes fonctions de la vie*, 93.

57. The tuning-fork chronograph was based on an eighteenth-century invention by Thomas Young, who had attached a stylus to a vibrating rod. In a later development, Helmholtz, among others, used electricity to maintain the vibrations of the chronograph. See Marey, *Méthode graphique*, 110.

58. Harmon, *Energy, Force and Matter*, 9.

59. Marey, *Animal Mechanism*, 23.

60. Marey, *Méthode graphique*, 458.

61. The direct and transmitting myographs traced the contractions of isolated muscle fibers stimulated by consecutive electrical impulses; the myographic "clips" were two supple pincers that transversely grasped the muscle and transmitted its contractile swelling to the stylus. See Marey, *Animal Mechanism*, chap. 4.

62. Because the special shoes were "inconvenient for making long marches," in 1877 Marey modified them. He put a small air chamber and spring inside the heel that was activated by the pressure of the foot on a metal tongue inside the shoe. Later the same year, Marey's assistant Victor Tatin devised a tubing bellows sole that could be slipped into any shoe. Marey, *Méthode graphique*, 497–98.

63. For the gallop of the horse the procedure was slightly modified: The inscribing apparatus contained five levers, "tracing on smoked glass the curves of the action of the four legs, and the reaction of the withers. The violence of the impacts on the ground is such that they would instantly have broken the apparatus used before. We have substituted a copper tube containing a lead piston suspended between two spiral springs. The shocks

given to this piston at each footfall, produce an effect like that of an air-pump acting on the registers. A ball of india-rubber, which can be pressed between the teeth sets the register going." Marey, *Animal Mechanism*, 70.

64. Marey, "Moteurs animés: Expériences de physiologie graphique," *La Nature*, 28 September, 1878, 273–78. Translated as "A Study in Locomotion," *Nature* 19 (1879): 465. In this article Marey also demonstrates how the graphic method can be used to record the rapid movements of a pianist's fingers over the keys.

65. The theory of the persistence of vision has subsequently been proved inadequate to account for our perception of movement. See Michael Chanan, *The Dream That Kicks* (London: Routledge and Kegan Paul, 1980), chap. 4, and Bill Nichols and Susan J. Lederman, "Flicker and Motion in Film," in *The Cinematic Apparatus*, ed. Teresa De Lauretis and Stephen Heath (New York: St. Martin's Press, 1980).

66. Chanan, *Dream That Kicks*, 64.

67. Marey, *Animal Mechanism*, 137.

68. "Its principal advantage is that, by turning it less quickly, we cause it to represent the movements much more slowly, so that the eye can ascertain with the greatest facility these actions, the succession of which cannot be apprehended in ordinary walking." Marey, *Animal Mechanism*, 237.

69. Described in Marey, *Animal Mechanism*, 177.

70. Ibid., 166; on the suspension phase of the trot see p. 155.

71. Ibid., 235.

72. Ibid., 183. A chronograph vibrating at 250 double vibrations per second was also held against the paper and left its mark. The frequency of the path traced by the insect's wing was measured against the path traced by the vibrations of the chronograph.

73. Marey, *Animal Mechanism*, 186.

74. Ibid., 235.

75. Marey, "Lectures on The Phenomena of Flight in the Animal Kingdom," *Annual Report of the Board of Regents of the Smithsonian Institution for 1868*, 1871, 242.

76. Marey, *Animal Mechanism*, 277. Marey introduces his plan by summarizing his results so far: "The reproduction of the mechanism of flight now occupies the minds of many experimenters, and we hesitate not to own that we have been sustained in this laborious analysis of the different acts in the flight of the bird, by the assured

hope of being able to imitate, more or less imperfectly, this admirable type of aerial locomotion. We have already met with some success in our attempts, which have been interrupted during the last two years. Winged apparatus has been seen in our laboratory, which when adapted to the frame-work which had held the bird gave it a rather rapid rotation. But this was only a very imperfect imitation, which we hope shortly to improve. Already a young and ingenious experimentalist, Mons. Alphonse Pénaud, has obtained much more satisfactory results in this direction."

77. Nadar was a renowned portrait photographer whose studio on the boulevard des Capucines in Paris was the site of the first impressionist exhibition (1874). In 1869 he founded the magazine *Aéronaute* (which expired after its fifth issue). Nadar is popularly remembered for his ballooning adventures, but this is in part a misconception, for he was also a proponent of heavier-than-air flight using the air screw. He wrote a "Manifesto upon Aerial Locomotion" in 1863, in which he "expressed the opinion that the principal obstruction in the way of navigating the air was the attention which had been given to balloons; that, in order to imitate nature, a flying machine must be made heavier than the air. Also that the surest means of success was the employment of the aerial screw." He built a monster balloon—the *Géant*—"out of the exhibition of which it was expected to realize sufficient profits to build a screw machine which should put an end to ballooning forever. But the Géant met with all sorts of mishaps; it gave no profits and entailed losses instead which nearly ruined Nadar." Octave Chanute, *Progress in Flying Machines* (New York, 1894, 53).

78. Charles H. Gibbs-Smith, *Aviation: An Historical Survey*, 2d ed. (London: Science Museum Publications, 1985), 43.

79. "Last week I finished a mechanical bird of my invention whose wings function more or less according to your theory." Pénaud to Marey, 5 March 1872, Archives, Collège de France. Pénaud also mentions the influence of Marey's experiments with the artificial insect and bird in his "Appareil de vol mécanique," *La Nature*, 24 April 1876, 327–31. In "Analyse des mouvements du vol des oiseaux par la photographie," *CRAS* 96 (1883): 1399–1406, Marey refers to Pénaud's declaration ten years earlier that both stroboscopic and successive instantaneous photography should be used to study the flight of birds.

80. Ader did little model or glider testing. His *Eole* of

1890 made a short, uncontrolled powered hop. His second aircraft, *Avion,* was never completed, and his *Avion III* of 1897 never left the ground.

81. Bernard to Sedillot, 11 January 1867; Archives, Collège de France. Bernard's techniques were those of the craftsman-artisan who felt that the more complicated the instrument, the more chance there was for error.

82. Marey, "Natural History of Organized Bodies," 287, 290.

83. De Parville (*Hommage à M. Marey,* 6) is uncertain about the date of their meeting; Chauveau ("Discours," in *Inauguration du monument élevé à la mémoire de Etienne-Jules Marey,* 8) gives 1864, which seems more likely.

84. Flourens's death left two vacant chairs in Paris. The first was the chair of comparative physiology at the Museum of Natural History, and the second was that of "organized bodies" at the Collège. By imperial decree at the request of Duruy in 1869, Bernard's chair of general physiology was transferred from the Sorbonne to the museum, where the laboratory facilities were greatly superior. Flourens's chair at the museum was simultaneously transferred to the Sorbonne and given to Paul Bert, a student of Bernard's and Marey's rival for a seat in the Académie des Sciences. See Joseph Schiller, "Claude Bernard and Brown-Séquard: The Chair of General Physiology and the Experimental Method," *Journal of the History of Medicine* 21 (1966): 260–70. Bernard's mild distaste for Marey may have been prompted by the fear that Marey would be elected to Flourens's museum chair and not the one at the Collège.

85. Fittingly, to the place vacated by the death of Jean Marie Poiseuille, whose 1828 hemodynamometer was one of the first instruments used to measure blood pressure.

86. "Rapport sur le Prix de Physiologie (Fondation Lacaze)," 1874, unpaginated typescript, Beaune.

87. Marey, *Animal Mechanism,* 2.

88. Ibid., 4.

89. Ibid., 3.

90. Ibid., 59.

91. Report of Léon Gosselin to the medical and surgical section, Académie des Sciences, 1876. Archives, Académie des Sciences. According to Charles-Edouard Brown-Séquard, however, Marey's position was precarious even in 1878, and he would have never been elected to the Academy had he had other competitors be-

sides Bernard's pupil, the extremely unpopular Paul Bert: "Marey's friends were in the minority; he had only fifteen to twenty-two faithful and constant voices. Out of forty-two to forty-six votes for him, twenty at least voted for him to avoid voting for Bert." Letter from Brown-Séquard to Arsène d'Arsonval, 2 May 1891, Archives, Académie des Sciences.

92. Marey, *Méthode graphique,* 108.

93. Marey, "Sur l'importance au point de vue médical des signes extérieurs des fonctions de la vie," *BAM,* 2d ser., 7 (1878): 627.

Chapter Three

1. Vincent (feu) et Goiffon, *Mémoire artificielle des principes relatifs à la fidèle représentation des animaux tant en peinture qu'en sculpture: Première partie concernant le cheval, ouvrage également intéressant pour les personnes qui se destinent à l'art de monter à cheval* (Paris, 1779), 85–87.

2. The wet-plate or wet-collodion process was invented in England in 1851 by Frederick Scott Archer and published by him in his *Manual of the Collodion Photographic Process* in 1852. The process was more sensitive to light than the earlier daguerreotype or calotype process. Since glass was the support used for the negative, the wet-collodion process also produced images that rivaled the daguerreotype in clarity and detail. Making a wet-plate negative was not easy: it involved "careful pouring of the collodion solution (a colourless, glue-like mixture of guncotton and ether mixed with potassium iodide) onto the glass plate, and tipping it at various angles until the plate was evenly coated. Then the coated plate was dipped into a sensitizing bath, a solution of nitrate of silver. The sensitized plate was exposed in the camera while it was still wet, and developed directly after exposure, for the ether in the collodion evaporated quickly, and the plate lost its sensitivity to light as it dried. The minimum time of exposure for landscape was about ten seconds; small portraits could be taken in a minimum time of about two seconds." Helmut Gernsheim and Alison Gernsheim, *The History of Photography* (New York: McGraw-Hill, 1969), 199.

3. Rejlander's proposal for series photographs incorporated a "battery of cameras and 'quick-acting' lenses ready charged and loaded." The horse and rider were to be 150 yards from the cameras on a dusty white road,

NOTES TO PAGES 44–47

and, wrote Rejlander, "as this is a *black art*," "I should think a *cross road* would be the proper point." Gustave Rejlander, "On Photographing Horses," *Photography Year Book and Photographer's Daily Companion*, 1873, 115.

4. But not a financially risky one. According to legend, Stanford supposedly hired Muybridge because of a $25,000 bet between Stanford and Fred MacCrellish, a San Francisco journalist. Yet "contemporary accounts indicate that Stanford never bet, not even on his own horses." Anita Ventura Mozley, introduction to Eadweard Muybridge, *Muybridge's Complete Human and Animal Locomotion* (New York: Dover, 1979), xxxvii, n. 23.

5. Muybridge, cited in Robert Haas, *Muybridge: Man in Motion* (Berkeley: University of California Press, 1976), 110. Although the sequential camera system had been suggested by Rejlander in 1873, the electromagnetic shutter system fashioned by Stanford's railroad engineer John D. Isaacs made it practicable.

6. Marey, *Le mouvement* (Paris: Masson, 1894); translated as *Movement* (New York: Appleton, 1895), 196.

7. In 1876 Gabriel Lippmann (1845–1921), professor of experimental physics and director of the physics research laboratories of the Sorbonne, invented the capillary electrometer, an interface of mercury and sulfuric acid that reacted to changes in an electrical current and thus, when connected to skeletal muscle, was "capable of registering the slightest electrical variation that occurred in living tissues" (Marey, *Movement*, 49). Marey blocked part of a small beam of light with the meniscus of the electrometer and illuminated an enlarged shadow image of the mercury surface. As the current (hooked up to the heart or some other muscle of an animal) passed through the column, the shadow changed its contour in response to the variation in the intensity of the electrical force. A narrow slit placed between the electrometer and a photographic plate that moved horizontally allowed him to record an image of a vertical bar that varied in height with the changing current. In 1877 Marey used another method of photographing the movement of the electrometer: he intermittently illuminated the changes that occurred in the mercury column (by means of an induction coil furnished with a condenser) and at the same time moved the photographic plate at right angles to the axis of the column. In the resulting image, the shadow of

the column was no longer a simple line but rather was "spread out in the form of a band, the sinuous border of which corresponds to the variations in the length of the column of mercury" (Marey, *Movement,* 49). The result also had a very close resemblance to the curve of the movements of the heart obtained by the graphic method. For a history of the capillary electrometer and Marey's work, see H. E. Hoff and L. A. Geddes, "The Capillary Electrometer: The First Graphic Recorder of Bioelectric Signals," *Archives Internationales de l'Histoire de Science* 14 (1961): 276–87.

The indirect photographic description Marey was applying to physiology had been used to copy readings from thermometers and hygrometers. Marey had also used photography briefly in his attempts to visualize sound. For details see Marey, *Méthode graphique*, 644–48; Louis Olivier, "La photographie du mouvement," *Revue Scientifique,* 3d ser., 4 (23 December 1882): 810; François Dagognet, *Etienne-Jules Marey,* (Paris: Hazan 1987), 31–37.

8. Marey, "Inscription photographique des indications de l'électromètre de Lippmann", *CRAS* 83 (1876): 278–80; Gabriel Lippmann went on to win the Nobel Prize not for the capillary electrometer, but for his theory and practice of color photography. Another Nobel Prize winner, E. D. Adrian, who won in 1932 for his work in the recording of neurophysiological phenomena, recognized Marey's and Lippmann's contributions in his acceptance speech as fundamental to his work. See Hoff and Geddes, "Capillary Electrometer," 287.

9. Marey, *Développement de la méthode graphique par l'emploi de la photographie* (Paris: Masson, 1885), 2.

10. Marey to Tissandier, 18 December 1878. The letter was published in *La Nature* on 28 December. In Anita Mozley, ed., *Eadweard Muybridge: The Stanford Years, 1872–1882,* rev. ed., (Palo Alto: Stanford University Department of Art, 1973), 116, and the same author's introduction to *Muybridge's Complete Human and Animal Locomotion,* xvii, "je rêvais" ("I was dreaming") is translated "I have devised," which incorrectly predates the construction of the gun by four years.

11. "Would you please assure Professor Marey of my high regard and tell him that the reading of his famous work on animal mechanism inspired Governor Stanford with the first idea of the possibility of resolving the problem of locomotion with the help of photography. Mr. Stanford consulted me about this, and at his request I re-

solved to assist him in his task. He asked me to pursue a more complete series of experiments. To this end we have constructed thirty cameras with electric shutters that, for the photography of horses, will be placed about twelve inches from each other. We will begin our experiments next May." Muybridge to Tissandier (written 17 February 1879), published in *La Nature*, 22 March 1879, 246. Since Stanford employed Muybridge in 1872, his statement that Marey's work first inspired Stanford to hire him seems at first glance to be a mistake: Marey's *Animal Mechanism* was not published in English until 1874. Perhaps Stanford had read reports of Marey's equine locomotion studies in 1872 (for example, in *CRAS* 75: 883–87). Yet given that the work Muybridge did for Stanford in 1872 was aimed at getting a single image of the horse, not a series—and only a series would resolve "the problem of locomotion"—perhaps what Muybridge wrote was true: the experiments for which Stanford considered Marey the inspiration were those done after 1876. Muybridge did not write or read French; the letter that appeared in *La Nature* was a translation. Muybridge's original letter has not been found.

12. Other attempts at animating lantern slides had preceded Muybridge's zoopraxiscope. The most popular of these was the Philadelphian Henry Heyl's animated dance sequences (1870). Heyl photographed models posing in phases of a dance movement and combined the resulting photographs on a glass disk that revolved in front of a magic lantern. Efforts like Heyl's that used photography to simulate motion—for example, those of Coleman Sellers (1861) and Alexander Becker (1857)—prepared the audience for Muybridge's success.

13. This mechanical bird existed in the Meudon Air Museum until it was destroyed in the bombardments of the Second World War.

14. Tatin made "a silk aeroplane, measuring 7.53 sq. ft. in surface, being 6.23 ft. across and 1.31 ft. wide, mounted in two halves at a very slight diedral angle, on top of a steel tube with conical ends which contained the compressed air. This reservoir was 4¾ in. in diameter and 33½ in. long, was tested to a pressure of 20 atmospheres, and worked generally at 7 atmospheres; its weight was only 1.54 lbs. and its cubical capacity 0.28 cub. ft. From this (the vital feature of the machine) the stored energy was utilized by a small engine, with oscillating cylinder, placed in a thin board on top of the

tube and connected by shafts and gearing to two propellers with four vanes each, located at the front of the aeroplane." Octave Chanute, *Progress in Flying Machines* (New York, 1894), 137.

15. Charles H. Gibbs-Smith, *Aviation: An Historical Survey*, 2d ed. (London: Science Museum Publications, 1985), 44.

16. Gibbs-Smith, *Aviation*, 58.

17. In the late 1890s Tatin developed a thirty-three-kilogram steam-powered model airplane with Marey's colleague Charles Richet. At the beginning of this century Tatin worked on the construction of the aviation pioneer Alberto Santos-Dumont's full-scale biplanes. See Victor Tatin, *Eléments d'aviation* (Paris: Dunod et Pinet, 1908).

18. On the date of Stanford's visit to Europe: Muybridge himself (in his article "Leland Stanford's Gift to Art and Science," in the San Francisco *Examiner*, 6 February 1881), and Robert Haas (*Muybridge: Man in Motion*, 127) have Stanford in Paris in autumn 1879. Anita Mozley, however, places Stanford at his house in Palo Alto for the official debut of the zoopraxiscope in autumn 1879, and in January 1880 for another private showing (Mozley, *Eadweard Muybridge*, 26 and 34 n. 21). Gordon Hendricks states that Stanford returned from Europe in August 1879 and left again in 1881: Hendricks, *Eadweard Muybridge: The Father of the Motion Picture* (New York: Grossman, 1975), 115.

19. *Le Globe*, 27 September 1881. English translation from the San Francisco *Alta California*, 16 November 1881, Muybridge Scrapbooks, Kingston Library, Kingston-on-Thames.

20. Marey, *Développement de la méthode graphique*, 12.

21. Marey, *La chronophotographie* (Paris: Gauthier-Villars, 1899), 8. For similar views see Louis Gastine, *La chronophotographie sur plaque fixe et sur pellicule mobile* (Paris: Masson and Gauthier-Villars, 1897), 13 ff., and Joseph Eder, *La photographie instantanée* (Paris, 1888), chap. 21.

22. The painters included Bonnat, J. L. Gérôme, Edouard Detaille, and Alexandre Cabanel. Françoise Forster-Hahn, "Marey, Muybridge and Meissonier: The Study of Movement in Science and Art," in Mozley, *Muybridge*, 85.

23. Marey, *Chronophotographie*, 24.

24. Muybridge to Frank Shay, 28 November 1881,

Collis P. Huntington Collection, George Arents Research Library, Syracuse University.

25. Eadweard Muybridge, *The Attitudes of Animals in Motion: A Series of Photographs Illustrating the Consecutive Positions Assumed by Animals Performing Various Movements* (Berkeley, Calif., 1881). Four copies were sold in London in 1882. Muybridge also gave a copy to Stanford (now with another copy in the Stanford University Museum of Art, Berkeley) and one to Marey in 1881 (now in the Musée Marey); Stanford presented one to Meissonier (now in the Houghton Library, Harvard). Two other copies are in Philadelphia, and one is at the Library of Congress. Muybridge's proof copy is in the Metropolitan Museum of Art, New York.

26. Muybridge to Shay, 23 December 1881, Collis P. Huntington Collection, George Arents Research Library, Syracuse University.

27. "I think it highly probable the hopes you kindly express in reference to the future experiments, are in a fair way of realization. M. Meissonier has ever since my acquaintance with him, taken the warmest interest in my illustrations of the attitudes of animals in motion, and has undertaken to see the means are provided for executing a new series of experiments during the coming season which I trust will completely eclipse those hitherto made, and *I trust you will approve of the engagement I made him on your behalf,* that we should have the advantage of your invaluable advice and assistance in the work" (emphasis added). Letter from Muybridge to Marey, 19 January 1882, California State Library, Sacramento, California.

28. Thomas Skaife's and M. Millotbrulé's pistol cameras were invented in June and July 1856; they were followed by the photo revolvers of Thompson de Briois (1862), Jonte (1872), and Enjalbert (1882).

29. Pierre-César Jules Janssen, "Méthode pour obtenir photographiquement l'instant des contacts avec les circonstances physiques qu'ils présentent," *CRAS* 76 (1873): 677. From Janssen's description an English prototype was constructed by John Henry Dallmeyer in April 1874, two months before Janssen had his own model built in France. A full description of Janssen's definitive instrument was published by him in the *Bulletin de la Société Française de Photographie,* April 1876, the year he was admitted to that Society. (He became president of the Society for the second time in 1899, taking over from

Marey, who had been elected president in 1894.) See Gérard Turpin, "Notes sur l'appareil de Janssen," *Les Informations de la Société Française de Photographie* 1 (January–February 1977): 1–12.

30. Janssen's revolver incorporated important features of two earlier inventions: the repeating mechanism of the Colt pistol of 1837, and the rotating slotted disk contained in the phosphoroscope of Edmond Becquerel (1871). Becquerel's phosphoroscope, which employed a single slotted disk, was used to measure luminescence spectra. See Becquerel, "Mémoire sur l'analyse de la lumière émise pour les composés d'uranium phosphorescents," *Annales de Chimie et Physique* 27 (1872): 539–79, and S. Leach and E. Migirdicyan, "Fluorescence à longue durée de vie de composés organiques," in *Actions chimiques et biologiques des radiations,* vol. 9 (Paris: Masson, 1966).

31. There is some confusion over the speed at which Janssen's instrument could produce an image, caused, strangely enough, by Marey. In his book *Movement,* 105, Marey cites "intervals of 70 seconds," mistaking the time taken to make an image with the time the plate took to make a revolution; subsequent authors—for example, Lucien Bull, Albert Londe, Georges Potonniée, Jean Vivié, and most contemporary writers—have followed his lead. Obviously Janssen did not need the complicated mechanism he devised for the photo revolver if he only wanted to make an image every seventy seconds. The question is fully discussed in Virgilio Tosi, *Il cinema prima di Lumière* (Turin: Edizioni Rai Radiotelevisione Italiana, 1984), 153–56, and Turpin, "Notes sur l'appareil de Janssen." Both authors comment on the mystery of Marey's error; perhaps it can be explained by the distance of almost twenty years that separated the writing of Marey's *Movement* from the appearance of Janssen's instrument.

32. Janssen, "Présentation du revolver photographique et épreuves obtenues avec cet instrument," *BSFP* 22 (April 1876): 104.

33. Janssen, "Présentation du revolver photographique," 105.

34. Cited, among other sources, in Michel Frizot, *La chronophotographie* (Beaune: Association des Amis de Marey and Ministère de la Culture, 1984), 67, and Tosi, *Cinema prima di Lumière,* 217. I have not been able to trace the source of this letter.

35. Marey, "Le fusil photographique," *La Nature*, 22 April 1882, 327–28.

36. The announcement of the gun to the Académie des Sciences brought a flurry of excitement. But Janssen's pleased response did not hinder him from reminding the Academy of his own claim to priority (in his "Note sur le principe d'un nouveau revolver photographique," *CRAS* 94 [1882]: 909–10). His insistence is worth remembering, first, because it was unnecessary: Marey had already praised Janssen's revolver, acknowledging it as the source of his own. Second, it would come up again when, in the polemic surrounding the invention of the cinema, Janssen's insistence would be used by others to discredit Marey's innovative genius.

37. Marey, "Fusil photographique," 329.

38. The small album in the Collège de France that is a record of the 1882–83 experiments contains a picture of this gun. Marey has written under it, "tir photographique: vieux fusil de munition" (photographic shooting: old supply rifle." Under the photographs taken with this gun he has written, "avec cible intérieure pour apprécier la justesse du tir" (with interior target to assess the accuracy of the shot).

Virgilio Tosi states that Marey had this instrument in his possession in Paris in late 1881 and brought it to Naples to practice with while awaiting the prototype of his photographic gun. Tosi, *Cinema prima di Lumière*, 217. Michel Frizot believes the rifle is possibly "a first attempt at a photographic gun, preceding the definitive one. Frizot, *E. J. Marey, 1830–1904: La photographie du mouvement* (Paris: Centre National d'Art et de Culture Georges Pompidou, Musée National d'Art Moderne, 1977), 63. I surmise, however, that the single-shot gun was made after the photographic gun. First, because all the photographs in the Collège de France album are placed in chronological order and those of the single-shot gun (and the pictures made with it) come after those of the photographic gun, not before. Second, because the single-shot gun was, in one way, an improvement over the photographic gun: the images it made were well modeled, not just silhouettes.

In *Physiologie du mouvement: Le vol des oiseaux* (Paris: Masson, 1890), 138, Marey describes a second single-shot gun: "I recently constructed a gun that gives only one image but with a powerful enough lens that the exposure time is reducible to the minimum. One thus obtains isolated images, but well modeled and large enough

to seize all the details of the pose of the bird that is represented. It is in this form that instantaneous photography seems most applicable to the determination of the attitudes that animals take at different instants in their movements. And it is with an instrument of this kind that one will have the best chance of gathering interesting information on the flight of those birds that cannot be raised in captivity."

39. By projection: he used a "megascope," enlarging the photographs to life size.

40. Marey, *Développement de la méthode graphique*, 2.

41. Marey, "Natural History of Organized Bodies," *Annual Report of the Board of Regents of the Smithsonian Institution for 1867*, 1868, 285.

42. Marey, "Détermination des inclinaisons du plan de l'aile aux différents instants de sa révolution," *CRAS* 74 (1872): 589.

43. Marey, *Développement de la méthode graphique*, 17.

44. The slotted-disk shutter in Marey's camera has its source in a similar device employed in Plateau's stroboscope. When the eye looked through the spinning disk onto a moving object beyond it, Plateau's slotted black disk "gave the curious result of making a fast-moving object appear completely immobile" (Marey, *Méthode graphique*, 420). Marey's substitution of the sensitive glass plate for the eye of the observer allowed the transformation of an otherwise ephemeral vision into an indelibly inscribed sequence of images.

45. Marey, "Lectures on the Graphic Method in the Experimental Sciences, and on Its Special Application to Medicine," *British Medical Journal*, 1 January 1876, 1.

46. In 1889, at Marey's behest, the International Congress of Photography, held concurrently with the Universal Exposition of that year, settled on "chronophotography" as the name to describe all sequential instantaneous photographic processes. This decision came from a commission, headed by Janssen, that took on the task of rationalizing the nomenclature in photography and photographic processes.

47. Marey, *Movement*, 127.

48. Marey, "The Physiological Station of Paris," *Science* 2 (23 November 1883): 679.

49. Anson Rabinbach, "The Body without Fatigue: A Nineteenth-Century Utopia," in *Political Symbolism and Modern Europe: Essays in Honor of George L. Mosse*,

ed. Seymour Drescher, David Sabean, and Allan Sharlin (New Brunswick, N.J.: Transaction Books, 1982), 42. I have relied on four excellent works for the following discussion: Rabinbach's essay, which is the fundamental study on the cultural impact of thermodynamics in the nineteenth century; Rabinbach's book *The Human Motor* (New York: Basic Books, 1990), an expansion and deepening of the first study; Robert Nye's *Crime, Madness and Politics in Modern France* (New Haven: Yale University Press, 1982), a work devoted to the implications of the metaphor of degeneracy and decline in France; and Alain Ehrenberg's *Le corps militaire* (Paris: Aubier, 1983).

50. Rabinbach, *Human Motor*, 48.

51. Rabinbach: "Body without Fatigue," 45.

52. Rabinbach, *Human Motor*, 5.

53. Ibid., 4.

54. Ibid., 68.

55. Ibid., 291.

56. Ibid., 292.

57. Nye, *Crime, Madness and Politics*, 319. "Health is the primary capital of man, particularly of the workers in the cities and in the fields. Health presides over the formation of fortune; through the mother, it influences the race. Physical education based on a rational method of corporeal exercise is the powerful ally if not the principal factor of capital." Congrès des Maires de France, cited by Philippe Tissié, *Revue des Jeux Scolaires et d'Hygiène Sociale*, October–December 1910, 220.

58. Nye, *Crime, Madness and Politics*, 321.

59. At first the length of service was five years, but multiple dispensations were allowed; in 1889 the time was reduced to three years, and in 1905 it was reduced again to two years, but with no dispensations. For this and the information below I have relied on Ehrenberg, *Corps militaire*, especially chapter 4. See also Jacques Ulman, *De la gymnastique aux sports modernes: Histoire des doctrines de l'éducation physique* (Paris: Vrin, 1977).

60. Léon-Michel Gambetta, 26 June 1871, speaking at Bordeaux, cited in Ehrenberg, *Corps militaire*, 91 n. 10.

61. As Ehrenberg points out (102 ff.), the new soldier was the result of the demands of the new warfare. The change from blocks of men fighting against other blocks to individuals fighting other individuals meant that the soldier was no longer constantly under the command of an officer, but rather was an isolated combatant who often had to make his own decisions. The goal of army training was therefore changed from producing obedient automatons to honing combatants who were both physically and intellectually resistant.

62. Eugen Weber, *France, Fin de Siècle* (Cambridge: Harvard University Press, 1986), 214. See also Weber's "Gymnastics and Sports in Fin-de-Siècle France: Opium of the Classes?" *American Historical Review* 76 (February 1971): 70–98. Weber convincingly argues that the gymnastic circles had a paramilitary function and provided the firm basis of Boulangist and nationalist politics. For Demeny's work, see Pierre Arnaud, ed., *Le corps en mouvement: Précurseurs et pionniers de l'éducation physique* (Paris: Privat, 1981); Ulman, *De la gymnastique aux sports modernes;* and the following by Georges Demeny: *L'éducation physique en Suède* (Paris: Editions Scientifiques, 1892); *Les bases scientifiques de l'éducation physique* (Paris: Alcan, 1893); *Plan d'un enseignement supérieur de l'éducation physique* (Paris: Alcan, 1899); *Mécanisme et éducation des mouvements* (Paris: Alcan, 1903); *Evolution de l'éducation physique: L'école française* (Paris: Fournier, 1909); *L'éducation de l'effort, psychologie-physiologie* (Paris: Alcan, 1914).

63. "Dear Sir,
We have created a new institution where we wish to study the most efficient means of developing the human body harmoniously by movement. There is a lot of confusion in these matters because physiologists, the only men capable of deciding the answers to the important questions, have no interest in them. Yet only experimentation can clear up the delicate physiological questions. For example, we think that graphs made with the sphygmograph during a gymnastic exercise would determine the precise effect of such an exercise on circulation. Thus one could justifiably condemn all those forced movements that cause the pressure in the veins to increase dramatically and possibly cause an aneurism.

There is a great deal of important research to be done, research that would be interesting for the vast field of exploration in animal mechanism you have opened; it would also hasten to determine the definitive rational gymnastic syllabus, which is pressing.

We would be happy to be able to put ourselves at your disposal for such experiments and to have some advice on the direction to give to our research" (Demeny to Marey, Beaune).

64. Demeny, *Evolution de l'éducation physique*, 258.

65. "Thank you for your offer to look over my proofs,

I'm counting on it, because in regards to everything that relates to geometry and mechanics, I'm always afraid of using the wrong formulas" (Marey to Demeny, 18 November 1892, Cinémathèque Française).

66. See Demeny, *Bases scientifiques de l'éducation physique,* and Marey in the *Revue Scientifique,* 29 December 1895 and 5 January 1896.

67. See Christian Pociello, "Georges Demeny," in Arnaud, *Corps en mouvement,* 209–21.

68. *Procès verbal, Conseil Municipal de Paris* (Paris, 1881), 263.

69. Ibid.

70. The albums of photographs Marey presented to the council are itemized in the appendix, catalog 1.

71. Two thousand francs each to Demeny and Marey and two thousand francs for equipment.

72. Marey, "The Work of the Physiological Station at Paris," *Annual Report of the Board of Regents of the Smithsonian Institution for 1894,* 1895, 406.

73. Marey, *Développement de la méthode graphique,* 23.

74. Ibid.

75. Marey, "The Physiological Station of Paris," *Science,* no. 2 (30 November 1883): 708.

76. Marey, "Physiological Station of Paris," 708.

77. A bright needle uniformly spinning around on a black velvet disk that was frozen in its path by the camera shutter; the intervals of time between successive exposures could be measured in the chronophotographs by the changes in the position of the needle.

78. Marey, "Emploi des photographies partielles pour étudier la locomotion de l'homme et des animaux," *CRAS* 96 (1883): 1827.

79. Ibid., 1828.

80. Ibid., 1828 n. 1.

81. Ibid., 1829.

82. Muybridge to Marey, California State Library, Sacramento. In his *Développement de la méthode graphique,* 21, Marey writes: "M. Londe showed me a camera of this kind of his devising, and M. Muybridge, on his part, sent me sketches of a similar instrument." Michel Frizot suggests that Londe's system might have been inspired by Muybridge's letter to Marey. Frizot, *Marey,* 78 and 81 n. 2. But according to Londe's own testimony, he was working on the camera before Muybridge's letter arrived. Albert Londe, *La photographie moderne* (Paris: Masson, 1896), 711. For a description of

Londe's earliest camera and its applications, see his articles "Obturateur circulaire," *BSFP* 29 (January 1883): 45–49, and "Appareil photo-électrique pour recherches médicales," *BSFP* 29 (May 1883): 125–30; Muybridge is not mentioned by Londe in either of these articles.

The multilens camera of which Muybridge sent Marey a sketch does not seem to be workable because the principle of intermittent motion was not incorporated. Muybridge himself, who would "probably take out a patent in the United States for an apparatus of this kind," as he says in the letter, does not seem to have used it. In 1884 he did use a single-lens "Marey-wheel" camera (see chap. 7 below) that had two rotating disks and one that had a single disk, but he soon gave up both in favor of his battery of cameras.

83. Londe produced a vast literature on photography and its applications and was a practitioner of almost all of them. See Albert Londe, *Titres et travaux scientifiques* (Paris: Gauthier-Villars and Masson, 1911). For a recent study of Londe see Bernard Denis and André Gunthert, "Albert Londe: L'image multiple," *La Recherche Photographique* 34 (May 1988): 7–15.

84. In a fascinating study, *Invention de l'hystérie, Charcot et l'iconographie photographique de la Salpêtrière* (Paris: Macula, 1982), Georges Didi-Huberman describes how photography was endorsed by Charcot to give scientific validity to the staged gestures and tableaux that were used to invent a visual model for hysteria.

85. Denis and Gunthert, "Albert Londe," 11.

86. Seventeen volumes appeared between 1888 and 1904.

87. The order in which the lenses were uncovered could be changed so that the lens followed the direction of the movement; the camera could produce a continuous or discontinuous series of pictures, at sixteen images per second. It was electrically operated. Londe and Charles Dessoudeix took out patents on the multilens cameras without protest from any quarter. In his "History of Chronophotography," *Annual Report of the Board of Regents of the Smithsonian Institution for 1901,* 1902, 323, Marey mistakenly gives 1883 as the date for Londe's twelve-lens camera.

88. Marey, *Développement de la méthode graphique,* 21 n. 1. According to the description on plate 31, album A (Beaune), the camera had ten lenses.

89. Not Marey, as Frizot notes (in *Marey,* 63, and in *Chronophotographie,* 118). In his small album in the

Collège de France, under the date Marey has inscribed "Images circulaires successives sur plaque tournant d'une mouvement uniforme, rotation lente (sujet Janssen). 4 tours à la sec., fenêtre étroite 1/100" (Circular images on a plate turning with a uniform movement, slow rotation [subject Janssen]. Four turns [of the disk shutter] per second, narrow slot, 1/100[th of a second exposure time]). Marey's description for negative 89 (Appendix, catalog 1) suggests that he also experimented with an intermittently moving plate. Janssen describes a camera incorporating a continuously rotating plate in "note sur le principe d'un nouveau revolver photographique," *CRAS* 94 (1882): 911.

90. Marey, "Etude de la locomotion animale par la chronophotographie," in *Comptes Rendu de l'Association Française pour l'Avancement des Sciences, Congrès de Nancy* (Paris, 1886), 66–67.

91. Marey's dynamometers would become the basic investigative tools in the study of work and fatigue; they were refinements of the 1849 dynamometer created by Jean Victor Poncelet and Arthur-Jules Morin.

92. The news was relayed to the French by a Dr. Blanc in 1873. "However," wrote Marey, "since the role of water sullied by choleric refuse in the propagation of the epidemic had not yet been considered predominant by us, I undertook to research the precise influence of that role in certain localities stricken by the disease." Marey, "Les eaux contaminées et le choléra," *CRAS* 99 (1884): 672.

The actual cause of cholera, a bacillus, was discovered by Heinrich Koch in 1883. See also Marey, "Sur l'épidémie de choléra," *BAM*, 2d ser., 13 (1884): 1113–20, 1460–68; and "Rapport sur l'épidémie de choléra en France pendant l'année 1884, fait à l'Académie de Médecine de Paris au nom d'une commission composée de MM. Bergeron, Besnier, Brouardel, Fauvel, Noël, Guéneau de Mussy, Legouest, Pasteur, Proust, Rochard et Marey (rapporteur)," *BAM*, 2d ser., 14 (1885): 1129–71, 1385.

93. As Marey explained it: "So far physicists had calculated only the amount of energy expended or gained by a person in walking along an inclined plane, in terms of the body weight lifted or lowered such and such a height. The first is a case of positive energy, and the second a case of negative energy. The amount of energy expended in different directions is the product of the body weight and the height of lift, an amount expressed in kilogram-meters. Looking at the matter in this light, progress along level ground would require no apparent expenditure of energy, yet it is accompanied by muscular exertion and consequent fatigue" (*Movement*, 156).

94. Marey, "Physiological Station of Paris," 711.

95. Marey identifies the point where the button was placed on the body as the pubis in the original article on the subject: "Locomotion de l'homme: Images stéréoscopiques des trajectoires que décrit dans l'espace un point du tronc pendant la marche, la course et les autres allures," *CRAS* 100 (1885): 1359–63, and he gives the location as the head in "Etude de la locomotion animale par la chronophotographie," 58.

96. J.-L. Soret (note presented by Marey), "Sur la détermination photographique de la trajectoire d'un point du corps humain pendant les mouvements de locomotion," *CRAS* 101 (1885): 273–75.

97. Marey to Demeny, January 1886, Cinémathèque Française.

98. Marey, "De la claudication par douleur," *CRAS* 107 (1888): 641–43.

99. Georges Demeny and Edouard Quénu, "Etude de la locomotion humaine dans les cas pathologiques," *CRAS* 107 (1888): 1550–64, and idem, "De la locomotion dans l'ataxie locomotrice," *CRAS* 108 (1889): 963–64. See also Georges Demeny, "La lumière à incandescence et l'analyse photographique des mouvements," *Revue de l'Electricité*, 11 February 1892, 69–70, and W. de Fonvielle, "Les progrès de l'électricité," *La Science Illustrée*, 16 January 1892, 122–24.

100. Marey, *Movement*, 135, 142. The experiments are outlined in a group of letters in Beaune from Lieutenant A. Andriveau to Marey and Demeny.

101. Marey, "Etude de la locomotion animale par la chronophotographie," 70.

102. The work was done with Calixte Pagès, with whom Marey published these experiments in 1886.

103. Marey, *Movement*, 208.

104. Ibid., 210.

105. Marey and C. Pagès, "Locomotion comparée: Mouvement du membre pelvien chez l'homme, l'éléfant et le cheval," *CRAS* 105 (1887): 149–56.

106. Marey, *Movement*, 24.

107. Marey, "Conditions de la rapidité des images dans la chronophotographie," *CRAS* 103 (1886): 537–38.

108. The strings that can be seen in these photo-

graphs looping down from the bird's legs were attached to small weights (not in view of the camera) that limited how high the bird flew. For Wilbur Wright's comments on Marey's discovery see chap. 5, n. 40.

109. Joseph Maria Eder, *History of Photography*, trans. Edward Epstean (New York: Dover Reprints, 1978), 512.

110. "I have shown that a single series of chronophotographic images projected on a vertical plane parallel to the axis of flight does not give sufficient information to explain the wing's mechanism." Marey, "Mouvements de l'aile de l'oiseau représentés suivant les trois dimensions de l'espace," *CRAS* 104 (1887): 323.

111. In 1887 Marey was also offered an observation post by his friend Alexandre-Gustave Eiffel on the gigantic tower the engineer was erecting on precisely the land Marey had first thought would be his. There is, however, no record of his taking up Eiffel's offer.

112. Marey, "Mouvements de l'aile de l'oiseau," 329.

113. Marey and Georges Demeny, "Etude expérimentale de la locomotion humaine," *CRAS* 105 (1887): 544–52; and Marey, "Représentation des attitudes de la locomotion humaine au moyen des figures en relief," *CRAS* 106 (1888): 1634–36. In his "Eloge" to Marey, the German physiologist Kronecker also describes sculptures of a trotting horse, but there is no mention of such a work by Marey, and no evidence has been found for its existence. Hugo Kronecker, "Eloge, Etienne-Jules Marey," in *Extrait de l'Association de l'Institut Marey* (Paris, 1905), 11.

114. Marey, *Vol des oiseaux*, 138.

Chapter Four

1. Marey, "Modifications de la photochronographie pour l'analyse des mouvements exécutés sur place par un animal," *CRAS* 107 (1888): 607.

2. "The size which we have selected for chronophotographic images [on film] is, as we said, precisely that adopted for the plates used for enlarging-cameras. Each photograph can be thrown on a screen, if required for public demonstration. The strip of film itself, or at least the series of positive images obtained from it by superpositions on a similar strip, can produce a series of effects following one another in such rapid sequence that the spectator sees the movement reproduced in all its phases." Marey, *Movement* (New York: Appleton, 1895), 123–24.

3. A full description of Marey's daylight-loading film was published in *La Nature*, 15 November 1890, 375–78, and in America in 1891 in the *Scientific American Supplement* 784 (10 January 1891): 12532. A film strip rolled onto its spool in contact with a longer and wider strip of black paper numbered to mark each frame was patented in 1895 by S. N. Turner. This patent was picked up by George Eastman and used in his Kodak (1898), the camera that put photography in the hands of everyone. See Joseph M. Eder, *History of Photography*, trans. Edward Epstean (New York: Dover Reprints, 1978), 490.

4. See Michael Chanan, *The Dream That Kicks* (London: Routledge and Kegan Paul, 1980), chap. 7, on the critical importance of celluloid to the birth of the cinema; and Reese V. Jenkins, *Images and Enterprise: Technology and the American Photographic Industry, 1839–1925* (Baltimore: Johns Hopkins University Press, 1976), on the history of Eastman's development of celluloid film.

5. In 1900 Marey wrote that while trying to solve the problem of equidistance in 1893 he tried perforations (using a pegged cylinder) to move the band, but other irregularities in the system wore out the perforations and the film became jumpy again. Moreover, "perforation, besides wearing, so as no longer to bring the pictures around regularly, also occupies a zone of one-tenth of an inch (2.5 millimeters) on each edge of the ribbon, a loss that is more important the narrower the film." Marey, "Exposition d'instruments et d'images relatifs à l'histoire de la chronophotographie," in *Musée centennal de la Classe 12 (photographie) à l'Exposition Universelle Internationale de 1900 à Paris: Métrophotographie et chronophotographie* (Paris: Belin, [1901]); English translation, "History of Chronophotography," *Annual Report of the Board of Regents of the Smithsonian Institution for 1901, 1902*.

Virgilio Tosi, whose familiarity with the mechanical aspects of Marey's cameras is unsurpassed, feels that incorporating a toothed cylinder into his camera would have been very difficult for Marey, necessitating a complete reelaboration of the machine. In Tosi's opinion, furthermore, Marey "lacked a strong motivation to move in that direction." See Tosi, *Il cinema prima di Lumière* (Turin: Edizioni Rai Radiotelevisione Italiana, 1984), 241.

6. Marey, "Appareil photochronographique applicable à l'analyse de toutes sortes de mouvements," *CRAS* 111 (1890): 626–29.

7. Marey, "La chronophotographie: Nouvelle méthode pour analyser le mouvement dans les sciences physiques et naturelles," *Revue Générale des Sciences Pures et Appliquées,* 2 (1891): 689–719. This camera also had two disk shutters rotating in opposite directions.

8. Marey, *Movement,* 222.

9. Ibid., 252.

10. See Marey, "Des mouvements que certains animaux exécutent pour retomber sur leurs pieds lorsqu'ils sont précipités d'un lieu élevé"; Emile Guyou, "Note relative à la communication de M. Marey"; Maurice Levy, "Observations sur le principe des aires"; Marcel Deprez, "Sur un appareil servant à mettre en évidence certaines conséquences du théorème des aires"; D. Nanu, "Note"; L. Lecornu, "Sur une application du théoréme des aires," all in *CRAS* 119 (1894): 714–21, 767–69, 871, 892–94; New York *Sun,* 19 December 1894.

L. P. Wheeler's account of a talk by the renowned Yale physicist Josiah Gibbs is typical of the curiosity that greeted Marey's experiment: "Gibbs' talk, which was given on December 4, 1894, was entitled 'On Motions by Which Falling Animals May Be Able to Fall on Their Feet,' and I remember clearly the amusement, tempered by admiration of his analytical skill, with which the audience received the explanation of how it was possible for a cat, by appropriate manipulation of its 'moment of momentum,' to fall upon its feet. This application of physical principles to an everyday if somewhat obscure phenomenon made a great impression on me." L. P. Wheeler, *Josiah Willard Gibbs* (New Haven: Yale University Press, 1952), 187.

11. Marey to Demeny, 30 May 1891, Librairie de l'Echiquier, Paris.

12. Marey to Demeny, 1 December 1891, Cinémathèque Française.

13. "To make film loops for the projector I would need some strong and smooth rubberized fabric that does not stretch—like the [enclosed] fabric I have found on the market here. Can one get a strong rubberized silk or a cotton or linen material that is very solid between the two coatings [of rubber]? You would greatly oblige me by making the rounds of the manufacturers and sending me some samples with the numbers written above, which you will keep copies of. On receipt of your samples, I will telegraph you to send me a band 4.5 meters long that the salesman should cut in three to make rolls for a postal packet. Each roll should be 33 centimeters wide by 4.5 meters long, supposing that the width of the fabric is 1 meter. I will return the twenty-ninth of this month and would like to bring back the bands with me [to Naples]. Marey to Demeny, 5 April 1892, Cinémathèque Française.

14. Marey, *Movement,* 311.

15. "I was a *préparateur* at the Collège de France earning 250 francs a month without hope of a future." Georges Demeny, *Les origines du cinématographe* (Paris: Henry Paulin, 1909), 22.

16. Marey to Demeny, 4 January 1884, Cinémathèque Française.

17. Marey urged Demeny to apply his research in the scientific basis of physical education to two areas where he could both earn money and make a name for himself: revising and compiling manuals for training, and teaching physical education instructors. "It is a matter of having for you the construction of the [gymnastics] manual and a teaching position to train instructors. If we can manage that, your career is made" (letter of 29 November 1888, Cinémathèque Française). This idea is constantly reiterated by Marey in his letters to Demeny until the late 1880s, when growing government interest in rational gymnastics ensured Demeny's place on a number of commissions constituted to study the question. By this time Demeny's scientific formation in Marey's laboratory "assured him of an indispensable social status. . . . The new theoretical light that he imposed on the concept of physical education . . . guaranteed its dignity as an object of scientific study and decisively contributed to its institutionalization. The professional corps of physical education teachers thus owe a large part of their existence to him." Christian Pociello, "Georges Demeny," in *Le corps en mouvement: Précurseurs et pionniers de l'éducation physique,* ed. Pierre Arnaud (Paris: Privat, 1981), 214.

18. For the most part, I have taken the history of the Marey-Demeny separation from Marey's letters to Demeny, now in the Cinémathèque Française. Demeny published his chosen extracts from these letters in his *Origines du cinématographe,* using the letters to defend himself against what he felt was unjust dismissal and also to defend his right to the title of inventor of cinema. An earlier piece entitled "Comment j'ai inventé le cinématographe?" delivered to the Ligue Française de l'Enseigne-

ment on 1 February 1909, was the basis of *Les origines du cinématographe*. Except for a small group of letters in the Musée Marey, Beaune, I have not been able to trace any of Demeny's letters to Marey.

19. Marey to Demeny, 29 March 1889, Cinémathè-que Française.

20. Marey's own interest in making speech visible dates back to the 1860s. His experiments in this area are described in *Méthode graphique,* 641–48. For the most part he experimented with registering the "manometric flames" of Rudolph Koenig, a naturalized French investigator of acoustical phenomena. Koenig used "capsules with membranous walls placed on little gas burners which vibrated in unison with the sonorous waves emitted by the voice or an instrument." Marey had dissociated their images in a revolving mirror, "but this fugitive phenomenon could not be fixed by photography until M. Marage, who has charge of the acoustic work at the Physiological Station, rendered the flames photogenic by substituting acetylene for ordinary illuminating gas. He has taken the photographs by chronophotography on a ribbon of sensitized paper." Marage chronophotographed the vibrations of vowels. Marey, "History of Chronophotography," 335. On these experiments see Marey, "L'inscription des phénomènes phonétiques," *Revue Générale des Sciences* 9 (1898): 445–56, 482–90.

An excellent account of the importance that Marey's interest in making speech visible had for the history of his graphing machines is given in François Dagognet, *Etienne-Jules Marey* (Paris: Hazan, 1987), 31–37.

21. Demeny, "Analyse des mouvements de la parole par la chronophotographie," *CRAS* 113 (1891): 216–17. Demeny published the chronophotographs of himself uttering "Vive la France" in *La Nature* on 16 April 1892. Marey's amused reaction is contained in this letter of 20 April: "Thank you for sending me [*La Nature*]. But you are hardly flattered! If the girls see you yelling 'Vive la France!' with that lamentable air it will certainly harm your establishment." Marey to Demeny, Cinémathèque Française.

22. Demeny, "La photographie de la parole," *Paris-Photographe,* 25 October 1891, 2.

23. Demeny's French patent 219,830 taken out on 3 March 1892 was for a "camera to produce the illusion of movement. Especially the movements of speech viewed directly or by projection by means of sunlight or the light of an oxyhydrogen or electric lantern." For descriptions

see, among others, those in *La Liberté,* 8 January 1892, and *Le Petit Journal,* 7 March 1892. Earlier reports of the photophone were written up in the English and American press in summer and fall 1891.

24. In fact, Anschütz unsuccessfully contested Demeny's patent. Anschütz's electrical tachyscope was a steel drum holding from fourteen to twenty-four diapositives ten centimeters (four inches) in diameter, illuminated by the intermittent flash of a Geissler tube. The images on the diapositives followed one another at approximately one-thirtieth of a second. The whole apparatus was hidden behind a wooden frame; the images were seen through a small aperture so that the number of people viewing at any one time was limited.

25. Marey to Demeny, 13 December 1891, Cinémathèque Française.

26. Demeny, "Les photographies parlantes," *La Nature,* 16 April 1892, 311.

27. London *Globe,* November 1892.

28. Marey had Otto Lund build a machine for Demeny that, like an enlarged photographic gun, took a series of negatives around the circumference of a continuously revolving disk made out of thick film twenty centimeters in diameter. The negatives could then be contact printed onto a glass disk.

29. Marey French patent 231,209, 29 June 1893. Marey claimed the method of transport of the film from one bobbin to another; the clamping mechanism that stopped the film long enough for an exposure to be made; the film rolled up with opaque black paper and glued at one extremity to twenty centimeters of red paper and at the other extremity to twenty centimeters of black paper; two shutters, of different dimensions, turning at a speed ratio of one to five, to be contained in the lens housing or placed against the film (as in the fixed-plate chronophotographe); and a machine that was reversible.

30. "My Dear Friend,
I pray you to send me your resignation without delay. It is an honorable way for you to leave, and I would not wish the administration to be obliged to intervene. You yourself certainly feel that this measure is necessary, that you are entirely uninterested in scientific research, and that I cannot get along without the help of an effective *préparateur.*

"In begging you to hasten with this matter, I must add that we have just time to regulate this affair before the vacation. I will wait for your letter, therefore, until

Thursday morning." Marey to Demeny, 25 July 1893, in Demeny, *Origines du cinématographe*, 60.

Tosi (*Cinema prima di Lumière*, 270), dates Marey's demand to February 1894, and Frizot (*Chronophotographie*, 154) dates it 10 April 1894; but in reality Marey and Demeny spent almost a year negotiating his leaving: see Marey's letters to Demeny in *Origines du cinématographe*, 60–63.

31. Demeny French patent 233,337, 10 October 1893. Demeny's patent was for a camera (which took sixteen images per second at an exposure rate of $\frac{1}{32}$ of a second), not a projector. In actuality, the problem of equidistant images was not solved by Demeny's eccentrically mounted roller, because as the amount of film taken up increased, it enlarged the diameter of the roller, augmenting the amount of film pulled past the lens. Thus, in his German and English patents applied for two months later on 19 December (and in an addition to his French patent granted 27 July 1894), the eccentric motion was transferred from the receiving bobbin to a roller (or "beater") adjacent to it, which "once per revolution, bore against the film, pulling through the exposing aperture a length equivalent to one frame." Brian Coe, "Appreciation of the Origins of Cinematography," *British Kinematography* 27 (December 1955): 177.

32. Marey, *Movement*, 318. In his later accounts of Demeny's actions, Marey was less sanguine: "While I was pursuing this research [on a projector], I learned that my *préparateur,* who knew my chronophotographe well, having used it numerous times at the Physiological Station, had patented this instrument under his own name. To make such a thing possible, he introduced in the construction of the instrument a modification that was well known in my laboratory, but one that I had not used." Marey, *La chronophotographie* (Paris: Gauthier-Villars, 1899), 26.

33. Demeny to Louis and Auguste Lumière, 6 October 1894, Demeny file, Beaune.

34. Louis Lumière to Demeny, 9 October 1894, Demeny file, Beaune.

35. Louis Lumière to Demeny, 28 March 1895, Maurice Bessy and LoDuca, *Louis Lumière, inventeur* (Paris: Prisma, 1948), 30. In an interview with Georges Sadoul and another for *Sight and Sound* in 1948, Louis Lumière stated that he made his first films in summer 1894. Georges Sadoul, "Entretien avec Louis Lumière, Bandol, Septembre 24, 1948," *Cahiers du Cinéma* 159

(1964): 8; Jay Leyda, ed., *Film Makers Speak* (New York: Da Capo Press, 1984), 289.

36. Demeny took out his certificate of addition for a reversible machine on 25 May 1895 and made improvements on it in additions of 15 June 1896 and 22 May 1897. The construction of the taking and projecting machines (under the names biograph and bioscope) was given over to Gaumont with the intention, at first, of selling them to amateurs for making animated portraits. The bioscope was a replica of the phonoscope, but the biograph constituted an improved chronophotographe, and Gaumont used it for projection for large audiences after 1897. See G. Brunel, *Le chronophotographe Demeny* (Paris, 1897).

For the next twenty years Demeny's beater remained one of the principal means of producing intermittent movement in motion picture projectors. The Jenkins and Armat projector was subsequently sold to Edison and marketed as the vitascope.

37. Demeny was accused of "perverting" the Swedish system of physical education by emphasizing exercises done with apparatus—barbells, rings, parallel bars, and so forth. The October–December 1910 issue of *Revue des Jeux Scolaires et d'Hygiène Sociale,* which reviews the history of the debate on rival methods of physical education, provides a typical example of the virulence of the attacks on Demeny: both his virility and his racial origins were called into question.

38. He could of course project his phonoscope disks, since the phonoscope was a projecting praxinoscope, but like all such instruments the small slots in the disk shutter allowed only a moderate amount of light to reach the images, so that their amplification was minimal; moreover, the phonoscope disk only held twenty-four images.

In the literature on the history of cinema there is some argument over whether Demeny succeeded on his own in projecting images before 1896. Jacques Delandes (in his *Histoire comparée du cinéma*, vol. 1, *1826–1896* [Brussels: Casterman, 1966]) and Léon Gaumont ("Note sur les origines de la cinématographie," *Les Annales,* October 1920), claim he did not; but J. Coustet (*Le cinéma* [Paris, 1921], 28) argues that he did. Demeny did adapt the phonoscope for projection, but he certainly did not project images made on film strips; this was left to Gaumont.

39. Dagognet, *Marey,* 121, exaggerates when he writes that Edison and Muybridge worked together. Edi-

son's fight to control the motion picture industry, which he carried on primarily through the courts (and when that did not work, through intimidation and beatings by gangs of thugs), was based on his attempt to secure recognition for the priority of his patents. To do this it was necessary for him to diminish his role as industrialist, perfecting and exploiting the work of others, and emphasize that of pure inventor—exactly the same edifice of belief constructed later by Louis Lumière. In 1894 when Edison launched his Kinetoscope he gave credit to both Marey and Muybridge as his inspiration (see Delandes, *Histoire comparée du cinéma,* 195). But during the patent wars he had to construct a history of cinematic invention with himself as sole creator. The work of other men, especially Muybridge, Marey, Demeny, and Friese-Greene, was by necessity ignored so that the invention of cinema would fall exclusively to his name. His highly publicized battles had the required effect, at least in America: although Edison was an inventor whose principal innovation was the art of exploiting the inventions of others, his name is still linked in the popular imagination with the sole invention of motion pictures.

40. Edison's lack of interest in projection was, according to information kindly related to me by Kinetoscope authority Ray Phillips, the critical factor in determining the direction of his motion picture work.

41. Gordon Hendricks, *The Edison Motion Picture Myth* (Berkeley: University of California Press, 1961). The important role played by Dickson's assistant William Heise in the motion picture work at West Orange is brought to light in Charles Musser's landmark history of early American cinema, *The Emergence of Cinema: The American Screen to 1907,* vol. 1 of *History of the American Cinema,* Charles Harpole, gen. ed. (New York: Charles Scribner's Sons, 1990), chap. 2. However, even though Edison ran an invention factory where the employees, like Dickson and Heise, worked out the details of his schemes, it was Edison alone who could seize on the practical applications of his (and others') ideas, and Edison alone who had the financial and organizational wherewithal to see such ideas through to completion.

42. A patent was issued to Edison and Dickson on 19 August 1890 for a magnetic ore separator.

43. Hendricks, *Edison Motion Picture Myth,* 159.

44. Ibid. Edison's idea of producing a positive image by pouring collodion over a shell appears baffling unless we take him to mean an *opaque* shell. A collodion nega-

tive could be converted into a seeming positive if it was viewed by reflected light against a dark background. This method of making collodion positives was first published in 1851; it was used almost exclusively in ambrotypes and tintypes, cheap imitations of the daguerreotype portraits that were immensely popular in the United States from 1860. See Helmut Gernsheim and Alison Gernsheim, *The History of Photography* (New York: McGraw-Hill, 1969), 237–39. I thank Joel Snyder for making this clear to me.

45. Hendricks, *Edison Motion Picture Myth,* 160.

46. Ibid., 159.

47. The eleven-by-fourteen-inch sensitized sheets of celluloid Dickson used were manufactured by John Carbutt, a leading American photographic plate maker. Carbutt offered the sheets as a lightweight substitute for glass plates; they were the first commercially successful application of celluloid as a base for photographically sensitive material. See Brian Coe, *The History of Movie Photography* (London: Ash and Grant, 1982), 61.

48. Itemized in Marey's letter to Demeny, 25 February 1889, Cinémathèque Française.

49. Hendricks, *Edison Motion Picture Myth,* 172. Edison and Dickson claimed that on his return from Paris Edison was presented with a talking motion picture made by Dickson with the kinetograph—a motion picture camera. Hendricks maintains that this early date is impossible. As evidence, he includes the absence of cables sent by Edison from Paris informing Dickson of Marey's work. Léo Sauvage (*L'affaire Lumière* [Paris: Lherminier, 1985], 111 ff.) agrees with Hendricks's conclusion but disagrees with the evidence. He feels that Edison did indeed keep Dickson up to date on concurrent work but that the cables were later suppressed or destroyed.

50. Albert E. Smith and Phil A. Koury, *Two Reels and a Crank,* 2d ed. (New York: Garland, 1985), 80.

51. Marey, "Nouveaux développements de la chronophotographie," *Comptes Rendus du Congrès des Sociétés Savantes* 1897, 140. In 1899, however, Marey wrote: The *Kinetoscope* is not without resemblance to my [1892–93 projector], and yet the American inventor . . . was in no way inspired by it. In the Kinetoscope the film circulates *without stopping,* but it is lit so well *from very close,* that the very frequent illuminations transmitted to the film by the window of the disk can be brief enough so that the film's displacement during such a rapid instant cannot be grasped" (Marey, "Chronopho-

tographie," 26). Marey seems here to contradict his earlier statement, but I think the contradiction can be resolved if we understand that he is making a distinction between Edison's Kinetoscope *camera* (properly called a kinetograph) and Edison's Kinetoscope *viewer*. Edison's camera and viewer were certainly inspired by Marey's chronophotographic camera: they employed a film moving from one reel to another and a disk shutter. But Edison's viewer was not inspired by Marey's projector: the Kinetoscope showed a continuously moving film, whereas in Marey's (and the Lumières') projectors the film stopped and started intermittently.

52. As we know from a letter in Beaune dated 12 November 1889 from Edison's private secretary, Marey had sent Edison a prepublication copy: "Mr. Edison has asked me to thank you for the copy of your book 'LE VOL DES OISEAUX,' which you very kindly sent him."

53. In England William Friese-Greene is held to be the inventor of the cinema. With Mortimer Evans, a mechanical engineer, he patented a sequence camera on 21 June 1889. Whether he projected sequences on transparent flexible film is still debated. Against the claim see Coe, *History of Movie Photography,* 56–60, and Brian Coe, "William Friese Greene and the Origins of Cinematography," *Photographic Journal* (London), March–April 1962, 25–40, 73–82, 86–93. For the claim see Chanan, *Dream That Kicks,* 86–93.

54. Marey, "Locomotion in Water Studied by Photography," *Scientific American Supplement* 784 (10 January 1891): 12532–33.

55. Dickson supposedly gave a demonstration of images made on celluloid on 20 May 1891. Hendricks (*Edison Motion Picture Myth,* 122), however, goes so far as to suggest that the strip shown was made from a series of glass plates: "There is also a possibility that all these frames are but a series of still photographs, separately posed, and then transferred to film." Hendricks insists throughout his study that Dickson and Edison did not have a workable machine until spring 1892: "It appears certain that although the only motion picture work at the laboratory resulting in a practicable apparatus until May, 1891, concerned a cylinder-viewer, a strip motion picture camera had been developed by October, 1892. It also appears certain that this development was helped by the knowledge of the work of other men—principally Marey and Friese Greene" (ibid., 141). Demeny should be added

to this list. See also Musser, *Emergence of Cinema,* 68–72.

56. In his patent Edison also claimed stereoscopic moving pictures and projection onto a screen that could be "colored to correspond with the subject of the photograph onto which the superposed [i.e., stereoscopic] pictures are thrown." Edison American patent 493,426, 14 March 1893, 3. All of Edison's patents and reissues were ultimately declared invalid on the grounds that they had been anticipated.

57. See Gordon Hendricks, *The Kinetoscope* (New York: Gauss, 1966), chap. 1, "The Camera."

58. Le Prince's description is in "Improvements for Producing Animated Photographic Pictures," *BJP,* 14 December 1888, 794.

59. "In 1895, Edison let Lumière patent perforations. The only way to understand this conduct on the part of such a well-informed expert is to admit that perforations had been discovered and applied before him, we do not know by whom. Our research has been fruitless on this point. Neither Edison nor Lumière, whom we have questioned, has been able to help us out." Félix Regnault, "L'évolution du cinéma," *Revue Scientifique,* 11 February 1922, 83.

Friese-Greene also incorporated sprocket holes in his paper-band camera of 1888. On the argument see file C37/833 of the Will Day collection in the Cinémathèque Française.

Edison used four rectangular perforations on each side of the image; The Lumière Cinématographe first incorporated the Reynaud system: two circular perforations, one on each side of the image. Later the Lumières adopted Edison's four perforations but kept them circular, twenty millimeters apart. Standardized perforations were suggested by Georges Méliès at the First International Congress of Film Editors in Paris in February 1909, and Edison's were adopted, a measure affected in no small way by Edison's monopolistic arrangement with Eastman, the world's major manufacturer of sensitized celluloid film.

60. Almost all European writers on the history of film attribute the success of Edison's machine not to its mechanical advances but to the fact that Edison had rolls of film available to him in lengths unobtainable in France.

61. It was only after Dickson left in 1895 and after the success of the Lumière Cinématographe that Edison bought the rights to Armat's vitascope projector.

62. Sadoul, "Entretien avec Louis Lumière," 4.

63. Coe, *History of Movie Photography,* 69. Although Edison did not patent the Kinetoscope in Europe, he did license the sale of the films for the machine. The desire to avoid paying the high prices Edison was charging for his films prompted most of the motion picture invention in England as well as in France.

64. Maurice Noverre quotes the following letter of C. L. Maurice, son of Clément Maurice, first director of the Cinéma Lumière in Paris, and Antoine's partner in the enterprise for one year: "One day, walking with Antoine Lumière, my father took him to see Edison's Kinetoscope. . . . On leaving the store, Clément Maurice said to père Lumière: 'The Kinetoscope is ingenious, but it constitutes, in my opinion, only a stage in the chronophotographic evolution: the synthesis of movement. Now what should be created is the projection of the animated image on a screen so that the spectator is not just one person but all of the public.' 'You are completely right,' responded Antoine Lumière, 'and the first thing I will do on my return to Lyons will be to talk to my sons about it'" (Maurice Noverre, *Le Nouvel Art Cinématographique,* no. 6 [8 September 1927]).

65. This account is given by Louis Lumière himself, and he insists that he never had his hands on a Kinetoscope: "I made my first film after having seen the Kinetoscope work; I saw this machine only once as a spectator, without being able to examine its interior mechanism." Sadoul, "Entretien avec Louis Lumière," 8.

66. Georges Sadoul, *Histoire générale du cinéma,* vol. 1, *L'invention du cinéma, 1832–1897* (Paris: Denoël, 1946), 149, and Noël Bouton, "Note pour M. le Dr. Poisot," [1920s], Beaune, believe that through their professional connections Marey and the Lumière family had become friends.

67. The following memoir was written in May 1937 by Georges Contremoulins, the *préparateur* who replaced Demeny at the Station:

Dear Sir,
You ask me to collect my memories on the subject of the creation of the Cinématographe so that some obscure points in your documents can be made clear. I hope I can satisfy you.

In my role as *préparateur* at the Physiological Station in the Parc des Princes from 1892 until 1896, I used Marey's chronophotographe to study the locomotion of small mammals, the fall of the cat and rabbit, the flight of insects, and so on. There-

fore I could appreciate the great value of this instrument, which, because it had a cam with variable durations, allowed one to freely take images from one to nine centimeters long on a band nine centimeters wide. In order to allow such variable framing, the band was not perforated; it advanced by starts because the film was halted by pinching it between the cam and the guiding path. Marey in fact was hostile to any idea of perforation.

The images were subsequently enlarged by projection. From them precise tracings were taken, and from these various studies were made: the relation between bony segments, muscular action, etc. In sum, it was work rather analogous to the animated drawings that are in vogue today. Marey had some positives contact printed from certain of these films, and he projected them directly with the taking camera, but these attempts ran into a snag: the stability of the framing was very difficult; the animated image would be displaced, sometimes above, sometimes below; the synchronization of the stoppages with the cam could not be rigorously maintained.

Marey spoke about it to [Jules] Carpentier, the able constructor of rue Delambre, who came one evening to boulevard Delessert at the beginning of 1894 to examine the camera. Since he did not find an immediate solution, he proposed to Marey, in my presence, to take away a chronophotographe in order to try to resolve the problem. He even impressed upon Marey the interest he would have in studying the machine from the point of view of its industrial applications. Marey immediately set one aside for Carpentier, and it was myself that brought it to him.

A year later, Carpentier brought back the camera and excused himself to Marey for not having found a satisfying solution. I was present at the laboratory, and I was a witness to this interview. Three or four weeks later, M. Lumière invited Professor Marey to the first projection of a cinematographic band that he had just made with a camera using a perforated band. This projection took place on 22 March 1895 at the offices of the Société d'Encouragement à [*sic*] l'Industrie Nationale. Marey soon learned that the constructor of L. Lumière's Cinématographe was none other than Carpentier!! I will always remember the astonishment and then the rancor of my master at this revelation. Marey had too fine a soul to let his deception be perceived. He believed it was best to respond by the most delicate irony. His letters were understood only by those who knew; later, they were turned against him.

A copy of this letter is in the collection of the Cinéma-thèque Française; written to Marey's partisan René Buhot, it has not been published in any of the many accounts of the invention of cinema in France. Most accounts, indeed,

date Carpentier's association with the Lumières from the summer or fall of 1895. See, for example Jacques Deslandes, "Les coulisses de l'invention," *Cinema 71* (January 1971): 33–39.

68. The up and down movement of the tooth and claw was "produced by a circular cam rotating in an almost oval hole in the pin frame and the in and out movement was executed by a pair of wedges on a rotating arm, one pushing the pins in, and the other withdrawing them. In an improved design . . . a triangular cam rotating in a roughly rectangular hole and a stepped groove on a rotating disk were used to provide the two movements. This new arrangement formed the basis not only of the Lumières' instrument but of a large number of later camera mechanisms, some still in use today." Coe, *History of Movie Photography,* 69.

69. Lumière French patent 245,032, for a camera used for making and showing chronophotographic positives.

70. Bouly French patent 235,100, 12 February 1892 (addition for reversibility on 27 December 93), was for a "reversible photographic and optical camera for the analysis and synthesis of movement called the Léon Bouly Cinématographe." It was delivered on 16 March 1894 and expired a year later for nonpayment of the second annuity. The machine was a sequence camera, of which one example still survives at the Conservatoire des Arts et Métiers and another at Eastman House, Rochester, New York. The Lumières' knowledge of Bouly's work is described in Sauvage, *Affaire Lumière,* 26, and by Louis Lumière in a 1948 interview with Sadoul quoted in Sauvage, 175. The Bouly "Cinématographe" is described by James Card, "The Historical Motion-Picture Collections at George Eastman House," in Raymond Fielding, ed., *A Technological History of Motion Pictures* (Berkeley: University of California Press, 1967; reprint 1983), 106.

71. At the offices of the *Revue Générale des Sciences* on 11 July and at the Sorbonne on 16 November.

72. Both Michel Frizot in *La Chronophotographie* (Beaune: Association des Amis de Marey and Ministère de la Culture, 1984), 166, and Brian Coe in *History of Movie Photography,* 71, state that Marey was filmed that day at Lyons. Although they looked somewhat alike, the figure leading the delegates is Janssen, not Marey.

73. "The Important event of this season has been the gains made in animated photography by the Lumières. In this area the interesting results of Muybridge and Edison are the best known. But the animated pictures created by

these inventors can be perceived by only one person at a time. With the Lumières, a whole assembly is called on to enjoy the astonishing illusion. The departure point for this new branch of photography is the photographic revolver invented on the occasion of the passage of Venus across the sun in 1874. . . . We know with what success the eminent current president of the Académie des Sciences and the Société de Photographie (M. Marey) took over the principle of this instrument, which, moreover, he completely transformed. But gentlemen, if the revolver and its derivatives give us the analysis of a movement by a series of its elementary aspect, the processes that allow us to realize the illusion of an animated scene by means of photography will take us much further. Honor today therefore to the Lumière brothers." Jules Janssen, speech to the Union Nationale des Sociétés Photographiques de France, 12 June 1895, reported in *BSFP,* 2d ser., 11, no. 17 (1895): 423.

74. Marey, "Nouveaux développements de la chronophotographie," 141.

75. Marey, "Nouvelles modifications du Chronophotographe," *BSFP,* 2d ser., 13, no. 9 (1897): 218–19.

76. In 1924, when the polemic over who invented the cinema was at its height, the Lumière brothers published a letter from Marey that suggests Marey tried to have them manufacture his cameras: "I regret that you did not believe it necessary to exploit my machines; I would have been happy to have entered into more intimate relations with you. But I understand your reasons; perhaps one day I will be successful in interesting you with another machine. I am very grateful to you for the generous support that you wish to give to the work at the Physiological Station. The ten thousand francs that you desire to contribute will be immediately employed." Marey to Auguste and Louis Lumière, 18 August 1899. Published in "Qui est le père du cinéma? Une déclaration des frères Lumière," *L'Oeuvre,* 23 March 1924. I have not been able to trace the original letter.

77. Marey French patent 257,178, 12 June 1896, with additions on 5 February 1897 and 11 June 1898. Marey was never in a position to manufacture either his instruments or his machines, and his film patents should be seen as part of his habit of patenting scientific instruments—beginning with the sphygmograph in 1869—rather than as a contribution to the "patent wars" that cloud the history of commercial cinema at the end of the century.

78. Marey, "Chronophotographe à pellicules non perforées," *BSFP*, 2d ser., 15 (May 1899): 273–77.

79. Frizot, *Chronophotographie*, 124.

80. Marey, *La chronophotographie* (Paris: Gauthier-Villars, 1899), 26–27.

81. Ibid., 31.

82. Louis Lumière finally did get himself admitted to the Académie des Sciences in 1919, but by ministerial decree rather than by the more usual election.

83. Early projections with the Cinématographe utilized the same technique of a transparent screen, often hung in the doorway between two rooms. See Louis Lumière, "The Lumière Cinematograph," in *A Technological History of Motion Pictures and Television*, ed. Raymond Fielding (Berkeley: University of California Press, 1967; reprint 1983), 50.

84. In the minds of the upper and middle classes, the 1897 fire started by a lamp used to project a Cinématographe film show, which killed over one hundred people at the Bazar de la Charité, only added to the instrument's ominous repute.

85. Marey to the Minister of Commerce, 22 March 1900, transcript, Cinémathèque Française.

Chapter Five

1. The International Congress of Physical Education was also held that summer in conjunction with the Universal Exposition. Demeny was its general secretary and Pierre de Coubertin and Charles Richet were among its vice presidents.

2. Eugen Weber, "Gymnastics and Sports in Fin-de-Siècle France: Opium of the Classes?" *American Historical Review* 76 (February 1971): 80.

3. Eugen Weber, *France, Fin de Siècle* (Cambridge: Harvard University Press, 1986), 197.

4. Weber, *France, Fin de Siècle*, 203.

5. Marey, "Sur la bicyclette," *BAM*, 3d. ser., 32 (1894): 278.

6. Eugen Weber, "Pierre de Coubertin and the Introduction of Organised Sport in France," *Journal of Contemporary History* 5 (April 1970): 24.

7. Weber, "Pierre de Coubertin," 14.

8. Marey, *Movement* (New York: Appleton, 1895), 139.

9. Marey and D. Mérillon, *Exposition Universelle Internationale de 1900 à Paris. Concours internationaux d'exercices physiques et de sports. Rapports publiés sous la direction de M. D. Mérillon. Commission Internationale d'Hygiène et de Physiologie, M. Marey, rapporteur* (Paris: Imprimerie Nationale, 1901), 5

10. Founded in 1881, the Racing Club was the first and foremost of the French sporting associations.

11. Marey to D. Mérillon, [1900], 8, Beaune.

12. Marey to Mérillon, 28, Beaune.

13. Marey to Mérillon, 36, Beaune.

14. "The craft can 'pitch' its nose up or down to initiate a climb or descent or 'yaw' its nose to the right or left in a flat turn in one plane. The third, or 'roll,' axis is employed when the machine, by raising one wing-tip and lowering the other, rotates about an imaginary line drawn through the centre of the fuselage." Tom Crouch, "Engineers and the Airplane," in R. Hallion, *The Wright Brothers: Heirs of Prometheus* (Washington, D.C.: Smithsonian Institution Press, 1978), 11.

15. To get into the air on a glider, the pilot usually jumped from a high elevation or was catapulted or, as in the case of the Wright brothers, propelled by an engine from a track.

16. Crouch, "Engineers and the Airplane," 14.

17. Charles H. Gibbs-Smith, *Aviation: An Historical Survey*, 2d ed. (London: Science Museum Publications, 1985), 58.

18. Gibbs-Smith, *Aviation*, 9. Gibbs-Smith points out that it was Ader who gave the French language the word *avion* for airplane.

19. Tom Crouch, *A Dream of Wings* (New York: Norton, 1981), 22.

20. Ibid., 290.

21. Ibid., 129.

22. Gibbs-Smith, *Aviation*, 63.

23. Marey wrote to Langley:

Davanne has passed your letter on to me where you express your desire to have a chronophotographic camera to take a series of images.

I no longer use the photographic gun, with which I could make only very small pictures—1½ centimeters. For eight years I have been using another camera that passes a sensitized film behind the lens. Less portable than the gun, this camera is superior to it in every other way. I have used it to gather a great number of images in a series, several of which have been published in my book called *Movement* (Paris, G. Masson, 1874) [*sic*].

I have made different modifications to the chronophotographe in these last years, and I am happy enough with the way it works. M. Edison probably has made some improvements to it, but I imagine his instrument is not very portable.

If I were in the country, I would have liked to send you a copy of my book, *Movement*. You will easily find it in Washington, I think, and you will see if my camera can satisfy your needs. In that case I can have one constructed for you with the modifications you desire if they are not too substantial. The price would be from two to three thousand francs.

Believe me, my dear colleague, I would be pleased to oblige you. It would make me very happy if my cameras could assist you in your excellent aviation research. These cameras in effect permit one to follow the movement of different forms moving in the air.

Marey to Langley, 21 June 1895, Smithsonian Institution Archives, Office of the Secretary, 1887–1907, record unit 31 (hereafter cited as Smithsonian, RU 31). Langley wrote with further specifications to Jules Carpentier on 2 July. Smithsonian Institution Archives, S. P. Langley, papers, personal correspondence.

24. Crouch, *Dream of Wings*, 152.

25. Marey to Langley, 12 January 1897, Smithsonian, RU 31.

26. Langley to Marey, 5 April 1897, Smithsonian Institution Archives Secretarial Papers, 1891–1906, Administrative File—Hodgkins Fund. Thomas George Hodgkins was an Englishman who had lived in Setauket, Long Island. He bequeathed $200,000 to the Smithsonian in 1891, "stipulating that one-half be used in 'the investigation of the properties of atmospheric air.' In 1892, when Hodgkins died, $50,000 was added which was used to support tuberculosis and air-pollution studies as well as such varied aeronautical research as E. J. Marey's photographs of birds in motion [*sic*]. . . . The regents allowed Langley to draw freely from this account for the construction of the aerodromes." Crouch, *Dream of Wings*, 134.

27. Marey to Langley, 19 November 1899, Smithsonian, RU 31.

28. Langley had wanted to exhibit in Paris the apparatus he used in actual flight as well as his pictures and drawings; on 31 October 1899 Langley asked Marey if such a small exhibition "would be desirable." In his reply in February 1900, Marey invited Langley to be the American delegate at the aeronautical congress, but then on 25 May Langley replied strangely that he could not be a speaker since his work was done for the government and he could not disclose its details. For the same reason (though he himself, he assured Marey on 18 June, had "nothing to hide"), Langley had also refused Marey's request to give a paper at the International Physics Congress held in Paris that same August. Langley-Marey correspondence, Smithsonian, RU 31.

29. Langley to Marey, 9 November 1900, Smithsonian, RU 31.

30. Marey, "Modifications de la photochronographie pour l'analyse des mouvements exécutés sur place par un animal," *CRAS* 107 (1888): 608.

31. Marey, "Le mouvement des liquides étudié par la chronophotographie," *CRAS* 116 (1893): 913–24. See also Pierre Noguès, *Recherches expérimentales de Marey sur le mouvement dans l'air et l'eau* (Paris: Publications Scientifiques et Techniques du Ministère de l'Air, no. 25, 1933).

32. Marey, *Movement*, 91–101.

33. Marey, "Emploi de la chronophotographie pour l'étude des appareils destinés à la locomotion aérienne," *CRAS* 113 (1891): 615.

34. Ibid., 617.

35. Marey, *Movement*, 98.

36. Marey to Demeny, 6 December 1886, Cinémathèque Française.

37. Marey, "Des mouvements de l'air lorsqu'il rencontre des surfaces de différentes formes," *CRAS* 131 (1900): 161. The wind tunnel measured fifty centimeters wide and deep by seventy-five centimeters high. The right wall was also of glass, and the left was painted white to reflect light. In front of the right wall was a lantern that burned magnesium.

38. In June Marey wrote that he had become aware of two other investigators working along the same lines with similar results. Ludwig Mach (the son of Ernst Mach) photographed fine silk threads, gas flames, dust, and hot and cold air currents moving around different shapes. J. Hele-Shaw of Liverpool used tubes of colored glycerin compressed between two sheets of glass to study the movement of liquids. Their experiments are described briefly in Marey, "Changements de direction et de vitesse d'un courant d'air qui rencontre des corps de formes diverses," *CRAS* 132 (1901): 1291–96.

39. Marey, "Les mouvements de l'air étudiés par la chronophotographie," *La Nature,* 7 September 1901, 234.

40. Wilbur Wright, "Some Aeronautical Experiments," lecture to the Western Society of Engineers, 18 September 1901, in Wilbur Wright and Orville Wright, *The Papers of Wilbur and Orville Wright,* ed. Marvin W. McFarland (New York: McGraw-Hill, 1953), 1:99. Probably through Chanute, Wilbur was also familiar with Marey's later, photographic, descriptions of flight: "Some years ago Prof. Marey made photographs of the flight of birds, employing a camera making fifty exposures a second. From these pictures it would appear that the bird's body rocks. The wings are moved diagonally forward on the downstroke, and backward on the upstroke. At the end of the downstroke the wings are in front of the centre of gravity so that the bird's body turns up in front and remains so while the wings are being raised with a backward movement. But the wings being thus brought back of the centre of gravity the axis of the body tilts downward again. By this backward and forward motion of the wings the bird rocks its whole body and thus inclines the plane of its wings upward and downward with every stroke." "Experiments and Observations in Soaring Flight," *Journal of the Western Society of Engineers,* December 1903, reprinted in Wright and Wright, *Papers,* 1:333.

41. Marey to Langley, 7 January 1903, Smithsonian, RU 31.

42. Marey, "Nécessité de créer une commission internationale pour l'unification et le contrôle des instruments inscripteurs physiologiques," *Journal of Physiology* (London) 23 (1898–99): 7.

43. Ibid.

44. Ibid.

45. A history of the Institut Marey is found in Louis Olivier, "L'Institut Marey," *Revue Générale des Sciences* 4 (1902): 193–99.

46. Finding money to support the ongoing work of the institute occupied Marey until the end of his life. Marey personally raised about forty thousand francs; his talents as a fund-raiser can be appreciated from his letters to Langley.

47. Charles Richet, "Discours," in *Hommage à M. Marey* (Paris: Masson, 1902), 11

48. Marey, "Discours," in ibid., 46.

49. "Etienne-Jules Marey" (obituary), *British Medical Journal,* 18 May 1904, 1289.

Chapter Six

1. Muybridge published an abridged version of *Animal Locomotion* in two volumes: *Animals in Motion: An Electro-photographic Investigation of Consecutive Phases of Animal Progressive Movements,* which was first published in 1899 and reprinted four times, and *The Human Figure in Motion: An Electro-photographic Investigation of Consecutive Phases of Muscular Actions* (1901), which was reprinted six times. In 1955 Dover Editions of New York republished the latter volume (with an introduction by Robert Taft), and in 1957 it reissued the former. In 1969 the Da Capo Press, "believing that the Dover reprints misrepresented the quality of the photographs" (Robert Haas, *Muybridge, Man in Motion* [Berkeley: University of California Press, 1976]: 199), published volume 1, *Males (Nude),* in its original format with a facsimile of the 1887 prospectus and catalog of the plates. In 1979 Dover published Eadweard Muybridge, *Muybridge's Complete Human and Animal Locomotion,* the complete set of 781 plates in three volumes with an introduction by Anita Ventura Mozley.

2. Muybridge, draft of a letter to Leland Stanford, San Francisco, 2 May 1892, Bancroft Library, University of California. Cited in Anita Mozley's introduction to *Muybridge's Complete Human and Animal Locomotion* (New York: Dover, 1979), xxxviii, n. 48.

3. Muybridge's case was based on the fact that *The Horse in Motion* contained photographs he had copyrighted. In May 1881 Stanford had paid Muybridge two thousand dollars for his work and for one dollar had sold him all rights to "any and all photographic apparatus, consisting of cameras, lenses, electric shutters, negatives, positives and photographs, magic lanterns, zoopraxiscopes; and patents and copyrights that have been employed in, and about the representation of animals in motion upon my premises at Palo Alto" (Bill of Sale and Assignment, Leland Stanford to E. J. Muybridge, 30 May 1881, Bancroft Library, University of California, Berkeley). In 1885 Muybridge finally lost the case he had instigated against Stanford. Depositions from the suit can be found in the C. P. Huntington Collection, George Arents Research Library, Syracuse University.

4. Muybridge, transcript of letter to Marey, London, 30 May 1882, California State Library, Sacramento.

5. Muybridge, transcript of letter to Marey, New York, 17 July 1882, California State Library, Sacramento.

6. Muybridge's illustrated magic lantern lecture was adopted from Marey's 1878 lecture on the gaits of the horse. Marey compared the way artists had depicted the gaits with the results he got with the graphic method. Muybridge compared the artistic representations with photographs. His lectures were constructed within the tradition of those popular nineteenth-century entertainments—the optical toys, music hall, and illustrated press—that were forerunners of the cinema. See John H. Fell, *Film and the Narrative Tradition* (Berkeley: University of California Press, 1986), and Erik Barnouw, *The Magician and the Cinema* (New York: Oxford University Press, 1981).

7. E. J. Muybridge, "Prospectus of a New and Elaborate Work upon *The Attitudes of Man, the Horse and Other Animals in Motion*" (New York: Scovill Manufacturing, 1883). The Scovill Company was the manufacturer of the cameras Muybridge had used in Palo Alto.

8. On Eakins's photographic work see Gordon Hendricks, *The Photographs of Thomas Eakins* (New York: Grossman, 1972); Charles Bregler, "Photographs by Eakins," *Magazine of Art* (Philadelphia), January 1943; and A. Hyatt Mayor, "Photographs of Eakins and Degas," *Metropolitan Museum Bulletin*, summer 1944, 1–7. On Eakins and Muybridge see William I. Homer, with the assistance of John Talbot, "Eakins, Muybridge and the Motion Picture Process," *Art Quarterly*, summer 1963, 194–216.

9. Eakins disliked the lines Muybridge had placed behind the horse: "I pray you to dispense with your lines back of the horse in future experiments. I am very glad you are going to draw out the trajectories of the different parts of the horse in motion as I have. . . . Have one perpend. centre line only behind the horse marked on your photographic plate. Then after you have run your horse and have photographed him go hold up a measure perpendicularly right over the centre of his track and photograph it with one of the cameras just used. . . . Do you not find that in your old way the perspective [is] very troublesome. The lines being further off than the horse a calculation was necessary to establish the size of your measure. The horses being a little nearer or a little farther off from the reflecting screen deranged and complicated the calculation each time." *Alta California*, 21 November 1878, and *Art Interchange*, 9 July 1879, cited by Lloyd Goodrich, *Thomas Eakins*, 2d ed. (Cambridge: Harvard University Press, 1982), 1:263.

To make zoetrope strips from Muybridge's photographs Eakins had to make drawings, for which he "plotted carefully with due attention to all the conditions of the problem, the successive positions of the photographs, and constructed, most ingeniously, the trajectories, or paths, of a number of points of the animal, such as each foot, the elbow, hock, centre of gravity, cantle of the saddle, point of cap of the rider, &c. Having these paths, and marking the beginning of the stride and the exact point at the other end of the diagram where the beginning of the next stride occurs, the whole stride can be divided into an exactly equal number of parts; . . . and the exact position of each point of the body determined for each of the twelve positions." Cited in Goodrich, *Eakins*, 263. When he chronophotographed the movements of a dark horse marked with pieces of white paper, Marey would effortlessly produce the results Eakins had so laboriously attained.

10. "The Zootrope," *Art Interchange,* 9 July 1879 (from Muybridge's scrapbook, Kingston-on-Thames, England).

11. Gordon Hendricks, "A May Morning in the Park," *Bulletin of the Philadelphia Museum of Art* 60, no. 285 (1965): 48–64.

12. The names of the members of the committee, the source of the initial outlay, and the actual amount of the project all vary according to different writers. See Marta Braun, "Muybridge's Scientific Fictions," *Studies in Visual Communication* 10, no. 3 (1984), 20n.10.

13. W. D. Marks, H. Allen, and F. X. Dercum, *Animal Locomotion: The Muybridge Work at the University of Pennsylvania* (Philadelphia: Lippincott, 1888; reprinted New York: Arno Press, 1973), 5.

14. Muybridge, cited in Anita Mozley, introduction to *Muybridge's Complete Animal and Human Locomotion,* xxxi.

15. Transcript of letter from Thomas P. Anshutz to J. Laurie Wallace, 18 June 1884, Archives of the Pennsylvania Academy of the Fine Arts. No photographs that Muybridge made with his two-disk camera have survived. Nor does Muybridge seem to have exhibited them: in August 1884 Muybridge gave a lecture at the University that was, according to Anshutz, "the same he gave us last year."

16. William Marks, "The Mechanism of Instantaneous Photography," in Marks, Allen and Dercum, *Animal Locomotion: The Muybridge Work,* 12.

17. Only two images, now in the collection of the Franklin Institute, Philadelphia, remain from this experiment.

18. Marks, "Mechanism of Instantaneous Photography," 15.

19. Transcript of letter from Thomas Anshutz to J. Laurie Wallace, August 1884. Archives of the Pennsylvania Academy of the Fine Arts. A description of the single-disk camera can be found in a letter from Dercum to George E. Nitzsche, 10 May 1929, Archives, University of Pennsylvania.

By the end of August or early September, Muybridge had started experimenting with his battery of cameras. In October 1885 Anshutz wrote that "the outcome of our photographic work this summer has I hear, been satisfactory to the University. The work of Maybridge [sic] being lacking in the correct time of exposure." Transcript of letter from Thomas Anshutz to J. Laurie Wallace, 2 October 1885, Archives of the Pennsylvania Academy of the Fine Arts. There are fourteen plates in *Animal Locomotion* that can be traced to later summer or early fall 1884.

The work Muybridge did with Dercum is described in Francis X. Dercum, "A Study of Some Normal and Abnormal Movements Photographed by Muybridge," in Marks, Allen, and Dercum, *Animal Locomotion: The Muybridge Work*, 123, 130 ff. In one case, to photograph tremors, Dercum and Muybridge created a geometrical subject. A patient was dressed for the experiment in dark blue tights with a white stripe along one arm and leg and a button on her wrist and hand. Muybridge took the photographs with the Marey-wheel camera. Dercum, "Study," 130. Muybridge made photographs of Dercum's patients with his battery of cameras in 1885. But to demonstrate their effectiveness, Dercum had to make drawings from them in which the phases of the movement overlapped. Dercum, "Study," 108–30.

20. Mozley, introduction to *Muybridge's Complete Human and Animal Locomotion*, xxix.

21. Homer, "Eakins, Muybridge and the Motion Picture Process," 212. Homer (p. 207) states that Eakins had a separate photographic studio of his own built on the university campus. Hendricks argues that Eakins built a studio in his backyard.

22. Muybridge printed a diapositive from each of the original camera negatives. From the composite of these diapositives a gelatin negative was then made, and a final collotype positive was printed from this negative. The collotypes varied in dimension from twelve by nineteen to six by eighteen inches. They were printed on nineteen-by-twenty-four-inch linen paper.

23. By 1885 Muybridge had incorporated a tuning-fork chronograph to measure the intervals between exposures (a full description is given in Marks, Allen, and Dercum, *Animal Locomotion: The Muybridge Work*, 26). However, not all the times given in the prospectus can be found in the notebooks Muybridge kept daily on the work (now housed at Eastman House, Rochester, New York), which are a more accurate record of what took place. The notebooks do show, however, the range of inaccuracies his system was prone to: out of 778 experiments recorded, there were 118 without any time record, 52 camera failures, 28 chronograph failures, and 95 darkroom-related mishaps such as fogging or breaking.

24. Muybridge, *Animal Locomotion: Prospectus and Catalogue* (Philadelphia: Lippincott, 1887), 9.

25. For a list of the other plates in *Animal Locomotion* that show these and the inconsistencies noted passim, see Braun, "Muybridge's Scientific Fictions."

26. There is an important temporal difference between these narratives and a written account, however. Because the photographic sequences exist all at once before our eyes on the print, the path of disclosure is created not only by Muybridge's disposition on the plate (his plot), but also by the viewer's choice.

27. In the end, the supervisory committee seems not to have given Muybridge much supervision or help: "Such help as I was able to give Muybridge was at the inception of his work in aiding in perfecting his then rather crude apparatus and subsequently by suggestions regarding technique, topics etc." (Edward T. Reichert to George Nitzsche, undated letter [ca. 1929], University of Pennsylvania Archives). Francis X. Dercum, who was responsible for the photography of abnormal locomotion, reported that except for himself and Eakins, everyone else was on summer vacation while Muybridge was working (letter to Nitzsche, 10 May 1929, University of Pennsylvania Archives), although we know that Andrew J. Parker, professor of physics, was present during work done at the zoo in 1885.

When the work was finished, the university decided to issue a companion volume of three essays written by William Marks, the engineer responsible for the chronograph Muybridge used, Harrison Allen, a physiologist, and Dercum. All three damned Muybridge's work with

faint praise. Marks and Dercum emphasized the advantage of Marey's single-camera system, while Allen wrote that many of the statements in his essay "could have been deduced from data already accessible to the writer but since he wrote the paper immediately after the inspection of the photographs his conclusion may be said to be based on them" (Marks, Allen, and Dercum, *Animal Locomotion: The Muybridge Work,* 35). But the last word should go to Pepper, who instituted the commission and the funding. In his introduction to these essays and to Muybridge's work, he notes: "The mass of novel material represented in this work is so great that it has not as yet been possible to subject any considerable portion of it to critical examination" (p. 7). It would not be an exaggeration to say that Pepper's attitude has been shared by all writers on Muybridge until the present.

28. In her article "Film Body: An Implantation of Perversions" (*Cine-Tracts* 3, no. 4 [1981]: 19–36), Linda Williams notes that the women are "consistently provided with an extra prop which overdetermines their difference from the male" (26), and that the gestures of women are almost always given within a narrative framework: both men and women lie down, for example, but the women lie down to read a newspaper or smoke. Williams, however, fails to connect such overdetermining and narrative strategies with the inconsistencies in the project as a whole.

29. Both Linda Williams and A. Gilardi, in his *Muybridge il magnifico voyeur* (Milan, 1980), read Muybridge in this way. Gilardi suggests a homosexual leaning.

30. The myth of Muybridge's "scrupulous scientific methods" (Aaron Scharf, *Art and Photography* [Harmondsworth, England: Penguin, 1974], 211), like the myth of his projecting photographs (rather than images drawn from photographs) with his zoopraxiscope in 1882, still flourishes.

31. "It is the artist who is truthful and it is photography which lies, for in reality time does not stop, and if the artist succeeds in producing the impression of a movement which takes several moments for accomplishment, his work is certainly much less conventional than the scientific image, where time is abruptly suspended." Auguste Rodin in conversation with Paul Gsell, cited in Scharf, *Art and Photography,* 226.

32. Marey, preface to *La photographie animée* by Charles-Louis Eugène Trutat (Paris: Gauthier-Villars, 1899), ix.

33. Ibid., vii. Michael Chanan, whose *The Dream That Kicks* (London: Routledge and Kegan Paul, 1980) is one of the most enlightening discussions on the relation of cinema and industry, sees Marey's stance as a "vulgar positivistic attitude [that] eliminates the truth of direct experience, and in particular ignores aesthetic experience as a form of knowledge" (p. 116).

34. Jeanne Thomas Allen, "The Industrial Context of Film Technology: Standardisation and Patents," in *The Cinematic Apparatus,* ed. Stephen Heath and Teresa De Lauretis (New York: St. Martin's Press), 28.

35. Chanan, *Dream That Kicks,* 48.

36. André Bazin, "The Myth of Total Cinema," in his *What Is Cinema?* vol. 1 (Berkeley: University of California Press, 1967), 22. Bazin (p. 17) also claims it is significant that Marey was "only interested in analyzing movement and not in reconstructing it." Bazin misses the point: Marey was certainly interested in reconstructing movement, but not for the purposes of reproducing it as the eye saw it.

37. Bazin, "Myth of Total Cinema," 21.

38. In his "Exposition d'instruments et d'images relatifs à l'histoire de la chronophotographie," in *Musée centennal de la Classe 12 (photographie) à l'Exposition Universelle Internationale de 1900 à Paris: Métrophotographie et chronophotographie* (Paris: Belin, [1901], 13–16, Marey himself reordered the chronology of his instruments. He placed the photographic gun after the fixed-plate camera and thus effectively created a history of his camera-assisted motion study that followed a logical evolution from fixed plates to moving plates to moving film. Marey was using the gun and collodion-gelatin negatives just before his first film experiments; this may in part explain his error.

39. Letter from Marey to the editor of *Le Gymnaste,* published in *Revue des Jeux Scolaires et d'Hygiène Sociale* 20 (October–December 1910): 195. According to a letter from Noël Bouton to Dr. Poisot written in the 1930s (Beaune), *Le Gymnaste* did not publish the letter because it found it defamatory.

40. Physical education in the lycées and universities of France was entrusted to two rival groups: army cadets who had graduated from the Ecole de Joinville and instructors provided by the "Union des Sociétés de Gymnastique," the union of the gymnastic circles. The former had, after 1907, reverted to a more severe form of the Swedish method that emphasized "rounded, aesthetic and

complete" movements; the latter included gymnastic apparatus in their teaching. Demeny wanted to ensure the control of gymnastics education by the Union, which adhered to his methods; Tissié and his followers wanted the army to take over all civil education.

41. Philippe Tissié, *Revue des Jeux Scolaires et d'Hygiène Sociale* 20 (October–December 1910): 214.

42. Charles Richet, speech given at the inauguration of Marey's monument, in *Inauguration du monument élevé à la mémoire de Etienne-Jules Marey au Parc des Princes à Boulogne-sur-Seine* (Paris: Gauthier-Villars, 1914), 16.

43. For a comprehensive account of Edison's suits for patent infringement see Charles Musser, *The Emergence of Cinema: The American Screen to 1907*, vol. 1 of *History of the American Cinema*, Charles Harpole, gen. ed. (New York: Charles Scribner's Sons, 1990).

44. Léo Sauvage, *L'affaire Lumière* (Paris: Pierre Lherminier, 1985), 18.

45. Ironically, this pantheon and its intended purpose finally came to pass with the creation in 1983 of the "Museum of Cinema" in what was the chateau of the Lumière family at Montplaisir, Lyons.

46. Sauvage, *Affaire Lumière*, 19.

47. Compte rendu des séances, *BAM*, 18 March 1924.

48. The following is a partial list of articles in chronological order:

1923: Paul Reynaud, *Cinéopse* 48 (11 June): 449–50.

1924: Pierre Noguès, *BAM*, 11 and 18 March; Maurice Montabré, "Qui a inventé le cinéma?" *Intransigeant* 15931 (18 March); Marcel Déat, "Qui est le père du cinéma?" *L'Oeuvre*, 23 March; letter from Louis Lumière, *Comoedia*, 24 March; Pierre Noguès' reply in *L'Oeuvre*, 27 March; L. P. Clerc, "Les origines du cinématographe," *Revue d'Optique, Théorique et Instrumentale* 3 (March): 201–10; L. P. Clerc, "L'invention du cinématographe," *Revue Française de Photographie*, 15 April; Georges Potonnieé, *BSFP* 31 (March).

1925: Pierre Noguès, "L'invention du cinématographe," *CRAS* 180:1–3, followed by L. Lumière's response: "A propos de l'invention du cinématographe."

1927: Georges Potonniée, "Les origines du cinématographe," *Revue Française de Photographie*, no. 175; P. Dubois, "En l'honneur de Marey," *Ciné-Journal: Le Journal du Film* 21 (19 August): 4–9.

1928: "Protestation contre la grande injustice commise envers l'illustre physiologiste français E. J. Marey par ceux qui

prétendent lui contester le mérite d'avoir créé la méthode cinématographique et inventé le premier cinématographe." Pamphlet signed and distributed by scientists, doctors, and associates of Marey.

1929: Maurice Noverre, "La vérité sur l'invention de la cinématographie," *La Nouvel Art Cinématographique*, 2d ser., no. 2 (April).

1930: Charles Richet, *BAM*, 24 June, 711–12. *L'invention du cinématographe*, a brochure favorable to Marey, was distributed by his followers at the Sorbonne when the ceremony celebrating the fortieth anniversary of the Lumière Cinématographe was held there.

1934: *Le progrès de Saône et Loire*, 18 March, 6 April.

1935: "Hommage à Louis Lumière" (Musée Galliéra), Ville de Paris, *Journal de Beaune*, 18 July, 10 October; *Le Progrès de Saône et Loire*, 3, 4, 8 September; Dr. Poisot, "Une mise au point: E. J. Marey et son oeuvre dans l'invention du cinématographe."

1936: Dr. Poisot, "Ce qui revient à Marey dans l'invention du cinématographe," *Progrès de la Côte d'Or*, 1 February; Léo Sauvage, "L'affaire Lumière, histoire d'une invention," *Vendredi* 3 (21 February); Jean-Pierre Liausu, in *Comoedia*, 6, 7, 10 March; René Buhot, *La Tribune Républicaine*, 12 March.

1937: René Buhot, "Le génial beaunois E. J. Marey est bien l'inventeur du cinématographe," *La Bourgogne Républicaine*, 26 July; *Revue Générale des Sciences*, 31 October; *L'Ecole Libératrice*, 10 July; René Buhot, *La voix de Marey: Histoire de l'invention du cinématographe*, part 1, Boulogne (Seine), pamphlet. The second part does not seem to have been published.

1938: *L'Action Laïque*, May; *La Nature*, 15 May.

49. Sauvage, *Affaire Lumière*, 9.

50. Session of 25 March 1926.

51. A. Lumière and L. Lumière, "Le Cinématographe," *Revue de Siècle* (May 1897), reprinted in idem, *Résume des travaux scientifiques de MM. Auguste et Louis Lumière, 1887–1914* (Lyons, 1914), 11. See also L. Lumière, "The Lumière Cinematograph," in Raymond Fielding, ed., *A Technological History of Motion Pictures and Television* (Berkeley: University of California Press, 1967; reprint 1983), 43–52.

52. John Cawelti, *Apostles of the Self-Made Man*, as quoted in Robert C. Allen and Douglas Gomery, *Film History: Theory and Practice* (New York: Alfred A. Knopf, 1985), 57: "Successful entrepreneurs were seen as forming an American aristocracy, an elite based not on birth or inherited wealth but on a combination of tradi-

tional values (frugality, hard work, and piety) and those demanded by the competitive world of industrial enterprise (self-confidence, initiative, and determination)."

53. Louis Lumière to Georges Sadoul, 6 January 1948, in Harry M. GeLduld, ed., *Film Makers on Film Making* (Harmondsworth, England: Penguin, 1970), 39.

54. Mainly through his supporter G. Michel Coissac, who wrote the influential *Histoire du Cinématographe* (Paris: Gauthier-Villars, 1925), and the writings of Georges Pontonniée, archivist of the Société Française de Photographie.

55. By G. Michel Coissac and by Jacques Ducom, *Le Cinématographe scientifique et industriel, son évolution intellectuelle, sa puissance éducative et morale* (Paris, 1911, 1923). Ducom worked for Gaumont, and he reproduced in his book Demeny's 1909 "Les origines du cinématographe." Coissac (*Histoire du Cinématographe,* p. 140) also insisted that Edison owed everything in his Kinetoscope to Demeny's phonoscope.

56. For the centenary, Charles Richet rephotographed and perforated many of Marey's films and projected them at the Académie de Médecine on 24 June 1930 and again at a meeting of American and Canadian doctors in Paris in August. For this he was accused of "truffage" by one Dr. Cazeneuve in *Lyon Médical* 31 (3 August 1930).

57. Particularly in Marey's "Nouveaux développements de la chronophotographie," *Comptes Rendus du Congrès des Sociétés Savantes,* 1897, and in his conference on chronophotography at the Conservatoire National des Arts et Métiers in 1899.

58. For example, Emile Roux-Parassac, *Et l'image s'anima, ou La merveilleuse et véridique histoire d'une grande invention* (Paris, 1930), one of the most important pro-Lumière tracts to appear at the time.

59. Georges Sadoul, *Histoire générale du cinéma,* vol. 1, *L'invention du cinéma, 1832–1897* (Paris: Denoël, 1946).

60. For example, in the 1960s, Jean Mitry's *Histoire du cinéma,* 3 vols. (Paris: Presses Universitaires de France, 1967–73), and Jacques Deslandes (with Jacques Richard), *Histoire comparée du cinéma,* 2 vols. (Paris: Casterman, 1966–69).

61. Henri Langlois, "A l'occasion du 125e anniversaire de J. E. Marey," *300 années de cinématographie: 60 ans de cinéma,* exhibition catalog (Paris: Musée d'Art Moderne, 1955).

62. A strong rebuttal to Sauvage's book, Bernard

Chardère's *Lumières sur Lumière,* was published in 1987 (Lyons: Institut Lumière and Presses Universitaires de Lyon).

63. Robert Haas, *Muybridge, Man in Motion* (Berkeley: University of California Press, 1976); Gordon Hendricks, *Eadweard Muybridge, the Father of Motion Pictures* (New York, 1975); and Kevin MacDonnell, *Eadweard Muybridge, the Man Who Invented the Moving Picture* (Boston: Little, Brown, 1972).

64. A comprehensive bibliography for all of those histories can now be found in Thomas Elsaesser, ed. (with Adam Barker), *Early Cinema: Space Frame Narrative* (London: British Film Institute, 1990).

65. See, for example, Mark Gosser, "The Literature of the Archaeology of Cinema," *Quarterly Review of Film Studies* 9, no. 1 (1984): 3–10, and Noël Burch, *Life to Those Shadows,* trans. and ed. Ben Brewster (Berkeley: University of California Press, 1990), which treats the "constitution of an Institutional Mode of Representation" in the beginnings of cinema.

Chapter Seven

1. Stephen Kern, *The Culture of Time and Space, 1880–1918* (Cambridge: Harvard University Press, 1983), 1. On this theme see also Jean Brun, "Le voyage dans le temps," in *Temporalità e alienazione* (Padua: Cedam, 1975).

2. Linda Nochlin, *Realism* (Harmondsworth, England: Penguin, 1971), 41.

3. Ibid., 43.

4. Marey, "A Study in Locomotion," *Nature* 19 (1879): 467; translation of "Moteurs animés: Expériences de physiologie graphique," *La Nature,* 28 September 1878, 273–78, and 5 October 1878, 289–95.

5. Ibid., 489.

6. Ibid.

7. Marey, "Représentation des attitudes de la locomotion humaine au moyen des figures en relief," *CRAS* 106 (1888): 1635–36.

8. But the point Marey makes in *Movement* has been almost universally ignored, and the Demeny picture is the image most often reproduced as the paradigm of Marey's work. See, for example, Aaron Scharf, "Marey and Chronophotography," *Artforum,* September 1976, 68, Linda Dalrymple Henderson, "Italian Futurism and 'The Fourth Dimension,'" *Art Journal,* winter 1981, 319,

and Beaumont Newhall, *The History of Photography*, rev. ed. (New York: Museum of Modern Art, 1982), 120. Scharf dates the picture 1891, Henderson dates it 1882. Demeny published the image in *La Nature*, October 1890.

9. Marey, *Movement* (New York: Appleton, 1895), 179.

10. Ibid., 172–73.

11. Ibid., 183.

12. I am grateful to André Jammes, who has the Marey studies of horses that Detaille owned, for pointing this out to me.

13. On painting and the photography of movement see Françoise Forster-Hahn, "Marey, Muybridge and Meissonier: The Study of Movement in Science and Art," in *Eadweard Muybridge: The Stanford Years, 1872–1882*, ed. Anita Mozley (Palo Alto: Stanford University Department of Art, 1972; revised ed., 1973), 98–103; Aaron Scharf, *Art and Photography* (Harmondsworth, England: Penguin, 1968), chaps. 8 and 9; Van Deren Coke, *The Painter and the Photograph* (Albuquerque: University of New Mexico Press, 1964); Erika Billeter, *Malerei und Photographie im Dialog von 1840 bis Heute*, exhibition catalog, (Zurich: Kunsthaus, 1977).

14. Gary Tinterow, "Degas and Muybridge," in *Degas*, exhibition catalog, (Ottawa: National Gallery of Canada, 1988), 459.

15. Henry, a champion of Seurat's art, wanted to create a rational aesthetics; he was particularly interested in Marey's graphic method and in his dynamometric studies because of their scientific rationalization and representation of rhythm. Henry often used Marey's work to illustrate his association of graphic rhythms with physiological and psychological states of energy and fatigue. See Charles Henry, "Sur la dynamogénie et l'inhibition," *CRAS* 108 (1882): 70–71; idem, "Introduction à une esthétique scientifique," *Revue Contemporaine*, 25 August 1885, 3–31; idem, "Rapporteur esthétique et sensation de forme," *Revue Indépendante*, April 1888, 73–90; and idem, *Le cercle chromatique* (Paris, 1889). There is disagreement about Seurat's acquaintance with Marey's chronophotography. See the letters by William I. Homer and Aaron Scharf in *Burlington Magazine* 104 (September 1962): 391–92; Scharf, *Art and Photography*, 362–63; and Robert Herbert, *Seurat*, exhibition catalog (Paris: Grand Palais, 1990), 389.

16. Kirk Varnedoe, *A Fine Disregard: What Makes Modern Art Modern* (New York: Harry N. Abrams, 1990), 122.

17. Eugène Véron, *L'esthétique* (Paris: Reinwald, 1878), 29.

18. Georges Guéroult, "Formes, couleurs et mouvements," *Gazette des Beaux Arts*, ser. 2, 25 (1882): 179.

19. Marey, "La chronophotographie: Nouvelle méthode pour analyser le mouvement dans les sciences physiques et naturelles," *Revue Générale des Sciences* 2 (1891): 690.

20. Robert de la Sizeranne, *Les questions esthétiques contemporaines* (Paris: Hachette, 1904), 197–98.

21. Ibid., 199–200.

22. Paul Souriau, *L'esthétique du mouvement* (Paris: Alcan, 1889); English translation, *The Aesthetics of Movement* (Amherst: University of Massachusetts Press, 1983), 119. Strangely, though Souriau's references are indisputably to Marey's work, the translation is illustrated with photographs from Muybridge's *Animal Locomotion*.

23. Souriau, *Aesthetics of Movement*, 118.

24. Paul Souriau, *La suggestion dans l'art* (Paris: Alcan, 1893), 136.

25. For the discussion below I am indebted to Stephen Kern's *Culture of Time and Space* and to Linda Dalrymple Henderson's *The Fourth Dimension and Non-Euclidean Geometry in Modern Art* (Princeton: Princeton University Press, 1983).

26. Kern, *Culture of Time and Space*, 18.

27. Henderson, *Fourth Dimension*, xix.

28. Ibid., 15.

29. Ibid.

30. Ibid., 17.

31. At one point Bergson's students had to bring a petition before the administration, demanding that a block of seats be set aside for them—seats that were usually taken up by the *gens du monde*, the more cosmopolitan intellectuals, and worse, by "rich women" who had nothing better to do and found Bergson very much the intellectual vogue.

32. Henri Bergson, *Matter and Memory*, trans. Nancy Margaret Paul and W. Scott Palmer (London: George Allen and Unwin, 1911), 246.

33. Bergson, *Creative Evolution*, trans. Arthur Mitchell (London: Macmillan, 1911), 339.

34. Bergson, *Matter and Memory*, 259.

35. Ibid., 281.

36. Bergson, *Introduction to Metaphysics*, trans. T. E. Hulme (London: Macmillan, 1913), 27. "By intuition is meant the kind of *intellectual sympathy* by which one places oneself within an object in order to coincide with what is unique in it and consequently inexpressible. Analysis, on the contrary, is the operation which reduces the object to elements already known, that is, to elements common both to it and other objects. To analyze therefore, is to express a thing as a function of something other than itself" (p. 6).

37. On Marey and Bergson see Marta Braun, "The Photographic Work of E. J. Marey," *Studies in Visual Communication* 9, no. 4 (1983): 21, and Anson Rabinbach, *The Human Motor* (New York: Basic Books, 1990), 110–13.

38. Giuseppe Prezzolini, *Il tempo della voce* (Milan and Florence: Longanesi and C. Vallechi, Longanesi, 1960), 241.

39. Bergson, *Mélanges*, ed. André Robinet (Paris: Presses Universitaires de France, 1972), 509. This seemingly incongruent meshing of science and pseudoscience was one of the more common threads linking the preeminent philosophers, scientists, and artists of the nineteenth century.

40. Bergson, *Mélanges*, 821; see also 355, 687, and 712ff.

41. Bergson, *Creative Evolution*, 319.

42. Bergson, *Matter and Memory*, 277.

43. Bergson, *Creative Evolution*, 33.

44. Ibid., 360.

45. Bergson, *Introduction to Metaphysics*, 41.

46. Bergson, *Creative Evolution*, 351.

47. Scharf, *Art and Photography*, 268.

48. The theoretical explanation is to be found in *Du cubisme*, by Albert Gleizes (1881–1953) and Jean Metzinger (1883–1956), published in 1912 (English translation in Robert L. Herbert, *Modern Artists on Art* [Englewood Cliffs, N.J.: Prentice-Hall, 1964]). On simultaneity, see Henderson, *Fourth Dimension*, 91, and Margit Rowell, *František Kupka, 1871–1957,* exhibition catalog (New York: Guggenheim Museum, 1975), 64.

49. Henderson, *Fourth Dimension*, 91.

50. "At the end of 1911, [the writer] Alexandre Mercereau was only one of the first among many defenders of cubism to declare that Henri Bergson had given his approval to cubism [in *Vers et Prose*, no. 27 (October–December 1913): 139]. André Salmon, in announcing the exhibition of the "Section d'Or" [*Gil Blas*, 22 June 1912], intimated that Bergson would write the preface to the catalog, which Bergson in fact did not do. Bergson would have been a powerful ally indeed, for by 1911 he had become a national sage in the eyes of the French. But if one examines the source of these rumours, an interview with Bergson published in *L'Intransigeant* [26 November 1911], one finds that Bergson admits never having seen the works of the cubists; on being shown a copy of this article by Metzinger, Bergson replied that he did not understand a single word of it! [See André Salmon, *Paris-Journal*, 30 November 1911.] Yet the legend persisted for years that Bergson approved of the cubists, even after a second interview in 1913 [in *L'Eclair*, 29 June 1913] in which he denied either knowledge or approbation of cubism." Edward Fry, *Cubism* (New York: McGraw-Hill, 1966), 67.

Umberto Boccioni was outraged that cubism would be considered an expression of Bergson's philosophy; he states this in his "Il dinamismo futurista e la pittura francese," published in *Lacerba*, 1 August 1913. For other sources of cubism, both philosophical and practical, see Kern, *Culture of Time and Space*, 148.

51. As cited in Henderson, *Fourth Dimension*, xxii.

52. Rowell, *Kupka*, 57. I have relied on Rowell for the discussion of Kupka below.

53. Ibid., 54.

54. According to Rowell (*Kupka*, pp. 62 and 139), a multiple-exposure photograph of Madame Kupka in the garden has been suggested as the source of these pastels, though no such photograph has yet been found.

55. Margit Rowell, "Kupka Duchamp and Marey," *Studio International* 189 (1975): 49.

56. Rowell, *Kupka*, 66. Henderson, *Fourth Dimension*, 107, states that the notation on the drawing must have been added after 1910–11, the date usually ascribed to the drawing, because the text recalls a passage from Gaston de Pawlowski's *Voyage au pays de la quatrième dimension*, which was not published until 20 May 1912.

57. Rowell, *Kupka*, 71.

58. Pierre Cabanne, *Entretiens avec Marcel Duchamp* (Paris: Pierre Belfond, 1967); translated by Ron Padgett as *Dialogues with Marcel Duchamp* (New York: Viking Press, 1971; London: Thames and Hudson, 1979; reprinted New York: Da Capo Press, 1987), 28.

59. Cabanne, *Dialogues with Marcel Duchamp*, 29.

60. Ibid., 34. But note that Duchamp also attributes

the same images to Muybridge: "The studies of horses in movement and of fencers in successive positions like those in the albums of Muybridge were well known to me." Interview with J. J. Sweeney, "Eleven Europeans in America: Marcel Duchamp," *Museum of Modern Art Bulletin* 13, nos. 4–5 (1946): 20.

61. Even more precisely, and despite Duchamp's statement above, they recall an overlapping skeletal dots-and-lines diagram of a figure descending a plane, found on page 290 of Paul Richer's *Physiologie artistique de l'homme en mouvement* (Paris: Doin, 1895).

62. Cabanne, *Dialogues with Marcel Duchamp*, 35.

63. *La pittura futurista: Manifesto tecnico* was preceded by *Manifesto dei pittori futuristi* (*Manifesto of Futurist Painters*) published 11 February 1910. It was printed by Marinetti before Balla's adherence to the movement, and the original text does not bear his signature. The manifestos marked the painters' public adherence to Marinetti's poetic crusade declaimed in the Paris *Figaro* in February 1909.

64. Umberto Boccioni, Carlo Carra, Luigi Russolo, Giacomo Balla, and Gino Severini, *La pittura futurista: Manifesto tecnico* (Milan, 11 April 1910), translated as *Futurist Painting: Technical Manifesto, 1910*, in Umbro Apollonio, ed., *Futurist Manifestos*, Documents of Twentieth-Century Art, 12 (New York: Viking Press, 1973), 27–28. The theory of the persistence of vision was crucial to the early theoretical program of the futurists; it formed the scientific basis of divisionism. See Gaetano Previati, *I principi scientifici del divisionismo* (Turin: Bocca, 1906). In Italy, unlike France, the theory was not used to establish the antinaturalism of photography.

Although Souriau's writing was diffused in Italy and known by the futurists (see "La poetica del dinamismo plastico" by Piero Quaglino in the exhibition catalog *Boccioni a Milano* [Milan: Gabriele Mazzotta, 1983]), 105. Souriau's eight-legged horse has not, to my knowledge, been connected to the futurists' twenty-legged horse. Maurizio Calvesi feels that the phrase about the horse was inserted in the futurist manifesto by Russolo, whose work at that time contained the repetitive element implied in the phrase. For his argument see Maurizio Calvesi, "Le fotodinamiche di Anton Giulio Bragaglia," in *Anton Giulio Bragaglia, Fotodinamismo futurista* (Rome: Nalato, 1913; reprint with critical essays, 2d ed., Turin: Einaudi, 1980), 176–77.

65. For an exhaustive bibliography on futurism and

photography, including works on futurist photography, see the following exhibition catalogs by Giovanni Lista: *Photographie futuriste italienne (1911–1939)* (Paris: Musée Moderne de la Ville de Paris, 1981) and *I futuristi e la fotografia* (Modena: Galleria Civica, 1986).

66. See, for example, Marey, "La cronofotografia," *Il Dilettante di Fotografia* (Milan) 3 (1892): 260–65, 390–94, 672–75.

67. Umberto Boccioni, Carlo Carrà, Luigi Russolo, Giacomo Balla, and Gino Severini, "The Exhibitors to the Public," preface to the catalog *Exhibition of Works by the Italian Futurist Painters* (London: Sackville Gallery, March 1912), in Apollonio, *Futurist Manifestos*, 48. A note in the preface states that the ideas expressed "were developed at length" in Boccioni's lecture.

68. On Bragaglia's relation with the futurists I have relied on the following articles published in Bragaglia, *Fotodinamismo futurista*: Calvesi, "Le fotodinamiche de Anton Giulio Bragaglia," Maurizio Fagiolo, "'Moderna magia,'" and Filiberto Menna, "Il fotodinamismo come tecnica trascendente." The same volume contains a bibliography of writings by Bragaglia compiled by Antonella Vigliani Bragaglia.

69. According the futurist poet Luciano Folgore, "The Bragaglia brothers did a 'futurist portrait' of me. In reality it was Arturo who took the photograph, insofar as of the two—Arturo and Anton Giulio—in this field Anton Giulio was the theorist and Arturo the executor." Lucian Folgore, "Un 'ritratto futurista,'" in *Anton Giulio Bragaglia*, ed. Mario Verdone (Rome: Bianco e Nero, 1965), 159. In an article in *La Repubblica* in July 1987, the youngest brother, Carlo Ludovico, claims the photographs as his work.

70. Bragaglia, *Fotodinamismo futurista*, 13.

71. Ibid., 10.

72. Ibid., 18.

73. Ibid., 19.

74. Ibid., 43.

75. See Carlo Ludovico Ragghianti, "Fotodinamica e fotospiritica," *Critica d'Arte* 172–74 (July–December 1980): 213–15. Interestingly enough, for Boccioni photography was the primary medium for documenting the "luminous emanations of our bodies." See Umberto Boccioni, "Fondamento plastico della scultura e pittura futuriste," in *Umberto Boccioni: Gli scritti editi e inediti*, ed. Zeno Birolli (Milan: Feltrinelli, 1971), 143. For the futurists' interest in spiritualism see Germano Celant,

"Futurism and the Occult," *Artforum,* January 1981, 36-44.

76. Bragaglia, *Fotodinamismo futurista,* 23.

77. Ibid., 23.

78. Ibid., 24.

79. Ibid., 28.

80. However, Caroline Tisdall and Angelo Bozzolla have observed that "when Bragaglia was invited to participate in the Grand Futurist evenings, it was only in the far flung regions—Sicily or Naples or minor centers like Gubbio—and presumably when Boccioni was not present." "Bragaglia's Futurist Photodynamism," *Studio International* 189 (1975): 13.

81. Balla, letter to his fiancée Elisa Marcucci, Paris, 1900, quoted in Susan Barnes Robinson, *Giacomo Balla: Divisionism and Futurism, 1871-1912* (Michigan: UMI Research Press, 1981), 129 n. 97. My translation.

82. In an interview in 1952 given to the Museum of Modern Art, Balla referred to these as "represent[ing] the way of walking of the person."

83. Letter from Boccioni to Sprovieri, 4 September 1913. In M. Gambillo and T. Fiori, eds., *Archivi del futurismo* (Rome: De Luca, 1958), 1:288. On the background to Boccioni's letter see Carlo Ludovico Ragghianti, "Fotodinamica futurista," *Selearte* 7, no. 39 (January-February 1959): 2-10.

84. Henri des Prureaux, "Il soggetto nella pittura," *La Voce* 4 no. 44 (1912), 13. The criticism rankled enough to provoke Boccioni to a public reply in *Lacerba* in August 1913 as his position against Bragaglia was maturing: "We have always rejected with disgust and scorn even a distant relationship with photography, because it is outside art. Photography is valuable in one respect: it reproduces and imitates objectively, and, having perfected this, it has freed the artist from the obligation of reproducing reality exactly." Umberto Boccioni, "Il dinamismo futurista e la pittura francese," translated as "Futurist Dynamism and French Painting," in Apollonio, *Futurist Manifestos,* 110.

In "Dinamismo plastico," written in December 1913, Boccioni returns to this theme: "It seems clear to me that this succession is not to be found in the repetition of legs, arms and faces, as many people have idiotically believed, but is achieved through the intuitive search for *the one single form which produces continuity in space.* Therefore, instead of the old-fashioned concept of sharp differentiation of bodies, . . . we would substitute a *concept of dynamic continuity* as the only form" (emphasis in the original). Translated as "Plastic Dynamism" in Apollonio, *Futurist Manifestos,* 92. From this point Boccioni's diatribe against photography formed an ongoing counterpoint to his praise of Bergson.

85. On this theme see Calvesi, "Fotodinamiche de Anton Giulio Bragaglia," 188.

86. See Brian Petrie, "Boccioni and Bergson," *Burlington Magazine* 116 (March 1974): 140-47. Giovanni Lista, *Photographie futuriste italienne,* 70, incorrectly insists that Boccioni read Bergson only in translation.

87. Umberto Boccioni, "Fondamento plastico," translated as "The Plastic Foundations of Futurist Sculpture and Painting," in Apollonio, *Futurist Manifestos,* 89.

88. Bragaglia also would write an introduction for the 1930 "Manifesto of Futurist Photography," by Marinetti and Tato (the pseudonym of the painter and photographer Guglielmo Sansoni). Tato's photographs combined chronophotography and photomontage.

89. Ivor Davies, "New Reflections on the *Large Glass:* The Most Logical Sources for Marcel Duchamp's Irrational Work," *Art History* 2, no. 1 (1979): 89.

90. Davies, "New Reflections on the *Large Glass,*" 93.

91. Jean Clair, *Duchamp et la photographie* (Paris: Editions du Chêne, 1977), 98 ff.

92. On Ernst and Marey see Charlotte Stokes, "The Scientific Methods of Max Ernst: His Use of Scientific Subjects from *La Nature,*" *Art Bulletin* 62 (September 1980): 453-65; Aaron Scharf, "Max Ernst, Etienne Jules Marey, and the Poetry of Scientific Illustration," in *One Hundred Years of Photographic History: Essays in Honor of Beaumont Newhall,* ed. Van Deren Coke (Albuquerque: University of New Mexico Press, 1975), 117-27.

Chapter Eight

1. André Liesse, *Le travail aux points de vue scientifique, industriel et social* (Paris: Guillaumin, 1899), 18.

2. Anson Rabinbach, *The Human Motor* (New York: Basic Books, 1990), 52. For this section I have relied on Rabinbach's groundbreaking work and that of Georges Ribeill: "Les débuts de l'ergonomie en France à la veille de la Première Guerre Mondiale," *Le Mouvement Sociale* 113 (October-December 1980): 2-36.

3. See, for example, Alfred Fouillée, *La science sociale contemporaine,* 3d ed. (Paris: Hachette, 1895); Louis

Querton, *L'augmentation du rendement de la machine humaine* (Brussels: Misch and Thron, 1905); Laurent Deschesne, "La productivité du travail et les salaires," *Revue d'Economie Politique* 13 (1899); Paul Louis, *L'ouvrier devant l'état: Histoire comparée des lois du travail dans les deux mondes* (Paris: Alcan, 1904); Liesse, *Travail aux points de vue scientifique, industriel et social.*

4. Liesse, *Travail aux points de vue scientifique industriel et social,* 19.

5. Marey, "Sur l'importance au point de vue médical des signes extérieurs des fonctions de la vie," *BAM,* 2d ser., 7 (11 June 1878): 615.

6. Marey, "L'économie de travail et l'élasticité," *La Revue des Idées* 1, no. 4 (1904): 161.

7. Not content with his personal observation, Marey hitched some of his friends to the cart. (They "were all struck by the same result.") Marey, "Du moyen d'économiser de travail moteur de l'homme et des animaux," in *Comptes Rendus de l'Association Française pour l'Avancement des Sciences, Congrès de Lille, 1874* (Paris, 1875), 1159.

8. Ibid., 1165.

9. Marey, "L'étude des mouvements au moyen de la chronophotographie en France et à l'étranger," *Revue Générale Internationale* 1, no. 1 (1896): 201–18; Félix Regnault and Commandant De Raoul, *Comment on marche* (Paris: Charles-Lavauzelle [1898]), with preface by Marey. Marey's (and Demeny's) graphic and chronophotographic studies of the military were elaborated on in Prussia in Otto Fischer and Christian Wilhelm Braune, *Über den Schwerpunkt des menschlichen Korpers* (Leipzig, 1889), in Otto Fischer, *Der Gang des Menschen* (Leipzig: Taubner, 1895), and in Nathan Zuntz and Wilhelm Schumburg, *Studien zu einer Physiologie des Marches,* 2d ed. (Berlin: Hirschwald, 1897).

10. See Jules Amar, *The Human Motor, or The Scientific Foundations of Labour and Industry,* trans. Elsie Butterworth and George E. Wright (London: Routledge, 1920), 435–36.

11. Marey, "Travail de l'homme dans les professions manuelles," *Revue de la Société d'Hygiène Alimentaire* 1 (1904): 198.

12. Marey, *Movement* (New York: Appleton, 1895), 139.

13. Marey, "Economie de travail et l'élasticité," 177.

14. Charles Fremont, "Les mouvements de l'ouvrier dans le travail professionel," *Le Monde Moderne* 2, no. 1 (1895): 187–93.

15. Auguste Chauveau, "Le dépense énergétique qu'entraînent respectivement le travail moteur et le travail résistant de l'homme qui s'élève ou descend sur la roue de Hirn: Evaluation d'après l'oxygène absorbé dans les échanges respiratoires," *CRAS* 132 (1901): 194–201. A Hirn's wheel is like a human hamster wheel with steps at equal intervals inside its circumference.

16. Auguste Chauveau, "Le travail musculaire et sa dépense énergétique dans la contraction dynamique, avec raccourcissement graduellement croissant des muscles, s'employant au soulèvement des charges (travail moteur)," *CRAS* 138 (1904): 1669–1675, and *CRAS* 139 (1904): 13–19; idem, "Le travail musculaire et sa dépense énergétique dans la contraction dynamique, avec raccourcissement graduellement décroissant des muscles, s'employant au refrènement de la descente d'une charge (travail résistant)," *CRAS* 139 (1904): 108–13.

17. As described by Amar, *Human Motor,* 178.

18. Marey had used the registering spirometer—a vat-and-tube apparatus that measured the quantity of air inhaled and exhaled—in his study of the effects of training on respiratory function. See Georges Demeny, "Appareils de mésure ayant pour but de déterminer avec précision la forme extérieure du thorax, l'étendue des mouvements respiratoires, les profils et les sections du tronc, ainsi que le débit d'air inspiré et expiré," *CRAS* 106 (1888): 1363–65, and Marey, "The Work of the Physiological Station at Paris," *Annual Report of the Board of Regents of the Smithsonian Institution for 1894,* 1895, 391–412.

19. Angelo Mosso, *Fatigue,* trans. Margaret Drummond and W. B. Drummond, 2d ed. (London: Swan Sonnenschein, 1906), 81.

20. Lando Ferretti, *Angelo Mosso, apostolo dello sport* (Milan: Garzanti, 1951), 8.

21. Mosso's fatigue tracings (which he called ergograms) contradicted the fatigue graphs Kronecker made. Kronecker's myograph tracings of a frog muscle (done between 1871 and 1873) had shown the curve of universal fatigue to be a constant, whereas Mosso demonstrated that it differed from one individual to another, depending both on the subject and on the conditions of the experiment.

22. Josefa Ioteyko, *The Science of Labour and Its Organization* (New York: E. P. Dutton, 1919), 12.

23. Anson Rabinbach, "The European Science of Work: The Economy of the Body at the End of the Nineteenth Century," in *Work in France: Representations, Meaning, Organization, and Practice,* ed. Steven L. Kaplan and Cynthia Koepp (Ithaca: Cornell University Press, 1986), 485.

24. Ribeill, "Débuts de l'ergonomie en France," 15.

25. Jules Amar, *Le rendement de la machine humaine* (Paris: Baillière, 1910), 25.

26. Ribeill, "Débuts de l'ergonomie en France," 17.

27. Rabinbach, *Human Motor,* 187.

28. Ribeill, "Débuts de l'ergonomie en France," 18.

29. Jules Amar, *The Physiology of Industrial Organisation and the Re-employment of the Disabled,* trans. Bernard Miall (London: Library Press, 1918), 196.

30. Ribeill, "Débuts de l'ergonomie en France," 19.

31. Ibid., 20.

32. As Ribeill describes it (ibid., 20), Toulouse called for the "application of experimental, scientific methods that, to be fruitful, must lead to the association of workers and savants." He intended to create a work laboratory that would determine aptitudes for different work and organize the selection of workers, study the conditions for the enactment of laws on work and their consequences, and send commissions to investigate the problems leading to strikes and suggest remedies for them.

33. Rabinbach, *Human Motor,* 249.

34. Cited in Ribeill, "Débuts de l'ergonomie en France," 23.

35. Ioteyko, *Science of Labour,* 4.

36. Ibid.

37. Rabinbach, "European Science of Work," 499.

38. Armand Imbert and Mestre, "Nouvelles statistiques d'accidents du travail," *Revue Scientifique,* n.s., 3 (1905): 520.

39. Armand Imbert, "De la mésure du travail musculaire dans les professions manuelles," *Revue de la Société d'Hygiène Alimentaire et d'Alimentation Rationnelle de l'Homme* 3 (1906): 636.

40. Amar, *Human Motor,* 279.

41. Imbert measured the muscular effort exerted both perpendicular (to support the load) and parallel to the handles (the force necessary to move the vehicle).

42. Armand Imbert and Mestre, "Recherches sur la manoeuvre du cabrouet et la fatigue qui en résulte," *Bulletin de l'Inspection du Travail* 5 (1905): 15–32;

Armand Imbert, "Etude expérimentale du travail de transport de charges avec une brouette," *Bulletin de l'Inspection du Travail* 9 (1909): 47.

43. Rabinbach, *Human Motor,* 184.

44. Armand Imbert, "Un nouveau champ d'action en hygiène sociale: L'étude expérimentale du travail professionnel," *Bulletin de l'Alliance d'Hygiène Sociale,* April–June 1912, 51.

45. Imbert, "Exemples d'étude physiologique directe du travail professionnel ouvrier," *Revue d'Hygiène et de Police Sanitaire,* no. 31 (1909): 750.

46. Ioteyko, *Science of Labour,* 53.

47. Among others Rabinbach cites L.-G. Fromont, director of the Belgian Société des Produits Chimiques von Engis, and Ernst Abbe, director of the Carl-Zeiss optical works in Germany. Rabinbach, *Human Motor,* 217–18 and passim.

48. Judith Merkle, *Management and Ideology: The Legacy of the International Scientific Management Movement* (Berkeley: University of California Press, 1980), 86.

49. John E. Sawyer, "The Social Basis of the American System of Manufacturing," in *Essays in American Economic History,* ed. A. W. Coats and Ross M. Robertson (London: Edward Arnold, 1969), 285.

50. Ibid., 290.

51. For the discussion below I have relied on David A. Noble, *America by Design: Science, Technology, and the Rise of Corporate Capitalism* (New York: Alfred A. Knopf, 1977); Harry Braverman, *Labor and Monopoly Capital: The Degradation of Work in the Twentieth Century* (New York: Monthly Review Press, 1974); and Merkle, *Management and Ideology.*

52. Noble, *America by Design,* 55.

53. Braverman, *Labor and Monopoly Capital,* 156.

54. Ibid., 160. In Germany, "The turning point came with the synthesis of aspirin—the first purely synthetic drug—by Adolf von Bäyer (1835–1917) in 1899. The worldwide success of aspirin within a few years convinced the chemical industry of the value of technological work dedicated to research alone." Peter Drucker, *Technology, Management, and Society* (London: Heinemann, 1970), 52.

55. Noble, *America by Design,* 6.

56. Harlow S. Person, "Basic Principles of Administration and Management: The Management Movement," cited in Noble, *America by Design,* 263.

57. Peter Drucker, *The Practice of Management* (New York: Harper and Row), 280.

58. But as Judith Merkle makes clear, "only Taylor's synthesis answered simultaneously problems of production and organization, at the same time that it responded with solutions to the industrial disruption of American society." Taylorism, Merkle feels, was not only a technique of speeding work, but a "method of social pacification" (Merkle, *Management and Ideology*, 10). On Taylor and Taylorism, see M. J. Nadworny, *Scientific Management and the Unions* (Cambridge: Harvard University Press, 1955); Daniel Nelson, *Frederick W. Taylor and the Rise of Scientific Management* (Madison: University of Wisconsin Press, 1980); *Le Taylorisme: Actes du colloque international sur le Taylorisme organisé par l'Université de Paris XIII 2–1 May 1983* (Paris, 1984).

59. Merkle, *Management and Ideology*, 38.

60. Taylor's "high-speed" steel, devised with the metallurgist J. Maunsel White, was a process of heat treating steel that permitted more metal to be cut at higher machine speeds, while at the same time it prolonged the life of the cutting tool. Nadworny, *Scientific Management and the Unions*, 10.

61. Merkle, *Management and Ideology*, 58.

62. Noble, *America by Design*, 274.

63. On Taylorism in France see Ribeill, "Débuts de l'ergonomie en France"; Charles S. Maier, "Between Taylorism and Technocracy: European Ideologies and the Vision of Industrial Productivity in the 1920s," *Journal of Contemporary History*, spring 1970, 27–61; Aimée Moutet, "Les origines du système de Taylor en France: Le point de vue patronal (1907–1914)," *Le Mouvement Sociale*, October–December 1975, 15–49; G. C. Humphreys, *Taylorism in France, 1904–1920* (New York: Garland, 1986).

64. As in America, in France engineers were instrumental in propagating Taylor's system of work rationalization. But the evolution of the engineer-manager has a totally different history there. From their beginnings as military engineers before the sixteenth century, engineers in France had been members of the ruling class; they were graduates of elite schools (one was the Ecole Polytechnique that Marey wished to enter); their training was primarily mathematical and theoretical; and they worked as state functionaries. The modern technocratic French engineer was a product of social and political change. The founding of the Ecole Centrale des Arts et Manufactures in 1829 provided a more technically based education geared specifically to civil and industrial concerns. The growth of industrialization and the birth of the new middle-class industrialist created room for the self-taught (often the sons of the industrialists themselves) and those who had been educated outside the circumscribed system of the grandes écoles; at the same time, the higher salaries paid by private enterprise were an incentive for the *polytechniciens* and *centraliens* to abandon state service. Thus, though the modern French engineer was the representative of science and technology in the corporation, he was much more concerned than his American counterpart to bring to business and industry the scientific method and spirit that defined the high status of his profession. For a history of engineering in France see André Thépot, ed., *L'ingénieur dans la société française* (Paris: Editions Ouvrières, 1985); Maurice Lévy-Leboyer, "Le patronat français a-t-il été malthusien?" *Le Mouvement Social*, July–September 1974, 3–49; and Moutet, "Origines du système de Taylor en France."

65. Amar, *Physiology of Industrial Organisation*, 12.

66. Amar, *Human Motor*, 466.

67. Cited in Ioteyko, *Science of Labour*, 85.

68. Jean-Marie Lahy, *Le système Taylor et la physiologie du travail professionel*, 2d ed. (Paris: Gauthier-Villars, 1921), 28.

69. Lahy, *Système Taylor*, 33.

70. Ibid., 34. On Taylor's lack of originality see also Charles Fremont, "A propos du système Taylor," *La Technique Moderne* 7 (1913): 301–8.

71. Lahy, *Système Taylor*, 52–53.

72. Ibid., 57–58.

73. Ioteyko, *Science of Labour*, 80.

74. Ibid., 80–81.

75. Ibid., 84.

76. Ibid., 77.

77. Noble, *America by Design*, 275.

78. Frank Gilbreth and Lillian Gilbreth, "Motion Study as Industrial Opportunity," in *The Writings of the Gilbreths*, ed. William R. Spriegel and Clark E. Myers (Homewood, Ill.: Richard Irwin, 1953), 220.

79. Frank Gilbreth, *Motion Study* (1911), in *Writings of the Gilbreths*, 196.

80. Gilbreth and Gilbreth, "Motion Study as an Industrial Opportunity," 220.

81. Robert Thurston Kent, Introduction to Gilbreth's *Motion Study,* 148.

82. Frank Gilbreth and Lillian Gilbreth, "Motion Study and Time Study Instruments of Precision" (1915), in *Writings of the Gilbreths,* 230.

83. Ibid.

84. Frank Gilbreth, *Motion Study,* 205.

85. Gilbreth and Gilbreth, "Motion Study as an Industrial Opportunity," 221.

86. Ibid., 222.

87. Ibid.

88. Gilbreth and Gilbreth, "Motion Study and Time Study Instruments of Precision," 227.

89. The European scientists had no doubts about the origins of Gilbreth's work. Lahy (*Système Taylor,* 36–37) accuses Gilbreth's chronophotography of being "neither new nor original." The chronograph clock that Gilbreth named after himself, Lahy says, had been invented by Marey "more than forty years ago to use in his admirable chronophotographic studies of movements." Lahy finds Gilbreth's forgetfulness of his predecessor "all the more strange given that Marey's reputation has become worldwide." Ioteyko (*Science of Labour,* 63) writes that Gilbreth "has gone back to Marey's chronophotographic process."

90. Gilbreth offered to write the introduction for the English translation of Amar's *Physiology of Industrial Organisation and the Re-employment of the Disabled,* and he adopted, with permission, Amar's method of making artificial limbs. Gilbreth papers, box NHL, Purdue University. A copy of Lahy's *Système Taylor* is also among Gilbreth's papers at Purdue.

91. Gilbreth, unpaginated typescript of a seminar, 15 October 1914, in the Gilbreth papers, Purdue University.

92. Gilbreth's attitude is best conveyed by this reluctant tribute to Taylor: "After many a weary day's study the investigator awakes from a dream of greatness to find

that he has only worked out a new proof for a problem that Taylor has already solved." *Motion Study,* 198.

93. Gilbreth, unpaginated typescript of a seminar, in the Gilbreth papers, Purdue Universty.

94. Gilbreth and Gilbreth, "Motion Study and Time Study Instruments of Precision," 229.

95. Ibid.

96. Gilbreth, typescript of unpublished management seminar, given in Providence, Rhode Island, 10 October 1914. Lillian Gilbreth, who according to Gilbreth scholar Jane Morely also felt it was important to emphasize her husband's originality, is of no help in clarifying the issue of influence. "Gilbreth did not know of Marey or Muybridge until after his work was well developed," she wrote in 1925 to Margaret Hawley; and over Hawley's statement, "As for motion study, Mr. Gilbreth was by no means the originator of it," part of Hawley's master's thesis "Pioneers in the Science of Management" (University of California), Lillian Gilbreth wrote, "Omit!"

In another letter written 30 November 1928 to an unnamed correspondent, Lillian Gilbreth wrote: "I am sorry, but I do not remember when Mr. Gilbreth became acquainted with Muybridge's work. I suppose I could trace the date in his diaries but not now. I do know that he had his work on the cyclegraph well underway and all complete but the refinements before Mr. James Butterworth an English friend wrote him that similar attempts to record work had been made by Muybridge and Marey." (Gilbreth Papers, Purdue University). Lillian Gilbreth's association of the names of Muybridge and Marey in this context is curious, since Gilbreth never mentioned Muybridge, nor does his work have the slightest connection with the photographer. On the other hand, Lillian Gilbreth was from a socially prominent Oakland, California, family to whom Muybridge's feats would have been legendary

Bibliography of Works by Marey

Abbreviations

Ann. Sci. Nat. (Zool.) *Annales des Sciences Naturelles (Zoologie)*
Arch. Phys. *Archives de Physiologie Normale et Pathologique*
BAM *Bulletin de l'Académie de Médecine*
BSFP *Bulletin de la Société Française de Photographie*
CRAS *Comptes Rendus des Séances de l'Académie des Sciences*
C.R. Soc. Biol. *Comptes Rendus des Séances et Mémoires de la Société de Biologie*
CRAF *Comptes Rendus de l'Association Française pour l'Avancement des Sciences*
Gaz. Heb. *Gazette Hebdomadaire de Médecine et de Chirurgie*
Gaz. Méd. *Gazette Médicale de Paris*
J. Anat. *Journal de l'Anatomie et de la Physiologie Normales et Pathologiques de l'Homme et des Animaux*
J. Phys. *Journal de Physique Théorique et Appliquée*
J. Physiol. *Journal de la Physiologie de l'Homme et des Animaux*
Rev. Cours Sci. *Revue des Cours Scientifiques de la France et de l'Etranger*
Rev. Mil. *Revue Militaire de Médecine et de Chirurgie*
Rev. Sci. *Revue Scientifique*
Soc. Phys. *Séances de la Société Française de Physique*

1857

"Recherches hydrauliques sur la circulation du sang." *Ann. Sci. Nat. (Zool.)* 8 (1857): 329–64.

1858

"Mémoire sur la contractilité vasculaire." *Ann. Sci. Nat. (Zool.)* 9 (1858): 53–58.
"Recherches sur la circulation du sang." *CRAS* 46 (1858): 483–85.
"Recherches sur la circulation sanguine." *CRAS* 46 (1858): 680–83.
"Interprétation hydraulique du pouls dicrote." *CRAS* 47 (1858): 826–27.

"Recherches sur le pouls dicrote." *C.R. Soc. Biol.,* 2d ser., 5 (1858): 153–58.

1859

"Du pouls et des bruits vasculaires." *J. Physiol.* 2 (1859): 259–80, 420–47.
"Des causes d'erreur dans l'emploi des instruments pour mesurer la pression sanguine et des moyens de les éviter." *C.R. Soc. Biol.* 3rd ser., 1 (1859): 55–59; *Gaz. Méd.,* 3d ser., 14 (1859): 463–64.
"Recherches sur le pouls au moyen d'un nouvel appareil enregistreur: Le sphygmographe." *C.R. Soc. Biol.,* 3d ser., 1 (1859): 281–309.
Recherches sur la circulation du sang à l'état physiologique et dans les maladies. Medical thesis. Paris: Rignoux, 1859.

1860

"De quelques causes des variations dans la température animale." *C.R. Soc. Biol.* 13 (1860): 27–29.
"De l'emploi du sphygmographe dans le diagnostic des affections valvulaires du coeur et des artères." *C.R. Soc. Biol.,* 3d ser., 2 (1860): 173–76.
"Variations physiologiques du pouls étudiées à l'aide du sphygmographe." *C.R. Soc. Biol.,* 3d ser., 2 (1860): 203–13.
"Recherches sur la forme et la fréquence du pouls au moyen d'un nouveau sphygmographe ou appareil enregistreur des pulsations." *CRAS* 50 (1860): 634–37.
"Recherches sur l'état de la circulation d'après les caractères du pouls fournis par un nouveau sphygmographe." *Gaz. Heb.* 25 (1860): 404–7.
"Recherches sur l'état de la circulation d'après les caractères du pouls fournis par un nouveau sphygmographe." Pamphlet. Paris: Martinet, 1860.
"Recherches sur le pouls au moyen d'un nouvel appareil enregistreur: Le sphygmographe." *Gaz. Méd.,* 3d ser., 15 (1860): 225–57, 236–42, 298–301.
"Recherches sur le pouls au moyen d'un nouvel appareil enregistreur: Le sphygmographe." Pamphlet. Paris: Thunot, 1860.

"De l'emploi de la sphygmographie dans le diagnostic des affections valvulaires du coeur et des anévrysmes des artères." *CRAS* 51 (1860): 813–17.

"De la chaleur animale." Unpublished paper filed with the secretary of the Académie de Caen, April 1860.

1861

"Loi qui préside à la fréquence des battements du coeur." *CRAS* 53 (1861): 95–98.

"Recherches nouvelles sur le pouls." *Archives Générales de Médecine*, 5th ser., 19 (1861): 22–25.

[With A. Chauveau] "Détermination graphique des rapports du choc du coeur avec les mouvements des oreillettes et des ventricules, expériences faite à l'aide d'un appareil enregistreur (sphygmographe)." *CRAS* 53 (1861): 622–25.

[With A. Chauveau] "Détermination graphique des rapports de la pulsation cardiaque avec les mouvements de l'oreillette et du ventricule, obtenue au moyen d'un appareil enregistreur (sphygmographe)." *C.R. Soc. Biol.*, 3d ser., 3 (1861): 3–11.

1862

[With A. Chauveau] "Détermination graphique des rapports du choc du coeur avec les mouvements des oreillettes et des ventricules, expériences faites à l'aide d'un appareil enregistreur (sphygmographe)." *Gaz. Méd.*, 3d ser., 17 (1862): 675–79.

[With A. Chauveau] "Deuxième mémoire sur la détermination graphique des rapports du choc du coeur avec les mouvements des oreillettes et des ventricules." *CRAS* 54 (1862): 32–35.

[With A. Chauveau] "De la force déployée par la contraction des différentes cavités du coeur." *C.R. Soc. Biol.*, 3d ser., 4 (1862): 151–54.

"Legge sulla frequenza delle contrazioni cardiache." *Lo Sperimentale* (Florence) 9 (1862): 250–62.

1863

[With A. Chauveau] "Appareils et expériences cardiographiques: Démonstration nouvelle du mécanisme des mouvements du coeur par l'emploi des instruments enregistreurs à indications continues." *BAM* 26 (1863): 268–319.

[With A. Chauveau] "De la force déployée par la contraction des différentes cavités du coeur." *Gaz. Méd.*, 3d ser., 18 (1863): 169–72.

[With A. Chauveau] "Tableau sommaire des appareils et des expériences cardiographiques de MM. Chauveau et Marey." Pamphlet. Paris: Martinet, 1863.

Physiologie médicale de la circulation du sang basée sur l'étude graphique des mouvements du coeur et du pouls artériel, avec application aux maladies de l'appareil circulatoire. Paris: Delahaye, 1863.

1864

"Du thermographe, appareil enregistreur des températures." *CRAS* 59 (1864): 459–61.

"Etude graphique des mouvements respiratoires." *C.R. Soc. Biol.*, 4th ser., 1 (1864): 175–81.

1865

"Le thermographe." *J. Anat.* 2 (1865): 182–89.

"Note sur la forme graphique des battements du coeur chez l'homme et chez différentes espèces animales." *CRAS* 61 (1865): 778–82.

"Etudes physiologiques sur les caractères du battement du coeur et les conditions qui le modifient." *J. Anat.* 2 (1865): 276–301, 416–25.

"Essai de théorie physiologique du choléra." *Gaz. Heb.*, 2nd ser., 2 (1865): 2–26.

"Essai de théorie physiologique du choléra." Pamphlet. Paris: Masson, 1865.

"Etude graphique des mouvements respiratoires et des influences qui les modifient." *J. Anat.* 2 (1865): 425–53.

"Forme des battements du coeur suivant l'état de la fonction circulatoire dans la série animale." *C.R. Soc. Biol.*, 4th ser., 2 (1865): 181–83.

"Etudes physiologiques sur les caractères graphiques des battements du coeur et des mouvements respiratoires et sur les différentes influences qui les modifient." Pamphlet. Paris: Ballière, 1865.

1866

"Nature de la systole des ventricules du coeur considérée comme acte musculaire." *CRAS* 63 (1866): 41–44.

"Nature de la contraction dans les muscles de la vie ani-

male." [Note presented by M. Coste.] *CRAS* 62 (1866): 1171–75.

"Etudes graphiques sur la nature de la contraction." *J. Anat.* 3 (1866): 225–42, 403–16.

"Nouvelles expériences pour la détermination de la vitesse des courants nerveux." *C.R. Soc. Biol.,* 4th ser., 3 (1866): 21–24.

"Du mouvement dans les fonctions de la vie. [Public course given at 14 rue de l'Ancienne Comédie.] 1. Exposition du sujet et de la méthode." *Rev. Cours Sci.* 3 (1866): 170–74.

"Du mouvement dans les fonctions de la vie. 2. Des appareils enregistreurs et de leur application en physiologie." *Rev. Cours Sci.* 3 (1866): 203–8.

"Du mouvement dans les fonctions de la vie. 3. Du rôle de l'électricité dans les phénomènes nerveux et musculaires." *Rev. Cours Sci.* 3 (1866): 331–36.

"Du mouvement dans les fonctions de la vie. 4. De la vitesse de la propagation de l'action nerveuse." *Rev. Cours Sci.* 3 (1866): 346–51.

"Du mouvement dans les fonctions de la vie. 5. Des phénomènes musculaires." *Rev. Cours Sci.* 3 (1866): 408–12.

"Du mouvement dans les fonctions de la vie. 6. De la contraction dans les muscles de la vie animale." *Rev. Cours Sci.* 3 (1866): 549–52.

"Du mouvement dans les fonctions de la vie. 7. Limite de fréquence des excitations électriques qui provoquent la contraction des muscles volontaires." *Rev. Cours Sci.* 3 (1866): 566–68.

"La physiologie dans ses rapports avec la science moderne." *Annuaire Scientifique* (ed. P. P. Dehérain) 1 (1866): 27–33.

1867

"De la production du mouvement chez les animaux." *Rev. Cours Sci.* 4 (1867): 209–18.

"Nature de la contraction dans les muscles de la vie animale." *J. Anat.* 4 (1867): 211–12.

"Histoire naturelle des corps organisés. [Course given at the Collège de France.] 1. Evolution historique des sciences." *Rev. Cours Sci.* 4 (1867): 257–61.

"Histoire naturelle des corps organisés. 2. Rôle de l'analyse dans les sciences: Puissance qu'elle emprunte à l'emploi d'instruments perfectionnés." *Rev. Cours Sci.* 4 (1867): 296–301.

"Histoire naturelle des corps organisés. 3 and 4. La synthèse expérimentale dans les sciences naturelles." *Rev. Cours Sci.* 4 (1867): 318–20, 353–56.

"Histoire naturelle des corps organisés. 5. Les lois en biologie." *Rev. Cours Sci.* 4 (1867): 374–77.

"Histoire naturelle des corps organisés. 6. Des appareils enregistreurs." *Rev. Cours Sci.* 4 (1867): 568–70.

"Histoire naturelle des corps organisés. 7. Des appareils enregistreurs en biologie." *Rev. Cours Sci.* 4 (1867): 601–6, 679–82, 726–31.

"Histoire naturelle des corps organisés. 8. Contrôle des appareils enregistreurs." *Rev. Cours Sci.* 4 (1867): 763–67.

"Histoire naturelle des corps organisés. 9 and 10. De la contractilité musculaire." *Rev. Cours Sci.* 4 (1867): 794–98.

"Histoire naturelle des corps organisés. 11. De l'élasticité musculaire." *Rev. Cours Sci.* 4 (1867): 809–15.

"Histoire naturelle des corps organisés. 12. Des excitants artificiels du mouvement." *Rev. Cours Sci.* 4 (1867): 820–29.

"Histoire naturelle des corps organisés. 13 and 14. Variations de la secousse musculaire." *Rev. Cours Sci.* 4 (1867): 833–36.

"Histoire naturelle des corps organisés. 15. Théorie de la contraction volontaire." *Rev. Cours Sci.* 4 (1867): 837–40.

1868

"Natural History of Organized Bodies." *Annual Report of the Board of Regents of the Smithsonian Institution for 1867,* 1868, 277–304.

"Des phénomènes intimes de la contraction musculaire." *CRAS* 66 (1868): 202–5; *Cosmos,* 3d ser., 2 (1868): 15–17.

"Rôle de l'élasticité dans la contraction musculaire." [Note presented by M. Delaunay.] *CRAS* 66 (1868): 293–94.

"Détermination expérimentale du mouvement des ailes des insectes pendant le vol." *CRAS* 67 (1868): 1341–45.

"Sphygmographie: Note sur un nouveau signe de l'insuffisance aortique." *C.R. Soc. Biol.,* 4th ser., 5 (1868): 73–75.

"Note sur le vol des insectes." *C.R. Soc. Biol.,* 4th ser., 5 (1868): 136–39, 212.

Du mouvement dans les fonctions de la vie: Leçons faites au Collège de France. Paris: Baillière, 1868.

1869

"Histoire naturelle des corps organisés. [Course given at the Collège de France.] 1. Vitesse des actes nerveux et cérébraux, le vol dans la série animale." *Rev. Cours Sci.* 6 (1869): 61–64.

"Histoire naturelle des corps organisés. 2. Les mouvements de l'aile chez les insectes." *Rev. Cours Sci.* 6 (1869): 171–76.

"Histoire naturelle des corps organisés. 3. Mécanisme du vol chez les insectes: Comment se fait la propulsion." *Rev. Cours Sci.* 6 (1869): 252–56.

"Histoire naturelle des corps organisés. 4. Du vol des oiseaux." *Rev. Cours Sci.* 6 (1869): 578–83, 601–4, 646–56, 700–704.

"De la forme des muscles pectoraux et du sternum des oiseaux dans leurs rapports avec la surface de l'aile." *C.R. Soc. Biol.*, 5th ser., 1 (1869): 112–13.

"Caractères graphiques du battement du coeur dans l'insuffisance des valvules sigmoïdes de l'aorte." *Arch. Phys.* 2 (1869): 61–77.

"Mémoire sur le vol des insectes et des oiseaux." *Ann. Sci. Nat. (Zool.)* 12 (1869): 49–150.

"Reproduction mécanique du vol des insectes." *CRAS* 68 (1869): 667–69. *Annals and Magazine of Natural History* (London) 4 (1869): 216–17.

"Mécanisme du vol chez les insectes." *J. Anat.* 6 (1869): 19–36, 337–48.

1870

"Des mouvements que le corps de l'oiseau exécute pendant le vol." *CRAS* 71 (1870): 660–63.

"Sur le mécanisme du vol des oiseaux." *CRAS* 70 (1870): 1255–58.

"Réponse à une revendication de priorité de M. Pettigrew pour la description du parcours en huit de l'aile de l'insecte pendant le vol." *CRAS* 70 (1870): 1093–94.

"Histoire naturelle des corps organisés. [Course given at the Collège de France.] 1 and 2. Du vol chez les oiseaux." *Rev. Cours Sci.* 7 (1870): 571–76, 601–65.

"Histoire naturelle des corps organisés. 3. De la résistance de l'air." *Rev. Cours Sci.* 7 (1870): 626–30.

"Histoire naturelle des corps organisés. 4. Synthèse du coup d'aile descendant." *Rev. Cours Sci.* 7 (1870): 725–29.

"Histoire naturelle des corps organisés. 5. Applications physiologiques des expériences schématiques faites sur le coup d'aile descendant." *Rev. Cours Sci.* 7 (1870): 748–52.

1871

"Lectures on the Phenomena of Flight in the Animal Kingdom." *Annual Report of the Board of Regents of the Smithsonian Institution for 1869,* 1871, 227–72.

"The mechanism of flight in the animal kingdom." *Annual Report of the Aeronautical Society* 6 (1871): 49–61.

"Théorie du boumerang." *Aéronaute* 4 (1871): 918–21, 958–61.

"Du temps qui s'écoule entre l'excitation du nerf électrique de la torpille et la décharge de son appareil." *CRAS* 73 (1871): 918–21.

"Détermination de la durée de la décharge électrique chez la torpille." *CRAS* 73 (1871): 958–61.

1872

"Mémoire sur le vol des insectes et des oiseaux." *Ann. Sci. Nat. (Zool)* 15 (1872): art. 13, 1–62.

"The Mechanism of Flight in the Animal Kingdom." *Annual Report of the Aeronautical Society* 7 (1872): 25–74.

"Détermination des inclinaisons du plan de l'aile aux différents instants de sa révolution." *CRAS* 74 (1872): 589–92; *Aéronaute* 5 (1872): 76–79.

"Mémoire sur la torpille: Gymnotus electricus." *Annales de l'Ecole Normale* 1 (1872): 85–115; *J. Anat.* 8 (1872): 468–99.

"Des allures du cheval, étudiées par la méthode graphique." *CRAS* 75 (1872): 883–87, 1115–19.

1873

"Le transformisme et la physiologie expérimentale." *Rev. Sci.* 11 (1873): 813–22.

"De la locomotion terrestre chez les bipèdes et les quadrupèdes." *J. Anat.* 9 (1873): 832–34.

"De l'uniformité du travail du coeur, lorsque cet organe n'est soumis à aucune influence nerveuse extérieure." *CRAS* 77 (1873): 367–70.

"Notice sur les titres et travaux de E. J. Marey." *Collection de l'Académie des Sciences* 36 (1873).

La machine animale: Locomotion terrestre et aérienne. Paris: Baillière, 1873 (2d ed. 1878; 3d ed. 1882; 4th rev. ed. Paris: Alcan, 1886).

1874

Animal Mechanism: A Treatise on Terrestrial and Aerial Locomotion. London: H. S. King; New York: Appleton, 1874 (2d ed., 1879; reprint 1884, 1890, 1893, 1901).

"Discussion sur le coeur." *BAM,* 2d ser., 3 (1874): 387–404, 411–17.

"Physiologie du vol des oiseaux: Du point d'appui de l'aile sur l'air." *CRAS* 78 (1874): 117–21.

"Sur un nouveau chronographe." *Soc. Phys.* 2 (1874): 4–6; *J. Phys.* 3 (1874): 137–39.

"De la résistance de l'air sous l'aile de l'oiseau pendant le vol." *Soc. Phys.* 2 (1874): 29–34; *J. Phys.* 3 (1874): 204–9.

"Nouvelles expériences sur la locomotion humaine." *CRAS* 79 (1874): 125–28.

1875

"Note sur la pulsation du coeur." *CRAS* 80 (1875): 185–89.

"Mouvements des ondes liquides dans les tubes élastiques." *Soc. Phys.* 3 (1875): 95–102; *J. Phys.* 4 (1875): 257–64.

"Du moyen d'économiser le travail moteur de l'homme et des animaux." In *CRAF, Congrès de Lille, 1874,* 1157–65. Paris, 1875.

"Mémoire 1: Du moyen d'économiser le travail moteur de l'homme et des animaux." In *Travaux du laboratoire de M. Marey,* 1:1–18. Paris: Masson, 1875.

"Mémoire 2: Sur la pulsation du coeur." In *Travaux du laboratoire de M. Marey.* 1:19–85. Paris: Masson, 1875.

"Mémoire 3: Du mouvement des ondes liquides pour servir à la théorie du pouls." In *Travaux du laboratoire de M. Marey,* 1:87–122. Paris: Masson, 1875.

"Mémoire 4: La méthode graphique dans les sciences expérimentales." In *Travaux du laboratoire de M. Marey,* 1:123–64. Paris: Masson, 1875.

"Mémoire 6: Expériences sur la résistance de l'air pour servir à la physiologie du vol des oiseaux." In *Travaux du laboratoire de M. Marey,* 1:215–53. Paris: Masson, 1875.

"Mémoire 7: La méthode graphique dans les sciences expérimentales." In *Travaux du laboratoire de M. Marey,* 1:255–78. Paris: Masson, 1875.

"Mémoire 9: Pression et vitesse du sang." In *Travaux du laboratoire de M. Marey,* 1:337–71. Paris: Masson, 1875.

"Appareils et instruments de physiologie du Professeur Marey." Pamphlet. Paris: Raçon, 1875.

Ecole Pratique des Hautes Etudes. Physiologie expérimentale. Travaux du laboratoire de M. Marey. Paris: Masson. Vol. 1, 1875; vol. 2, 1876; vol. 3, 1877; vol. 4, 1878–79.

1876

"Description d'un loch à cadran indiquant à tout instant la vitesse d'un navire." In *CRAF, Congrès de Nantes, 1875,* 319–22. Paris, 1876; *J. Phys.* 5 (1876): 184–88; *Soc. Phys.* 4 (1876): 17–21.

"Apparatus for Registering Animal Movements." *Nature* (London) 14 (1876): 214–15.

"De la méthode graphique dans les sciences expérimentales et des applications particulières à la médecine." In *Bulletin du Congrès International de Médecine, Bruxelles, 1875,* 220–25. Paris, 1876.

"Lectures on the Graphic Method in the Experimental Sciences, and on Its Special Application to Medicine, Delivered at the Medical Congress in Brussels, September 21st, 1875." *British Medical Journal,* 1 January 1876, 1–3, 15 January 1876, 65–66.

"Des mouvements que produit le coeur lorsqu'il est soumis à des excitations artificielles." *CRAS* 82 (1876): 408–11.

"Cardiographes et cardiographie." In *Dictionnaire encyclopédique des sciences médicales,* ser. 1, 12:425–53. Paris: Masson, 1876.

[With G. Carlet] "Circulation." In *Dictionnaire encyclopédique des sciences médicales,* ser. 1, 17:390–484. Paris: Masson, 1876.

"Inscription photographique des indications de l'électromètre de Lippmann." *CRAS* 83 (1876): 278–80.

"Le coeur éprouve à chaque phase de sa révolution des changements de température qui modifient son excitabilité." *CRAS* 82 (1876): 499–501.

"Des variations électriques des muscles et du coeur en particulier étudiées au moyen de l'électromètre de M. Lippmann." *CRAS* 82 (1876): 975–77.

"Rapport sur le mémoire du Dr. Edouard Maragliano de Bologne ayant pour titre 'Le dicrotisme et le polydicrotisme.'" *BAM,* 2d ser., 5 (1876): 367–75.

"Mémoire 2: Des excitations artificielles du coeur." In *Travaux du laboratoire de M. Marey,* 2:63–86. Paris: Masson, 1876.

"Mémoire 5: La méthode graphique dans les sciences expérimentales." In *Travaux du laboratoire de M. Marey,* 2:133–219. Paris: Masson, 1876.

"Mémoire 8: Pression et vitesse du sang." In *Travaux du laboratoire de M. Marey,* 2:307–43. Paris: Masson, 1876.

Notice sur les titres et travaux scientifiques du Dr. Marey. Paris: Lahure, 1876.

1877

"Recherches sur les excitations électriques du coeur." *J. Anat.* 13 (1877): 60–83, 520–21.

"Sur la décharge de la torpille, étudiée au moyen de l'électromètre de Lippmann." *CRAS* 84 (1877): 354–56.

"Sur les caractères des décharges électriques de la torpille." *CRAS* 84 (1877): 190–93; *Soc. Phys.* 5 (1877): 17–21.

"Sur un nouvel appareil destiné à la mesure de la fréquence des mouvements périodiques." *Soc. Phys.* 5 (1877), 109–10; *J. Phys.* 6 (1877): 367–68.

"Loch à cadran: Odographe." In *CRAF, Congrès de Clermont-Ferrand, 1876,* 302–6. Paris, 1877.

"Mémoire 1: Sur la décharge électrique de la torpille." In *Travaux du laboratoire de M. Marey,* 3:1–62. Paris: Masson, 1877.

1878

"La décharge électrique de la torpille, comparée à la contraction musculaire." In *Comptes rendus du Congrès International de Médecine, Congrès de Genève, 1877,* 1–11. Paris, 1878.

"La systole ventriculaire étudiée avec l'électromètre de Lippmann." *CRAS* 88 (1878): 278.

"Moyen de mesurer la valeur manométrique de la pression du sang chez l'homme." *CRAS* 87 (1878): 771–73.

"Moteurs animés: Expériences de physiologie graphique." *La Nature,* 28 September 1878, 273–78, 5 October 1878, 289–95; letter to *La Nature,* 28 December 1878, 54.

"Sur l'importance au point de vue médical des signes extérieurs des fonctions de la vie." *BAM,* 2d ser., 7 (1878): 611–22, 626–27.

"Sur la méthode graphique." *BAM,* 2d ser., 7 (1878): 689–90, 824–26.

La méthode graphique dans les sciences expérimentales et principalement en physiologie et en médecine. Paris: Masson, 1878.

1879

"Nouvelles recherches sur les poissons électriques: Caractères de la décharge du gymnote; effets d'une décharge de torpille lancée dans un téléphone." *Soc. Phys.* 7 (1879): 32–35; *CRAS* 88 (1879): 318–21; *J. Phys.* 8 (1879): 162–64.

"A Study in Locomotion." *Nature* (London) 19 (1879): 438–43, 464–67, 488–89; *Popular Science Monthly* 15 (1879): 317–27.

"Sur un nouveau polygraphe, appareil inscripteur applicable aux recherches physiologiques et cliniques." *CRAS* 89 (1879): 8–11.

"Sur l'effet des excitations électriques appliquées au tissu musculaire du coeur." *CRAS* 89 (1879): 203–6.

"Discussion sur les mesures définitives contre les épidémies." *BAM,* 2d ser., 8 (1879): 171–82.

"La circulation du sang." [Conference given at the Sorbonne, 13 March.] *La Nature,* 3 May 1878, 338–42, 10 May 1879, 355–58, 24 May 1879, 390–94.

"Mémoire 5: Note sur les variations de la force et du travail du coeur." In *Travaux du laboratoire de M. Marey,* 4:167–73. Paris: Masson, 1879.

"Mémoire 6: Recherches sur la tension artérielle." In *Travaux du laboratoire de M. Marey,* 4:175–216. Paris: Masson, 1879.

"Mémoire 7: Emploi d'un nouveau polygraphe pour l'inscription simultanée de la pulsation du coeur et du pouls artériel." In *Travaux du laboratoire de M. Marey,* 4:217–31. Paris: Masson, 1879.

"Mémoire 8: Sur un nouveau schéma imitant à la fois la circulation générale et la circulation pulmonaire." In *Travaux du laboratoire de M. Marey,* 4:233–52. Paris: Masson, 1879.

"Mémoire 9: Nouvelles recherches sur la mesure mano-métrique de la pression du sang chez l'homme." In *Travaux du laboratoire de M. Marey*, 4:253–57. Paris: Masson, 1879.

"Appareils et instruments de physiologie." Pamphlet. Paris: Lahure, 1879.

1880

"Des variations de la force du coeur." *CRAS* 90 (1880): 159–61.

"Caractères distinctifs de la pulsation du coeur, suivant qu'on explore le ventricule droit ou le ventricule gauche." *CRAS* 91 (1880): 405–7.

"Note sur les variations de la force et du travail du coeur." *Rev. Sci.* 25 (1880): 942–44.

"Modifications des mouvements respiratoires par l'exercice musculaire." *CRAS* 91 (1880): 145–47.

"Etudes sur la marche de l'homme." *CRAS* 91 (1880): 261–63.

"Uniformity in Graphic Records." *Archives of Medicine* (New York), 1880, 174–77.

"Une révolution en médecine." *Le Monde de la Science et de l'Industrie*, no. 10 (December 1880).

"A Revolution in Medicine." *Minerva*, no. 3 (3 April 1880): 340–62.

"Sur des nouvelles manières d'inscrire les mouvements des liquides." In *Comptes rendus du Congrès International de Médecine, Congrès d'Amsterdam, 1879*, 217–31. Paris, 1880.

1881

"Inscription microscopique des mouvements qui s'observent en physiologie." *CRAS* 92 (1881): 939–41.

"Sur un nouveau thermographe." *CRAS* 92 (1881): 1441–42.

"Etudes sur la marche de l'homme." *Rev. Mil.* 1 (1881): 244–46.

"Modifications des mouvements respiratoires par l'exercice musculaire." *Rev. Mil.* 1 (1881): 247–49.

La circulation du sang à l'état physiologique et dans les maladies. Paris: Masson, 1881.

1882

"Sur la reproduction par la photographie des diverses phases du vol des oiseaux." *CRAS* 94 (1882): 683–84.

"Photographies instantanées d'oiseaux au vol." *CRAS* 94 (1882): 823.

"Emploi de la photographie instantanée pour l'analyse des mouvements chez les animaux." *CRAS* 94 (1882): 1013–20.

"Tableau mobile des différentes attitudes du cheval à une allure quelconque." *CRAS* 94 (1882): 1683.

"Analyse du mécanisme de la locomotion au moyen d'une série d'images photographiques recueillies sur une même plaque et représentant les phases successives du mouvement." *CRAS* 95 (1882): 14–16.

"Emploi de la photographie pour déterminer la trajectoire des corps en mouvement avec leurs vitesses à chaque instant et leurs positions relatives: Application à la mécanique animale." *CRAS* 95 (1882): 267–70.

"Reproduction typographique des photographies, procédé de M. Ch. Petit." *CRAS* 95 (1882): 583–85.

"Le fusil photographique." *La Nature*, 22 April 1882, 326–30; *BSFP* 28 (May 1882): 127.

"La photographie du mouvement." *La Nature*, 22 July 1882, 115–16.

"The Photography of Movement." *Scientific American* 47 (9 September 1882): 166.

"Instantaneous Photography of Birds in Flight." *Nature* (London), 26 (1882): 84–86.

1883

"Analyse des mouvements du vol des oiseaux par la photographie." *CRAS* 96 (1883): 1399–1406; *Aéronaute* 16 (1883): 143–51; *BSFP* 29 (3 August 1883): 211.

"Emploi des photographies partielles pour étudier la locomotion de l'homme et des animaux." *CRAS* 96 (1883): 1827–31.

"Analyse des mouvements du vol des oiseaux par la photographie." *Soc. Phys.* 11 (1883): 144–48.

"De la mesure des forces dans les différents actes de la locomotion." *CRAS* 97 (1883): 782–86, 820–25.

"La Station Physiologique de Paris." *La Nature*, 8 September 1883, 226–30, 29 September 1883, 275–79.

"The Physiological Station of Paris." *Science* 2 (1883): 678–81, 708–11.

"Rapport sur un cas d'ectopie congénitale du coeur." *BAM*, 2d ser., 12 (1883): 1208–22.

"Ectopie cardiaque." *BAM*, 2d ser., 12 (1883): 956–57.

"De la locomotion humaine." *BAM*, 2d ser., 12 (1883): 1127–35.

"Ectopie congénitale du coeur." *Gaz. Méd.*, 6th ser., 5 (1883): 498, 523, 546.

"Le vol des oiseaux." *La Nature*, 16 June 1883, 35–37.

De grafische methode. The Hague: Stemberg, 1883.

1884

"Les forces utiles dans la locomotion." *Comptes Rendus du Congrès Internationale d'Hygiène et Démographie* 1 (1884): 110–31.

"Analyse des mouvements par la photographie." *J. Phys.*, 2d ser., 3 (1884): 199–203.

"Sur l'épidémie de choléra." *BAM*, 2d ser., 13 (1884): 1113–20, 1460–68, 1589.

"Sur la physiologie de la locomotion." *BAM*, 2d ser., 13 (1884): 1590–96.

"Réponse à M. Girard-Teulon sur le vol des oiseaux." *BAM*, 2d ser., 13 (1884): 1565.

"Rapport sur diverses communications relatives au choléra." [Commissaires: MM. Vulpian, Richet, Paul Bert, Pasteur, Bouley, Gosselin; Marey, rapporteur.] *CRAS* 99 (1884): 315–16.

"La propagation du choléra par les eaux contaminées." *CRAS* 99 (1884): 621–31.

"Analyse cinématique de la marche." *CRAS* 98 (1884): 1218–25.

"Les eaux contaminées et le choléra." *CRAS* 99 (1884): 667–83.

"Etudes sur la marche de l'homme au moyen de l'odographe." *CRAS* 99 (1884): 732–37.

"Des forces utiles dans la locomotion." *Rev. Sci.* 17 (1884): 513–24.

"Les eaux contaminées et le choléra." Pamphlet. Paris: Masson, 1884.

Développement de la méthode graphique par l'emploi de la photographie. Paris: Masson, [1884].

1885

"Rapport sur l'épidémie de choléra en France pendant l'année 1884, fait à l'Académie de Médecine de Paris au nom d'une commission composée de MM. Bergeron, Besnier, Brouardel, Fauvel, Noël, Guéneau de Mussy, Legouest, Pasteur, Proust, Rochard et Marey (rapporteur)." *BAM*, 2d ser., 14 (1885): 1129–71, 1385.

"Locomotion de l'homme: Images stéréoscopiques des trajectoires que décrit dans l'espace un point du tronc pendant la marche, la course et les autres allures." *CRAS* 100 (1885): 1359–63; *Soc. Phys.* 13 (1885): 67–71.

"Etudes pratiques sur la marche de l'homme: Expériences faites à la Station Physiologique du Parc des Princes." *La Nature*, 24 January 1885, 119–23.

[With G. Demeny] "Locomotion humaine, mécanisme du saut." *CRAS* 101 (1885): 489–94.

[With G. Demeny] "Mesure du travail mécanique effectué dans la locomotion de l'homme." *CRAS* 101 (1885): 905–9.

[With G. Demeny] "Variations de travail mécanique dépensé dans les différentes allures de l'homme." *CRAS* 101 (1885): 910–15.

[With C. Pagès] "Analyse cinématique de la locomotion du cheval." *CRAS* 101 (1885): 702–5.

La méthode graphique dans les sciences expérimentales et principalement en physiologie et en médecine. 2ème tirage augmenté d'un supplément sur le développement de la méthode graphique par la photographie. Paris: Masson, 1885

1886

"Observations relatives à une communication de M. Guérard sur l'épidémie cholérique de 1885." *CRAS* 102 (1886): 118.

"Etude de la locomotion animale par la chronophotographie." In *CRAF, Congrès de Nancy 1886*, 53–78. Paris, 1886; *Rev. Sci.* 38 (1886): 673–88.

"Etude sur les mouvements imprimés à l'air par l'aile d'un oiseau: Expériences de M. Muller." *CRAS* 102 (1886): 1137–39.

"Conditions de la rapidité des images dans la chronophotographie." *CRAS* 103 (1886): 537–38.

"Des lois de la mécanique en biologie." *Rev. Sci.* 38 (1886): 1–9.

[With G. Demeny] "Analyse cinématique de la course de l'homme." *CRAS* 103 (1886): 509–13.

[With G. Demeny] "Parallèle de la marche et de la course suivi du mécanisme de la transition entre ces deux allures." *CRAS* 103 (1886): 574–83.

[With C. Pagès] "Analyse cinématique de la locomotion du cheval." *CRAS* 103 (1886): 538–47.

1887

"Photography of Moving Objects and Animal Movement Studied by Chronophotography." *Scientific American Supplement*, no. 579 (5 February 1887): 9244–46; no. 580 (12 February 1887): 9258–60.

"Le mécanisme du vol des oiseaux étudié par la chronophotographie." *CRAS* 104 (1887): 210–15.

"Mouvements de l'aile de l'oiseau représentés suivant les trois dimensions de l'espace." *CRAS* 104 (1887): 323–30.

"Figures en relief, représentant les attitudes successives d'un goéland pendant une révolution de ses ailes." *CRAS* 104 (1887): 817–19.

"Nouvel odographe à papier sans fin." *CRAS* 104 (1887): 1582–84.

"Figures en relief représentant les attitudes successives d'un pigeon pendant le vol: Disposition de ces figures sur un zootrope." *CRAS* 104 (1887): 1669–71.

"La photochronographie appliquée au problème dynamique du vol des oiseaux." *CRAS* 105 (1887): 421–26.

"Recherches expérimentales sur la morphologie des muscles." *CRAS* 105 (1887): 446–51.

"De la mesure des forces qui agissent dans le vol de l'oiseau." *CRAS* 105 (1887): 504–8.

"Du travail mécanique dépensé par le goéland dans le vol horizontal." *CRAS* 105 (1887): 594–600.

"Physiologie du vol des oiseaux." *Rev. Sci.* 40 (1887): 65–70.

"Le mécanisme du vol des oiseaux éclairé par la photochronographie." *L'Amateur Photographe* 20 (15 October 1887): 559–61; *La Nature*, 5 December 1887, 8–14.

[With G. Demeny] "Etude expérimentale de la locomotion humaine." *CRAS* 105 (1887): 544–52.

[With C. Pagès] "Locomotion comparée: Mouvement du membre pelvien chez l'homme, l'éléphant et le cheval." *CRAS* 105 (1887): 149–56.

1888

"The Mechanism of the Flight of Birds." *Nature* (London) 37 (1888): 369–74.

"Représentation des attitudes de la locomotion humaine au moyen des figures en relief." *CRAS* 106 (1888): 1634–36.

"Valeurs relatives des deux composantes de la force déployée dans le coup d'aile de l'oiseau, déduites de la direction et de l'insertion des fibres du muscle 'grand pectoral.'" *CRAS* 107 (1888): 549–51.

"Modifications de la photochronographie pour l'analyse des mouvements exécutés sur place par un animal." *CRAS* 107 (1888): 607–9.

"De la claudication par douleur." *CRAS* 107 (1888): 641–43; *France Médicale* 2 (1888): 1565–67; *Gaz. Méd*, 7th ser., 5 (1888): 517–19.

"Des mouvements de la natation de l'anguille, étudiés par la photochronographie." *CRAS* 107 (1888): 643–45.

"Décomposition des phases d'un mouvement au moyen d'images photographiques successives recueillies sur une bande de papier sensible qui se déroule." *CRAS* 107 (1888): 677–78.

"Le problème mécanique du vol." *Rev. Sci.* 42 (1888): 289–300.

1889

"Des lois de la morphogénie chez les animaux." *Arch. Phys.*, 4th ser., 1 (1889): 88–100.

"La photochronographie et ses applications à l'analyse des phénomènes physiologiques." *Arch. Phys.*, 4th ser., 1 (1889): 508–17.

"Des effets d'un vent intermittent dans le vol à voile." *CRAS* 109 (1889): 551–54.

"Malformations héréditaires." [Note.] *Rev. Sci.* 43 (1889): 605.

"Le vol des oiseaux (préface d'un nouveau livre)." *Rev. Sci.* 44 (1889): 481–84.

1890

"La locomotion aquatique étudiée par la photochronographie." *CRAS* 111 (1890): 213–16.

"Appareil photochronographique applicable à l'analyse de toutes sortes de mouvements." *CRAS* 111 (1890): 626–29.

"La locomotion dans l'eau étudiée par la chronophotographie." *La Nature*, 15 November 1890, 375–78.

"Des appareils enregistreurs de la vitesse." *La Nature*, 29 March 1890, 259–63.

Physiologie du movement: Le vol des oiseaux. Paris: Masson, 1890.

1891

"Locomotion in Water Studied by Photography." *Scientific American Supplement* 784 (10 January 1891): 12532–33.

"Le vol des insectes étudié par la photochronographie." *CRAS* 113 (1891): 15–18.

"Emploi de la chronophotographie pour l'étude des appareils destinés à la locomotion aérienne." *CRAS* 113 (1891): 615–17.

"L'analyse des mouvements par la photographie." *Paris-Photographe*, 1 (1891): 5–12.

"La chronophotographie: Nouvelle méthode pour analyser le mouvement dans les sciences physiques et naturelles." *Revue Générale des Sciences* 2 (1891): 689–719. Reprinted as *La photographie du mouvement*. Paris: Levé, 1892. Translated by A. von Heydebreck as *Die Chronophotographie*. Berlin: Mayer und Müller, 1893.

"La cronofotografia." *Il Dilettante di Fotografia* (Milan) 3 (1892): 260–65, 390–94, 672–75.

1892

"Le vol des insectes étudié par la photochronographie." *La Nature*, 30 January 1892, 135–38.

"Le mouvement des êtres microscopiques analysé par la chronophotographie." *CRAS* 114 (1892): 989–90.

"Le mouvement du coeur, étudié par la chronophotographie." *CRAS* 115 (1892): 485–90.

1893

"Des mouvements de natation de la raie." *CRAS* 116 (1893): 77–81; *La Nature*, 18 February 1893, 177–78.

"Le mouvement des liquides étudié par la chronophotographie." *CRAS* 116 (1893): 913–24; *Soc. Phys.* 26 (1893): 243–44.

"Hydrodynamique expérimentale: Le mouvement des liquides étudié par la chronophotographie." *La Nature*, 6 May 1893, 359–63.

"Etude chronophotographique des différents genres de locomotion chez les animaux." *CRAS* 117 (1893): 355–59.

"Les applications de la chronophotographie à la physiologie expérimentale." *Rev. Sci.* 51 (1893): 321–27.

"Annonce de la parution de 'Le mouvement.'" *CRAS* 117 (1893): 572.

"Photographie expérimentale." *Paris-Photographe* 3 (1893): 95–104.

"Locomotion comparée chez les différents animaux: Nouvelles applications de la chronophotographie." *La Nature*, 2 September 1893, 215–18.

[With G. Demeny] *Etudes de physiologie artistique faites au moyen de la chronophotographie*. Première série, vol. 1. *De mouvement de l'homme*. Paris: Berthaud, 1893.

1894

"Sur la bicyclette." *BAM*, 3d ser., 32 (1892): 278–80.

"Comparative Locomotion of Different Animals." *Annual Report of the Board of Regents of the Smithsonian Institution for 1893*, 1894, 501–4.

"Lettre à M. Brown-Séquard, sur la mesure des mouvements qui échappaient jusqu'ici à l'observation." *Arch. Phys.*, 5 ser., 6 (1894): 182–85.

"Les mouvements articulaires étudiés par la photographie." *CRAS* 118 (1894): 1019–25; *Rev. Sci.*, 4th ser., 1 (1894): 775–78.

"Des mouvements que certains animaux exécutent pour retomber sur leurs pieds lorsqu'ils sont précipités d'un lieu élevé." *CRAS* 119 (1894): 714–17; *Paris-Photographe* 4 (1894): 403–5.

"Mécanique animale: Des mouvements que certains animaux exécutent pour retomber sur leurs pieds lorsqu'ils sont précipités d'un lieu élevé." *La Nature*, 10 November 1894, 369–70.

"La Station Physiologique de Paris." *Rev. Sci.*, 4th ser., 2 (1894): 802–8.

Le mouvement. Paris: Masson, 1894

1895

"La Station Physiologique de Paris." *Rev. Sci.*, 4th ser., 3 (1895): 2–12.

"The Work of the Physiological Station at Paris." *Annual Report of the Board of Regents of the Smithsonian Institution for 1894*, 1895, 391–412.

"Observation à propos d'une communication de M. d'Arsonval sur la décharge de la torpille." *CRAS* 120 (1895): 150–51.

"Observations à propos d'une communication de M. Ch. Frémont sur les applications que pourra recevoir un

nouveau microscope dans la chronophotographie." *CRAS* 121 (1895): 322–23.

"Allocution à propos de la séance anniversaire de la Société Royale de Londres." *CRAS* 121 (1895): 849–51.

"Allocution prononcée à l'occasion de la séance publique annuelle du 23 Décembre 1895." *CRAS* 121 (1895): 969–78.

Movement. Trans. E. Pritchard. New York: Appleton, 1895; London: Heinemann, 1895

1896

"Observations au sujet d'une communication de M. Bouny sur la mesure du travail dépensé dans l'emploi de la bicyclette." *CRAS* 122 (1896): 1395–96.

"L'étude des mouvements au moyen de la chronophotographie en France et à l'étranger. 1. La chronophotographie sur plaque fixe." *Revue Générale Internationale* 1, no. 1 (1896): 201–18.

"The Work of the Physiological Station at Paris." Pamphlet. Washington, D.C.: Government Printing Office, 1896.

1897

"Allocution." *BSFP*, 2d ser., 13 (1897): 103–5.

"Nouvelles modifications du chronophotographe." *BSFP*, 2d ser., 13 (1897): 217–25.

"Nouveaux développements de la chronophotographie." *Comptes Rendus du Congrès des Sociétés Savantes, Revue des Travaux Scientifiques, Section des Sciences,* 1897, 118–48.

"Nouveaux développements de la chronophotographie." Pamphlet. Paris: Imprimerie Nationale, 1897.

"La méthode graphique et les sciences expérimentales. Discours d'ouverture de l'Association Française pour l'Avancement des Sciences." In *CRAF Congrès de St. Etienne,* 1897, 155–64. Paris, 1897; *Rev. Sci.,* 4th ser., 8 (1897): 161–66.

"Pour une institution de contrôle et d'information des appareils enregistreurs." *Intermédiaire des Biologistes* 1 (1897): 2.

"Un appel aux physiologistes." *Intermédiaire des Biologistes* 1 (1897): 7–8.

"Inscription des phénomènes phonétiques d'après les travaux de divers auteurs." *Journal des Savants,* October 1897, 48–52.

"Extraction des projectiles contenus dans le crâne et dont le siège précis a été déterminé par la méthode de MM. Remy et Contremoulins." *BAM,* 3d ser., 38 (1897): 478–81; *CRAS* 125 (1897): 836.

Preface to *Phonétique expérimentale: La parole d'après le tracé du phonographe,* by H. Marichelle. Paris: Delagrave, 1897.

Preface to *Traité des variations du système musculaire de l'homme et de leur signification au point de vue de l'anthropologie zoologique,* by Anatole F. Le Double. Paris: Schleicher Frères, 1897.

1898

"Nécessité de créer une commission internationale pour l'unification et le contrôle des instruments inscripteurs physiologiques." *Journal of Physiology* (London) 23 (1898–99): 6–7, *Zentralblatt für Physiologie* 12 (1899): 483.

"La chronographie appliquée à l'étude des actes musculaires dans la locomotion." *CRAS* 126 (1898): 1467–79, 1836.

"Mesures à prendre pour l'uniformisation des méthodes et le contrôle des instruments employés en physiologie." *CRAS* 127 (1898): 375–81.

"Sur un mémoire présenté au nom de M. Marage: 'La voix des sourds-muets.'" *BAM,* 3d ser., 40 (1898): 443.

"L'inscription des phénomènes phonétiques." Part 1. "Méthodes directes." Part 2. "Méthodes indirectes: Critique des résultats." *Revue Générale des Sciences* 9 (1898): 445–56, 482–90.

"Analyse des mouvements du cheval par la chronophotographie." *La Nature,* 11 June 1898, 22–26.

Preface to *Le saut des obstacles: Recherches expérimentales,* by Maxime Guérin-Catelain. Paris: F. de Lauray, 1898.

Preface to *Comment on marche: Des divers modes de progression, de la supériorité du mode en flexion,* by Félix Regnault and Cdt. de Raoul. Paris: Charles-Lavauzelle, 1898.

1899

"La chronographie appliquée à l'étude des actes musculaires dans la locomotion." *Intermédiaire des Biologistes* 2 (1899): 7–14.

"Nouveaux perfectionnements de la chronophotographie" (1898). *Zentralblatt für Physiologie* 12 (1899): 493.

La chronophotographie (conference given at the Conservatoire National des Arts et Métiers, 29 January 1899). Paris: Gauthier-Villars, 1899.

"Cinquante ans d'application de la méthode graphique en physiologie." *C.R. Soc. Biol.* 50 (1899): 39–47.

"Chronophotographe à pellicules non perforées." *BSFP*, 2d ser., 15 (1899): 273–77.

"Le chronophotographe projecteur (sans perforation de pellicules)." *BSFP*, 2d ser., 15 (1899): 564–65.

Preface to *La photographie animée*, by Charles-Louis Eugène Trutat. Paris: Gauthier-Villars, 1899.

1900

"Des mouvements de l'air lorsqu'il rencontre des surfaces de différentes formes." *CRAS* 131 (1900): 160–63.

"Nouveaux développements de la méthode graphique par la chronophotographie." *Rev. Sci.*, 4th ser., 14 (1900): 257–63.

"Discours à l'occasion du décès de M. Milne-Edwards." *BAM*, 3d ser., 43 (1900): 490–93; *Rev. Sci.*, 4th ser., 13 (1900): 546–48.

"Sur les travaux de la commission internationale pour l'unification de la notation des appareils enregistreurs." *BAM*, 3d ser., 44 (1900): 464–65.

"Le chronographe projecteur à pellicules non perforées." *Bulletin du Photoclub de Paris*, February 1990, 38–42.

"Au sujet du service des eaux de Paris." [discussion.] *BAM*, 3d ser., 44 (1900): 145.

1901

"Allocution," *C.R. Soc. Biol.* 53 (1901): 1157–58.

"La chronophotographie et les sports athlétiques." *La Nature*, 13 April 1901, 310–15.

"Changements de direction et de vitesse d'un courant d'air qui rencontre des corps de formes diverses." *CRAS* 132 (1901): 1291–96.

"Les mouvements de l'air étudiés par la chronophotographie." *La Nature*, 7 September 1901, 233–34.

"Discours pour le décès de M. Potain." *BAM*, 3d ser., 45 (1901): 4–6.

"Discours prononcé à l'Académie de Médecine en quittant la présidence." *BAM*, 3d ser., 45 (1901): 8–16.

"Première session de la commission internationale de contrôle des instruments et d'unification des méthodes employées en physiologie." In *Rapport fait au Vème Congrès International des Physiologistes*. Turin, 1901.

"Discours au banquet de la Conférence Scientia, janvier 1901." *La Nature*, 2 February 1901, 156–59.

"Rapport lu en séance plénière de la Commission d'Hygiène et de Physiologie à l'Exposition Internationale de 1900 à Paris." Pamphlet. Paris: Imprimerie Nationale, 1901.

"Exposition d'instruments et d'images relatifs à l'histoire de la chronophotographie." In *Musée centennal de la Classe 12 (photographie) à l'Exposition Universelle Internationale de 1900 à Paris: Métrophotographie et chronophotographie*. Paris: Belin, [1901].

[With D. Mérillon] *Exposition Universelle Internationale de 1900 à Paris. Concours internationaux d'exercices physiques et de sports. Rapports publiés sous la direction de M. D. Mérillon. Commission Internationale d'Hygiène et de Physiologie, M. Marey rapporteur.* Paris: Imprimerie Nationale, 1901.

[With A. d'Arsonval and A. Chauveau] *Traité de physique biologique.* Vol. 1. *Mécanique: Actions moléculaires et chaleur.* Vol. 2. *Radiations: Optique.* Paris: Masson, 1901–3.

1902

"Rapport sur les travaux adressés au concours pour le prix Meynot." *BAM*, 3d ser., 48 (1902): 8–17.

"History of Chronophotography." *Annual Report of the Board of Regents of the Smithsonian Institution for 1901*, 1902, 317–40.

"Le mouvement de l'air étudié par la chronophotographie." *J. Phys.*, 4th ser., 1 (1902): 129–35.

"The movements of the air studied by chronophotography." *Scientific American* 86 (1902): 75–76.

"Premiers travaux de la commission internationale de contrôle des instruments enregistreurs et d'unification des méthodes en physiologie." In "Rapport présenté par M. Marey à l'Assemblée Générale de l'Association des Académies, le 16 avril 1901." Pamphlet. Paris: Gauthier-Villars, [1902].

"Discours." In *Hommage à M. Marey,* 13–17, 41–46. Paris: Masson, 1902.

Preface to *Le tir en temps de paix et en temps de guerre (Etude psycho-physiologique),* by Commandant Firmin Degot. Paris: Chapelot, 1902

1903

"Fonctions et organes." *Rev. Sci.* 19 (1903): 33–39.

1904

"L'économie de travail et l'élasticité." *La Revue des Idées* 1, no. 4 (1904): 161–76.

"Travail de l'homme dans les professions manuelles." *Revue de la Société Scientifique d'Hygiène Alimentaire* 1 (1904): 193–98.

"Catalogue des travaux publiés par Marey." *Archives Italiennes de Biologie* 41 (1904): 491–98.

Index